AESTHETICS, INDUSTRY, AND SCIENCE

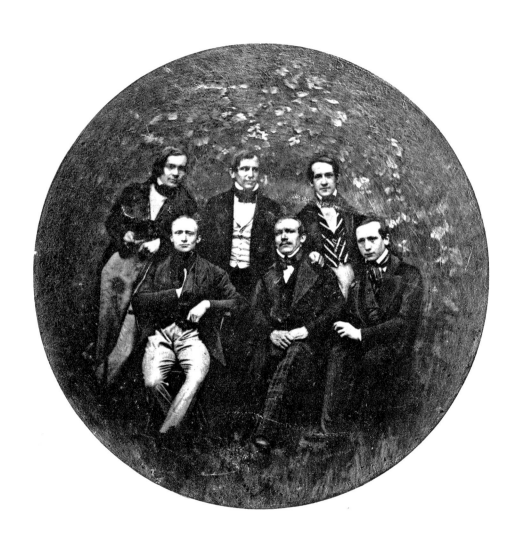

Aesthetics, Industry, and Science

HERMANN VON HELMHOLTZ AND THE BERLIN PHYSICAL SOCIETY

M. NORTON WISE

THE UNIVERSITY OF CHICAGO PRESS

Chicago and London

The University of Chicago Press, Chicago 60637

The University of Chicago Press, Ltd., London

© 2018 by The University of Chicago

Published 2018

Printed in China

27 26 25 24 23 22 21 20 19 18 1 2 3 4 5

ISBN-13: 978-0-226-53135-9 (cloth)

ISBN-13: 978-0-226-53149-6 (e-book)

DOI: 10.7208/chicago/9780226531496.001.0001

Library of Congress Cataloging-in-Publication Data

Names: Wise, M. Norton, author.

Title: Aesthetics, industry, and science : Hermann von Helmholtz and the Berlin Physical
 Society / M. Norton Wise.

Description: Chicago ; London : The University of Chicago Press, 2018. | Includes
 bibliographical references and index.

Identifiers: LCCN 2017029422 | ISBN 9780226531359 (cloth : alk. paper) | ISBN 9780226531496
 (e-book)

Subjects: LCSH: Helmholtz, Hermann von, 1821–1894. | Physikalische Gesellschaft zu Berlin. |
 Science—Germany—Prussia—History—19th century.

Classification: LCC Q127.G3 W485 2018 | DDC 509.2/2—dc23

LC record available at https://lccn.loc.gov/2017029422

To Elaine
and to
Erin and Licia

CONTENTS

INTRODUCTION

On January 5, 1845, the Prussian cultural minister Karl Friedrich von Eichhorn received a request from a group of six young men to form a new Physical Society in Berlin. By the time their statutes were approved in March, they numbered forty-nine and were meeting biweekly to discuss the latest developments in the physical sciences and physiology. They were preparing to write critical reviews for a new journal, *Die Fortschritte der Physik* (Advances in physics), and from the beginning they set out to define what constituted progress and what did not. Their success in this rather aggressive endeavor has long fascinated historians of science. In fields from thermodynamics, mechanics, and electromagnetism to animal electricity, ophthalmology, and psychophysics, members of this small group established leading positions in what only thirty years later had become a new landscape of physical science populated by large institutes and laboratories of experiment and precision measurement.

Methodology

How was this possible? How could a bunch of twenty-somethings, without position or recognition, and possessed of little more than their outsized confidence and ambition, succeed in seizing the future? What were their resources? I will explore that question largely with respect to their cultural and intellectual resources, looking at the prehistory and context for their initial successes. This focus on context involves two methodological perspectives. I aim, first, not for a story of causes or influences, in the sense of pushes and pulls, but of conditions of possibility. That is, I aim for a historical narrative within which the choices and actions of members of the Berlin Physical Society emerge as an unfolding of possibilities available to them within their context.

The second perspective concerns the choice of scale for this context. Rather than pursuing in the first instance the participation of the Berlin Physical Society in the European-wide development of instruments, measurements, and laboratories, I take an intensely local stance. Nearly all of the members were Berliners. They had been educated in Berlin and now aimed either for academic careers or to further their industrial interests within the city. By "intensely local" I mean that I will always look for the local sources of knowledge, methods, and materials on which they drew for their inspiration and their capacity to act. While they were not isolated from what was happening

in the scientific hubs of Paris and London, their access to those happenings and their evaluation of them depended on local sources. For example, how did Hermann Helmholtz, trained as a medical doctor, happen to know about Émile Clapeyron's rather obscure mathematical analysis of the Carnot cycle, and why did it matter? The answer to both questions almost certainly lies in part in a review article for the *Fortschritte der Physik* by Gustav Karsten, president of the Physical Society, who had been at the home of Gustav Magnus, godfather of the Society, when Rudolph Clausius discussed Clapeyron's paper as republished in Berlin in Poggendorf's *Annalen der Physik*. Such contingent conjunctions of particular people at particular times often lie behind major developments, such as Helmholtz's famous articulation of what would become the law of conservation of energy. The big stories are made up of a diversity of little ones, and it is in the little ones that we initially have to seek for possibilities and meanings. This is a version of the view familiar from many studies of scientific practice, especially in laboratories, that practice is local and tacit. I want to develop the theme, however, for the way in which intellectual values prominent in the Berlin Physical Society were located in the cultural life of the city.[1]

In pursuing this goal I will prioritize two facets that until recently have not usually been considered either together or in their interrelation with natural science: aesthetics and industry. More particularly, I will attempt to show how the concepts and methods of natural science pursued by the Berlin Physical Society expressed twin aims that pervaded the cultural environment with which they identified. The first, guided by neoclassical aesthetics and the neohumanist educational ideal of *Bildung* as self-realization, was to reshape the sensibilities of Prussian subjects as active citizens of a modern state (albeit a military state), and the second was to transform the Prussian economy by jump-starting industrialization. Aesthetic sensibility and material aspiration were intimately linked.

In pursuing this story, I have been continually inspired by a growing body of work in the cultural history of science. Recent books closely related to my project are Sven Dierig's *Wissenschaft in der Maschinenstadt: Emil Du Bois-Reymond und seine Laboratorien in Berlin* (2006), Myles Jackson's *Harmonious Triads: Physicists, Musicians, and Instrument Makers in Nineteenth Century Germany* (2006), Henning Schmidgen's *Die Helmholtz-Kurven: Auf der Spur der verlorenen Zeit* (2009), John Tresch's *The Romantic Machine: Utopian Science and Technology after Napoleon* (2012), Alexandra Hui's *The Psychophysical Ear: Musical Instruments, Experimental Sounds, 1840–1910* (2013), and Robert Brain, *The Pulse of Modernism: Physiological Aesthetics in*

Fin-de-Siècle Europe (2015). These works will not allow any assumption of a divorce between aesthetic and material aims.

Nevertheless, their interrelation requires elaboration in concrete terms for any particular case, which defines my purpose. To achieve it for the Berlin Physical Society will require drawing on the work of many other scholars in diverse areas. Except where necessary for clarification or missing information, I will offer little in the way of new archival findings. Rather, I will attempt to provide an interpretive synthesis of some of the most well-founded analyses by other historians who have done detailed studies in the various areas I survey, usually for quite different purposes. This synthesis, however, will involve significant extensions in many respects, most broadly concerning the role of aesthetics and industry in natural science but also in the reinterpretation of specific scientific developments that this broader perspective both motivates and informs. Such reinterpretations will be most telling in the final chapters, on Helmholtz, but they depend on positioning his action within the local context of Berlin and the resources there on which he and his compatriots were able to draw.

The historiographical aims that I mean to realize make somewhat unusual demands on the reader, for they require following a rather broad cultural portrayal in the early chapters into the details of scientific work toward the end. I hope to show that the cultural analysis is necessary to understanding in detail how the work was done. To those familiar with German cultural history, who may find the first five chapters on museums, *Bildung*, and neoclassicism to their liking, I ask that they carry it with them into the sometimes esoteric material of chapters 7 and 8, whose very unfamiliarity should enhance the meaning and significance of cultural assumptions. On the other hand, to those more familiar with the history of physics and physiology, I ask that they take considerable time to enter into the environment of art, architecture, technical education, and industrial processes in order to expand the meaning of particular instruments and methods. The book will be successful if it facilitates this double communication.

There is another historiographical issue of quite general interest. Recent scholarship on the history of Prussia has been highly revisionist. Based on empirically grounded studies, it makes a number of claims about how widespread assumptions of earlier scholarship have exaggerated and misrepresented the foundations of Prussia's rise to a dominant position in Germany and Europe during the nineteenth century. Beginning with the much-celebrated reforms of the Prussian Army before and after the Napoleonic Wars, we can no longer assume their uniqueness, their effectiveness, or their

actual contribution to modernization of weaponry or industrial production. Similarly, we cannot assume that state-sponsored technical education was actually a primary factor in early industrial development, at least before mid-century and the onset of the Second Industrial Revolution in the science-based chemical and electrical industries. And we should divorce ourselves from the traditional view that the famous Deutscher Zollverein (German Customs Union) after 1834 made a major difference, if any difference at all, either to economic growth or to German unification under Prussia. These and other revisionist contentions are of major significance. I have no reason to doubt their overall validity.

The question remains, however, of the significance of the now-controversial beliefs—about military modernization, technical education, and trade agreements—for those people during the 1830s and 1840s who considered them to define the major trends they were experiencing and who shaped their own lives and aspirations around them. That is in large part the case for the members of the Berlin Physical Society. An account of the local context that created and validated these beliefs here runs into a problematic relation with long-term outcomes. It will be clear throughout that I have chosen as my subject the constitution of belief as motivation and expectation rather than empirical economic and political outcomes. Nevertheless, I will try to point out the differences as they emerge, particularly in chapters 3 (industry), 4 (military), and 6 (Zollverein).

Finally, the story I write concerns the place of a group of ambitious young men, who sought their careers and identities in the sciences, within those multifaceted concepts of the "public" (*Öffentlichkeit*) and the middle-class "citizenry" (*Bürgertum*) that have long occupied historians. Particularly relevant here is their attention to the *Verein* movement, the proliferation of local voluntary societies devoted to music, reading, art, gardening, science, and other activities of enlightenment and self-realization. The *Verein* was one of the primary organizations through which the public acquired their consciousness of possessing the rights and responsibilities of citizens in a modern state and of being the agents of progress in the *Vormärz*, the decades preceding the March Revolution of 1848. The Berlin Physical Society was such a *Verein*, including common attributes such as election of members and officers, recording of the minutes of meetings, and publication of its own journal of progress, the *Fortschritte der Physik*. Recent scholarship stresses the heterogeneity of the *Vereine* along with the tensions that were inherent in their simultaneous ideals of individuality and sociability, openness, and exclusivity.[2] Enlightenment liberalism thus stood in uneasy relationship with

the credentialing by education and property that a *Verein* typically imposed. Nevertheless, in their very heterogeneity and tensions, they represent that spectrum of the public who have been identified with the dynamics of *civil society*. Jürgen Kocka and others have used that term analytically, both as an evolving yardstick for development and comparison over the nineteenth and twentieth centuries and as an integrative concept for social and cultural history:

> Of central importance was the vision of a modern, secularized society of free and self-reliant individuals who would manage their relations with one another in a peaceful and reasonable way, through individual competition as well as through voluntary cooperation and association, without too much social inequality and without the tutelage of an authoritarian state.[3]

Crucial aspects included individual rights, public debate, rule of law, constitutional and parliamentary government, and often market capitalism. But cultural practices and aesthetic values also played their ever-present and changing roles. For early nineteenth-century Prussia, if one unites the dominance of neoclassical aesthetics and the neohumanist concept of *Bildung* with the goal of civil society, the result may best be expressed as what Hans Baron famously labeled *civic humanism* (*Bürgerhumanismus*), which is a term I will employ in early chapters below. It captures more specifically the cultural context within which the members of the Berlin Physical Society shaped their actions. It underrepresents, however, the social dynamics of industrialization in which an emerging proletariat, class formation, and the "social problem" were becoming apparent. Although these structural social developments appear tangentially, I will not address them specifically. The social and political issues that directly concerned Society members were those of their own station, of civil society as civic humanism.

Chapters

To gain initial entry into the cultural life of Berlin, I begin in chapter 1 with a very large painting of a celebratory occasion in 1824, *Parade auf dem Opernplatz* (completed in 1830). Against the background of a military parade down Unter den Linden, it depicts a crowd of spectators, many of whom would have been easily recognizable to any knowledgeable citizen. They constitute a considerable spectrum of "the public" (*die Öffentlichkeit*) of interest here, especially the *Bildungsbürgertum*, the educated elite, who populated the institutions of city and state from administrative departments

to the opera to academies of art and science. Everything about this painting is important, including buildings, statues, and individuals who will appear in the remainder of the book.

Taking the painting as an image of the public, I structure the book in a series of chapters conceived as ever-more specific layers drawn from it, reaching only at the end for some extraordinary scientific achievements of Hermann Helmholtz. Early chapters therefore focus on public institutions within and around which major debates occurred, debates that set the agenda for what were regarded as progressive modernizing policies among dominantly liberal elements of the citizenry, whether politically, economically, militarily, or culturally. Not surprisingly, the claim to modernity itself served as a powerful lever of action, with the call of *Wissenschaft*, of human and natural science, increasingly potent. Despite widespread critiques of modernization theory, the internal dynamics of "progress" remain salient. They defined a key context for the program of the Berlin Physical Society and its explicit organ of progress, the *Fortschritte der Physik*.

Thus, chapters two and three, as two parts of "Pegasus and the Muses (Museums) of Art, Industry, and Science," begin from a broadly public view of progress. They pick out two individuals from the spectators of Krüger's *Parade* as foci for exploration of two of the institutions of technical education that emerged in the 1820s from struggles between the ministries of culture and trade over the proper conception of *wissenschaftlich* education. The result would be a problem-oriented and practical approach in both the School of Building (Bauschule) and the Industrial Institute (Gewerbeinstitut), albeit with different aims (public and private) and at different levels of scientific training (higher and lower).[4]

The architect Karl Friedrich Schinkel provides the focus for chapter 2. It begins from the still-famous buildings that he designed to reimagine the state in neoclassical dress and ends with the rejuvenated Bauschule, for which he produced another classicizing and highly innovative architectural structure. With reference to these buildings, "Pegasus" refers to Schinkel's repeated use of the winged horse as the symbol of progressive action within his vision of civic humanism and *Bildung* (as self-realization through education). Pegasus played this role as the inspiration for the Muses. As such, he stands, within Schinkel's conception, for the significance of museums as incubators for an experimental approach to art and science. The chapter develops this conception both for Schinkel's great art museum (the Altes Museum) and for museums generally, including the museums that dominated the new University of Berlin and played a prominent role at the Bauschule.

I elaborate here a point made by others in different contexts, that the pursuit of experimental science emerged from within the museum. At the Bauschule the museum theme for architecture intersects with collections of precision instruments, materials, and models for the teaching of geodesy, chemistry, mineralogy, and mechanics as explicitly "technical" subjects. Not least we first meet the young star of mathematical analysis, Gustav Lejeune Dirichlet, as one of the people who brought to Berlin that integrative subject for the arts and sciences, descriptive geometry. It will come as no surprise to find also behind Dirichlet and others at the Bauschule the patronage of Alexander von Humboldt, whose role in the promotion of science in Berlin would be difficult to exaggerate.

Chapter 3 continues this story of museums for the institutions led by Schinkel's intimate friend and collaborator Peter Beuth, the leading promoter of Prussia's industrialization. In the House of Industry (Gewerbehaus) Beuth directed three institutions: a body of official advisors to the state on industrial development, known as the Technical Deputation (Technische Deputation); a Society for the Advancement of Industry (Gewerbeverein), consisting largely of private workshop and factory owners who were interested in enhancing their methods but with the leadership of professors and administrators; and the Gewerbeinstitut, devoted to providing basic training in the sciences for students who would take their place in the industrial economy as a new generation of craftsmen, factory managers, and entrepreneurs. Here again the conception of the museum collection as the source of inspiration for future-oriented education and industrial development played a crucial role. Models and drawings of machines for factory production occupied center stage. Alongside them, however, stood exemplars of classical art and architecture to inform the aesthetic value of commodities produced. At the same time, workshops and laboratories provided opportunities for experiment and for hands-on training of advanced students.

Here, revisionist history raises the issue of outcomes. Did state-sponsored schools like the Gewerbeinstitut actually make a significant difference to early industrialization? I will note the question but not attempt to resolve it. I am primarily concerned with the vision of science-based education that the Bauschule and the Gewerbeinstitut embodied in their curricula and with the way in which that vision extended into the University, where practical training was virtually nonexistent before the 1840s except in the private homes of professors. It is significant, therefore, that a number of the University professors who inspired the young members of the Berlin Physical Society also taught courses in mathematics and natural science at the Bauschule and the

Gewerbeinstitut. I suggest that they acted as mediators who carried some of the goals of the technical schools into their own careers and into the training that they began to promote at the University.

A different stratum of Berlin society appears in chapter 4 on "Modernizing Military Schools." It may surprise many readers to find that despite the conservative reputation of the Prussian Army, the military schools were administered by some of the most progressive liberals in Berlin. The chapter focuses initially on General Gerhard von Scharnhorst, who led the modernization of the army before the Befreiungskriege (Wars of Liberation from Napoleon) and whose gleaming statue, with Pallas Athena lecturing to students, stands so prominently behind the public in the *Parade*. The image expresses the lasting liberal belief that the army could or should contribute to social and political reform. Recent historiography argues that the belief was exaggerated in the first place and that the reforms did not succeed in eroding aristocratic privilege. But strong liberal groups existed throughout the army, with the schools in Berlin being a particularly notable case.

Scharnhorst founded the Kriegsschule (War College) in 1810 as the military parallel to the new University of Berlin, established in the same year, and with a similar emphasis on *Bildung*. The Kriegsschule and the United Artillery and Engineering School (Vereinigte Artillerie- und Ingenieurschule), which split off in 1816, aimed at raising up elite army officers as citizen-soldiers, including nonaristocratic officers. They placed mathematics and natural science at the core of their curricula and adopted subjects and teaching methods that had proved effective in Napoleonic France. As professor at the Kriegsschule, for example, Dirichlet introduced differential and integral calculus and taught descriptive geometry. More generally, the "method of application," which focused on problem sessions and ultimately laboratory exercises, helped to maintain a close connection between theory and practice. But most importantly, it aimed to nurture independence and self-motivation. Not surprisingly, a number of the University professors whom the members of the Physical Society took as their mentors in natural science also taught at these military schools and mediated the relation to the University.

The reforming drive of the military schools lasted until the early 1830s, when the tide of conservative restoration largely halted it. Recognition in current scholarship of the strength of that conservatism has undermined as well the belief that the army was a serious source of technical innovation. And yet in local terms, innovation occurred.

One of the products of the Artillerie- und Ingenieurschule was Lieutenant Werner Siemens, who was among the young officers who joined the Physical

Society in 1845. With one of the several instrument makers who also joined, he would found in 1847 the telegraph company that originally supplied the army and ultimately became the Siemens Corporation. His own mechanical and electrical inventions supported not only his entrepreneurial pursuits and his work for the Artillery Testing Commission but also some of the precision experimental measurements of Hermann Helmholtz. Helmholtz himself was trained at another of the military schools in Berlin, the Friedrich-Wilhelms-Institut for army doctors. Although its students attended lectures taught almost entirely by University professors, they also acquired much more clinical and laboratory experience.

Following the preceding account of how the pursuit of modernity infused both civilian and military technical education, chapter 5 serves as a kind of hinge connecting that broad cultural and institutional foundation to quite specific aspects of the ideology of the Berlin Physical Society that were built on it. What's in a Line? provides an extended interpretation of the iconography that was inscribed in the certificate of membership of the Society by its most charismatic member, Emil du Bois-Reymond, who had wanted to be an artist before he turned to physiology.

The interpretation develops a characteristic feature of the neoclassical aesthetics prominent among Berlin artists: their emphasis on the line as the origin and the proper foundation for drawing and painting. This emphasis infused all of the technical schools as well as the Academy of Art. One of its many expressions was the descriptive geometry that they all adopted, where mathematical rigor met aesthetic sensibility. Among members of the Society, as among admired predecessors such as Alexander von Humboldt, it took the form of an attempt to represent laws governing physical processes in terms of curves, curves produced by instruments capable of expressing the dynamics of nature in visual form. In Du Bois-Reymond's iconography, this central role of the line appears as the historical confluence of neoclassical enlightenment with industrial progress, and it epitomizes the *Fortschritte der Physik* (Advances in physics) that the Society, as a progressive *Verein*, hoped to generate.

Turning to the full spectrum of membership in the Society, in chapter 6 I seek to characterize the wide variety of interests they represented and the resources they found for their instrument-based research. I begin the chapter, however, from the experience of the organizers with two inspiring professors: Johannes Mueller for anatomy and physiology and Gustav Magnus for technology (including chemistry and physics). Mueller's "laboratory" returns to the emphasis of chapter 2 on the museum as the original location

for much experimental work, starting here from anatomical analysis using microscopes produced by Berlin's best instrument makers. Magnus, on the other hand, provided something quite unusual, a private laboratory and lecture room in his luxurious new home, where he established a regular Physical Colloquium and provided selected students with the opportunity to do chemical and physical experiments with modern apparatus. Magnus's house was in many ways the cradle of the Physical Society, not least because he also provided access to the industrial life of the city, including its instrument makers, and to military engineering as well.

Themes of chapters 3 and 4 here reappear in chapter 6 in relation to Beuth's Gewerbeverein, where Magnus occupied a key position, and to the Artillerie- und Ingenieurschule, where he had taught chemistry and physics. The great exhibition in 1844 of industrial production from the Zollverein was dedicated to Magnus. In its celebration of the assumed contributions to industrial development of the Zollverein, it epitomizes that problematic history. Nevertheless, the affiliation with it of Magnus and his protégés suggests a quite prominent aspect of the original Physical Society. It is one that has not received sufficient attention in the literature. Of the original Berlin members, well over half came with a distinctly technical-industrial orientation, whether for new industries, the army, or instrument making. Industrial interests, for example, extended from electroplating to the efficiency of blast furnaces and from the fermentation of wine to producing mineral water. I take this technical-industrial environment, along with the role of precision measurements, to have been pervasive in the Physical Society and to have deeply informed the more strictly "scientific" work of the members, including their preference for sharp critique and rigorous experiments.

That said, it is also striking that analysis of industrial processes did not constitute the primary research goal of the organizers of the Society. Within a very few years both instrument makers and army lieutenants disappeared, as did most of the explicitly industrially oriented research. Specialization and professionalization were developing in Berlin along with the rest of Europe. Nevertheless, the local context of industrialization continued as a resource for both concepts and instruments.

In order to carry the dual themes of industry and aesthetics to their most forceful conclusion in specific works of physics and physiology, in two final chapters I give reinterpretations of the most famous early achievements of Hermann Helmholtz. In chapter 7 I take up his enunciation in 1847 of the *Erhaltung der Kraft* (*Conservation of Force*, later *Energy*). Throughout the chapter, I locate his resources within the local context. More particularly,

it resituates three issues that have been widely discussed in the Helmholtz literature: the *Lebenskraft* (vital force), the concept of work, and Kantian metaphysics. A thread running through all three is the problem of *Begreiflichkeit der Natur* (comprehensibility of nature). Helmholtz's early experimental work on animal heat provides a pointed expression of the problem of the *Lebenskraft* in relation to his increasing turn to topics that occupied the Physical Society and to precision physical measurements. The requirement for *Begreiflichkeit* became the expression in mechanical terms of interconversions between different forms of force: mechanical, chemical, thermal, electrical, and magnetic.

In resolving this problem Helmholtz turned to French engineering sources well known in the technical schools in Berlin, specifically I believe to writings of Ferdinand Minding, who was teaching analytical mechanics at the Bauschule as well as at the University. Minding brought "rational mechanics" and "industrial mechanics" together, giving the concept of "work," which the French engineers had developed to analyze the transmission of value through a factory, a quite general place in mechanics. In developing this analysis of work, Helmholtz did something unusual: he articulated a conception of *Kraft* as a quantity-intensity duality, as simultaneously a capacity to produce a quantity of work and to produce a tension. This dualistic mode of conceiving otherwise familiar terms lay behind his original conceptions of "potential" and of what he called *Spannkraft*. It informs as well his adoption of concepts embodied in the dynamometers and indicator diagrams that engineers used to measure the work done by machines and engines.

From this perspective, Helmholtz's *Erhaltung der Kraft* can be seen as a reworking of Enlightenment concepts of rational mechanics for the era of working machines. And that view suggests another such reworking, a reworking of the categories of quantity and intensity in Kant's *Metaphysische Anfangsgründe der Naturwissenschaften* (*Metaphysical Foundations of Natural Science*). Drawing heavily on Michael Friedman's comprehensive interpretation of the *Metaphysical Foundations*, I propose a reading of Helmholtz's key term *Spannkraft* as an attempt to provide a metaphysical grounding for his conservation argument in Kantian terms, replacing Kant's fundamental determinations of "quantity of matter" with "quantity of force" (as work). *Begreiflichkeit* thereby acquired both mathematical and metaphysical expression while eliminating the *Lebenskraft*. The reified concept of work took its place at the center of mechanics.

Reuniting this theme of the working machine with the aesthetics of the line, in chapter 8 I take up Helmholtz's experimental determinations of the

course of contraction of frog muscles and of the velocity of propagation of the nerve impulse, in which curves drawn by the contracting muscles became the central referent. In "A Spectacle for the Gods," I aim, first, to show how, beginning in 1848, Helmholtz developed his conceptions and his instruments for muscle contraction in the dualistic terms of the *Erhaltung der Kraft*. Surprisingly, the relation of these two early works has never found a satisfactory accounting in the literature, and yet it inaugurated the field of physiology of work and energy. Admittedly, the analysis requires patience, but it also shows how deeply the technical-industrial context penetrated into the details of Helmholtz's remarkable work.

Second, I aim to show how Helmholtz's understanding of the curves recorded by his frog drawing machines (*Froschzeichenmaschine*) expressed the aesthetic values that he espoused at the same time for his teaching of anatomy at the Academy of Art. Those values revolved around his conception of artists' capacity for *lebendige Anschauung* (lively intuition), which enabled them to recognize the ideal *Form* lying behind any expression that this *Form* might take in a particular *Gestalt*. The appeal to *Form* played a critical role in justifying his otherwise subtle and quite unstable measurements.

In a brief epilogue on *Kunst-Technik*, I round out Helmholtz's aesthetic conception of the relation of art and science with reference to a famous lecture, "Optisches über Malerei" ("On the Relation of Optics to Painting"). The discussion focuses on his idea of *anschauliche sinnliche Verständlichkeit* (intuitive, sensual intelligibility), a term with greater breadth than the conceptual intelligibility of *Begreiflichkeit*. The capacity to realize such *Verständlichkeit*, in Helmholtz's exposition, depended not simply on an untrained insight but on mastery of *Technik*, the tools, skills, knowledge, and acquired sensory awareness that made authentic intuition possible. In the interrelation of these ideas of *Verständlichkeit* and *Technik*, we see how the context of aesthetics, industry, and science within which the Berlin Physical Society shaped its agenda came to expression in some of Helmholtz's most important work. I close with a look backward at some of the key moments in that wider development.

NOTES TO INTRODUCTION

1. A valuable parallel to this perspective is Philips, *Acolytes of Nature*, in which from a broad perspective on German intellectual and social life, she seeks to locate the origins and developing meaning of *Naturwissenschaft* (natural science).

2. On *Vereine* in the *Vormärz*, see Hoffmann, *Geselligkeit und Demokratie*, 35–55. On

the "public" more broadly, see the illuminating survey by Melton, *Rise of the Public*, and the analytic review by La Vopa, "Conceiving a Public."

3. Kocka, "Difficult Rise of a Civil Society," 280.

4. Klein, *Humboldts Preussen*, provides a thorough analysis of ambitions and conflicts over technical and scientific training among Prussian administrators in the late eighteenth and early nineteenth centuries, providing important background to my discussion in these two chapters.

PARADE AUF DEM OPERNPLATZ

On a sunny morning in the late summer of 1824, a great parade of heavy cavalry rode down Unter den Linden, the boulevard of royal display and of public self-presentation in Berlin, running from the Brandenburg Gate in the west to the Royal Palace of King Friedrich Wilhelm III in the east. The spectacle celebrated a long-delayed visit of the King's eldest daughter Charlotte (Czarina Alexandra of Russia from 1825) and her husband Archduke Nicholas (Czar Nicholas I), whom the King treated like a son. It also symbolized the continuation of the Prussian-Russian alliance, which had endured since the Wars of Liberation from Napoleon (Befreiungskriege), 1813–1815. To mark the occasion, Nicholas commissioned Franz Krüger, a painter favored at the court for his portrait-like renderings of high-spirited horses and their equally high-born riders, to capture the spectacle (fig. 1.1). Nicholas himself led the 6th Brandenburg Cuirassier Regiment, of which the king had made him formal commander upon his betrothal to Princess Charlotte in 1817. Krüger's *Parade auf dem Opernplatz* gives a panoramic view, a carefully constructed wide-angle perspective. Measuring two and a half by three and three quarters meters, it took six years to complete and set a new standard for the genre. It will provide the stage here on which the young men who would found the Berlin Physical Society in 1845 formed their identities and their ambitions.[1] They and their science are my ultimate goal.

The painting captures the eye from a distance for its bright and animated realism, almost photographic in architectural detail and full of motion. On reflection, however, the picture has a strange composition. It inverts the expected social order. Structurally, Krüger has borrowed a technique familiar from landscape paintings, in which a valley or stream running diagonally before a mountainous terrain focuses attention on the action of symbolic figures in a sylvan foreground. Similarly, he uses the strong diagonal formed by the parade route to separate background from foreground. But the royal court, who formed the actual social focus of the spectacle and in the tradition of such paintings of historical events should have been foregrounded, are displaced into

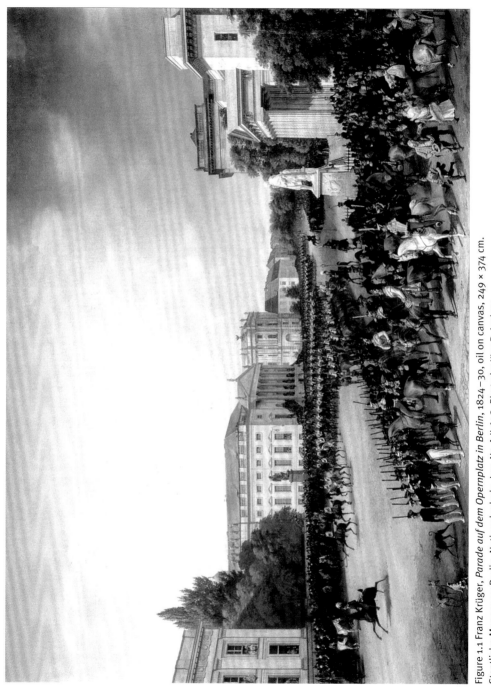

Figure 1.1 Franz Krüger, *Parade auf dem Opernplatz in Berlin*, 1824–30, oil on canvas, 249 × 374 cm. Staatliche Museen zu Berlin, Nationalgalerie, Inv.-Nr. A II 648. Photo by Jörg P. Anders.

the background. They sit on their horses in the near anonymity of the shadows cast by the grand buildings defining the far side of the street, although on very close inspection each is presented in a miniature portrait. Friedrich Wilhelm is visible astride a light brown horse between the Prinzessinenpalais on the left, private residence of his second wife, and the tall statue on the tree-shaded Opernplatz of General G. L. von Blücher, one of the heroes of the Befreiungskriege. Nicholas, rather than riding at the head of his troops, is riding in the opposite direction to salute the king, with his back to the viewer. The royal princes and top generals, so dark as to be almost unrecognizable, observe from their horses to the left and right of the king.

In sharp contrast, the viewer's interest lights immediately on the highly individualized crowd on the right. They pay little attention to the theater of absolute monarchy before them but attend to their own theater of seeing and being seen. Krüger apparently shares their vision of themselves as the new center of social importance, for he presents each of them in miniature portraits as well. They form a kind of microcosm of that diverse body called the "public" (*Öffentlichkeit*; see the introduction) and are people who would be recognized by anyone familiar with public life in Berlin in the late twenties. Over fifty have been identified. They include a number of aristocratic administrators and advisors who saw themselves as representatives of the new Prussia governed by a professional elite of civil servants composed of well-educated citizens, the so-called *Bildungsbürgertum*.[2]

The movement from background on the left to foreground on the right thus portrays a kind of social transition: from the military rulers to a collection of mounted middle-level officers in the center mixed with standing notables to the more fully civilian society on the right. Modern viewers may be likely to see in this a challenge to the authority of Friedrich Wilhelm and Czar Nicholas. But that cannot be quite how the rulers saw it, since the czar and czarina both expressed their delight with the painting. Friedrich Wilhelm even commissioned Krüger to repeat it for "Eine preussische Parade" in 1839. He certainly did recognize, however, that the *Bildungsbürgertum* had acquired a position in society, and an attendant administrative role, that was as necessary to the well-run state as their promotion of political responsibility in a civil society was problematic.

The Public

As discussed in the introduction, the task of this volume will be to locate the pursuit of natural science within this state-centered construction of public consciousness by looking for the resources of the ambitious young

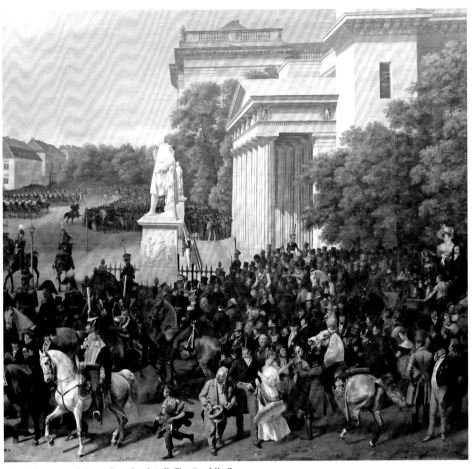

Figure 1.2 Krüger, *Parade*, detail. The "public."

reformers who founded the Berlin Physical Society in 1845. In his *Parade,*
Krüger has collected together a number of the major figures for this cultural
location. Literally, the painting locates them in relation to buildings that sym-
bolize architecturally the new position of the educated elite in society and
that here stand behind them (fig. 1.2). The prominent Doric columns define
the portico of the Neue Wache, built between 1816 and 1818 by Karl Friedrich
Schinkel, whose neoclassical buildings were reshaping civic consciousness.
Literally the "new guardhouse" of the royal guard but figuratively the "new
guard," the Neue Wache symbolized in the minds of liberals the new citizen
army (including some middle-class officers) that had defeated Napoleon in

the Befreiungskriege, also called, with the stress on domestic liberalization, the Wars of Freedom (Freiheitskriege).

The "new guard," in this vision, would be the agents responsible for maintaining constant vigilance against external aggression and for building the Prussian future, despite increasing signs of reactionary absolutism. As a visionary participant in this movement toward a modernized state, Schinkel had designed the Neue Wache as a bridge between civilian and military life.[3] It stands between the new University of Berlin rising behind it, established in 1810 on the educational theories of Wilhelm von Humboldt, who was then directing cultural affairs in the interior ministry, and the eighteenth-century Armory (Zeughaus), symbol of Prussian military might under Frederick the Great. The armory itself is not actually visible, for we view the scene from one of its upper windows, where Krüger stood to construct his panorama. But we should see Schinkel's neoclassicism in its intended function, uniting military and public virtue and testifying to the Humboldtian ideal of *Bildung*, of the cultivated self, as the model of the self-motivated citizen in a modern state.

This ideal appears most explicitly in the glistening white statue of General Gerhard von Scharnhorst as a latter-day Greek hero. Krüger has made him the central focus of the painting, much enlarged by its wide-angle perspective. He stands before the Neue Wache as an integral part of Schinkel's design, paired with another hero of the wars, General Friedrich Wilhelm von Bülow, largely obscured behind him. Scharnhorst had led the reorganization of the army that followed its humiliation by Napoleon in 1806, pressing constantly for the eradication of aristocratic privilege, for utilization of the talents of commoners in the officer corps, and for activating the latent strength and self-motivation of the entire citizenry in the army. After his death from wounds suffered in the battle of Groß-Görschen in 1813, he was lionized as the hero of liberation but also of liberal reform. Particularly significant for the painting was his foundation of the Kriegsschule in 1810 as a kind of military university for training young officers whose position would be based on accomplishment rather than birth. Although on a smaller scale, the Kriegsschule emphasized many of the same virtues of *Wissenschaft* (science, both natural and human) and *Bildung* that marked Humboldt's plans for the University at the same time except that Scharnhorst placed mathematics at the center of the military curriculum in parallel with classical languages at the University.

Scharnhorst's statue provides an image of civic humanism. The sculptor Christian Daniel Rauch, friend of Schinkel and client of Humboldt's, presented him as a classical warrior-intellectual. His educational role appears

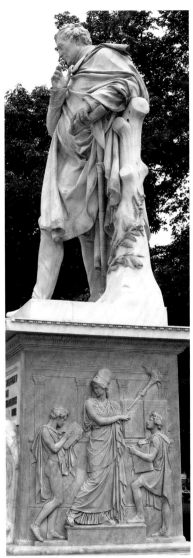

Figure 1.3 Sculpture of General Gerhard von Scharnhorst by Christian Daniel Rauch, 1822. Author's photo.

on the side of the tall pedestal supporting his statue, fully visible in Krüger's painting and in figure 1.3. Pallas Athena, goddess of war but representing also practical reason and democracy, lectures to two young students while carrying the torch of enlightenment. Her book carries the names of military reformers from Montucla to Frederick the Great to Scharnhorst. If her lecture follows Scharnhorst's guidelines, she might be presenting a theme that will form a connecting thread for this volume: mathematical analysis is to the natural sciences and physical action what linguistic analysis is to the human sciences and moral action. Among Prussian educational reformers, the two sorts of analysis were often treated like two grammars, with many interrelations but serving different ends. Rigorous study of classical language and literature opened the mind to objective reflection on everyday human behavior, but from a distant and higher perspective, appropriate to a citizen of the world. So too mathematics—always including mechanics and geometrical drawing— trained students to reason logically and abstractly about the behavior of particular physical objects. For Scharnhorst, much of this educational methodology represented an attempt to incorporate into the Prussian Army lessons learned from their enemies in France, where the citizen army had been a key element in the defense of the revolution and where the new *École polytechnique* provided the engineering model for training officers.

Taken as a whole, then, and in its positioning between the University and the armory, the Neue Wache embodied in art and

architecture an idealized vision of the relation between civic and military life in a revitalized Prussian state. But if its white marble still glistened in the sun in the 1820s, its original symbolism had already begun to lose some of its uplifting spirit. The representative figures of Scharnhorst and Humboldt were no longer setting the goals of the Kriegsschule and the University. Conservative aristocrats who gained the king's ear following the Befreiungskriege/Freiheitskriege had been able to thwart plans for a full-fledged citizen army just as they fended off the widespread expectation for representative, constitutional government that had attended the war. Most infamous were the Karlsbad Decrees of 1819, pushed on the German Confederation by the Austrian foreign minister, Prince Metternich, in response to a supposed threat to the established monarchical order signaled by the murder of a conservative journalist by a deranged student. The decrees sharply limited the freedoms of students, professors, and the press. Still, Friedrich Wilhelm did not allow the voices of aristocratic conservatism to dictate policy. Instead, he swayed one way or the other, depending on the threat to his own rule, effectively using the claims of modern civil society against those of historic aristocratic legitimacy and vice versa.[4] But there were real losses among the reformers.

Scharnhorst had been replaced as minister of war immediately after his death by his liberal intellectual heir, General Karl von Boyen, but Boyen resigned in protest of the Karlsbad Decrees in 1819 to be replaced by the more moderate General Albrecht Georg von Hake. For his part, Humboldt, who had been serving in the foreign ministry and was supported by Boyen, badly misjudged the political situation leading to the Karlsbad Decrees, and he blamed Hardenberg, who took deep offense and forced him to resign. Humboldt largely retired from active public life to his Charlottenburg villa and his family estate at Tegel, northwest of Berlin. There his client and friend Schinkel performed a masterful neoclassical renovation to provide a proper setting for Humboldt's persona and his collection of classical art. Meanwhile, Humboldt's old position in cultural affairs had become a full ministry in 1817, with Karl Freiherr von Altenstein in charge. In Krüger's painting, Altenstein sits tall on a white horse toward the back of the crowd, dressed in black coat and top hat (fig. 1.4).

By the time Krüger completed his work in 1830, the torch of public intellectual in the Humboldt family had passed from Wilhelm to Alexander, who returned from Paris in 1827 as a Renaissance man of science, having completed the extraordinary expedition to South America that won him the acclaim of professional and public audiences alike. He appears in the painting (fig. 1.5) on the left of a group of six prominent men surrounded by horses.[5]

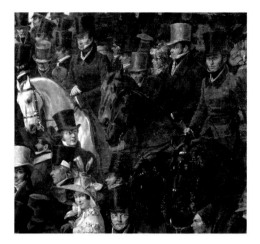

Figure 1.4 Krüger, *Parade*, detail. Altenstein (white horse), Krüger (mounted, brown coat), and Johanna Krüger (white dress).

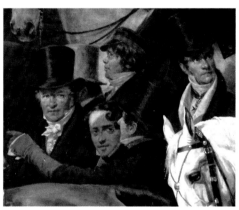

Figure 1.5 Krüger, *Parade*, detail. A. v. Humboldt (*left*, in top hat), Beuth (in red-banded cap), and music notables.

The shift from Wilhelm to Alexander may be taken as a sign of the increasing recognition of the importance of science for the state and of an already developing shift in educational policy from the ideal to the real, with more attention to practical concerns. In this, Alexander von Humboldt became a ubiquitous presence as chamberlain to the king, advisor to his ministries on the advancement of science, and the leading patron of promising young scientists, including at least two of those who would constitute the Berlin Physical Society in 1845: its most charismatic leader, Emil du Bois-Reymond, and its most profound intellect, Hermann Helmholtz. Krüger has recognized Humboldt's prominent public role by placing him at the 1824 parade even though he did not return to Berlin until 1827. He will reappear continually in the chapters to follow.

If the Neue Wache represents a bridge between the ideals of civilian and

military culture and more specifically between the University and the Kriegs-schule, it may be taken as well to suggest a whole variety of similar bridges that Schinkel, the Humboldt brothers, and their peers were attempting to build between intellectual and material development for a state guided by civic humanism. Among these bridges was the Vereinigte Artillerie- und Ingenieurschule (United Artillery and Engineering School), which split off from the Kriegsschule in 1816. For over twenty years it remained under the joint directorship of two of the leading advocates of middle-class officers, Prince August of Prussia, cousin of the king, who headed the artillery and provided a social center for the "court liberals," and General Gustav von Rauch, head of the engineering corps and one of the radical parliamentari-ans around von Boyen. They may well be among the mounted reviewers of the parade accompanying the king, for the reaction following the Karlsbad Decrees did not expunge liberal reformers from the military any more than from government administration and certainly not from the Berlin military schools. Along with their goals for civil society, they continued to advance science-based professional education into the 1830s. Emblematic of this pro-cess of reform at the Vereinigte Artillerie- und Ingenieurschule is the fact that Werner Siemens could acquire there the basic technical training that brought him into contact with the other members of the Berlin Physical Society and launched him on his entrepreneurial career. In a similar way, the Friedrich-Wilhelms-Institut for army doctors would launch Helmholtz.

The school that Siemens had actually wanted to attend was the civilian counterpart of the Artillerie- und Ingenieurschule, the Allgemeine Bauschule, where Schinkel became the leading light following its reconfiguration in 1819. Schinkel's presence in Krüger's painting (fig. 1.6, in black top hat behind the actress Karoline Bauer) can serve here to recall his role in technical educa-tion. The Bauschule trained architects, civil engineers (*Baumeister*), and in-spectors of construction primarily to serve the needs of the state. They were the builders of the fast-growing city surrounding Krüger's painting, including streets, canals, bridges, and machinery as well as buildings.

Closely connected with the Bauschule but engaged in state promotion of private industry was the Gewerbeinstitut (Industrial Institute), founded and directed from 1820 by Peter C. W. Beuth, who also directed the Bauschule from 1831. The infinitely energetic Beuth, Schinkel's intimate friend, occu-pied a key administrative role in the Ministry of Trade. Krüger has placed him with Alexander von Humboldt (fig. 1.5), wearing his red-banded cap, thereby grouping together the major forces of industry and science in Ber-lin. Beuth's Gewerbeinstitut trained a carefully selected group of students in

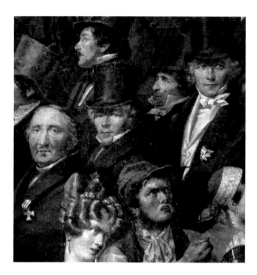

Figure 1.6 Krüger, *Parade*, detail. Schinkel (*center*, in top hat), Schadow (*left*, with iron cross), Rauch (*right*, top hat), and Bauer.

basic sciences and in the latest techniques of metalworking, chemical processes, and industrial machinery. He hoped that the best among them would provide the model for a more sophisticated generation of tradesmen, factory managers, and entrepreneurs who could lead Prussia's industrial takeoff and its entry into competition with the British. The general success of this endeavor is debatable. But its most famous, if also unusual, student was August Borsig, whose machine works and iron foundry built much of the Prussian railroad system around midcentury. These economic actors do not yet appear as public figures in Krüger's painting of 1830. By 1839, however, when he redid the painting with the same structure for *Eine preussische Parade*, they would play a more prominent role.[6] Similarly, although the professoriate is not particularly visible in the 1830 painting, they would show up in considerable numbers among the public citizens of 1839. In elevating their presence, Krüger captured something considerably more general than his own position as professor at the Academy of Art. His role there, however, is an important part of the picture he paints.

Engagement with the arts—theater, music, drawing, painting, sculpture, and architecture—is a feature of the self-representation of the public that will require attention in the chapters that follow. Krüger expressed this involvement in a self-conscious presentation of his colleagues and peers. He himself is there (fig. 1.4), mounted, on the right from Altenstein, wearing a brown coat and top hat, while his wife Johanna, below Altenstein, wears a white dress and wide-brimmed bonnet. In figure 1.6, C. D. Rauch, sculptor of the Scharn-

horst statue, is the tall man in top hat and white vest to the right of Schinkel. Johann Gottfried Schadow, director of the Academy of Art, displays the iron cross on his lapel to the left of Schinkel.[7] And Henriette Sontag (fig. 1.7), a singer beloved by her public, stands in an open coach in the upper-right corner of the crowd with the virtuoso violinist Paganini seated beside her.

The presence of so many artists among the *Bildungsbürgertum* signals here the intimate relation that would exist between art and science for the young members of the Berlin Physical Society. Drawing especially, which they all studied as part of their cultural education at the *Gymnasium*, will figure prominently. Meanwhile, and purely stylistically, the distinctly realist turn of the Biedermeier style in Berlin, with its focus on scenes of everyday life in urban streets, landscapes, and portraiture, will help to suggest how drawing, in both figurative and geometrical representations, could come to play a constitutive role in the technical practice of the natural sciences and in their perceived relation to the human sciences. The *Parade*, with its masterful drafting of architectural detail and perspective as well as its naturalistic portraits of horses and people, may stand for the genre. But Schadow, renowned for his neoclassical sculptures, captured it already in 1801, when he countered a critique by Goethe of the "demand for reality or utility" in Berlin art, with the remark, "every work of art is treated here as a portrait or likeness."[8] This realist but simultaneously classicist aesthetic will appear as characteristic for the Berlin Physical Society.

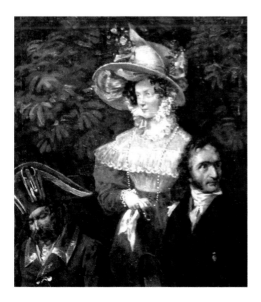

Figure 1.7 Krüger, *Parade*, detail. Sontag and Paganini.

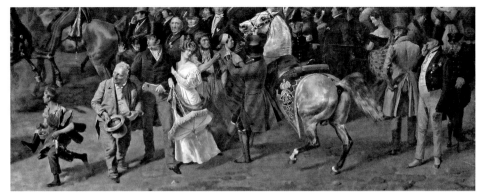

Figure 1.8 Krüger, *Parade*, detail. Symbolic Berlin figures.

Krüger's depiction of the public, finally, contains a number of symbolic figures who reflect a slight nervousness or irony about the privileged position of elite society (fig. 1.8). On the far right a former soldier who has given his leg for the *Befreiungskriege/Freiheitskriege* (he wears a service medal) nearly disappears from view. Plainly visible in front of Schinkel, however, a young workman in cap and neck bandana (also fig. 1.6) stands his ground in the midst of the gentrified society, shaking his fist at the disruptive white stallion of a cavalry officer whose groom in bright red coat seems about to lose control. The shoeshine boy, running across the foreground, gently suggests the social reality of the poor beneath all this elegance, while beside him, the hairdresser of court and theater Johann Warnicke, with hat in hand, seems to bow to applause for his talents, displayed to his left by the elaborately coiffed Karoline Bauer (on the arm of the singer Heinrich Blume). This social diversity in the public sphere has a political expression in the presence of a few advocates of a new social order, such as the jurist and professor Eduard Gans (fig. 1.4, front, right of Johanna Krüger), who would be suspected of revolutionary intrigue when in 1830 the July Revolution in France unsettled Prussia. Indeed, in September 1830, continual unrest and threatened riots in Berlin led to the prohibition of assemblies of more than five persons.[9]

It is out of this restive citizenry, so conscious of its independence and of its expected role in establishing civic humanism in Prussia—but prohibited by royal decree from smoking in the city streets—that I want to draw the character of the Berlin Physical Society. Nearly all of its members were born in the 1820s, many to parents whom Krüger might well have included in his collection of miniature portraits. As the painting so clearly shows, the

Table 1.1 Helmholtz's subjects of study, his teachers, and their institutional affiliations

Physics and chemistry:

Turte	Artillerie- und Ingenieurschule	
	Friedrich-Wilhelms-Institut	
	University	
	Director, Royal Powder Factory	
Dove	Gewerbeinstitut	
	Kriegsschule	
	Artillerie- und Ingenieurschule	
	Friedrich-Wilhelms-Institut	
	University	
	Gymnasia	
Mitscherlich	Kriegsschule	
	Artillerie- und Ingenieurschule	
	Friedrich-Wilhelms-Institut	
	University	
Magnus	Gewerbeinstitut	
	Artillerie- und Ingenieurschule	
	University	

Mathematics:

Minding	Bauschule	
	University	
	Gymnasia	
Dirichlet	Kriegsschule	
	Bauschule	
	Gewerbeinstitut	
	University	

Natural History:

Link	Gaertnerschule	
	Friedrich-Wilhelms-Institut	
	University	
	Director, Royal Botanical Garden	

Anatomy and physiology:

Müller	Friedrich-Wilhelms-Institut	
	University	
	Director, Anatomical Theater and Anatomical Museum	

Note: Helmholtz's teachers of natural science while at the Friedrich-Wilhelms-Institut and afterward, showing the variety of schools at which they had taught (not all simultaneously). Minding and Dirichlet, only indirectly teachers of Helmholtz, are included.

absolutist military state provided the context for their activity, its resources, and its potential rewards.

The Technical School Network

The significance of this context for students of the sciences can perhaps best be seen by looking briefly at the technical schools, which aimed explicitly to advance Prussia's industrial and military position in Europe. This is true for the founders of the Berlin Physical Society despite the fact that only a handful studied at the technical schools, having earned their new doctoral degrees instead from the University. The resolution of the conundrum lies in the bridgework that connected the University with technical education. Nearly all University professors of natural science also taught courses at the technical schools, although these courses were oriented more toward material practice than the parallel university lectures. The professors and their courses constituted a set of active linkages in a vibrant educational network.

An initial sense of both the density of this network and the potential access to it that a single individual might enjoy can be obtained simply by considering the activities of Hermann Helmholtz's professors and mentors in natural science during the period of his medical studies at the Friedrich-Wilhelms-Institut and afterward. A striking fact is that all of them taught at two or three or more institutions at the same time and that over the course of their careers they moved widely through the technical schools. Table 1.1 gives their names and locations.[10]

Putting this information into a diagram, as in figure 1.9, one line for each

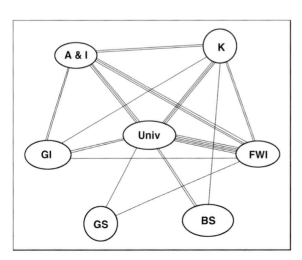

Figure 1.9 Network of Berlin schools as connected by Helmholtz's teachers.
A & I = Artillerie- und Ingenieurschule;
K = Kriegsschule;
FWI = Friedrich-Wilhelms-Institut;
BS = Bauschule;
GS = Gärtnerschule;
GI = Gewerbinstitut;
Univ = University.

joint teaching relation shows the literal sense in which they helped to constitute a network of technical education. The diagram also suggests how Helmholtz and other motivated students of natural science had access via their professors to the resources available and the values expressed through that network. A closer look in the three chapters to follow will show how both interconnections and content were maintained by a variety of administrative policies loosely coordinated between the ministries of trade, culture, and war, where the citizenry depicted in *Parade auf dem Opernplatz* often exercised their powers.

NOTES TO CHAPTER ONE

1. For this painting, I am indebted to Elaine Wise, who recognized its potential for this book. On Krüger's work, see the catalog and articles in Bartoschek, *Der Maler Franz Krüger.*

2. Franke, *Berlin*, stresses the social displacement in the painting and makes a convincing argument for seeing Krüger's parade pictures as self-representations of the public. She provides identification keys on a foldout sketch and in app. 1 and in the discussion on pp. 128–44. See also Franke, "Franz Krügers Zeitgeschichtsbilder."

3. Bergdoll, *Schinkel*, 48–55.

4. Brose, *Politics of Technological Change*, develops the balancing argument as a consistent theme. See also Brose, *German History*, 99–102.

5. Others in the group are P. C. W. Beuth (rear), discussed below, and the famous opera directors and composers Gaspare Spontini (right)—whose productions in the 1920s featured scenery inspired by Humboldt's exotic South American vegetation—and Giacomo Meyerbeer (center, facing front).

6. Identifications by Elise Mai, 1890, in *Alt-Berlin*, introduction by P. Lindenberg (Berlin: Spiro, 1904), reproduced in Franke, *Berlin*, app. 2.

7. Other well-known artists in the group are Karl Begas (behind Schadow) and Karl Wilhelm Wach (behind Schinkel).

8. Schadow, "Über einige in den *Propyläen abgedruckte Sätze Goethes*," quoted in Ostländer, "Malerei des Biedermeier," 141, 153–54. Here and throughout the translations are mine unless noted.

9. Reported in *Vossische Zeitung*, September 13, 1830 (in Franke, *Berlin*, 134).

10. Cahan, *Letters*, 17, lists Helmholtz's instructors and courses. Their teaching locations derive from a wide variety of sources, biographical and institutional, which will appear below.

PEGASUS AND THE MUSES (MUSEUMS) OF ART, INDUSTRY, AND SCIENCE

Section 1: Altes Museum, University, and Bauschule

*Fine art, which sets everything in proportion and calm, is perhaps a touchstone [*Probierstein*]. Previously, fine art followed after politically great events and was a consequence of them. It would be perhaps the fullest bloom of a new mode of conduct in the world if fine art led the way, somewhat as experiment in science precedes discovery and can be seen as a characteristic element of the modern age.*

— Karl Friedrich Schinkel, ca. 1825

Looking again at Franz Krüger's *Parade auf dem Opernplatz* (fig. 1.1), it will be apparent that the painting is full of movement and that this animation is carried largely by the horses that gave the artist his nickname "Pferde Krüger." But the horses serve not only to lend dynamic action to the picture. As in Krüger's paintings of horses generally, they are individualized portraits that convey character, mood, and social station. In particular, the white and gray cavalry horses in the foreground of the public (fig. 1.2) may be seen to embody complementary postures in the iconography of the horse as symbolic for human society. On the left, under full control and lending to the scene a sense of elegance and order, prances the dressage horse. On the right, a similar horse, but now portrayed as a powerful stallion, without his rider and straining against his groom, displays a potential for untamed action.[1] This dual rendering of the horse mirrors the forces operating within society, representing both the established order, which dominates the picture, and the disruptive tendencies of contemporary development, as suggested by the worker, quite out of place in elite society, who shakes his fist at the missing cavalry officer's unruly mount. This tension can serve here to reintroduce the progressive roles of two small groupings of people pointed out in chapter 1.

Just behind the drama of the stallion, Krüger placed his figures of fine art, including Gottfried Schadow, Karl Friedrich Schinkel, and Christian Daniel Rauch (fig. 1.6). We will find that they carry the power of art for social transformation as well as social order.

In the second grouping, behind the white dressage horse (fig. 1.5), Krüger positioned Alexander von Humboldt and Christian Peter Wilhelm Beuth.[2] Their social-political roles as the inexhaustible promoters of scientific and industrial progress, respectively, had become familiar to all well before Krüger completed his painting in 1830. Beuth appears in his signature red-banded black cap, signaling his service during the Napoleonic Wars in the cavalry of Wilhelm von Lützow's Freikorps, where he was promoted to second lieutenant, won the Iron Cross, and confirmed his lifelong love of horses. From these two groups, I will focus attention here and in the following chapter on the close relationship between Schinkel and Beuth in their efforts to modernize Prussian life.

The two horses and the dual forces of order and progress, or of calm and creative passion, recall the roles assigned to the flying horse Pegasus in Greek mythology, both as a source of inspiration for the muses and as the steed who carried the warrior Belleraphon against the Chimera. Indeed, the horses pictured belong to officers of the Hussars, the elite light cavalry who originated in Poland and Hungary and whose long tradition included their regular depiction as flying horsemen with wings (fig. 2.1).[3]

We will find that the dual virtues of Pegasus figured prominently in the conception of a modern society that Schinkel envisaged and in the interrelationship that he and Beuth nurtured between art, industry, and science. Taking inspiration from Eric Dorn Brose's "Aesthetic View from Pegasus,"[4] I will develop that relationship as it was expressed in Schinkel's buildings and in the new institutions of technical progress that they housed. I am especially interested in "museums" in an expansive sense, including collections of many kinds. I begin in this chapter with Schinkel's art museum, the Altes Museum, and its corollary museums of natural science at the new university and at the Allgemeine Bauschule (General School of Building). In the following chapter I take up the Gewerbehaus (House of Industry), where Beuth oversaw three interrelated bodies that depended crucially on museums: the Technische Gewerbe-Deputation (Technical Deputation for Industry), the Gewerbeinstitut (Industrial Institute), and the Verein zur Beförderung des Gewerbefleisses in Preussen (Society for the Advancement of Industry/Industriousness in Prussia).

Schinkel's Civic Architecture

Historians of art and architecture who study Schinkel's neoclassical buildings, paintings, and drawings have regularly emphasized the ways in which he projected the concept of *Bildung* into architectural space.[5] As

Figure 2.1 Alexander Orlowski, *Hussaria's Attack*, 1825, gouache on paper, 53.5 × 38.5 cm. Muzeum Narodowe w Warszawie, Rys. Pol. 8467. Photo by Wilczyński Krzysztof.

the central ideal of neohumanist cultivation and education, *Bildung* implied active self-formation as an integral part of the larger world, both mentally and physically, leading to a heightened aesthetic awareness as well as the capacity for moral judgment and disciplined action. This goal was thoroughly bound up with the ideal of the free individual in the modern state, which Wilhelm von Humboldt had built into the reform of Prussian education from 1809 and into the University of Berlin in 1810. It epitomized the self-identity of the educated elite (*Bildungsbürgertum*), especially in their hope for participation in a revitalized and liberal state following the Befreiungskriege/ Freiheitskriege.[6] As Wilhelm von Humboldt sought to incorporate that ideal into the cultural organization of the state, so Schinkel—whose career Humboldt advanced and who in 1820–24 rebuilt Humboldt's villa at Tegel in neoclassical style—sought to materialize it in buildings that would help to shape personal and civic life. In the modern age, public and private life would be shaped increasingly by industry. And here, too, Schinkel would collaborate

with Beuth to promote the unification of neoclassical aesthetics with indus-trial development.

In this edifying spirit of *Bildung* and of civic humanism, Schinkel pre-pared his *Sammlung architectonischer Entwürfe* (*Collection of Architectural Designs*), consisting of drawings of his own works both realized and pro-posed. In the terms I will develop here, the collection constitutes a museum, or "paper museum," of neoclassical design, providing exemplary works as sources of inspiration for new designs.[7] For this concept of the collection as a museum, I want to adapt Barry Bergdoll's argument that Schinkel aimed to produce a language of architecture, a visual language whose cultural role would be analogous to that ascribed by Wilhelm von Humboldt to classical languages.[8] Humboldt sought a language for citizens of the world, providing an objectifying distance from local conditions along with the richness of con-cepts and expression required to critique those conditions and to inspire new directions. Schinkel's attention focused on the language of architecture for public spaces. Public buildings should both enrich social life and shape the consciousness of the people as citizens in a modern state. Thus, for example, his *Sammlung architectonischer Entwürfe* include several evolving versions of the *Neue Wache*, which served as the bridge of the citizen-soldier between the University and the Armory (chap. 1) as well as the backdrop for the public in Krüger's *Parade*.[9]

Another fine example of civic humanism is Schinkel's Schauspielhaus (Theater, fig. 2.2). Built in 1818–1820 to replace an older theater destroyed by fire, the Schauspielhaus sat on the central main market square, the Gen-darmenmarkt, between two eighteenth-century churches (originally built 1701–8 with domes added 1780–85). These elegant twin structures—the German Church and French Church—represent the complementary rela-tionship of the two main religious groupings of Berlin's citizens, Lutherans and Huguenots. The Huguenots had been invited into Prussia by Kurfürst Friedrich Wilhelm in 1685 in expectation of resuscitating the economy and population after the devastation of the Thirty Years War. Although these eco-nomic hopes were not immediately realized, the French community became increasingly important during the course of the eighteenth century as a res-ervoir of knowledge in the skilled crafts, commerce, literature, and science, especially under Friedrich II (Frederick the Great), when French became the language of status and administration as well as of the Enlightenment, as embodied in his Akademie der Wissenschaften (Academy of Sciences). Thus, the Gendarmenmarkt was one of the most important public spaces in Berlin. Schinkel designed his Schauspielhaus to enhance the sense of civic

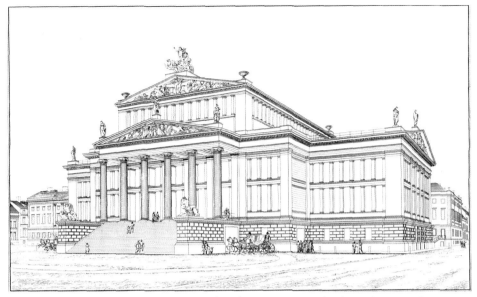

Figure 2.2 K. F. Schinkel, Schauspielhaus (*front*), in *Sammlung Architektonischer Entwürfe*, plate 7.

pride and responsibility that one should feel when attending a performance or mingling with other citizens on the market square.

To capture in classical imagery the functions of civic enlightenment in the theater, Schinkel placed statues of the nine muses on the corners of the roof looking down on the square. They act here under Apollo Musagetes, whose chariot drawn by griffins is about to soar into the sky from atop the front gable. But the inspiration of the muses for the arts and sciences is connected more prominently in Schinkel's work with Pegasus, who stands with wings raised high atop the rear gable (fig. 2.3). Although nurtured by the muses, Pegasus was the son of Neptune, who one day became angered by the muses' excesses of song and revelry on Mount Helicon and sent Pegasus to calm them. When he stamped his hoof on the sacred mountain—here represented by a rock under his right hoof—the spring called Hippocrene began to flow. Ever since it has lent an air of serenity to the muses' inspiration but without suppressing their passions.[10]

Theatrical performances under the gaze of Pegasus and the muses should awaken a self-conscious sense of individual humanity and moral action at the same time that they entertained. Schinkel aimed at this effect even in the internal design of the theater and in the classical plays that would be

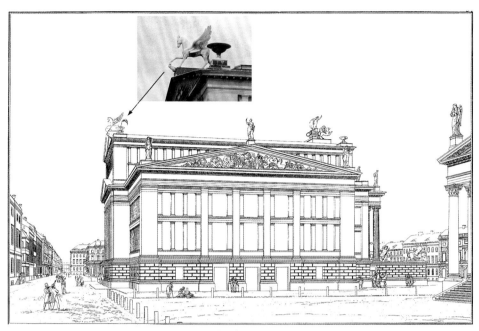

Figure 2.3 K. F. Schinkel, Schauspielhaus (*side*), in *Sammlung Architektonischer Entwürfe*, plate 11. Insert, author's photo of Pegasus sculpture.

performed there, following the aesthetic principles of Goethe and Schiller, Humboldt and Fichte. The first production at the Schauspielhaus, for its opening in 1821, was Goethe's *Iphigenia in Tauris*.[11] Of course the theater also provided a space to see and be seen. Prominent among the public, as depicted in the *Parade*, would have been the writers, actors, directors, singers, and musicians who realized the theatrical and musical performances.

Struggle for the Future: The Art Museum

A similarly inspirational work of civic architecture is Schinkel's art museum (1823–30, called the Altes Museum after construction of the Neues Museum, 1841–55). Originally proposed in 1797, following the model of the Louvre in Paris, the Altes Museum converted the exclusive collections of the monarchy into a national cultural repository open to all. It faces the royal palace across the large square of the Lustgarten (Pleasure Garden). For his *Sammlung architektonischer Entwürfe*, Schinkel presented a classical scene looking out from the upper-level entry hall (fig. 2.4).[12] No doubt this complex perspective drawing testifies to the representational power of descriptive geometry in the hands of a master. It shows also how Schinkel employed this

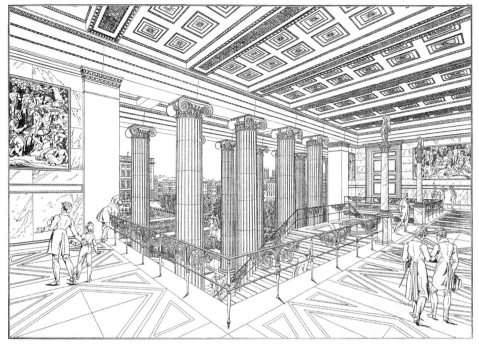

Figure 2.4 K. F. Schinkel, Altes Museum, upper entry hall, in *Sammlung Architektonischer Entwürfe*, plate 43.

power to depict an arena of open social discourse and education, an epitome of *Bildung* in a public space. A father points out to his son the meaning of one of the allegorical frescos while two fashionable young men engage in intimate dialogue. As Ziolkowski has stressed, Schinkel here presents an ideal of "conversation among educated laymen (and not professional artists or scholars)."[13]

On the walls of the main entry hall below, behind the great row of columns, two long frescoes narrated an allegorical history of the world, beginning with the life of the gods and continuing with the life of mankind, in a cycle from morning/spring to night/winter. Dominating the central position of midday/summer, Pegasus appears on Mount Helicon surrounded by the muses (fig. 2.5), with the waters of Hippochrene falling into a pool below "from which happy mankind receives the drink of spiritual awakening."[14] But the awakening was hardly tranquil. In a scene that recalls the sensuality of paintings of Leda and the Swan, Pegasus here shows his wild side, while the muses, for all their classical beauty, are as erotic as they are serene.[15] Inspiration, it

appears, will not leave humanity undisturbed any more than social reform would do in Krüger's *Parade*.

In this we see the function of the museum itself in the minds of its progressive organizers, including here not only Schinkel but also Wilhelm von Humboldt, who headed the museum's final installations commission (*Einrichtungscommission*) appointed in 1829, which had responsibility for organizing the exhibition of 450 classical sculptures and nearly two thousand paintings.[16] As an embodiment of the muses, including at least three sculptures of Apollo Musagetes and many of individual muses, these carefully selected collections would awaken, educate, and elevate public taste and judgment. But their purity of form and enduring beauty should direct attention not toward the antique past but toward a future guided by classical ideals. In this changing

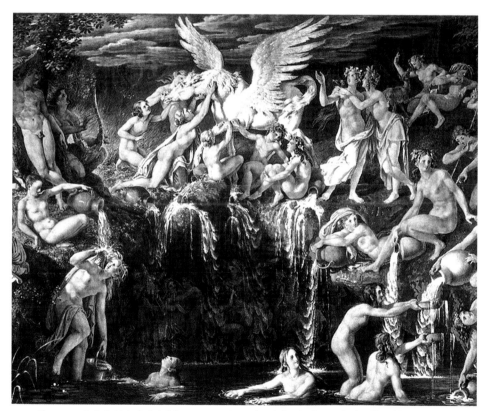

Figure 2.5 K. F. Schinkel, detail from preparatory sketch for the fresco in the Altes Museum of *Entwicklung des Lebens auf der Erde vom Morgen zum Abend (Menschenleben)*, central section for midday/summer, in Vogtherr, *Königliche Museum*, foldout.

orientation, the museum participated in the so-called discovery of history as an ongoing process, or more generally in the discovery of time. From the late eighteenth century, that truly world-changing development began to occur across the entire spectrum of academic and cultural life. In the natural sciences it would culminate by midcentury in evolutionary theory and the second law of thermodynamics.[17] But museums stood at its center.

For the theme of the changing historical conception of the art museum, I have found particularly cogent Elsa van Wezel's recent study of the Altes Museum and the Neues Museum as exemplifying a movement in the theory of art after 1800 "from imitation to inspiration."[18] Even after the conflict between the ancients and the moderns had long been settled, aesthetic theorists of the eighteenth century still conceived of beauty as an absolute ideal exemplified by classical sculpture and by paintings of the High Renaissance. But by the 1820s beauty had become historical. The classics, while still valued above all other works, provided not an ideal to be copied but a source of creative inspiration. Wilhelm von Humboldt put it succinctly in his long essay of 1796–1797 on "The Eighteenth Century": "In the first period after the reestablishment of the sciences [the Renaissance], we grasped eagerly after the works of the ancients, in order to acquire from them instruction about particular objects. Later on, fortunately, we have abandoned this unrewarding path; we have felt that the ancients are not actually destined to act didactically but rather inspirationally."[19]

This changing orientation toward history came to be played out concretely in a conflict between Schinkel and his supporters, who quickly established their authority with the king and his ministers, and Aloys Hirt, a widely knowledgeable professor at the Akademie der Künste (Academy of Art) and professor for theory and history of the figurative arts (*zeichnende Künste*) at the University from its inception in 1810. Hirt had originally promoted the idea of a museum in 1797 and had been the leading advisor on its conception and collections ever since. He and Schinkel constituted the first planning commission formally appointed by the king in 1823, but by 1829 Hirt's views had lost their sway. In retrospect it is apparent that cultural politics had moved out from under him. He represented an Enlightenment that had been displaced by the idealist movement, identified philosophically with Schiller, Hegel, Schelling, Fichte, and others who shared a belief in the unending development of the human spirit while differing widely on the motor of that development and on the relation of the temporal material world to the eternal spiritual world, or of man to God.[20]

The conflict between Hirt and Schinkel, as Wezel shows, represents widely

differing views on the structure of history, that is, cyclical versus progressivist. For Hirt the classics displayed in its most perfect form a universal process of rise and decline with which other periods could be compared and that contemporary artists could hope to imitate through close analysis. In his view the art museum would serve essentially as a repository of past greatness and a place of study. In this Hirt agreed with Hegel—who during the 1820s was delivering his lectures on aesthetics at the University close by—that art had reached its pinnacle in the classical age. But Hegel's dialectics of the human spirit formed no part of Hirt's cyclical conception. Schinkel's views, on the other hand, have often been associated with Hegel and with Schiller, but Wezel nicely draws out much closer connections with Schelling, whose works he studied, and with Humboldt. For them, producing works of art constituted one of the highest of human pursuits. Art, they contended, in contrast to other idealists, was capable of directly connecting matter and spirit, the sensual reality of the material world with the abstract ideality of the spiritual world, in an unendingly fruitful dynamic interaction. To express this relation concretely in architecture and art was Schinkel's constant pursuit. Like them also, he stressed the inexhaustible fecundity of individual uniqueness (*Eigentümlichkeit*) whereby great art would continue into the present and future. The museum would serve to stimulate this ongoing historical development. Importantly, for Schinkel as for Schelling and especially Humboldt, the museum was an institution of the state whose interests they served. And the state, in order to raise up a morally advanced society, had the responsibility of developing a higher aesthetic sensibility in its citizens as part of the all-important process of *Bildung*.[21]

The difference in orientation between Hirt and Schinkel is most apparent with respect to the question of whether the needs of the public or of art students and experts should take priority. The answer was embodied in the museum building itself, both in the decision to erect a museum separate from the Akademie der Künste, as Schinkel proposed, and in his conception of it. He conceived his architectural design from the perspective of public enlightenment, moving from the outside in. Starting from a view of the exterior grandeur of the building itself, with its long row of massive Ionic columns (figs. 2.10, 2.12), visitors would enter through a great rotunda, conceived as a Pantheon with figures of the Greek gods in white marble (fig. 2.6), and only then enter the exhibition rooms. They would thereby be brought gradually from an initial sense of spiritual awe into more intimate contemplation of the full range of classical sculptures on the first floor and then of the historical succession of schools of painting on the second. To Hirt, thinking from the

Figure 2.6 Carl Emanuel Conrad, *Rotunde im Alten Museum*, 1834, watercolor, 45.7 × 42.1 cm. Stiftung Preussische Schlösser und Gärten Berlin-Brandenburg, GK ll (5) 3837a. Photo by Roland Handrick.

inside out, Schinkel's design was both grandiose and unsuited to the practical needs of students, artists, and scholars like himself at the Akademie der Künste, where he had hoped to see the museum located. Public enlightenment entered his conception almost as an afterthought.[22]

When the new commission was established in 1829, Hirt had been dismissed, and the other members agreed on the priority of stimulating pub-

lic engagement through pure aesthetic effect. In addition to Humboldt and Schinkel, major voices were the external advisor Carl-Friedrich von Rumohr, a well-known independent art historian, and Gustav Friedrich Waagen, who had emerged as assistant to the original commission as a key expert on the works in the collections and who would become the new director for paintings. Already in a memorandum of 1828, Schinkel and Waagen repeatedly stressed *Das Publicum*: "The loftiest and actually the main purpose consists in our view therein: to awaken *im Publikum*, where it still slumbers, appreciation for the fine arts as one of the most important branches of human culture, and where it is already awakened to provide it with worthy nourishment and the opportunity for ever more refined development." Far below this main goal came satisfying the interests of students and scholars and conveying art-historical knowledge. So critical was the emphasis on aesthetic pleasure that Waagen and Schinkel stated it as an often-quoted axiom: "first delight, then teach." Waagen would inscribe that rule with emphasis in the catalog of the painting collection: "the main purpose of the museum [is] *the granting of aesthetic pleasure*."[23]

Works that fulfilled this aesthetic goal were those called "classical," epitomized by ancient sculptures and by paintings of the High Renaissance. They were the works that would uncontestably inspire artists and laymen alike, directly, without commentary. Important here, however, is Schinkel's and Waagen's emphasis on perfection of scientific and technical means: "Classical, however, are those in which the artist not only conceives and grasps his subject in an appropriately genuine and beautiful way but also, in possession of all the scientific and technical means, which serve art for representation, expresses that subject with full clarity in an effortless, fitting, and beautiful way" (cf. Helmholtz, chap. 9). This emphasis within aesthetics on mastery of available technical means points not only to the necessity of artistic training but also to the essential historicity of great works. Full appreciation of the historical genius behind them required that they be set in comparative context, as occupying a particular place with respect to somewhat lesser works and in the course of historical development. This relativized historicist ordering, although secondary to aesthetic effect, nevertheless occupied an important place in the Schinkel-Waagen evaluation of the classical: "so that the classical itself appears no longer as a wonder and mystery fallen into the world but as fully comprehensible." The same sense of historicity would lead to recognition of "how foolish it is to designate [any particular path] as the only correct one" and indeed to an appreciation of contemporary attempts to produce great art.[24]

For the movement "from imitation to inspiration," the lesson could not have been clearer. No longer would a collection of art works attempt to present examples of beauty conceived as an absolute idea, conforming to a set of rules to be studied and reproduced, but rather as examples of beauty recognized for their individuality and for their expression of a particular cultural moment. For the practical consideration of how the museum was to be used, this implied that time and space for the traditional copying exercises of students would be restricted. Their activities, said Humboldt in his final commission report, disturbed peaceful contemplation by the public and contributed exceedingly little to the progress of art. He recognized, however, that some compromise would be necessary to meet the needs of the Akademie der Künste, which he hoped could find another venue for copying. Ideally, the gallery "would not serve at all for mere practice in drawing and painting."[25] We will see this same move away from copying and toward self-realization in the case of drawing instruction at the military schools (chap. 4).

In brief, the case of the Altes Museum, shows in rich detail how cultural politics in Berlin had come to be dominated by the conception of history as a movement into an open-ended future. In often-repeated phrasing, Schinkel remarked during the midtwenties, "'Historical' is not to hold onto the past alone or to repeat it; thereby history would expire; to act historically is what leads to the new and whereby history is advanced." But which "new" and how should it enter the present? These questions suggested the relation of art to the natural sciences contained in the epigraph to this chapter: "Fine art, which sets everything in proportion and calm, is perhaps a touchstone [*Probierstein*]. Previously, fine art followed after politically great events and was a consequence of them. It would be perhaps the fullest bloom of a new mode of conduct in the world if fine art led the way, somewhat as experiment in science precedes discovery and can be seen as a characteristic element of the modern age."[26] In this conception of modernity, works of art collected in museums would be analogous to experiments in the making of history, displayed for their capacity to stimulate exploration of an unknown future. Art, like science, would aim at discovery.

Museums of Science

Schinkel's surprising suggestion points in two directions at once. In the first place it calls up enthusiastic conceptions of the relation of art and science as expressed by writers and philosophers whose work he knew. The historian of chemistry Ursula Klein, remarking on the widespread interest in chemical experimentation in the early nineteenth century, points to Fried-

rich Schlegel's statement that poetry and writing are "permanent experimentation." In this Schlegel agreed with his friend the poet Novalis (Friedrich Freiherr von Hardenberg, a distant nephew of Chancellor Hardenberg) who sought to develop an entire system of knowledge centered on the concept of experiment in chemistry and physics. The philosophers Schleiermacher and Schopenhauer both took notes on the chemistry lectures of the renowned Martin Heinrich Klaproth at the University, while Schelling and Hegel made chemical reactions central to their systems of *Naturphilosophie*.[27] But in relation to museums and experiment, one must think above all of Goethe, whose interest in natural science also began with chemistry (and alchemy) in his private laboratory such that chemical attractions and repulsions became the metaphor for his famous novel of 1809, *Die Wahlverwandschaften* (*Elective Affinities*).[28] His prodigious collecting of botanical, osteological, and mineralogical specimens (to say nothing of books and art works) has often been emphasized.[29] Less attention, however, has been paid to his view that the task of experiment in chemistry and physics is the collection of as many diverse findings as possible on any particular subject. Accordingly, in his *Farbenlehre* (1810), he amassed an enormous collection of experiments on color, organized in what he regarded as a natural order. The collection of experiments thus constituted a kind of natural history museum, exhibiting nature's infinitely creative bounty and expressing its myriad forms naturally and truthfully (fig. 2.7). In contrast, Newton's single-minded experiments with a prism to decompose light were destructively invasive and his mathematics deceptive.[30] Relevant here is that Goethe's engagement with experiment included Schelling's and Hegel's *Naturphilosophie* as well as views of Schiller and the Humboldt brothers.

In this context of enthusiasm for experiment, Schinkel's study of Schelling provides part of the background for his remarks on art as experiment. But they also point in a more local and practical direction to the fact that museums had played a major constitutive role in the new university since it opened in 1810. Only recently have historians devoted much attention to this intriguing subject.[31] Famously, the University was established under Wilhelm von Humboldt as head of the new Section for Culture and Public Education of the Ministry of the Interior in Hardenberg's government from 1809. But the ultimate relation of museums to the University emerged out of a series of struggles from the late 1790s involving many interested parties over the fate of the scattered royal collections, especially those of natural history and art in the *Kunstkammer* of the Berlin palace. In 1798 they and other collections, such as those of the so-called Bergakademie (Mining

Figure 2.7 Goethe, *Farbenlehre*, plate 1. History and Special Collections for the Sciences, University of California, Los Angeles, Library Special Collections. Description from Miller, *Goethe: Scientific Studies*, plate III: "1: color wheel; 2: color wheel (inset shows effects of acyanoblepsia); 3: objective halo on a candle-lit wall; 4: subjective halo seen around a candle flame; 5: method for observing colored shadows; 6: alternate method for observing colored shadows (shadow at sunrise or sunset); 7: flame against a black background; 8: test for acyanoblepsia; 9: double image in blue liquid against a reflective background; 10: fading of a blindingly bright colorless form; 11: landscape without blue as seen by an acyanoblepsic."

Academy),[32] Botanischer Garten (Botanical Garden, in Schöneberg), and Bibliothek (Library) had been placed under the control of the Akademie der Wissenschaften, which expected to keep them. In the context of plans for the University, in 1807 the academy appointed a reorganization commission chaired by Alexander von Humboldt, who had come to Berlin for a time after his famous expedition to South America and Mexico (1799–1804). His draft report recommended that the Akademie der Wissenschaften be much more closely linked to the Akademie der Künste but that it should be kept separate from the prospective University (although with the Botanical Garden, Observatory, and Library perhaps standing detached between academies and University). He also suggested that the scattered natural science collections (*wissenschaftliche Hülfsmittel*) should be united under a single authority, if not yet in a single location, and that the art collections might go to the Akademie der Künste. The commission subsequently developed these suggestions for its formal report in July 1809 (after Alexander had returned to Paris) but with considerable escalation of its claims over the various natural science collections, which it assigned to its different sections with directors drawn from their members.[33]

Thus it came as a most unwelcome surprise to the Akademie der Wissenschaften when in September 1809, contrary to the commission's explicit recommendation but following the advice of Wilhelm von Humboldt, all of the natural science collections (plus the observatory but not the chemical laboratory) were removed from their control and placed directly under Humboldt's section for culture and education in the interior ministry. Initially he envisaged a three-legged structure in which the academies and other purely scientific medical institutes would form one leg, the collections another leg ("library, observatory, botanical garden, and the natural-historical and art collections"), and the University a third. Together they would form an organic whole in which "each part, while maintaining an appropriate independence, yet together with the others participates in a common final purpose."[34] Not long afterward, however, Humboldt delegated responsibility for the collections to the University and to newly appointed professors as their directors and curators.

Basically, the Humboldtian program, resulting from a fraught process of negotiations, separated the responsibility for research alone of the Akademie der Wissenschaften from the University's additional educational mission, of which the collections now formed a key part: the advancement of state and society through *Bildung*. It also put the capstone on a process of specialization that had already been in progress under the Academy's oversight, defin-

itively splitting the royal collections into specialized museums with professional curators. As a result, an Anatomical Museum, a Zoological Museum, and a Mineralogical Museum (under joint authority with the *Bergakademie*) formed the original core of the University. Indeed, a floor plan of 1809 gave museums five-sixths of the University's home in the Prince Heinrich Palais on Unter den Linden. That plan may never have been realized, but still in 1880 the three main museums occupied two-thirds of the building.[35]

Figure 2.8 shows the plan of the Zoological Museum in 1830 on the third floor. The anatomical and mineralogical museums occupied the second floor. These museums continued to grow, and new museums were added throughout the nineteenth century. What would become the Botanical Museum in 1880 had started already in 1815 as a Herbarium (for dried flora) attached to the Botanical Garden. The massive Museum für Naturkunde opened in 1889 to accommodate much of the three ever-expanding natural history museums. And in 1899 Rudolph Virchow finally saw his pathological-anatomical collection at the Charité hospital housed in a new Pathology Museum.[36]

With respect to the royal art collections, as noted above, the original negotiations had envisaged a separate art museum more closely tied to the Akademie der Künste, no doubt in part because it maintained its own teaching responsibility and had a special cultural role in *Bildung*. Thus, the place of the art collections played out differently between Academy and University, leading to the largely independent Altes Museum (as above). Nevertheless, art history, taught by Hirt, Waagen, Kügler, and Heinrich Gustav Hotho

Figure 2.8 Zoological Museum in the University, ca. 1830, in Bredekamp, Brüning, and Weber, *Theater der Natur und Kunst: Katalog*, 251, with added indication of the full floor plan.

(a student of Hegel), continued as an important part of the University's curriculum.[37]

It is difficult to overestimate the significance of its many museums for the basic function of the University, not only for teaching, where they supplied the content for the subjects to be taught, especially in lecture demonstrations, but for research as well. And it is in relation to the museums that we need to see the emergence of experimental laboratory science on a broad scale. The Mineralogical Museum provides an illuminating example. Uniting the collections of the Bergakademie, the royal Mineralienkabinett, and a number of private collections, including Alexander von Humboldt's specimens from America, the consolidated museum opened in 1814 under the direction of the new professor of mineralogy from 1810, Christian Samuel Weiss. From the outset, then, the Mineralogical Museum epitomizes a major movement from scattered collections to centralized, professionally curated museums. The breadth and depth of such comprehensive collections helped to stimulate the comparative and historicizing approach to classification that became characteristic of nineteenth-century museums and that we have seen as a point of negotiation at the Altes Museum.[38]

Weiss was educated in physics in Leipzig, where he taught from 1803 to 1808, and then studied mineralogy in Freiberg with the famed A. G. Werner before his call to Berlin. Methodologically, Weiss favored noninvasive, qualitative techniques of observation and experiment similar to those of Goethe, resting on detailed and systematic knowledge of the natural diversity exhibited in large collections rather than on analytic experiments and quantitative measurements. And he pursued a theory of crystallization based on the dynamics of macroscopic polarities—characteristic of *Naturphilosophie*—rather than forces acting between microscopic atoms. Using these methods and ideas, Weiss developed guidelines for crystal classification referred to axes and zones, which became foundational for modern crystallography.[39]

Despite his own attachment to qualitative macroscopic methods, however, Weiss promoted a broad-based exploration of mineralogy and welcomed the chemical explorations of others,[40] especially his student and longtime collaborator Gustav Rose, who became extraordinary professor of mineralogy in 1826. Gustav was the brother of the chemist and mineralogist Heinrich Rose and developed close ties with the chemist Eilhard Mitscherlich, both also professors at the University and members of the Akademie der Wissenschaften.

An important point here is that Gustav Rose, working within the domain of the Mineralogical Museum, built his career on analytical investigations of the

Figure 2.9 Mineral sample (ca. 7.5 cm) containing titanite (tiny reddish-brown crystal, ca. 4 mm) used by Gustav Rose in his dissertation of 1820, showing that titanite and sphene had the same chemical composition, with labels by Rose and Weiss. Museum für Naturkunde, Berlin, Mineralogisch-petrographischen Sammlungen, Inv.-Nr. 0075/99. Photo by Carola Radke.

relation of the chemical and physical properties of minerals to the external features explored by Weiss. His experiments in chemical synthesis directly extended Mitscherlich's discovery of chemical isomorphism (similar crystal structure of similar chemical compounds) and polymorphism (different structures for a single compound) and depended on the presence in the museum of characteristic specimens exhibiting these properties. The Mineralogical Museum, as a collection of nature's extraordinary experiments, provided the inspiration for Rose's own experiments (fig. 2.9). It is in this light that we should see his extensive contribution to the museum collections, including many specimens collected on an expedition to Russia with Alexander von Humboldt.[41]

If the museum stimulated Rose's experiments, it nevertheless lacked a laboratory adequate for carrying them out. While Mitscherlich controlled the chemical laboratory of the Akademie der Wissenschaften and Weiss directed a relatively new laboratory at the Bergakademie (where Rose may also have worked), the University housed no regular laboratories at all until the

late 1860s, and hands-on laboratory work was not yet regarded as a necessity for students. The philosophical faculty, unlike the faculties of medicine, law, and theology, did not train students for professional careers, certainly not research careers. They did prepare students for the state examinations that qualified them to teach in the *Gymnasium* system or to enter the state administration. But their general mission was student *Bildung*. Instructors at all levels, from *Privatdocent* to professor, typically carried out their own research in private laboratories and brought experimentation to their students through lecture demonstrations. It did, however, become increasingly common for them to invite select students to work in their laboratories (chap. 6).

The pressure for experimental laboratory research and measurement grew within the museums from two interrelated developments. New techniques of analysis and synthesis, like those of Rose and Mitscherlich, were increasingly seen to serve the classificatory interests of the museum itself even while extending and transforming them. And simultaneously, the needs of agriculture, industry, and medicine, which were already strongly represented in the rapid expansion of museums, were seen to depend ever more critically on experimental natural science.[42] That is, the motivations for laboratory research were emerging within the museums themselves as venues for scientific knowledge. The museums were, so to speak, the culture medium for experimentation.

The succession of generations that Weiss and Rose represent at the Mineralogical Museum can be repeated for other professors and the museums for which they were responsible: J. H. F. Link at the Botanical Garden and Herbarium with his three younger colleagues, D. F. L. Schlechtendal, Adalbert von Chamisso, and Karl Sigismund Kunth; Karl Asmund Rudolphi at the Anatomical Museum and his student and successor Johannes Mueller (chap. 6); and Martin Hinrich Karl Lichtenstein and Christian Gottfried Ehrenberg at the Zoological Museum.[43] In a comprehensive analysis of the situation for "Medicine between Collection and Experimentation," Volker Hess puts it succinctly for the origins of the "laboratory revolution" in medicine: "In medicine not the [research] seminar and the laboratory but the collections stood at the center of what characterized the new university."[44]

This Berlin history of the museum-laboratory relation, although it played out in highly local terms, is in many ways a European story. It also has a longer history. In an early example, Mary Terrall has shown how closely interrelated were the personal collections and experimental research of R. A. F. Réaumur before the mid-eighteenth century.[45] But the more general institutional development appears to have come later with the museum movement in the

sciences of the first half of the nineteenth century. Historians of science now widely recognize that this movement lay at the heart of the turn to modern experimental science in general. In his account of "museological science," John Pickstone nicely emphasized the role of the museum as the primary repository of technical and scientific knowledge, of state investment in those areas, and of imperial and industrial display. Developing a similar perspective for the rise of laboratory science in Britain, Sophie Forgan observed that "laboratories grew up as it were in the shadow of the museum."[46] She meant this literally, in that laboratory spaces and buildings were built either within or adjacent to museums, especially in relation to higher education, as at Oxford and Cambridge after midcentury. Independent laboratories emerged as the culmination of this process. The Cavendish Laboratory for physics at Cambridge (James Clerk Maxwell) opened in 1871 and the Physiological Laboratory (Michael Foster) in 1878. In Berlin the great university institutes, centered around laboratories separate from museums, were built about the same time: chemistry (1869, Hofmann), physics (1877, Helmholtz), and physiology (1877, Du Bois-Reymond).[47] But the laboratories did not displace museums, nor even slow their construction.

In short, Schinkel's perception of creative art work as being like experiment in the sciences should be seen as an expression not only of the perceived place of experiment in many idealist philosophical and literary conceptions but even more importantly of the actual place of experimentation in the museums of the still very young University.

Technological Modernism

In continuing the theme of experiment here I want to reemphasize the role of the museum as the house of the muses, as the inspiration for both aesthetic appreciation and new investigations in a state struggling to reinvent itself. This orientation toward the future is apparent even in the usage of the term *museum*, as in a weekly magazine of art, edited by Schinkel's friend and biographer Franz Kugler, titled simply *Museum: Blätter für bildende Kunst* (Museum: News magazine for plastic arts). With the new art museum and fountain as its emblem (fig. 2.10), it provided a forum for discussion of the latest developments in the world of art, primarily the fine arts but also the art of design and production of fine products for the consumer market, or *Kunst-Technik*.

The regular column on "Art and *Kunst-Technik* in Their Latest Aspects," for example, contained each year a report on the annual celebration and exhibition of Beuth's Verein zur Beförderung des Gewerbfleisses in Preussen

№ 10. **Jahrgang V.** 1837.

Von diesem Blatte erscheint wöchentlich 1 Bog. in Quarto, so oft es die Verständlichkeit des Textes erfordert, wird eine Beilage gegeben.

Der Preis des Jahrg. ist 5 thlr der des halb. - 2⅔ und wird das Abonnement prä numerando entrichtet. Man unterzeichnet auf dies Blatt, ausser bei dem Verleger, aufallen ... Pr. Postämtern und in jeder oliden Buchhandlung.

MUSEUM,
Blätter für bildende Kunst.

Figure 2.10 Masthead of *Museum: Blätter für bildende Kunst*.

(Society for the Advancement of Industry/ Industriousness in Prussia), or Gewerbeverein. In 1836 the report commented on the great significance of material products for the nation: "As industry reaches into social life in a more vital and many-sided way than art, so exhibitions of this kind obtain a celebratory national character, which has great influence on the consciousness and the views of a people."[48] Material culture, the Museum writer recognized, could be a more powerful force for the elevation of public consciousness— for *Bildung*—than the fine arts themselves.[49] For the celebration, the rising star of Berlin painting, Adolph Menzel, designed a place card showing traditional German craftsmen reaching out to grasp the winged smokestack of a steam locomotive (fig. 2.11). Pegasus was now flying into the industrial future of *Kunst-Technik*. Appropriately, the pages of *Museum* celebrated the rejuvenation of German society, as of German art.[50]

In choosing the name *Museum* for his organ of sociocultural renewal, Kugler followed a well-established precedent of the *Verein* movement (see the introduction), of which the Gewerbeverein is a somewhat unusual, state-generated example. "Museum" was a favorite name for the *Vereine*.

The sense thereby conveyed of the museum as a place of progressive thought and action suggests why Pegasus and the muses could move readily

Figure 2.11 Adolf Menzel, place card for 1836 *Fest* of the Gewerbeverein, lithograph. *Museum* 4 (1836): 49.

between the houses of the fine arts and those of industry and science. This movement, as represented already by the Gewerbeverein in the pages of *Museum* and in Menzel's portrayal of Pegasus as a locomotive, may be seen in a view of the Altes Museum by Karl Daniel Freydanck (fig. 2.12). As a talented painter working at the Royal Porcelain Factory (Königliche Porzellan Manufaktur, or simply KPM), Freydanck depicted memorable scenes of royal landscapes and cityscapes for the luxurious vases, plaques, and table settings produced at the factory.[51] In this painting, with its well-dressed citizens strolling through the Lustgarten, Freydanck has made no attempt to disguise what might seem an incongruous element just to the right of the museum. It is the chimney of a steam-engine house. The engine pumped water from the

Spree River to fill a reservoir atop the museum, supplying a sixty foot fountain, which is out of the picture on the right but dominates the iconic image of Kugler's *Museum* in figure 2.10.[52]

The presence of the engine house marks the attempt of Schinkel and Peter Joseph Lenné, the renowned landscape architect who often collaborated with him, to employ the latest technological possibilities in their creations. For the Lustgarten, Schinkel had designed a grand five-story engine tower in neoclassical style with a double-story hall below for two engines and with three reservoirs on the upper stories to supply not only the main fountain but smaller pieces of water art in the local area as well as irrigation for the garden. Lenné had reconceived the Lustgarten as a civic *Volksgarten* (garden of the people), featuring orange trees and richly planted flower beds, but they had to settle for Friedrich Wilhelm's parsimonious approval of the utilitarian engine house in Freydanck's painting and a formal garden layout

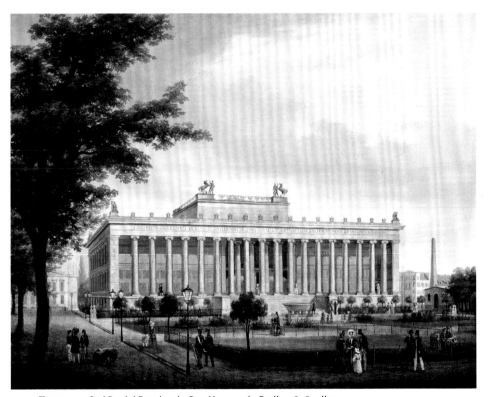

Figure 2.12 Carl Daniel Freydanck, *Das Museum in Berlin*, 1838, oil on canvas, 27.7 × 35.7 cm. Stiftung Preussische Schlösser und Gärten Berlin-Brandenburg, KPM-Archiv (Land Berlin), G 7. Photo by Jörg P. Anders.

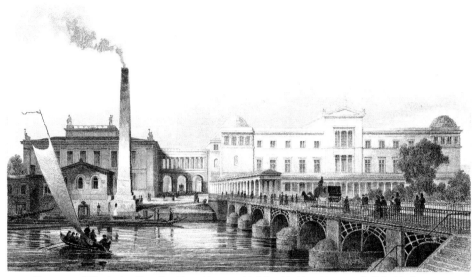

Figure 2.13 Wilhelm Loeillot, *Das Neue Museum* (*right*), with Altes Museum (*left*) behind engine house, ca. 1850, engraving. Author's print.

with rectangles of lawn bordered by spherically clipped acacia trees. A small engine built by the recently established Berlin firm of Franz Anton Egells (chap. 3) pumped water to a reservoir atop the museum, but rather unsatisfactorily, provoking repeated complaints.[53]

Nevertheless, the technological modernism that Schinkel and Lenné sought to promote succeeded in modest terms. It is even more explicit in a later picture (figure 2.13), viewed from across the Spree behind the engine house. The engraving, one of many done by Wilhelm Loeillot for popular publications by Georges Gropius, gives a celebratory view of the Neues Museum (1841–1855), designed by the Schinkel protégé Friedrich August Stüler. The prominence of the smoking chimney serves to illustrate the point that in midcentury Berlin steam engines and smoke did not yet carry the connotations of dirt and disease in a teeming industrial city that they would soon acquire. To be revolted by the wastelands of Manchester, as Schinkel was (chap. 3), meant not that industrialization should be avoided but that it should be achieved in a socially uplifting manner. He and especially Lenné envisaged a city interspersed with parks and with green spaces along canals and boulevards to enrich the lives and health of the workers who occupied the rapidly expanding tenements and factories in its northeastern sections.[54]

Allgemeine Bauschule (General School of Building)

For the theme of technological modernism in neoclassical dress, the example of Schinkel's building for the Allgemeine Bauschule (1832–36) is instructive (fig. 2.14). The painting by Eduard Gaertner, the leading architectural painter in Berlin, displays Schinkel's transposition of classical forms into the medium of utilitarian brick. Here, as in the church rising behind it, the Friedrichs-Werdersche Kirche (1825–30), he rejuvenated the north German tradition of bare brick (*Backstein*), undisguised by a stucco finish or stone facade, which would become a hallmark of the Schinkel school throughout the century.

Although common in inexpensive construction for factories, the style had not been seen in formal public buildings and churches since the late Middle Ages (thus *Backsteingotik*, as referenced in the Friedrichs-Werdersche Kirche). Architectural elegance in the use of brick required not only the retraining of craftsmen to work with greater finesse but also higher levels of

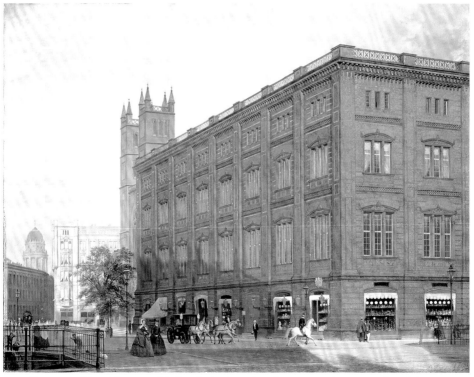

Figure 2.14 Eduard Gaertner, *Die Bauakademie*, 1868, oil on canvas, 63 × 82 cm. Staatliche Museen zu Berlin, Nationalgalerie, Inv.-Nr. A II 61 a. Photo by Jörg P. Anders.

control over materials and production processes to achieve durability and strength of material, uniformity of color, and standardized sizes and shapes. Decorative sculptural elements in matching terra cotta, which had not been possible in the original *Backsteingotik*, required new techniques for casting and firing terra cotta. Schinkel's extensive collaboration with the sophisticated new producer in Berlin, Tobias Christian Feilner (chap. 3), was originally responsible for these innovations, including a unique 2.5-meter-tall statue of the archangel Michael over the entry of the Friedrichs-Werdesche Kirche. The celebrated *Backstein* house that Schinkel built for Feilner, completely original for personal residences at the time, provides another example of elegant terra cotta castings along with a first experiment in polychrome brick. But it was actually a rising Feilner competitor, Cornelius Gorman, who produced the series of reliefs (described below; fig. 2.18) with which Schinkel enlivened the Bauschule.[55]

As emphasized in a new German-language journal for progressive builders in 1836, Schinkel employed native brick "for the most various types of construction and forms and, through perfection of the technical handling, to encourage new advances in fabrication itself."[56] He stated this commitment to technical innovation in the acclaimed structure of the building itself, which supported the entire weight of the floors and roof on vertical brick piers with essentially nonstructural fill walls for mounting the windows. In much of his work Schinkel pushed the limits of materials and structures to project classical ideals into the present and future (fig. 2.15), magnificently in an iron staircase for the remodeled palace of Prince Albrecht, and more modestly in his use of cast zinc at Prince Karl's palace at Glienicke for architectural decoration, which he advocated at the Gewerbefleiss Verein.[57]

The Allgemeine Bauschule—literally General School of Building but better described as a School of Civil Engineering and Architecture—was the signature institution of the Building Department, which was joined with the Department of Trade and Industry within what may be called the trade ministry.[58] The Bauschule occupied the second floor of the new building, with the Building Department on the third floor. Also on the third floor, Schinkel had his living quarters as director of the department (from 1830). In their pathbreaking building in 1836, the Bauschule and the department presented the image of a political economy powered by technological development in neoclassical dress. But attaining that image had been a long process.

The stages of reorganization of the Bauschule from its foundation in 1799 as the Bauakademie until its reincarnation as the Allgemeine Bauschule in 1831 provide a critical perspective on this process as seen through the differing

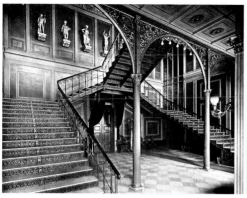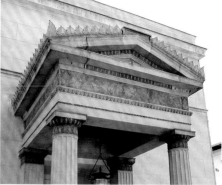

Figure 2.15 Iron staircase, Prince Albrecht's Palace, Berlin. Sievers, *Schinkel*, 152. Zinc architectural elements, Prince Karl's Palace, Glienicke. Author's photo.

orientations of the ministries of culture and trade toward the place of technology in modern education.[59] The Bauakademie had the primary purpose of training civil engineers for state service in the Building Department and its provincial representatives: surveyors, *Baumeister* (the all-inclusive term for state-licensed architects, civil engineers, and building supervisors), and *Bauinspector* (building inspectors). But from the beginning a group of self-consciously modernizing members of the Building Department (including Schinkel's mentors[60])—who promoted increased technical training for designers and builders of roads, bridges, and canals—encountered resistance from members of the Akademie der Künste, who were more nearly invested in the aesthetics of public buildings. That the Bauakademie was closely connected with the Akademie der Künste and came under the administrative authority of what would become the Ministry of Culture begins to suggest some of its difficulties.[61]

The Bauakademie had been conceived as similar to the French École des ponts et chaussées but without the preparatory function in mathematics that the elite École polytechnique provided for all of the *Écoles d' application* (including the École des mines and the École du genie et d'artillerie).[62] Attempting to provide both preparatory and specialized training, the Bauakademie had difficulty meeting the demand for theoretically sophisticated architects and engineers who also possessed thorough "positive," or practical, knowledge. A royal order of 1801 required that the Bauakademie should produce "practical building administrators and no professors." Wanted were not theoreticians but theoretically informed practitioners. Responding to this demand, the directorial board defended its *wissenschaftlich* orientation: "We

cannot do without scientific courses [Collegia], because they alone can engender sound judgments and information in the *Baumeister*, while the lack of them degrades him to the empiricist, from *Baumeister* to construction worker."[63]

To develop this scientific basis for sound practice, the curriculum included mathematics through geometry, optics and perspective, mechanics of solid and fluid bodies, general and specialized forms of construction, and drawing instruction of all kinds: freehand, architectural, situational, and machine drawing. But efforts to maintain high standards in terms both of prior *Gymnasium* education and of curricular requirements produced disappointing results. Faced with perennial complaints from the Building Department, the Bauakademie was reorganized initially in 1801 and then again in 1809 when the Akademie der Künste took over its direction.[64] In 1817, when a major reorganization of the ministries produced the independent Cultural Ministry (Ministerium der geistlichen, Unterrichts- und Medizinalangelegenheiten, or Ministry for Religious, Educational and Medicinal Affairs), the new minister Altenstein proposed drastic action. He had the mathematician J. G. Tralles draw up a plan for transforming the school into a broad-based mathematical-technical educational institute (Mathematisch-Technische Lehranstalt) for architects and engineers in construction, mining, and perhaps the technical branches of the army. Such a move, however, required the cooperation and financial support of the newly formalized Ministry of Trade under Count Hans von Bülow, longtime economic liberal and cousin of Hardenberg. Problems of differing commitments and mistrust immediately emerged perhaps in part because Tralles was a university professor and member of the Akademie der Wissenschaften (itself under criticism for its lack of practical function for the state) with limited connections to the technical world.[65] His plan, reflecting the French polytechnic model, called for an intensive three-year course based on relatively high-level mathematics as the essential integrating subject for the diverse practical activities of *Baumeister*. Although he explicitly differentiated this mathematical-technical training from what the University could offer, stressing the basic requirement for positive knowledge, to the trade ministry the proposed institute still carried the taint of impracticality.[66]

Their reservations were expressed by Johann Albert Eytelwein, head of the Building Department (Abteilung für Bauwesen), one of two departments of the Ministry of Trade, the other being the Department of Trade and Industry (Abteilung für Handel und Gewerbe, or simply Gewerbedepartement). Eytelwein was himself a mathematician but with long experience in the Building

Department and on the directorial board of the Bauakademie. Neither the name change to emphasize mathematical-technical education, with its implied loss of focus on "the education of able surveyors and civil engineers," nor an exclusionary prerequisite of algebra and geometry for admission met his approval. Eytelwein recommended instead a four-year Bauakademie that would provide its own preparatory (or remedial) training for surveyors in one and one-half years and then continue with two and one-half years of more advanced but still focused training for *Baumeister*. Minister von Bülow agreed and reemphasized "the pressing need to educate able construction administrators."[67]

The difference in approach to technical education is telling. Tralles and Altenstein conceived of it as developing from a general *wissenschaftlich* education as its foundation; Eytelwein and Bülow wanted the particular needs of surveyors, engineers, and architects to thoroughly stamp their *wissenschaftlich* education from the outset. Both ministries aimed at a flexible mathematical-technical training, but from opposite directions, from generalized to specialized versus from specialized to generalized. Attempts by a joint commission over the next several years to find an agreeable compromise failed. The attempts demonstrated, however, the increasingly aggressive stance of Bülow's new trade ministry toward industrial progress through education. As a result, Altenstein in 1820 strategically withdrew from this particular attempt to realize his elevated view of how scientific and technical education should be integrated, capitulating to the need "to give up all great plans and to concentrate everything on the establishment of an institution for the education of surveyors and actual construction administrators."[68] Even on this assumption, a provisional plan (showing Eytelwein's strong preferences) failed to satisfy Altenstein's reduced expectations. He proposed a radical split: a transfer to the trade ministry of responsibility for technical education at the Bauakademie while the cultural ministry continued to oversee the higher education of "real (*eigentlich*) architects" at the Akademie der Künste.[69]

Two important developments in the years 1819–1820 are implicated in Altenstein's withdrawal. Those years mark a watershed of conservative reaction against the liberal reforms of civil and military organization that had occurred under chancellors Stein and Hardenberg and ministers of war Scharnhorst and Boyen. As noted in chapter 1, the Karlsbad Decrees of 1819, which expressed the reactionary politics of Austria's Prince Metternich, led to the fall of Humboldt and Boyen and severely dampened prospects for parliamentary

government. One quite general response among liberals who continued to push for reforms was to devote their still considerable weight to pragmatic goals and the claims of professional expertise.

A second closely related but much more definitive development for Prussia's industrial beginnings was the rise within the trade ministry of the dynamic young Christian Peter Wilhelm Beuth, who from 1817 became the driving force in Bülow's ministry. He was responsible in that year for recommendations on the formation of what became provincial *Gewerbeschulen*, which led to Altenstein's withdrawal from that area as well as the Bauakademie.[70] For nearly thirty years, from 1818 to 1845, he would head the ministry's second section, the Department of Trade and Industry (Gewerbedepartement). There he immediately took over and restructured the Technische Gewerbe-Deputation (Technical Deputation for Industry), responsible for advice on industrial policy and examination of patent applications, and in 1821 he founded both the Gewerbeverein and the Gewerbeinstitut (Industrial Institute), developed more fully in chapter 3, where we will meet again the continuing tension between the ministries.[71] Eytelwein, as head of the Building Department, collaborated in Beuth's three-part initiative. Thus, it is not surprising that Altenstein in the Ministry of Culture faced an increasingly uncompromising position from the trade ministry on the reorganization of the Bauakademie.

Not until the end of 1823 were the struggles between trade and culture over curriculum and resources largely concluded with a joint report approved by the king.[72] The Akademie der Künste would retain only the aesthetic training of architects while the Bauakademie would provide all mathematical, scientific, and engineering instruction. This formal separation of technical from aesthetic roles entailed that the engineer Eytelwein would now direct the Bauakademie, replacing the sculptor Johann Gottfried Schadow, who remained director of the Akademie der Künste. But the separation was never complete. While the Eytelwein-Beuth regime continued to stress the professional function of the Bauakademie as a school for *Baumeister*, largely in state service, they were also constantly aware of their aesthetic cultural role. Thus, the struggle was never simply one of humanistic culture versus materialistic trade and industry or the claims of the ideal versus the real. Beuth's own constant attempt to marry aesthetics with industry is illustrated in his personal library, which contained over two hundred volumes on Greek and Roman art, architecture, and literature along with nearly as many volumes on modern technology and engineering.[73] From the other side, Altenstein continued to promote the "higher" polytechnic ideal for pure and applied

science in other guises until 1835.[74] These attempts failed over much the same differences of orientation that had already played out at the Bauakademie despite Altenstein's attempts to balance theoretical and practical education, including support for laboratory instruction in chemistry and physics (chap. 6, re Magnus).

Education at the Bauschule

The striking feature of this ongoing disagreement is how close and yet how far apart were the ministerial goals for training architects and engineers for state service. That irony is heightened in recognizing that the teaching staff of the Bauakademie continued to include university professors under the authority of the cultural ministry and yet the trade ministry so distrusted the university rhetoric of pure science and nonutilitarian freedom of learning that, as Eytelwein had written already in 1820, for the purposes of the Bauakademie, universities "promise no benefit, because the instruction . . . must be given in the necessary relation and in a prescribed sequence, if it is to serve its purpose."[75] Relevance and ordered progression were key. And although Altenstein and Tralles had called for the mathematical-technical institute precisely because they, too, believed the University could not provide the required practical knowledge, their proposed institution continued to look like a university to those suspicious of its elitist features and protective of their own practical needs and interests. This sharp critique of university instruction and the fact that the trade ministry so definitively won out over the cultural ministry for control of the Bauakademie gives a clear signal of the pressures that were emerging even within the University itself for a more hands-on approach to a rapidly changing material world. We have seen one aspect of that movement already in the way museums throughout the University began to nurture experimental science alongside their ever-growing collections.

Eytelwein's administration aimed at reinforcing the basic distinction of practice-oriented from generalized *Wissenschaft* even while producing an increasingly sophisticated corps of state architects and civil engineers with a higher level of scientific education.[76] From 1822, completion of the *secunda* at the *Gymnasium* (all but the final form) became an entrance requirement for the Bauakademie, reaffirming the status value of classical languages and literature for all civil servants. But technical training clearly dominated. The curriculum for 1824–1825 included four courses in mathematics—algebra and geometry, descriptive geometry and perspective (all by the University professor Martin Ohm), analysis and higher geometry, and practical geometry—

two in mechanics, and a combined course in physics, chemistry, and mineralogy in relation to construction.[77]

In 1831 Beuth took over as director himself and further enhanced the technical curriculum. Under the new name of Allgemeine Bauschule, the school added a year of advanced instruction for those seeking promotion from *Baumeister* (already qualified for the normal construction of buildings and roads and with two years of experience) to *Bauinspector*. These building inspectors now had two choices of specialization either in the construction of machines and waterworks or of elegant public and private buildings (*Stadtgebäude* and *Prachtgebäude*). For state service, they were required to qualify in both areas. The curriculum thus became considerably more nuanced and rigorous, with inspectors passing through a series of five theoretical and practical exams. Table 2.1 gives a full schedule of courses.[78]

In considering this curriculum in relation to the role of museums of art and science, it will be useful to collect the courses in several (interrelated) groups: aesthetics, drawing and construction, mathematics and mechanics, and experimental and natural-historical sciences. Instruction in each of these areas depended on extensive and ongoing collections of models, drawings, casts, and minerals. Their acquisition is documented in the files of the cultural and trade ministries, which show the constant attention of Peter Beuth.[79]

Aesthetics

The neoclassicizing aesthetic context of Berlin speaks through the explicitly art-historical courses in the curriculum, all taught by Wilhelm Stier, especially the two on "ancient monuments" but probably also his culminating course on "comparative history of architecture." Stier had trained as an architect at the Bauakademie (1815–17) and then practiced and traveled widely, especially in Italy, before returning to Berlin, where he worked with Schinkel and taught at the Bauakademie from 1828. There he advanced to professor and became a member of both the Akademie der Künste (1841) and the Akademie der Wissenschaften (1842).[80] In this double membership Stier illustrates from the aesthetic side the relatively close relations that often existed between art and technology and science.

The two design courses of Friedrich August Stüler no doubt had a similar emphasis on classical aesthetics. Stüler was an architect who studied simultaneously at the University, the Bauakademie and the Akademie der Künste (1818–20). A Schinkel favorite and a fast-rising star, he would attain the title Architect of the King (*Architect des Königs*) in 1842. He is known for his classical and Renaissance buildings, partly in the Backstein style, and

Table 2.1 Curriculum of the Allgemeine Bauschule mid-1830s

Course type, semester, and subject	Teacher
Baumeister-Curriculum:	
First Semester	
1. **Physics**	Prof. Schubarth, in the Gewerbeinstitut
2. Elementary analysis, plane and spherical trigonometry, analytic geometry, stereometry and descriptive geometry	Prof. Dirichlet (1832–34), in the Gewerbeinstitut
3. Principles of building construction	Bau-Inspector Linke
4. *Lecture on antique monuments*	W. Stier
5. Architectural drawing	W. Stier
6. Geometrical shadow construction and perspective	Land-Baumeister Brix
7. Landscape drawing	Prof. Rösel
Independent of this teaching plan Prof. Accum holds lectures on **physics, chemistry and mineralogy**	
Second Semester	
1. **Chemistry**	Prof. Schubarth
2. **Botany**	Prof. Kunth
3. Statics of solid bodies	Brix (Gewerbeinstitut, 2 days; Bauschule, 1 day)
4. Principles of building construction	Bau-Inspector Linke
5. Principles of construction of simple machines	Ober-Mühlen- und Bauinspector Schwahn
6. *Lecture on antique monuments*	W. Stier
7. Architectural drawing	W. Stier
8. Landscape drawing	Prof. Rösel
Third Semester	
1. **Technical mineralogy**	Prof. Köhler (since 1833)
2. Practical applications of the statics of solid bodies	Brix
3. Lecture on details of machines and on drawing them	Fabriken-Commissionsrath Wedding [teaching also at the Gewerbeinstitut]
4. Elements of hydraulic architecture	Linke
5. Construction of economic buildings, hydraulics, roads, etc. (*Cameralbau*)	Linke
6. Freehand drawing	W. Stier

Table 2.1 *Continued*

Course type, semester, and subject	Teacher
Fourth Semester	
1. <u>Mechanics of solid bodies, hydrodynamics and aerodynamics</u>	Brix
2. Construction of commonest machines and their cost reckoning	Wedding (until 1837); then Baumeister (later Geh. Ober-Baurath) Salzenburg
3. Drawing of ornaments	W. Stier
4. Instruction in making estimates	Linke
5. Lecture on construction supervision and course of business, etc.	Linke
6. Lecture on road construction	Linke
Bauinspector-Curriculum:	
First Semester	
1. <u>Advanced analysis and theory of curves</u>	Dr. Minding (since 1835)
2. Lecture on machines of compound nature	Wedding
3. *Lecture on city architecture*	Bau-Rath and Director Stüler (since 1834)
4. *Design of city buildings*	Stüler
5. **Higher geodesy**	Prof. Berghaus
Second Semester	
1. <u>Analytical dynamics</u>	Dr. Minding
2. Design and evaluation of compound machines	Wedding
3. *Design of buildings in higher style*	Stüler
4. *Comparative history of architecture*	W. Steir
5. General hydraulic architecture	Ober-Baurath Hagen

Source: Dobbert und Meyer, *Chronik der königlichen technischen Hochschule zu Berlin,* 48.

Note: Font styles indicate subjects: roman = drawing and construction; italics = aesthetics; underline = mathematics and mechanics; bold = experimental and natural-historical sciences.

Figure 2.16 Cast iron beams in the Neues Museum. Author's photo.

most especially for the Neues Museum (fig. 2.13). Both architecturally and in the relation between the Neues Museum and the collections within it, Stüler brought to fruition the historical sense of a progressive movement into the future that had taken root at the Altes Museum. His transposition of the modern materials and structures of factory buildings, for example, is displayed in his use of an iron skeletal structure for the enormous building, including support beams for the ceilings, cast or wrought in Hellenic forms to serve aesthetic and structural purposes simultaneously (fig. 2.16). Such innovative construction depended on the new iron and machine works of August Borsig (chap. 3), who supplied most of the ironwork as well as a small railroad to distribute materials throughout the building and a steam engine for a central elevator.[81]

Drawing and Construction

The most basic subject at the Bauschule was drawing. Among six courses, Stier took students from basic architectural drawing to freehand drawing and drawing of ornaments, while with building inspector Rösel they spent a year on landscapes. Stüler's design courses might well be added as the culmination of the series, showing candidates for *Bauinspector* specializing in stately public and private buildings what they might aspire to in Berlin. For all of this teaching of drawing, collections of models and books of drawings provided a fundamental resource.[82] Much more extensive was the collection of architectural plans assembled over the years by the Building Department and available in a dedicated room of the Bauschule. The collection can rightly be

called a museum in the same sense as the museums of mineralogy, anatomy, and zoology at the University, and for similar purposes of study and teaching. When Stüler was designing the Neues Museum, for example, he would have had available Schinkel's drawings for other buildings, elements of which he adapted to his own designs, whether for differentiation (the great staircase) or inspiration (its ceiling).[83]

The ultimate aim of drawing was of course actual construction. *Bauinspector* Linke provided seven courses in the basic principles of construction and construction management as well as general road building and hydraulic engineering (canals, locks, coffer dams) that relied on a large collection of models.[84] Higher-level hydraulics came from the Building Department's expert on harbors, canals, and dikes, *Ober-Bauinspector* Gotthilf Hagen, who taught also at the United Artillery and Engineering School (chap. 4). Hagen had studied with the great mathematician Friedrich Wilhelm Bessel in Königsberg before turning to construction. His experimental discovery of the law of laminar flow (Poiseuille-Hagen law) and numerous publications led to his membership in the Academy of Sciences in 1842.[85] Hagen joined *Fabriken-Commissionsrath* Johann Wilhelm Wedding in training those *Bauinspector* students who specialized in machine construction and water works rather than buildings. Broadly trained, partly in mathematics, at Breslau and Berlin Universities Wedding also studied at the Bauakademie and spent two years as a machinist in England. After returning to Berlin in 1828, he became one of the key members of Beuth's Technical Deputation (chap. 3) and taught also at the Gewerbeinstitut while writing numerous articles for the journal of the Gewerbeverein.

Mathematics and Mechanics

The relatively high level of the technical subjects taught by Hagen and Wedding suggests why students also attended seven courses in mathematics and mechanics, beginning with lectures by the precocious young mathematician Johann Peter Gustav Lejeune Dirichlet, a protégé of Alexander von Humboldt who came to Berlin in 1828 as professor at the Kriegsschule (chap. 4), associate professor at the University, and member of the Akademie der Wissenschaften (chap. 5). In one semester Dirichlet brought students up through trigonometry and analytic geometry to descriptive geometry. Descriptive geometry was based on the representation of three-dimensional objects by successive projections into two dimensions but including shadows, shading, and perspective. It had become a standard of French education for engineers, craftsmen, and artists following its introduction by Gaspard Monge

at the École polytechnique in 1795. For example, Charles Dupin (chap. 3), one of Monge's intellectual heirs, would include it in his popular course on geometry at the Conservatoire national des arts et métiers.[86] It was seen as an ideal basis for connecting the more abstract mathematics of differential and integral calculus with the real world of material objects and mechanical processes but also with the aesthetic world of art (chap. 4. 5). Thus, it was a subject perfectly suited for the integration of practical and theoretical learning envisaged by Eytelwein and Beuth (but also by Tralles). It would play that role at all of the technical schools in Berlin, and it served as one of many mediating links between them. For example, Dirichlet taught his course for the Bauschule in Beuth's Gewerbeinstitut, where it served students aiming at industrial careers, much as Dupin intended at the Conservatoire. Descriptive geometry probably also provided the basis for the course in shadow construction and perspective, which *Land-Baumeister* Brix taught also at the Gewerbeinstitut. As a former student and intellectual heir of Eytelwein, Brix became another mainstay of the Technical Deputation and the Gewerbeverein (chap. 3).[87]

Mathematics as a separate subject continued only in the third year with an advanced course in analysis and the theory of curves by Dr. Ferdinand Minding, Privatdocent at the University and a proponent of French engineering mathematics as well as an important developer of Gaussian geometry.[88] He would replace Dirichlet in 1835. Much mathematical training, however, occurred through mechanics, which was always included with mathematics rather than with physics and chemistry. Students took a series of four courses in mechanics, from the theoretical and practical statics of solid bodies and the dynamics of solids, water, and air, all taught by Brix, to Minding's more advanced course in analytical dynamics. Unusually, for his two-volume textbook on the calculus applied to mechanics and geometry, the publisher required, and Beuth supported, a guarantee from the Bauschule to purchase one hundred copies.[89] Minding will appear in chapter 7 as an important source for Helmholtz's classic work on conservation of energy.

Experimental and Natural-Historical Sciences

From the perspective of technological modernism at the Bauschule, it is noteworthy that students learned their chemistry and physics entirely from a practical and industrial perspective. Ernst Ludwig Schubarth taught the basic courses, although he had no student laboratory and surely taught experimentation by demonstration alone. After habilitating at the Medical Faculty in Berlin, Schubarth became associate professor for materia medica and

chemistry at the University and one of Beuth's most stalwart contributors at the Gewerbeinstitut and Gewerbeverein, serving for years as editor of its journal. His *Elemente der technischen Chemie* (1831, later *Handbuch*), written for instruction at the Gewerbeinstitut, went through many editions, as did his earlier *Lehrbuch der theoretischen Chemie* (1822).

A similar practical orientation, but much more colorful, marked the supplementary lectures in chemistry, physics, and mineralogy by Friedrich Christian Accum (until his death in 1838). He had made his name in London with the pioneering Gas Light and Coke Company, which began operations in 1812. His numerous publications on practical chemistry included several on modern crystallography and analytical mineralogy. They also extended to treatises on culinary chemistry and even the chemical adulteration of food (1820), which had brought him both fame and a lawsuit and led him to leave England. At the Bauschule he published a two-volume work on *Physical and Chemical Properties of Building Materials* (1826).[90]

Accum's combination of chemistry with mineralogy is reminiscent of the work of Gustav Rose (with Mitscherlich) at the Mineralogical Museum but with more practical focus. The same integration of chemistry, mineralogy, and industry (or laboratory, museum, and factory) appeared again at the Bauschule in the basic course in mineralogy, taught by their professor Friedrich Wilhelm Koehler as "Technical Mineralogy," for which the school built a considerable collection of minerals and for which he wrote his brief *Outline of Mineralogy for Lectures in Higher Schools* (1831).[91] Koehler taught also at Berlin's Gewerbeschule, using his *Chemistry in Its Technical Relations* (1834), which recommended to teachers Mitscherlich's *Chemie* for its numerous experiments (along with Berzelius) and Schubarth's *Elemente* for its technical operations (along with Dumas).[92] The network in Berlin was very tight.

Others closely connected to the museological world at the Bauschule were two close associates of Alexander von Humboldt, Karl Sigismund Kunth and Heinrich Berghaus, who taught botany and "higher geodesy," respectively. Kunth had come to Berlin in 1820 as professor of botany at the University and vice director of the botanical garden. He had spent the previous seven years in Paris carrying out the preparation, cataloging, and publication of over four thousand of Humboldt's and Aimé Bonpland's botanical specimens from the New World. This great project lasted until 1825, producing a "museum" in seven volumes of the famous *Nova Genera*. He continued to exploit the American flora in his many books and to develop the herbarium (officially the Botanical Museum after 1880), which complemented the botanical garden from 1815.[93]

Heinrich Berghaus, too, first began his friendship with Alexander von Humboldt in Paris during the conclusion of the Befreiungskriege in 1815 and came to Berlin as a geographer in the Ministry of War working on its cartographic projects. In 1821 he was called to teach at the Bauakademie, becoming professor in 1824. Berghaus's access to high-profile patronage may help to explain the special attention his reworked course on "higher geodesy" received in 1831. For teaching measuring techniques used in establishing latitude, longitude, and elevation, Beuth authorized an expensive collection of instruments from the best makers in Berlin, especially Pistor and Schiek (see chap. 6 for their microscopes).[94] The course also included the various means of projection used for maps. Berghaus's own extensive map-making activities culminated in a famous geographical "museum," the first comprehensive *Physical Atlas* of the world, for which Humboldt had helped to collect the materials. And like Humboldt's *Kosmos*, which it was intended to illustrate, its numerous maps depicted the earth's climate, magnetism, geology, plants, animals, and peoples. It was as well an innovative work of art, featuring drawings and engravings, many in full color, done at his "Geographical School of Art" in Potsdam (1839–48). The example in figure 2.17 uses a distinctly Humboldtian physiognomical style to give an idealized geological history of the cooling earth with the succession of plants and animals that have occupied it.[95] This and many other charts and maps show how critical physical and chemical measurements and analysis had become to museological presentation. Thus, Berghaus appears as an epitome of the curricular pursuits at the Bauschule, from mathematics to botany, from drawing to construction, wrapped with aesthetic sensibility.

Pegasus at the Bauschule

Given the manner in which the Bauschule built its modernizing technological emphasis on a neoclassical as well as a mathematical and scientific foundation, it would be surprising if Schinkel had not contributed to the theme in the symbolism of the building itself. Indeed, in a poignant representation of these hopes for a rejuvenated classical spirit, Schinkel once again turned to Pegasus. In a series of expressive terra cotta reliefs, cast by Tobias Feilner's new competitor Cornelius Gormann,[96] that Schinkel placed in sets of three under the second story windows on each side of the building, he depicted the history of architecture, beginning with the decline of classicism and concluding with its rejuvenation at the Bauschule (selection, fig. 2.18). In the first set, flanked by dejected builders, Pegasus is nearly prostrate on the ground, his drooping wings conflated with those of a limp Genius, an

Figure 2.17 A Humboldtian physiognomical cross section of the earth's crust (foldout), in Berghaus, *Physikalischer Atlas*, pt. 3, no. 11. David Rumsey Historical Map Collection (http://www.davidrumsey.com).

Figure 2.18 K. F. Schinkel, Bauschule reliefs, Pegasus/Genius series, detail, from Schinkel, *Sammlung architektonischer Entwürfe*, plate 118.

alternative figure for the flight of inspiration deriving from the Etruscan and Roman tradition. In the second set classicism is still in ruins. But in the third set the Genius/Pegasus has regained his flight, and the builders to the left and right are back at work laying a foundation stone and carving Gothic ornamentation. Succeeding reliefs show them learning to use the level, the chalk line, and the compass and once again building Roman and Gothic arches.[97]

The mission of the Bauschule, as depicted here, was to resuscitate the architectural Genius/Pegasus, and with him the muses, to build the spirit of civic humanism into the newly emerging social order. That ideal has been attained in the final set of reliefs, where instead of a Genius, four young builders pull together to move a large building block. It is a scene of communal action repeated from the central image (fig. 2.19) in Schinkel's celebrated painting of the neoclassical ideal, *Blick in Griechenlands Blüte* (*View of the Flowering of Greece*, 1825).[98] On an imaginary construction site, heroic young citizens are building a great temple as a monument to the renewal of their republic (indicated by soldiers on the left, not shown here, returning home from battle—or from the Befreiungskriege/Freiheitskriege). They are building their own future through cooperative work, their imagination guided by a long frieze

Figure 2.19 K. F. Schinkel, Bauschule relief (*top*), from Schinkel, *Sammlung architektonischer Entwürfe*, plate 118, and (*bottom*) K. F. Schinkel, *Blick in Griechenlands Blüte* (1825), copy by Wilhelm Ahlborn (1836), detail, oil on canvas, 94 × 235 cm. Staatliche Museen zu Berlin, Nationalgalerie, Inv.-Nr. NG2/54. Photo by Andres Kilger.

reminiscent of the Parthenon in democratic Athens and supported by a row of Ionic columns like those of the Altes Museum, which Schinkel was then in the midst of building. Even the winged Genius is here, on a sculpted monument between the columns on the right, lifting a wounded warrior.

Schinkel's regular symbolic use of the winged Genius and of Pegasus and the muses points toward more concrete locations for their action at the Bauschule, in its museums, as collections of exemplary accomplishments, or "experiments" leading into the future where students could find stimulation for their work with modern materials and methods, much as the art museum was intended to function for citizens, artists, and students alike. As noted previously, Schinkel more nearly realized his own goals for a museum of neoclassical inspiration in his *Sammlung architektonischer Entwürfe*, from which

several of the images in this chapter are taken. The *Bauzeitung* (Construction news) recognized the collection as a work from which "every architect can collect a treasury of original ideas, carried out in the spirit of classical works of the old architecture."[99]

NOTES TO CHAPTER TWO

1. I am indebted to Doris Kaufmann for an illuminating discussion of the symbolic complement of dressage elegance and untamed strength.

2. Franke, *Berlin*, foldout 2.

3. The saddle blankets identify the horses as belonging to Hussars. Franke, *Berlin*, 142. Aleksander Orlowski (1777–1832) was a prolific painter of horses and portraits in Poland and Russia.

4. Brose, *Politics of Technological Change*, especially chap. 3, "The Aesthetic View from Pegasus," 98–132. Also, Brose, *German History,* 138–43. Importantly, while I treat the pervasive neoclassicism of Schinkel and Beuth as looking toward the future, Brose tends to represent it as looking to the past and, particularly for Beuth, as ultimately conservative. Beuth's anti-Semitism, his arrogance, and his opposition to rapid development of railroads complicate any simple view.

5. The Schinkel literature is immense. An entry point is the large exhibition catalog Altcappenberg, Johannsen, and Lange, *Schinkel* [exhibition catalog], and Altcappenberg and Johannsen, *Schinkel.*

6. Marchand, *Down from Olympus*, 36–74, succinctly describes the institutionalization of the neohumanist vision of *Bildung.*

7. Compare the extravagant *Paper Museum of Cassiano dal Pozzo: A Catalogue Raisonné* (London: Miller, 1996–), 34 vols.

8. Bergdoll, *Schinkel*, 46–48. I am indebted below to Bergdoll's interpretation of Schinkel's civic architecture. See also Trempler, "Preussen als Kunstwerk."

9. Schinkel, *Sammlung architektonischer Entwürfe*, plates 1–4.

10. Schinkel, *Sammlung architektonischer Entwürfe*, plates 7–18. For Pegasus in Schinkel's work, see Linnebach, "Pegasus" and Trempler, *Schinkel's Motive*, 91–97, 111–119, 191–193. The sculptures here of Apollo and of Pegasus are by Friedrich Tieck, after Schinkel's designs.

11. Linnebach, "Pegasus," 112; Bergdoll, *Schinkel*, 60.

12. To this important building, Schinkel devoted 11 plates (37–48) in his *Sammlung architektonischer Entwürfe.*

13. Ziolkowski, *German Romanticism*, chap. 6, 367, surveys the sources for this "gallery dialogue." The frescoes are not the ones Schinkel ultimately designed for the space.

14. Described, after Schinkel's own account, by Kugler, "Vorhalle des Museums." Blomberg, *Schinkel's Wandgemälde*, reproduces eighteen preliminary scenes for the full frescoes. Given in black and white in Vogtherr, *Das königliche Museum*, 131 (foldout); Van Wezel, *Die Konzeptionen*, 86–91; and Börsch-Supan and Grisebach, *Schinkel*, 30–33. Linnebach, "Pegasus," 115.

15. Interestingly, Correggio's similarly erotic painting of *Leda and the Swan* occupied

the central position in the painting gallery of the museum, linking its two major divisions, the Italian Renaissance on one side with Dutch and German masters on the other. Vogtherr, *Zwischen Norm und Kunstgeschichte*, 58–60.

16. Sheehan, *Museums*, gives a broad account of the museum movement, esp. chap. 2 for the Altes Museum in Berlin.

17. Rudwick, *Bursting the Limits of Time*, gives a thorough analysis for geology. For the dominance throughout the Enlightenment of the conception of natural states as states of dynamic equilibrium, see Wise, "Mediations," and "Time Discovered." A quite general discussion is Toulmin and Goodfield, *Discovery of Time*.

18. Taken together, the three dissertations by Van Wezel, *Die Konzeptionen*; Vogtherr, *Das königliche Museum*; and Stockhausen, *Gemäldegalerie Berlin*, provide a thorough reworking of the history and significance of the Altes Museum.

19. Humboldt, "Das achtzehnte Jahrhundert," 25; Van Wezel, *Die Konzeptionen*, 17. Vogtherr, *Das königliche Museum*, exhumes sources for decisions about the museum, including especially sources available since 1989.

20. A much more positive reassessment of Hirt's role is in Bredekamp and Labuda, "Kunstgeschichte," 242–51.

21. Van Wezel, *Die Konzeptionen*, chap. 1, 19–37, on Hirt and chap. 2, 39–62, on Schinkel. Sheehan, *Museums*, 87–89, succinctly surveys Hegel's perspective while too readily associating it with the organization of the Altes Museum, 89f. Ziolkowski, *German Romanticism*, 310–14, argued that the concept of the museum as a place for the edification of the public (Schinkel, Humboldt) only replaced that of a study or academy (Hirt) in the years 1815–1848, with the Altes Museum as the first and leading example in Prussia. See also, Bergdoll, *Schinkel*, 70–71, 80–85. For the "dynamicization" (*Dynamisierung*) of contemporary art that accompanied Humboldt's historicization and more generally for Humboldt's focus on the interrelation of the purposes of the state with those of the individual, see Lübbe, "Museumsgründung," 100–101, and "Musealisierung."

22. Van Wezel, *Die Konzeptionen*, controversy, 53–62, and detailed discussion of Schinkel's architecture, 63–91. Vogtherr, *Das königliche Museum*, controversy, 119–23, and state function, 123–29.

23. Schinkel and Waagen (drafted by Waagen but expressing Schinkel's views as well), "Über die Aufgaben," 210–11. Waagen, *Verzeichniss*, vii. Stockhausen, *Gemäldegalerie Berlin*, gives a full account of the painting collection. Van Wezel, *Die Konzeptionen*, Schinkel-Waagen memorandum, 92–97, paintings and sculptures, 98–105. See also Tieck (new director of the sculpture collection and himself a prominent sculptor), *Verzeichniss*.

24. Schinkel and Waagen, "Aufgaben," 211–12. Focusing on a sharply critical response by Humboldt to Schinkel's and Waagen's report, Vogtherr has drawn attention to Humboldt's and Rumohr's preference for an ordering of the paintings that collected aesthetically similar works together, avoiding comparisons that seemed too jarring, versus what they regarded as an overly chronological and historical ordering by their younger colleagues. While important for the increasingly art-historical direction of later museums, Vogtherr's discussion tends to underplay the commission's overwhelming agreement about the main purpose of the museum, to develop aesthetic sensibility in the public. Wil-

helm von Humboldt, "Bemerkungen zu Hrn. Dr. Waagen's Aufsatz Ueber die Principien der Gemälde-Aufstellung," reproduced in Vogtherr, *Zwischen Norm und Kunstgeschichte*, 61–64. See also Vogtherr, *Das königliche Museum*, 149–159.

25. Humboldt, "Bericht," 562. In the end, the demands of the *Akademie* apparently won out, since the museum opened in 1830 with only Monday and Saturday set aside for viewing by the properly dressed public ("jedem anständig Gekleideten") and the other four weekdays allocated to copying. Vogtherr, *Das königliche Museum*, 149.

26. Peschken, *Das Architektonische Lehrbuch*, 71, also 115 on proper historical relation of classical to present works. Van Wezel, *Die Konzeptionen*, 49. Ziolkowski, *German Romanticism*, 376–77, concludes his chapter on Schinkel's museum with "uselessness" as one of its attributes. This is surely a misconception, which would block not only the passage to Schinkel's other buildings but also to the workshop and the laboratory, as discussed below.

27. Klein, "Laboratory Challenge," 769, and "Chemische Wissenschaft," 447f. On Schlegel's conception of poetry as "chemical" experimentation, see Chaouli, *Laboratory of Poetry*, e.g., 108–12. Daiber, *Experimentalphysik des Geistes*, gives a full discussion of Novalis's sources, conceptions, and encyclopedia project.

28. Adler, *"Eine fast magische Anziehungskraft,"* 73–83, chemistry on 84–139.

29. Trunz, "Goethe als Sammler." Hamm, "Goethes Sammlungen."

30. On experiment as collecting, see Goethe, "Experiment as Mediator." For the collection of experiments on color, see especially Goethe, *Zur Farbenlehre* (any edition), pt. 1, sec. 1–3, where the phenomena are organized under three main categories (physiological, physical, chemical) with multiple subcategories. I thank John Tresch for discussion of the museum and Goethe. See Tresch, *Romantic Machine*, 38–39. On Goethe's political, economic, and religious views as expressed through his *Farbenlehre*, see Jackson, "Spectrum of Belief."

31. Groundbreaking for this story was a big exhibition filling the Martin-Gropius-Bau in Berlin in 2000–2001 and the accompanying publications: Bredekamp et. al., *Theater der Natur und Kunst.* Bruch and Tenorth, *Geschichte der Universität*, is the definitive work on the history of Berlin University. Vol. 4, Tenorth, Hess, and Hoffman, *Genese der Disziplinen*, includes several articles concerned with museums (cited below).

32. What has often been called a *Bergakademie* was actually a curriculum for training students and cadets of the Mining Corp under the *Bergwerks- und Hüttendepartment*. Klein, *Humboldt's Preussen*, 97–131, gives considerable attention to its role in the technology-science relationship.

33. Vogtherr, *Das königliche Museum*, 55–73, summarizes the early negotiations. See Humboldt, "Entwurf zur Reorganization." See also Segelken, "Sammlungsgeschichte," A. v. Humboldt on 49–50. Klein, *Humboldt's Preussen*, 288–306, on A. v. Humboldt's reorganization efforts.

34. Vogtherr, *Das königliche Museum*, 70–71. Wilhelm von Humboldt to Friedrich Wilhelm III, July 24, 1809, in Humboldt, *Gesammelte Schriften*, vol. 10, *Politische Denkschriften*, vol. 1, 148–54, on 150. Very similarly expressed in the king's order establishing the University, "Kabinetsordre vom 22 September 1809, betreffend die Verbindung der Akademie mit

der zu errichtenden Universität," in Harnack, *Geschichte*, 2:357–58; interpretation in vol. 1, pt. 2, 586–88. The three-legged idea actually corresponds rather closely with Alexander's report. In an undated draft memorandum "Ueber die innere und äussere Organisation der höheren wissenschaftlichen Anstalten in Berlin," Wilhelm expressed himself more reservedly with regard to the collections, or "Hülfsmittel," remarking that the point was not to pile up "dead collections," which could easily "dull and repel the spirit." Humboldt, *Gesammelte Schriften*, vol. 10, *Politische Denkschriften*, 1:250–60, on 255. Müller-Wille and Böhme, "Biologie," 429, suggest Humboldt may have been acting tactically to defuse territorial disputes.

35. Bredekamp and Brüning, "Vom Berliner Schloss," on 139. The 1880 figure is in "Geschichte des Museums," http://www.naturkundemuseum-berlin.de/institution/geschichte/ (accessed June 30, 2012; no longer posted).

36. On the dramatic expansion and transformation of the museum movement in the late nineteenth century and its public significance from a biological perspective, see Nyhart, *Modern Nature*, esp. chap. 6, 7.

37. Bredekamp and Labuda, "Kunstgeschichte," treat not only Hirt's important role in relating the University with the Museum but also those of the younger historians and philosophers of art Waagen, Kugler, and Hotho.

38. Analysis of this movement in Te Heesen, "Vom naturgeschichtlichen Investor," showing how consolidation undercut the role of previously important private collections, such as that of the Gesellschaft naturforschende Freunde, and noting that Weiss was obligated, following the example of his predecessor Dietrich L. G. Karsten, to transfer his private collection to the new Museum. Hamm, "Goethes Sammlungen," discusses Goethe's strong support for the movement in his role as administrator for the Duke of Weimar. In general, see Grote, *Macrocosmos*; Kuhn, "Der Naturgegenstand"; Sheehan, "Von der fürstlichen Sammlung"; Lenoir and Ross, "Geschichtsmuseum."

39. Damaschun, Böhme, and Landsberg, "Naturkundliche Museen," and Damaschun's contributions to the exhibition, "Die Bedeutung der Dimension," in Bredekamp, Brüning, and Weber, *Theater der Natur und Kunst*: Katalog, 281–92, esp. 283 on "Dynamik contra Atomistik" and on Weiss's notes added to D. L. G. Karsten's translation of Haüy, *Lehrbuch*.

40. In this he followed his Wernerian predecessor D. L. G. Karsten, father of Karl Karsten and grandfather of Gustav Karsten, the first president of the Berlin Physical Society (chap. 6). On the grandfather's role in the Mining Corps, and especially that of Karl Karsten, see Brose, *Politics of Technological Change,* 133–63.

41. Guntau, "Natural History," and Rudwick, "Minerals," provide a broad introduction to how mineralogy gradually incorporated chemical and crystallographic means of analysis. (Rudwick also notes that books of illustrations of mineral specimens served as proxy museums.)

42. For chemical laboratories generally and the positions and laboratories of Klaproth, Hermbstaedt, Mitscherlich, and Heinrich Rose, see Klein, "Chemische Wissenschaft," 449–58, who makes the critical point that chemistry was not sharply separated from a broad range of subjects dealing with materials (*Stoffe*): mineralogy, pharmacology, botany, technology, and even physics.

43. Müller-Wille and Böhme, "Biologie," 425–46, nicely summarize how the museums shaped the research of these professors. Similarly, for the relation of art professors and lecturers to the Altes Museum, see Bredekamp and Labuda, "Kunstgeschichte."

44. Hess, "Medizin," 501.

45. Terrall, *Catching Nature in the Act.*

46. Pickstone, *Ways of Knowing.* Forgan, "Architecture of Display," 155, 142. Also Gooday, "Placing or Replacing," for the need to locate the laboratory in a wider social context of museums, workshops, and even the kitchen.

47. I do not discuss here the place of the museum with respect to the temporality of nature itself. Two aspects of the museum-laboratory relation should be differentiated: first, the way in which the museum collection became the object of analysis by experimental means (mineralogy to chemical analysis; taxonomy to morphology to experimental physiology), and second, the way in which the collection itself became historical (mineralogy to geognosy to evolution; taxonomy to morphology to evolution). See, e.g., Klein, "Shifting Ontologies"; Matyssek, *Virchow*, 1, 17–21, 33–35. Both Rudwick, "Minerals," and Nyhart, "Natural History," discuss how evolution entered natural history. A nuanced account of evolution among German academics, centered around morphology, is Nyhart, *Biology Takes Form*, pt. 2.

48. "Kunst und Kunsttechnik in ihren neuesten Erscheinungen: Das Stiftungsfest des Gewerb-Vereins zu Berlin," *Museum: Blätter für bildende Kunst*, 4 (1836): 47–49, on 47. I leave *Kunst-Technik* untranslated as it needs to include aesthetics and technology simultaneously. See Helmholtz's aesthetics in chap. 8, 9.

49. This topic is receiving considerable attention in cultural studies. See, e.g., the workshops and publications of the Kunst und Technik Graduiertenkolleg at the Technische Universität Hamburg-Harburg, http://www.tu-harburg.de/kunstundtechnik/index.html.

50. It is noteworthy that Franz Kugler and Adolph Menzel collaborated closely as author and illustrator on their great work of national identity, *Geschichte Friedrich des Grossen, gezeichnet von Adolph Menzel* (Leipzig, 1840), rejuvenating Frederick the Great's reputation as enlightened and progressive leader. For extended analysis, see Paret, *Art as History*, 3–60, including the role of historicism.

51. Hoff, *Freydanck*, 79. Ostergard, *Along the Royal Road*, 121.

52. Trempler, "Preussen als Kunstwerk," 174, and Trempler, *Schinkels Motive*, 89–96, 111–209, interpret the fountain as an integral part of the museum, extending the inspirational message of Pegasus at the pool of Hippochrene to the entire building. See also Dorgerloh, "Wege zur Nation," esp. 112–13, Kat. 70.

53. Rave, *Schinkel, Berlin*, 2:116–23; engine tower, 1:226. Hinz, *Lenné*, 135–36.

54. Lenné, "Schmuck- und Grenzzüge der Residenz Berlin," quoted at length in Hinz, *Lenné*, 177–85. Schönemann, *Lenné*.

55. Klinkott, *Die Backsteinbau*, chap. 1, "Karl Friedrich Schinkel und die Wiedergeburt der Märkischen Backsteinarchitektur": Friedrich-Werdersche Kirche, 36–39; Feilnersche Wohnhaus, 50–52; and Bauschule, 52–62. Lippold, "Backstein."

56. Flaminius, "Bau des Hauses," 4. Bergdoll, *Schinkel*, 201.

57. Schinkel, "Bericht." Lorenz, *Konstruktion als Kunstwerk*, 79–86, 133, 136, 143–62, 268–86, presents Schinkel's work with iron but argues that he never took on the new medium in a fully architectonic manner, which was left to Stüler.

58. An independent Ministerium für Handel, Gewerbe und Bauwesen existed under Bülow from 1817 to 1825 but was then administered as a section of the Interior Ministry from 1825–1830 and finally of either Finance or Interior until 1848. Mieck, *Preussische Gewerbepolitik*, 30. Strecke, *Anfänge und Innovation*, 226–227.

59. Lucidly portrayed by Lundgreen, *Techniker*, 7–40. Klein, *Humboldt's Preussen*, 131–38, places the beginnings of the Bauakademie within her much larger story of the relation of *wissenschaftlich* to technical priorities in the Prussian administration of the late eighteenth to early nineteenth centuries. Strecke, *Anfänge und Innovation*, provides a detailed history of the Building Department and Bauakademie. See especially chap. 5 on the founding of the Bauakademie and chap. 6 on aesthetic considerations.

60. Bollé, "Bemerkungen." Famous among Schinkel's mentors is David Gilly, who contributed a large collection of construction models.

61. Strecke, *Anfänge und Innovation*, 117–36.

62. Illuminating history in Belhoste, *La formation d'une technocratie*, and the essays in Belhoste, Dalmedico, and Picon, *La formation polytechnique*.

63. Becker, *Von der Bauakademie* 11–12.

64. Becker, *Von der Bauakademie*, 9–12, curriculum on 10. Dobbert and Meyer, *Chronik*, 19–41.

65. At a deeper level, the contest involved a long-running struggle within the ministries over the proper role of technically trained experts, whether they should be full-fledged administrators with a deciding voice in government (the technocratic vision) or should be regarded rather as advisors to those who did merit such a voice. This debate tended to divide the dominant administrators trained in law from a decreasing number trained in cameralism. The trade ministry, and the Building Department within it, strongly favored a technocratic political liberalism. The all-important Peter Beuth had both legal and cameralist credentials. Brose, *Politics of Technological Change*, 100–104. Strecke, *Anfänge und Innovation*, 146–66. Lundgreen, "Engineering Education," esp. 41–45.

66. Lundgreen, *Techniker*, 33–34. Note that Lundgreen's citations to documents in the Geheimes Staatsarchiv Preussischer Kulturbesitz in Berlin need updating. Here his DZA, II/8, Bd. 1 (Kultusministerium) corresponds to the current classification GStA PK, I. HA Rep. 93 B Ministerium der öffentlichen Arbeiten (the former trade ministry), Nr. 30, on the following pages (Bl.): Altenstein to Bülow, July 8, 1817, Bl. 10f; Tralles' full proposal, July 8, 1817, Bl. 11–23f (Bl. 14–15 missing). This folder Nr. 30 is labeled "Acta betreffend die neue Organisation der Bauakademie zu Berlin. 1817–1823." Folders Nr. 31 and 32 continue the series for 1823–1830 and 1831–1849.

67. Ibid., Eytelwein, July 27, 1817, Bl. 24–31, on 24f. Bülow, September 8, 1817, Bl. 37–43f, on 37. The proposals of Tralles and Eytelwein actually show a great deal of similarity after the first year, with both, for example, including intensive study of descriptive geometry.

68. Ibid., Altenstein to Bülow, February 26, 1820, Bl. 63f.

69. Ibid., "Entwurf eines provisorischen Organisationsplans der Bau-Akademie" (Uh-

den and Eytelwein), July 21, 1820, Bl. 69–73; communicated to the ministers, July 29, 1820, Bl. 68; Eytelwein's uncompromising position, September 6, 1820, Bl. 77–79f; Altenstein's proposal of split, 16 November 1820, Bl. 80. Lundgreen, *Techniker*, 34–35.

70. Lundgreen, *Techniker*, 37–39. Straube, *Die Gewerbeförderung*, 13–19, reproduces Beuth's report and related documents.

71. In reference to Beuth's activities, I translate both *Gewerbe* and *Gewerbefleiss* as "industry," including the sense of "industriousness."

72. GStA PK, I. HA Rep 93B Ministerium der öffentlichen Arbeiten, Nr. 31: report with addenda detailing separation of instruction, December 5, 1823, Bl. 6–9f, 14–15f; king's approval, December 31, 1823, Bl. 11. Also in GStA PK, I. HA Rep. 76 Kultusministerium Ve, Sekt. 17, Abt. I, Nr. 3 Bd. 2 ("Acta betreffend Reorganization der königlichen Bauakademie zu Berlin und Uebergabe derselben an das königliche Ministerium für Gewerbe und Bauwesen"), Bl. 22–26f.

73. *Verzeichniss.*

74. The story has had two inadequate tellings. Manegold, "Eine École Polytechnique," seeking the origins of the Technische Hochschule, stresses neohumanist hostility to natural science, and especially technology, on the part of a philosophical faculty at the University dominated until the early thirties by philologists and Hegelian idealists. Schubring, "Mathematics," seeking the emergence of pure mathematics as a discipline, dismisses any significant role for the technical schools in promoting mathematics and natural science.

75. GStA PK, I. HA Rep. 93 B Ministerium der öffentlichen Arbeiten, Nr. 30, September 6, 1820, Bl. 77–79f.

76. Lorenz, *Konstruktion als Kunstwerk*, 114–15.

77. Dobbert and Meyer, *Chronik*, 42–45, curriculum on 43.

78. Ibid., 48–49.

79. Particularly informative for the various materials and their costs are three large folders in the Geheimes Staatsarchiv, "Die Anschaffung der Werke, Zeichnungen, Instrumente und Modelle zur Gebrauch beim Unterricht in der Allgemeine Bauschule," GStA PK, I. HA Rep. 76 Kultusministerium Vb, Sekt. 4, Tit. XI, Nr. 15, Bd. 1 (for 1835–38), Bd. 2 (for 1835–38), and Bd. 3 (for 1839–47).

80. Hermann Arthur Lier, "Stier, Wilhelm", *Allgemeine Deutsche Biographie* 36 (1893): 207–8, http://www.deutsche-biographie.de/pnd104136421.html?anchor=adb.

81. Van Wezel, *Die Konzeptionen*, 149–67. Lorenz, *Konstruktion als Kunstwerk*, 74–76, 188–94, 242–45, and 319–41(railroad and elevator, 193, 326–27).

82. The Bauschule maintained collections of plaster casts of architectural details and statues as well as sheets and books of drawings of ancient buildings and ruins in Athens and Rome. "Die Anschaffung . . . Bd. 1," e.g., Bl. 9f, August 22, 1830, Bl. 34, December 30, 1830. For Stüler's lectures, in particular, they paid for rather expensive drawings from local draftsmen. "Die Anschaffung . . . Bd. 1," e.g., Bl. 174, May 17, 1834, and Bl. 181–90 for July and August 1834, also "Anschaffung . . . Bd. 2," passim. An extensive inventory of the collections of the Bauschule in 1835 appears in "Die Anschaffung . . . Bd. 2," Bl. 41–52, made by Bauinspector Linke before moving to the new building, which gives 103 plaster models

acquired for Stier's courses since May 1829 plus 200 earlier models from the deceased Professor Gentz in 1804.

83. Van Wezel, *Die Konzeptionen*, 164–65.

84. Linke's inventory (n82, above) of the model collections at the Bauschule in 1835 gives 369 objects in the Modellkammer for various types of construction: Wasserbau, Brükkenbau, Schiffbaukunst, Maschinenbau, Landbaukunst, etc.

85. Neumann-Redlin von Meding and Adam, "Hagen."

86. Dupin, *Développements de géométrie.*

87. Nottebohm, *Chronik*, 13–14. The library of the Gewerbeinstitut contained at least twenty books on descriptive geometry (or projective geometry) published before 1845, not counting many others on perspective or theory of projection. *Katalog der Bibliothek*, 2–14. Lorenz, *Konstruktion als Kunstwerk*, 115–16, on Brix.

88. Gottlob Kirschmer, "Ferdinand Minding," *Neue deutsche Biographie* 17 (1994): 536–37.

89. "Die Anschaffung . . . , Bd. 2," Bl. 70–71, April 21–22, 1836. Minding, *Handbuch*. Other relevant textbooks of Minding are *Sammlung von Integraltafeln* and *Anfangsgründe der höheren Arithmetik.*

90. Accum, *Physische und chemische Beschaffenheit*. Cole, "Accum."

91. See, e.g., "Die Anschaffung . . . Bd. 1," Bl. 8off, beginning April 18, 1833, with notes from Beuth. Koehler, *Grundriss.*

92. Koehler, *Die Chemie*, vi. See also his *Lehrbuch der Chemie*. Early career in the annual report and invitation of 1831, *Zu der öffentlichen Prüfung der Zöglinge des Cölnischen Real-Gymnasii*, 34–35, where he taught chemistry, physics, mineralogy, and technology for two years. The invitation featured his essay "Ueber die Naturgeschichte des Kreuzsteins: Eine mineralogische Abhandlung," 1–11, which lauded the work of Weiss.

93. Kunth, *Nova genera*. Lack, "Berlins grüne Schatzkammer," gives a summary history of these facilities.

94. On September 1, 1831, "Die Anschaffung . . . Bd. 1," Bl. 13, interior minister Schuckmann requested Berghaus's course proposal be delivered to Beuth. Bl. 109–12f, September 26, 1833, give lists of existing instruments and of new instruments to be acquired. A Pistor and Schiek quote (Bl. 126) for 900 thaler includes three theodolytes, three telescopes of two kinds, five barometers of three kinds, and five thermometers. More extended price lists from Pistor and Schiek at Bl. 128 and J. G. Greiner at Bl. 127. See also "Die Anschaffung . . . Bd. 2," Bl. 38f, October 8.1835, giving Pistor and Schiek invoice for 719 thaler for three new theodolites and other equipment and the Linke inventory of 1835 (Bl. 41–52) including twenty-one instruments acquired for Berghaus.

95. Viktor Hantzsch, "Heinrich Berghaus," *Allgemeine deutsche Biographie* 46 (1902): 374–79. Heinrich Berghaus, *Physikalischer Atlas; oder, Sammlung von Karten, auf denen die hauptsächlichsten Erscheinungen der anorganischen und organischen Natur nach ihrer geographischen Verbreitung und Vertheilung bildlich dargestellt sind*, 2nd ed. (Gotha: Perthes, 1852).

96. Lippold, "Backstein," 106.

97. Rave, *Genius der Baukunst*, 35–39. Rave presents the *Genius* as an inspirational fig-

ure in Schinkel's life, much like Pegasus and here intermingled with him. Rave, *Schinkel, Berlin*, 3:38–60, esp. 53–54. See also Bergdoll, *Schinkel*, 203–5, and Trempler, "Preussen als Kunstwerk," 156, 180–85.

98. For Schinkel's *Blick* and its context, see Johannsen, "Der Traum," 262; Buttlar, "Freiheit."

99. Flaminius, "Bauschule," 3n.

PEGASUS AND THE MUSES (MUSEUMS) OF ART, INDUSTRY, AND SCIENCE

Section 2: Gewerbehaus

Industry, which we intend to promote, is the basis of the wealth of a nation, and since true industriousness is unthinkable without virtue, so is it also the basis of national strength altogether.
— Christian Peter Wilhelm Beuth, 1821

With these words Beuth opened the first meeting of the Verein zur Beförderung des Gewerbfleisses in Preussen (Society for the Advancement of Industry/Industriousness in Prussia) on January 15, 1821, with 140 Berlin members.[1] Subsequent meetings of the Gewerbeverein soon could be held in what came to be called the Gewerbehaus, the House of Industry, where Beuth integrated three institutions to jump-start Prussian industry: the Technische Deputation, the Gewerbeinstitut (Industrial Institute), and the Gewerbeverein, along with his own living quarters.[2] Figure 3.1 shows the Gewerbehaus in 1830, on the right. Having begun in 1821 with the purchase of the Palais on the far end for 32,000 thaler, the Gewerbehaus underwent a series of acquisitions, additions, and alterations costing over 150,000 thaler, all designed by Schinkel, until it acquired the classical appearance shown in the painting.[3]

The urban landscape from 1830 is again by Eduard Gaertner (see fig. 2.14), one of the young Berlin realists. His choice of people for his street scene suggests the network of personal relations within which the pursuit of industry would be practiced. Before the Gewerbehaus stand Beuth (in his red-banded cap) and Schinkel (in top hat). In the middle of the street, Gaertner himself greets Franz Krüger (painter of *Parade*, chap. 1) on horseback. And on the left, in white trousers, the prominent sculptor C. D. Rauch (of the Scharnhorst statue, chap. 1) stands in conversation with a small assembly in front of his workshop and apartment.[4] The street is the Klosterstraße, already known for its concentration of arts and crafts. Gaertner's painting thus expresses visually the theme that art and industry were to be conjoined in the Gewerbehaus. It was a theme of Gaertner's own life and affiliations.

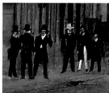
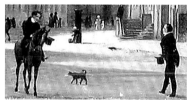

Figure 3.1 Eduard Gaertner, *Die Klosterstrasse*, 1830, oil on canvas, 32 × 44 cm. Staatliche Museen zu Berlin, Nationalgalerie, Inv.-Nr. A II 736. Photo by Jörg P. Anders.

Son of a craft family, he acquired his professional training during a six-year apprenticeship at the Royal Porcelain Factory KPM, After a year there as a journeyman, he joined the workshop of Theater Inspector Carl W. Gropius in 1821 as a painter of scenery, including sets designed by Schinkel for productions at the newly erected Schauspielhaus.[5] Gropius and his two brothers were well known in Berlin as publishers and as manufacturers of fine silks and printed cloth as well as proprietors of a popular diorama in Berlin. And as we should now expect, Carl Gropius was a founding member and active participant in the Gewerbeverein.[6]

In his new Gewerbehaus Beuth set out to integrate state promotion of

industry with private enterprise and the education of entrepreneurs. The "state" here functioned as the Technische Deputation, which Beuth had rejuvenated as its new director in 1819. The Technische Deputation had its origins in the famous "plan for a new organization for fostering business enterprise in the Prussian state" of Freiherr vom Stein in 1807, which inaugurated the Stein-Hardenberg reform era following the collapse of Prussia in the face of Napoleon's army in 1806. As proposed in 1810, the deputation would have consisted of a high-level body of technical experts advising the ministries. Opposition to such technocracy by the king and even the liberal Hardenberg left a much less authoritative body, although progressive figures such as Christian Kunth, then *Staatsrat* (counselor of state) in the interior ministry, attempted to give it a leading role. Its original goals included much of what Beuth would actually accomplish with Kunth as his (usually) constant supporter and Stein himself as a member of the new Gewerbeverein.[7]

Born in 1781 as the son of a doctor in Cleve on the Rhine, Beuth obtained his university training in law and *Kameralwissenschaft* (cameralism or administrative policy) at Halle. He apparently educated himself in machine technology only after joining the Prussian state service in Potsdam in 1809 and moving to Berlin a year later as senior tax counselor (*Obersteuerrat*) in the finance ministry. There he became a member of the Commission for Reform of Taxation and Industry (Kommission für Reform des Steuer- und Gewerbewesens). His rapidly developing career thus emerged directly from the Stein-Hardenberg reforms. But the Wars of Liberation, insufficient funds and space, and unfocused leadership in the ministry virtually paralyzed the Technische Deputation. Beuth's own action for industrial development began during the wars while he served in the cavalry of Lützow's *Freikorps*. Quartered in Lüttich (Liège) in 1814, he used his free time to study machine production at the factory of John and James Cockerill, who had come from England with their machine-building father and were already known for their advanced designs and methods. Soon afterward, having become a high-level counselor (*vortragender Rat*) in the Department of Trade and Industry, with Kunth as his supervisor Beuth brought the Cockerill brothers to Berlin to establish a new wool-spinning plant. Opening in 1815, it became a model for machine manufacture in the textile industry and a conduit for supply of machinery from the Lüttich plant, including steam engines built "in the English manner" (presumably using the double-acting Watt principle for higher efficiency).[8]

This success stamped Beuth's immediate ambitions, for in 1816 he was already planning an industrial study tour in Scandinavia. In 1817 he produced for minister Hans von Bülow, in the newly independent Ministry of Trade, Industry, and Building, a harsh critique, with extensive suggestions for correcting the situation, of virtually everything that had so far been accomplished for industrial development. In brief, he required of the Technische Deputation that it would consist only of the very best men in their field possessing extensive knowledge of practical operations both domestic and foreign and recognized with commensurate salaries. He also required that the deputation devote itself entirely to solving problems of industrial development, leaving those of trade to others. For this purpose Beuth had already identified four crucial elements: a current technical library; collections of drawings, models, and working machines (or museums); workshops for producing these essential items; and laboratories for original experiments. The deputation should not only carry on its usual roles of advising the ministry and judging patents, it should also distribute its knowledge of methods and machines to all interested parties and should regularly publish the latest information, doing everything possible to improve the miserable state of existing technical literature. Finally, it should "promote the influence of a refined taste and knowledge of antiquity." Schinkel should join the deputation. In other words, the Technische Deputation should promote industry with aesthetics, especially classical aesthetics. Succeeding reports and recommendations were largely approved by the king in 1819 followed by Beuth's appointment as director.[9]

Beuth's aspiration for the integration of civic humanism and industrialization would inform his entire career. Schinkel incorporated them in a depiction of the two sides of Beuth's mind in an 1836 Christmas present (fig. 3.2). In his country house in Schönhausen, north of Berlin, Beuth dozes in his armchair flanked by his beloved horses and dogs. His dreams are placed between complementary visions of traditional and modern life. On the right, his passion for books, manuscripts, and art appear in objects from his study in Berlin with a view behind the curtains to the rural landscape in Schönhausen, where he works in the garden with an assistant.[10] On the left lie the tools of industry before a smoking locomotive with a cityscape in the distance. They represent the railroad being constructed from Berlin to the industrializing port city of Stettin (Polish, Szczecin) on the Baltic, not far from Schönhausen. Ironically, despite his role in making them possible, Beuth would oppose state commitment to large railroad projects as too early in Prussia's

EPOCHA ANNI DOM MDCCCXXXVI

Figure 3.2 K. F. Schinkel, "Representation of my [Beuth's] state of mind." Christmas gift, 1836.

development and as draining away scarce capital, setting him in sharp opposition to free-trading administrators and industrialists alike as well as to some prominent spokesmen for the army.[11]

Technische Gewerbe-Deputation

Schinkel's image captures the dynamic character and the inherent tension of Beuth's passionate commitments over the preceding two decades, since his initial appointment as head of the Department of Trade and Industry in 1818 and the Technische Deputation in 1819. One of his initial acts was to reconstitute the deputation. He kept four of the six previous members, including Sigismund Friedrich Hermbstaedt, for chemical technology, and he retained the factory commissioner Heinrich Weber, who was producing a detailed guide to the most advanced factories in Berlin. The new Cockerill plant figured prominently (fig. 3.3). With reforming enthusiasm, Weber gave a sharply worded wake-up call to technically illiterate and fearful officials, urging them to recognize the limitations of their one-sidedly humanistic education and to pay attention to the "progress of national industry."[12]

Among Beuth's new additions to the nine-member deputation, in addition to Schinkel, was August Leopold Crelle, a mechanical engineer (*Maschinenbaumeister*), self-taught mathematician, and senior counselor (*Oberbaurat*) in the Building Department who would soon found a leading journal for pure and applied mathematics (*Journal für die reine und angewandte Mathematik*,

This success stamped Beuth's immediate ambitions, for in 1816 he was already planning an industrial study tour in Scandinavia. In 1817 he produced for minister Hans von Bülow, in the newly independent Ministry of Trade, Industry, and Building, a harsh critique, with extensive suggestions for correcting the situation, of virtually everything that had so far been accomplished for industrial development. In brief, he required of the Technische Deputation that it would consist only of the very best men in their field possessing extensive knowledge of practical operations both domestic and foreign and recognized with commensurate salaries. He also required that the deputation devote itself entirely to solving problems of industrial development, leaving those of trade to others. For this purpose Beuth had already identified four crucial elements: a current technical library; collections of drawings, models, and working machines (or museums); workshops for producing these essential items; and laboratories for original experiments. The deputation should not only carry on its usual roles of advising the ministry and judging patents, it should also distribute its knowledge of methods and machines to all interested parties and should regularly publish the latest information, doing everything possible to improve the miserable state of existing technical literature. Finally, it should "promote the influence of a refined taste and knowledge of antiquity." Schinkel should join the deputation. In other words, the Technische Deputation should promote industry with aesthetics, especially classical aesthetics. Succeeding reports and recommendations were largely approved by the king in 1819 followed by Beuth's appointment as director.[9]

Beuth's aspiration for the integration of civic humanism and industrialization would inform his entire career. Schinkel incorporated them in a depiction of the two sides of Beuth's mind in an 1836 Christmas present (fig. 3.2). In his country house in Schönhausen, north of Berlin, Beuth dozes in his armchair flanked by his beloved horses and dogs. His dreams are placed between complementary visions of traditional and modern life. On the right, his passion for books, manuscripts, and art appear in objects from his study in Berlin with a view behind the curtains to the rural landscape in Schönhausen, where he works in the garden with an assistant.[10] On the left lie the tools of industry before a smoking locomotive with a cityscape in the distance. They represent the railroad being constructed from Berlin to the industrializing port city of Stettin (Polish, Szczecin) on the Baltic, not far from Schönhausen. Ironically, despite his role in making them possible, Beuth would oppose state commitment to large railroad projects as too early in Prussia's

EPOCHA ANNI DOM MDCCCXXXVI

Figure 3.2 K. F. Schinkel, "Representation of my [Beuth's] state of mind." Christmas gift, 1836.

development and as draining away scarce capital, setting him in sharp opposition to free-trading administrators and industrialists alike as well as to some prominent spokesmen for the army.[11]

Technische Gewerbe-Deputation

Schinkel's image captures the dynamic character and the inherent tension of Beuth's passionate commitments over the preceding two decades, since his initial appointment as head of the Department of Trade and Industry in 1818 and the Technische Deputation in 1819. One of his initial acts was to reconstitute the deputation. He kept four of the six previous members, including Sigismund Friedrich Hermbstaedt, for chemical technology, and he retained the factory commissioner Heinrich Weber, who was producing a detailed guide to the most advanced factories in Berlin. The new Cockerill plant figured prominently (fig. 3.3). With reforming enthusiasm, Weber gave a sharply worded wake-up call to technically illiterate and fearful officials, urging them to recognize the limitations of their one-sidedly humanistic education and to pay attention to the "progress of national industry."[12]

Among Beuth's new additions to the nine-member deputation, in addition to Schinkel, was August Leopold Crelle, a mechanical engineer (*Maschinenbaumeister*), self-taught mathematician, and senior counselor (*Oberbaurat*) in the Building Department who would soon found a leading journal for pure and applied mathematics (*Journal für die reine und angewandte Mathematik*,

1826) as well as a journal for architecture (*Journal für die Baukunst*, 1829). He would also take responsibility for planning the Berlin-Potsdam railroad, opening in 1838. The presence of people like Crelle and Hermbstaedt suggests the emphasis of Beuth's program on building a basis in natural science and mathematics for industrial advancement, much as at the Bauakademie for construction but at a lower academic level.

In pursuing these goals, Beuth aimed to establish a specialized version of the great industrial museum in Paris, the Conservatoire national des arts et métiers,[13] already well known as a progressive postrevolutionary model for public enlightenment. Founded in 1794 by a decree of the Convention, the Conservatoire promoted technical innovation, worker education, and national industry by assembling a "repository of machines, models, tools, drawings, descriptions, and books from all the arts and trades," that is, a museum or set of museums. Building on the former royal collection (largely from the famous eighteenth-century mechanic Vaucanson) and on private

Maſchinenbau-Anſtalt und Wollen-Manufactur
der Herren **Ch.** *James et John* Cockerill *zu Berlin.*

Figure 3.3 Cockerill machine works and wool manufacture, in Weber, *Wegweiser*, vol. 1, title page.

collections confiscated during the revolution, the museum grew rapidly. Its first catalog, published in 1818, included over 2,500 machines and models, a physics cabinet of about seven hundred items (mechanics, hydrostatics, optics, electricity, etc.), and a collection of some six hundred drawings of machines and manufacturing processes. Its library contained more than ten thousand volumes.[14]

On a much smaller and more focused scale, Beuth and his Technische Deputation at the Gewerbehaus assembled their own collections of books, machine drawings, and working models, starting with the rather haphazard acquisitions of the earlier Technische Deputation but continuing now systematically to acquire a full spectrum of foreign and domestic exemplars. From his first reform proposals in 1817, Beuth had stressed how indispensable drawings were for a modern technical education, and his correspondence from the 1820s and 1830s shows his energy in pursuing their acquisition.[15] Similarly for models, noting in 1822 that "a model collection like the Conservatoire des Arts et des Metiers is lacking in Berlin," Beuth set out to build one. It would focus especially on textile manufacture and machine building, the branches of industry judged to be the most important (textiles) and the least advanced (machines) in Prussia. As Weber presented it, fine, low-priced English textiles threatened to wipe out the market for rough and expensive Prussian goods. Only the gradual understanding that high-quality textiles depended on refined machine production rather than the familiar older machines and handwork had begun to reverse an otherwise inevitable decline of the Prussian industry.[16] The models collection thus included an entire wool-spinning installation from Cockerill and another from the innovative Berlin builder Tappert. Many other models were of English extraction, but masterful local creations from such builders as Hummel, Hoppe, and Egells were also represented.[17]

To build these models of the latest and best machines, the Gewerbehaus included up-to-date workshops for forging, casting, and machining of metal parts and for carpentry and locksmith work. Four craftsmen worked here continuously. They even had a small steam engine to power an assortment of machines for cutting, rolling, drawing, and turning metals, including three fine lathes built from English designs.[18] The models were typically made from the same materials as the original machines and were scaled consistently to one-third size. The workshops, like the models they produced, inevitably took on an experimental character. But the explicitly experimental work took place in four new laboratories in the Gewerbehaus. They were surely the most diverse set of laboratories in Berlin: a physical laboratory, a chemical

laboratory, and two industrial or technological laboratories, one containing two large hydraulic presses for investigating the strength of materials and one containing three furnaces for experiments on glass making, steel production, and metallurgical processes.[19] Here the natural sciences so often stressed in Beuth's program had their direct application.

Complementing the collections of drawings and models was a smaller collection of full-sized machines. Many came from Britain, some as legal imports, many others through industrial espionage, whether as reproductions made from detailed drawings either copied from originals or newly produced by the draftsmen who often accompanied factory tours. More devious means of circumventing British export prohibitions on advanced machines involved purchasing them in Britain, disassembling them, and sending the parts by diverse routes to Berlin, for reassembly, thorough study, and drawing.[20] In all these cases the drawings were intended for remanufacture and were given free of charge to interested machine builders, while the original machines were sometimes given as rewards to deserving manufacturers to spread their use.

The collections of drawings, models, and machines assembled at the Gewerbehaus, along with a fast-growing library of printed books,[21] constituted the repository of technical knowledge passing in and out of the institution. That is, they were museums for progressive action, like those of the Conservatoire, but also in the sense of Schinkel's *Sammlung architectonischer Entwürfe.* They provided exemplary works to educate and stimulate the imagination of machine builders and manufacturers for modern productions. And especially when considered in their intimate relation to the supporting workshops and laboratories at the Gewerbehaus, they played a role similar to what Schinkel proposed for the presentation of works of art at the Altes Museum, as analogues of scientific experiments that looked toward new creations.[22] Once again, they illustrate the way in which museums (as residences of the muses) gave birth to laboratories and collecting to experimenting.

Importantly, aesthetics continued to play an important part in this analogy between artistic and scientific experiment. That is particularly clear in the energy that Beuth put into acquiring, alongside machine drawings and models, an extensive collection of plaster models of antiquities. They came from museums all over Europe (British Museum, Royal Danish Museum, and Neapolitan Museo Borbonico) as well as from domestic suppliers, and they included such diverse figures as Bacchus, Venus, Plato, and an Amazon, but also architectural elements, such as the capital and base of a marble column from Pompeii and an ornament from the door of the house of Eumachia. Not

to be forgotten is Beuth's personal library containing over two hundred books on Greek and Roman art and literature.[23]

Schinkel contributed to this aesthetic effort at the Gewerbehaus as well, where he joined Beuth in producing a magnificent collection of *Vorbilder für Fabrikanten und Handwerker* (Exemplars for manufacturers and craftsmen). Two large-format volumes contain numerous engravings of works from (mostly) Greek and Roman antiquity made from drawings by Schinkel and others of objects from sites in Greece and Italy and from museums and private collections throughout Europe. Three sections contain, respectively, decorative architectural elements; implements, containers, and smaller monuments; and decorations for fabrics and knitting (where arabic designs from the Alhambra appear).

The selections, as Beuth explained, were intended for currently practical objects (e.g., fig. 3.4), which could be reproduced on the basis of the scaled drawings and sold in the international market alongside those of such famous manufacturers as Wedgewood. Their larger purpose, however, was *Bildung*. Producers themselves needed to acquire the sensibilities necessary to realize the "spirit of the exemplar" and to put the "stamp of *Bildung*" on their works. Classical aesthetics would then "exert an influence on the cultivation of taste" among the general public.[24] Thus, manufacturers and craftsmen would contribute to cultural elevation through the materialization of *Bildung*, much as expressed in the *Museum* magazine (chap. 2) and in Menzel's locomotive-as-Pegasus for the Gewerbeverein. Beuth again was stressing the significance of *Kunst-Technik* for modern society.

Figure 3.4 Kunst-Technik: designs for china and fabric. [Beuth and Schinkel], *Vorbilder für Fabrikanten und Handwerker* (plates, 1821), section I, plate 29, and section III, plate 1.

But here we meet an important distinction. Manufacturers and craftsmen, Beuth insisted, were not to pretend that they could produce the exemplars themselves; they were to imitate. The creation of suitable exemplars was the work of trained artists, trained through disciplined study, critique, and talent. The distinction is not so much between high and low culture as between the roles of composer and musician, the one who writes and the one who performs. Beuth had seen enough tasteless art and architecture to think that the merger of aesthetics and industry required specialized training on both sides.

Despite this restriction, the volumes of exemplars provide an elegant illustration of the constant theme in Beuth's industrial initiatives stressing the role of drawings as the indispensable medium of technical knowledge. More generally, and to continue the theme from Schinkel's *Sammlung architektonischer Entwürfe,* collections of drawings constituted the language of technical knowledge. Since wider communication constituted one of the primary aims of the Technische Deputation, Beuth included a first-rate workshop for copper engravings in the Gewerbehaus. The engravers produced remarkably fine plates for many publications of the deputation and of the Gewerbeverein, but particularly impressive are the engravings that accompany articles in its journal, *Verhandlungen des Vereins zur Beförderung des Gewerbfleisses in Preussen* (Proceedings of the Society for Advancement of Industry in Prussia; abbr. *Verhandlungen* or *VdVBG*).

Gewerbeinstitut

Although museums of drawings and models juxtaposed with workshops and laboratories were to serve as primary agents for promoting progressive factory production, Beuth did not suppose that redirecting established manufacturers into new practices would by itself produce the generation of creative *Techniker* (later engineers) and entrepreneurs whom he imagined could launch Prussia into the sophisticated world of modern industry in competition with the British. They required systematic education. Again the Conservatoire in Paris provided an instructive example. It had always mounted public lectures intended especially for those industrious citizens who would ground a new political economy. In 1819 this role was institutionalized with the appointment of three regular professors who were not only leading figures in their fields but who were dedicated to public education: the engineer and geometer Charles Dupin, the political economist Jean-Baptiste Say, and the chemist Nicolas Clément-Desormes.[25]

Dupin's several trips to Britain during 1816–1820 had convinced him that the amazing growth of British wealth depended on industrial education. Fol-

lowing his mentors, Lazare Carnot and Gaspard Monge, he developed at the Conservatoire enormously popular courses and textbooks on industrial mechanics and descriptive geometry.[26] Say, following his own mission to Britain for the restoration government of Louis XVIII to report on the industrial economy, had much the same opinion as Dupin. His *Catéchisme d'économie politique* (1815) put in a simple dialogue form a revised version of arguments from his already famous *Traité d'économie politique* (1803). Say replaced Adam Smith's theory of labor value with "utility value," replacing at the same time the mere labor of workers with their "industry," or industriousness, including the exercise of their talents and acquired knowledge in producing the utility of products. Say's focus on producing utility put the industry of wage earners, including engineers and scientists, on the same footing as the industry of capitalists and landowners, however different their actual work. It also made his course and textbook on industrial economy relevant to all productive agents in the economy.[27]

Beuth did not have the resources of the Conservatoire, but the personnel of the Technische Deputation allowed him to establish in the Gewerbehaus in 1821 a highly focused Gewerbeinstitut[28] with the aim of raising up a small cadre of young men (thirteen in the first year, but continually expanding) who would be able to create new machines and products, modernize existing manufactures, and perhaps establish new ones. In Beuth's view, such private *Techniker* required not only intimate familiarity with machines and materials but knowledge of the natural sciences requisite for understanding and extending the latest technical processes. So the Gewerbeinstitut occupied from the outset a place both literally and figuratively next to the Technische Deputation, making full use of its members as teachers; of its collections/museums of drawings, models, and publications as teaching materials; and of its workshops and laboratories for advanced students.

A historiographical comment is necessary here. Several studies have cast serious doubt on the traditional view that technical education played a prominent role in the industrialization of Germany during the first half of the nineteenth century. Wolfgang König puts it directly: "technical schools contributed little to early industrialization in Germany." Peter Lundgreen makes a similar claim for both France and Germany, drawing for comparison on Britain and America, where very little technical education existed.[29] Their basic argument begins from the French *Écoles d'application*, which were established not to promote private industry but to serve the needs of government administration in the areas of civil engineering (École des ponts et chaussée), mining engineering (École des mines), and military engineering (École du

génie et d'artillerie). In Germany too, following the French model, credentialing of state engineers—not industrial improvement—set the agenda for the technical schools. Attaining this elite status presupposed Latin at the *Gymnasium* followed by a mathematics-based curriculum at a relatively high level. But such a "school culture" for state engineers melded poorly with the actual needs of industry for practical training, which therefore continued to be based on the apprenticeship system of "shop culture."

Importantly, the one exception to this rule for Germany was the Gewerbeinstitut, whose students would have neither Latin nor high-level mathematics and could not qualify for state administrative service. Beuth insisted that their training in mathematics and natural science maintain its practical orientation, for it was intended explicitly to prepare them for positions in private industry.[30] Even so, it remains an open question whether the Gewerbeinstitut had a significant effect on industrialization or merely contributed to a movement taking place independently. And that question, considered for Germany more generally, quickly runs into the role of technical schools in the so-called Second Industrial Revolution of the later nineteenth century, when new technical universities (*technische Hochschulen*, which the Gewerbeinstitut would become in a merger with the Bauschule in 1879) were created to meet a perceived need. Lacking convincing evidence, a reasonable conclusion may be, with König, that Germany's early investment in technical education was effectively "investment in the future—only the future lay at a greater distance than the founders had expected."[31]

This important question, however, is not mine. I am interested instead in the institutionalization at the Gewerbehaus of the belief that scientific and mathematical training did indeed hold the key to industrial competition with Britain and, in turn, the belief that the natural sciences had much to learn from engagement with industry. For this purpose the struggle between the trade ministry and the cultural ministry over the proper conception of *Wissenschaft* in technical education emerges once again. Beuth and his allies in the trade ministry continued to insist on a practice-oriented approach to mathematics and natural science for private engineers. But a surrogate issue played out with respect to the role of Latin in their preparatory training.

The conflict had taken a nearly fixed form by the time Beuth expressed its content directly in a document of 1833, when he presented the trade ministry's full support, in opposition to Altenstein in the cultural ministry, for provincial authorities in Silesia to require that *Gewerbeschulen*, without Latin, be established in every district, thereby to provide a *wissenschaftlich* preparation for students wishing to continue in technical-industrial careers. Observing

that "it is unbelievable on what a low level the construction workers—mill builders—in brief all technical crafts—stand there," Beuth was delighted that the *Gewerbetreibende* (craftsmen and manufacturers) themselves, as well as the authorities, recognized that scientific education was indispensable if they were to reverse what he called "the Chinese and Spanish Stagnation" that had settled over Silesia and return to competition in the world market. Perhaps the working classes were correct that "a few thousand talented construction workers, mechanics, dyers, and bleachers contribute more to the prosperity of the province than just as many [Latin] philologists."[32]

It was not Latin itself but the exclusive status of Latin in elite education that was Beuth's target. He argued repeatedly for the equal right of the private productive classes to obtain the knowledge they required for their life's work through public instruction. This they could not do at the classical *Gymnasien*, as he had learned anew at the Gewerbeinstitut: "Experience with young people who entered the Gewerbeinstitut having obtained a first-class degree in preparation for the University [Gymnasium Abitur, Reife No. 1] . . . showed that their knowledge in mathematics and natural sciences was such an inadequate patchwork that they had not even attained the level of the 2nd class [first year, or lower class] of the Institut."[33] The lesson, however, and the comparison with the classical *Gymnasium*, had been inscribed in the Gewerbeinstitut from the beginning. In his 1822 report on its foundation to minister von Bülow, Beuth complained that "a school is lacking for the necessary preparatory knowledge." This lack of preparation in the relevant sciences meant that the students potentially interested in them for their technological import could not appreciate even the few science courses that previously had been offered publically in Berlin, since they typically took the form of university-like academic lectures. "For as foolish as one would find it to dispense with school preparation in philology and to [try to] train philologists through instruction in the manner of academics, so perverse, it appears to me, . . . would it be to consider an effective [preparatory] school of natural sciences as superfluous for the thorough training of those who use these far-reaching natural sciences on a daily basis and to content oneself with academic lectures."[34] By 1833 Beuth had rendered this "foolishness" in a more politically aggressive manner in defending the rights of the Silesian citizenry: "It comes down to this: whether the productive class should be barred from this benefit to spend usefully the time it can spend on theoretical training or should waste the time in large part on things for which it has no use and is bound to forget [i.e., Latin]."[35]

A crucial feature of this formulation is its strong association of the natural

sciences with utility and industry, with the material progress of society generally and of the productive classes particularly. The science-utility connection, though not its positive connotations, was shared by all sides. It identified the natural sciences as the *Realfächer* (realist, or material and practical subjects), putting them in a distinctly third-rate position in the classical *Gymnasien* behind more idealist subjects. But simultaneously the connection asserted the claim of the natural sciences to be the basis of the state's economic well-being, providing a polemical contrast to the philology-centered disciplines that opened sinecures at state expense—hence the term *Brotwissenschaften* (literally, bread disciplines)—for the paper-shuffling bureaucracy. Even the financial support of the Gewerbeinstitut embodied this distinction of *Brotwissenschaften* from *Naturwissenschaften*. When *Ritterschaftsrat* E. L. A. F. K. von Seydlitz died without heirs in 1829, he left 68,000 thaler to the school, primarily to endow scholarships, for he was convinced that "an emergency exists in Germany, to advance exact science: mathematics, physics, chemistry, etc.; otherwise, because of the many bread-worshipers [*Artolatristen*] it will perish. The army of salaried bureaucrats, jurists, and cameralists whom the state must feed for its horse treadmill suck the marrow out of the state; art and industry go for bread; the independent people decline ever more. Anyone, therefore, who would promote this mischief with their fortune commits a sin against the Holy Ghost, and in that I will not partake."[36] Instead, he endowed the Gewerbeinstitut.

Seydlitz modeled his action after Lord Brougham, the organizer of the Society for the Diffusion of Useful Knowledge in Britain, whose attempts to bring science to the people included such improbable works as Mary Somerville's abridgment of Laplace's *Mécanique céleste* and many contributions to their *Penny Cyclopaedia* and Library of Useful Knowledge from such prominent people as the mathematician Augustus de Morgan. With Beuth as his executor, Seydlitz aimed at drawing students from the higher classes away from the philology-centered disciplines of officialdom and toward the industrially oriented sciences. "Only young people whose parents were not craftsmen should receive these scholarships, and the intent of the bequeather should be considered, above all in admissions, that the scholarships should turn the sons of the higher classes away from the so-called *Brotwissenschaften* and dispose them toward the establishment of technical, bourgeois industries."[37]

The association of science with industry centered on laboratory science, typically called "practical" in contrast to "theoretical" lectures at the University, where there were no teaching laboratories except in the homes of professors (sometimes supported by state funds for equipment). The first

institutionalized laboratory in Berlin where students could obtain some laboratory experience may have been the Institute for Chemical Technology (Institut für chemische Gewerbskunde) of Sigismund Friedrich Hermbstaedt. As a major figure in the industrial development of Prussia, Hermbstaedt held a wide variety of advisory and teaching posts, including professor of technological chemistry (1810) and chemistry (1811) at the new University and professor of chemistry at the Kriegsschule (1820). He was a prolific author of texts on chemical technology, served on the Technische Deputation and its precursor from 1797, and would become chair of the chemical and physical section of Beuth's Gewerbeverein in 1821. So important had Hermbstaedt been to the early development of chemical industry in Berlin that the administration completed for him in 1802 a house and laboratory valued at 20,000 thaler. This Institute for Chemical Technology constituted in effect a personal chemical institute with a sizeable auditorium (12 m × 5 m) where he held his lectures and laboratory space over twice as large.[38] Hermbstaedt's unusual operation served as a partial model for Beuth, who planned a much more ambitious Industrial Institute, including a broader and more systematic training in the natural sciences in parallel with technological instruction. In the Gewerbehaus, furthermore, teachers and students would have access to the full resources of the Technische Deputation and its museums, workshops, and laboratories.

The curriculum at the Gewerbeinstitut extended initially over two intensive years with only two weeks of vacation each year. Beuth ran the school with military discipline and handpicked the entering students (aged about nineteen despite hopes for qualified students at sixteen). "This institution," he wrote in 1829, "is designed only for very capable, disciplined, orderly, and moral people; others will be removed."[39] The first year (lower class) aimed to provide knowledge and skills sufficient for the ordinary operations of a technical trade.[40] As shown in table 3.1 for the winter term in 1826, instruction during six days per week stressed linear and freehand drawing, geometry, and physics (with chemistry), always with reference to practical applications and prototypes from the collection of models.

The second year (upper class) took these foundations to a higher level, adding perspective (with machine drawing and soon also descriptive geometry), algebra of second degree equations, trigonometry, statics and mechanics, and more focused study of chemical theory, reactions, products, and fabrication. Originally only four hours per day, class time had quickly grown to six or seven hours. An additional half year (*Suprema*), added in 1826 for students concentrating on mechanical industries, became a third full year in

Table 3.1 Curriculum of the Gewerbeinstitut in 1826 (winter semester)

Day	Hours	Subject	Teacher	Classes
Monday	8–12	Linear drawing	Frank	}Both classes
	10–12	Modeling	Wichmann	
	8–12	Working out of exercises	. . .	Suprema
	2–4	Geometry	Wolff	Lower class
	2–5	Physics	Schubarth	Upper class
	2–4	Perspective	Frank	Suprema
Tuesday	8–12	Freehand drawing	Mauch	Both classes
	8–12	Working out of exercises	Severin	Suprema
	2–4	Physics	Schubarth	Lower class
	2–5	Geometry	Wolff	Upper class
	2–5	Designs and estimates	Severin	Suprema
Wednesday	8–12	Linear drawing	Frank	Both classes
	8–12	Working out of exercises	. . .	Suprema
	2–4	Reckoning	Nicolas	Lower class
	2–5	Geometry, trigonometry	Wolff	Upper class
	2–5	Principles of machines	Severin	Suprema
Thursday	8–12	Freehand drawing	Mauch	}Both classes
	10–12	Modeling	Wichmann	
	8–12	Working out of exercises	. . .	Suprema
	2–4	Physics	Schubarth	Lower class
	2–5	Arithmetic und algebra	Wolff	Upper class
	2–4	Perspective	Frank	Suprema
Friday	8–12	Linear drawing	Frank	Both classes
	8–12	Working out of exercises	. . .	Suprema
	2–4	Geometry	Wolff	Lower class
	2–5	Physics	Schubarth	Upper class
	2–5	Estimates	Severin	Suprema
Saturday	8–12	Freehand drawing	Mauch	Both classes
	8–12	Working out of exercises	. . .	Suprema
	2–4	Calculating	Nicolas	Lower class
	2–5	Geometry, trigonometry	Wolff	Upper class
	2–5	Principles of machines	Severin	Suprema

Source: Nottebohm, *Chronik*, 11.

1831. Student numbers had reached one hundred by 1840 while the curriculum became ever-more advanced, having added mineralogy and analytical mechanics as well as daily laboratory work in chemistry. Midcentury marked a watershed in technical-scientific education. Growth then accelerated rapidly to reach over six hundred in 1869, followed by a steep decline before the renamed Gewerbeakademie joined with the Bauschule in 1879 to form Berlin's new Technical University (Technische Hochschule).[41]

The second year at the Gewerbeinstitut largely matched the first year at the Bauschule, including by 1830 several courses taught jointly, as indicated in table 2.1 for Schubarth, Dirichlet, and Brix and a bit later for J. W. Wedding. By using this joint teaching arrangement and by drawing instructors largely from the Technische Deputation, Beuth was able to maintain a high-quality program on limited funds. As the school matured, instructors also produced many practically oriented textbooks, including technological chemistry by Schubarth, Wolff's geometry, the mechanics of solid bodies by Brix, and Minding's integral tables for use in calculus.[42]

Advanced students during their second year and afterward could extend their training in the workshops and laboratories at the Gewerbehaus as well as in its collections of drawings and models and in the library. Others started work in the new industries that Beuth was promoting and with which he maintained close contact. A leading example is the machine and engine works of F. A. J. Egells (whose pumping engine would supply the fountain before the Altes Museum, fig. 2.10). In 1819, in expectation of establishing a new machine-building works in Berlin, the trade ministry had sent Egells on a study tour (or espionage tour) of British plants with 1,000 thaler for maintenance and bribes, which soon had to be increased. Egells's successful education in firms throughout the industrial north and London extended to 1822, when he returned to Berlin to found his own plant with considerable support from the trade ministry, including the purchase of two English lathes.[43]

Egells began operations with Prussian and English patents already in hand for a small and innovative steam engine, the so-called *Bügelmaschine* (fig. 3.5). The engine took its name from its unusual stirrup-shaped connecting rod, which rises and falls with the piston rod (top of drawing) as it oscillates back and forth with the crank that drives the flywheel (bottom). Unlike large beam engines, this fairly portable machine did not require a massive support structure. It sat on a cast-iron table and could be installed in the small workshops and factories of Berlin's emergent industry.[44] Egells actually delivered his first full-size engine to a client in 1824 or 1825, after he had built a detailed scale model (paid for by Bülow himself) and had sold the patent for

Figure 3.5 *Bügelmaschine*, Egells, ca. 1825, in Matschoss, *Die Entwicklung der Dampfmaschine*, 391.

his *Bügelmaschine* in England.[45] Once established, his operation grew rapidly to employ several hundred workers by 1830, building a few engines but mostly machinery and tools of other kinds. It became a training ground for the new generation of machine builders, thus realizing Beuth's aim in providing state support only for new industries that would have a multiplier effect. But in 1830 there were still only twenty-five steam engines in Berlin, three from Egells.[46]

Among the students of the Gewerbeinstitut who gained their practical expertise with Egells was one of its least promising but ultimately most famous products, Johann Friedrich August Borsig, who attended from 1823 to 1825 but left early without a diploma. Borsig's apparent distaste for Beuth's scientific emphasis was balanced only by their shared passion for uniting art with industry. Borsig then spent two years learning machine construction with Egells and eight years as technical director of a new Egells iron foundry before launching his own works in 1837 next door in the Chausseestraße at

Figure 3.6 Karl Eduard Biermann, *Die Giesserei und die Werkstätten von Borsig im Jahre 1837 am Oranienburger Tor*, 1847, oil on canvas. Archiv Stiftung Deutsches Technikmuseum Berlin.

Oranienburgertor (fig. 3.6). The street had become the new center for machine building in Berlin—popularly called "*das Feuerland*" (land of fire)—and an important nursery for all of Prussia.[47]

Borsig was just in time for the Berlin-Potsdam railroad then being constructed according to plans by Crelle, formerly of the Technische Deputation. Dedicating himself to locomotive construction, Borsig turned out his first example in 1841, named "Borsig" but based on an American model. Within a few years he had made the designs his own and began rapidly to expand his operations to all aspects of iron work, machine production, and even architectural and cultural monuments (chap. 2). At midcentury the Borsig works epitomized big industry in Berlin. They employed over a thousand workers and had turned out five hundred locomotives by 1854, when Borsig died of a heart attack.[48]

Gewerbeverein

Egells and Borsig suggest the larger context of industrial advancement in which the Technische Deputation and the Gewerbeinstitut would play leading roles. Beuth attempted to give direction to this larger sphere

through his third institution in the Gewerbehaus, the Gewerbeverein (Verein zur Beförderung des Gewerbefleisses), modeled on the success of similar associations for the advancement of industry in England, France, and Bavaria, as he reminded his audience in his opening address. His success was impressive. The Gewerbeverein grew continuously from its initial membership of about 350 in 1821 to nearly one thousand in the period 1837–1842, followed by a steep decline.[49] The rapid growth occurred during the period when *Vereine* of all kinds provided social venues for the self-formation of Prussian citizens before the revolution of March 1848. This *Vormärz* period also marked the beginnings of German industrialization, when people such as Borsig and then Werner Siemens (chap. 3) tied their fate to railroads and telegraphs in the takeoff phase of German industry.[50] But one could equally identify the period as the takeoff phase of German natural science, when organizations such as the Berlin Physical Society also made their appearance as *Vereine* (chap. 6). Of course, all three of these developments—social, industrial, and scientific— were closely interrelated, as the Gewerbeverein so clearly illustrates.

Looking at its organization in 1821 under Beuth as president and Kunth as first vice president, one finds five sections that largely mirror the scientific subject areas in the second-year curriculum of the Gewerbeinstitut: chemistry and physics (8), mathematics and mechanics (8), art of building and fine arts (6), calculation (3), and manufacture and trade (24). In parentheses are the numbers of members of the administrative committees, which reflect the sizes of their respective sections in the Verein. The smaller numbers for the *wissenschaftlich* committees suggest the intended role of their sections as foundational for the directly industrial and much larger section of manufacture and trade. This same relation is reflected in the chairs of the scientific committees, who were drawn from the technical schools and the University. Schinkel chaired the committee for the art of building and fine arts, and Hermbstaedt chaired the physics and chemistry committee. Johann Philipp Grüson, University professor and academician (with whom Rudolph Clausius of thermodynamics fame would study statics and dynamics in 1841), administered the section for mathematics and mechanics, joined by Eytelwein and soon Brix.

This direct relation of technical education to industrial development would turn out to be fertile soil for the Berlin Physical Society, as the Gewerbeverein members in the physics and chemistry section included a number of professors and fathers of the young men who would found the Society—Turte, Karsten, Knoblauch and Soltmann—while the mathematics and mechanics group included one of their mathematical instrument makers, the interna-

tionally known Carl Heinrich Pistor. Over the next decade, two important mentors of the members of the Society would become leading Gewerbeverein members for chemical and physical technology: Eilhard Mitscherlich, professor of chemistry, and especially Gustav Magnus, professor of technology. Magnus would serve in the administrative section through the 1840s, actively promoting the Verein's activities.

Magnus's case is paradigmatic. The professors who joined the Gewerbeverein took industrial development as one of the primary goals of their science, a goal that they carried with them into the University as a need for practical (laboratory) education to accompany theoretical lectures and for the lectures themselves to attend to topics of practical (industrial) significance. As professor of technology, Magnus regularly took his students to visit industrial sites around Berlin, including Borsig's rapidly expanding iron and machine works at Oranienburger Tor (fig. 3.7).

Aside from its regular meetings, the main activity of the Gewerbeverein was the publication of its journal, the *Verhandlungen*. Using the full resources of the engraving shop at the Gewerbehaus and active participation of

Figure 3.7 Karl Eduard Biermann, *Die Eisengiesserei and Maschinenbauanstalt von A. Borsig, zum 10. Firmenjubiläum*, 1847, oil on canvas. Archiv Stiftung Deutsches Technikmuseum Berlin.

Figure 3.8 Borsig's prizewinning locomotive "Beuth." *VdVBG* 23 (1844), plate v.

the Technische Deputation, Beuth and his longtime editor Schubarth turned out a journal of showpiece quality both in content and production values, especially in its numerous technical drawings. A rather special example is Borsig's description of his 1844 masterpiece for the railroads, the locomotive he dubbed "Beuth" (fig. 3.8).[51] Borsig's locomotive occupied center stage at the big industrial exhibition organized by the Verein in 1844, where it won a gold medal. Importantly, it was Gustav Magnus, already the "godfather" of the young men who would form the Berlin Physical Society, to whom the official report of the exhibition was dedicated and who served as one of its expert advisors (chap. 6).

Readers of the *Verhandlungen* would find many articles on local innovations, sometimes small but useful, sometimes more ambitious, such as Feilner's extension of the range of pottery and terra cotta production in collaboration with Schinkel (chap. 2). Also common were articles by leading members of the Verein, such as Wedding, instructor in machine design and theory at the Bauschule and the Gewerbeinstitut, who reported on such things as the latest steam-powered carding machine or a machine for dividing and cutting gear wheels or the famous machine works of H. Maudslay in London. Beuth himself contributed articles of every kind: a new coffee

machine, discovery of a Greek temple in Corfu, the Egyptian textile industry, and the use of treadmills in prisons as well as many innovations in methods and machinery.[52]

Occasionally the *Verhandlungen* contained monographic articles on subjects of quite general import. The liberal economics of the Verein found its expositor in Captain Moritz von Prittwitz of the Corps of Engineers, who was then establishing his considerable reputation for building fortifications in Posen and in Ulm. Prittwitz had joined the corps in 1813 for the Befreiungskriege / Freiheitskriege and was occupied from the beginning of his career with fortifications, including three years in France, 1815–1818, where he apparently immersed himself in the works of the French mathematical engineers.[53] Subsequently, at the United Artillery and Engineering School in Berlin (chap. 4), he became a leader in the reform of engineering education to include more mathematical and scientific analysis. And like his French sources, especially Dupin, he sought to integrate engineering with Smithian political economy as revised for the industrial economy by Say and taught at the Conservatoire.

As for Say, Prittwitz regarded the price of all products to be determined by production costs, with all costs treated in the same way, whether for muscular or intellectual work or capital or land. Supply and demand in the market equilibrated and optimized relative prices and determined whether the production costs of a product could be repaid by sale. The production cost with which Prittwitz primarily concerned himself, however, was direct production by men and animals rather than machines (perhaps because his series on industrial economy was never finished). Nevertheless, in his "Economy of Mechanical Forces for the Purposes of Industry," he adopted for the measure of men and animals what was fast becoming the measure for working machines, namely, work done.[54]

Concerning first the exercise of human power (*Menschenkraft*) on the principle that self-interest was by far the most effective "lever" for motivating human action, Prittwitz strongly advocated that office workers and laborers alike, so far as their "merely mechanical" activity was concerned, such as copying, should be paid for piecework (*Gedingarbeit*), directly coupling wages to production, rather than for day labor (*Tagelohnarbeit*), which promoted laziness. True to his machine-based account, Prittwitz made laziness the analogue of friction in machines. While piecework produced continual acceleration in the machine, day labor produced friction.[55] The task of the manager of an office or business, like that of any machine builder, was to re-

duce friction by perfecting both the individual parts of the machine and the communications between them.

For his comparative study of men and animals more generally, for which he provided extensive data across countries and localities, Prittwitz adopted the recent analysis of French mathematical engineers, especially Dupin's *Géométrie et mécanique des arts et métiers et des beaux-arts.*[56] As machines replaced humans in the industrial economy, particularly with respect to the Smithian labor theory of value but continuing with Say's utility theory, an immediate question was, what is the proper measure of equivalence between the muscular labor of men and the work of machines? In a tradition extending from the *ancien régime* with Coulomb through Lazare Carnot's work during the revolutionary and Napoleonic period and continuing with Navier, Christian, Dupin, Coriolis, and Poncelet thereafter, French engineers had clearly enunciated the concept of mechanical work and had made it the basis of the subject they called "industrial mechanics," as distinct from the "rational mechanics" of elite mathematicians such as Lagrange, Laplace, and Poisson.[57]

Work, or *travail*, thus came to refer to a standard weight raised to a standard height by whatever means and in whatever time, or more generally to any force multiplied by the distance over which it acted in the direction of the motion. In Germany the comparable terms *mechanische Wirkung* (mechanical effect), *Nutzeffect* (useful effect), or just plain *Arbeit* (work) were becoming common (although Prittwitz still preferred *mechanisches Moment*, which, like Watt's term *horsepower*, referred to the work done by a man or animal during a given time, such as a day[58]). Using the newly standard measure made it possible—by means of what Coriolis, at the École des ponts et chaussée, would label the "principle of transmission of work" (*principe de la transmission du travail*)—to follow the work through an entire factory: from the site of its production by a "motor" (windmill, waterwheel, or steam engine) through the shafts, gears, and pulleys that distributed it throughout the factory to the working machines that ultimately produced a product for sale, such as a bolt of cloth. The contribution of the machinery to the cost of production of the cloth could therefore be measured in terms of the work consumed for carding, spinning, and weaving plus work lost because of friction and other sources of waste. *Value* thus circulated through the factory as the capacity to do work, from its production by motors to its consumption by productive and unproductive forces. Work, in the perspicuous expression of Navier, was "mechanical money" (*monnaie mécanique*).[59]

Prittwitz's study of the economy of mechanical forces stressed the need for manufacturers to account for and actually to measure the work done by machines, men, and animals, which showed wide variations in efficiency across methods, manufacturers, nationalities, customs, and breeds. When he began publishing his series in 1829, the instruments available for such measurements were both primitive and few. When he finished ten years later, they were multiplying rapidly and incorporating ever-more sophisticated analytic tools from engineers and natural scientists.

It would be difficult to overestimate the importance of this transformation of the technological and scientific world centered on the 1830s. It occurred across the board for physical measurements, whether one looks to working machines, the metallurgical effects of heat, the bleaching power of chemicals, the rhythms of the tides, or astronomical cycles. In every domain, technological sophistication both tracked and enabled the coevolution of economic and scientific change. One way to capture the movement qualitatively is to note how formerly static and approximate measurements became dynamic and precise. A good example concerns the measurement of work done by machines as well as work lost because of friction, which could be as much as half the total work done. The subject will figure prominently in chapter 7, on Helmholtz's analysis of force and work, but a brief introduction will illustrate the point about dynamic measurement.

On the subject of friction, a big monographic report appeared in the *Verhandlungen* for 1837–1838 by Landbaumeister Brix (now factory commission counselor) who taught mechanics courses at the Bauschule and Gewerbeinstitut and served in the Gewerbeverein on the administrative committee for mathematics and mechanics. "There are in the domain of natural phenomena," Brix began, "perhaps few things that have captivated the attention of physicists so long and, I may say, with so little success, as the phenomena of friction."[60] Looking at his subject historically, Brix surveyed attempts in the eighteenth century to find simple rules that would govern static and sliding friction under varying conditions of contact area, load, and materials. The definitive work in this genre had been done by Captain Charles-Augustin de Coulomb of the French Corps du génie, who among his other major accomplishments in engineering and physics, won the prize of the French Academy in 1781 for a study of friction in simple maritime machines, such as pulleys, capstans, and inclined planes.

To discover the "laws of friction," Coulomb employed a sled with loads up to 1,650 pounds sliding on runners of variable surface area and pulled along a level surface by a rope passing over a roller and carrying adjustable falling

weights. Varying both sliding surfaces (oak, beech, iron, copper, brass) and lubricants (water, talc, fat), Coulomb found that in general the frictional force was independent of surface area and proportional to the load.[61] Nevertheless, his laws could better be called rough generalizations, for Coulomb had no way to actually measure either the tension in the pulling rope or the sled velocity at any moment during the course of a trial but only the static force of the falling weight and the average velocity of sliding. Although such static measures had been adequate for the simple and slowly acting machines of the late eighteenth century, they were no longer adequate for the factory machines and engines of the 1830s, as required by the Gewerbeverein. Much more precise dynamical measures were required to show how frictional force varied with change in velocity over time.

Instruments for this purpose only emerged in the 1830s from the French study of industrial mechanics, especially at the École de l'artillerie et du génie in Metz.[62] About 1829 Colonel Jean-Victor Poncelet, who had been charged by the minister of war in 1824 with creating a course on the science of machines, first began suggesting a series of so-called dynamometers that would provide an accurate graphical recording of the force exerted by any motive power during the variable course of its action, from which the work being done immediately followed. Poncelet's younger collaborator Captain Arthur Morin actually perfected the suggestions, and it was his extensive measurements on friction, using the self-recording dynamometers, that provided the basis for Brix's report.[63] The report gave not only extensive data on coefficients of friction between many different materials commonly used in machine building but theoretical calculations as well for such critical considerations as the effect of free play (*Spielraum*) on the friction between a rotating shaft and its bearing. Distributed among these practical considerations was a thorough compilation of references to the best engineering literature available. In offering resources such as this, the Gewerbeverein reached well beyond the audience of machine builders and manufacturers to the natural scientists who drew inspiration from its concerns and would contribute experimental and theoretical results in their turn.

Pegasus Revisited

Precision measurements and experiments begin to draw attention to the changing character of the Gewerbehaus as a museum. Like the Conservatoire, it centered originally around its collections of models, drawings, and books. And like the Conservatoire, the workshops and laboratories that it also incorporated served its museological purpose: to provide exemplary

works of both past and contemporary innovations seen as experiments looking toward the future, or as Forgan put it, "the laboratories grew up . . . in the shadow of the museum."[64] In retrospect, however, as already discussed in chapter 2, it has become clear that as measurements and experiments became increasingly important, the laboratories began to overshadow the collections. Models of machines, however stimulating to the imagination of machine builders, could provide neither the measurements of coefficients of friction nor the theoretical analysis that Brix supplied.

The shift in emphasis is apparent also in the curriculum of the Gewerbeinstitut. Table 3.1 already showed that in its first five years, although the curriculum continued to stress drawing, the hours of instruction in physics, chemistry, mathematics, and machinery increased significantly, filling an additional half year. Later alterations continued the trend, with extra hours and teachers for so-called repetition sections in geometry, chemistry, and physics (see chap. 4) and a third full year of instruction, which included more advanced classes in applied mathematics and analytical mechanics (taught by Brix), theory of machines and machine design (taught by Wedding), and techniques and processes of chemistry based on chemical principles (taught by Schubarth), as well as daily work in the chemical laboratory for students pursuing careers in chemical industry[65] This development accelerated after Beuth resigned his directorial position in 1845, when entering students were required to have completed their *Abitur* at a *Gymnasium* or *Realschule*. Similarly, their teachers became ever-more academically oriented. Between 1849 and 1860, ten of the fifteen teachers hired were already professors or soon acquired that rank, whether at the University, the Akademie der Künste, the Gewerbeinstitut itself, or elsewhere. Two of the full professors at the University, who were key mentors in experimental physical science for members of the Berlin Physical Society, also took on courses at the Gewerbeinstitut. Gustav Magnus taught chemical technology there from 1850 to 1856. Ernst Heinrich Dove taught physics from 1849 to 1868. Other well-known scientists and professors at the University were Georg Hermann Quincke (from 1860, physics), the later Nobel Prize winner Adolf von Baeyer (from 1860, organic chemistry)—both of whom had worked in Magnus's laboratory—and the founder of modern mathematical analysis Karl T. W. Weierstrass (1856–64, mathematics).[66]

Clearly the Gewerbeinstitut was no longer organized around the concept and resources of a museum supported by ancillary laboratories but around laboratory analysis and research on their own terms. No doubt this changing character of the Institute was not an outcome envisaged by those such

as Beuth and Schinkel, who actually initiated the experimental emphasis. It will be useful, therefore, in concluding this chapter, to recapture the museological vision of industry with aesthetics that Beuth and Schinkel originally imagined as the result of the modernizing industrial movement they so effectively promoted. One way to do that is to examine their responses to the great industrial dynamo that they witnessed in Britain. Beuth's letters from his factory tour of Britain in 1823 and the letters and diaries of Schinkel, who joined him in 1826, provide telling observations. They show not only a sense of awe at the machinery and manufactures they visited and at the sheer size of the operations but deep ambivalence about British industrial culture. Characteristic on the positive side is Beuth's description to Schinkel of the Manchester cotton mills:

> The wonder of the modern age, my friend, is to me the machines and their buildings here, called factories. Such a box is eight- or nine-stories high, forty-windows long, and four-windows deep. Every story is twelve-feet high, arched, with nine-foot spans the entire length. The pillars are of iron, also the beams they support, with partitions and surrounding walls like playing cards [*Kartenblätter*]. . . . A mass of such boxes standing on very high points, which dominate the surroundings—with yet higher steam-engine chimneys, like needles, so that one cannot grasp how they can stand—make a wonderful sight in the distance, especially at night, when the thousands of windows shine bright with gaslight. Bright it must be—can you imagine it—where one worker must oversee eight hundred and forty threads, threads [exceedingly fine] of which two hundred and sixty hanks make up a pound.[67]

The people, too, were welcoming and generous, but English culture was quite another thing. "*Maschinenwesen* [literally, the being or essence of machines] has been said to be contrary to the poetic nature of the people," remarked Beuth in his ironic mode, but "how without poetry could a street be named Brass-Nose-Street; . . . how without poetry could this country have forty religions and only two sauces." Similarly, every bourgeois house had a music room and a drawing room, "only music and drawing seldom mean much." In short, Beuth found British culture, like British cooking, of little interest or simply "tasteless."[68]

The booming city of Glasgow, to which Beuth devoted an extended report in the *Verhandlungen*, provided an important exception, not only for the extraordinary collection of antiquities he found at the Hunterian Museum or because Glasgow was the city of two of his heroes, Adam Smith and James

Watt, but particularly because what he saw as provision for the education of the working classes and support for the poor set it apart from English industrial cities. The University of Glasgow and the Andersonian Institute (which became the first of the mechanics institutes in Britain in 1823), along with a variety of public and private schools, seemed to have enlivened purely mechanical work with *Wissenschaft*, much as Beuth sought to do at the Gewerbehaus. "Where [natural] science is not introduced in industry," he asserted, "there is no securely grounded industry, there is no advancement."[69] It was Andrew Ure himself (author the *Philosophy of Manufactures* in 1835), then lecturing at the Andersonian, who described to Beuth its aims for the education of working men and showed him its facilities, including an impressive collection of mechanical models and books that was growing rapidly with "science and its applications." In other words, Glasgow provided a storehouse of ideas for Beuth's ambitions at the museum-based Gewerbehaus. Once again, his account of Glasgow mirrors rather closely that of Dupin at the Conservatoire both in terms of the character of the people and the exemplary role of Ure and the Andersonian.[70]

More surprising than his interest in museum-based technical education is Beuth's detailed account of Glaswegian provisions for the poor, which in England he had experienced as a "plague on the land" (*Landplage*). Although he condemned handouts that did not encourage self-help, he admired the work of church charities providing for those who required only modest aid: the city hospital (almshouse), for those with no resources of their own, and the 129 Friendly Societies for poor relief generally. In order to respond to widespread unemployment during recurring crises, the city had set large numbers of people to work on improvements to streets and public spaces. To Beuth's sensibilities, "In such a great factory city, the care of the poor is particularly crucial."[71]

Schinkel's impressions of Britain matched Beuth's. To be sure, he marveled at the famous landmarks: Brunel's work on the Thames tunnel, then under construction; the Southwark Bridge of Rennie and West (completed in 1819, boasting, at 240 feet, the longest cast-iron arch ever built); the great London workshops of Maudsley; and sophisticated machines and factories of every kind in Birmingham, Sheffield, Leeds, Edinburgh, Glasgow, and Manchester. If he was amazed by "colossal" constructions such as the Telford suspension bridge over the Menai Straits in the north of Wales (the first ever, with chains 700-feet long supporting a span of 560 feet), he found more to his taste the refined inventions for everyday life that he observed, such as

the advanced ventilation and heating system of a hospital in Derby and its steam-driven washing machine.[72]

While British machinery called forth from Schinkel words such as *magnificent, highest refinement, first-rate, excellent*, and *admirable* (*herrlich, höchsten Raffinerie, vorzüglich, vortrefflich*, and *bewunderungswurdig*), his observations of British art, architecture, and music evoked mostly scorn: *bad, horrible, totally uninteresting, laughable*, and *unbearable* (*schlimm, schrecklich, ganz uninteressant, jämmerlich*, and *unerträglich*). Of Birmingham he remarked, "How sad is the sight of such an English factory city. Nothing that could have pleased the eye presents itself to us." This deplorable lack of beauty found a parallel in the deplorable condition of unemployed workers in the city: "a great deal of poverty reigns there, and . . . for me there is nothing here to find."[73] In fact, it was the poverty reigning in the great British factory cities in 1826 that most distressed their Prussian visitors. In Schinkel's diagnosis, the machine-driven processes of industrialization in Britain, which had produced such extraordinary transformations of life and landscape, had now driven the country over the top with speculation. The four hundred cotton factories that had arisen in Manchester since the Napoleonic Wars had produced a glut of goods that the world could not absorb, with the result that "twelve thousand workers stand rotting together on the street. . . . One is very much in doubt about what should become of this fearful state of things."[74]

Whatever that future might be, it would not be the future that Schinkel and Beuth envisaged for their modernized Prussia. The problem was that in Britain, *Maschinenwesen* itself had been driving development for fifty years—"as long as the machines have in fact been propelling their own nature"—at the expense of both aesthetic and social values.[75] Instead, the advancement of industry in Prussia would integrate machines and factories into a culture of artistic sensibility and social responsibility, of civic humanism. These values were inherent in the culture of the museum as Schinkel and Beuth conceived it. For them it represented the acquisition of *Bildung* in a neo-Athenian republic. Such a republic would also integrate parks and apartment houses into factory districts and smaller, more orderly towns into the surrounding countryside.

In 1837, to capture this idealized vision for his constant companion, Schinkel turned once more to his own favored symbol of human inspiration, Pegasus (fig. 3.9). Just as he gave wings to theater and art, the soaring winged horse here carries an androgynous Beuth, wearing an earring, over a factory town that he has founded. In Schinkel's satiric image, Beuth, the lover

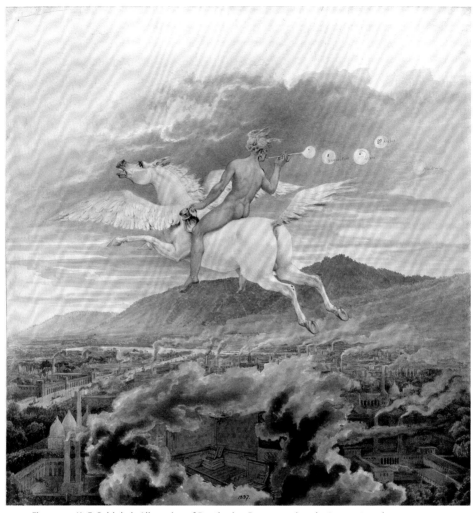

Figure 3.9 K. F. Schinkel, *Allegorie auf Beuth, den Pegasus reitend*, 1837, watercolor, 37.4 × 35.9 cm. Staatliche Museen zu Berlin, Kupferstichkabinett, SM 54.12.

of horses, appears as Bellerophon, who rode Pegasus to slay the Chimera. But it is not yet clear whether the modern-day Bellerophon will also lose his seat while attempting to fly with Pegasus into the heavens. That Beuth is blowing soap bubbles suggests potential hubris and the ephemeral nature of material life, *Vanitas*. The bubbles refer to the popular theme in seventeenth-century Dutch art of *homo bulla* (man is a bubble) in reference to the transience of wealth, power, and life itself. The captions on the bubbles call up Beuth's earthly desires and their ultimate fate: "7,000,000 Eink[ommen]" (a

ridiculously large income), "Ischia" (the spa island off Naples where Beuth dreamed of having a villa), "Araber" (Arabian horses), and "Min. Gloria" (*sic transit gloria mundi*, so passes the glory of the world).[76] But the bubbles have not yet burst. For now, they drift over the factory town like its wafting smoke, seemingly of a piece with the clouds drifting in the sky. For in the eyes of Beuth and Schinkel, the industrial city has not yet, and need not ever, acquire the grim visage and human misery of the juggernauts of Birmingham, Manchester, and Liverpool. Within the ring of clouds in the foreground, an image of Beuth's study appears, showing stacks of books whose titles tell of his unending pursuit of industry with aesthetics: *Kunst*, *Gewerbe Verein*, *Acta Gewerbe Verein*, and *Kunst Verein*.

Mirroring his friend's perception of progressive human action, Beuth in 1841 would choose Schinkel's winged Genius to mark his premature death (fig. 3.10). "It had to be chosen from among his own designs," said Beuth, and he selected one that Schinkel had proposed in 1837 to memorialize their long-time collaborator at the *Gewerbehaus*, S. F. Hermbstaedt.[77] In Beuth's conception, Schinkel himself had provided precisely the inspiration for aesthetics and industry that he had represented in the figure of the Genius / Pegasus in

Figure 3.10
Schinkel's gravestone.
Beuth, "Schinkel's Grabdenkmal.".

the reliefs for the Bauschule. And if experimental science was beginning to overshadow the role of the museum in the new institutions they had built, that represented in part the natural outcome of the role they had ascribed to Pegasus as the spiritual motor for experimental works that would move human history into the future.

NOTES TO CHAPTER THREE

1. Beuth, "Rede bei Eröffnung."

2. The exhibition catalog, Brandt-Salloum, *Klosterstrasse 36*, provides an excellent introduction to the Gewerbehaus and to the relevant archives.

3. Rave, *Schinkel, Berlin*, 3:61–65. Nottebohm, *Chronik*, 53–60, includes a full list of costs. On Schinkel's innovative construction with iron for the Gewerbehaus, see Lorenz, *Konstruktion als Kunstwerk*, 152–58 (plates) and 272–82 (text).

4. Trost, *Gaertner*, fig. 7.

5. Ibid., 6–10.

6. "Namenverzeichniss der Mitglieder, am 7. Januar 1822," *VdVBG* (1822): 8–12.

7. The writings of Conrad Matschoss, despite their hagiographic and technological determinist character, remain indispensable references for Beuth's activities at the Gewerbehaus. On Stein and the early technical deputation, see Matschoss, *Preussens Gewerbeförderung*, 19–26, "Geschichte," 240–50. Brose, *Politics of Technological Change*, provides a much more complex portrait of Beuth as an elitist, antimodernist, and anti-Semite. He also gives a more realistic and deeply researched portrayal of the difficulties that Beuth and his allies faced in promoting technology and industry, 48–49, 56–59, 101–4.

8. Lotz, "Cockerill," 106. Straube, "Beuth," 4. Matschoss, *Preussens Gewerbeförderung*, 30–31.

9. Matschoss, "Geschichte," 251–255, on 253. Straube, *Die Gewerbeförderung*, 31–39, contains basic documents. Mieck, *Preussische Gewerbepolitik*, 33–35.

10. Beuth's library contained at least 178 works on horses (although not in the auction catalog, *Verzeichniss*). Matschoss, *Preussens Gewerbeförderung*, 67–68, 72–73. Reihlen, *Beuth*, 55.

11. Altcappenberg, "'Letzte Lebensphilosophie,'" analyzes the series of seven paintings that Schinkel gave to Beuth as birthday and Christmas gifts; this one on p. 203, fig. 4, and pp. 205–7. On Beuth's role in the railroad controversies, see Brose, *Politics of Technological Change*, 128, 209, 217–18, 221–22, 235. His antipathy for railroad speculation apparently merged with his anti-Semitism, e.g., 100, 112–13, 128, 221.

12. Weber, *Wegweiser*, 1:15.

13. Straube, "Beuth," 139; Matschoss, "Geschichte," 258. Beuth visited the Conservatoire in 1823 and again with Schinkel in 1826. Beuth to Minister Bülow, May 8, 1823, Akten des Handelsministeriums, in Matschoss, *Preussens Gewerbeförderung*, 126–27.

14. *Catalogue général des collections du conservatoire royal des arts et métiers*. Informative articles on the Conservatoire national des arts et métiers collected in Fontanon, Le Möel, and Saint-Paul, *Le conservatoire*; quotation from Ferriot, "Le musée," 146. Klemm,

"Geschichte," surveys the development of technical museums accompanying the emergence of polytechnic institutes. On the Conservatoire itself, see Mercier, *Un conservatoire*. Trischler, "Das Technikmuseum," discusses three different modes of reading the history of technical museums in the long nineteenth century, including the postrevolutionary, industrializing mode.

15. Straube, *Die Gewerbeförderung*, 18–19, 34–36n48.

16. Weber, *Wegweiser*. First volume on textile production, second on machine building, including such details as sharply reduced prices for Cockerill's steam engines (2:306–10).

17. Matschoss, "Geschichte," 258; *Preussens Gewerbeförderung*, 42–43.

18. GStA PK, I. HA Rep. 76 Kultusministerium Vb, Sekt. 4, Tit. X, Nr. 2, Bd. 3 contains records of acquisition of materials (e.g., clay, jacaranda wood) and expensive machines (lathes, crane, high-pressure steam engine) for the model workshops (1830–43).

19. Matschoss, "Geschichte," 257, *Preussens Gewerbeförderung*, 44; Straube, *Gewerbeförderung*, 35–36, "Beuth," 141. GstA PK, I. HA Rep. 76 Kultusministerium Vb, Sekt. 4, Tit. X, Nr. 1, Bd. 1 and 2 record the acquisition of apparatus and instruments for both chemical and physical laboratories (organized by Schubarth, below). The physical collection, for example, was surprisingly extensive, including high-quality optical and electrical instruments from Pistor and Schieck costing nearly 4,000 thaler (list of January 6, 1826).

20. Matschoss, "Geschichte," 259, *Preussens Gewerbeförderung*, 43. Straube, *Die Gewerbeförderung*, 36, 48–53.

21. By 1866 the library contained at least six thousand volumes, most carrying much earlier dates. See *Katalog der Bibliothek*.

22. Mercier, *Un conservatoire*, emphasizes this character also for the Paris museum. Forgan, "Architecture of Display," 140, makes the same point more generally, stating that museums were "about *modern* objects, the latest instruments, the newest methods of manufacture."

23. GStA PK, I. HA Rep. 76 Kultusministerium Vb, Sekt. 4, Tit. XI, Nr. 2, Bd. 1 (1821–27) and Bd. 3 (1829–31) [Bd. 2 lost], document this program. See the *Verzeichniss* of Beuth's library.

24. [Beuth and Schinkel], *Vorbilder*, text vol., 1–2.

25. Role of Dupin, Say, Clément, and others in Fontanon and Grelon, *Les professeurs*.

26. Dupin, *Géometrie et mécanique*, *Développements de géométrie*, and *Voyages dans le Grande-Bretagne*. All of Dupin's major works were in the library of the Gewerbeinstitut. See *Katalog der Bibliothek*.

27. Say, *Cours complet*. Say's utility value derived from transforming matter (or a product) from one form or location to another. His version of stock included not only capital and land but all faculties natural or acquired (e.g., learning), any of which could be employed directly or "let out" (for wages, interest, or rent) to an undertaker who made profits on them. Decrease in price, resulting in increase of wealth, resulted from progress of intelligence and industry, e.g., more efficient machinery and adaptation of forces of nature. On Say generally, particularly as juxtaposed with Ricardo, see Hollander, *Jean-Baptiste Say*. A major issue concerns Say's ambivalent acknowledgment that, as Ricardo insisted, utility value had to be distinguished from cost of production.

28. Called the Technische Schule until 1827.

29. König, "Verwaltungsstaat," 115, "Technical Education"; Lundgreen, "Engineering Education."

30. Lundgreen, "Techniker und frühindustrieller Arbeitsmarkt in Preussen," despite general demand for their services, shows striking differences in the prospects for establishing an independent business for those specializing in building trades (78%), machine-building and metal trades (9%), and textile trades (32%).

31. König, "Verwaltungsstaat," 121.

32. "Votum des Ministers des Innern für Handel und Gewerbe betreffend das Gewerbe-Schulwesen in der Provinz Schlesien," Akten des Handelsministeriums, reproduced in Matschoss, *Gewerbeförderung*, 147–49.

33. "Votum des Ministers," Matschoss, *Preussens Gewerbeförderung*, 148.

34. Beuth, "Bericht"; also Straube, "Beuth," 129–30.

35. "Votum des Ministers," Matschoss, *Gewerbeförderung*, 149.

36. "Auszug aus dem Testament des Ritterschaftsraths v. Seydlitz," in Matschoss, *Gewerbeförderung*, 124–25. Nottebohm, *Chronik*, 13. Von Seydlitz was from the family of the storied cavalry general Friedrich Wilhelm von Seydlitz under Frederick the Great.

37. "Auszug," Matschoss, *Preussens Gewerbeförderung*, 125.

38. Mieck, "Hermbstaedt," stresses the all-encompassing sense of "technology" in cameralist writings, as is evident in Hermbstaedt, *Grundriß der Technologie*. On Hermbstaedt's chemistry as characteristic of leading Lavoisieran ideas of the period 1790–1820 but not yet engaged in the deep transformations of analytic organic chemistry that would soon appear from Dumas and Boullay using Berzellian chemical formulas, see Klein, "Shifting Ontologies," 301, 309

39. Straube, "Beuth," 123, quotation on 134. A growing source of students were the provincial *Gewerbeschulen* established under Beuth's direction first in Berlin in 1824 and then in twenty of the twenty-five provinces of Prussia by 1835. Lundgreen, *Techniker*, 41–54. Reihlen, "Beuth," 54, gives a full list of the schools and their students at the Gewerbeinstitut in 1849.

40. Lundgreen, *Techniker*, 54–60, shows how Beuth normalized the first year at the Gewerbeinstitut to what the best students from a provincial *Gewerbeschule* should already have attained, although they rarely reached that level before 1850.

41. Nottebohm, *Chronik*, 3–14, student numbers and graph on 79–84. Brandt-Salloum, *Klosterstrasse 36*, 90–92. Except for the addition of the *Suprema*, the curriculum for 1826 is very like Beuth's original plan for 1821, with extended hours for the same subjects. GStA PK, I. HA Rep. 76 Kultusministerium Vb, Sekt. 4, Tit. I, Nr. 1, Bd. 1, April 18, 1821.

42. Schubarth, *Elemente der technischen Chemie*; Wolff, *Lehrbuch der Geometrie*; Brix, *Elementar-Lehrbuch*; Minding, *Sammlung von Integraltafeln*.

43. Mieck, "Egells," 75–76; Reihlen, *Beuth*, 33; Matschoss, *Preussens Gewerbeförderung*, 48. Egells was not the first successful engine builder in Berlin but the first with state support. Already in 1816 Georg Christian Freund, with private funding from the (not yet famous) scientific instrument maker Carl P. H. Pistor, had begun to produce high-quality Watt-style engines. Mieck, "Egells," 70–71.

44. Matschoss, *Die Entwicklung der Dampfmaschine*, 1:172, 391–93.

45. Prussian patents, first established in 1815, required pretesting by the Technical Deputation in contrast to patents in Britain, France, and the United States. They were seldom granted (averaging nine per year, 1815–21) and offered only limited protection. Obtaining an English patent was far more advantageous. Straube, "Beuth," 142–45; Reihlen, *Beuth*, 47–49; Matschoss, *Preussens Gewerbeförderung*, 53–54.

46. Reihlen, *Beuth*, 33–34; Brandt-Salloum, *Klosterstrasse 36*, 129. GStA PK, I. HA Rep. 120 Ministerium für Handel und Gewerbe, A V 5, Nr. 12, gives a list of the owners, uses, horsepower, and types of the twenty-five engines, including the 4 hp machine at the Gewerbeinstitut; 4, 16, and 8 hp for the machine builders Hummel, Tappert, and Egells; and the largest, of 30 hp, for the wool-spinning factory of James Cockerill (total 226.5 hp). Mieck, "Egells," indicates that Egells had built perhaps thirteen steam engines before 1830. For analysis and statistics on the distribution of steam engines throughout Prussia, see Banken, "Die Diffusion."

47. Mieck, "Egells," 77–79. Development of Borsig's works in Vorsteher, *Borsig*, 25–30, 87–114.

48. Illuminating analysis of the art-technology relation in Borsig's iron work is found in Lorenz, *Konstruktion als Kunstwerk*, 87–93, 174–81, 198–205, 217–19, 246–47, 342–43, 364–82. See also Vorsteher, "Borsig." On Borsig's great engine for the fountains and gardens of Sanssouci in Potsdam, see Wise, "Architectures for Steam," 124–30.

49. England: Society of Arts (1754); France: Société d'encouragement pour l'industrie nationale (1802); Bavaria: Polytechnische Verein (1815). Beuth, "Rede bei Eröffnung," 16. Statistics from Matschoss, *Preussens Gewerbeförderung*, 160.

50. Recent discussion by Pierenkemper and Tilly, *German Economy*.

51. Borsig, "Beschreibung." "Beuth" produced 135–50 hp and could travel up to 42 kmh. Reconstruction on display at the Museum für Verkehr und Technik, Berlin; brochure by Pierson, *Die Beuth-Lokomotive*.

52. All from the *VdVBG*: Herr Feilner, "Ausdehnung des Betriebes der Töpfereien auf Erzeugung von Bauornamenten" (1828): 93; J. W. Wedding, "Beschreibung einer Dampfbürstmaschine für Tuch, von Hoguet & Teston" (1831): 284; "Die mechanische Werkstatt von H. Maudslay in London" (1833): 248; "Maschine zum Theilen u. Schneiden metallener Räder von Sharp, Robert & Co. (Manchester)" (1835): 67; Beuth, "Kaffeemaschinen" (1822): 104; "Griechische Tempel, auf Korfu entdeckt" (1823): 212; "Verwendung der Tretmühle in Gefängnisse" (1824): 233; "Egyptens Textilindustrie" (1825): 83.

53. Prittwitz, *Prittwitz'sche Adels-Geschlecht*, 172.

54. Prittwitz, "Ueber die Oekonomie der mechanischen Kräfte." Given his overall title, it seems the series was never finished, having not yet reached machines. Prittwitz, *Kunst reich zu werden*, relies heavily on Say but does not treat work done by machines.

55. Prittwitz, "Ueber die Oekonomie der mechanishen Kräfte," pt. 2, 284–89.

56. Listed in the library of the Gewerbeinstitut. *Katalog der Bibliothek*, 27.

57. Vatin, *Le travail*, surveys this French tradition. Also Darrigol, "God, Waterwheels, and Molecules," 305–17. A parallel story for Britain is Wise and Smith, "Work and Waste."

58. Prittwitz, "Ueber die Oekonomie der mechanishen Kräfte," pt. 1, 189–93.

59. Coriolis, *Du calcul de l'effect des machines*, 18; Navier, "Sur les principes," 376. Both in the library of the Gewerbeinstitut. *Katalog der Bibliothek*, 24–26.

60. A. Brix, "Ueber die Reibung."

61. Ibid., 145–50.

62. Belhoste and Picon, "Les caracteres généraux de l'enseignement,"

63. Poncelet, *Cours de mécanique industrielle, Cours de mécanique appliquée aux machines*, 1:v and 2:274–88; Morin, *Nouvelles expériences sur le frottement*. These and other books of Poncelet and Morin were in the library of the Gewerbeinstitut. *Katalog der Bibliothek*, 34–37.

64. Forgan, "Architecture of Display," 155.

65. Nottebohm, *Chronik*, 13–20.

66. Ibid., 69–77, with full table of teachers hired, 1821–71.

67. Beuth to Schinkel, July 1823, in Wolzogen, *Aus Schinkels Nachlass*, 3:141–42.

68. Ibid., 3:142–45. Interestingly, Beuth's library contained at least forty books on cooking. *Verzeichniss*, 60–61.

69. Beuth, "Glasgow," 169.

70. Dupin, *Voyages dans la Grande-Bretagne*.

71. Beuth, "Glasgow," 165–68, quotation on 165.

72. Wolzogen, *Aus Schinkels Nachlass*, 3:79–80, 119–20; 2:157. For drawings, references, and discussion of Schinkel's often-discussed perceptions see Schulz, "Schinkels englische Reise."

73. Wolzogen, *Aus Schinkels Nachlass*, 3:71.

74. Schinkel to his wife Susanne, July 19, 1826, in Wolzogen, *Aus Schinkels Nachlass*, 2:162; 3:113.

75. Ibid., 2:164.

76. I thank Elaine Wise for the *homo bulla* and *Gloria mundi* interpretations. See also Altcappenberg, "'Letzte Lebensphilosophie,'" 200, 203 (fig. 5), 205, and another of the series, "Villa Beuthiana auf der südwestlichen Küste der Insel Ischia," 200, 206 (fig. 7), with Beuth's note, "Meine kunftige Villa auf Ischia."

77. Beuth, "Schinkels Grabdenkmal." Schinkel's gravestone still stands in the Dorotheenstädische Friedhof in Berlin, as do those of Hermbstaedt, Beuth, Borsig, and Magnus.

MODERNIZING MILITARY SCHOOLS
Self-Acting Officers and Instruments

If you are unable to find a capable teacher, study Burg's lessons in geometrical drawing or another good work of the kind and then train yourself in drawing, that is, above all in the doctrine of geometrical projection. . . . Your main study must now be mathematics, especially applied, further physics and drawing.
— Werner Siemens to his brother[1]

It was 9 a.m. on October 12, 1823, when Lieutenant Meno Burg, instructor of mathematics and drawing at the Vereinigte Artillerie- und Ingenieurschule (United Artillery and Engineering School), assembled with his colleagues to receive King Friedrich Wilhelm III and his chief military advisor and friend General Job von Witzleben for their inaugural inspection of the elegant new home of the school at Unter den Linden 74, near the Brandenburger Tor (fig. 4.1). This was the first day of instruction for the

Figure 4.1 Eduard Gaertner, *Vereinigte Artillerie- und Ingenieurschule*, 1833, lithograph. Author's print.

Figure 4.2 Eduard Gaertner, *Schloss Bellevue*, 1847, watercolor, 21.1 × 36.0 cm. Staatliche Museen zu Berlin, Kupferstichkabinett, Inv. SZ 5. Photo by Jörg P. Anders. Insert, author's photo of cannon "Le Drole."

hundred students who would live and work in the new building. Heading the reception were Burg's patron, Prince August, chief of the artillery corps and the king's second cousin (nephew of Frederick the Great), and General Gustav von Rauch, chief of the engineers, both leading liberals in Berlin. Present also was Karl Friedrich Schinkel, architect of the neoclassical structure.[2] As the king toured the large hall of drawing, remarking occasionally on the student works exhibited on its walls, Prince August presented the teacher whose drawing instruction and textbook he had personally nurtured. Turning to Burg, the king clapped him on the shoulder and praised the great success of his methods, which he had seen demonstrated in student drawings included in the annual exhibitions of the Academy of Art: "keep up the good work." Especially fitting, he thought, was a fine drawing of the French cannon (fig. 4.2) mounted in front of Prince August's family palace at Bellevue (recently renovated by Schinkel), which Burg had hung beneath the prince's portrait. This was no ordinary cannon. Bearer of the improbable name *Le Drole*, it was the eight-pound artillery piece that Friedrich Wilhelm had presented to the prince on the battlefield in 1813 as a "memorial and reward" after he led an attack that dislodged the French from a village near Leipzig. It led to the capture of a battery of fifteen cannons, including *Le Drole*, just before the

decisive battle there. Continuing his rounds, the king also approved of Burg's organization of the new library and of the hall of models before climbing to the roof of the building to take in a panoramic view of the city.[3]

This scene captures important aspects of the new face of military education, beginning with the building for the school itself. In its neoclassical architecture, as in so many of his buildings, Schinkel carried out for the artillery and engineering corps the architectural merger of technological modernization with the reinvention of Greek artistic virtues. At Bellevue in 1823 Schinkel had deployed these themes more personally in remodeling the second floor to produce an appropriate setting for the social gatherings that Prince August hosted for Berlin's liberal elite, including the Humboldt brothers and Peter Beuth along with reformers in uniform.[4] Visitors to this space of cultural and political discourse were probably familiar with an imposing portrait of the prince painted by Franz Krüger (fig. 4.3). It depicts August in another of Schinkel's classicizing renovations, this one for the reception hall of the prince's palace on the Wilhelmsstrasse in 1817. Schinkel's architecture and Krüger's painting, along with Burg's inspired drawing instruction, begin to suggest that aesthetic values played an important role in military reform and education just as the ideal of *Bildung* shaped so much of cultural life more generally.

Franz Krüger executed his commission with the realistic exactness that would become one of his hallmarks, reproducing Schinkel's design for the reception room down to the details of the palmetto frieze and chairs. But the rational formality of the room and the prince's stiff stance are belied by the seductive softness of his great love, Julie Récamier, the subject of the painting within the painting. The impossible romance of Prince August with the renowned French beauty, already married to the head of a large banking concern, had blossomed while he and his adjutant Carl Clausewitz were captive guests in Paris and Geneva in 1807. But the collapse of her husband's financial empire combined with Prussian state interests to doom their relationship. Her parting gift to him in 1808 was the portrait by Francois Gérard. Their lost love became as much a part of his persona as his capture of French cannons.[5]

Such images of courage and intimacy surely colored the atmosphere in these rooms in which some of the most avid reformers in the military and civilian administration debated liberal causes: parliamentary government, economic and political freedom, and the education of a responsible citizenry. One such cause was religious freedom, including full participation of Jews in the state, even in the military. The prince had welcomed Meno Burg, a

Figure 4.3 Franz Krüger, *Der Prinz August von Preussen*, ca. 1827, oil on canvas, 63 × 47 cm. Staatliche Museen zu Berlin, Nationalgalerie, Inv.-Nr. A I 152. Photo by Andres Kilger.

Jew educated at the famous Gymnasium zum Grauen Kloster and at the Bau-akademie, into the artillery in 1813 after Burg had been thrown out as a volunteer for the infantry. And he continued to promote Burg, who would ultimately reach the rank of major in 1847, even while the king exerted pressure for his baptism. Many others had accepted this requirement for full citizenship, including the family of Burg's future colleague Gustav Magnus, who would be Werner Siemens's physics professor at the Artillerie- und Ingenieur-schule and mentor of the Berlin Physical Society. But Burg stood firm behind his protector Prince August.[6]

Ironically, much of what the king found laudable in Burg's work—his library and models but most especially his method of teaching drawing—Burg had imported from the French engineers of the École polytechnique and the École d'application d'artillerie et du génie, whose cannons the prince had captured. One of Burg's later students, whose exemplary drawings the king would have appreciated at the exhibitions of the Academy of Art in 1838, 1839, and 1840, was Helmholtz's relative, Lieutenant Leithold. Another, in the exhibition of 1838, was Werner Siemens, who exhibited "Part of a Wall, with Capstan and 12 Pound Cannon."

As the epigram to this chapter indicates, Siemens found in the descriptive geometry of Burg's *Die geometrische Zeichnenkunst* the best starting point for his brother's technical education in mathematics and physics. Indeed, when the book first appeared in 1822, Prince August commanded its use in all nine brigade schools of the Prussian artillery, and it was adopted much more widely. At his request, Burg sent a copy to the Czar of Russia, who found the book so admirable that he rewarded Burg with a diamond ring. This is the czar, formerly Archduke Nicholas, who had commissioned Franz Krüger to paint the cavalry parade that thematizes this book, with Nicholas commanding his troops.[7]

Burg, like teachers at the Bauschule at the same time, adapted his methods from the descriptive geometry begun by Monge and continued by Dupin and other French engineers. That is, his drawing methods derived from the same sources as the self-recording dynamometers of Arthur Morin that we saw Brix reviewing for the Gewerbefleiss Verein, instruments that, along with the closely related indicators for steam engines, would supply models for graphic recording devices designed by Siemens, Du Bois-Reymond, and Helmholtz. Similarly, descriptive geometry supplied a remarkably important method of uniting drawing with mathematics and technical precision with aesthetic form, for it embodied, in a widely disseminated practice, the great project of neohumanist modernization.

The teaching methods of Burg and others at the Artillerie- und Ingenieur-schule provide yet another point of entry to the heterogeneous locations for practical science and laboratory teaching in Berlin. For Burg's teaching, and Prince August's promotion of it, were part of the continuing reform of technical education in Prussia, aiming simultaneously at military modernization and state-supported industrialization. On the military side, the educational movement began before the Befreiungskriege with the foundation of the Kriegsschule. It involved as well the Artillerie- und Ingenieurschule and the Friedrich-Wilhelms-Institut for military doctors. The reforms gained considerable momentum during the 1820s, partially in association with the civilian technical schools, the Bauschule and Gewerbeinstitut, until conservative forces curtailed the movement after 1832. Nevertheless, a student in Berlin in the 1830s could gain inspiration and some hands-on training for laboratory work at the military schools, particularly the Artillerie- und Ingenieurschule, where Siemens studied, and for Helmholtz at the Friedrich-Wilhelms-Institut.

Scharnhorst and Military Reform

Scientific education of military officers grew up with the Kriegs-schule. It was founded simultaneously with Berlin University in 1810 under the leadership of Gerhard von Scharnhorst, the hero of Prussian independence and liberal reforms whose classicized statue by Christian Daniel Rauch stands so prominently before the Neue Wache in Krüger's *Parade* (fig. 1.2), providing the architectural bridge between the University and the Armory and the backdrop for the public. These materialized symbols of the union between civic virtue and military vigilance now require grounding in the program that Scharnhorst led to produce officers qualified by education and accomplishment for a citizen army, as suggested by the allegory on the pedestal showing Pallas Athena lecturing to the students (fig. 1.3).[8]

Scharnhorst had founded the Kriegsschule while heading the Military Reorganization Commission appointed by King Friedrich Wilhelm III following Napoleon's crushing defeat of the Prussian Army at Jena and Auerstedt in 1806 and the humiliation of the Peace of Tilsit. Prussia was reduced to a minor state with its policy dictated by Napoleon. Its territory was reduced by half, its population by over half, and its army by five-sixths.[9]

Neither Prussian nor noble by birth, Scharnhorst had originally been recruited from Hannover, one of the secondary German states that stood directly between revolutionary France and Frederician Prussia in the wars that tore apart the old German Empire and restructured alignments through-

out Europe. He received his own military education from 1773 at a unique academy run by Count Wilhelm zu Schaumburg-Lippe-Bückeburg in his small principality bordering Hannover, where Scharnhorst absorbed over four years the count's lessons on modern warfare and its intimate relation to social-political changes. He also acquired a deep commitment to Enlightenment values and to the necessity not only for professional education among officers but more importantly for the acquisition of a broad capacity for personal judgment, reflection, and flexibility: for *Bildung.* For the next fifteen years Scharnhorst himself taught mathematics, engineering sciences, and a wide variety of military subjects, particularly from 1782 at a new Artillery School in Hannover, whose curriculum he helped to organize. Gradually he established his reputation as a prolific writer and journal editor on the latest military issues, as an innovator in artillery technology, and ultimately as a battlefield commander when Hannover joined the First Coalition against republican France in 1793. If he went into the war already aware of the many changes taking place in warfare, he came out realizing that in fact a "revolution in warfare" had occurred, epitomized by French methods and by the psychological advantages of soldiers who identified with the nation. In 1797 he published his penetrating analysis of the strengths and weaknesses of the French and allied armies.[10] Prussia soon began seeking his services, and he finally transferred to Berlin in 1801 with an offer of ennoblement to cap his new position as lieutenant colonel in the artillery.

By then the "revolution in warfare" meant exploiting high mobility to make aggressive attacks with maximum force on an enemy army in the field as opposed to the incremental occupation of territory and fortresses characteristic of eighteenth-century positional warfare. High mobility involved organization of ever-larger armies in permanent divisions, each composed of all three arms—infantry, cavalry, and artillery—and capable of waging independent battles. It meant also using more effective field artillery: lighter, mounted on horse-drawn carriages, and employing more sophisticated aiming devices. And it meant soldiers carrying flintlock muskets with fixed bayonets replacing the pike.

None of these innovations was unique to the French, but the revolution in warfare was French in two crucial respects.[11] First, the new French army consisted of soldiers and officers animated to some degree by their own identification with the national state, that is by citizen-soldiers. The *levée en masse* of 1793 supplied the army with a continuous stream of men, reaching over a million in 1794, many highly motivated if poorly trained. Unable quickly to drill them in the disciplined movements of the widely spread, three-tiered

lines of professional soldiers operating in open terrain, the French commanders learned to take advantage of broken and forested landscapes and to make much more extensive use of attack columns with leading or flanking *tirailleurs* (skirmishers), men fighting independently or in small groups with aimed fire. Although such tactics were by no means new to Prussia, Scharnhorst became convinced of the necessity of developing them much further, it being "an accepted truth that the French *tirailleurs* decided the majority of the affairs in this war."[12] During the crucial years of 1794–1795 they carried muskets produced in unprecedented numbers under a command economy organized by the technocratic engineers Lazare Carnot and Prieur de la Côte-d'Or.[13] This mobilization of the *levée en masse*, even if its success was highly exaggerated, invoked the ideal of an entire people at war against the enemies of the Republic in defense of freedom and equality: soldiers, craftsmen, seamstresses, even children and old men.

> From this moment until our enemies have been driven from the territory of the Republic, all Frenchmen are permanently requisitioned for military service.
>
> Young men will go forth to battle; married men will forge weapons and transport munitions; women will make tents and clothing; children will make bandages from old linen; and old men will be brought to the public squares to arouse the courage of the soldiers, while preaching the unity of the Republic and hatred against kings.[14]

Under similar orders and motivation, the soldiers of the Republic foraged for their own food and supplies, requisitioning them from the civilians whose territory they invaded (and sometimes plundered). This foraging policy joined with *tirailleur* tactics to characterize the citizen-soldiers as individuals acting creatively and independently in contrast to the supposedly unmotivated subjects and mercenary professionals of the monarchical armies, whose "loyalty" was thought to depend on constant drilling and rigid discipline and therefore to extend no further than the direct oversight of an officer's commands. Again, all of this has been exaggerated.[15] Still, if traditional military discipline quickly returned under Napoleon, if state manufacture of armaments returned to capitalist production, and if officer training became increasingly elitist, the French army nevertheless remained a citizen army with considerable nationalist identity and with many officers qualified by examination and merit.

Secondly, the new form of warfare was French in that Napoleon mastered its elements like no one else. From his Italian campaign of 1796 and especially

the second Italian campaign of 1799, he developed his trademark marches at high speed deep into enemy territory, beyond his own communication and supply lines, to provoke decisive battles on his own terms, battles aimed not at conquering territory but at total destruction of the main force of the opposition, often using the so-called interior line to split much stronger forces and defeat them by turns. These Napoleonic battles unfolded in a flexible manner rather than following a preestablished plan. Beginning with probing assaults and developing according to the contingent dynamics of the engagement, they relied on relatively independent action on the part of field commanders while Napoleon himself gauged the overall development and sought out a critical location and moment when he could send into action strong forces previously held in reserve, thereby forcing the decision. His reputation for brilliance, unpredictability, and ferocity became a major weapon in itself.[16]

In 1801, the year Scharnhorst arrived in Berlin from Hannover, Prussia sent troops to Hannover to forestall the threat of French occupation, which would separate the western provinces from the capital in Berlin. But the Prussians soon withdrew for fear of offending Napoleon, who did occupy the kingdom in 1803, putting him within eighty miles of Berlin. By then Scharnhorst had already written a variety of communiqués to Friedrich Wilhelm, advising reforms that needed to be made in order to mobilize the full capacity of the population. They would have involved far-reaching social-political transformations, such as granting commissions to middle-class and noble officers alike on the basis of merit, instituting universal conscription to establish a national army, and generating a sense of patriotic loyalty through legal protections, property rights, and trade freedoms. Such proposals were already under active discussion in Berlin but were not fully established. Undeterred, Scharnhorst focused his attention initially on reconstituting an Institute for Young Officers, which would ultimately form the basis of the Kriegsschule. There he began to raise up a new breed of officers instilled with the ideals of *Bildung*. Recent literature especially stresses the significance of Scharnhorst's focus on education and *Bildung* as his first priority for the new army.[17] His young followers would form the core for his reform efforts. Several participated immediately in the modernization of the army, among them both Prince August, whose effective grenadier battalion in 1806 had already been partially retrained, and his adjutant, the fiercely patriotic Clausewitz, who came from a Prussian family claiming nobility.

Promoting reform on a broader scale as well, Scharnhorst agreed to act as the first director of a voluntary study group, the famous Militärische Gesellschaft, which met weekly from 1801 to 1805 to discuss specific aspects of the

theory and practice of military affairs, starting always from a written text by one of the members. The society also sponsored lectures and essay competitions on the latest developments, which helped to draw in men with experience and ambition. As always in the promotion of *Bildung*, history played a key role. Each winter season a historically significant battle was chosen for discussion over many meetings with different members presenting various aspects and views. In short, the society acted like a large university seminar. With nearly two hundred members by 1805, it spread reflection on the need for reform of both tactics and organization and the need for educated officers through all ranks of the officer corps even though opposition to reform remained significant. The society included older adherents of the Frederician system, such as General Ernst Friedrich von Rüchel—whom Scharnhorst enlisted as president—as well as experienced younger officers, such as Captain August Count Neithardt von Gneisenau and Captain Karl von Boyen—soon to be Scharnhorst's closest collaborators on the reorganization commission—and of course Scharnhorst's dedicated students at the Institute for Young Officers, such as Lieutenant Clausewitz and Lieutenant August Rühle von Lilienstern. He even succeeded in gaining the participation of Baron vom Stein, who would become chancellor in 1807 and originate the famous Stein-Hardenberg reform era.[18]

Stein's presence in the Militärische Gesellschaft signals the close relation between military and social-political reform. Importantly, all three of the leading reformers—Scharnhorst, Stein, and Hardenberg—brought their liberal conceptions originally from outside Prussia. In this they mirror the recruitment of talent for both the Prussian administration and the officer corps, with over one-third of all senior officers being non-Prussian in 1805 and over half of the senior engineering officers.[19] In the larger state of Prussia they found room to exercise their ambitions. Although movement between armies had long been common, this mobility took on added significance in the new environment, when outside origins tended to reflect a mediating position between revolutionary France and traditional Prussia, often expressed in Scharnhorst's case as a policy of moving forward by integrating the new with the old. (Of course this "foreign" liberalism would prove a liability when the threat of Napoleon had passed after 1815.[20])

The originally somewhat marginal outsiders achieved their real effectiveness after the crisis of defeat in 1806, which not only exposed the inadequacy of the organization and tactics of the army but also of the supposed courage and honor of the aristocratic officer corps, too many of whom surrendered their forces without a fight in the face of Napoleon's continuing march across

northern Prussia. Scharnhorst, by contrast, emerged as one of the few heroes of the defense and as the king's choice to head the Military Reorganization Commission. Its members included a number of like-minded officers, such as von Boyen, who had also distinguished themselves in 1806. The most important was the outspoken "Count" Neidhardt von Gneisenau, another reforming outsider who had mastered Napoleon's tactics independently and whose brilliant and daring leadership both in 1806 and in the Befreiungskriege to follow would make him the most famous commander in the army. His genius and patriotism endeared him to Clausewitz, who became his intimate friend. Besides these two experienced officers, however, it was Scharnhorst's former students from the Institute for Young Officers who articulated and organized the movement. Karl Wilhelm von Grolman served on the commission (and would become perhaps the most outspoken republican in the officer corps). Clausewitz headed Scharnhorst's office as his closest personal assistant, disciple, and friend. Karl Ludwig von Tiedemann and Count Friedrich Karl von Dohna-Schlobitten also played key roles on his personal staff. And Johann Karl Braun (who would become the leading member of Prince August's Commission on Science and Technology in 1828) assisted with weapons development and manufacture.[21]

It was in this context of national renewal that Scharnhorst launched the Kriegsschule in 1810 to produce through education more of the dedicated professional officers who might be able to liberate Prussia from Napoleon's grip.[22] That hope lay behind the famous decree of Friedrich Wilhelm in 1808 (actually drafted by Grolman) opening the officer corps to nonaristocratic talent: "From now on, in peacetime, only knowledge and *Bildung* shall confer a claim to the rank of officer, in wartime, superior courage and vision. From the entire nation, therefore, all individuals who possess these qualities can make a claim to the highest positions of honor in the military. All previously recognized class privilege stops in the military and everyone, without consideration of birth, has equal duties and equal rights."[23] In fact, the numbers of untitled officers increased significantly only in the lower ranks. In the artillery, untitled field-grade officers were common, but the proportions remained nearly equal from 1789 to 1817.[24]

Titled or not, students at the Kriegsschule constituted an elite meritocracy from the beginning, admitted by examination (initially minimal) for three years of intensive study, and destined to become the cream of the officer corps. In Scharnhorst's reorganized command structure, that meant that the most promising would join a newly authoritative general staff, with a select few becoming chiefs of staff to the commanding generals of the per-

manent divisions. With some exceptions, the concept succeeded admirably in the Befreiungskriege when Gneisenau, Boyen, Grolman, Clausewitz, and Rauch occupied these key positions of divisional chiefs of staff. With intimate knowledge of Scharnhorst's strategy as chief of the general staff and minster of war, they acted as advisors to the commanding generals in the field in deciding how best to realize that strategy in a given situation. Scharnhorst aimed thereby to better Napoleon's one-man rule by promoting greater flexibility and independence of tactical action of the divisional commanders without losing overall coordination.[25]

The capacity for independent action, in fact, was the single most important quality that the Kriegsschule and other institutions of reform sought to instill in army officers of all ranks as well as in the soldiers under their command. This ideal stamped its curriculum and its pedagogy.[26]

Independence called for both reasoning power and reflective judgment. Thus, Scharnhorst conceived the Kriegsschule as a specialized university for officers similar in its lecture format and in its ideal of *Bildung* to Humboldt's new civilian university but emphasizing the practical requirements of professional soldiers who would have to exercise their reason and judgment in battle. The demand to maintain an intimate relation between theory and practice, therefore, infused all aspects of the curriculum. Courses on artillery and fortifications met this requirement with detailed problems and field excursions. More theoretical courses on warfare, such as those on tactics and strategy taught in 1810–1811 by Scharnhorst's former students Clausewitz and Tiedemann, took another approach. Following their mentor's lead, they made theory subservient to practice by drawing extensively on military history as the ground of empirical reality. Clausewitz's lectures on the so-called little war—the secondary operations of light troops, which depended essentially on the skills of the *tirailleurs*—made the claims for realism integral to the "enterprising spirit" of the new soldier: "This free play of intelligence, which operates in the little war, this clever union of boldness with caution . . . is the quality that renders the little war so extraordinarily interesting."[27]

Importantly for the history of natural science in Prussia, however, military subjects did not form the core of the curriculum. Mathematics did, occupying eight hours per week in 1810–1811, or as much time as Tiedemann's and Clausewitz's courses together. Mathematics took the place at the Kriegsschule that classical languages held at the University—as the training ground for the mind, much like mathematics at the Bauakademie. Already imbued with this ideal of education, Clausewitz had made his French captivity in 1807 an occasion for intensive study of mathematics. Scharnhorst had always

stressed the priority of mathematics and logic and insisted on it again in his reports to the king on the first year of operations: "I regard it as the foundation of all further mental training and all other forms of knowledge," and again, "this discipline should be regarded not only as the basis of all further military education but also as the most exquisite means to instill acuteness and a certain logical form of thought."[28]

This view of mental formation did not imply any disrespect for classical wisdom, but only for an overconcentration on ancient languages. In fact, the military reforms themselves drew considerable inspiration from the neohumanist movement, with direct reference militarily to the original humanist return in the sixteenth and seventeenth centuries to the organization of classical Greek and Roman armies. For Scharnhorst, this meant especially Raimondo Montecuccoli, the famous seventeenth-century field marshal of the Austrian army. Known as an intellectual who wrote the most widely read books on the art of war from Machiavelli to Napoleon, his references to Greek and Roman sources nearly equaled his contemporary references. And like Scharnhorst after him he stressed a realistic approach, covering subjects from mathematics and fortification to the place of war in the political order.[29] Of course mathematics itself always looked to its classical roots for both the transcendent value of Euclid and the power of Archimedes's machines of war. So it could occupy a natural position at the core of a military curriculum both neohumanist and practical.

More specifically, "mathematics" included not only geometry and analysis but the mechanics of solid and fluid bodies and even the theory of machines, for the Kriegsschule would nurture logical minds attuned to material reality. Chemistry, physics, and other sciences constituted part of this training as well, for the modern officer needed to know the basics of the sciences that were transforming military technology. The highly mobile army required staff officers who could employ meteorology, cartography, and geography in planning efficient marches. It needed artillery and engineering officers who understood something of the chemical and physical properties of gunpowder, the strengths of different materials, construction of machines of all kinds, methods for reducing friction between moving parts, and ballistics in relation to gun mounts, aiming devices, and range estimates. Just as the new warfare carried a French imprint, so did the education of its officers. From the outset, the Kriegsschule began adapting for its own needs (but at a considerably lower level) the mathematical and scientific training that French officers received, first in the two preparatory years of the École polytechnique (fully militarized by Napoleon in 1805) and subsequently in such schools as

the École d'application d'artillerie et du génie. By 1818–1820, the Kriegsschule was structuring its curriculum as in table 4.1, with ever-more mathematical and physical sciences (thirty-six hours) and humanities (sixteen hours) and relatively less specifically military education (thirty hours), concentrated in the third year.[30]

Thus the Kriegsschule acquired early on a tendency toward a fairly high-level *wissenschaftlich* education. And although students there did not study drawing, their aesthetic sensitivities were sharpened in literature classes for two hours a week over two years. Their academic pursuits, however, were not supposed to extend so far as to make soldiers into scholars, a problem that frustrated Napoleon about the graduates of his own military schools even as his policies made them increasingly elitist and mathematical. "Officers should not be trained as actual mathematicians," summarizes the original intentions of Scharnhorst and the school's planning commision.[31] Nevertheless, both the number and level of courses escalated after the Befreiungskriege, in which Scharnhorst died of wounds suffered in 1813. His close friend and collaborator Karl von Boyen succeeded him as minister of war and began to adapt the school for a much-expanded national army with a more elaborate hierarchy, which only heightened the expectations of military education. When in 1816 the artillery and engineering officers split off in a separate school, the Kriegsschule looked to some critics like a pretend university providing a high-level mathematical and intellectual education to ill-prepared students who could make little use of it.

One of these critics was Clausewitz, who returned to the school as military director in 1818. As he pithily expressed the need for "positive" knowledge, "no civil engineer and no artist is trained at universities." In terms that parallel those of Beuth and Eytelwein concerning the Bauschule, he was arguing in an often-cited report to war minister von Boyen in 1819 that university-style lectures were not a valid model for the school. Students had neither the full intellectual preparation of the classical *Gymnasium* (at most they left after the *Secundum* at age sixteen) nor an extended period after their schooling to acquire experiential knowledge—as did lawyers, civil servants, and doctors—following their university education. Thus, the school had to provide its students simultaneously with a moderate level of general *Bildung* and with skills for practical military action.[32]

Around this widely acknowledged but frustrating demand revolved continual negotiation: should the Kriegsschule look more like an intellectual's university or a professional's polytechnic? Neither pole would suit. The debate is characteristic of the position of the Kriegsschule in the Prussian polity

Table 4.1 Curriculum of the Kriegsschule, 1818–1820

Year and subject	Hours/week
First:	
Finite analysis	5
Introduction to higher mathematics	5
Enzyklopädie[a]	4
General history	2
Tactics	3
Artillery	3
Military geography and history of war	5
	27
Second:	
Applied mathematics[b]	7
Infinite analysis	5
Physics	4
History of German literature	4
General history	4
Artillery	1
Engineering sciences	4
	29
Third:	
Higher geodesy	2
Chemistry	4
Foreign literature	2
Military statistics	4
History of war	2
Applied tactics	4
Activities of the general staff	2
Siege warfare	4
Knowledge of horses	2
	26

Note: Schedule includes lecture hours only. Practical military exercises, repetition hours for mathematics, and probably chemical laboratory work were held on Wednesdays and Saturdays.

[a] Boyen's favored "Encyclopädie" (overview of philosophy) was dropped after his resignation in 1819, apparently replaced by theoretical and practical drawing, which had been abandoned when the artillerists and engineers left in 1816.

[b] Applied mathematics included analytical mechanics, hydraulics, and the study of machines.

between, on the one hand, the neohumanist educational movement associated with Wilhelm von Humboldt's founding of the University and the central role of the classical *Gymnasium* as the producer of culture, and on the other, technological modernization of the army. Scharnhorst, Boyen, Clausewitz, August, and their allies struggled to find stable ground in this inherently conflicted landscape. They sought to establish a degree of parity between military and civilian *Bildung* in a common *Kultur* but without sacrificing expert knowledge. Continually complicating matters were the politically reactionary moves of conservative aristocrats, who continued to dominate the higher ranks of the officer corps and increasingly gained the king's confidence after the Befreiungskriege. They sought to regain their lost privileges by diluting the purely academic requirements for entry and advancement.

Practical thus became a watchword both for attempts to undermine the reforms and for reformers seeking to ensure the legitimacy of their enterprise. Inevitably, perhaps, the politically liberal aspects of reform would gradually disappear into its seemingly "apolitical" professionalism.[33] In this slow swing from democracy to technocracy and from idealism to realism, the natural sciences occupied a hinge position. Depending on circumstances and audience, they could turn either toward mathematical humanism and aesthetics or toward practical engineering and industry. One of the hinge issues was the role of laboratories, whose place in higher education would remain problematic through midcentury.

Science Teaching Policy

The goal of *wissenschaftlich* education and civilian parity was to be ensured in the first instance by splitting off the administrative directorate, the Militärdirektion (Clausewitz's office), from the directorate responsible for the curriculum and teachers, the Studiendirektion, and by composing the latter body of two civilians and two officers, one of whom served as chairman. The chairman from 1816 to 1847 was Rühle von Lilienstern, one of Scharnhorst's favorites at the Institute for Young Officers and a lover of music who also studied natural sciences, philosophy, and politics. He had developed into an erudite and popular liberal who wrote extensively, valued his four-year contact with Goethe in Weimar, and won accolades for his service during the Befreiungskriege. He favored an intensive intellectual training for military officers. This preference produced some conflict with Clausewitz, whose report of 1819 was directed in part against what seemed to him Rühle's overly scholarly curricular direction. Although they agreed on the fundamental

role of mathematics, for example, Clausewitz thought its higher-level study a waste of time for people who would never use it and wondered whether it did not render those who devoted themselves to it "useless for practical military life." He wanted fewer courses, optional pursuit of nonmilitary subjects, and a deeper study of war itself. But his critique disappeared in the political turmoil following the Karlsbad Decrees of 1819, when von Boyen, who loyally supported Wilhelm von Humboldt's perhaps wrongheaded attacks on Chancellor Hardenberg for selling out the cause of liberal political reform to Metternich, was forced out of his ministerial position. His close friend Grolman also resigned. Deeply depressed by the growing force of reaction, Clausewitz gave up trying to affect the curriculum and retreated to his study to write a variety of political and historical essays and to work continually on his comprehensive study *On War*. Nothing remained, he wrote to a friend, "but to withdraw indignantly into one's own innermost being and to shut oneself off against the world." As a contributing cause of this withdrawal, disagreements with Rühle over practicality have sometimes been cited, but they apparently depended more on differing views of appropriate levels and subjects than on the relation of theory to practice, for it was under Rühle's long chairmanship of the Studiendirektion that the so-called *praktische Uebungen* were most extensively developed in the 1820s, particularly in mathematics and science.[34]

In the sciences, Rühle had the support of Ernst Gottfried Fischer, who served as one of the civilian directors from the inception of the Kriegsschule in 1810, when he also became extraordinary professor of experimental physics at the University. Originally from a relatively poor pastor's family, Fischer rose from *Gymnasium* teaching to become a full member of the Academy of Sciences (associate in 1803, full in 1808). His French connections solidified through his translation and commentaries on Berthollet's famous chemistry books of 1801 and 1803 and through the French translation of his own widely used *Lehrbuch der mechanischen Naturlehre* (1805) by Madame Biot-Brisson and Jean Baptiste Biot. But Fischer's access to power came especially through his private teaching. He had tutored Wilhelm and Alexander von Humboldt in mathematics, natural science, and ancient languages from 1783 to 1789 and remained friends with them. Later he taught the sons of Moses Mendelssohn and from 1810 to 1816 the children and young relatives of Friedrich Wilhelm himself, including Crown Prince Friedrich Wilhelm and Prince Wilhelm (later Kaiser Wilhelm I).[35]

Fischer first published his educational philosophy on entry into the Academy of Sciences in 1803 as a critique of the strengths and weaknesses of Pes-

talozzi's already famous methods for instilling in schoolchildren, through rigorous practice, a vivid *Anschauung* (visual intuition) for arithmetic and measurement. While admiring of many aspects, Fischer thought the method too mechanical for the *wissenschaftlich* education of creative minds and for a properly national system.[36] As developed much more fully in 1806, his views seem tailor made for the Kriegsschule. While a defender of the classics as the basis for higher intellectual and moral attainments, he stressed also the need for a more practically oriented education for many careers in the modern state and economy. Thus, he advocated melding the neohumanist *Gymnasium* ideal with the moribund *Realschule* movement to produce a new *Real-Gymnasium* based on mathematics and running in parallel with the classical school. While of equal status and sharing much of their curricula, the two schools would interchange the relative weights they placed in the higher classes on classical languages versus mathematics and natural science. As for Scharnhorst and other military reformers, classics and natural science appeared in a complementary, not antagonistic, relationship. Although never fully realized, Fischer's proposals would play an important role in the reinvigorated *Realschule* movement by midcentury.[37]

In another key administrative decision, the Kriegsschule appointed teachers for the nonmilitary subjects who were simultaneously engaged as professors at the new university. This policy, as at schools under the ministries of culture and trade, maintained strong interrelations between the technical schools and the University and between the technical schools themselves. For the professors it meant they were expected to fulfill their role in the state, and to make up their full salaries, by teaching in several different schools simultaneously, an onerous task. For the ministries responsible for the different schools, however, it meant they could employ experts in specialized subjects while sharing the costs with other ministries. As the professors, few in number, circulated through the various schools, they also established personal connections that deepened the network and made it to some degree self-perpetuating.

An instructive example comes from the ordinary professor of physics at the University, Paul Erman, who also taught and lived at the Kriegsschule (1810–43), having established himself originally at the French *Gymnasium*, somewhat like Fischer. Erman was a prominent member of the French Huguenot community who enjoyed close friendships with Fischer and Clausewitz. He was married to Karoline Hitzig, from the prominent Jewish publishing family, whose sister Adelaide married a wealthy middle-class officer, F. A.

O'Etzel (later General von Etzel), another friend of Clausewitz who in 1820 became professor of military geography at the Kriegsschule and later joined Gneisenau's staff. Etzel's daughter in turn married the physicist Heinrich Wilhelm Dove (chap. 5), a student and friend of Erman, who then succeeded Erman at the Kriegsschule in 1843 and, like Erman, lived there with his family.[38] Careers in Berlin depended on these personal and family relations. Wealth also helped. The O'Etzel-Hitzigs paid 57,000 thaler for their house in the Leipziger Straße at a time when the entire Artillerie- und Ingenieurschule cost only 77,000 thaler.

In 1816 the new Artillerie- und Ingenieurschule split off from the Kriegsschule. Modeled in part on the École d'application d'artillerie et du génie,[39] it would serve the needs of the technical branches for officers who could combine the general *wissenschaftlich* orientation of the Kriegsschule with more intensive technical training (extending initially, however, over only two years). Its creators and joint military directors, Prince August and General von Rauch, played a prominent role in its curriculum and put their liberal stamp on the entire institution. Their Studiendirektion also included civilians and aimed to employ the most able professors available in Berlin.[40] For chemistry and physics they had the services of Carl Daniel Turte, who actually combined academic, military, and industrial pursuits: as extraordinary professor of physics at the University who taught also at the Friedrich-Wilhelms Institute for army doctors; as an artillery officer and director of the royal powder factory; and as a leading member of Beuth's Gewerbeverein. In his place in 1832 would come the civilian academic Gustav Magnus, godfather of the Berlin Physical Society.

As at the *Kriegsschule*, mathematics at the Artillerie- und Ingenieurschule formed the foundation of the curriculum not only as a fit training for the reason and judgment of decision makers but as a flexible foundation for all other technical subjects. An order of the king now formally required that at least the mathematics classes be taught exclusively by civilians. For this reason Meno Burg, as an army officer, had to switch from teaching mathematics to an exclusive focus on drawing.[41] The civilian policy, coupled with the foundational role of mathematics, continued at both schools for decades and led to the recruitment of some rather prominent mathematicians. Among those at the Kriegsschule was Martin Ohm, professor at the University, who also taught at the Artillerie- und Ingenieurschule in the midthirties when Werner Siemens studied there. His assistant from 1827 to 1834 was his ultimately more famous brother Georg Simon Ohm (whose pathbreaking work on Ohm's law

for electrical circuits appeared in 1827). Gustav Lejeune Dirichlet (chap. 3, 5) was professor at the Kriegsschule from 1828 to 1855, where he taught descriptive geometry in the first year, as he did at the Bauschule. In his three-year mathematics sequence he also introduced integral and differential calculus for the first time.[42]

Although the mathematical emphasis represented in part the reformers' imitation of the educational system of their designated French enemies, it served simultaneously—and more deeply in Prussia—as a connecting link between the two sides of neohumanism that we find continually reappearing: classical *Bildung* and technical *Fortschritt*. The claim that mathematics was practically necessary for all science and technology was constantly buttressed by its claims to pure reason, identified with Kantian philosophy as well as Euclid's *Elements*. From the natural scientific side, Fischer's major mathematical work derived from a critique of Kant's views. From the humanist side, Johannes Schulze, Fischer's successor on the Studiendirektion of the Kriegsschule (1831–64), was deeply involved in a series of attempts to establish a polytechnical institute in Berlin.[43] At the same time, he was acting as the primary agent of Wilhelm von Humboldt's neohumanist educational policies in the cultural ministry. Finally, an important advisor from the late twenties was again Alexander von Humboldt, Wilhelm's brother, a pupil of Fischer, the king's chamberlain, and by far the most significant patron of natural science in Prussia.[44]

The Method of Application and Cultivation of the Self

Despite the grand ideals and extensive provisions for *Wissenschaft* at the military schools, results were poor. The Ober-Militär-Prüfungs-Kommission, which grew up with the educational reforms after 1808 and was responsible for all officer examinations in the military, complained constantly of poor performance. And just as constantly, the directories of studies at the Kriegsschule and the Artillerie- und Ingenieurschule proposed remedies to their superiors. Unwilling to give up either social liberalization or its attainment through *Wissenschaft*, they continually emphasized higher entrance requirements, more directed coursework, and especially increased practical training to ingrain active capacities into theoretical learning.

At both schools attempts had been made from the beginning to import from the engineering schools in Paris and Metz the "method of application." Meno Burg had successfully initiated the method for drawing at the Artillerie- und Ingenieurschule in his first classes of 1816. It assumed, first, that a general

theoretical basis was required for efficient and versatile learning of practical skills, and, second, that theory and practice should be learned in parallel. The theoretical-practical distinction had two applications. Originally it divided time spent in the classroom, the theoretical part, from *praktische Uebungen* in the field, held on Wednesdays and Saturdays and for six weeks in the summer. These "practical exercises" included troop movements and artillery emplacements, use of measuring instruments, a trip to study the Spandau fortress, and visits to the royal powder factory, the armory, and the *Laboratorium* (where cartridges and various explosive devices were assembled). Very quickly, however, it came also to divide the classroom day between theoretical lectures in the morning and *praktische Uebungen* in the afternoon, now conceived as the French "repetitions," or problem sessions and science laboratories.[45] That the same term, *practische Uebungen*, covered both military and academic exercises and that both included a *Laboratorium* suggests one of the reasons why laboratories for teaching would regularly be associated with "materialistic" training for military pursuits, crafts, and industry, at least until midcentury. Only very gradually would teaching laboratories acquire a primary identification with the research ideal of *Wissenschaft.*

Burg's innovation in this setting was both early and radical. Following his own training at the Bauschule, he proposed to begin the two-year drawing sequence with a full five months of theory based on descriptive geometry to be followed by four months of practice in the first year and nine months in the second. The organizing committee rudely rejected this proposal, telling him simply to follow the traditional method of learning to draw by copying approved examples from the works of mature draftsmen. Burg responded with a *Promemoria* arguing the necessity of descriptive geometry for correct representation according to "mathematical laws" while pointing out numerous errors in the standard exemplars. As noted in chapter 3, descriptive geometry rests on the representation of a three-dimensional object by its projections into two or three perpendicular planes and its reconstruction from those planar figures. Further construction of the shadows cast by light from one or more directions, with accompanying shading, provides convincing realism (fig. 4.4). Accurate perspective construction provides another level of sophistication.

This much concerns the mathematical laws. Of much more general import, Burg charged that the older method produced not a versatile and creative draftsman (*Zeichner*) but a mere copier (*Abzeichner*). And here he adopted the pervasive aesthetic language of liberal humanism—self-motivation,

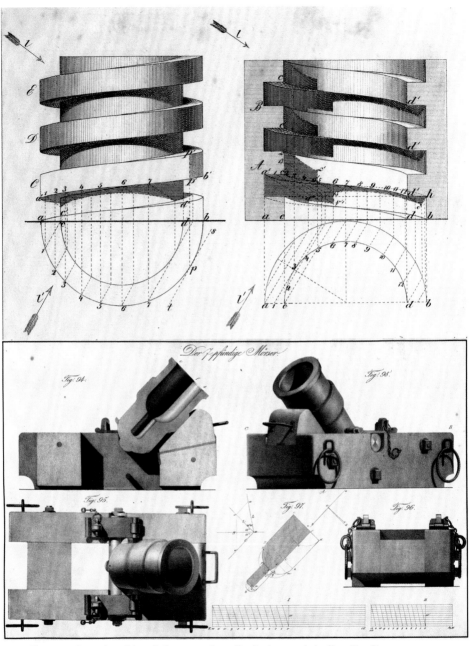

Figure 4.4 Examples of descriptive geometry, with shadows and shading. *Top*, Burg, *Geometrische Zeichnenkunst*, 140 and plate 30. *Bottom*, Burg, *Zeichnen und Aufnehmen des Artillerie-Materials*, 81 and plate X.

creativity, *Geist*, inner *Form* (see chap. 8), and true nature—all embodied in a proper drawing, an expression of one's own being as well as the authentic character of an object, through the drawn line:

> The draftsman must create out of himself and out of the store of knowledge he has acquired by instruction and must be able, using the shapes and dimensions given to him, to let the image, in its outlines and in its inner forms [inneren Gestaltungen], gradually emerge in lines, that is, to complete a proper linear drawing, and if required, by shading of the image, to give it an illumination that is correct for the lessons presented and corresponds to nature.

The old method of copying could never provide the virtues of this aesthetics of self-formation. It had presented its instruction "only mechanically . . . from a method unsatisfying to the spirit and thus tedious, without any self-development."[46] Burg's explicit contrast of merely mechanical copying with the creative and artistic expression that he ascribed to what is often thought of today as mechanical drawing points once again to the sought-after integration of machines and culture that Beuth so forcefully promoted for industrial development. The historian John Tresch has captured the corresponding aims of the French in his *Romantic Machine*, dispelling the still too common view that romanticism implied antimechanism. Of course the French comparison hovered like a specter in Prussia, which Burg did not fail to exploit for his *Géometrie descriptive.*

That Burg could present such a critique to his superiors says much about the initially expansive mood of the postwar period. The event also gives concrete form to an ethos of officer training that was widely dispersed in the military schools, although best known through the pedagogical writings of famous strategists such as Scharnhorst and Clausewitz. The spirit of disciplined but independent judgment, of taking every situation as unique and requiring creative, even artistic, treatment, continued as well in some of the more famous students from the period, such as Helmut von Moltke. An impoverished nobleman from Mecklenburg brought up in the Danish army, von Moltke studied at the Kriegsschule from 1823 to 1826, where he developed a taste for geography, physics, and military history. Shortly afterward he took up his lifelong assignment to the general staff, where he initially wrote serialized novels and translated Gibbon's *Decline and Fall of the Roman Empire* in order to maintain the horses and the respectable standard of living required of his position but where he advanced rapidly. Von Moltke remains famous for his roles in the Austrian War of 1866 and the Franco-Prussian War of 1870–

1871, when he made the general staff into the most powerful body in the army, the center of both policy and command. He also carried further and realized in action the premium placed on mobility and flexibility by Scharnhorst and Clausewitz, exploiting the new capacities of railroads and telegraphs for dispersed mobilization followed by rapid concentration for battle. But von Moltke's views on the requirements of command could almost have been taken from Burg's views on the task of a draftsman. "It is obvious," von Moltke wrote in 1865, "that theoretical knowledge will not suffice, but that here the qualities of mind and character come to a free, practical, and artistic expression, although schooled by military training and led by experiences from military history or from life itself."[47] This is not to say that any direct connection existed between Burg and von Moltke, who in any case became politically conservative, but to give specific expression to the view that instilling the quality of independent judgment constituted the number one goal of officer training and that this quality was seen in aesthetic terms.

Long before von Moltke wrote those words following the Austrian campaign, the liberal social-political cast that they carried during the reform period had largely disappeared into the more technocratic goals consistent with resurgent conservatism, both politically and militarily. But the strength of the reformers is apparent from the list of their adherents in table 4.2. Their accomplishments in technical education, furthermore, remained to a considerable degree in the curricula of the military schools.

This list registers many of the most notable liberals in the army. Eric Dorn Brose, whose portrayal I largely follow here, writes of them and their compatriots as "liberal brothers in arms." Although serious disagreements existed among them—even personal distaste, such as that of Clausewitz and Gneisenau for Valentini, Rühle, and Radowitz—they constituted through their interactions a potent political force. Rühle, Valentini, and Müffling belonged to a group of intellectuals, including the all-important Johannes Schulze in the cultural ministry and supported by Hake, whom Chancellor Hardenberg once (mis)named the "teutonische Jacobiner." Rühle and Schulze dreamed of a civilian-military state in which the *Gymnasien* and universities would provide joint military and civilian education. Three other close-knit groups were the "court liberals" around Prince August, which crucially included Witzleben; the moderate-liberal Gneisenau-Clausewitz circle; and the radical parliamentarians represented by Boyen, Krauseneck, Rauch, and Aster.[48]

Despite this heavyweight liberalism in the higher ranks, Burg's memorandum produced intense debate in the Studiendirection of the Artillerie- und Ingenieurschule. It carried the day only because Prince August once again

Table 4.2. High-ranking liberal officers responsible for military education in Prussia from the Befreiungskriege to the 1830s

Artillerie- und Ingenieur-Schule:
 Military directors
 Prince August (chief of artillery)
 Gustav von Rauch (chief of engineers) until 1837, then
 Ernst Ludwig Aster, another committed liberal

Kriegsschule:
 Military director
 Carl von Clausewitz, 1818–30, died 1831.
 Chairman, directory of studies
 Otto August Rühle von Lilienstern, 1816–47.

Ober-Militär-Examinations-Kommission, President (*Präses*):
 Neithardt von Gneisenau, 1819–31, Clausewitz's close friend and
 leader of the army liberals after Scharnhorst; died 1831

General-Inspekteur des Militär-Erziehungs- und Bildungswesens:
 Georg von Valentini, 1828–37, Rühle's brother in law

Generalstab, Chef:
 Karl von Müffling, until 1829, succeeded by his friend
 Johann Krauseneck, another prominent parliamentarian

Kriegsminister:
 Hermann von Boyen, until 1819, followed by a succession of liberals
 Georg Leopold von Hake, 1820–33
 Job von Witzleben, 1833–37
 Gustav von Rauch, 1837–41

Militärkabinett, Chef:
 Job von Witzleben, 1817–33; personal friend and advisor to the king;
 intimate of Wilhelm von Humboldt

stepped in to say that it was worth a try in the experimental first years of the new school. His interest in Burg's rationalized system, however, extended not simply to its liberal *Geist*; he sought above all a systematic mode of instruction that would produce *ein Geist* among all draftsmen in the artillery and engineering corps, which constantly felt the lack of uniformity, as well as competence and numbers, among their technical staff. It was on this basis that the prince commissioned Burg to write his textbook and on which he sold its adoption to the king.[49]

If in Burg's case the controversy concerned the value of theory, in other

technical subjects it focused on whether practical exercises were really necessary, especially given their cost in time and money. Traditional university-style lectures, if presented to well-prepared students, seemed adequate to some educators. After all, there were no repetition hours at the University. No doubt hostility to liberal reforms on the part of some traditional officers also played a role. It was not until 1826 that Prinz August attempted to establish fully the method of application even in mathematics but failed for lack of funds, succeeding only in 1832. Behind the new reforms stood the vanguard of military and social progress listed above. In practice, however, the reforms were carried out by a few younger officers. At the Artillerie- und Ingenieurschule, a restructured and expanded Studiendirektion included representatives of the two military directors. Rauch, for the engineers, chose Captain Moritz von Prittwitz, whom we have seen in chapter 3 as the acclaimed builder of fortifications at Posen and Ulm and an important promoter of the liberal political economy of J. B. Say in Beuth's Gewerbeverein. Prittwitz had also been an enthusiastic participant in Burg's French-inspired mathematics instruction in 1815. Prince August, for the artillery, chose Captain Joseph Maria von Radowitz, a very well-connected protégé of the "teutonic Jacobin" Rühle von Lilienstern at the Kriegsschule, who also had Radowitz appointed to its Studiendirektion. There he would work closely with another "Jacobin," Schulze. Radowitz represented the method of application quite directly, having been a student at the École polytechnique who came away fully convinced of its methods. He also fought for France in 1812 in Friedrich Wilhelm's tactical alliance with Napoleon against Russia, for which Prussian loyalists such as Clausewitz and Gneisenau, who had resigned in protest from the army and fought for Russia, never forgave him.[50]

Radowitz is a particularly intriguing figure because his association during the 1820s with leading liberals stands in such contrast with his historical reputation as a leading conservative thinker of the 1830s and as the person most responsible for the foreign policy of his close friend King Friedrich Wilhelm IV following the revolution of 1848. But he was a modernizing conservative who opposed absolute monarchy and saw the two crucial tasks of the state to be finding solutions to the "social problem" of the emerging proletariat and the "national problem" of German unity. He stood for the historically derived legitimacy of church and aristocracy and detested the "bureaucratic absolutism" of the Prussian ministries, but he also came to support constitutional monarchy and (defanged) parliamentary government.[51] So far as the military schools are concerned, these commitments should probably be connected more closely with the onset of reaction in the 1830s than with his

earlier associations. But as one historian has put it, "In the educated circles of Prussia, one-time Romantics turned liberal, radicals turned conservative."[52]

At the Artillerie- und Ingenieurschule the activities of Prittwitz and especially Radowitz produced a thoroughgoing transformation by 1832. By extending the course of studies to three years, more time was allotted not only to military tactics but to descriptive geometry, higher analysis, physics, and chemistry. Similarly, by adding applied mathematics (mechanics of solid and fluid bodies), analysis, physics, and chemistry to the examinations for artillery and engineering officers, these subjects acquired much greater weight. The overall restructuring, however, aimed to nurture self-motivated officers. No longer were lecturers allowed simply to dictate from a book, as had been common. Instead, whenever possible, students would have textbooks for self-study and would take notes only on explanations and commentary by the professor, which they would elaborate on their own in their notebooks. Homework could now be assigned, with the requirement that the work had to display the students' own industry rather than results copied from a book. Professors could actively engage the students with questions and quizzes during the lectures, and they were to encourage students to ask their own questions.[53] In short, the Artillerie- und Ingenieurschule (and the Kriegsschule as well) embedded in their regulations the ideal qualities of the citizen-officer: independent, self-controlled, self-confident, and self-acting (*selbstständig, selbstbeherrschend, selbstbewusst, selbsttätig*).

The feature attached most strongly to Radowitz's name in this entire cultivation of the self was the method of application, now formally instituted as separate repetition classes to accompany all mathematics lectures and a laboratory for chemistry. "The advantages that these excercises confer, not merely to make the student familiar with the spirit of science but especially also to translate knowing into doing and generally to stimulate the development of the understanding, is widely recognized." Recognized, yes, but not realized. In chemistry, for example, Turte had long included laboratory practice in his course but not as the separate laboratory class that it now became, with a new *Repetent* hired to teach the laboratory for 200 thaler yearly. Table 4.3 gives the weekly schedule of hours at the Artillerie- und Ingenieurschule in 1832–1833, showing the division between theoretical instruction in the morning lectures and practical training in the afternoon (combined for drawing).[54]

This is the year in which Gustav Magnus, mentor of the Physical Society in Berlin, replaced Turte for physics and chemistry. Mathematics and drawing clearly dominate the curriculum and with physics and chemistry constitute

Table 4.3 Curriculum of the Artillerie- und Ingenieur-Schule, 1832–1833

Hours per week and subject	Together			Art.	Eng.
	I	II	III	III	
Artillery	4	3	...	8	...
Art of fortifications	4	3
Architecture	15
Tactics	...	3	...	3	...
Mathematics	6	4	4
Physics and chemistry	...	4	4
Drawing	8	5	2	4	5
German language	2
French language	2	4
History	2	2
Geography	2	2
Morning hours	30	30	10	15	20
Mathematical repetitions	6	6	4
Work in chemical laboratory	4
Knowledge of horses	...	4
Military and practical exercises	4	2
Fencing	2
Afternoon hours	10	12	10

Note: Number of hours per week in each course for the three years of study (I–III) and the differences between artillery and engineering specialization in the third year.

nearly half of the forty-hour week for all three years. The repetitions and "Arbeit im chemischen Laboratorium" have a somewhat different status from the activities actually labeled as practical exercises, but the latter still include "Arbeiten in [Feuerwerk] Laboratorium" along with field exercises, use of instruments and machines, and visits to various military installations and factories.[55] Magnus would maintain this implicit association of laboratory and industry. He would couple it, however, with a strong research orientation.

Under Radowitz's orchestration the method of application was instituted also in the Kriegsschule, sometimes with such extraordinary *Repetenten* for mathematics as Ohm and Dirichlet. At neither school, however, did the

separate mathematics repetitions meet expectations. Students complained, attendance dwindled, and results on the officer exams disappointed. Some judged the fault to lie with repetitions that did not match the lectures and with *Repetenten* who simply gave their own lectures.

Probably considerable weight should be given to the fact that the liberal administrators suffered heavy political losses. Müffling had already been transferred out of Berlin in 1828, and Clausewitz and Gneisenau died of cholera in 1831. But the revolutionary disruptions of 1830 and 1832 were especially costly. Witzleben was demoted from his position next to the king in 1833 (while becoming Kriegsminister), Rühle was thoroughly compromised, and Radowitz became a leading voice of modern conservatism. For all of these reasons, separate repetitions in mathematics largely ceased at both schools by 1840. But this did not mean that the method of application disappeared. Rather, it remained in the curriculum in a less distinct but perhaps more basic form as part of the lectures, which were assigned extended hours that partially incorporated the repetitions. The chemistry laboratory continued without interruption.[56] In spite of continuing complaints, therefore, the Artillerie- und Ingenieurschule remained one of the few places in Prussia where a motivated student could acquire a fairly solid technical training.

Friedrich-Wilhelms-Institut

Another such location was the Königliches medizinisch-chirurgisches Friedrich-Wilhelms-Institut, established in 1795 to train army doctors.[57] Hermann Helmholtz attended from 1838 to 1843. He had actually wanted to study physics at the University, but the expense, which his father could ill afford, coupled with poor job prospects, made the army medical track a more realistic alternative. Even though the nearly free education required eight years of subsequent military service, it attracted many applicants, making acceptance difficult. Helmholtz succeeded with the aid of a high-level family connection, the former *Generalchirurgus* (surgeon general) of the army C. L. Mursinna. Typically for the Berlin educational network, his teachers also taught at other technical schools and at the University. Two from the older generation were Turte, from the Artillerie- und Ingenieurschule, and J. H. F. Link, from the Botanischer Garten and Gärtnerschule. Turte had been instructing the doctors in physics since 1806, and Link had been teaching natural history since his arrival in Berlin in 1815. Importantly, the lectures of these progressive and popular older professors did not meet the standards of professional science that characterized ambitious students who were two generations younger, such as Helmholtz and the friends he

would join in the Berlin Physical Society (chap. 6). As Helmholtz wrote to his parents during his first year, "Link apparently suffers from an excess of *Geist*; the good man is just as grandiose as Turte, at least in natural history, where he still carries on with a philosophical introduction (ach Gott!)." But the science courses of the intermediate generation—Dove in physics, Eilhard Mitscherlich in chemistry, and Johannes Müller in anatomy and physiology—infused medicine with the latest scientific knowledge and with the discipline of physical experiment, perhaps a bit too much discipline for Helmholtz: "Müller's physiology is excellent, Mitscherlich's zoological chemistry very interesting, ditto experimental chemistry, jam packed, a little bit boring."[58]

At the Friedrich-Wilhelms-Institut, unlike the University, discipline meant military discipline: students had a more rigorous schedule of classes, more repetition hours, a year of clinical instruction, and a full year of internship at the Charité hospital. This extensive practical training, which characterized the military schools generally, was normally not available to medical students at the University, who had to travel to cities such as Vienna or Paris to obtain it.[59] On the theoretical side, however, differences were not great. Just as the war ministry had been setting policies since the founding of the Kriegsschule that would reduce the disparity between educated civilians and military officers, so military doctors were required from 1825 to meet the same requirements as civilian doctors, from their entrance exams to their final state examinations.[60] In sum, had Helmholtz studied medicine at the University rather than the Friedrich-Wilhelms-Institut, he would have heard a nearly identical set of lectures, albeit with less clinical training.

This same equilibrating effort, with its attendant sharing of professors, meant that educational reforms tended to affect both civilian and military institutions. Johannes Müller's appointment in 1833 is illustrative. He was called to Berlin (as second choice) specifically for his energetic and innovative work in the new analytical methods of experimental physiology and microscopic anatomy, which were seen as necessary if Berlin were to excel among the best medical schools of Europe. And in fact Müller would become the center of a new Berlin school of medical research and education (chap. 6). With the specific goal of establishing such an integrated movement, cultural minister Altenstein carried on the negotiations personally, acting with the advice of his deputy Schulze and with recommendations from the philosophical and medical faculties of the University. From Altenstein's perspective, the expectation that Müller would be able to increase his salary by teaching at the military medical school formed part of a package of incentives that reflected

his integrative policy, as shown by the salary breakdown that he originally suggested:

1. University professor of anatomy and physiology 1000 thaler
2. Director, Anatomical Theater and Anatomical Museum 300 thaler
3. Member (possible), Medical Scientific Deputation 300 thaler
4. Professor (possible), Friedrich-Wilhelms-Institut 250 thaler
5. Member (possible), Academy of Sciences 500 thaler

From the perspective of the war ministry, however, the military professorship was a requirement of Müller's appointment. Formal letters passed between the ministers to ensure that outcome, which Müller in fact welcomed. One of his own requirements was that the Charité hospital—established in the eighteenth century to serve the Prussian Army and where military training and care still held priority—should hire a professional anatomical demonstrator (a *Prosector*) to make preparations of diseased tissues and to maintain an up-to-date collection for practical use by doctors and medical students in the clinics, as was the case in the great hospitals of Paris. This collection would complement the several thousand pathological preparations at the more academically oriented Anatomical Museum.[61]

Thus, the pursuit of technical modernity traveled rapidly round the circle of institutions that constituted medical training and practice in Berlin, civilian and military. And that pursuit ran in parallel with the rest of the network of technical schools. It should now be clear that this network acted as a loosely coordinated if decentralized agency for the educational goals of modernizing and industrializing liberals in the military state.

Werner Siemens

One extraordinary participant in this promotion of military-industrial development, as well as the training of the self for creative independence, was the young Werner Siemens, born in 1816, the year the Artillerie- und Ingenieurschule was founded. While at the Lübeck *Gymnasium* (Katherinenschule) for three years, Siemens had become aware of his poor facility for classical languages, the mainstay of the school, in comparison with his unusual talent for things technical and mathematical, in which the school provided little training. He therefore fixed on studying civil engineering and architecture at the Bauschule in Berlin as one of the few opportunities for technical study then available. In preparation, he obtained a tutor in mathematics and surveying, an aristocratic lieutenant who had formerly served in the Prussian

artillery corps, Freiherr von Bülzingslöwen. Much as in Helmholtz's case, however, the expense of the Bauschule exceeded his father's agricultural means, so Bülzingslöwen advised young Siemens that he could obtain the same education by joining the engineering corps and attending the Artillerie- und Ingenieurschule at the cost of the state. Indeed, from 1826 to 1832, before the Artillerie- und Ingenieurschule added its own third year, a few of its best students spent a third year at the Bauschule taking advanced courses.[62]

The project, however, proved not so simple for the seventeen-year-old Siemens. Having obtained an interview with General von Rauch through a distant cousin in the horse artillery in Berlin, he learned that high demand meant he would have to wait four or five years for a place in the engineering corps. Rauch advised him to try the artillery. There he found the same problem in an interview with Oberst Wilhelm von Scharnhorst, son of the famous general and commander of the Third Artillery Brigade, but the fact that Scharnhorst recognized the maiden name of Siemens's mother, Deichmann, as from the town that bordered his estate apparently made the difference. Scharnhorst granted Siemens entry to the competitive examinations that now determined acceptance to the Artillerie- und Ingenieurschule. Of fifteen candidates, he was one of four who passed.[63] Again like Helmholtz, Siemens experienced from the start of his career the effects of the reforms that had professionalized the technical services and encouraged middle-class talent while benefiting simultaneously from the traditional advantages of family.

While at the Artillerie- und Ingenieurschule, from 1835 to 1838, Siemens devoted himself not only to Burg's descriptive geometry, which he so strongly recommended to his younger brother Wilhelm as the basis for a training in the natural sciences (epigraph, this chapter), but to these *Lieblingswissenschaften* themselves: mathematics, physics, and chemistry. He recalled that the teaching of Martin Ohm, Gustav Magnus, and C. G. H. Erdmann had opened to him "an interesting new world" to which he ascribed his later success.[64] On his first posting, in Magdeburg, he turned that new world into artillery science with his earliest independent chemical experiments on friction fuses (*Frictionsschlagröhren*) for firing cannons. He had been inspired by the success of another relative, A. Siemens, an officer in the Hanoverian artillery corps, but his own almost comical efforts extended only to shattered window frames in his room and a broken ear drum. Better results followed early in 1842 during his second posting from experiments carried out in a rather comfortable prison cell that he converted into a laboratory, having been sentenced to five years confinement for acting as a second in a duel (pardoned within two months). This time he discovered a process for elec-

troplating gold, which derived from his familiarity with Daguerreotyping and built on the recent discovery by Moritz Jacobi (chap. 6) of *Electrotypie*, or *Galvanoplastik*, for reproducing small images and sculptures. Siemens immediately patented his process and licensed it to a local jeweler.[65]

Having become known in the artillery corps for his chemical-technical creativity, Siemens was assigned to the Spandau powder factory (Turte's domain) in the pyrotechnics division (*Luftfeuerwerk*), where he employed recent chemical advances to produce an impressively large and colorful fireworks display for the birthday of Czarina Alexandra (formerly Princess Charlotte). Its great success led to a new assignment late in 1842 to the artillery workshop (*Artillerie Werkstatt*) in Berlin, which would prove critical for his entire career. Within a year, based on his patent, he had entered into a profit-sharing agreement on a gold and silver electrotyping plant in Berlin, the first in Germany. And his brother Wilhelm had gone to England, where he sold their English patent to the leading competitor in electrotyping, G. R. Elkington, yielding the hefty sum of 1,500 pounds.[66] But other inventions fizzled. As a result, Siemens rededicated himself to the natural sciences, mastery of which he now regarded as a prerequisite for the successful pursuit of profitable inventions. He found particular welcome and support in the lectures offered by Magnus, Dove, and Riess, through whom he apparently met the young organizers of the Berlin Physical Society. He also began work with the Artillery Testing Commission (Artillerie Prüfungs-Commission) on measuring the velocity of projectiles, work that would prove crucial for his own entry into the electrical industry as well as for the muscle and nerve measurements of Emil du Bois-Reymond and Hermann Helmholtz.[67]

These new acquaintances relieved for Siemens what he recalled as the most frustrating problem he faced—communication. "There still ruled at that time an unbridged gulf between science and technology." With sarcastic inflection he blamed both the traditional attachment of military and bureaucratic authorities to agriculture and the "eminent bearers of science who held it as incompatible with their dignity to show a personal interest in technical progress."[68] Siemens did recognize that Beuth and his Gewerbeinstitut (along with the Technische Deputation and Gewebefleiss Verein) had done much to advance *Technik* in northern Germany. He also recognized the importance of the Polytechnical Society in Berlin, another of those *Vereine* of like-minded individuals that figured so prominently in forming middle-class consciousness. Siemens took a lively part in their discussions of technological innovation, which brought him into active contact with Berlin entrepreneurs.

Although Siemens was certainly unusual among artillery officers as an in-

ventor and entrepreneur, his activities nevertheless represent the values of self-motivated action and technical-scientific capacity that the corps sought to instill in officers trained at the Artillerie- und Ingenieurschule. They also suggest how the business of weaponry was becoming identified with the advancement of industry through research, development, testing, and manufacture. Historians have emphasized, however, that the army maintained a quite conservative stance with respect to technological modernization of weaponry. Particularly striking has been opposition to the famous "needle gun" (bolt-action rifle with firing pin), which was taken to signify the evils of mechanization and industrialization.[69] But at a mundane level, friction fuses and gold-plated spoons required similar sorts of skills and factories. More profoundly, the large-scale industries soon required by the Prussian Army were often the same as those of civil society, as is apparent in the cases of railroads and telegraphs, where civilian and military interests regularly competed. Siemens would enter the telegraph business in 1847 when the market in Prussia was exclusively military and when he served on the army's telegraph commission. Not until 1849 were civilian lines allowed.

This interpenetration of military and civilian interests can best be illustrated by detailed examples. I begin with a "differential governor" for steam engines that Werner and Wilhelm Siemens invented from 1842 to 1843. Working at the machine works of Count Stolberg in Magdeburg, Wilhelm had encountered the problem of regulating a steam engine whose power was supplemented by a waterwheel or windmill. The engine needed to be precisely and smoothly self-regulating, running at a constant speed under variable conditions. The problem suggested to Werner a differential principle modeled on that of a screw and nut combination in which the screw and the nut would be turned separately in the same direction, one driven at a desired reference speed and the other driven by the engine. When turning at the same rate, the screw and nut would experience no relative displacement, but any difference could be used to control the engine.[70]

Figure 4.5 is an easily understood drawing that the Siemens brothers provided for their ultimate patent application in 1845. Meno Burg would have been pleased with the result of his instruction. The conical pendulum (*a*, front view) rotates around the vertical axis to provide the reference speed for a small gear (*b*, top view, effectively the "nut"), which engages with the worm gear (*c*, the "screw"), driven by the engine through the pulley (*d*). If the speeds of the pendulum and the engine differ, the worm gear and its shaft will be displaced to the left or right, moving the counterweighted lever (*e*), which regulates the speed of the engine by controlling its steam valve.

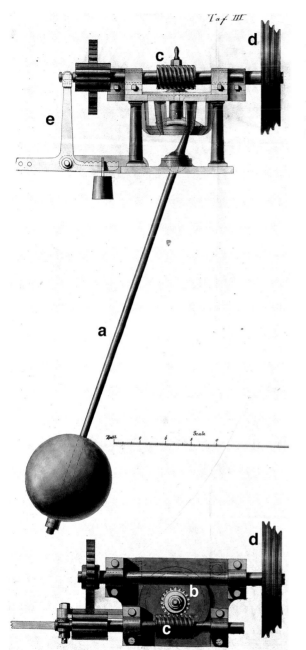

Figure 4.5 "Gebrüder Siemens: Maschinenregulator," detail, front and top views, 1845. Geheimes Staatsarchiv Preussischer Kulturbesitz, Berlin, I. HA Rep. 120 TD Technische Deputation für Gewerbe, Patente Schriften, Nr. S 410.

The centerpiece of this differential governor, in addition to the differential principle itself, was the independently rotating conical pendulum used to establish the reference speed, which led Wilhelm to adopt the alternative name "chronometric governor." In its chronometric and differential characteristics it differed significantly from the standard centrifugal governor of Watt, whose two revolving balls on a conical pendulum had become an icon of steam power. On the Watt device the conical pendulum rotated always at a rate proportional to that of the engine rather than at its own constant rate. If the engine slowed, the angle of the rotating balls would decrease, causing a steam valve to open (and the reverse for increased speed). Although simple and inexpensive, this direct-acting centrifugal governor did not provide the smooth operation of the Siemens differential governor, whose chronometric independence made it much more sensitive to deviations of speed. Wilhelm and Werner embodied their differential principle in a variety of different mechanisms suitable for different situations. In each case the conical pendulum, whether in single or double form, provided the independent reference for self-regulation.[71]

Fitted with such a governor, the engine truly marched to its own drummer, supplying a measure of independence of action for the work-producing engine. In these terms it could be said that Siemens equipped the engine with qualities analogous to those he idealized in the independent citizen and that the reformed Artillerie- und Ingenieurschule sought to inculcate in its young officers.[72] Similar qualities characterize several of Werner Siemens's instruments of the 1840s, when self-acting devices were proliferating. The best known of Siemens' machines is his modification of Charles Wheatstone's "dial telegraph" to make it self-acting. The patent for this device launched Siemens into the telegraph business in 1847 in partnership with the master mechanic J. G. Halske (chap. 6).[73]

Another important self-acting instrument derived in part from the chronometric governor but was developed specifically for the artillery corps. Siemens had become acquainted in Berlin with the master clockmaker C. G. F. Leonhardt, and it may well have been from Leonhardt that he adopted the chronometric pendulum for self-regulation. Leonhardt had been employed by the Artillery Testing Commission in 1839 for a high-priority project. He was to realize the idea of using a precision clock, engaged and disengaged electromagnetically, to make measurements of projectile velocities. The clock would measure the flight time over a given distance between two gates triggered by the passage of a projectile. It was intended to replace the error-plagued method of shooting a cannonball into a mass of wood, suspended

as a ballistic pendulum, and using the angle of deflection of the pendulum to calculate the initial velocity of the ball. More accurate measurements would allow more reliable testing of different powders, loads, projectiles, and guns, leading to their standardization, which would enable gunners in the field to aim their weapons with much greater accuracy. This long-sought goal of all European armies had entered a new phase in the late 1830s, when electromagnetic methods seemed to offer advantages over mechanical ones. Siemens joined the Prussian effort late in 1842, effectively entering an international competition to succeed first. The priority dispute that followed led him to publish the whole affair. He also became enthralled with electrical instruments.[74]

Leonhardt had designed a free-running chronometer regulated by a conical seconds pendulum. Pointers could be engaged with the pendulum to rotate over a large indicating face, readable to at least a thousandth of a second. Leonhardt and the commission, with suggestions from Siemens, tried various alternatives for starting and stopping the pointers using small levers operated by electromagnets in circuits either opened or closed, directly or indirectly, by the passage of the projectile. By 1844 they had reduced their error to a few thousandths of a second but were still short of their goal. The problem lay in the variability of the time required for the electromagnets to act and in the use of mechanical linkages. Siemens devised a solution: use electrostatic circuits, closed directly by the projectile, to register its passage between two gates as successive sparks on a rapidly rotating cylinder.

To realize this "electrical chronoscope" (*elektrischen Chronoskop*), he adapted an instrument employed by the competition, L. C. F. Breguet and Wheatstone, who were already contesting with each other for priority. They too employed a conical pendulum, but rather than controlling clock pointers, it regulated the rapid rotation of a cylinder on which weights dropped by electromagnets made small marks (thus an "electromagnetic chronoscope"). In their use of the rotating cylinder, they were adapting one of the techniques of self-recording developed by engineers for the dynamometers and indicators used to measure the work done by engines and other motive powers (chap. 3, 7). But their instrument was no more direct reading than Leonhardt's and suffered from similar errors of interposed electromagnetic and mechanical action. Siemens proposed instead to make the marks on the cylinder by spark discharges from a Leyden jar triggered immediately by the passage of the projectile. "My aspiration was to eliminate every mechanical intermediary between the ball and the time-register, thus to let the spark mark itself directly on the cylinder."[75]

Figure 4.6 Time-measuring cylinder. Siemens, "Geschwindigkeitsmessung," 66.

Leonhardt undertook to carry out the plan, which required a finely ma-chined steel cylinder running uniformly at high speed. Figure 4.6 is Siemens's schematic drawing of some essential elements: (*a*) the small recording cyl-inder 2.25 inches in diameter and 0.5 inches high, (*b*) an electrostatic "sty-lus" nearly grazing the cylinder, and (*c*), a worm gearing to turn the cylinder sixty times per second. Not shown is the drive mechanism itself, consisting of Leonhardt's clockwork propelled by a falling weight and regulated once again by a conical pendulum. The system worked as follows. A cannonball passed through two small gates, each consisting of two parallel wires. At each gate, as the ball burst through the wires, it established electrical contact between them to complete a circuit containing a charged Leyden jar, thereby releasing a spark discharge between the stylus and the rotating cylinder. From the dis-tance between the two sparks on the cylinder Siemens and Leonhardt could in principle read off time intervals as small as 1/400,000 of a second, corre-sponding to the movement of a cannonball of about one millimeter. Even in practice they could measure projectile velocities over distances of only a few feet, or even inside a cannon barrel.[76]

The precision of this electrostatic technique exceeded by about two or-ders of magnitude any competing method. The velocities measurable so im-pressed Siemens that he proposed a modified version of the instrument to measure the velocity of electricity itself along a conducting wire. With this suggestion Siemens concluded his account of the priority dispute, having rendered it irrelevant.[77] But the suggestion had already taken on a new life. Having met the young men who were forming the Berlin Physical Society in January 1845, he became one of its charter members. In that context, artillery measurements of extremely short time intervals, using the self-acting tech-nique, quickly translated into new horizons for physics and physiology. Sie-

mens's instrument, united with the steam-engine indicator, would become the basis of Helmholtz's "frog drawing machine," enabling a frog muscle to draw its own curve of work done during a contraction and to measure the propagation speed of the nerve impulse (chap. 8).

If Siemens's self-regulating governor had embodied in a machine the values of independence and self-control promulgated at the Artillerie- und Ingenieurschule, then his electrical chronoscope took that embodiment a step further, into the realm of objective, self-registered knowledge. Without the intervention of any human hand, the chronoscope recorded with unheard-of precision the invisible passage of the cannonball, or in Siemens's terms, it allowed the cannonball to inscribe its own passage directly on the revolving drum. This is the same sort of self-registering action that was ascribed to the indicator in reading out the internal states of the steam engine, which could trace its own production of power as a diagram. Both instruments shared the qualities of self-action that seemed to guarantee objective knowledge of the external world.

Importantly, however, the relation of self-registering instruments to the ideal of independent knowledge and action in a self-acting citizen should not be separated out from the aesthetic qualities that accompanied that ideal of the citizen. Only as joint values did they inform the claims of middle-class officers, civil servants, and entrepreneurs to occupy a leading position in society while justifying the goal of liberal policy makers to exploit the capacities of citizens for the strength of the state. The dual virtues are evident in the prominence of the ideal of *Bildung* in all of the technical schools.

NOTES TO CHAPTER FOUR

1. Werner Siemens' advice to Wilhelm Siemens on beginning to study natural sciences in Göttingen; letter of June 26, 1841, in Matschoss, *Siemens*, 3–4.

2. I build here on a description of the king's visit by Brose, *Politics of Technological Change*, 164.

3. Burg, *Geschichte meines Dienstlebens*, 98–100. For the building, see Bonin, *Geschichte*, 2:164, and Poten, *Geschichte*, 4:394. *Le Drole* is now in the army museum at the Hôtel national des invalides, Paris, apparently recovered after World War I. In addition to Napoleon's large *N* and its manufacture at Strasbourg, Crucy, in 1811, it bears an inscription giving the circumstances of its capture and presentation. For a stirring account of the battles at Leipzig, see Clark, *Iron Kingdom*, 367–71.

4. Brose, *Politics of Technological Change*, 81–82.

5. Honisch and Krieger, *Deutsche Malerei*, 140. Krieger and Ostländer, *Galerie der Romantik*, 141.

6. Haas and Henning, *Prince August*, 153. Burg, *Geschichte meines Dienstlebens*, 11–17.

7. Burg, *Die geometrische Zeichnenkunst*, 21, 147. Börsch-Supan, *Die Kataloge*: Leithold, 1838, no. 917; 1839, no. 966; 1840, nos. 892. 908; Siemens, 1838, no. 908. Burg, *Geschichte meines Dienstlebens*, 77–83.

8. Clausewitz, *Ueber das Leben*. Paret, *Clausewitz*, 56–65. The standard biography is Lehmann, *Scharnhorst*. A study emphasizing the idealist intellectual context, especially Schleiermacher, is Hornung, *Scharnhorst*. A good short biography is Stübig, *Scharnhorst*. See also Stadelmann, *Scharnhorst: Schicksal und geistige Welt*.

9. Dwyer, "Prussia," 253–54.

10. Scharnhorst, "Entwicklung."

11. A classic account is Delbrück, *Geschichte der Kriegskunst*, 4:457–514. Paret, *Yorck*, provides a lucid analysis of the military reforms, remarking of the late eighteenth-century change in troop formations that "the decisive innovation in infantry fighting . . . consisted in the acceptance of open-order tactics by the line infantry" (37), not only in advance of attack columns but as integral components in which the third tier were trained as skirmishers (65–73). See also Paret, "Napoleon" and Shy, "Jomini." White, *Enlightened Soldier*, chap. 3, "The Revolution in Warfare," 56–86.

12. Scharnhorst, "Entwicklung," 84; Paret, *Yorck*, 73–110.

13. Alder, *Engineering*, especially chap. 7, on musket production in Paris, 1794–1795.

14. Quoted in Shy, "Jomini," 144–45, from *Archives Parlementaires de 1787 à 1860*, 1st ser., 72 (Paris, 1907), 688–90.

15. Recent myth-busting interpretations have undermined the radical contrast between French and Prussian soldiers and methods, as well as the contrast between liberal and conservative Prussian generals, and have placed greater weight on systemic issues of geography, demographics, and social change, especially in relation to Prussia's insecure position in the prerevolutionary state system of Europe and its need suddenly to adapt to Napoleon's complete abrogation of the diplomatic conventions of that system. Summary by Showalter, "Prussia's Army," and Dwyer, "Prussia."

16. Paret, "Napoleon and the Revolution in War." Shy, "Jomini." Delbrück, *Kriegskunst*, 4: 475–477.

17. Particularly informative is White, *Enlightened Soldier* (Institute for Young Officers, 87–102). See also Hornung, *Scharnhorst*; Hartmann, *Clausewitz*; Büchel, "Der Offizier"; and Sikora, "Ueber die Veredelung."

18. Full list of members in White, *Enlightened Soldier*, 203–211. Others who appear below are: Hake, Valentini, Grolman, Tiedemann, Rauch, and Müffling.

19. Paret, *Clausewitz*, 59.

20. Craig, *Politics*, 65–71, summarizes the progress of reaction.

21. Hornung, *Scharnhorst*, 141–90; Paret, *Clausewitz*, 137–46; Brose, *Politics of Technological Change*, 72, 171–75.

22. Dwyer, "Prussia," 253, makes the critical point that this military aim of defeating Napoleon was not the goal of the larger reform movement in terms of foreign policy, which instead aimed at strengthening the state in its ability to pay its huge war indemnity after 1806 and at making Prussia an attractive ally to Napoleon, mitigating his hegemony in northern Europe.

23. Beginnings of the Kriegsschule in Scharfenort, *Kriegsakademie*, 6–14 and n6. Nottebohm, *Hundert Jahre*, 1–14, quotation 5–6; but cf. 13, excluding "rohe, nur nothdürftig qualificierte Subjecte aus der untersten Volksklasse." Conrady, *Leben und Wirken*, 1:158–62.

24. Statistics in Paret, *Yorck*, 263–66.

25. Development of the general staff and its relation to the ministry in Craig, *Politics*, 51–53, 62–63, and Holborn, "Prusso-German School."

26. Scharnhorst to Professor Stützer, December 4, 1809, *Ausgewählte Schriften*, 319–21.

27. Original first-year curriculum, Poten, *Geschichte*, 4:156; Scharfenort, *Kriegsakademie*, 9–11 and n16; Schwertfeger, *Die grossen Erzieher*, 42. Paret, *Clausewitz*, 62–63, 69–71, 186–99, quotation on 188–89 from Clausewitz, "Charakter des kleinen Krieges," 239. Paret, *Yorck*, 21–25, 76–81, 177–78.

28. Paret, *Clausewitz*, 127; Poten, *Geschichte*, 4:157–58, quotation on 157; Scharfenort, *Kriegsakademie*, 6–24, quotation on 16.

29. Scharfenort, *Kriegsakademie*, 27; Rothenberg, "Maurice of Nassau," 55–63.

30. Poten, *Geschichte*, 4:258–59; Scharfenort, *Kriegsakademie*, 30 and n29; Schwertfeger, *Die großen Erzieher*, 44. As these sources, plus Bonin, *Geschichte*, made extensive use of documents from the war ministry, which have not survived, they provide the basis for discussion of the military schools.

31. Scharfenort, *Kriegsakademie*, 11. Alder, *Engineering*, 303–12, summarizes recent work on the transformation of the French engineering schools from their originally democratic aims in the mid-1790s to their enduring elitist form after 1800.

32. Scharfenort, *Kriegsakademie*, 11 (Scharnhorst), 20 (Clausewitz), 32. Poten, *Geschichte*, 4:257. Paret, *Clausewitz*, 272–79, discusses Clausewitz's recommendations to von Boyen in some detail.

33. Alder, *Engineering*, 303–18, makes a similar turn in France a central theme. In Prussia, unlike France, the universities continued to hold a much higher status than the engineering schools.

34. On Rühle, see Priesdorff, *Soldatisches Führertum*, 4:389–93 (no. 1360). Paret, *Clausewitz*, 273–74, quotation on 281, from a letter to Carl von der Groeben, December 26, 1819, in Kessel, "Boyens Entlassung."

35. Scharfenort, *Kriegsakademie*, 25, 371; Klemm, "Fischer," 45–48, 54–57; Fischer, *Lehrbuch*; Berthollet, *Recherches, Essai.*

36. Fischer, "Pestalozzis Lehrart."

37. Fischer, *Zweckmässigste Einrichtung*; Klemm, "Fischer," 49–54.

38. Erman, *Erman*, 91–94; Paret, *Clausewitz*, 213, 258, 310. Etzel became head of the optical telegraph network and a promoter of the electric telegraph, in whose development Siemens would play a leading role. "Etzel, August von," *Allgemeine Deutsche Biographie* 6 (1877): 402–3. Brose, *Politics of Technological Change*, 172.

39. Belhoste and Picon, *L'École d'Application* contains workshop papers on aspects of the training at Metz.

40. The king's order is reprinted in Bonin (*Geschichte*, 287–90), who summarizes Rauch's career (190–94). Poten, *Geschichte*, 4:384–419, gives the most detailed account available of the curricular history of the Artillerie- und Ingenieurschule to 1845.

41. Burg, *Geschichte meines Dienstlebens*, 69.

42. Scharfenort, *Kriegsakademie*, 164–68, 381; Lampe, "Dirichlet"; Dobbert and Meyer, *Chronik*, 43, 48.

43. Schubring, "Mathematics," 161–94, passim.

44. Klemm, "Fischer," 40; Fischer, *Untersuchung.* Alexander von Humboldt called Schulze "the most active and most important man in the ministry of Herr von Alt[en-stein]." Letter to Dirichlet, August 10, 1828, Biermann, *Briefwechsel*, 45–46. On Schulze generally, see Varentrapp, *Schulze.*

45. Scharfenort, *Kriegsakademie*, 11–12, 20–21; Poten, *Geschichte*, 4:158–59.

46. Burg, *Geschichte meines Dienstlebens*, 74–75.

47. Quoted in Holborn, "Prusso-German School," 289.

48. Brose, *Politics of Technological Change*, chap. 2, "Liberal Brothers in Arms," 72–97. For the political and professional positions occupied by various officers, see Poten, *Geschichte*, vol. 4; Nottebohm, *Hundert Jahre*; and Scharfenort, *Kriegsakademie*, passim. For military careers, see Priesdorff, *Soldatisches Führertum*, index (online at http://www.grosser-generalstab.de/priesdorff/priesdorff_a.html. Paret, *Clausewitz*, 192n, cites Valentini's characterization of Clausewitz as "highly repugnant," returned by Clausewitz as "the schoolmaster" for Valentini. For "teutonic Jacobins," see Brose, *Politics of Technological Change*, 75–76, and Nottebohm, *Hundert Jahre*, 25–26, citing Treitschke, *Deutsche Geschichte*, 2:605.

49. Burg, *Geschichte meines Dienstlebens*, 77–82, including August's letters to Burg and to the king.

50. Burg, *Geschichte meines Dienstlebens,* 40n. Nottebohm, *Hundert Jahre*, 23–25, on enemies of reform. Poten, *Geschichte*, 4:396–97, on Radowitz and Prittwitz. Bonin, *Geschichte*, 198–206, on Prittwitz in Posen. Scharfenort, *Kriegsakademie,* 153–56; Brose, *Politics of Technological Change*, 77, and Biermann, *Briefwechsel*, 39–48, on A. v. Humboldt's view of Radowitz's influential role at the Kriegsschule, his mathematical work, and the hiring of Dirichlet (chap. 5).

51. Beck, "Changing Concerns," 86–91, summarizes Radowitz's form of conservatism. Sheehan, *German History*, 711–15.

52. Stamm-Kuhlmann, "Restoration Prussia," 65, also citing Brose, *Politics of Technological Change*, 259.

53. Poten, *Geschichte*, 4:398.

54. Ibid., 397–408, quotation on 402; table on 406.

55. Ibid., 406.

56. Poten, *Geschichte*, 4:262–67; Scharfenort, *Kriegsakademie*, 156–57.

57. Official history in Schickert, *Die militärärtzlichen Bildungsanstalten.*

58. Helmholtz to his father, May 15, 1839, in Cahan, *Letters*, 63, with biographical and teaching information on Turte, Link, Müller, and Mitscherlich, 49–50n, 58–59n.

59. Arleen Tuchman, "Helmholtz and the German Medical Community," in Cahan, *Helmholtz*, 21–23.

60. Broman, "Rethinking Professionalization" and "Bildung und praktische Erfah-

rung," grounds the history of this development in the debate over *Bildung* vs. practical training for doctors.

61. Stürzbecher, "Zur Berufung Johannes Müllers," gives many documents and other useful information on which this account is based; salary breakdown at 204, letter of Altenstein to Müller, February 8, 1833. On the broader context of Müller's appointment, see Otis, *Müller's Lab*, 12–14.

62. Siemens, *Lebenserinnerungen*, 13–14; Poten, *Geschichte*, 4:395–96; Bonin, *Geschichte*, 163.

63. Siemens, *Lebenserinnerungen*, 15–16.

64. Ibid., 19, 21. Carl Gottlieb Heinrich Erdmann was professor of physics, chemistry, and pharmacy at the Thierarznei-Schule in Berlin but sometimes taught at the Artillerie-und Ingenieurschule, the Kriegsschule, and the Oberfeuerwerkschule, further indicating the extent of the teaching network at the technical schools.

65. Siemens, "Preussisches Patent"; *Lebenserinnerungen*, 26.

66. Siemens, *Lebenserinnerungen*, 29–30.

67. Ibid., 33–34. Peter Theophil Riess was a physicist in Berlin elected to the Academy of Sciences in 1842.

68. Ibid., 34–35.

69. Brose, *Politics of Technological Change*, 164–89. Showalter, *Railroads and Rifles*, 76–139.

70. Siemens, *Lebenserinnerungen*, 28–29.

71. Siemens, "Beschreibung."

72. Politically, these virtues are well illustrated in Siemens's action about 1845 in signing a petition for religious freedom, along with other officers and in the response of their commanding general. Siemens, *Lebenserinnerungen*, 39–40.

73. Siemens, "Patentgesuch."

74. Siemens described the Prussian project in "Anwendung." He reviewed the spectrum of French, British, Russian, and Prussian alternatives and their priority disputes in "Geschwindigkeitsmessung," *FdP [1845]* 1 (1847): 46–72. On this context see Schmidgen, *Die Helmholtz-Kurven*, 107–13. On the eighteenth-century history, see Steele, "Muskets and Pendulums," and Alder, *Engineering*, 87–124.

75. Siemens, "Anwendung," 11. Similarly expressed in Siemens, "Geschwindigkeitsmessung," 65.

76. Siemens, "Geschwindigkeitsmessung," 66–69.

77. Siemens, "Anwendug," 14; "Geschwindigkeitsmessung," 51, 70.

WHAT'S IN A LINE?

5 It is a curious fact of the history of science that only toward the middle of the nineteenth century did scientists of every stripe acquire the habit of trying to represent natural processes in terms of curves. Of course Kepler's ellipses for planetary motion and Galileo's parabolas for cannonballs had been available for two hundred years. But there were no magnetic lines of force, no supply-and-demand curves, no bell-shaped curves for the propensity to commit suicide, no Carnot diagrams for steam engines, and no blood-pressure recorders. Within a very short period, however, curves became the most mundane and utterly commonsensical way to describe virtually anything going on in the world. This movement took off between about 1830 and 1850. It occurred all over Europe, but one of the places of intense local activity was Berlin. Even more particularly, the young men who founded the Berlin Physical Society in 1845 made the curve their emblem of progress in scientific knowledge.[1]

Figure 5.1 shows their certificate of membership, this one for Emil du Bois-Reymond, physiologist and charismatic energizer of the group, who did the drawing himself. The tree on the left is a tree of knowledge, where youthful heroes of physical science are carrying out their investigations. Many of these athletic experimenters are using instruments that produce curves representing nature's laws.

In this chapter I put a historical foundation under this elaborate image. It is apparent that Du Bois-Reymond had considerable artistic talent. In fact, after finally taking up medicine and physiology, he acknowledged to his fiancée that "art was my actual talent" and regretted that he had not made it his career as had his aunt, his grandmother, and his renowned great-grandfather Daniel Chodowiecki, who had directed the Berlin Akademie der Künste at the turn of the eighteenth century. Du Bois-Reymond could study Chowdowiecki's engravings at any

This chapter originated as the Rothschild Lecture at Harvard University, April 2001. An earlier version appeared in Epple and Zittel, *Cultures and Politics*, 61–102.

Figure 5.1 Certificate of Membership in the Berlin Physical Society of Emil du Bois-Reymond. Staatsbibliothek zu Berlin-Preussischer Kulturbesitz, Handschriften Abteilung. Sammlung Darmstädter, Emil du Bois-Reymond, 3 K 1841 (3), Bl. 59.

time in his mother's collection.[2] Similar, if less grand, family histories could be given for several others among the founders of the Berlin Physical Society. Ernst Brücke, whose father, two uncles, and a stepbrother were Berlin artists, had considered following their lead. Hermann Helmholtz's aunt was a member of the Akademie der Künste, and his superior while he served as a military doctor in Potsdam was Wilhelm Puhlmann, a family friend and founder of the Potsdam Kunstverein. Helmholtz married Puhlmann's niece Olga von Velten and through Puhlmann became friends with the great artist Adolph Menzel (fig. 2.11). These three—Brücke, Helmholtz, and Du Bois-Reymond—successively taught anatomy to students at the Akademie der Künste in the 1840s. Although Brücke and Helmholtz continued to play active roles in the theory and practice of art throughout their lives, Du Bois-Reymond would become quite skeptical by 1890 of the cultural value of at least modern art.[3] Finally, a key figure for the entire group was Gustav Magnus (fig. 5.2, *left*). It was in Magnus's house, located just across an arm of the Spree River from the Altes Museum, that the members of the Society got their start in experimental science. The picture on the left in figure 5.2 is by Magnus's brother Eduard, a highly successful portrait painter. The pictures in the center and at the right in figure 5.2 show the elegant Eduard Magnus drawn by his friend Adolph Menzel and Menzel drawn by Eduard, respectively.

Figure 5.2 (l. to r.) *Gustav Magnus* by Eduard Magnus. Magnus House, Deutsche Physikalische Gesellschaft. Author's photo. *Eduard Magnus* by Adolph Menzel, 1841, lead pencil, 45.5 × 32.7 cm, and *Adolph Menzel* by Eduard Magnus, 1837, watercolor, 40.7 × 27.5 cm. Staatliche Museen zu Berlin, Kupferstichkabinett, SZ Menzel Kat. 1115 and SZ Magnus 14.

What now was the relation between these close circles of involvement in the world of art and the pursuit of curves as the expression of nature's truths? My account will depend on developing some interrelationships between the nineteenth-century revival of Albrecht Dürer's art, the analytic mathematics of Gustav Lejeune-Dirichlet, Heinrich Wilhelm Dove's meteorological representations, and the physical investigations of Du Bois-Reymond, and it will involve the ubiquitous Alexander von Humboldt, whose pioneering work with visual representation in curves would find new purchase.

Berlin Realism

April 18, 1828, was the three hundredth anniversary of Dürer's death, and a great commemoration was held in Berlin as well as in Dürer's native city of Nuremberg. The iconic status that Goethe was already acquiring for German culture by that date is well known; less familiar may be the fact that Dürer had become the personification of Germanness at a time when the Germans had discovered the Gothic as their own, a wellspring of their unifying national character even though political unity eluded them. Dürer *was* the Gothic, incorporating the romantic, the rational, and the Christian in one figure. This Gothic identity can be extracted from any number of his celebrated drawings, woodcuts, and engravings (e.g., *Knight, Death, and the Devil*). But the degree to which Dürer was himself very nearly worshipped as a Christlike figure is difficult to comprehend, even after seeing many Christo-morph portrayals, such as a series of episodes from his life imitating scenes from the life of Christ, commissioned for the celebration in Nuremberg.[4] The theme appears also in the altar wall that graced the auditorium of the Singa-kademie in Berlin for the celebration there (fig. 5.3).

Karl Friedrich Schinkel designed the altar, which was apparently executed by others.[5] A larger-than-life statue of Dürer, modeled after the most famous of his Christomorph self-portraits, stands in the middle beneath a large painting of the ascent of Christ into heaven. The painting is essentially an enlargement of one of Dürer's woodcuts, *The Trinity*. The seated female figures to his right and left recall his work in "scenographia" (perspective), "painting," "sculpture," and "military architecture," the interrelation of which thematizes this chapter. Schinkel had no difficulty incorporating the Gothic Dürer into the modernizing statuary and frame, for Schinkel's neoclassicism, as emphasized in chapter 2, looked forward, toward an age of technology and industry, and it brought aspects of the Dürer renaissance with it.

One such aspect was what Berlin artists admired as Dürer's realism, which provided a point of reference for their own realist tradition. That tradition

Figure 5.3 K. F. Schinkel's design for the Dürer celebration at the Singakademie, 1828, watercolor, 46.8 × 53.1 cm. Museen der Stadt Nurnberg, Inv. Nr. GNM St. N. 10521.

has often been referred back to Du Bois-Reymonds's great-grandfather Chodowiecki, whose woodcuts recall Dürer's. Another canonical reference is a sharp critique from Goethe in 1800, who complained that Berlin artists had lost sight of the universal ideals of classical Greece and become mired in provincialism, both historically and geographically: "In Berlin . . . naturalism seems to be at home with the demand for realism and utility and generally to manifest the prosaic Zeitgeist. Poetry is suppressed by history, character and the Ideal by portraiture, . . . and the universally human by nationalism." In response, Gottfried Schadow, sculptor, painter, and soon to be director of the Akademie der Künste, called on the memory of Chodowiecki and Dürer in defense of a naturalism that mirrored real people with real emotions. In Berlin, he said, "one gives priority to those artworks that truly and honestly

depict an existing model; every work of art is treated here as a portrait, a reflection of nature [*Konterfei*]." Representative is his famous double sculpture of the two princesses (*Prinzessinnen von Preussen*, 1795–97), the future Queen Luise and her sister Fredericke. Regarded as an epitome for German neoclassicism, it presents their teenage beauty in lifelike individual portraits expressed through the pure lines of universalizing classical purity. The universal lies within the particular, he insisted, and not the particular within the universal.[6]

Schadow's perspective can serve as the motto for my own conception of "intensely local" history of science. Within existing circumstances in Berlin I seek the meanings and resources through which the curve came to seem nature's own means of expression for the Berlin Physical Society. They would produce curves that made claims on universality. But like Schadow, I locate their potentially universalizable accomplishments within a local portrait.

It was Schadow who organized the Dürer celebration in 1828. By that time he had himself become the representative of established academic art. A restive younger generation had organized themselves in 1825 into the Verein der jüngeren Kunstler (Society of Younger Artists). But even in their desire for renewal, the Verein maintained Schadow's realist principles and his pursuit of a truly national art, though with less reverence. Dürer remained their spiritual referent and the focus of a raucous yearly party (fig. 5.4). Adolph Menzel joined them in 1834. The invitation card for the Dürerfest of 1836 is one of a series he produced from 1834 to 1837.[7] Godfather Dürer frowns benevolently down from the clouds on his reveling disciples.

The Line

Leaving Dürermania, consider now Dürer's line. The educated public probably had their best opportunity to actually own and study his works through his famous illustrations for the prayer book of Emperor Maximillian I, the Holy Roman Emperor in Nuremberg whose patronage he enjoyed. A lithographic reproduction appeared in 1808 with regular republications afterward.[8]

It is Dürer's drawings in the margins, rather than the text, that attracted attention. In these drawings, exemplified in figure 5.5, the lines of the Gothic images metamorphose from one form to another and thence into organic spirals and intricate arabesques, sometimes attached to the text itself.[9] The style found numerous imitators in the nineteenth century, especially following the 1828 celebrations. The most elaborate was a set of drawings done by Eugen Neureuther, with Goethe's enthusiastic support, to illustrate a collection of

Figure 5.4 Adolph
Menzel, invitation
card for Dürerfest,
Verein der Jüngeren
Künstler, 1836,
lithograph, 11.8 ×
11.3 cm. Staatliche
Museen zu Berlin,
Kupferstichkabinett,
325–97.

Goethe's poems and ballads (fig. 5.6).[10] A more typical imitation was another of Menzel's invitation cards for the annual Dürerfest of the Verein der jüngeren Kunstler in 1837 (fig. 5.7).

Notice how Menzel's line moves smoothly between the plant forms, the written message, and the formal arabesque at the bottom, which symbolically ties the whole together. With the Dürer, Goethe, and Menzel illustrations in mind, it will be apparent that Du Bois-Reymond's certificate for the Physical Society (fig. 5.1) also alludes to Dürer's drawings for the prayer book in its basic style, organized by the line that metamorphoses from form to form: from the tree with its *Verein* of experimenting youth to the arabesque at bottom center to the writing of Du Bois-Reymond's name, "Emil Bois," at bottom center to the name of the engraver, H. R. Heidel, at bottom right, who would become an associate member of the Society.[11]

So far, then, I have wanted only to establish that Du Bois-Reymond conceived his iconography and employed his own line within what had become a popular genre in the Dürer revival, which carried considerable symbolic significance for hopes of rejuvenation of the German nation. It may be in-

dicative of a more direct parallel between Menzel's and Du Bois-Reymond's images that in 1841 he founded a similarly radical group calling itself the Society of Younger Natural Scientists (Jüngere Naturforscherverein), whose five members would form a nucleus for the Physical Society four years later.[12] Like the Younger Artists and the Younger Natural Scientists, the Physical Society would present itself as a vanguard for this movement into the future.

Consider further, however, the function of Dürer's line. The art historian Friedrich Teja-Bach has given an illuminating analysis. He shows the lines and arabesques to be integral to Dürer's theory and practice of drawing. They interpret, so to speak, the naturalistic images of the drawings. Compare in figure 5.5 the arabesque at the top border with the camel at the bottom. As can be seen by superposition (fig. 5.8), the arabesque provides a kind of paraphrase or epitome of the camel. It consists of a line that gives the basic shape of the camel and then returns to play rhythmically on its own forms in

Figure 5.5 Albrecht Dürer, *Randzeichnungen zum Gebetbuch Maxmilians I*, fol. 42v, 1515. Teja-Bach, *Struktur und Erscheinung*, 172.

a suggestion of the organic unity of the actual animal and perhaps its rhythmic movement.[13]

This example suggests that Dürer's arabesque provides an abstract essence of naturalistic objects and processes. The abstract line represents an ideal form in the sense of a Platonic idea. This reading attains more depth through Teja-Bach's discussion of how Dürer treated his line as a form of writing.[14] While the pictures continue the text allegorically, the spiral lines and arabesques write out the pictures in an ideal symbolic form.

A similar relation between object, arabesque, and writing is apparent in the drawings of Du Bois-Reymond and Menzel (fig. 5.1, 5.7). The effectiveness of these depictions, however, depended on other, much more widespread expressions of the relation between objects and curves. One of these appeared

Figure 5.6 Neureuther, *Randzeichnungen*, title page.

Figure 5.7 Adolph Menzel, invitation card for Dürerfest, Verein der Jüngeren Künstler, 1837, lithograph, 13.9 × 10.8 cm. Inscription: "Alles schweige, jeder neige ernsten Tönen nun sein Ohr!!! Er wendete die Blüthe höchsten Strebens das leben selbst an dieses Bild des Lebens." Staatliche Museen zu Berlin, Kupferstichkabinett, 336–97.

in a genre of drawings and paintings typically titled "the origin of drawing" or "the invention of painting." The origin myth goes back to Pliny the Elder and continued as a literary tradition into the modern period. It came to be widely represented in drawings and paintings, however, only from about 1770, in close association with neoclassical ideals (as well as with the popular art of the silhouette and Johann Caspar Lavater's *Physiognomische Fragmente*, illustrated by Chodowiecki).[15] At least six of these allegorical depictions were produced by a lineage of Berlin artists: Christian Bernhard Rode (1790), Schadow (1804), Franz Ludwig Catel (1806), Schinkel (1830), Johann Erdmann Hummel (1834), and Wilhelm Eduard Daege (1834).[16] As the story goes, a Corinthian maid named Dibutades, whose young lover was about to go off to war, was inspired to outline his shadow on the wall in order to keep his image clearly before her during his absence. Thus, drawing and painting originated in love. Her father Butades, being a potter, filled the silhouette with clay and fired it in his kiln, producing a permanent image.

In neoclassical aesthetics the story had particular relevance because it gave such prominence to the firmly drawn line, as opposed to color, as the

foundation of art. This emphasis was appropriately figured in all of the "origin" drawings and paintings as the line of the silhouette obtained by linear projection. Sharp outlines and smooth surfaces symbolized definiteness, unity, and above all rationality, seen in contrast to an overembellished sentimental Rococo style. This aspect is particularly apparent in Schinkel's *Erfindung der Malerei* (Invention of painting; fig. 5.9), which repeats a scene from the cycle of *Menschenleben* frescos for the Altes Museum, just preceding Pegasus and the Muses (fig. 2.5). It transforms the characters so that a youthful male does the drawing in a group of classically figured nudes placed in a pastoral scene with sheep and shepherds, as though representing nature herself. Unmistakable is the weight Schinkel places on the drawn line, making it literally charcoal black, standing out sharply from its light background.

A closely related aspect of this neoclassical aesthetics is the ideal of beauty apparent in the bodies of the allegorical figures. They are almost androgynous in their smoothly muscled bodies, typically represented for males by

gymnasts.[17] The same is true in the *Erfindung der Malerei* done by Daege two years later (fig. 5.10), which recovers the characters of the original myth.

Dibutades and her lover, in their purity and perfection, show no signs of hardship or battle despite the props of sword and helmet. In both paintings, the "Invention" is of the means to capture an ideal human *Form*, as revealed through a particular model and yet reaching for the universal, as for Schadow, above. The silhouette captures reality not in its irregularities and imperfections but in its smoothed outlines. The artist, therefore, cannot simply copy nature but must attain the beautiful through an *Anschauung* (an educated visual intuition as opposed to an analytic concept) of its proper *Form*. These basic terms are characteristic of the German idealist tradition

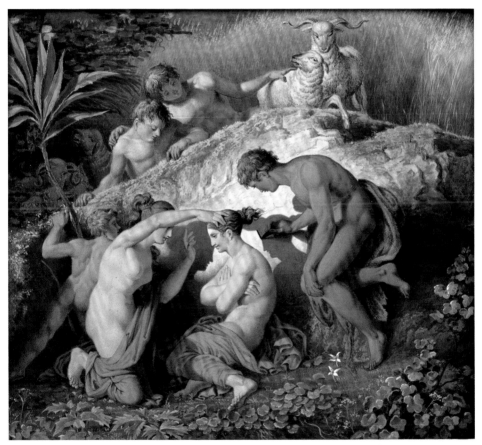

Figure 5.9 K. F. Schinkel, *Erfindung der Malerei*, watercolor, 1830. Von-der-Heydt-Museum Wuppertal, G184.

Figure 5.10 Wilhelm Eduard Daege, *Erfindung der Malerei*, 1832, oil on canvas, 176.5 × 135.5 cm. Staatliche Museen zu Berlin, Nationalgalerie, Inv.-Nr. A I 216. Photo by Jörg P. Anders.

Figure 5.11 Johann Erdmann Hummel, *Erfindung der Zeichenkunst*, 1834, pen and brown ink, 24.3 × 27.4. Staatliche Museen zu Berlin, Kupferstichkabinett, SZ 39.

in which both artists worked and were represented in the philosophies and aesthetics of Kant, Goethe, Schiller, and others, but especially Fichte and Hegel in Berlin. Among Schinkel's and Daege's immediate contemporaries in the Berlin Akademie der Künste, a great deal of diversity existed. Nevertheless, they generally shared the terms of an idealist neoclassicism. In this we will find that they shared a great deal with Du Bois-Reymond, Brücke, and especially with Helmholtz when he taught anatomy at the Akademie der Künste (chap. 8).

Another professor at the Kunstakademie whose *Erfindung der Zeichenkunst* (*Invention of Drawing*) is particularly salient here is Hummel (fig. 5.11). The drawing's space of linear projection and perspective signals Hummel's courses on architecture, projection, and optics. Once again Hummel emphasizes the drawn line in black charcoal while epitomizing the neoclassical ideal of beauty. Dibutades's lover is a youth on the verge of manhood. He exhibits the supple and well-defined body of a young athlete while still recall-

ing the naive innocence and smooth contours of an ambiguously feminine or androgynous adolescence. Quite typically, he avoids both the insensitivity of a crudely muscular masculinity and the danger of falling into the watery softness that would connote feminine emasculation.

While maintaining the ideals of neoclassicism, Hummel's rendering transforms both the story of Dibutades and the genre of depictions based on it. Normally the potter Butades did not actually appear at all. And if he had, he would have been producing a flat clay model of the silhouette of Dibutades's lover. Here his role is both prominent and different. He is engaged in his everyday work of manufacturing large numbers of vases, all with the same classical form, which his assistant arranges on drying racks in the background. The origin of drawing is now manifested in the potter's sharp-eyed concentration on the relation of his daughter's drawing hand to his own shaping hand, the relation of the artist to the craftsman.

Thus, Dibutades is the muse who inspires Butades with the beauty of *Form* that she transposes from the idealized beauty of her lover. Her mediating inspiration is reinforced in Hummel's composition through the gentle touch of her lover's fingers, which unites his arm with hers and passes their complementary virtues into the line of the silhouette. Their relation reinforces also the view that the firm smooth contour of masculine beauty should maintain an affinity with the softer lines of a more feminine form. These ideals then pass through Butades attentive eye to his work in clay. Just as Dibutades's line captures the visual essence of her lover, so a similar line becomes the materialized essence of Butades's vase, whose classical silhouette he shapes in the clay as it rotates on the potter's wheel.

Hummel thus closely juxtaposes the work of art with craft manufacture and connects them through the neoclassical line. His metaphorical picture also seems to depict his teaching of descriptive drawing at the Akademie der Künste, where he promoted the training of the mind through the hand and eye. A grasp of the basic principles of geometrical projection acquired through "numerous examples and drawings" lay behind the capacity to render correctly, as though by second nature, the realistic effects of light and shadow. "Through industrious exercise," he said, "the mind as well as the eye becomes practiced in correctly conceiving the appearances in nature and in making the laws on which they rest more intuitively apparent [*anschaulicher*]." One is reminded of Pestalozzi's pedagogical classic, *ABC der Anschauung* (1803), which taught mathematical *Anschauung* through hands-on exercises and had become a required reference in the training of both aesthetic and natural philosophical intuition.[18]

Figure 5.12 [Beuth and Schinkel], *Vorbilder für Fabrikanten und Handwerker* (1821), section II, plate 1.

To see Hummel's conception of the potter's curve in practical use, one need only look at representative drawings (fig. 5.12) from the *Vorbilder für Fabrikanten und Handwerker* (Exemplars for manufacturers and craftsmen) that Beuth and Schinkel published at the Gewerbehaus (fig. 3.4). As observed previously, the collection constituted a canon of aesthetic forms, mostly classical, for the consumer goods of bourgeois life: tableware, fabrics, furniture, and architectural ornamentation. It aimed at the materialization of *Bildung*, an attempt to elevate public taste and civic virtue through the artistic quality of the material environment within which the citizens of a modern state would live their lives. As shown for the elegantly simple vases of figure 5.12, the *Kunst-Technik* of the exemplars made quite explicit, even *anschaulich*, the sought-after relation between ideal curves and manufactured objects. Much more complex exemplars, such as a Corinthian column with its capital of acanthus leaves and decorative objects such as rosettes, received similar

Figure 5.13 J. E. Hummel, *Das Schleifen der Granitschale*, 1831, oil on paper, 46 × 75 cm. Staatliche Museen zu Berlin, Nationalgalerie, Inv.-Nr. A I 884. Photo by Jörg P. Anders.

treatment in terms of lines essential to their form. As a whole the collection emphasized not only smoothly flowing lines but also the periodic curves employed for cornices, decorative borders, fences, and wallpaper.[19]

The great neohumanist project for personal and public *Bildung* through the universal forms of classical art and architecture extended throughout Beuth's operations at the Gewerbehaus. The administrative committees of the Gewerbeverein, for example, placed craftsmen and entrepreneurs alongside professors, artists, and state administrators. Specifically, while Schadow, Schinkel, and Rauch all participated on the committee for architecture and fine art, Hummel's brother Caspar, a mechanic and founder of a machine factory in Berlin, served with professors, bureaucrats, and shop owners on the committee for mechanics and mathematics.[20] Hummel himself effectively captured this interrelationship on canvas in a well-known series of paintings depicting the machinery required to polish and to manipulate a huge granite bowl, designed by Schinkel, which stands before the Altes Museum. Its sinuous reflecting surface, here emerging under the turning power of a steam engine (supplied by the Berlin builder Georg Christian Freund) rather than a potter's wheel, provided an opportunity for Hummel to display his virtuosity in the techniques of optical projection.[21] Thus we may imagine the design,

the polishing machinery, and the painting all under the aegis of the classical line of the great bowl.

Geometrical Realism

Having observed some of the ways in which curves were seen to capture essences in both theoretical and practical terms, I return to Hummel's *Invention of Drawing* (fig. 5.11) to raise a closely related subject to which Dürer's name had been attached since the sixteenth century, namely, geometrical drawing and perspective, but in the new nineteenth-century form of descriptive geometry. It will be apparent that Hummel places the origin of the classically curved but otherwise arbitrary lines of drawing within a highly mathematized space ruled by linear perspective and by the linear projection of shadows cast by the oil lamp of enlightening antiquity. As professor at the Akademie der Künste, Hummel specialized in producing such constructions in ever-more intricate detail, using multiple lighting sources, multiple mirrors, and multiple perspective, as in the exercise of figure 5.14.

He received high praise from the critics for the extraordinary optical effects that he was able to incorporate in a fully natural manner in his finished paintings. For this period at least, artistic sensibilities in Berlin cohered rather well

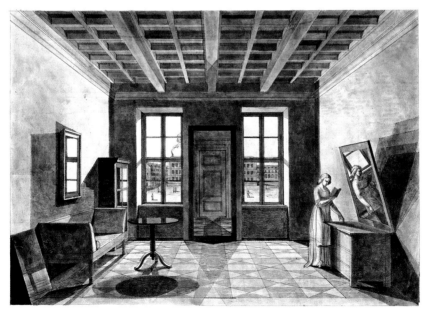

Figure 5.14 J. E. Hummel, *Inneres eines Wohnhauses*, pen and ink, 39.1 × 54.1. Staatliche Museen zu Berlin, Kupferstichkabinett, SZ 96.

with geometrical precision in drawing. We have seen that architectural realism in painting characterized the works of well-known artists such as Franz Krüger (chap. 1) and Eduard Gaertner. Gaertner's *Die Klosterstrasse* (fig. 3.1) appeared in an engraved version for a great collection in Nuremberg to honor Dürer.[22] With its depiction of Beuth, Schinkel, Gaertner, Krüger, and Rauch in the street in front of the Gewerbehaus, it suggests how closely related were the fine and manual arts in Berlin. We have seen one specific vehicle for this convergence in the teaching of descriptive geometry to students at the Bauschule, Gewerbeinstitut, Kriegsschule, Vereinigte Artillerie- und Ingenieurschule, and now the Akademie der Künste, for that was effectively Hummel's subject as well, though he preferred the projective techniques of the earlier Berlin mathematician Johann Heinrich Lambert.

Werner Siemens has served as a marker for this movement in his study of descriptive geometry with Meno Burg, who quoted Dürer in support of his own teaching. Like Hummel at the Kunstakademie, Burg presented descriptive geometry as the vehicle for learning to produce correct representations according to "mathematical laws." Again like Hummel, and as observed in chapter 4, Burg couched this mathematical ideal in the all-important tropes of *Bildung* and *Anschauung*—self-realization, creative action, truth to nature, reaching the inner *Form* of things—all expressed through the properly expressive line: "The draftsman must create out of himself . . . and must be able, using the shapes and dimensions given to him, to let the image, in its outlines and in its inner forms [*inneren Gestaltungen*], gradually emerge in lines."[23]

Burg's students at the Artillerie- und Ingenieurschule, like Hummel's at the Akademie der Künste, could reach beyond mechanical reproduction to an authentic creative work only through extensive theoretical and practical exercise with the mathematical laws of projection until the discriminating use of these laws became an expression of the self, even in the depiction of a gun emplacement by Lieutenant Siemens. Here was an aesthetics for a particular time and place. What may look today like "mechanical drawing" was in the eyes of these drawing instructors a path toward attaining *Bildung* and an aesthetics for the modern world.

Another good example comes from Du Bois-Reymond's closest friend during his student days, the architect Anton Hallmann. Figure 5.15 suggests the transition from student exercises in descriptive geometry to a realistic anatomical drawing of the architecture of muscle and bone. Interestingly, Hallmann learned his descriptive geometry at the Artillerieschule in Hannover, much like Siemens in Berlin.[24]

Figure 5.15 Anton Hallman, "Schattenwürfe eines Gebälks" (*left*), "Beckengelenk und Oberschenkelmuskeln" (*right*), 1830. Bayerische Staatsbibliothek München, Abteilung für Handschriften u. Alte Drucke. Ana 355. A.I.c., image 25 urn:nbn:de:bvb:12-bsb00065352−1 and Ana 355. A.I.b., image 13. urn:nbn:de:bvb:12-bsb00065350−1.

Had Werner Siemens had the financial means to study at the Bauschule, as he wished, he might have studied descriptive geometry with Gustav Lejeune Dirichlet. Earlier, the instructor would have been Martin Ohm, a serious mathematician himself and brother of Georg Simon Ohm of Ohm's law fame. That such high-powered analysts were teaching descriptive geometry to architects and civil engineers, military officers, and future technological entrepreneurs speaks once again to the perceived centrality of the subject and to its role as a crucial link—both aesthetically and practically—between the fine arts, modern industry, and the mathematical sciences in a culture obsessed with neohumanist and neoclassical ideals.

The Mathematics of Curves

The widespread teaching of descriptive geometry begins to suggest why the Berlin Physical Society might have been particularly interested in the role of curves in the sciences. But it does not yet suggest how they learned to connect the irregular curves of nature's reality with the highly regular idealized forms of geometry. It was a long-standing problem. Dürer himself had worked on it. Figure 5.16 shows a page from his sketchbook where he was trying to rationalize naturalistic spiral curves in relation to a perfect circle. The attempt proved unsatisfying. In fact, in one of his most famous etchings,

Figure 5.16 Dürer, geometrical construction, 1514, in *Das Skizzenbuch*, plate 133.

appropriately titled *Melencolia I* (fig. 5.17), the celestial figure of astronomy, and more generally of mathematics in both theory and practice—with her book, compass, ruler, saw, plane, and other instruments of analysis and construction strewn about—sits in deep contemplation of the relation between human capacities for mathematical and material construction on the one hand and natural objects on the other. Whether her mood is one of frustrated incapacity or of optimistic striving to close the gap is debated among art historians. But the comet in the night sky, still a symbol of frightening events and of God's arbitrary creative power, suggests the degree to which natural phenomena have so far eluded her rationalizing aims. Nature's reason, or God's reason, as Dürer would have preferred, far exceeded geometry.[25]

This is not the place to take up the long history of the problem or even the partially successful means that Dürer's geometry and nineteenth-century descriptive geometry offered for dealing with it. To do so would be to investigate, for example, the advantages of projecting an arbitrary three-dimensional

Figure 5.17 Dürer, *Melencolia I*, 1514.

curve into two perpendicular planes, yielding a decomposition into complementary two-dimensional curves, which are much easier to manipulate conceptually or to cut into stone.[26] Rather than follow such techniques further, it will be more illuminating to jump instead to a new mode of mathematical analysis followed by Dirichlet and Ohm. This will soon bring us back to Alexander von Humboldt, who in many ways stood behind the new physics and mathematics of curves.

While Dirichlet was teaching at the military and technical schools, as well as the University, he was also developing the methods of mathematical analysis that initially won him his fame. Most important for physical scientists was a rigorous proof, first presented in 1829, of the generality of the recent discovery by the French engineer and mathematician Joseph Fourier that many mathematical functions (think of a curve plotted on the x and y axes) could be represented as an infinite sum of harmonic waves, or sine and cosine functions.[27] A familiar example of such a "Fourier series" would be the

decomposition of the complicated motion of a violin string into a summation of its harmonic vibrations with various amplitudes. The importance of this seemingly simple procedure makes it worth a brief description.

Formally, but still thinking of a function $f(x)$ as a curve plotted on the x and y axes, suppose that $y = f(x)$ is the vertical ordinate of the curve for any point on the horizontal abscissa x, and suppose further that $f(x)$ is given over a definite interval of x, say $-\pi$ to $+\pi$. Then the general representation of the function as a Fourier series is

$$y = f(x) = a_0/2 + a_1 \cos x + a_2 \cos 2x + \ldots + a_n \cos nx + \ldots$$
$$+ b_1 \sin x + b_2 \sin 2x + \ldots b_n \sin nx + \ldots,$$

where the a's and b's are coefficients determined by integrals of the function y over the interval

$$a_n = (1/\pi) \int y \cos nx \, dx$$
$$b_n = (1/\pi) \int y \sin nx \, dx.$$

Fourier used such series primarily to solve problems in heat conduction, published in 1822 as the *Théorie analytique de la chaleur* (*Analytical Theory of Heat*). Dirichlet studied in Paris from 1822 to 1826, where Fourier became an important mentor and encouraged his talented young friend to carry his own analysis further. This Dirichlet did after his arrival in Berlin in 1828.

Without entering on the technical treatment, it is correct to say that Dirichlet established the validity of the Fourier series representation for a very broad class of functions of interest in the physical world, so broad that they exceeded the confines of analytic functions that could be expressed in terms of a definite mathematical relation or law. The term *analytic function*, as formalized by Euler in 1748, referred in the first instance to algebraic laws (e.g., $y = x^2$) but extended to trigonometric, logarithmic, and other laws.[28]

Throughout the great flowering of analytic mathematics—from D'Alembert and Euler through Lagrange, Cauchy, and Fourier—mathematicians continued in practice to treat all functions as analytic functions expressible as laws even when they recognized that greater generality was necessary to treat arbitrary curves "not determined by any definite equation, [but rather] of the kind wont to be traced by a free stroke of the hand," as Eurler put it.[29] Thus, Fourier's own proof of the validity of his series lacked generality.

In 1837 the Berlin physicist Heinrich Wilhelm Dove inaugurated the annual review *Repertorium der Physik*, which contained survey articles on the current state of research in various areas of physics. Although the review

would deal primarily with experimental physics, as did Dove himself, he invited Dirichlet to join the editorial consortium as the representative for mathematical physics. For the first volume, Dirichlet presented his results on Fourier series, remarking that "the remarkable series, which in a determined interval represents functions that follow no law or in different parts of this interval follow entirely different laws, have found . . . numerous applications in the analytical treatment of physical problems."[30] He went on to prove with full rigor that such arbitrary curves could be analyzed mathematically by de-composing them into Fourier series as sums of simple waves with different wavelengths and amplitudes. Figure 5.18 gives an elementary example for a "rectangular" function: a level straight line at $y = a$ between two points o and b on the x axis that drops discontinuously to o at its end points. The sum of only the first five terms in the Fourier series (dashed line) is already converging to the rectangular shape. More generally, the most nonlawlike looking curve could be analyzed into a sum of the simplest of harmonic laws. For physical processes, these waves were often taken to represent the underlying rhythms of nature.

It is difficult to overemphasize the importance of this result for the history of physics. In a most lucid and accessible way, it turned a whole range of purely experimental physics into mathematical physics through the curve, at least in principle. So enthusiastic was Bernhard Riemann, who studied with Dirichlet in Berlin from 1847 to 1849 and wrote his *Habilitationschrift* of 1854 on Fourier analysis, that he claimed Dirichlet's results covered "all cases in nature . . . for however great is our uncertainty about how the forces

Figure 5.18 Sketch of the Fourier series for the function $y = a$ over the domain (o, b) showing the sum (*dashed line*) of the first five sine wave contributions.

and conditions of matter change infinitesimally in position and time, we can nevertheless assume with certainty that the functions to which Dirichlet's investigations do not extend do not occur in nature."[31]

The second person who brought Fourier analysis to the attention of a broad audience in Berlin was Georg Simon Ohm, who had actually taught Dirichlet as a *Gymnasium* student in Cologne. Ohm moved to Berlin in 1826 to complete his now classic book on the electric circuit and then took up a part-time position at the War College for five years, where Dirichlet held his professorship. Ohm is known today largely for Ohm's law, which says in modern terms that the current I through any section of a circuit is proportional to the electrical tension E (potential difference) across the section divided by its resistance R, so that $I = E/R$. Ohm himself expressed a more general time-dependent relation for the electric potential at any point, closely resembling Fourier's differential equation for the temperature in a bar conducting heat. Drawing on this analogy with heat conduction, Ohm solved the equation for electric potential with a Fourier series. Although Ohm himself supplied no graphic illustrations of curves, his results showed once again the great power of harmonic decomposition as an expression of physical processes.[32]

I will not pursue further either Fourier analysis or Ohm's work except to note that the Berlin Physical Society would adopt Ohm, whose work had been only slowly recognized, as one of their heroes in the cause of rigorous experimental and mathematical science. His analysis of the physics of hearing, which contested existing theories of the combinations of simple harmonic tones that one would hear, provided the starting point for Helmholtz's well-known work on the sensations of tone and on combination tones from the midfifties.[33] Drawing on his own sensory experience as a pianist—and not coincidentally a pianist committed to the intellectual discipline of "classical" music and ideal forms as opposed to mere virtuosity—he assumed that the fibers of Corti in the inner ear act like resonantly vibrating piano strings to provide a kind of Fourier analysis of complex sounds.[34] Fourier analysis had by then become a pervasive tool of mathematical physics.

Return now to Dove, who had published Dirichlet's review article in his *Repertorium*. In the 1830s and 1840s Dove was omnipresent in Berlin education. In addition to teaching physics at the University, where Du Bois-Reymond attended his lectures, Dove taught at various times at the Friedrich-Wilhelms-Institut for army doctors, where he was among Helmholtz's teachers; the Kriegsschule (where he lived with his family); the Artillerie-und Ingenieur-Schule; at one or more *Gymnasien*, including the Friedrich-Wilhelms-Gymnasium, where his geometry course included exercises in

geometrical drawing; and at the Gewerbeinstitut.[35] He was also one of the pioneers in Berlin of the use of curves to represent physical laws, especially laws that seemed to defy mathematical expression. This work connected his interests directly to Dirichlet's.

Already in his first publication as a newly habilitated *Privatdocent* in Berlin ("Meteorological Investigations of the Wind," 1827), Dove sought to show that the direction of the wind—which appeared to change so arbitrarily "that people had given up trying to discover anything lawlike in it"—actually obeyed a regular law that could be revealed by barometric observations. On the basis of published measurements taken over ten years in Paris, he succeeded in representing mathematically the average yearly barometric pressure (and temperature and humidity) as a periodic function of the direction of the wind from 0° to 360° around the compass but evaluated only at discrete observation angles. For that purpose he borrowed an astronomical technique from the Königsberg astronomer Friedrich Wilhelm Bessel, remarking on how strange it was that the use of periodic functions in meteorology had languished for fifty years, ever since Lambert (Hummel's referent) first employed them.[36]

Dove expressed the barometric pressure $b(m)$ around the compass as an arbitrary function represented as an infinite sum of sine functions, much like a Fourier series but evaluated only for a number of discrete directions of the wind, indexed by m,

$$b(m) = u + u'\sin(m \cdot 2\pi/n + U') + u''\sin(m \cdot 4\pi/n + U'') + \ldots,$$

where the u's and U's are arbitrary amplitudes and phase angles. He then, using a least-squares procedure of Bessel's, fit the first three terms of the series to average barometric data obtained for winds directed toward sixteen compass points to obtain an empirical law of atmospheric pressure as a function of wind direction (and similarly for temperature and humidity). Since the third term turned out to be small, he could write an approximate law for a continuous function of the angle x in the simplified form

$$b(x) = a - c \sin (x + \alpha).$$

It will be apparent why Dove would have been interested in publishing Dirichlet's proof of the validity of Fourier analysis of empirical curves.

Although Dove did not publish the curves for these laws, he suggested that the reader should construct them from his tables to show the cycle of the barometer as the wind moved around the compass. Such a graphic representation, sketched in figure 5.19, would also show the symmetry between

Figure 5.19 Sketch of Dove's approximate law for atmospheric pressure as a function of angle around the compass, $b(x) = a - c \sin(x + \alpha)$.

opposite sides of a line drawn from NNE to SSW, identifying what he called the "meteorological meridian," by analogy to geographical and magnetic meridians.[37]

Better known among Dove's analyses with curves is his "law of storms," according to which storms are rotating systems rather than centripetal winds blowing toward a point of low pressure and normally rotate counterclockwise in the Northern Hemisphere and clockwise in the Southern Hemisphere. Dove explained the law as resulting primarily from the effect that the rotation of the earth has on storms moving from lower to higher latitudes with secondary effects on both rotation and progression resulting from prevailing winds. Figure 5.20 exemplifies the law of storms for the rotation and progression of a cyclone in the Bay of Bengal.[38] This is one of Dove's lasting attempts to articulate meteorological laws through the use of curves.

Alexander von Humboldt: Patron of the Curve

If by 1840 Dove and Dirichlet represented current practice in the physical and mathematical uses of curves, there stood behind them, both intellectually and politically, a patron of enormous prestige. Alexander von Humboldt had come back to Berlin in 1827 after twenty years in Paris, where he published the great volumes that contain the scientific account of his travels in South America and Mexico with Aimé Bonpland from 1799 to 1803. A

Figure 5.20 Dove, "Ueber das Gesetz der Stürme," plate 2, fig. 9, showing a hurricane in the Bay of Bengal.

favorite of King Friedrich Wilhelm III, Humboldt had officially held the title of chamberlain since 1805 and returned to Berlin at the king's insistence to take up his duties with an enhanced salary of 5,000 thaler. He returned like a modern Columbus. His lectures at the University and at the Singakademie in 1827–28—overlapping with the Dürerfest at the Singakademie—made him a sensation in Berlin society and laid the foundation for one of the most popular scientific books of the nineteenth century, his five-volume *Kosmos* (1845–62).

Not so well known is that images of lush tropical landscapes from his *Vues des cordillières* (1810) and of mysterious peoples associated with them had already become familiar to Berlin opera goers in the scenery that Schinkel designed for Mozart's *Magic Flute* (1816) and for a series of other operas: *Athalia* (1817), *Fernand Cortez* (1818), *Armida* (1820), and the Spontini opera *Nurmahal*, which complemented Humboldt's lectures of 1828.[39] Images of exotic lands and peoples thus surrounded Humboldt's popular persona as he went about establishing his scientific presence. The famous lectures at the Singakademie were followed by an epochal meeting in Berlin of the Verein Natur-

forscher und Ärzte, which Humboldt organized with his longtime friend, professor of zoology Hinrich Lichtenstein. It attracted participants from all over Germany as well as foreign guests, and it helped to instill a new sense of pride and confidence among German scientists. Staging was important, as Humboldt clearly understood, for with Schinkel's help, he employed some of the same sort of operatic scenery that already carried his popular image. For a celebratory evening session, held in one of Schinkel's greatest buildings, the Schauspielhaus, with Humboldt himself as the featured speaker and with King Friedrich Wilhelm III in attendance, Schinkel adapted his earlier Queen of the Night scene from *The Magic Flute* for a backdrop. Like stars in the heavens above Zoroaster's temple, the names of Germanic scientists, from those of the first magnitude, such as Copernicus, Kepler, Euler, Leibniz, and Kant, to somewhat lesser lights, such as Stahl, Bernoulli, Lambert, Fraunhofer, and Klaproth, shined down on their earthly heirs. Music, too, enhanced the unifying spirit of the evening, including a choral piece composed at Humboldt's request by the precocious young Felix Mendelssohn-Bartholdy, one of the talented family of Abraham Mendelssohn-Bartholdy (son of Moses Mendelssohn and pupil of E. G. Fischer, chap. 4), at whose home Humboldt was a welcome guest.[40]

As the cultural life of the city shaded seamlessly into the life of science, Humboldt went about promoting the first-class research structures that he envisaged for Berlin, drawing heavily on his personal relationship with the king, with his minister of culture Altenstein, and with numerous friends throughout Berlin society.[41] He recruited young talent wherever he saw it, including the newly arrived Dirichlet and Dove. Almost immediately he set up a magnetic observatory to extend earlier work from 1806 to 1807, recording hourly and daily variations in the direction of the earth's magnetic field. For the purpose, Abraham Mendelssohn-Bartholdy offered the large garden of the family home, while the ubiquitous Schinkel contributed the design for a small iron-free observing house built of brick and using copper nails and hardware. Around this small observatory, linked through Humboldt's promotional activities into an international network of six sites all taking corresponding observations, the charismatic organizer attracted the young physicists and mathematicians of Berlin: Dirichlet, Dove, Magnus, Encke, and Poggendorf, among others. It was Dove who proudly took charge of publishing their results of 1829–1830, including plates of curves of magnetic declination comparing the Berlin observations with simultaneous readings from the other observatories from South America to Russia.[42]

Humboldt's own use of curves was already well established. Famous are

his "physiognomic" projections of landscapes in South America and Mexico. In their simplest form they were vertical cuts, yielding a silhouette of rising and falling elevations over mountains, plateaus, and valleys, from which much could be read about the character of the landscape. These physiognomic silhouettes had deep significance for Humboldt. "The physiognomy of a country," he wrote, "the grouping of its mountains, the breadth of its plateaus, and their elevation, which determines their temperature, everything that belongs to the structure of the globe, stands in intimate connection with the advances of the population and with the well-being of the inhabitants." It functioned much like Lavater's physiognomic reading of human character. As a young man, in fact, Humboldt had taken drawing lessons from Chodowiecki, who did Lavater's illustrations.[43] In the more elaborate form of the "physiognomy of plants," Humboldt inscribed characteristic species on his vertical projections as well as on the more usual surface projections, yielding changing zones of vegetation with changing elevation, latitude, and longitude. Through physiognomy, Humboldt sought not a botanist's taxonomic classification of the vegetation but rather "that through which its mass individualizes the total impression of a region," a mode of description suitable for a landscape painter in an analytic mood.[44] From this macroscopic analysis he identified eighteen main forms of plants characteristic of different climate zones, from the tropics to northern latitudes and from sea level to the tops of mountains. (Cf. fig. 2.17, from Humboldt's protégé Berghaus, at his "Geographical School of Art.")

Importantly here, and as Michael Dettelbach has persuasively argued, the painterly character of Humboldt's physiognomy of plant zones cannot be split off as a romantic remnant from his equal emphasis on precision measurement of physical quantities (temperature, pressure, altitude, and magnetic parameters). In fact, for Humboldt, quantitative mapping was precisely what would reveal the qualitative landscape. Building on Dettelbach and on Marie Noelle-Bourget's rendering of the Humboldtian interrelation of people and instruments as a "Republic of Instruments," John Tresch has stressed that Humboldt did not see machines as the antithesis of the human, nor did he see the subjective as the antithesis of the objective. Rather, mechanical instruments served as mediators between the human mind and nature. In this, says Tresch, Humboldt was drawing on his understanding of Kant and Schiller and aiming at an integration of aesthetic understanding with rational knowledge.[45]

This conception finds a nice confirmation in Humboldt's plans for magnetic research on arriving in Berlin. Locating the beginning of the "natural-

scientific civilization of the world" in the seventeenth century, he associated the civilizing era with new instruments, conceived as "new organs . . . new means to set humans (contemplating and knowing) in a more intimate contact with the external world: telescope, thermometer, barometer, pendulum clock, and a tool of more general purpose, the infinitesimal calculus."[46] These new organs did not merely extend the human senses, they carried newly intimate sensibilities that related qualitative aesthetics to quantitative measure.

The passage between quantitative and qualitative is particularly apparent in the curves with which Humboldt attempted rigorously to define the distribution of climatic zones over the surface of the earth. His "isothermal lines" of 1817 were curves of constant annual mean temperature mapped over the Northern Hemisphere for both surface position and mountain elevation (fig. 5.21).[47] For Humboldt, the isothermal lines continued to express the physiognomy of nature, a concept that included both art and science, somewhat like descriptive geometry.

Figure 5.21 Isothermal lines from America to China (*horizontally*) and from the equator to the north pole (*vertically*). The lower figure shows how the isotherms vary with altitude (*vertically*) and latitude (*horizontally*). Humboldt, "Des lignes isotherme," 1817.

By the time he arrived in Berlin and expressed his conception of magnetic research in terms of "new organs" of sensibility, Humboldt envisaged a much broader program to incorporate variations over time into the curves of nature, as in the variations of magnetic lines, and to extend his method to a whole range of meteorological measurements. The time had come to discover whether "the pressure of the atmosphere, the quantities of rain falling from the air, the relative frequency of prevailing winds, and the direction of isothermal lines, like the distribution of magnetism over the earth, are subject to secular variations."[48] This is the program that Dove made into his life's work, adapting Humboldt's method of curves to reveal the laws of meteorology. Indeed, the curve of figure 5.19, relating the direction of the wind to average barometric pressure, was inspired in part by Humboldt's isothermal lines and his extensive observations on climate. Dove had just completed his *Habilitationsschrift* on the distribution of heat over the earth, the distribution that Humboldt had depicted in isothermal lines.[49]

The lines inevitably also recall Humboldt's personal acquaintance with Joseph Fourier at the Paris Academy of Sciences and with his *Analytical Theory of Heat* of 1822. Based on this theory, Fourier had become a leading proponent of the view that the earth was a cooling body, most likely having been formed originally as a molten mass. That view, which informed all of Humboldt's work in physical geography, had major implications for the isothermal lines at the surface of the earth as well as for the internal temperatures that Humboldt and others had measured deep in mines and in the water issuing from springs. He looked forward in 1817 to the "beautiful analytical work with which Fourier will soon enrich general physics."[50]

Humboldt knew Fourier well by the time the young Dirichlet joined Fourier's circle in 1825. And it was at Fourier's instigation that Humboldt arranged for Dirichlet to obtain his appointments in Prussia, first at the University of Breslau in 1827, and from 1828 at the Kriegsschule, the University, and the Academy of Sciences in Berlin. Humboldt's loyal friendship smoothed Dirichlet's entire career, including even his marriage in 1832 to Rebecca Mendelssohn-Bartholdy (daughter of Abraham), following his introduction to the family by Humboldt.[51]

The year 1828 was a great year for curves. As though in a stellar conjunction, Dürer, Humboldt, Dirichlet, and Dove arrived simultaneously in Berlin, with the careers of Dirichlet and Dove hitched to Humboldt's star in terms of both patronage and intellectual interests. Unlike Dirichlet, Dove never formed a close personal relationship with Humboldt, but for both of them, their pursuit of curves as the expression of nature's laws had direct roots in

Figure 5.22 *a*, Humboldt's suggested isothermal lines through a mountain. *b*, Du Bois-Reymond's proposed correction. Schwartz and Wenig, *Briefwechsel*, 98–100.

Humboldt's isothermal lines. Those lines would continue right into the next generation, along with Humboldt's patronage, to the benefit of both Du Bois-Reymond and Helmholtz.

In 1849, while writing his *Kosmos*, Humboldt turned to Du Bois-Reymond for an opinion on what, according to Fourier's theory, the isothermal lines would look like on a vertical projection through a mountain. Responding that Fourier's treatise contained nothing specifically on the temperature inside mountains and that the mathematical analysis had exceeded his own capacities, Du Bois-Reymond nevertheless knew the theory well enough to discount Humboldt's suggestion of parallel lines and to propose a more realistic distribution (fig. 5.22).[52]

Laws as Curves in the Berlin Physical Society

In Du Bois-Reymond and Helmholtz we see how the Humboldt-Dove-Dirichlet nexus of curve production became a part of the scientific literacy of a new generation often using curves to capture the lawlike character of apparently nonlawlike phenomena in nature. We see too how crucial was Dove's role both as a ubiquitous teacher in the Berlin educational network and as editor of the *Repertorium der Physik*. And while he no doubt exposed several members of the Berlin Physical Society to the virtues of graphic representation, he also brought to their attention the latest works on electricity by Ohm and by Faraday, whose lines of magnetic force prefigured his own lines of storms. Du Bois-Reymond carried both the electricity and the lines

into physiology in the early 1840s. He can serve here as an introductory guide to this constellation.[53]

In 1841, at the suggestion of his distinguished mentor in physiology Johannes Müller, Du Bois-Reymond took up the study of electrical stimulation of nerves and muscles in order to replicate and extend recent results of the Italian physiologist Carlo Matteucci. The project quickly turned into Du Bois-Reymond's lifework (and Matteucci into his arch enemy), expressed in a series of volumes on *Untersuchungen über thierische Electricität* (1848–84).

His usual experimental animal was the frog, whose advantages Müller had established for his own studies of nerves and which Matteucci also exploited. Figure 5.23 shows the nerve of the frog's left leg connected to an electrical circuit through the spongelike electrodes on the left. Du Bois-Reymond's drawing will recall his talents as a draftsman. Normally he operated on excised muscles and nerves and made every effort to represent his results graphically. Figure 5.24 depicts his first major discovery, the law of the frog current, in its mature form. The diagram shows a rectangular section of freshly prepared muscle, with fibers running longitudinally, and a curve of current strength, which surrounds the rectangle.

This curve of current (focusing on the top-left portion) resulted from placing two electrodes a short distance apart and moving them in steps between the *x*'s along the longitudinal surface and down the cross section. Du Bois-Reymond's sensitive galvanometer showed that a current would always flow between the electrodes in the direction of the arrow around the corners, with a strength increasing to the corner (5) and then decreasing to the midpoint

Figure 5.23 Prepared frog. Du Bois-Reymond, *Thierische Elektricität*, vol. 2, pt.1, plate 4, fig. 129.

Figure 5.24 Diagram of Du Bois-Reymond's law of the frog current. Ludwig, *Lehrbuch*, fig. 81.

on the cross section (7). The ordinates of the curve are the dashed lines parallel to the bisecting line of the corner. No current flows with the electrodes placed symmetrically next to the midpoint at I and 7. This inventive representation, with the curve superposed on the muscle section itself and showing all of the symmetries of the phenomenon, suggests Du Bois-Reymond's fascination with laws as curves.[54]

Frogs, however, were not Du Bois-Reymond's only experimental animal. In figure 5.25 he has represented himself with the youthful beauty of a Greek athlete. He is measuring the current that passes over his body when his right bicep is strongly contracted and the left bicep remains relaxed. As discussions by Sven Dierig and Gabriel Finkelstein make clear, Du Bois-Reymond's ability consistently to produce deflections of his galvanometer actually resulted from a highly skilled performance that he had mastered only after extensive practice in controlling his own body. Other experimenters who lacked the muscular control that Du Bois-Reymond had attained through years of gymnastic exercise were unable to achieve his consistent results (although Alexander von Humboldt succeeded at the age of 78).[55]

In a preceding experiment, using the same setup, Du Bois-Reymond's two index fingers were immersed in baths of water at different temperatures, one at 0° centigrade and the other varying from 0° to 45°. In this case the curve he ultimately obtained (fig. 5.26) was quite simple, increasing from 0 to a maximum at 30° and then decreasing rapidly to 0 again at 45°.[56]

Dierig convincingly argues that in his classical self-representation, Du Bois-Reymond intended to portray himself as an Apollonian figure. Within the neohumanist value structure of the *Bildungsbürgertum*, Apollo epitomized

Figure 5.25 Self-depiction as experimenting Greek athlete (Apollo). Du Bois-Reymond, *Thierische Elektricität*, vol. 2, pt. 2, p. 287, and plate 5.

Figure 5.26 Curve of current between immersed fingers. Du Bois-Reymond, *Thierische Elektricität*, vol. 2, pt. 2, p. 208, and plate 5, fig. 146.

manly beauty and the virtues of athletic exercise, particularly gymnastics, as a component of *Bildung*. One of the original promoters of the gymnastics movement, J. C. F. Guts Muths, in fact regarded the most famous sculpture of Apollo, the Apollo of Belvedere, as epitomizing the shaping of moral and physical manliness through gymnastics.[57] This interpretation of Du Bois-Reymond's self-image is thoroughly consistent with the ideal of beauty that his closest collaborator in founding the Physical Society, Ernst Brücke, held throughout his life, reflecting the neoclassical aesthetics that he had learned from his artist father and uncles and that he recognized in the bodies of gymnasts and acrobats.[58] Extending this reading, it was through similarly disciplined training with his electrical apparatus that Du Bois-Reymond attained his consistent curve of current as a function of temperature differences. His Apollonian stance thus represents an effacement of his own subjectivity and the attainment of a view from Olympus, an objective and universally valid view in which his trained body behaves like the other mechanically and electrically stabilized parts of his apparatus, consistently producing a response curve that carries the verisimilitude of nature's laws.

Among the members of the Physical Society, such attempts to represent laws as curves ultimately aimed less at employing the disciplined self as a recording instrument than at developing the skills to use mechanical and electrical instruments that would draw the curves directly, thus "self-recording"

or "self-registering" instruments. But as observed previously with respect to Hummel's *Invention of Drawing* and to descriptive geometry, the relation between the disciplined hand and the machine remained quite subtle through the 1830s. It had not yet become the dichotomy of artist and machine that would ultimately demote Hummel's descriptive realism to photographic mechanics and that would put descriptive geometry more nearly in the category of mechanical drawing than of artistic perspective. For the experimenters of the Physical Society, one aspect of this continuing overlap of values between the creative *Anschauung* of the disciplined artist on the one hand and what has sometimes appeared as "mechanical objectivity" but what Du Bois-Reymond called "mechanical beauty" on the other was surely the delicacy of the sensitive instruments they were attempting to perfect.[59] Simply to obtain consistent results with Du Bois-Reymond's galvanometer, for example, required practiced skills analogous to those of his Apollonian gymnastics. In a characteristic statement introducing his *Thierische Elektricität* he wrote, "The multiplier [galvanometer], as the mechanic can supply it, is not, like the barometer, the thermometer, or the sextant, a finished work of art. It is a not-yet-justified balance into which the speaking soul of subtle equipoise must first be breathed."[60] The same "speaking soul" (*redende Seele*) had to be breathed into other self-registering instruments that members of the Physical Society would develop. They epitomized the goal of extending human sensibility to reveal underlying curves that met the ideal of truth to nature (*Naturwahrheit*).

The Tree of Knowledge

Return now to Du Bois-Reymond's certificate of membership in the Berlin Physical Society (fig. 5.1), and particularly to the lush tropical tree of knowledge detailed in figure 5.27, on which the modernizing scientists perform their feats. To its fruiting and flowering higher branches one of the heroes of Enlightenment has tied the banner of the Physical Society. These smoothly muscled athletic boys conspicuously employ physical instruments to carry out analytic experiments in the various branches of physics, which the group planned to review in its new journal, *Die Fortschritte der Physik* (*Advances in Physics*).

From his perch in the higher branches, a young astronomer aims his telescope to reveal the line of epicyclic motions of a comet, now tied to the tree of knowledge, while a symbolic Newton with a large prism similarly analyzes the spectrum of sunlight, symbolized as an arabesque of harmonic loops, reminiscent of both Dürer and Fourier. A new Galileo on the right

erwähl

der zeit

G.

Figure 5.27 Tree of knowledge (detail of fig. 5.1).

demonstrates the law of falling bodies, indicating that the distance increases with the square of the time. The gymnast on the left, surely representing Du Bois-Reymond himself, performs his exercises on an electromagnet. His neighbor attempts to fathom the watery depths with a perfectly straight black plumb line (cf., the "invention" paintings), unaware that the deceitful nymphs below are busy making a tangle of it. Of the performers at the base of the tree, one investigates the lines of Chladni figures (by bowing a metal plate covered with dust), another carries out a geometrical analysis, a third draws electrical sparks from a Leyden jar, and a fourth tests the laws of hydrodynamics with a curiously phallic pump. The prominence in this scene of physical instruments and of curves is everywhere apparent.

Equally apparent, the curves are conceived as inscribed by the instruments, which reveal the inner meanings of nature. The heroes themselves, in their neoclassical beauty, seem to play much the same role as Du Bois-Reymond's Apollonian experimenter. If so, they should be seen as operating outside the realm of individual subjectivity, their classicized universality rendering them as objective performers on their instruments of analysis. Thus, Du Bois's iconography again states the central theme that curves, especially harmonic or rhythmic curves, conceived as representing the essence of natural objects and processes, played an extraordinarily important role in the view of knowledge held by the members of the Physical Society, a view that carried across the boundaries of art, technology, and science. Brücke, in articulating his aesthetic ideal (in contrast to the modern art of the late nineteenth century), focused on the line as the critical feature of "ideal art": "In order to be beautiful in our sense,. . . a figure must present good lines in all postures whatever that occur in ideal art and from all perspectives, for the leading role of the lines is first and most important in every work of art that makes higher claims."[61] The same was true of the curves produced by the Physical Society, which aimed for ideal mathematical truth. As Du Bois-Reymond expressed it in the introduction to his *Animal Electricity*, even though one could only rarely obtain knowledge of causal relations in a mathematically expressible form, it was always possible "to conceive of the magnitude of an observed effect (*Wirkung*) . . . as an unknown [mathematical] function of all the circumstances that have an influence on it." Then changes in the effect could be observed in relation to changes in any one of the circumstances while holding all others constant. In this way, "The dependence of the effect (*Wirkung*) on each circumstance presents itself in the form of a curve . . . whose exact law remains . . . unknown but whose general character one will in most cases be able to trace."[62]

Figure 5.28 Du Bois-Reymond's initial mapping of the frog current in his laboratory diary of 1841–42. Staatsbibliothek zu Berlin-Preussischer Kulturbesitz, Nachlass Du Bois-Reymond, K. 10, Journal 2, Bl. 28v.

Figure 5.28 shows Du Bois-Reymond searching for such a graphical trace of the *Wirkung* of the frog current and a first sketch of the curve he would obtain (cf. figure 5.24).[63] His view of the relation between laws and curves mirrors those that Hummel, Burg, Dirichlet, and Dove had all expressed in different ways. It carries Dürer's Platonic idealism into the nineteenth century but with the crucial addition of Fourier analysis, precision instruments, and graphical analysis, which seemed finally to provide the tools to put Dürer's idealist vision of knowledge into a realist form. Still, in 1877 Du Bois-Reymond would express the priority of curves in a popular lecture on "Cultural History and Natural Science," referring back to his initial statement and buttressing it with developments to follow (chap. 8): "I first at that time laid an axis of abscissas in the nerve, while Ludwig let the bloodstream itself draw its pressure pulses in curves and Helmholtz let the muscle draw its own contractions."[64]

Looking once again at Du Bois-Reymond's allegory in figure 5.27, if we follow the vertical display downward, we leave the light of day and the scenes

of rational analysis above ground and move into the subterranean domain, where the roots of the tree of knowledge lie buried in the mythological past. This underworld recalls Du Bois-Reymond's polemic, immediately following his extended discussion of mathematical-physical methods and the significance of curves, against the dark and vitalistic notion of a *Lebenskraft*, which he ascribed to the speculative romanticism of contemporary physiologists and to their ignorance of physical methods.[65] Here Mephistopheles steps out of the flames of hell to observe the searching figure in the cave, from Plato's *Republic*, who with book in hand is vainly attempting to decipher dim shadows on the wall, imprisoned in his own imaginings. This is an elaborate joke, for the figure seems to be borrowed from Raphael's famous painting of *The School of Athens*, where Plato cradles the *Timaeus* (containing his idealist modeling of the universe by the Craftsman) in his left arm while pointing to heaven with his right index finger. In Du Bois-Reymond's rendering, he lacks the instruments of enlightenment that the new physicists regard as necessary for ascending the Platonic scale from the visible to the intelligible: from the realm of mere images or imagination in the cave, through actual things, to the abstracted mathematical diagrams that represent these things in conscious thought (before attaining intuitive knowledge of pure forms).[66] Outside, bearded giants with torch and urn evoke the powers of fire and water while plucking grapes to share with another of the voluptuous water nymphs.

Finally, as the roots of knowledge descend to their primordial source in the feminized world of the nymphs, a snake entwines itself on a root like that ancient symbol of medical art the Aesclepius. The serpent is ironically juxtaposed with the lowly frog, whose muscles and nerves were already providing the primary material for the new electrophysiology of Du Bois-Reymond and Helmholtz. This juxtaposition again suggests Dierig's interpretation of Du Bois-Reymond's self-image: he deployed his instruments "in combat with the frog" and with the dark powers of vitalism, much like Apollo directed his arrows against the serpent Python. In this watery domain, the rationalized curves of nature's authentic script—cometary trajectory, spectrum of sunlight, Chladni figures, geometrical diagram, and the pronounced black plumb line—take on an inaccessibly complex variability, apparently reminiscent of the seductive charms lurking in a dangerously feminine sea of romanticism. It is as though Du Bois-Reymond's lines quote from the classicist tradition of water metaphors, referring perhaps to Ovid's *Metamorphoses*, where the water nymph Salmacis became enraptured by the young Hermaphroditus, who had inherited from his father Hermes and his mother Aphrodite an incomparable combination of classical beauty, firmly muscled yet softly curved.

Unable to seduce the virgin Hermaphroditus, Salmacis held him in a forced embrace in the waters of her spring while entreating the gods to unite them forever. This they did literally, producing a half man, half woman. Anguished by his fate, Hermaphroditus obtained from Hermes and Aphrodite a similar curse on any man who entered the spring. From the Renaissance onward, and certainly for the generations of young males who read the *Metamorphoses* in their *Gymnasien*, the story implied danger to masculinity: "A man who bathes in the spring of Salmacis emerges as a halfman. Through contact with the water his body is rendered immediately effeminate."[67] If Du Bois-Reymond's athletic heroes feel the seductive attractions of the vital force, their machines of objectivity elevate them beyond its emasculating grasp.

For interpreting the cultural location of Du Bois-Reymond's playful but intense promontory of science, its horizontally arrayed background is important. For the lush tropical growth emerges out of scenes of both classical purity and industrial progress. From a galley nearly lost in the distance on the left, classicism proceeds through the Egyptian obelisks, sphinx, and pyramid to the Parthenon of Athens and on up to an eighteenth-century scene of academic learning, with a professor in wig and frock coat lecturing to the passively assembled students outside his temple. Only in the present of the mid-nineteenth century do the students themselves, freed from temples and priests, take over the task of making knowledge through experimental research. From the right, their new mode of action has emerged from the era of sailing ships and stands before those newly domesticated powers of Neptune and Vulcan, the steamship and the railroad, which appear on the Bay of Naples before a gently smoking Vesuvius.

The background panorama thus carries forward to the viewer dual ideals of knowledge making, or *Wissenschaft*—namely, neoclassical learning and material progress—which had continually played off one another during the period when the members of the Berlin Physical Society were forming their identities. These ideals were set constantly before their eyes not only by the professors of natural science whom they chose as mentors but by the policies for progress pursued by key figures within the often conflicted ministries of war, commerce, and culture. Du Bois-Reymond's imagery, in brief, places the young heroes wielding their implements of *Fortschritt* at the juncture of a vertical history leading upward from mythology to truth and a horizontal history projecting forward both from neoclassical ideals on the left and from industrial drive on the right, uniting those forces in the movement to the future. That movement is carried by the instruments that draw the lines of nature's script.

Thus, the growth of the tree of knowledge seems to express Du Bois-Reymond's hopes for his own work, penned as an epigram from Goethe's "Hoffnung" (Hope) at the front of a laboratory notebook begun on New Year's Day, 1850.

Schaff', das Tagwerk meiner Hände,	Fulfill the daily work of my hands,
Hohes Glück, daß ich's vollende,	Wondrous luck that I complete it,
Laß, o laß mich nicht ermatten!	Let me, oh let me not grow weary!
Nein, es sind nicht leere Träume,	No, they are not empty dreams:
Jetzt nur Stangen, diese Bäume	Now only sticks, these trees
Geben einst noch Frucht und Schatten.[68]	Will one day yet give fruit and shade.

NOTES TO CHAPTER FIVE

1. Among the most important "precursors" in the late eighteenth century was E. F. F. Chladni, whose curves showing vibration patterns produced by bowing a sand-covered metal plate were popular scientific attractions throughout the nineteenth century. On their significance for detailed musical and scientific research and instrument manufacture, which parallels my story in many respects, see Jackson, *Harmonious Triads*, e.g., 13–44 on Chladni's own work; 111–50 and 200–205 on Wilhelm Weber's mathematical and experimental acoustics; 151–81 on precision manufacture before midcentury.

2. Finkelstein, *Emil du Bois-Reymond: Neuroscience, Self, and Society*, 16; "Making of a Liberal German Scientist," 54. Emil du Bois-Reymond to Jeannette Claude, March 10 [1853], Staatsbibliothek Preußischer Kulturbesitz, Berlin, Handschriften Abteilung, Dep. 5, K.11, Nr. 5 [letter 66] (Nachlaß Runge-du Bois-Reymond). For Wilhelmine (Minette) du Bois-Reymond's collection, see Engelmann, *Chodowiecki's sämmtliche Kupferstiche*, xviii, xxx.

3. Brücke, *Brücke*, 2–4, 137, *Schönheit und Fehler*; Du Bois-Reymond, "Naturwissenschaft und bildende Kunst"; Finkelstein, *Neuroscience, Self, and Society*, 237–38; Dierig, "Die Kunst des Versuchens," 123–46, on 138. More synthetic discussions are Lenoir, "Politics of Vision," "Science and Craftsmanship"; Hatfield, "Helmholtz and Classicism."

4. Białostocki, *Dürer*, 91–144. See Koerner, *Moment of Self-Portraiture*, for Dürer's Christomorph self-portraits.

5. Białostocki, *Dürer*, 121–23; Mende and Hebecker, *Das Dürer Stammbuch*, 113–15.

6. Goethe, "Flüchtige Uebersicht"; Schadow, "Ueber einige in den Propyläen," both in Busch and Beyrodt, *Kunsttheorie*, 91–100. Schadow's sculptures in Wesenberg, *Nationalgalerie Berlin*, 363–71: "Prinzessinnen Luise u. Fredericke von Preussen," 1795–97, Inv.-Nr. B II 34; "Johann Wolfgang von Goethe," 1822–23, Inv.-Nr. B I 59.

7. Börsch-Supan, "Menzel," 386; Lammel, *Menzel*, 50–55, with Menzel's depiction of a leading Verein member as Don Quixote riding a bedraggled Pegasus against the academic professors.

8. Dürer, *Randzeichnungen*.

9. I will use *arabesque* in a quite limited way to refer to abstract graphic images such as that at top center in Dürer's drawing. Busch, *Die notwendige Arabeske*, analyzes the full

arabesque genre, including complexly interwoven modes of literary as well as graphic representation.

10. Neureuther, *Randzeichnungen*.

11. Sculptor and draftsman Hermann Rudolf Heidel (1811–65), for whose identity I thank Gerhard Rupp.

12. Du Bois-Reymond, *Jugendbriefe*, 86 (March 29, 1841). Schwartz and Wenig, *Briefwechsel*, 36.

13. Teja-Bach, *Struktur und Ersheinung*, 165–93, camel discussion on 172–73, 177.

14. Ibid., 282–97.

15. Rosenblum, "Origin of Painting," discusses both linearity and silhouettes. Lavater, *Physiognomische Fragmente*. Muecke, "'Taught by Love.'" I thank Claudia Swan for discussion and references.

16. See Wille, " Die Erfindung," who shows a different version of Hummel's drawing below, dating it 1834, and does not mention Daege. Börsch-Supan and Grisebach, *Schinkel*, 267, catalog no. 207a; Wilhelm Eduard Daege in Nationalgalerie Berlin, Inv.-Nr. A I 216.

17. Fend, *Grenzen der Männlichkeit*, esp. chap. 3, illuminates the neoclassical line and its gender coding. Mosse, *Image of Man*, 24–36 on the neoclassical ideal of masculine beauty, and 40–45 on the perceived role of gymnastics in sculpting this ideal.

18. Hummel, *Die freie Perspektive*, 1:vii–viii. See also Hummel, *Geometrisch-praktische Construction*; Pestalozzi and Buss, *ABC der Anschauung*.

19. [Beuth and Schinkel], *Vorbilder*. For a comparison with Du Bois-Reymond's experimental practices, see Dierig, "Apollo's Tragedy," 103, 109–10.

20. *Verhandlungen* (1822): 13.

21. Hummel deployed his projection techniques in three paintings of the granite dish. Two are in the Nationalgalerie (Wesenberg, *Nationalgalerie Berlin*), Inv.-Nr. A I 884 (polishing) and Inv. Nr. A I 843 (installed). A preliminary version of the third (turning over) is in the Stiftung Stadtmuseum Berlin, Abteilung Gemälde, Graphische Sammlung, Skulpturen. Biographical information in Hummel, *Hummel*. Freund's engine in Mieck, "Egells," 73.

22. Eduard Gaertner, *Klosterstraße*, engraving, 1830, in Mende and Hebecker, *Das Dürer Stammbuch*, 152.

23. Burg, *Die geometrische Zeichnenkunst*, 147; *Geschichte meines Dienstlebens*, 71–75, paraphrasing his original memorandum of 1816. Olesko, "Aesthetic Precision," 37–46.

24. Dierig and Schnalke, *Apoll im Labor*, give the comparison between Hallmann's architectural and anatomical drawings, with several exemplars.

25. Teja-Bach, *Struktur und Erscheinung*, 279–82. Panofsky, *Dürer*, 1:156–71, makes the figure "geometry" and gives the negative reading. Schuster, *Melencolia I*, 1:107–37, argues that the figure is "astronomy" and that her mood is one of striving, not depression.

26. Belhoste, "Représentation."

27. Dirichlet, "Sur la convergence."

28. Jahnke, "Algebraic Analysis," 114, 121, 127.

29. I am indebted to Moritz Epple for discussion of these issues. Youschkevitch, "Concept of Function," 64–70, quote on 68. Lützen, "Foundation of Analysis," 156–58.

30. Dirichlet, "Ueber die Darstellung," 152. More specifically, Dirichlet considered single-valued, piecewise continuous functions.

31. Riemann, "Ueber die Darstellbarkeit," 237.

32. Ohm, *Die galvanische Kette*, 170–76.

33. Turner, "Ohm-Seebeck Dispute"; Jackson, *Harmonious Triads*, 172–79; Ohm, "Ueber die Definition des Tones," "Noch ein Paar Worte"; Helmholtz, "Ueber Combinationstöne"; *Die Lehre von den Tonempfindungen*.

34. On Helmholtz's theory and practice of music, see Hui, *Psychophysical Ear*, 55–87, and Hiebert and Hiebert, "Musical Thought."

35. Neumann, *Dove*, 13–14. *Gymnasium* courses in *Zu der öffentlichen Prüfung der Zöglinge des Königlichen Friedrich-Wilhelms-Gymnasiums*, 53–60.

36. Dove, "Einige Meteorologische Untersuchungen," 545, 550; rev. version in *Meteorologische Untersuchungen*, 97–120. Bessel, "Einleitung," ix–xi.

37. Dove, "Meteorologische Untersuchungen," 585, 590.

38. Dove, "Ueber das Gesetz der Stürme," using charts of storm rotation and progression from other meteorologists in the United States and Britain, here from H. Piddington for a hurricane in the Bay of Bengal, June 3–5, 1839.

39. Humboldt, *Vues des cordillières*, e.g., plates 31, 33, 41, 42, 63; Harten, *Die Bühnentwürfe*, 132–35, 228, 233–35, 237, 266, 271, 274, 340; Muthmann, *Humboldt und sein Naturbild*, 91–102. More on Humboldt's exotic presence in Wise and Wise, "Staging an Empire," 138–44.

40. Humboldt and Lichtenstein, *Amtlicher Bericht*, 19 (schematic order of names for the backdrop); Rave, *Schinkel, Berlin*, 3:363 (drawing of the hall with backdrop in the Schauspielhaus). See also Jackson, "Harmonious Investigators" and *Harmonious Triads*, 45–74, who gives a stirring account of the role of music among the *Naturforscher*.

41. Biermann, *Humboldt: Vier Jahrzehnte*.

42. Humboldt, "Ueber die Mittel," 333; Dove and Humboldt, "Korespondierende Beobachtungen"; Dove, *Gedächtnissrede*, 22–23.

43. Dettelbach, "Face of Nature"; Humboldt, *Essai politique*, 119f; Beck, *Humboldt*, 1:11.

44. Humboldt, *Physiognomik der Gewächse*; Humboldt and Bonpland, *Geographie der Pflanzen*.

45. Bourget, "La république des instruments"; Tresch, *Romantic Machine*, chap. 3, "Humboldt's Instruments: Even the Tools Will Be Free," 61–88.

46. Humboldt, "Ueber die Mittel," 319.

47. Dettelbach, "Face of Nature," 473–87; Humboldt, "Des lignes isotherme," chart on 19.

48. Humboldt, "Ueber die Mittel," 319.

49. Dove, "Einige meteorologische Untersuchungen," 578; *De barometri mutationibus*; "De distributione caloris."

50. Humboldt, "Des lignes isotherme," 94.

51. Biermann, *Briefwechsel*, intro. and early letters from 1825, *Dirichlet: Dokumente*, 12; Kummer, "Gedächtnissrede," esp. 314–24.

52. Du Bois-Reymond to Humboldt, shortly after August 18, 1849, in Schwarz and Wenig, *Briefwechsel*, 98–100.

53. I am indebted to both of the two recent biographies of Du Bois-Reymond: Finkelstein, *Emil du Bois-Reymond: Neuroscience, Self, and Society*, and Dierig, *Wissenschaft in der Maschinenstadt*. Finkelstein is oriented especially toward the problem of identity experienced by sons of the *Bildungsbürgertum*, while Dierig highlights the industrial context.

54. This description refers to the somewhat simplified picture in Ludwig, *Lehrbuch*, 1:316–17, fig. 81. Original sketch here as figure 5.28. Final version in Du Bois-Reymond, *Thierische Electricität*, 1:583–95, and plate V, fig. 57. Du Bois-Reymond's initial publication, following his doctorate of 1843, was "Vorläufiger Abriss."

55. Dierig, *Wissenschaft in der Maschinenstadt*, 122–34, n95, "'Die Kunst des Versuchens,'" 124–32; Finkelstein, *Emil du Bois-Reymond: Neuroscience, Self, and Society*, 98–103, fig. 6.1, 6.2. In a letter to Helmholtz, August 3, 1852, Du Bois-Reymond stated that the experiments and drawing were complete; Kirsten, *Dokumente*, 135–37.

56. Du Bois-Reymond, *Thierische Elektricität*, 2.2:208, plate V, fig. 146. Experiment and figure from 1852.

57. Dierig, "Die Kunst des Versuchens, " 140–43; Guts Muth, *Gymnastik*, 9, cited in Mosse, *Image of Man*, 41. Finkelstein, *Emil du Bois-Reymond: Neuroscience, Self, and Society*, 180–82, describes Du Bois-Reymond's mobilization of gymnastics in the context of the revolution of 1848 and liberal politics in the 1860s.

58. Brücke, *Brücke*, 139–46.

59. Dierig, "Die Kunst des Versuchens," 133–37; "Apollo's Tragedy," 109–10; *Wissenschaft in der Maschinenstadt*, 139–44. *Mechanical objectivity* is the term of Daston and Galison, "Image of Objectivity," and *Objectivity*, chap. 3.

60. Du Bois-Reymond, *Thierische Elektricität*, 1:xvii–xviii; Dierig, "Die Kunst des Versuchens," 128; Finkelstein, *Emil du Bois-Reymond: Neuroscience, Self, and Society*, 60.

61. Brücke, *Schönheit und Fehler*, 3.

62. Du Bois-Reymond, *Thierische Elektricität*, 1:26–27; Holmes and Olesko, "Images of Precision," 201.

63. Although *Wirkung* simply means "effect" (also "action" or "agency"), it becomes a term of art on virtually every page of the notebook.

64. Du Bois-Reymond, "Culturgeschichte und Naturwissenschaft," 612–13; Finkelstein, *Emil du Bois-Reymond: Neuroscience, Self, and Society*, 230.

65. Du Bois-Reymond, *Thierische Elektricität*, 1:xxxiv–xl.

66. Zeyl, Donald, "Plato's Timaeus," in *The Stanford Encyclopedia of Philosophy*, edited by Edward N. Zalta, Spring 2013 ed., http://plato.stanford.edu/archives/spr2013/entries/plato-timaeus. I thank Josiah Ober for drawing my attention to the role of curves in the *Republic*. See also Izumi, "Role of Stereometry, " on the "tool in the soul" vs. actual tools of construction.

67. Nicolaus Reusner, *Emblemata* (1581), cited by Fend, *Grenzen der Männlichkeit*, 38–39, from Arthur Henkel and Albrecht Schöne, *Emblemata: Handbuch zur Sinnbildkunst des 16. und 17. Jahrhunderts*, special ed. (Stuttgart, 1978), 2:1629–30.

68. Du Bois-Reymond, *Laboratory Diary*, January 1850—March 1856, Journal 8, Versuche 1, flyleaf. I thank Sven Dierig for this reference. Du Bois-Reymond's version varies slightly from Goethe, "Hoffnung," in Trunz, *Goethes Werke*, 131. The literal translation is mine.

THE BERLIN PHYSICAL SOCIETY

Your excellency knows too well what an impressive influence the natural sciences exert on all technical operations and how every advance in the former must be utilized in the latter. This allows me to hope that an attempt to make practically useful the new determinations of the elasticity of water vapor will not be regarded as a fruitless enterprise.
— Gustav Karsten to Cultural Minister Eichhorn[1]

We have seen the priority of the line in the cultural and scientific life of Berlin when the members of the Berlin Physical Society were coming of age. We have also seen the priority of instruments, both mathematical and physical, that could reveal those expressive lines. What we have not seen with sufficient depth is the degree to which the instruments were entwined with industrial pursuits, as in the epigraph above from Gustav Karsten. Many historians studying the activities of the Berlin Physical Society have stressed the central role of instruments, and yet the specific location of those instruments in Berlin's industrial culture has often been missing. In this chapter I want to draw out some of the main referents for that location as well as buttress the term *Handwerksgelehrte* (craftsman-scholars) that Otto Sibum has adopted from a nineteenth-century critic to describe a new sort of professor whose learning derived from laboratories full of machines. Sven Dierig has developed the concept at length for Du Bois-Reymond.[2]

The Membership

On January 5, 1845, Gustav Karsten was among six young bourgeois men who wrote to Cultural Minister Karl Friedrich von Eichhorn with "the request for approval of the foundation of a physical society in Berlin." The chain of approval for such a *Verein* took until April. But already on January 14 they had met to formalize their new society with the certificate of membership on which Emil du Bois-Reymond had inscribed the complex allegory of the tree of knowledge, dedicated to the advance of physical investigations of the organic as well as the inorganic world.[3] Just five months later they would record their auspicious assembly

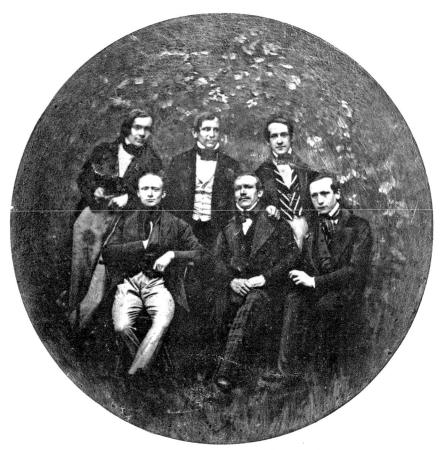

Figure 6.1 Organizers of the Berlin Physical Society. *Top*, left to right: Karsten, Heintz, Knoblauch. *Bottom*, Brücke, Du Bois-Reymond, Beetz. Daguerreotype, June 14, 1845. Archiv der Deutschen Physikalischen Gesellschaft, 60001.

in a picture that has been obligatory for every later celebration and history (fig. 6.1). They are posed before the grape arbor at the family home of Karsten, their chosen president. He had made himself something of an expert on the new photochemistry of daguerreotypes and stands on the left in the picture holding a stopwatch to time the exposure.

Young Karsten, who had studied physics with Dove and mathematics with Dirichlet, embodies the constellation of values inscribed in the certificate, interrelating aesthetics, industrial development, and physical and mathematical analysis. These values were set constantly before the members not only by the professors of natural science whom they chose as mentors but by

the policies for progress pursued by key figures within the often-conflicted ministries of war, trade, and culture, not least by Karsten's father Geheim Oberbergrath Carl Karsten, who served in the interior ministry as the chief expert of the state on everything to do with metals. The elder Karsten was also a prolific author and journal editor, member of the Academy of Sciences, a major promoter of science-based metallurgical industry, an engaged political and economic liberal, Beuth's longtime deputy (*Stellvertreter*) in the Gewerbefleiss Verein, and a very close friend of Johann Gottfried Schadow, director of the Academy of Art.[4]

The interlinkage of ministerial goals in relation to the self-perception of the Physical Society can be read implicitly in the epigraph: Karsten, as the son of the chief metallurgical expert of the state, including the *army*, is writing to the minister of *culture* to advertise the probable significance for *industry* of recent measurements on the elasticity of steam as reported in his paper in the first number of the Society's new journal, which he edited, *Fortschritte der Physik* (*Advances in Physics*). In choosing Karsten as their president and editor, the members had picked the person with the most direct access to the circles of liberal power in Berlin. He and his colleagues were fashioning themselves as agents for the realization of goals already prominently represented among the progressive elite.

They aimed also, however, at an inclusive membership that would cut across class barriers to mobilize not only academic learning but the practical knowledge and skills of craftsmen and engineers. Over its first two years the Physical Society enlisted a total of sixty-one members (some joining and leaving) from a broad social and professional spectrum, including six master mechanics, six army lieutenants (almost certainly former and present students of Magnus and Dove at the Artillerie- und Ingenieurschule and the Kriegsschule), many technologically or industrially oriented members, seven sons of city and state councilors plus two active councilors, and eight aristocrats (table 6.1).[5] Of the forty-nine members who were not master mechanics or lieutenants, I have been able to identify forty-two, of whom thirty-five held doctoral degrees, mostly fresh from the University. In its origins it was a highly educated but diverse *Verein*.

Appropriately for such *Vereine*, which often took the form of reading societies, the members held their first meeting in a common reading room of the *Kadettenhaus*, where their secretary Wilhelm Beetz was teaching physics (and where his father taught geography).[6] Not all members were equal, however. As shown on Du Bois-Reymond's certificate (fig. 5.1), he was an "ordinary member" (*ordentliche Mitglied*). This category, which in a March 1847

Table 6.1. Membership of Berlin Physical Society 1845–1847

Name	Title[a]	Status[b]	Berlin[c]	Discipline	Specialty	Early reviews in *Fortschritte der Physik*[d]	Comments[e]
Bayer	Lieut		x				Unidentified
Becker							Unidentified
Beetz, W.	Dr	o	x	Physics	Electricity	Galvanism, electrotechnology	Magnus lab ca. 1842/44
Böhm						"Protocoll" (April 4, 1845) Calumbite of G. Rose	Unidentified
Böhn	Lieut von		x				Unidentified
Bötticher, F. U.	Mech	ao	x	Scientific instruments	General	Pantograph, goniometer	Partner of Halske
Brauns, D. A.		ao	x	Medicine, geology		*Galvanoplastik* (with Beetz)	Medical Dr., geologist, and traveler
Brücke, E.	Dr	o	x	Physiology	Eye	Retina, muscles, optics	Family of Berlin artists
Brünnow, F.	Dr		x	Astronomy	Observational astronomy	none	Father Geh. Kanzleirat Kammergericht
Brunner, C.	Dr	o		Physics	Heat of fusion	Cohesion, capillarity	In Bern; Magnus lab ca. 1844/47
d'Arrest, H. L.	Dr	o	x	Astronomy	Observational astronomy	None	Father Rechnungsrat
d'Heureuse, A.	Dr	o	x	Technology/ chemistry	Hydrodynamics	Pumps, turbines, locks	Owner, mineral water business
Du Bois-Reymond, E.	Dr	o	x	Physiology	Animal electricity	Nerve and muscle action	Father Geh. Oberbergrat

Name	Title	Status		Discipline	Subfield	Specialty	Notes
Du Bois-Reymond, P.	Dr		x	Mathematics		None	Emil's brother
Duve, F.	Mech	ao	x	Scientific instruments	Optical instruments	None	Deceased 1849
Eichhorn, K. H. A.		ao	x	Technology/chemistry	Agriculture	None	Ag. schools; Magnus lab ca. 1851/52
Eisenstein, F. G. M.	Dr	o	x	Mathematics	Number theory	Mathematics of physics	Precocious Dirichlet student
Erlach	Dr von	o					In Genf, then Zurich; unidentified
Ewald, J. W.	Dr	o	x	Geology/mineralogy	Paleontology	Optical effects of crystals	Brother-in-law of Du Bois-Reymond
Feilitzsch, F. C. O.	Dr von	o	x	Physics	Magnetism and galvanism	None	In Bonn
Girard, H.	Dr		x	Geology/mineralogy	Earthquakes and volcanos	None	
Grossmann, R.	Dr	ao	x	Technology/physics		Electrochemical dissolution	Publications in *VdVBG*
Halske, H. R.	Mech	ao	x	Scientific instruments	Diverse	Instruments: optical, dividing	Partner of Bötticher, then Siemens
Heidel, H. R.	Sculpt	ao	x	Fine art	Sculptor	Engraver of Certificate	Sculptor of *Iphigenie* at Sanssouci
Heintz, W.	Dr	o	x	Physics	Physical chemistry	Specific and latent heat	Apothecary with own lab
Helmholtz, H.	Dr	o	x	Physiology, physics	Heat	Physiological heat	Magnus lab ca. 1845/46
Horn	Lieut von	ao	x		Elasticity of solids		Famous military family

Table 6.1. *Continued*

Name	Title[a]	Status[b]	Berlin[c]	Discipline	Specialty	Early reviews in *Fortschritte der Physik*[d]	Comments[e]
Jungk, C. G.		o	x	Physics	Electromagnetism	Telegraphy, electromagnetism	*Gymnasium* teacher
Karsten, G.	Dr	o	x	Physics	Physical chemistry	Many and diverse reviews	Father Geh. Oberbergrat
Kerndt, K. H. T.	Dr	ao	x	Technology/chemistry	Agriculture	None	Founded agricultural institute
Kiréewsky	Dr von	o		Physics	Electromagnetism	None	In St. Petersburg
Kirchhoff, G.	Dr	o		Physics	Electromagnetism	Theories of Weber and Neumann	In Königsberg, student of Neumann
Knoblauch, C. H.	Dr	o	x	Physics	Heat	Radiant heat, atomic theory	Father Geh. Finanzrat
Krönig, A. K.	Dr	o	x	Physics	Atomic theory, magnetism	Cohesion, Faraday rotation	*Gymnasium* teacher; kinetic theory
Kuhn, K.	Prof Dr	o		Mathematics, physics	Technological physics	Meteorology, electrotechnology	In Munich; military schools
Lamont, J.	Prof Dr	o		Astronomy	Earth magnetism	None	In Munich
Langberg, C.	Dr	o		Physics	Heat conduction	Conductivity of metals	In Oslo, Magnus lab ca. 1844
Leonhardt, C. G. F.	Mech	ao	x	Scientific instruments	Clockmaker	Telegraph	Deceased 1848
Mahlmann, W.	Dr	o	x	Meteorology		None completed (died 1848)	Collaborator with Humboldt and Dove

Martins, C. O. A.	Mech	ao	x	Scientific instruments	Optical instruments	Measuring planarity of glass	Son-in-law and partner of Pistor
Morozowicz, O.	Lieut von	o	x	Physics, geography	Mechanics, geognosy	Hydrodynamics, acoustics, mathematical geography	Became head Prussian land survey
Pistor, C. P. H.	Mech	ao	x	Scientific instruments	Mathematics and optics	none	Geh. Ober-Postrat
Pochhammer, M.	Dr von	ao	x	Technology/ physics	Applied aerodynamics	Atmospheric railroad	Joined Catholic-apostolic movement?
Poselger, H.		ao	x	Meteorology		Meteorological optics, electricity	Father Stadtrat and Prof. Kriegsschule
Quincke, H.	M.-R. Dr	ao	x	Medicine		None	Geh. Medicinal-Rat; son G. Quincke
Radicke, F. W. G.	Dr von	o	x	Physics	Theoretical optics	Wave theory and effects	In Bonn; optics for *Rep. d. Phys.*
Röbber, E.				Physics	Measurement technology	Hearing frequency limits	In Brunswick
Rohrbeck, W. J.		ao	x	Technology/ chemistry	Equipment supply	None	
Siemens, W.	Lieut	o	x	Technology	Mechanics, telegraphy	Measuring short time intervals	
Simon							Unidentified
Soltmann, A. or K.?	Dr	ao	x	Technology/ chemistry?	None	None	Father Hofrat; mineral water business

Table 6.1. Continued

Name	Title[a]	Status[b]	Berlin[c]	Discipline	Specialty	Early reviews in *Fortschritte der Physik*[d]	Comments[e]
Soltmann, G. E.?		ao	x	Technology/chemistry?		None	Took over mineral water business
Spörer, G.	Dr	ao		Physics	Mechanics	Theoretical and applied mechanics	In Bromberg
Stengel							In Zwickau; *unidentified*
Traube, L.	Dr	ao	x	Medicine	Pathology	None	Famous medical doctor
Traube, M.	Dr	ao	x	Technology/chemistry	Fermentation	None	Wine merchant
Wächter, A.	Dr	o	x	Technology/chemistry	Porcelain	Specific gravity, eudiometry	Arcanist at KPM
Wiedemann, G.	Dr	ao	x	Physics		None (soon major contributor)	In Heidelberg, then Giessen
Wiesing	Lieut		x				In Heidelberg, then Giessen
Wilhelmy, L. F.	Dr	o		Chemistry, physics	Chemical kinetics	None	In Heidelberg, then Giessen

[a] *Mechanicus*, Lieutenant, Doctor (where known), Professor, and Aristocrat (von).
[b] Ordinary (o) or extraordinary (ao) member on March 1847 list.
[c] Present (x) in the city (where known).
[d] Examples from 1845–46.
[e] Various relevant identifiers, such as location outside Berlin, father as city or state councilor, worked in Magnus's lab, etc.

listing for the cultural ministry included only seventeen members from Berlin (counting Helmholtz in Potsdam), constituted the nucleus of the Society, with an additional twenty-one extraordinary members from Berlin and twelve ordinary members from other towns.[7] Although the discussion below of the Society's activities will focus on the ordinary Berlin members, I want to begin by characterizing first, their immediate role models for the instrument-based research that they brought to their enterprise, and second, the local sources for the instruments they employed and the pervasive industrial context of their pursuits.

Johannes Müller and Gustav Magnus

Two locations have dominated discussions by historians of science of the laboratory resources available in Berlin to the youthful organizers of the Berlin Physical Society. They are the "laboratories" of Johannes Müller and Gustav Magnus, where nearly all of them developed their passion for experimental research.

Johannes Müller

On August 2, 1836, three years after his arrival in Berlin from Bonn as professor of anatomy and physiology, Johannes Müller delivered a *Festrede* at the forty-second anniversary celebration of the Friedrich-Wilhelms-Institut, or *Pépinière*, the medical school for army doctors where Helmholtz would begin his studies in 1838. Müller used the occasion to advertise the uniqueness of his program of research in its integration of chemical with microscopic analysis. He also emphasized its practical value in clinical medicine for distinguishing surgically treatable bone cancers from untreatable ones and the fact that this combined means of investigation had previously been completely lacking in medicine. Shortly afterward, as was his custom, he sent the published lecture to cultural minister Altenstein, one of his patrons since his medical school days in Bonn, ensuring that not only his military audience but also the cultural ministry recognized the significance of the work. In December the Academy of Sciences heard a similar presentation, emphasizing that "microscopic analysis must go hand in hand with chemical investigation. Many things that look similar under the microscope are chemically distinct."[8] More generally, the creative strength of Müller's program, for his own research but especially for his students, was the complementary relation he promoted between biological and physical methods of experimental investigation even though he himself did little experimental physiology after 1840.[9]

Müller deployed several analytic tools: exquisite dissections, the best microscopes available, skillful drawings, and organic chemistry. With these tools he had done groundbreaking work in multiple areas of anatomy and physiology, especially vision and the nervous system, and had established his famous doctrine of specific nerve energies according to which each type of sensory nerve produces its own sensation in consciousness; thus, a blow to the eye produces the sensation of light. Müller's real love, however, was comparative anatomy. His physiological investigations were always grounded in comparative anatomy, through which he aimed to reveal the grand plan that he believed encompassed the diversity of all organisms controlled by a life force. To this end he devoted enormous amounts of time, energy, and money to his Anatomical Museum, which after major renovations in the late 1830s occupied the west wing on the second floor of the University building (fig. 2.8). But it could never contain Müller's ambition. During his time in Berlin he increased the size of the collection from 7,197 specimens to 19,577.[10]

The ever-expanding collection left little space for anything that could be called a laboratory. Müller and his associates—a prosector who prepared specimens, a favored student who acted as his paid personal assistant, plus other privileged students—did their dissections and their experiments in the midst of bottled specimens or in obscure corners. Working conditions were similar in Müller's other major venue, the Anatomical Institute (or Theater), which he codirected with his colleague on the medical faculty Friedrich Schlemm. Downstairs was a large dissecting hall where up to two hundred medical students at a time dissected parts of cadavers. Upstairs Müller had two small rooms next to the lecture hall, and it was here that he and his chosen collaborators carried on their work when they were not at the museum. Neither location housed any serious equipment for experimental work, so they had to cobble together their own. This they often did in their own living quarters, usually consisting of one or two very small rooms. In short, Müller's laboratory consisted physically of a hodgepodge of spaces in the Anatomical Museum, Anatomical Institute, and student rooms.

Much more importantly, the "laboratory" consisted of a small group of assistants and students from the University and the Friedrich-Wilhelms-Institut working side by side who were in awe of their mentor's enormous reputation and equally enormous energy. They benefited immeasurably from his inspiration and his support for their research interests, even when, as for those of his students who would join the Berlin Physical Society, they did not share his passion for anatomy and the collections of the Anatomical Museum. Put in terms of the relation of museums and laboratories presented in chapter 2,

the experimental physiology that they would so successfully promote literally grew up within the Anatomical Museum during the period from 1840 to 1842, where they all began their research with microscopic anatomy. Du Bois-Reymond on the formation of blastomeres by cleavage of fertilized frog eggs (with Müller's prosector, the anatomist Karl Reichert), Ernst Brücke on various aspects of vision (supplementing anatomy with geometrical optics), and Hermann Helmholtz on the origin of the nerves of invertebrates in ganglionic cells (his dissertation).[11] Acquisition of a compound achromatic microscope and the commitment of serious money that it entailed (100 to 200 thaler, minimally the living expenses of a student for one year) was both a prerequisite for doing a dissertation with Müller and a rite of passage, a marker of a new research identity.

In 1840 Du Bois-Reymond spent a well-invested baptismal gift from his grandfather to obtain a Pistor microscope (fig. 6.2), while Helmholtz saved up money when he was hospitalized for an illness in 1841 to purchase his. For them and for their like-minded peers, the microscope served also as a passage into a broader commitment to instrument-based research.[12] Beginning from microscopic anatomy, they were able, with Müller's encouragement

Figure 6.2 C. H. Pistor, Grosses Stangen Mikroskop, ca. 1840. Dr. Timo Mappes collection (http://www .musoptin.com).

and often at his suggestion, to redirect their efforts into the experimental physiology that modern research in the museum seemed to require.

The conditions for this movement had already been established during the 1830s in relation to his two favorite students, Jacob Henle and Theodor Schwann, with both of whom he had worked closely in Bonn. Henle became his prosector at the museum while Schwann served as his assistant. But while Henle was attracted to Müller's comparative anatomy and by 1840 had established himself as an independent authority on microscopic anatomy, Schwann took up Müller's physiological interests and used microscopy en route to such quantitative studies as the need of chicken embryos for oxygen (his dissertation), the tension and contraction of muscles, and protein digestion (with Müller). Henle's and Schwann's joint work with Müller and with Matthias Schleiden led to Schwann's announcement of the famous cell theory, that all organisms whatsoever, both plant and animal, consist of cells. Both Henle and Schwann became role models for the next generation of students, Schwann even more than Henle because he explicitly contested Müller's belief that the organization of living organisms required reference to a *Lebenskraft* (vital force) that could not be understood in terms of chemical and physical laws. Schwann's denial of this claim was particularly insistent in his book on the cell theory in 1839, where he treated the cellular growth of tissues as analogous to the growth of crystals, an analogy that included cellular differentiation and (ideally) would require nothing more than the physics and chemistry of matter to explain the full development of an organism.[13]

The irony in this insistent movement into physical-physiological research and explanation in the 1830s has always been that the conditions for carrying it out did not yet exist. The University itself had neither laboratories to train students in either chemistry or physics nor any research instruments for the use of professors. Even lecture demonstrations required apparatus brought from professors' personal cabinets. By comparison, Müller's small rooms for research were a luxury to excite the imagination of ambitious students, however modest the microscopes available or the apparatus they were able to construct. His example and his personal attention opened a vista on a new world of independent research and self-definition. But again, the vista included only dimly the edifice of chemical and physical experimentation toward which Müller's program has seemed to point. Even the prestigious chemist Eilhard Mitscherlich had no laboratory at the University, although he controlled a fine chemical laboratory in the house provided for him by the Academy of Sciences, including a lecture room.[14] Thus the beginnings of chemical and physical teaching laboratories lay largely outside the University

itself. We have seen important sources for those beginnings in the technical schools (chap. 2–4). The process through which their development helped to shape the identity of the Physical Society can be seen quite clearly through the mediating position between those schools and the University occupied by Magnus especially but also Dove.

Gustav Magnus

In 1845 Johannes Müller's wealthy younger colleague Gustav Magnus became ordinary professor (full professor) of technology at the University while Heinrich Wilhelm Dove became ordinary professor for physics. Dove was a stimulating expositor of the latest work in experimental physics who inspired several members of the Berlin Physical Society, including Du Bois-Reymond, Karsten, Siemens, and Helmholtz. Yet it was Magnus and not Dove who by 1845 had established the physical laboratory that would give birth to the Physical Society in the same year. Why? This deceptively simple question opens a wide arena, for much more was at issue than Magnus's wealth, though that was decisive. I begin from the military schools where both men were professors.

An attempt to establish a cabinet of instruments and models for lecture demonstrations entered organizational discussions for the Kriegsschule in 1809, apparently at the request of Paul Erman and Martin Heinrich Klaproth as the prospective professors for physics and chemistry. The plan died for lack of funds. At the University events were similar. In 1814 the rector and senate applied to the cultural ministry on behalf of Erman and Ernst Gottfried Fischer for such a cabinet. Erman supplied a list of apparatus costing 6,000–8,000 thaler. In the enthusiasm following the Befreiungskriege, the request was actually approved by an order of the king for gradual acquisition over a number of years. The funds never materialized. Somehow, however, Erman did acquire a respectable cabinet at the Kriegsschule. This became attractive to Dove (Erman's son-in-law) when he succeeded Erman in physics in 1838 and began living at the school with his family. Dove also continued teaching at a *Gymnasium* as well as at the University, ferrying his instruments about in a basket. Not until 1844 did the University acquire its own cabinet and then by a very different path.[15]

As discussed in chapter 4, the reformers of military education following the Napoleonic Wars saw training in mathematics and physical science as a requirement for the modern officer. They promoted especially the French "method of application" through repetition sections. For the technical branches especially, this meant practical exercises in chemistry and physics

as well as mathematics and drawing. But they had no laboratories and no room for any; even the cost of hiring *Repetenten* for mathematics presented a problem. At the Artillerie- und Ingenieurschule, lieutenant colonel and professor Turte (or Tourte), teaching chemistry and physics, provided an interim solution by establishing a laboratory and lecture room in his home, for which the school paid him a rent of 100 thaler annually until 1823, when they occupied their new building, containing its own teaching laboratory. Turte, however, must have provided much of its equipment, for when he left the school in 1832 to devote himself more fully to directing a new powder factory at Spandau, they agreed to reimburse him for his collection of instruments with 720 thaler in the first year and declining amounts thereafter. The budget then included 200 thaler for a *Repetent* in chemistry and another 300 for supplies.[16]

Turte's experience provided a direct precedent for the career of Gustav Magnus. Magnus was the fourth of six sons in a baptized Jewish family that owned a bank in Berlin and whose members were highly educated and moved in elite society. His older brother Martin took over the bank in 1821, while brother Eduard was the celebrated portrait painter of figure 5.2, member of the Akademie der Künste from 1837 and professor from 1844. Magnus's own intellectual path began in a newly founded *Gymnasium*-level institute that emphasized the natural sciences. He continued his studies at the University with the chemists Mitscherlich and Gustav and Heinrich Rose and the physicists Poggendorff and Erman. After completing his doctoral dissertation in September 1827 with Mitscherlich on the rare element tellurium, Magnus went for a year to work in the laboratory of the famous chemist Jöns Jacob Berzelius in Sweden, following in the footsteps of both the Roses and Mitscherlich. Berzelius not only formed close personal bonds with his "students," resulting in a long-term correspondence with Magnus, but took them on trips to local industrial sites where production depended critically on chemical processes, a practice that Magnus would make a central part of his own teaching.[17]

After several months in Paris, trying unsuccessfully to get to know the chemists there, and another year of chemical experimentation in Berlin, Magnus decided in 1830 to devote his *Habilitation*—conferring the right to teach as a *Privatdocent* (private instructor) and therefore to receive student fees—to chemistry and technology. He was clearly positioning himself to meet the highly competitive conditions for chemistry and physics in Berlin. Chemical technology at the University was still the fiefdom of the venerable Hermbstaedt, but he was then seventy years old. He was already being

challenged for students by Ernst Ludwig Schubarth, extraordinary professor (associate professor) for chemistry at the University and closely aligned with Beuth at the Gewerbehaus (chap. 3). After obtaining a transfer from the medical faculty to the philosophical faculty, Schubarth had begun offering lectures on technology in 1828. Magnus very likely knew, however, that the transfer occurred over the objections of Hermbstaedt and Mitscherlich and did not suggest a future ordinary professorship. Schubarth's application for Hermbstaedt's position on his death in 1833 was rejected by the philosophical faculty.[18]

Magnus's *Habilitation* consisted of his doctoral thesis on tellurium plus ten largely chemical papers already published. For his trial lecture (*Probevortrag*) in January 1831, he offered "Die Lehre von den Dämpfen" (The study of vapors). If practical chemistry and physics were generally in high demand, that was certainly the case for steam technology, in which Prussia found itself still importing most of its engines from Britain or the Cockerill plant in Belgium. For the summer semester, the new *Privatdocent* offered a course in practical chemical exercises to be taught in his own apartment. To his pleasant surprise, the demand for such hands-on experience exceeded his capacity of eight students. A year later he set up his course on "Technologie, durch Exkursionen erläutert" (Technology, illuminated by excursions) in direct opposition to Hermbstaedt's principle lecture "Allgemeine Technologie, mit Exkursionen," which since 1817 had featured visits once or twice a week to industrial facilities in Berlin. Unwilling to cede the ground, Hermbstaedt announced his course for the same noontime hour as that of his young rival. That did not distract Magnus. Nevertheless, he faced the problem of acquiring apparatus and laboratory space. And he needed a job.[19]

Immediately following his *Habilitation* in 1831, Magnus proposed to the cultural ministry that since he required equipment in order to offer courses on technology, he would purchase and house the apparatus himself and then obtain reimbursement from the state. Altenstein agreed, and from 1833 supplied up to 500 thaler per year (initially for four years, then with yearly extensions until 1843). Magnus's home teaching arrangements expanded accordingly. The outlook brightened further in 1831 with Turte's impending departure from the Artillerie- und Ingenieurschule. Writing to Berzelius, he expressed his enthusiasm for the appointment, especially because the Artillerie- und Ingenieurschule intended to establish a physical cabinet, which would also give him some capacity for independent research. Indeed, the school's budget for 1833 included an extra 610 thaler to expand the physical-chemical cabinet beyond what Turte had supplied.[20] Magnus could now combine

Turte's resources at the Artillerie- und Ingenieurschule with his own home physical laboratory, all funded by the state. These were enviable conditions, possible only because of their perceived technological importance and only with the joint support of the ministries of war and culture.

Comparable resources were rare. Hermbstaedt did occupy a large house containing a lecture room and laboratory (chap. 3) but apparently did not institute a regular teaching laboratory or take on research students. Mitscherlich, too, had the chemistry laboratory of the Academy, but he took on few research students and taught no laboratory courses at the University. A major difference for Mitscherlich's students at the Friedrich-Wilhelms-Institut was a teaching laboratory, which had existed since 1822. Very likely Turte, too, had established practical exercises there from the beginning in parallel with the laboratory at the Artillerie- und Ingenieurschule from 1823. For Hermann Helmholtz in 1839, for example, this meant that while attending six hours of lectures on experimental chemistry per week at Mitscherlich's house, he also had four hours of repetition in the school's laboratory, an opportunity that neither medical nor chemistry students at the University could enjoy unless by special arrangement with one of the professors to use his private space and equipment.[21] As in the case of clinical practice in medicine, the army supplied its students—its technical students, that is—with laboratory training unavailable at the University.

The qualification is important, for it was not the army command in general that insisted on laboratory training but only the technical branches. The cultural ministry and the University did not oppose such training in general but saw it as a requirement only for technically oriented study. That distinction seems to have been in play in 1833 when Hermbstaedt suddenly died. Magnus and Mitscherlich both applied for his position at the Kriegsschule. In what was surely an arrangement between the ministries of war and culture (perhaps also the trade ministry, because of Hermbstaedt's and Schubarth's position with Beuth), they divided Hermbstaedt's positions. The more senior Mitscherlich got the chemistry job at the Kriegsschule while Altenstein advised Magnus to withdraw and wait for Hermbstaedt's position in technology at the University, which he then obtained as an extraordinary professor in the following year.

Magnus's technology position requires a digression. There has been a long tradition in the literature of representing him as basically a physicist rather than a chemist, and one who rejected technology as his field of activity before being appointed in 1834 as extraordinary professor for physics. But his actual appointment was for technology. Stefan Wolff has corrected

this misapprehension and observed that Magnus did very little research in physics itself before 1840, when he was elected to the Academy of Sciences as a chemist. His chemical experimentation, however, as Wolff also observes, did lead fairly regularly into physical analysis of such things as capillarity and specific gravity. And already from 1833, in alternating semesters with his technology course, he began offering a course in general physics, illustrated with experiments, for which he obtained additional funds for apparatus from the ministry.[22]

The result of the division of Hermstaedt's positions, whether explicitly intended or not, was a de facto acknowledgment of the more theoretical orientation of chemistry at the University and the Kriegsschule—neither of which had facilities for practical exercises—compared to the Artillerie- und Ingenieurschule and the technology position at the University. Either man could have done either job; indeed, Mitscherlich, too, had long promoted practical chemistry and industry. The division of duties apparently represented traditional institutional emphases and the desire to obtain the most effective distribution of resources for the state.

This scenario also gives one straightforward answer to the question of why Magnus, still a *Privatdocent* in 1833, was funded for the collection of instruments and not Dove, who had already become extraordinary professor of physics in 1828 in Königsberg before he obtained a transfer to Berlin a year later. The traditional response has centered on Magnus's family wealth and social connections versus the punishing conditions under which Altenstein approved Dove's transfer to Berlin.[23] No doubt those factors were in play, but also, from the perspective of the cultural ministry, Magnus was positioned on the practical technological track and Dove on the more theoretical one. That division continued in 1845, when Magnus became ordinary professor for technology and Dove for physics. And while Magnus taught at the Artillerie und Ingenieurschule, Dove went to the Kriegsschule in 1838 (replacing his former physics professor and his wife's uncle, Paul Erman). Nevertheless, as in the case of Mitscherlich, these identities were anything but fixed. From 1836 Dove edited the reviewing journal, *Repertorium der Physik*, which stressed experimental physics. He also worked closely with Alexander von Humboldt on magnetic observations, which became the basis for the work in meteorology for which he is best known (chap. 5). In 1841 Dove in fact replaced Magnus at the Artillerie- und Ingenieurschule.[24]

The conditions of Magnus's departure from the Artillerie- und Ingenieurschule are now crucial. Simply put, he married an heiress and no longer needed the money. In 1840 Magnus married Bertha Humblot, daughter of

Figure 6.3 Spiral staircase in Magnus's baroque mansion, after restoration, 1994. Becker, "Zur Geschichte des Magnus-Hauses," 120.

Pierre Humblot of the major *wissenschaftlich* publishing house Duncker und Humblot (which brought out, e.g., the *Verhandlungen des Vereins zur Beförderung des Gewerbefließes* of Beuth's Gewerbeverein). Her wealth apparently funded the purchase of a large and elegant house on the Kupfergraben (fig. 6.3), directly across an arm of the Spree river from the Neues Museum and within sight of the Royal Palace to the right. In between stood Schinkel's architectural masterpiece, the Altes Museum, with the Volksgarten in front (fig. 2.8).[25]

In these rather grand surroundings, and beginning from his state-supported cabinet, Magnus established the private laboratory and lecture room—and in 1843 the Physical Colloquium—that have become so famous as the place of origin of the Berlin Physical Society. Magnus thus took the existing precedents to an entirely new level of elegance and professional commitment. He also jealously guarded the great advantage in teaching physics that he possessed over Dove and over Paul Erman's physicist son Adolf as the

caretaker of a cabinet of instruments owned by the state. Their complaints led in 1844 to the transfer of the state's share of Magnus's cabinet to the University building. He still controlled access (as director from 1847), but this was the first step in the University's acquisition of laboratory equipment, if not yet a physics laboratory. The laboratory itself remained in Magnus's house, where in an 1863 rental arrangement it became the first physics laboratory of the University.[26]

In sum, taking full advantage of extraordinary state support and personal wealth, Magnus was able through his teaching initiatives to carry over into physics the expectations for laboratory research that had already grown up in the technical schools and especially in chemistry, including the intimate association between a small group of coworkers that he had experienced with Berzelius. In this process, his professorship for technology played a constitutive role, maintaining his ever-present awareness of the industrial significance of chemical and physical processes. Indicative of this continuing role are his participation through the 1840s in the administrative section of Beuth's Gewerbefleissverein and the fact that as late as 1850–56 he took up lecturing on chemical technology at the Gewerbeinstitut (chap. 3). Dove, too, lectured there from 1849 to 1868.

Instrument Makers and Industry

If Johannes Müller's students and assistants found his promotion of experimental physiology to be compromised by his continued adherence to the goals of *Naturphilosophie* and the *Lebenskraft*, they found in Gustav Magnus precisely the rejection of those speculations and the commitment to material explanation that they sought. Through his Physical Colloquium and laboratory he offered to hungry students of the natural sciences a vision of what rigorous physical methods could provide. Five of the six organizers of the Physical Society—Karsten, Beetz, Du Bois-Reymond, Ernst Brücke, and Wilhelm Heintz—plus two other members—Hermann Eichhorn and Fabian von Feilitzsch—were among the ten men present for the first meeting of the Colloquium in April 1843. Rudolph Clausius was there as well but did not join the new Physical Society until 1851, perhaps out of respect for his mentor Magnus, who apparently was not entirely pleased with this extension of his Colloquium in the interests of youthful independence. He nevertheless continued to promote that independence by awarding access to his private laboratory to those who could propose on their own initiative an experiment of significance that required his assistance and instruments and by presenting the finished research projects of his protégés to the Academy of Sciences.[27]

There is considerable disparity in the literature regarding the number of early Physical Society members who not only attended Magnus's Colloquium but also carried out experimental work in his laboratory, from a maximum of all the organizers (except Heintz, a trained pharmacist who had acquired his own laboratory) to a minimum of only Beetz and a few other early members, including Helmholtz (table 1, comments).[28] Nevertheless, their admiration for his mentorship and his skill with instruments was unanimous. This recognition, coupled with the central role of instruments in the Society's iconography, should signal that the instruments themselves were important carriers of Magnus's inspiration. Their use provided hands-on appreciation of the artistry embodied in precision measurement. Magnus also provided personal familiarity with the master mechanics who could construct them, for they had supplied many of the 234 instruments that he turned over to the University cabinet in 1844.[29] That six instrument makers became early members of the Physical Society suggests the importance of such relations on which all experimenters relied if precision was their goal.

A striking testimony to Magnus's role in promoting this and other forms of industrial technology appears on opening the official report of the Berlin Gewerbe-Austellung of 1844. Organized largely by Beuth's Gewerbefleiss Verein, it was the first such exhibition to represent the entire German Zollverein (Customs Union). The multivolume report, covering all areas of German industrial production, bears the dedication "To the Royal Professor Herr Dr. Magnus" (fig. 6.4). His inspiration clearly extended broadly over the exhibition. His specific responsibility, however, concerned the section—one of six—that allied scientific instruments and clocks with light metal work, jewelry, and weapons. Along with Dove, J. F. Encke (director of the Berlin observatory), and several others, Magnus acted as expert advisor to the section. Karsten's father Carl, Beuth's second at the Gewerbefleiss Verein, played a parallel role for the section on heavy metal work.[30]

It is interesting to see that here in 1844, at the beginning of the takeoff period of German industry, the very luxuriance of the exhibition evoked memories of the recent past. Its ideological appeal was to national *Fortschritt* and *Freiheit*, to the advances made in the thirty years since the German people, "with streams of its blood," had established its independence from France in the battles of the Befreiungskriege and then, under the Zollverein from 1834, had exploited the relative freedom of trade among its members that released the "battle of material interests" so evident in the exhibition.[31] In retrospect, the report contains the original celebratory rhetoric for a long historiographical tradition that has identified the Zollverein as one of the primary roots of

Amtlicher Bericht

über die

Allgemeine Ausstellung

deutscher

Gewerbs-Erzeugnisse

in Berlin 1844.

―――――

Dem

Königl. Professor

Herrn Dr. Magnus

in Berlin.

German, and especially Prussian, economic advance and of German unification. That historiography has been severely challenged in recent years by the empirically grounded contention that "The Zollverein did not strengthen Prussia's position in Germany, either economically or politically."[32] That the exhibition provided a powerful material basis for the ideology, however, loses none of its significance for the local context of the Berlin Physical Society.

In that light, the fact that the official report was dedicated to their mentor Magnus makes it all the more natural that these same sentiments of progress, open competition, and distrust of the French would animate the Society and would sound throughout their journal, *Fortschritte der Physik*. Indeed, the

very instruments on which they based their own claims to *Fortschritt* depended directly on the advancements in industry that the exhibition celebrated. Its report repeatedly called attention to the virtues of precision and reliability that German instruments exhibited in comparison with their French competitors and to the way in which German makers responded directly to the requirements of individual customers, thus building *Fortschritt* into their engagement with immediate needs as opposed to French (and English) makers, who were depicted as producing largely standardized models.[33]

The exhibition occupied nearly seventy thousand square feet at the great Zeughaus (the Armory) on the East end of Unter den Linden, just a stone's throw up the Kupfergraben from Magnus's house. There his "students" could study in detail the broad swath of industrial progress, as Du Bois-Reymond did with "lively" (*lebhaft*) interest.[34] And they could examine the work of four of the instrument makers who would join their Society as extraordinary members. The partners Bötticher and Halske, for example, who had established their own workshop only in 1844, exhibited an apparatus for microscopic photography (Daguerreotype) and a precision chemical balance. Halske was already constructing instruments for the electrophysiological work of Du Bois-Reymond, who met him at the workshop of the precision mechanic Wilhelm Hirschmann, himself a former partner of Pistor. It was a highly inbred group. Du Bois-Reymond then introduced Halske to Siemens at a meeting of the Physical Society, and in 1847 the two of them would form the Telegraphenbau Anstalt Siemens und Halske.[35]

The firm of Pistor and Martins, appropriately described in the report as "a worthy firm of long-standing and proven reputation," exhibited large reflecting circles for astronomical measurements as well as sextants. C. P. H. Pistor, who had founded the workshop in 1813, established his reputation in part with that epitome of precision machines, the dividing engine. Surprisingly, he was especially well connected among the liberal elite, including among his intellectual friends Ludwig Achim von Arnim, Clemens Brentano, Heinrich von Kleist, Daniel Friedrich Schleiermacher, and Karl Friedrich Schinkel. As Geheimer Rath im preussischen Postdienst he produced in 1840 the standard of measurement for the Prussian foot. In honor of his accomplishments, Pistor received the doctor of philosophy degree in 1843 at the age of sixty-five. We have seen his key role in providing instruments for the Bauschule and the Gewerbeinstitut in chapters 2 and 3, along with his earlier partner (1824–36), F. W. Schieck, whose microscopes became independently famous in the 1830s. Pistor's younger associate Martins spent his entire career with Pistor, as apprentice, employee, son-in-law, and partner. Their astronomi-

cal instruments appeared in observatories throughout Europe and America. Not surprisingly, Pistor and Martins were one of three makers of scientific instruments who won the silver prize medal of the exhibition, the quality of their exhibited work having already been attested by Geheimer Conferenzrath Schumacher, director of the Altona observatory and editor of the *Astronomische Nachrichten*, to which several Society members contributed. As noted above, Du Bois-Reymond had purchased his own Pistor microscope in 1840.[36]

Mechanicus Leonhardt, the older clockmaker with whom Siemens had collaborated in measuring projectile velocities and with whom he originally hoped to develop electric telegraphs, did not exhibit in 1844, but he had won a third prize medal (*Ehrendenkmunze*) at the 1827 exhibition, when Knoblauch's father, *Geheimer Finanzrath, Stadtältester, and Kaufmann* Carl Knoblauch, served on the selection committee. Of the master mechanics in the Society, therefore, only Duve, a venerable maker of mechanical and optical instruments who died in 1849, does not appear as an independent exhibitor. Martins, Leonhardt, Bötticher, and Halske all published reviews in the *Fortschritte* in 1845–1846 (see table 6.1).[37]

Thus, the Society nurtured within its membership its own source of the sophisticated instruments on which it focused its identity and that signified its commitment to a science-based industrial future. This latter commitment is as evident in the membership as it is in the iconography of their certificate. Even looking aside from the army lieutenants, who can be thought of as engineers and technical specialists, such as Werner Siemens and Otto von Morozowicz, at least twelve other members, including eight with doctorates, employed their scientific expertise in commercial and industrial enterprises. Their interests ranged over mineral water (Dr. d'Heureuse, Dr. Soltmann, and Soltman II), wine (Dr. Traube II), agriculture (Eichhorn and Dr. Kerndt), pharmacy (Dr. Großmann, Rohrbeck, Simon, and Dr. Wilhelmy), china (Dr. Wächter), and *Galvanoplastik* (Dr. Brauns). Both Karsten and Beetz also contributed actively to what could be called technoscience. Here again we see why the official report of the 1844 exhibition would have been dedicated to Magnus. Collecting instrument makers together with military and economic interests, at least twenty-six of the Berlin members of Magnus's protégé Society in the period 1846–1847 represented the city's blossoming technical-industrial culture. A few examples will enliven that picture.

Something of an institution in Berlin was the Anstalt für künstliche Mineralwasser (Establishment for Artificial Mineral Water) of Dr. Struve and Soltmann, which opened in 1823 with a Prussian patent and the king's

gez.v. Hintze.　　　Verlag von George Gropius in Berlin.　　　gest.v. Barber.

MINERAL - BRUNNEN TRINKANSTALT.

Figure 6.5 Johann Heinrich Hintze, *Mineral-Brunnen Trinkanstalt*, ca. 1833, lithograph. Spiker, Berlin.

attendance.[38] In their *Trinkgarten* (fig. 6.5), an upscale alternative to a *Biergarten*, bourgeois clients could imbibe not beer but water, the most sophisticated and chemically perfected mineral water available, also called *Heilwasser* (water of health). Struve's operation extended over much of Europe and even to the beach resort of Brighton, England, where he set up a garden called the Royal German Spa. His Berlin partner, C. H. Soltmann, was an apothecary and royal counselor who served with Magnus in the administrative section for chemistry and physics of the Gewerbefleiss Verein. Of Soltmann's several sons, two of whom joined the Physical Society, A. Soltmann obtained a doctorate in chemistry and physics, K. Soltmann received a degree in medicine, and Gustav Emil Soltmann became head of the water establishment. A fourth, Lieutenant Hermann Soltmann, was a close friend of Lieutenant Werner Siemens. It was in their *Trinkgarten* in 1845, working with Leonhardt, that Siemens had a career-defining experience. Upon encountering difficulties in getting an early model of a Wheatstone dial telegraph (hand cranked, magnetoelectric) to send signals reliably across the garden,

he generated the basic idea for a self-acting telegraph, soon to be realized in partnership with Halske.[39]

From the initial meetings of the Physical Society, one of its members was the apothecary W. J. Rohrbeck, who ran a supply store for chemical, physical, and pharmaceutical instruments. At an early meeting of the Physical Society, for example, he demonstrated a new form of *Lothrohr* (mouth blowpipe) used for qualitative and quantitative assays of metals.[40] Soon associating himself with the international firm of J. F. Luhme in London, he could offer an expansive inventory, as indicated in a later advertisement (fig. 6.6). It begins, "The factory and store of chemical and physical instruments of W. J. Rohrbeck . . . recommends itself to universities, teaching institutions, and manufacturers of technical products for equipping and perfecting chemical laboratories, chemical and physical cabinets, as well as for supplementing them with all the newest apparatus." It included advanced instruments for spectral analysis from Kirchhoff and Bunsen, polarization equipment from Dove and others for controlling sugar production, and another polarization

Die Fabrik und Lager chemischer u. physikalischer Instrumente von *W. J. Rohrbeck.*

(J. F. Luhme & Comp.) in Berlin

empfiehlt sich den Universitäten, Lehranstalten und Fabrikanten technischer Erzeugnisse zur Einrichtung und Completirung chemischer Laboratorien, chemischer und physikalischer Cabinette, sowie mit allen neuesten Apparaten zur Ergänzung, namentlich **Apparate für Spectral**-Analyse von Kirchhoff & Bunsen, von 20 bis 85 Thlr. dergl. mit einem Rohr von Mousson mit 1 und 2 Prismen, nebst dazu gehörigen Bunsen'schen Lampen und Stativen von 24 bis 36 Thlr., — Saug- und Druck-Pumpen-Modelle von 2 bis 18 Thlr., — Modelle für mechanische Potenzen 22 bis 35 Thlr., — Hydraulische Pressen mit Glas- oder Messing-Stiefel 40 bis 45 Thlr., — Modelle zur Erläuterung der Brücken- waagen 18 Thlr., — Polarisations-Kaleidoscope, Debus- cope, Polarisations-Apparate von Dove, Nörrenberg, Seebeck, dergl. für Zuckerfabrikation, und für **Aerzte,** — Polarisations-Apparate von Mitscherlich, mit neuerer Verbesserung von Kindler à 25 Thlr. nebst Beschrei- bung. — Sämmtliche chemische und pharmaceutische Glas- und Porzellan-Gegenstände zu sehr ermässigten Preisen. [1513]

Figure 6.6
Advertisement for W. J. Rohrbeck's scientific instruments. *Pharmazeutische Zeitung* 7 (1862): 144.

apparatus from Mitscherlich with the latest improvements. Thus, Rohrbeck provided a kind of commercial interchange between the interests of the Society and those of scientific education and industry as well as medicine and pharmaceuticals.

In an example that goes even more directly to the character of the Society, the *Fortschritte* for both 1845 and 1846 reviewed the exciting new field of *Galvanoplastik* (galvanic forming or sculpture), also called *Elektrotypie*. It was seen as a copying process for three-dimensional objects parallel to *Daguerreotypie* for two-dimensional images. The *Gewerbe-Ausstellung* exhibited the results of both processes. Its report compared them in typically chauvinist manner as the "northern" art (substantial) of *Galvanoplastik* versus the "southern" art (superficial) of *Daguerreotypie*, observing that the northern art had "called forth entirely new branches of industry." The Physical Society would immediately take up both processes in 1845, with Karsten providing a comprehensive literature survey of photochemistry in general, including a long section on the theory and practice of *Daguerreotypie*, and with Brauns and Beetz tackling *Galvanoplastik*.[41]

The process of *Galvanoplastik* began from a mold of wax, wood, or plaster that was coated with a conducting film such as graphite or a metallic wash. For the basic copper process, the mold was submerged as a cathode in an electrolytic solution of copper sulfate and sulfuric acid along with a copper plate of similar size as an anode. An electric current from a battery passing through the electrolyte then deposited a layer of copper on the mold in fine detail and as thin or as thick as one wished. Popular objects initially were ancient coins, medallions, and prints (fig. 6.7), then somewhat larger luxury goods such as jewelry boxes. But the size was limited by the battery power available until Werner Siemens invented his "dynamo-electric machine," announced by Magnus to the Berlin Academy in 1867, allowing for full-size sculptures.[42] Among industrial uses, letterpress printing became one of the most common.

Another local figure, Moritz Jacobi, had invented *Galvanoplastik* itself in 1837. He had previously developed electric motors in Koenigsberg and Dorpat before being recruited in 1837 to St. Petersburg.[43] Jacobi came from a Jewish banking family in Potsdam and was known in Berlin as the older engineering brother of the brilliant mathematician Carl Jacobi, founder of the mathematical-physical seminar in Königsberg, who was teaching in Berlin from 1843 on a royal pension and as a member of the Academy of Sciences.

It was David August Brauns, a young medical practitioner with wide-ranging technological interests, later turning to geology and travel as far as

Figure 6.7 Early examples of *Galvanoplastik*, or electrotype. *a*, 1841 self-portrait in copper by G. B. Spencer in England, 16.3 cm diameter. *b*, "Faust in his Study," 1840 *Galvanoplastik* from a woodcut by Count Franz von Pocci in Munich, 11 × 8.5 cm. *c*, Nineteenth-century copy of an 1815 medal by Benedetto Pistrucci celebrating the end of the Befreiungskriege at Waterloo, with busts of the allied monarchs, 6.3 cm diameter. British Museum, numbers 2006,0314.1, 2012,7057.1, 1945,0901.40.

Japan, who first reviewed *Galvanoplastik*.[44] For 1845 he could cite twenty-six new articles from German, Russian, Italian, British, French, and other journals.

> Galvanoplastik is a discovery, which through its scientific grounding as well as through its easy and simple execution and its surprising results has gained the interest not only of scholars, artists, and professional craftsmen but also of many thinking amateurs of all classes and countries.

Such widespread interest from science, art, and industry meant that enterprising experimenters tried variations on every aspect of the basic process in search of improvements. It had become a "characteristic domain of *Technik*" rather than of "dazzling discoveries."[45] Nevertheless, it required intimate knowledge of electrochemistry as well as practical skills. In 1846 Wilhelm Beetz, specializing in electrochemistry and electrotechnology, joined Brauns

to review another twenty-eight articles, including one by Jacobi himself on his (unsatisfactory) attempt to use a magnetoelectric machine (electric motor) to avoid the limited capacity of the battery as a current source for *Galvanoplastik*.[46]

This interaction between a core (ordinary) scientific member of the Society and a more practically and perhaps culturally oriented extraordinary member should be seen as characteristic for the Society in its early days, when scientifically trained young men were trying to fashion their lives with no obvious path that would lead to a successful career. The Traube brothers, sons of a Jewish wine merchant in Ratibor (a germanified town in Polish Silesia), provide a somewhat different example. Dr. Ludwig Traube (1818–1876) is well known today as a cofounder, with Rudolph Virchow, of experimental pathology in Germany. But it was not always so. He completed his medical degree in 1840, in part studying physiology and microscopy with Müller, but as a Jew he had to pursue his experimental work outside the established research networks of the Charité and the University. Nevertheless, he found fellowship in the Physical Society from 1845, when he also established with Virchow the short-lived *Beiträge zur experimentellen Pathologie*. It was the Revolution of 1848 that opened the opportunity for his *Habilitation* and teaching at the University as a *Privatdocent*. Only in 1857 was he finally appointed extraordinary professor at the Friedrich-Wilhelms-Institut (where Virchow and Helmholtz both trained as army doctors), after which his career quickly accelerated.[47]

Moritz Traube (1826–94) found a different path but also one that involved his participation with his brother Ludwig in the Physical Society from 1845. Having obtained his doctorate in chemistry in 1847, advised by Mitscherlich and examined in physics by Magnus, he tried work for a year in a dye works in Berlin and then pursued further studies in medical subjects before returning home to take care of the wine business in 1849. As a wine merchant, working in his attic, Traube did experimental work on the chemistry of fermentation and on oxygen chemistry in organisms.[48] These were just the areas in which Helmholtz had shortly before begun his work on conservation of force, presented to the Physical Society in 1847 (chap. 7).

Fortschritt

The preceding examples introduce members of the Physical Society whose activities have rarely been mentioned in the literature. They help to convey the degree to which technical-industrial culture permeated the lifeworld of the Society. The *Gewerbe-Ausstellung* was not simply a display that they went to visit; in a very real sense it occupied their meetings, their pur-

suits, and their consciousness. The instruments, materials, and processes of the industrializing world that they saw blossoming all around them provided a primary source of their inspiration. In the very materiality of this new world they recognized the means for constructing the science of the future, a future that they themselves could build.

If Magnus and other professors, working within the contested terrain of the ministries, had already put in motion the process of reforming science at the University by stressing instrument-based experimental knowledge, the Physical Society brought that process to a pointed culmination in their *Fortschritte der Physik*.[49] By consolidating their individual ambitions around this enterprise and by recruiting the most talented young men in Berlin to aid in their cause, they were able to take hold of science, or better, to take hold of the moment as scientists. Their effectiveness seems almost unbelievable. After all, not one of them held a position of any rank, authority, or prestige in the University. But they had time, for none taught at three institutions simultaneously, as their mentors had done. They also combined enviable self-discipline with enormous energy, and they possessed a confidence bordering on arrogance. No doubt they held these qualities as individuals, but no one of them as an individual could have so affected the future of physical science in Berlin, much less Germany. Instead, they realized their ambition by agreeing jointly on a definite project and infusing that project with an ideology of progress that was closely tied to the liberal side of material and political culture in the Prussian capital.

From their first organizational meeting on January 14, 1845, they began planning publication of the *Fortschritte der Physik* and ten days later began dividing up the responsibility for reports, aimed at reviewing publications in physics during the current year, at subsequent meetings.[50] "Physics" covered a broad territory. The branch of optics, for example, included physiological optics, the chemical effects of light, and optical instruments. But anything that seemed purely anatomical or purely chemical was excluded. Similar restrictions kept electricity inside the limits of electrophysiology and electrochemistry and contained heat between physiological heat and chemical heat. So "physics" meant the study of any natural phenomenon, whether inorganic or organic, that involved mechanics, light, heat, sound, electricity, or magnetism. Initially, it included also the "applied physics" of instruments and industrial technology. The entire spectrum was to be covered each year, beginning with reports delivered at the meetings, an impossible goal. Each of the actual reports at meetings treated only one or two papers, while the published reviews added many more and redistributed authorship. Karsten

had constant problems collecting the reviews; publication lags grew from two to four years by 1853. Nevertheless, the project gained a solid foothold and maintained the intellectual focus, social solidarity, and progressive drive of the Society.

Although presented in the benign form of an annual roundup of the latest work in physics, the *Fortschritte der Physik* served also as a court of judgment about what constituted *Fortschritt* and what did not. Reviews did not spare feelings; they pushed an agenda. Some reviews lavished praise; others seem now simply polemical, especially those of Du Bois-Reymond. But pursuing a bit further the categories of praise and blame in such reviews sheds light on their larger function.

Exemplary for praise is C. G. Jungk's account of the young Gustav Kirchhoff's rigorous mathematical solution for the distribution of electric current flowing in a plane, illuminated diagrammatically with curves of constant tension (equipotential lines, fig. 6.8).[51] (Compare the use of curves by Dove, Humboldt, Du Bois-Reymond, and Karsten, figs. 5.19–24 and 6.10.) The analysis earned him a prizewinning doctorate at Königsberg and an invitation to become a corresponding member of the Physical Society. Jungk called it a "problem of the highest interest," which Kirchhoff had solved through "acute observations." Similarly, Karsten did not hesitate, in his historical review on the elasticity of steam, to judge that Magnus and Victor Regnault had pushed precision measurement to the very edge of present possibility, and again, that K. H. A. Holtzmann had developed a theory (of conservation of force) that appeared to capture the law of nature itself. Readers of more than a few

Figure 6.8 Kirchhoff's equipotential lines for a copper plate with battery connections at A_1 and A_2. Current flows perpendicularly to the lines.

reviews could not fail to understand that rigorous laws and precision measurements alone would henceforth constitute *Fortschritt* in physics.[52]

More revealing of the Society's aggressive tendencies are the negative reviews. Targets of special delight were efforts to make physics out of the Hegelian dialectics of nature. In this vein, Spörer ridiculed G. F. Pohl's showing that the planets obey Kepler's laws because they follow rules similar to those of electromagnetism. Using "the mysterious hypothesis that the basic impulsion is altered by a periodic alternation of the prevalence of attractive and repulsive factors," Pohl had discovered a new law, which "is supposed to transform our entire astronomy." Unfortunately, as Spörer took the trouble to show, the law was trivially false. This case was particularly germane because the older generation of Berlin physicists and mathematicians had been incensed when Pohl, who had been teaching at a *Gymnasium* in Berlin and was a follower of Hegel's *Naturphilosophie*, had written a dismissive and uncomprehending review of Ohm's 1827 book on the galvanic circuit. Then in 1829, for reasons still unclear, Pohl was granted an extraordinary professorship at the University by the cultural ministry while Ohm was left searching for a regular position. In 1832 Pohl even obtained an ordinary professorship at Breslau. Although he offered an easy target, he served a useful polemical purpose in the Physical Society's struggle for cultural authority.[53] Since Ohm's law had meanwhile achieved international recognition, they were on the side of righteousness.

Such tactics could enhance legitimacy not only when directed against speculative metaphysics at home but also when directed against the ever-problematic French. An example is Beetz's outraged defense of Ohm against the prestigious physicist C. S. M. Pouillet's attempt to denigrate his accomplishments and even to claim Ohm's work for his own, meanwhile using gross misreadings of both Fechner and Poggendorf in support of his case. (But see chap. 8 for Helmholtz's use of Pouillet for his frog curves.) Only Pouillet's inability to read German, Beetz surmised, could have led to such misrepresentations. Despite his wish to keep personal relations out of science, therefore, it was his duty to defend "the science of the fatherland" against foreign attack.[54] In the wake of such blasts, criticisms such as Pohl's of the rigorous experimental and mathematical methods that Ohm had used appeared as the scientific equivalent of treason. And in this light even Du Bois-Reymond's polemics look somewhat more representative, as when he castigated Blandet, who had reported qualitative experiments on the human voice performed on cadavers, for not fixing the larynx mechanically, as Johannes

Müller had already done nine years previously, "in order to make the tension of the vocal cords accessible to rigorous quantitative experiments," and for not even knowing of this far more sophisticated German work, "as so commonly among his countrymen."[55]

Although nationalism is clearly evident in the attempts of the Physical Society to possess *Fortschritt*, it would be easy to overdo the point, losing the spirit of youthful enthusiasm that it expressed. The members usually extended their role as the new arbiters of validity only to rooting out what they regarded as shoddy work while wielding their newly acquired skills in measurement and mathematics as the tools of judgment. Thus, Brünnow gave short shrift to J. W. Draper's attempt in the *Philosophical Magazine* to show that capillarity is an electrical phenomenon, pointing out Laplace's mathematical demonstration that it could not result from an inverse-square law, such as governed electrostatics. Similarly, Radicke revealed at length the futility of R. Moon's attacks in the same British journal on Fresnel's theory of light as transverse waves, laughing at Moon's conclusion that "Fresnel was satisfied with a series of possibilities, upon which he has built a theory, not only of no value in itself, as having nothing solid to rest upon, but from its crudity and manifold errors discreditable to himself and to the age by which it has been received."[56] In such tactics as quoting Moon as a parody of himself, the young gods of the tree of knowledge attempted to add comedic irony to their reforming zeal. It was with an only slightly insecure arrogance that they presented themselves as the wave of the future and prepared to take on the world.

Division of Labor

To take on the scientific world still meant, for those in the relatively provincial capital of Berlin, to gain recognition from the savants in Paris and to a lesser degree in London, much as the Prussian Army defined itself technically in relation to French armaments and education and much as Prussian industry defined itself technically against British machinery and factories. These associated referents for military and industrial sophistication are evident in a report on the activities of the Physical Society during its first year written by Du Bois-Reymond for publication in the widely read French journal *Revue scientifique et industrielle.* A highly reconstructed report, it correlates only loosely with the protocols of the actual meetings kept by the Society's secretary, Wilhelm Beetz. Du Bois-Reymond's account serves instead to advertise the most impressive researches of the members drawn from seventeen published papers, but it represents quite accurately the self-image of

the Society in the eyes of its leading members. Ever the astute rhetorician, Du Bois-Reymond identified the unique virtue of the Berlin Society with its organization according to the acclaimed motor of industrial efficiency—division of labor. Its meetings, he said, provided a thorough overview of all work being done "in the vast domain of pure and applied physics." To that end they divided up the work, with each member reporting on the branch of his special study. "In this way the apparently insurmountable task of a history of contemporary physics finds itself accomplished without effort by the aid of the same principle of division of labor that plays so great a role in industrial enterprise."[57]

Continuing this association with the powers of the modern state, Du Bois-Reymond celebrated Siemens the artillery officer and his brother the London engineer for their new "chronometrical governor" for steam engines (fig. 4.5). In Du Bois-Reymond's optimistic view, this governor was "destined to replace the centrifugal force regulator of Watt," for the Siemens brothers had already employed their governor with great success in several industrial establishments in Berlin. Even in England, he claimed, the new governor was beginning to find general use. It would be difficult to think of a more symbolically appropriate claim for presenting the Physical Society as an agency to be reckoned with, for the Watt device with its two revolving balls, sitting atop engines everywhere, had become the iconic governor of steam power.[58]

Du Bois-Reymond drew out the practical import of other work as well, such as that of Karsten on the physical properties of solutions of cooking salt in relation to temperature and concentration, "studied both from the point of view of industrial production and from that of science." And he closed his report with Karsten's extensive survey and calculations on the elasticity of steam and on the weight of water vapor contained in a unit volume of air, providing information "of great importance in certain operations of the metallurgical arts, where one makes use of blowing machines." Karsten had shown, for example, that the efficiency of the new hot-air blast furnace, which had already transformed iron refining, depended crucially on the moisture content of the air (figure 6.9).[59]

Despite Du Bois-Reymond's pride in these accomplishments, there is a certain ambiguity in his presentation. Taken overall, the industrial setting seems to be just that, the setting that gives physical science its great significance for the state, even many of its concepts and tools, and yet not its purpose. This ambiguity becomes more interesting through positioning another of Siemens's appearances more carefully.

Du Bois-Reymond returned to Siemens's accomplishments to describe his

Figure 6.9 Hot-air blast furnace. Piping along the bottom delivers hot air from a large stove and blowing engine (not shown) through a pressure regulator on the left to the two injectors in the combustion area of the furnace. Dufrénoy et. al., *Voyage métallurgique*, *I*, Plate VII.

design for the Prussian Artillery Commission of the "electromagnetic chronoscope" for measuring the velocity of a projectile (fig. 4.6). In publishing the work, Siemens had wanted to establish priority for the Prussian Artillery Commission over its French and British competitors in using electromagnetic circuits for such time measurements. Du Bois-Reymond, in his chauvinist mode took the opportunity to rehearse the claim. There must surely be some humor, however, in the fact that his thrust failed when the French edi-

tor of *Quesnevilles révue scientifique et industrielle*, Abbé Moigno, seemed to have simply omitted all but a small paragraph of the account, eliminating its sting as well as its technical content. Fuming at the high-handed dismissal, Du Bois-Reymond published the missing text in the *Fortschritte* with thinly veiled accusations of willful sabotage. But then he was forced to reduce the charge to negligence when Moigno explained that the omission was accidental.[60] So far we are on the field of military-industrial and nationalist competition. But though Du Bois-Reymond certainly admired and applauded Siemens's activity there and was happy to exploit its effect, his own interests and career ambitions did not lie with the aims of army or industry. Instead, their technological accomplishments provided his resource base. In particular, the military work of Siemens and others on measuring very short time intervals had in fact been the source of Du Bois-Reymonds's own proposal, which he placed second in his report, for measuring "the velocity of propagation of the nervous principle and that of the action of the muscles."[61] Although Du Bois-Reymond himself had not realized the idea for those measurements, his friend Helmholtz soon would, famously, while drawing on the same resources (chap. 7).

If publication of the idea for the nerve and muscle measurements here served largely to secure another priority claim, it also sent warning of an impending coup to Carlo Matteucci, Du Bois-Reymond's nemesis in electrophysiology, who had a penchant for co-opting Du Bois-Reymond's discoveries as his own. Matteucci's researches, probably not coincidentally, were summarized in a report following Du Bois-Reymond's as having won him "the greatest scientific distinction of modern times, the Copley Medal," from the Royal Society of London and granting to Du Bois-Reymond nothing more than that his researches "contradicted in several points those of Matteucci."[62] It was on this field that Du Bois-Reymond imagined himself and the Physical Society winning their laurels. But they could not play without the mechanical and engineering skills of men like Siemens. This is one of the most striking features of science in the mid-nineteenth century.

More generally, the Society could not play without the collaborative work of the instrument makers whom they had drawn into their midst as extraordinary members and whose presence signified in real terms their socially liberal political stance. Fully appreciating this situation, Du Bois-Reymond included reports on the precision instruments produced by Pistor and Martins, Boetticher and Halske, and Leonhardt, whom he elevated to "ingénieurs en instruments de précisions" and "ingénieurs en instruments de physique."[63] In Prussia the French *ingénieur* still denoted an officer in the engineering

corps, or more loosely the artillery, like Siemens; in France it included civil engineers from the École des ponts et chausées. To extend the title to master mechanics trained by apprenticeship, therefore, tended to raise their status to that of potential members of an academy of sciences, which they could never have been either in Paris or Berlin. But Du Bois-Reymond's construction is again ambiguous. However progressive his intent, his new titles also suggested that a *Mechanicus* required such elevation in order properly to count as a member. Like most nineteenth-century liberalism, that of the Physical Society was not of a leveling democratic sort. It envisaged only raising those of lower status to a more meritorious rank. This example serves nicely to show how the newly organized Society, in its social as in its intellectual aims, sought to bring the agents of material progress within the purview and methods of *Wissenschaft* by pulling them up from below and from outside academic life. But that life remained exclusive.

Wissenschaft belonged to university-educated doctors pursuing research with philosophical intent. Karsten could study soda from both industrial and scientific perspectives because he possessed the credentials for science. Siemens, as an officer from the Artillerie- und Ingenieurschule, already stood on uncertain ground. But instrument makers were not *Wissenschaftler*. Thus, Du Bois-Reymond's division of labor includes what Charles Babbage in England called a division of mental labor in the factory system,[64] its analogue here being a hierarchical division between the sciences and the crafts and between ordinary and extraordinary members. Not surprisingly, therefore, Du Bois-Reymond's report on the division of labor contains primarily the work of the ordinary members who founded the Society with him and took on responsibility for different branches of instrument-based physical research: Beetz, Brücke, Heintz, Karsten, and Knoblauch, with a brief appearance by the newly recruited Helmholtz. In fact, in his case, their expectations for the productivity of the division of labor were already proving correct, as will become apparent in the two following chapters. A little foreshadowing of that story will indicate the effectiveness of cross-fertilizing specialization in the Society as well as the integration of instruments and explanations that it fostered.

As noted above, Wilhelm Beetz had made himself an expert on the electric and magnetic properties of matter and on electrotechnology (e.g., *Galvanoplastik*). Du Bois-Reymond singled out his analysis, following a suggestion of Faraday, of the passivity of oxidized iron to induced magnetization. But Beetz also studied under a microscope the spark discharge produced between the points of an open secondary circuit by a self-interrupting voltaic circuit as recently invented by Christian Neef in Frankfurt (the famous Neefian induction

coil). Beetz concerned himself primarily with the character and location of the light produced in the rapidly oscillating discharge and its dependence on temperature. Through his work, however, the elegant little machine became readily available to Du Bois-Reymond, and to Helmholtz after him, for use in studying the physiology of muscles and nerves under repetitive electrical stimulation as already initiated by Neef and others.[65]

A similar transfer of capacities came from Ernst Brücke, the Society's expert on physiological optics. Through microscopic anatomical investigation combined with optical analysis, Brücke studied the physical effect of the various components of the eye on the light entering it and registered on the retina, aiming to untangle purely optical effects from the locus of sensations. For vertebrate animals, he showed how the layer of "rods" behind the retina served to maintain precision of focus. And he attributed the changes of color in the apparent glow of a dog's eyes not to "glow" at all, nor to physiological changes in the tapetum, as had been thought, but to light reflected from different parts of it depending on the relative position of the eye of the observer.[66] Brücke's physicalist physiology provided the immediate background for Helmholtz's famous invention in 1850 of the ophthalmoscope for viewing the retina.

Brücke also explained the invisibility of light outside the red end of the spectrum as the result of the opacity of the optical media of the eye to radiant heat. This conflation between light and heat (also in Du Bois-Reymond's report) signals the increasing belief among Society members that heat is motion and that radiant heat is a wave motion either analogous to light or identical to it. In this they followed the well-known work of Macedonio Melloni on reflection and refraction of radiant heat. In practical terms, Brücke adopted Leopoldo Nobili and Melloni's use of a thermomultiplier (thermocouple plus galvanometer) to register transmitted heat, as did others in the group, including Helmholtz. More theoretically, Helmholtz took Melloni's experiments as definitive for the identification of heat with motion.[67]

The Society's local specialist on radiant heat was Knoblauch. Also following Melloni, he investigated the effect of seventy different diffuse reflecting surfaces on the heat radiated from four different sources by comparing the effect of the reflected and direct rays on a thermomultiplier after transmission through various diathermal (transmitting) media. This rather complex experiment showed that the effect of diffuse reflection depended on the source of the heat and, in Knoblauch's view, that the effect resulted from selective absorption at the reflecting surface of the particular radiation emitted from the source. In one sense these studies made more problematic the relation

of heat to light since, as Du Bois-Reymond put it, the two kinds of radiation showed no systematically analogous changes after diffuse reflection. On the other hand, the theory of selective reflection could potentially account for such differences if heat and light were both wave motions but of different wavelength. Knoblauch thus placed himself at the center of one of the major questions of physics but without speculating on the true physical theory, as was characteristic of the Society. He also took up the closely related question of mechanical work being converted into heat (as one would expect if heat were motion), reporting in the *Fortschritte* on two of James Joule's papers in which Joule gave measurements of a mechanical equivalent of heat. Again, Knoblauch declined to discuss Joule's "theoretical remarks" on the nature of heat as motion. But Knoblauch's report would supply all that Helmholtz knew of Joule's work when he wrote his classic paper on the conservation of force in 1847.[68]

A second specialist on questions of heat was Wilhelm Heinrich Heintz, but in relation to chemistry rather than physics. He wrote, for example, a long review for the *Fortschritte* on experiments done to measure the heat released in chemical reactions, especially in combinations with oxygen. He was careful to point out that the expectations of one contributor, the Russian chemist G. H. Hess, who treated heat as a chemical substance rather than motion, were not born out. On the chemical theory, when one substance combined with another in successive integral proportions, any heat released should also have shown integral proportions, but it did not. On the other hand, Hess's results did show that the amount of heat liberated in a given chemical combination depended only on the final product, not on whether the process was direct or indirect. Such path independence, which came to be called Hess's law, suggested some form of conservation principle. Once again, Helmholtz made immediate use of these and others of Heinz's results.[69]

In their president and editor, the physicist Gustav Karsten, the Society had yet another broad-based specialist concerned with heat, especially from the industrial perspective, as Du Bois-Reymond stressed. Karsten's extensive tabulation of measurements and calculations on the density of steam—which he advertised to cultural minister Eichhorn in the epigraph to this chapter—is typical for his stress on precision measurements. He also supplied an account of Karl Holtzmann's theory of the production of heat by mechanical work, which Helmholtz would exploit as one of his basic references for thinking about the problem.[70] Karsten stood at the forefront of *Fortschritte* in other respects as well, ranging from his use of the method of least squares to obtain a power-series representation of his data on common salt to his

exploration of photographic chemistry. The latter produced the picture of the founders in figure 6.1 and his extensive survey of the literature that had already accumulated by 1845.

Du Bois-Reymond reported for himself on his several interrelated studies of the electrophysiology of frog muscles and nerves, especially "the laws governing the excitation of motor nerves by the electric current" and the laws of muscular contraction and compression. His reports emphasize the analytic tool that he had come to see as the expression of nature's own language and on which he had based the iconography of the Society itself, namely, the line that could make the laws immediately visible. For example, a curve of current density in a nerve versus time would make clear that nerve excitation depended not on the height of the curve, which registered the "intensity" of the current (*force électro-dynamique*), but on the "form" of the curve, its rate of change or slope. The excitation was thus a case of electromagnetic induction, "as in magneto-electric machines." On the other hand, the "sum of the electrodynamic effects of the current" in a given time would be given by the area under the curve in that time, which would have an electrochemical equivalent in the quantity of zinc oxidized in a battery while producing the same current. In this visual distinction between the slope and the area, Du Bois Reymond hoped to make plain that Matteucci's attempt to find the electrochemical equivalent of the excitation, and thereby of the work done by the excited muscle, was incoherent ("gar keinen Sinn hat"). More importantly, Du Bois-Reymond's explicit introduction of the problem of the relation between electrochemical equivalents and mechanical work done, like Knoblauch's concern with the mechanical equivalent of heat, constituted a critical piece of the background to Helmholtz's work on conservation. His focus on induction, furthermore, pointed up the necessity of finding the mechanical equivalent of electromagnetic induction.[71]

A similar emphasis on the interpretive significance of curves, but in a nonaggressive mode, concerned measurements made by Müller's former assistant, Theodor Schwann, of the force of contraction of a muscle in relation to the distance from its fully contracted position. The force appeared to decrease linearly as the muscle contracted, somewhat like Hooke's law for an elastic band contracting, and yet not quite, because when Du Bois-Reymond actually graphed Schwann's data, the curves revealed a characteristic convexity toward the axis of abscissas. Thus the actual law was the law of the curve. Paying attention to its form might suggest the true character of the action responsible for contraction.[72]

Du Bois-Reymond's discussions of curves convey a definite aesthetic

sense of their value in terms of simplicity, precision, and depth of insight. It is also a very practical aesthetic, emphasizing economy of presentation and force of persuasion. These were qualities becoming widely appreciated in his milieu. Dove, for instance, had first called his attention to the slope of the curve of current as its salient feature for excitation. But it was engineers who had made the most effective use of curves in analyzing the operation of machines and engines. The instrumental and utilitarian association stayed with the curves as they found wider employment. Karsten's work on the solution of common salt in water provides a characteristic example. Although "an exact knowledge of the general laws" controlling the complex phenomena could not be expected, he had been able to provide an empirical equation for calculating the precise tables required by *Salinisten* to operate with economy. He then produced a graphic representation "in order to be able to survey at a glance [*auf einen Blick*] all of the characteristics of the salt-solution," otherwise contained in over a hundred pages of tables.[73]

In Du Bois-Reymond's formulation, "Several other parts of his work present more of interest from the technical point of view and are destined to guide the operations of large-scale exploitation of this precious alimentary substance. [But] the curves [*tracés graphiques*] . . . offer an immediate perception [*aperçu facile*] of the principal laws that he has managed to establish" (fig. 6.10). We will find Helmholtz, too, exploiting the potential of the curve as an instrument of engineering and *Anschauung*. By then, however, Du Bois-Reymond had already given the prescription for functional relations (chap. 5): "The dependence of the effect on each circumstance presents itself in the form of a curve . . . whose exact law remains . . . unknown but whose general character one will in most cases be able to trace."[74] The *Fortschritte* for 1846 contained at least fourteen reviews of articles that employed curves in a similar way, including one on "isochromatische Curven oder Linien," referring directly back to Alexander von Humboldt's isothermal lines, and others to the now-familiar lines of magnetic force of Faraday.[75]

The image of division of labor with which Du Bois-Reymond chose to introduce the Berlin Physical Society to the world captures rather well the way in which they divided up the work in order mutually to enhance the productivity of each member. And in evoking industrial enterprise it suggests both the productivity of their work for the modern state and their commitment to instruments—often instruments deriving directly from army and industry—as machines for advancing knowledge. It acknowledges, too, their dependence on sophisticated instrument makers to build in the refinements that they required for precision. All of this makes the Society look like

Figure 6.10 Karsten's curves of volume and density of salt solutions over a range of temperatures from 0° to 100°C, intended to capture "at a glance" the full scope of their variations. Karsten, "Der Auflösungen des reinen Kochsalzes."

an efficient factory of knowledge, like a modern laboratory. And indeed, its members would be key leaders in the laboratory movement that swept so much of physical science by the 1870s. Appropriately, Sven Dierig chose the factory metaphor to characterize the Physiological Institute that Du Bois-Reymond was able to establish in Berlin following the Franco-Prussian War.[76] The image of the research laboratory as factory, however, depends not only on the availability of state support but also on a crucial social-academic shift of the 1840s.

The Physical Society Post-*Verein*

Throughout this chapter I have depicted the Physical Society as a relatively open and socially diverse study group, albeit with some hierarchy of membership. That structure marks the social-political character of the Society as a typical *Verein* of the *Vormärz*, providing in principle a forum for the social mixing of all levels of respectable society (the public [*die Öffentlichkeit*]), often with a rational liberal political outlook, however moderate (see the introduction). In the Physical Society, technical knowledge served as a carrier of meritocracy and, to that degree, of democratization. From this perspective, the presence of eight aristocrats along with several mechanics

looks rather natural. From this perspective also, as well as from the presence of the sons of city and state councilors (d'Arrest, Brünnow, Karsten, Knoblauch, Poselger, Soltmann), the Physical Society looks somewhat like a small, second-generation version of the Gewerbefleiss Verein, which had organized the 1844 exhibition.

But of course there was a major difference. The new Verein aimed not primarily to enhance industrial technology by drawing scientific expertise out of the University but to draw the technical world into the University, to insist that *Fortschritt* would henceforth turn on the mastery of mechanical and electrical instruments as well as on books and learning. Thus Dierig applies the label *Handwerksgelehrte* (craftsman-scholar) to Du Bois-Reymond, adopting the term that Sibum applied to people such as Moritz Jacobi, who occupied both worlds, like a *Fledermaus* (flying mouse, or bat). Eugen Dühring originally applied the derogatory label to Helmholtz and similar laboratory scientists in 1880 because of their supposed guild-like behavior in the University, making experimental work an indispensable requirement for research in every domain of the natural sciences.[77] The change in direction that they helped to enforce has often seemed intellectually revolutionary, as indeed it was, but it was a subtle shift nonetheless in which the existing ideological orientation and social form of the Verein were turned toward reorganizing academic science.

Following the March Revolution of 1848, this newly activist character of the Physical Society found an epitome in their petition to the Academy of Sciences, instigated by Du Bois-Reymond and delivered in June, to open Academy meetings to nonmembers.[78] They expressed the "hope that the principle of public access [*Prinzip der Öffentlichkeit*] would take its place in the domain of science and that it might please the Academy to open the doors of its meeting rooms to all those who venerate in it the finest representative of German science," thereby recognizing the source of strength "in a constitutional state." A nearly full spectrum of the Society—twenty-one of forty-eight members, including four mechanics and several other economically interested members (but lacking any lieutenants or aristocrats except von Morozowicz)—signed the petition along with eighty-four others, including Alexander von Humboldt. As expressed in a more polemically worded appeal in January 1849, they expected the Academy to find through public meetings "that one can be very, very learned and yet a man of the people." One of the carriers of this message was certainly the prominence of technical expertise in industrializing Berlin. The Academy, however, opened its doors only a little, to more guests invited by members.[79]

As observed above, the enterprise of reforming academic science was not the primary interest of mechanics and other nonacademics in the Physical Society. They provided a critical support base for the Society, both materially and socially, but among the mechanics only Halske, and among the engineers and commercial-industrial members only Siemens, contributed more than an occasional review to the *Fortschritte der Physik*. The academic reform campaign was the work of the university-trained men who made up the main body of the Society and whose academic careers were at stake in its success. They were among the many people producing what has become known as the professionalization of science. One effect was the disappearance of mechanics from their membership. Pistor died in 1847, Leonhardt in 1848, and Duve in 1849. They were not replaced. The young army officers vanished just as quickly. Much more broadly, engineers found that organizations of natural science did not meet their needs. In 1856 they formed their own professional society, the Verein deutscher Ingenieure.

These new organizations turned upside down the traditional ideal of a *Verein* as a meeting ground for crossing social boundaries. Instead they established stronger exclusionary barriers. The Physical Society as a *Verein* in its *Vormärz* configuration did not survive the failure of the 1848 revolution.[80] By the end of 1849 at least forty-four of fifty-five members held a doctorate and fifteen had obtained professorships. Of the remaining eleven, seven were original members. Only two new army officers appeared, with one of them carrying the new face of the Society in his titles: Lieutenant *Doktor* von Bruchhausen. Manifestly, the original Verein was fast becoming a professional academic society.

The professionalization of science in the nineteenth century has long been a subject of historical and sociological interest, and the physiologists of the Berlin Physical Society have been one of the cases most prominently (or too prominently) discussed because of the success of their physicalist program and the fame several of them attained. Timothy Lenoir has provided the most persuasive (and provocative) case for a definitive turn in their orientation following the Revolution of 1848. Bitterly disappointed with the debacle, they largely abandoned their pursuit of major social-political change and accommodated themselves to the reestablished reality of a conservative monarchical society. But they did so by identifying themselves with the "material interests" of the rapidly industrializing state and re-presenting their reductionist physiology as an example for modern society.[81] I find Lenoir's basic argument unexceptionable. I would add emphasis, however, to the thorough grounding of the Physical Society in the industrial context from its inception

and on the role of the physiologists' peers in physics and chemistry, which lends considerably more continuity to the development.

My interests have been focused on where the Physical Society came from rather than on where it went. Continuing that theme, the following two chapters will explore how Hermann Helmholtz in the 1840s drew on the resources available to him in the local context of Berlin and the Physical Society to produce two of his most famous works, on conservation of force and on the propagation of the nerve impulse.

NOTES TO CHAPTER SIX

1. Gustav Karsten to Cultural Minister Eichhorn, August 18, 1846, sending his review of new research from the first number of the *Fortschritte der Physik*. Staatsbibliothek zu Berlin, Preussischer Kulturbesitz, Handschriftenabteilung, Slg. Darmst., La 1859 (9), Gustav Karsten, Bl. 56. Gustav Karsten, "Gäse und Dämpfe."

2. Sibum, "Experimentalists"; Dierig, *Wissenschaft in der Maschinenstadt*.

3. The relevant documents are GStA PK, I. HA Rep. 76 Kultusministerium Vc, Sekt. 2, Tit. 23 A, Nr. 50, Bd. 1, Bl. 1; I. HA Rep. 77 Kultusministerium, Tit. 662, Nr. 2, Bl. 10–11 and 16–20. "Protocoll," January 14, and April 18, 1845. Detailed in Fiedler, *Die Physikalische Gesellschaft*, 28–33; Schreier, Franke, and Fiedler, "Geschichte der Physikalischen Gesellschaft," F-13, discuss the character and status of *wissenschaftliche Vereine* in the first half of the nineteenth century, including the appearance of quite specialized groups such as the Berlin Physical Society. They also assemble much of the existing literature on the Society.

4. On the struggles between economic liberals like Karsten and the conservative elite of the Mining Corps and between state and private iron production, see Brose, *Politics of Technological Change*, 41–163. Wilhelm von Gümbel, "Karsten, Karl Johann Bernhard," *Allgemeine Deutsche Biographie* (1882), https://www.deutsche-biographie.de/gnd116061235 .html#adbcontent. Peschken-Eilsberger, "Das Schadow Haus," 30.

5. Table 6.1 summarizes information from many sources: Berlin address books; correspondence in the Staatsbibliothek Preussischer Kulturbesitz, Handschriftenabteilung; *Poggendorffs Biographisches-Literarisches Handwörterbuch*; *Fortschritte der Physik*; Schreier, *et. al.*, "Geschichte der Physikalischen Gesellschaft," and others.

6. Bezold, "Festrede," 19–25; "Zur Vollendung"; Warburg, "Zur Geschichte der Physikalischen Gesellschaft."

7. Membership list of March 1847 in GStA PK, Rep. 76 Kultusministerium Vc, Sekt. 2, Tit. 23 A, Nr. 50, Bd. 1, Bl. 8.

8. Müller, "Über den feinern Bau," 11; Stürzbecher, "Auf dem Briefwechsel"; "Zur Berufung Johannes Müllers."

9. My account is indebted to Otis, *Müller's Lab*. The literature is large and diverse in interpretation.

10. Otis, *Müller's Lab*, 26–31. Specimen numbers from, Du Bois-Reymond, "Gedächtnisrede auf Johannes Müller," 290–91. On the relation of anatomy and physiology in Müller's conception of "morphology" and *Naturphilosophie*, see Nyhart, *Biology Takes Form*, 39–47.

11. Reichert, "Über den Furchungs-Process"; Brücke, "Über die stereoskopischen Erscheinungen" (here almost pure geometry); Helmholtz, *De fabrica systematis*.

12. At the 1844 industrial exhibition in Berlin, *Mechanicus* F. W. Schieck (former partner of Pistor) displayed seven microscopes, from 110 thaler for a mid-sized instrument to 200 thaler for a large one including a micrometric measuring device. *Amtlicher Bericht*, pt. 2, sec. 1, p. 420. Student living expenses and Müller's own microscopes in Otis, *Müller's Lab*,15, 58n87, Du Bois-Reymond's microscope on p. 80. Du Bois-Reymond to Hallmann, August 19 and December 26, 1840, *Jugendbriefe*, 66, 79. Helmholtz's microscope in Koenigsberger, *Helmholtz*, 1:45.

13. Otis, *Müller's Lab*, 42–75, cell theory on 62–64.

14. On the Academy chemical laboratory, which Mitscherlich took over in 1822, see Klein, *Humboldts Preussen*, 241–44, 286–88.

15. Erman, *Erman*, 125, 174. A. Dove, "Dove."

16. Poten, *Geschichte*, 4:392–95, 408–9.

17. Wolff, "Gustav Magnus," 11–16, based on ministerial archives and Magnus's correspondence with Berzelius in Archiv der Nobelstiftung in Stockholm. Standard biography (hagiographic but informative) in Hofmann, "Gustav Magnus"; "Magnus, Heinrich Gustav." Eduard Magnus in Wirth, *Berliner Malerei*, 129–38.

18. Mieck, "Hermbstaedt," 368–69, 372–73.

19. Wolff, "Gustav Magnus," 20; Mieck, "Hermbstaedt," 369.

20. Wolff, "Gustav Magnus," 20–21. Both Erman, *Erman*, 175, and Hermann, "Physiker und Physik," 404, give the 500 thaler figure. Poten, *Geschichte*, 4:408–9.

21. Cahan, *Letters*, 49, 58–59.

22. Wolff, "Gustav Magnus," 22–23.

23. Having lost the ordinary professorship in Königsberg to Franz Neumann, Dove accepted a position at a Berlin *Gymnasium* while requesting a transfer of his Königsberg position to Berlin. Altenstein approved the transfer under severe conditions: no salary for two terms and only 200 thaler per year thereafter. Despite Dove's increasing reputation and election to the Academy in 1837, his University salary increased only in 1841 under the new cultural minister, J. A. F. Eichhorn. Dove, "Dove."

24. Dove, "Dove."

25. Becker, "Zur Geschichte des Magnus-Hauses"; Becker, "Geschichte des Hauses," in Becker and Jacob, *Das Magnus Haus in Berlin-Mitte*, 32–71.

26. Schreier, Franke, and Fiedler "Geschichte der Physikalischen Gesellschaft," F-11.

27. Karsten, "Vorbericht," *FdP [1845]* 1 (1847): iii–x.; Helmholtz, "Zur Erinnerung an Rudolph Clausius"; Wiedemann, "Feier."

28. Ebert, "Die Gründer," gives the larger number. Kant, "Magnus und seine Berliner Physiker-Schule," 43–45, can confirm, among those who later became *Ordinarien*, only Beetz, Brunner, Eichhorn, Helmholtz, Langberg, and Wiedemann.

29. Hermann, "Physiker und Physik," 404. Pringsheim, "Gustav Magnus," also stresses the role of Magnus's instruments.

30. *Amtlicher Bericht*, pt. 1, pp. 26–27. The exhibition began August 15, 1844, and ran for eight weeks. The Central-Ausstellungs-Kommission, under the overall direction of the

Gewerbe-Departement in the finance ministry, contained sixty-three members of the Gewerbefleiss-Verein plus three members of the Technical Deputation, along with a few representatives of other ministries.

31. *Amtlicher Bericht*, pt. 1, p. iv, from a *Festrede* at the exhibition. See also pp. 9–13 on the Zollverein and free competition.

32. A good summary is Voth, "Prussian Zollverein," 124.

33. *Amtlicher Bericht*, pt. 2, sec. 1, p. 427, 425 (on the elegance combined with durability of German eyeglasses vs. the French *Galanterie-Arbeiten*); and see below on German *Elektrotypie* vs. French *Daguerreotypie*.

34. Du Bois-Reymond to Hallman, September 3, 1844, in E. Du Bois-Reymond, *Jugendbriefe*, 119. Dierig, "Die Kunst des Versuchens," 143.

35. *Amtlicher Bericht*, pt. 2, sec. 1, p. 421, 435. On Du Bois-Reymond's relation to Halske and the instrument-building culture of Berlin, see Dierig, *Wissenschaft in der Maschinenstadt*, 30–48; Goetzler, "Halske," 135–40; Du Bois-Reymond, "Halske"; Schreier, Franke, and Fiedler "Geschichte der Physikalischen Gesellschaft," 36–37.

36. *Amtlicher Bericht*, pt. 2, sec. 1, pp. 410–11; Zaun, *Pistor & Martins*. On the Prussian foot, see Bessel, "Ueber das preussische Längenmaass," Pistor on 196; Schumacher, "Reflexions-Instrumenten der Herren *Pistor* und *Martins*" (observations made by Schumacher's son Richard, September 1844–March 1846).

37. For Leonhardt and Knoblauch, see Mieck, *Preussische Gewerbepolitik*, 243. Titles of original papers, mostly as published but first presented at meetings of the Physical Society, are given in the *Vorbericht* of each volume, beginning with vol. 2, which includes 1845 and 1846. The published papers compare somewhat roughly with the "Protocoll" of the 1845 meetings. On early work establishing Duve's reputation, see Fischer, "Sehr vollkommenen Parallelspiegeln."

38. Grosse, "Struve."

39. Siemens, *Lebenserinnerungen*, 37–38. For images of telegraphs see Steven Roberts, *Distant Writing: A History of the Telegraph Companies in Britain between 1838 and 1868*, Instrument Gallery, image 60 (Siemens and Halske, 1847) and image 82 (Wheatstone, 1843) (http://distantwriting.co.uk/instruments.html).

40. Rohrbeck presentation on April 18, 1845; "Protocoll." Pochhammer had discussed improvements to the Lothrohr of Batka on February 21.

41. *Amtlicher Bericht*, pt. 2, sec. 1, p. 352, 422 (quotation). Karsten, "Chemische Wirkung des Lichtes."

42. Siemens, "Ueber die Umwandlung von Arbeitskraft" (presented by Gustav Magnus). Wheatstone independently invented a similar generator at the same time. A rare exception in size is the 1865 electrotype of the *Porta di San Ranieri* (by Bonanus of Pisa, ca. 1180, in Pisa Cathedral) in the Victoria and Albert Museum (no. 1865–58). The doors are 290 cm × 165.5 cm (http://collections.vam.ac.uk/item/O40945/porta-di-san-ranieri-electrotype-bonanus-of-pisa/).

43. See Sibum, "Experimentalists," for Jacobi's relation to the academic world; Jacobi, *Die Galvanoplastik*.

44. Brauns, a practical medic (*praktischer Aerzt*, without completion of the doctorate),

published such technologically oriented books as *Praktisches Taschenbuch für Ingenieure und Techniker* and *Die technische Geologie*, obtained his doctorate in geology in Halle in 1874, and published a number of books on regional geology, including the environs of Tokyo, while traveling extensively with his wife, the writer C. W. Emma Brauns (born Eggers). *Poggendorffs Biographisches-Literarisches Handwörterbuch*, vol. 3 (Leipzig: Barth, 1898).

45. Brauns, "Galvanoplastik."

46. Brauns and Beetz, *FdP [1846]* 2 (1848): 421–36, on 426–27. Jacobi, "Vorläufige Notiz über galvanoplastische Reduction." Beetz had already reviewed some galvanoplastik apparatus, *FdP [1845]* 1 (1847): 467–70, including papers by Jacobi.

47. Schmiedebach, "Pathologie bei Virchow und Traube"; Pagel, "Traube."

48. Franke, "Traube."

49. Gustav Wiedemann later observed that Magnus had already planned a review like the *Fortschritte* in his Colloquium, *VdVPG* 40 (1895), 32–36, on 35.

50. See "Protocoll."

51. Kirchhoff, "Ueber den Durchgang eines elektrischen Stromes," discussion of galvanometer measurements and curves for fig. 3 on pp. 508–12.

52. Warburg, "Zur Erinnerung an Gustav Kirchhoff"; C. G. Jungk, in *FdP [1845]* 1 (1847): 451–56, reviewing Karsten, "Gase und Dämpfe," 90–91.

53. G. Spörer, February 21, 1845; "Protocoll." *FdP [1845]* 1 (1847): 544–48, on 545, reviewing Pohl, *Kepler'schen Gesetze*. See, however, Gustav Karsten's quite balanced posthumous appreciation of Pohl's "Reihe trefflicher exacter Experimentaluntersuchungen" along with his commitment to *Naturphilosophie* in "Pohl, Georg Friedrich," *Allgemeine Deutsche Biographie* 26 (1888), https://www.deutsche-biographie.de/gnd104208791.html#adbcontent. See also Jungnickel and McCormmach, *Intellectual Mastery of Nature*, 1:18, 28, 56, 121, 127, 229–30, who make this a case (doubtful) of the cultural ministry being devoted to Hegel.

54. Wilhelm Beetz, in *FdP [1845]* 1 (1847): 442–47.

55. Emil du Bois-Reymond in *FdP [1845]* 1 (1847): 145–46.

56. F. Brünnow, in *FdP [1845]* 1 (1847): 30–31; F. W. G. Radicke in *FdP [1845]* 1 (1847): 163–75, on 175.

57. [Du Bois-Reymond], "Progrès des sciences," 81. The report is unsigned, but Du Bois-Reymond's pen is apparent. The published papers are listed in the "Vorbericht" of *FdP* 2 (1848): xv–xvi. Interestingly, several teachers of Physical Society members, as well as other familiar Berlin scientists, were "Collaborateurs étrangers" of the journal: Mahlmann, Magnus, Dove, Poggendorff, Riess, Jacobi, Mitscherlich, and Rose.

58. [Du Bois-Reymond], "Progrès des sciences," 81–82. Siemens, "Beschreibung," 81–89.

59. [Du Bois-Reymond], "Progrès des sciences," 92, 96. Gustav Karsten in *FdP [1845]* 1 (1847): 43–46, summarizes his "Auflösungen des reinen Kochsalzes in Wasser." Karsten, "Gase und Dämpfe," "Hygrometrische Tabellen," and "Hygrometrische Tabellen zur Anwendung." *FdP [1846]* 2 (1848): 116–18.

60. Siemens, "Geschwindigkeitsmessungen"; "Anwendung": [Du Bois-Reymond], "Progrès des sciences," 86; restored text with Du Bois-Reymond's irritation in *FdP [1845]*

1 (1847): 610–14. The loose relation between Society meetings and publications is nicely illustrated in that it was actually Knoblauch who first reported on the measurement of short-time intervals, discussing Poncelet at the first meeting where reports were presented, February 21, 1845. He continued with Breguet's measurements of projectile velocity on March 7, when Du Bois-Reymond and Siemens followed with a report on similar apparatus, especially the Leonhardt-Hartmann clock, which preceded Siemens's invention. All of this got collapsed into Siemens's published review. Cf. "Protocoll."

61. [Du Bois-Reymond], "Progrès des sciences," 82.

62. Matteucci, "Recherches sur les phénomènes électro-physiologique," 96, 99. Du Bois-Reymond let loose his outrage at Matteucci in Du Bois-Reymond, "Der sogenannte Frosch- und Muskelstrom."

63. [Du Bois-Reymond], "Progrès des sciences," 87.

64. Babbage, *Economy of Machinery and Manufactures*, 135–43.

65. [Du Bois-Reymond], "Progrès des sciences," 85, 95; Beetz, "Elektrische Phänomene"; Neeff, "Ueber einen neuen Magnetoelektromotor," "Ueber das Verhältnis der elektrischen Polarität," and Neeff's original—not self-interrupting—device, "Das Blitzrad."

66. [Du Bois-Reymond], "Progrès des sciences," 85; Brücke, "Physiologische Optik," 224–25, and "Anatomische Untersuchungen."

67. Moigno deleted this report on Brücke, but Du Bois-Reymond restored it in *FdP [1845]* 1 (1847): 610–11. Brücke, "Physiologische Optik," 224; "Ueber das Verhalten der optischen Medien." Both Knoblauch and Christian Langberg, from Oslo, carried out research on heat conduction using a thermomultiplier (Langberg at least in Magnus's laboratory). Achieving great sensitivity and stability with this instrument, however, proved a constant challenge. In using it to detect the heat produced in working muscles, Helmholtz would find it necessary to redesign all of its components and to have his galvanometer built by Halske, along with a redesigned Neefian induction coil.

68. [Du Bois-Reymond], "Progrès des sciences," 83–84; Knoblauch, "Wärmeentwicklung"; "Strahlende Wärme," 366–70; "Ueber die Veränderungen."

69. Heintz, "Wärmeentwicklung"; [Du Bois-Reymond], "Progrès des sciences," 83. Heinz also showed the Society that there are probably left-polarizing sugar solutions on March 7, 1845; "Protocoll."

70. [Du Bois-Reymond], "Progrès des sciences," 86, 91, 95; Karsten, "Gase und Dämpfe," 90; Holtzmann, *Ueber die Wärme*.

71. [Du Bois-Reymond], "Progrès des sciences," 83, 85–86, 91, on 83, 85; "Einwirkung," "keinen Sinn" on 506. Du Bois-Reymond's discussion of the rate of change of the nerve current is bound up with his discovery of what he called "unipolar induction": the excitation of a nerve and muscle when connected to one end of an open secondary circuit under electromagnetic induction from a primary. The nerve and muscle thus acted as a "rheoscopic frog" in the tradition of Galvani.

72. [Du Bois-Reymond], "Progrès des sciences," 89–90.

73. Karsten, "Der Auflösungen des reinen Kochsalzes," 3–4, 82.

74. [Du Bois-Reymond], "Progrès des sciences," 92–93; *Thierische Elektricität*, 1:26–27; "Culturgeschichte und Naturwissenschaft," 612–13.

75. E.g., Brewster, "Schreiben on A. v. Humboldt" (part of a long review by Poselger), and several papers of Faraday, reviewed by Krönig, *FdP [1845]* 1 (1847): 543–61.

76. Dierig, *Wissenschaft in der Maschinenstadt*, pt. 3, "Fabrik," 145–272. See also Todes, *Pavlov's Physiology Factory.*

77. Sibum, "Experimentalists"; Dierig, *Wissenschaft in der Maschinenstadt*, 30–48.

78. Finkelstein, *Emil du Bois-Reymond: Neuroscience, Self, and Society*, 83–85.

79. Schreier, Franke, and Fiedler, "Geschichte der Physikalischen Gesellschaft," 17–18. Schreier, "Magnus und die Physikalische Gesellschaft" reproduces the petition with signatures, 61–64, from the *Akademiearchiv.*

80. On the post-1849 "golden age" of the *Verein* movement, which the Physical Society did not share, see Hoffmann, *Geselligkeit und Demokratie*, 55–73.

81. Lenoir, "Social Interests."

THE MECHANISM OF MATTER
Hermann Helmholtz's *Erhaltung der Kraft*

Just as the authentic work of art bears no foreign intrusion without being spoiled, so also to him [Goethe] is nature in her harmony disturbed, tormented, confounded by the intrusion of the experimenter, and therefore she deceives the invader through a distorted image.
— Helmholtz[1]

Figure 7.1 The nymphs of nature tangle the straight lines of the Berlin Physical Society. Detail, fig. 5.1.

Hermann Helmholtz entered into the circle of young men who had formed the Physical Society when he returned to Berlin from his post as an army doctor in Potsdam in the fall of 1845 to complete his state medical examinations. In December he began some modest experimental work in the private laboratory of Gustav Magnus, perhaps facilitated by Johannes Müller, with whom he had completed his doctorate in 1843. Helmholtz scholars have rightly emphasized that on stepping into Magnus's house, the young army doctor entered Berlin anew, joining a concentrated node of activity and aspiration. There Helmholtz first met Emil du Bois-Reymond and through him another Müller

student, Ernst Brücke, who became his initial points of reference for physical analysis of physiological processes.[2] But more important than meeting them individually, he met them as participants in that mutually reinforcing company of physiologists, physicists, chemists, engineers, mechanics, and their technical-industrial peers who constituted the new Physical Society. Without the intensity and the intellectual and technical resources of this group, and without their self-assertive promotion of rigorous physical methods, it is difficult to imagine Helmholtz pursuing the work that first established his fame.

At the same time, his own attraction to physics and mathematics ran deep. As he expressed it much later, they offered an escape from two self-diagnosed disabilities in the world he faced. "I was a sickly boy"—confined for much of his first seven years to his room or to bed and being small in physical stature—and "I had a weak memory for unconnected things"—thus wanting the most critical skill, memory, required for the classical *Gymnasium* in Potsdam, where his father Ferdinand Helmholtz was subrector and professor of philology. Helmholtz first found empowerment through geometry and then physics. His father supported this alternative even though "mathematics was always regarded in the school as a subject of secondary rank."[3] Helmholtz found that knowing the "law of the phenomena" allowed him to put disconnected fragments in order and thereby to remember them even more effectively than through another favored mnemonic, the rhythm of poetry. "I was first of all a great admirer of poetry," he recalled, but it was law that gave him a sense of power. As he loved poetry, so he "acquired a great love of nature," but inflected always with the urge to dominate it: "And, in fact, that which first fascinated me was the intellectual mastery over Nature . . . by the logical form of law . . . the magical key that puts power over Nature in the hands of its possessor." It thereby "developed into a drive of passionate fervor. This drive to dominate reality by acquiring an understanding of it . . . to discover the causal connection of phenomena, has guided me through my whole life."[4] Thus, Helmholtz's love of poetry, as of music and of art, requires always to be seen as stressing conceptual clarity, discipline, and clean lines, devoid of any mysterious powers that would defy analysis. He was immersed simultaneously in the neoclassical aesthetics discussed in chapter 5 and in the experimental culture of the Physical Society described in chapter 6.

Helmholtz's self-analysis from 1891 matches well his earlier expressions of the necessity of supplementing poetic intuition with physical law and of subjecting the "descriptive natural sciences of botany, zoology, anatomy, etc.," to causal analysis. In 1853, for his first popular lecture, he chose to articulate this view by launching a critique of the excesses of Goethe himself, whose attacks

on the Newtonian analysis of colors had already been widely denounced by Helmholtz's physicalist forbears in Berlin, Fischer, Erman, Dove, and Magnus among them. As Helmholtz's earliest foray into the contest brewing between the *Naturwissenschaften* and *Geisteswissenschaften*, his lecture attempted a clear distinction between *Erklärung* (explanation) and what would soon be called *Verstehen* (understanding). Lacking a specific word for this latter process of acquiring through immersion in another historical (or natural historical) formation a direct intuitive awareness of the ideas essential to its complex existence, Helmholtz let Goethe exemplify its indefinite contours and limited accessibility: "Such an *aperçu*, such a becoming-aware, conceptualization, presentation, concept, idea, or whatever one likes . . . always retains an esoteric character." In contrast, *Erklärung* provided lucid analysis through abstract concepts removed from subjective impressions. "For a natural phenomenon is fully explained physically only when one has traced it back to the ultimate forces of nature that ground it and are effective in it," by which he meant "a world of invisible atoms, motions, attractive and repulsive forces, that work in a law-governed but complex entanglement scarcely to be deciphered at a glance." Goethe's attempt to protect direct perception from invasive analysis was, for all its attractions, "senseless" as explanation. "We can conquer the mechanism of matter . . . only by subordinating it to the purposes of our moral intelligence. We must familiarize ourselves with its levers and pulleys . . . in order to be able to rule them according to our own will, and therein lies the great significance of physical research for the culture of man and its full justification."[5]

In this drive for conceptual domination, Helmholtz moved well beyond Alexander von Humboldt's idea of the civilizing power of natural science, which extended the intimate contact with nature of human sensibilities (chap. 5). He may be said to have supplemented Humboldt's aesthetics of sensibility with an insistence on *Begreiflichkeit*, the much-discussed concept of comprehensibility (also intelligibility or graspability) deriving from Kant, which will figure importantly below.

Helmholtz's Goethe lecture, from which I have taken my chapter epigraph, suggests why he found his natural home in the Physical Society. In terms of Du Bois-Reymond's iconography (fig. 7.1), Goethe's views on light remained with the entangling nymphs of nature in the mystical underworld. In contrast, Newton's spectral analysis with a prism occupied a high branch in the tree of knowledge (fig. 5.27), epitomizing the confluence from left and right of intellectual and material civilization through natural science. If during his youth at the Potsdam *Gymnasium* Helmholtz had adapted himself only

with difficulty to a system of education that subordinated his own talents to ancient languages, in 1845 he had found a promising social and intellectual node from which to redress the grievance. And although the new cultural ministry under Eichhorn, in granting permission for a group of brash young men to found the Physical Society, surely did not recognize a new cultural force for attaining the long-sought balance of philology with natural science, it is clear that its members saw the Society as just such an agency. While preserving their own strong aesthetic values, they set out to rid the natural sciences of anything that smacked of mysterious and unanalyzable forces.

I seek in this chapter the particular materials that Helmholtz found in his new milieu for building the foundations for that project and especially for his extraordinary work of 1847, *Ueber die Erhaltung der Kraft* (*On the Conservation of Force*). Known as the most general and profound of many statements of what would become the principle of conservation of energy, it is one of the all-time classics of the history of science. A thorough conceptual analysis of the short treatise is that of Fabio Bevilacqua.[6] I will supplement his and other accounts in three primary areas corresponding to three sections below: the role of Justus Liebig and the *Lebenskraft* in Helmholtz's earlier papers; the role of engineering mechanics in the *Erhaltung* itself;[7] and an interpretation of Helmholtz's puzzling concept of *Spannkraft* within a Kantian quantity-intensity duality.[8] Throughout I will emphasize his local resources in Berlin, particularly through the Physical Society and its engagement with the industrializing city. And I will draw out the interrelation that Helmholtz forged between his engineering sources and his Kantian metaphysics.

The *Lebenskraft* and the *Stoffwechsel*: Liebig as Foil

In 1843 Justus Liebig, at the height of his renown in organic chemistry, cannot have imagined that a freshly minted young army doctor was about to publish a paper directly attacking a key component of his new book on *Animal Chemistry* whereby oxygen was responsible for both putrefaction and fermentation, which he regarded as much the same process.[9] Apparently fearless of authority, Helmholtz sharply criticized the stance of "many of our greatest chemists" (here Liebig and Gay-Lussac) who simply "ignored and treated as physiological fantasies" the experiments of physiologists showing that the processes of decomposition were always closely associated with "processes of life."[10] Like other young physiologists who worked with Johannes Müller in the University's Anatomical Museum, Helmholtz may have been busy checking aspects of Liebig's new book, which Müller wanted to incorporate into the new edition of his *Handbuch der Physiologie des Men-*

schen für Vorlesungen (Handbook of human physiology for lectures, 1844).[11] On the basis especially of microscopic work by Theodor Schwann, Müller's much-admired former student and assistant, the physiologists believed that fermentation depended on the presence of yeast as a living microorganism, and perhaps putrefaction similarly. Their own "greatest chemist" and one of Helmholtz's teachers, Eilhard Mitscherlich, had also strongly supported Schwann's work on fermentation in an article of 1841 against his longtime antagonist Liebig. It was apparently Liebig who satirized Schwann as S. C. H. Windler (*Schwindler*, or swindler), who wrote about little animals that eat sugar and piss alcohol. He ridiculed Mitscherlich in similar fashion.[12]

Helmholtz thus confronted Liebig's view, that decomposition resulted from propagation of the chemical motions of oxidation, with the physiologists' empirical finding that oxygen was not sufficient. Dismissing Liebig's counterclaims, Helmholtz asserted that his own "very simple, easily performed experiments rigorously prove, as only a chemical experiment can prove, that *geglühte Luft* [air passed through a red-hot glass tube to kill any microorganisms] is completely incapable of calling forth putrefaction or fermentation."[13]

Indeed, his method was simple. It involved nothing but a sealed beaker containing a boiled organic mixture into which he introduced *geglühte Luft* containing oxygen. Nothing happened for eight weeks, but as soon as he allowed a little unsterilized air inside, putrefaction began within two to four days. Whatever initiated putrefaction in the organic substance, it was not oxygen, despite Liebig's bald assertions.[14] The same negative result followed when Helmholtz produced the oxygen gas in the beaker by electrochemical decomposition of water.

If Helmholtz sided with his physiological friends in his repeated criticisms of Liebig, he also subjected their own view—that putrefaction, like fermentation, depended on the action of microorganisms—to a similarly simple examination. Following a "purely mechanical path," he employed a piece of bladder as a semipermeable membrane to separate out the action of liquid or gaseous substances from that of microorganisms or their "seeds" (*Keime*).[15] Putrefaction, he concluded, could proceed independently of life processes (just as it proceeded independently of oxygen).[16] Fermentation, on the other hand, did depend on the presence of vegetable organisms (yeast). Liebig erred on both counts; Schwann only on putrefaction. Just what the actual agents of putrefaction might be remained obscure.

Noteworthy in Helmholtz's early work is that his methods were entirely physical, even "mechanical," involving techniques for isolation, glassblow-

ing, electrical decomposition, and endosmosis, as well as skill with that newly definitive instrument, the microscope (chap. 6). But they involved neither quantitative measurements nor laws of force let alone mathematical analysis. It was only during the years 1845–1847 that these signature elements of his later corpus would take on their insistent tone. To see how, it is enough to focus on two developments: first, on his continued aggressive use of Liebig as his foil, and second, on how his own work evolved as he took on more sophisticated means of physical analysis, especially when he entered the company of the Berlin Physical Society.

Helmholtz's attack on Liebig's *Animal Chemistry* was surely overdetermined. Liebig's perceived dismissal of the physiological experiments from Müller's shop might have been enough by itself. But when coupled with a famous polemic that Liebig launched in 1840 against Berlin chemists, especially Mitscherlich, and his ridicule of both Schwann and Mitscherlich, he became an irresistible target.[17] In addition, his grand speculative theorizing made the target large and soft. But perhaps most frustrating for Helmholtz— whose continuing critiques exude frustration—Liebig regularly insisted that he represented the claims of rigorous physical science while employing anything but rigorous arguments, whether theoretically or experimentally. All of this came to a head for Helmholtz, as I will argue here, in Liebig's theory of the *Lebenskraft*, which he employed to understand the *Stoffwechsel* in the animal body—literally the exchange of stuff, or metabolism—but focusing especially on the muscles.

Stoffverbrauch and Muscle Action

In the fall of 1843 Helmholtz began his military service as a staff doctor to the elite Royal Hussar Regiment in Potsdam, where he had minimal contact with his peers and professors in Berlin, only a short train ride away.[18] Working in a rudimentary laboratory at his parents' home, for his 1845 paper "Ueber den Stoffverbrauch bei der Muskelaction" he took up what he regarded as "one of the most important questions of physiology concerning directly the nature of the *Lebenskraft* itself, namely, whether the life of organic bodies is the effect of a special, self-generating, purposefully acting force or the result of forces active also in lifeless nature only peculiarly modified through the manner of their interaction."[19] In these often-quoted lines, he was contrasting the idea of a force generating itself from nothing with Liebig's laudable "attempt to derive the physiological facts from known chemical and physical laws" through which the question had taken on the form of "whether or not the mechanical force and the heat produced in organisms can be derived

completely from the *Stoffwechsel*." His precise question may be expressed in a conceptual equation. Did an equality obtain between the force released in the *Stoffwechsel* (S) and the sum of the mechanical force W and the heat H produced, $S = W + H$.

Helmholtz could not actually write such a conceptual equation, however, without clarifying and finding measures for the broad and slippery term *force* (*Kraft*), extending from the Newtonian forces of gravity, electricity, and magnetism through the engineering concept of work to less well-defined ideas of thermal force, powers of nature, and the *Lebenskraft*. Helmholtz's work over the next several years may be read as a concerted effort to resolve this ambiguity of *force*. Nevertheless, the ambiguity continued to play an essential role in the process and should be seen as a creative tension in Helmholtz's struggle to make Liebig make sense. The struggle would find expression in his own work as a duality of force, which has bedeviled interpreters and to which I return below. *Force*, therefore, must be read with the ambiguity attached.

In order to clarify Helmholtz's response to Liebig, I will give a rereading of Liebig's often-discussed presentation of the *Lebenskraft* as part 3 of his *Thier-Chemie*, where he took it to be the source of motion and other mechanical effects in muscles as well as the force of tissue growth and form.[20] It was indeed a special force, but nevertheless physical: like gravity, electricity, and magnetism but acting only at very small distances, like chemical affinity. It was certainly not self-generating: "out of nothing can no force, no activity, arise," Liebig insisted. The cause of vital phenomena "is not chemical force, not electricity, not magnetism; it is a force that possesses the most general characteristics of all causes of motion and of change of form and structure [*Beschaffenheit*] in matter. It is a peculiar force because it has manifestations not possessed by any of the other forces."[21] Thus, Liebig's *Lebenskraft* was a force of arrangement or organization of the particles of matter associated with the different structures and different properties of chemical compounds of the same composition, especially those in muscle tissue before and after it lost its *Lebenskraft*. His discussion has been recognized as a valiant attempt to give the concept a purely material and physical description.[22]

Liebig even attempted to narrate the actions of the *Lebenskraft* in the common language of mechanics (for which I add the symbols). He employed the terms *Kraftmoment* (moment of force) for a moving force or pressure acting over a time (Pt) to produce a quantity of motion (mv) and *Bewegungsmoment* (moment of motion) for a force acting over a distance (Pr), either to lift a weight or to produce motion (*lebendige Kraft* or *vis viva*, mv^2). But he

did not employ either the symbols or the simplest equations of mechanics, such as $Pt = mv$, or $2Pr = mv^2$. The resulting ambiguity of meaning shows the challenge readers like Helmholtz faced in trying to analyze the concept of "force." Liebig used "quantity of force" for both moment of force (mv) and moment of motion (mv^2), treating them as more or less equivalent and interchangeable, thus conflating the two different measures of force that mechanicians had struggled over during the so-called *vis viva* controversy of the eighteenth century but that had been differentiated functionally long before his writing.[23] For example, with respect to chemical force from a battery carried by a wire as a "current of chemical force" to another component such as an electromagnet, he wrote confusingly that "the *Kraftmoment*...passes into a *Bewegungsmoment*, with which one can bring about mechanical motions." This notion of electric current provided Liebig with an analogy for the passage of *Lebenskraft* from the muscles through the nerves to produce motion in organs of involuntary action (heart, lungs, intestines, uterus). It traveled as a "current of *Lebenskraft*," which then acted as a *Bewegungsmoment* in the organ.[24] But the bewildering mechanical language did little to relieve the *Unbegreiflichkeit* (incomprehensibility) with which Helmholtz would soon damn the *Lebenskraft*.

Focusing now only on the key role of the *Lebenskraft* (L) in muscles, it supplied the mechanical force of muscles working to produce motion or lift weights ($L = W$). But this expenditure of *Lebenskraft* left the muscle unprotected against the chemical forces of oxidation (O), which proceeded proportionally and produced bodily heat ($O = H$). The quantity of *Lebenskraft* consumed in the process derived from a change in the form of a proportional amount of muscle tissue, leaving it without vitality, unable to grow and unprotected from attack by inspired oxygen circulating in the blood ("current of oxygen").[25] Oxidation of this nonliving and formless tissue yielded animal heat and produced carbonic acid (carbon dioxide) and water vapor to be expired through the lungs. If summarized in an equation, Liebig's conception of the forces involved in the *Stoffwechsel* would look something like this:

$S = L$ (*Lebenskraft* consumed) + O (oxygen consumed)
$= W$ (mechanical force produced) + H (heat released).[26]

I note particularly that Liebig's *Lebenskraft* was not converted into heat, which he thought derived entirely from oxidation.

In posing anew the question of the *Stoffwechsel*, the skeptical Helmholtz seems to have been asking whether in fact a supposed *Lebenskraft* played

any role at all, whether the sum of mechanical force and heat were not simply equal to an equivalent of all chemical affinities released in the *Stoffwechsel* (by oxidation and other reactions) without the contribution of any special *Lebenskraft*:

$$S = O = W + H.$$

Unable to take on the great question as a whole, he nevertheless tried to establish a preliminary fact, that repeatedly contracting muscles, isolated from circulation and respiration, undergo a measurable chemical change (i.e., W derives from O without invoking any L). The only thing known about this question, he observed with some irony, was that meat from hunted animals chased to death had an unusual taste. Liebig had used this very example to argue that the muscles, having expended all of their *Lebenskraft*, had changed their state from living to nonliving tissue.[27] Crucially, Helmholtz made no direct mention of Liebig's scheme for the *Lebenskraft*, which had occupied sixty-five pages of his book. I believe we have to take this omission, both here and below, as a strategic decision, made because he could not disprove Liebig's speculation rather than because he thought it viable.[28]

For his experiments, like his mentors and peers, Helmholtz employed frogs. Cutting pairs of legs from two to four freshly killed frogs, he left one leg from each pair resting as a control while he stimulated contractions in the muscles of the other legs by successive electrostatic shocks communicated from one to the other in series until after four to five hundred shocks over a few minutes, no further contractions occurred.[29] Through an exacting if rudimentary protocol for removing the muscles from the bones and carrying out a series of washings, dissolutions, dryings, and careful weighings, he was able to obtain a series of extracts from the muscles in alcohol, water, and spirits (ethyl alcohol). The extracts revealed definite differences in weight, and thus in composition, between the electrified and nonelectrified muscles. These weight ratios remained remarkably constant over nine trials. More limited experiments on pigeons and fish confirmed the basic results.

This showed that "during the action of the muscles a chemical transformation of the compounds contained in them occurs," thereby suggesting, but certainly not proving, that W derives from O. Of course he had no way to measure the magnitude of either force. As for Liebig, Helmholtz simply passed over in silence his claim that from the connection of the *Stoffwechsel* with the force consumed by mechanical motions, "no other conclusion can be drawn than that the active or utilizable *Lebenskraft* in certain living parts of the animal body is the cause of its mechanical effects."[30]

Heat and Muscle Action

A second part of the great question of the *Stoffwechsel* remained, whether it supplied heat *H* as well as mechanical force *W* during muscle action. Helmholtz turned his attention to this question already in 1845, when at Müller's request he began to draft a review essay on animal heat for the medical *Hand-wörterbuch* edited by members of the Berlin medical faculty. But the new project coalesced with his return to Berlin in September to prepare for his state medical examinations and to work in Magnus's laboratory,[31] at his invitation and with his more sophisticated apparatus, to extend his results on putrefaction and fermentation. It was apparently while working there "almost daily for three months" that Helmholtz entered the circle of young men who had formed the Physical Society only nine months previously. The question of animal heat also entered a new world.

Little is known in detail about Helmholtz's activities during the five months he spent in Berlin from September 1845 to February 1846 except that his career changed dramatically through his new associations. Most obviously, his skepticism about the *Lebenskraft* merged with the polemics of the charismatic Emil du Bois-Reymond, in whom Helmholtz found a lifelong friend. He also found in Du Bois-Reymond a critically important intellectual collaborator on electrophysiology and on electrical instruments. Du Bois-Reymond's own instrumental capacity depended on his relationship with Halske (Siemens partner from 1847 in telegraph engineering). The significance of Helmholtz's close relationship with Du Bois-Reymond is undisputed, along with their physiological compatriot Ernst Brücke. Much less prominent have been the nonphysiologists in the Physical Society who focused on phenomena of heat and the measurement of conversion equivalents when heat was produced from other forms of force: Gustav Karsten on the power available from steam; Wilhelm Heinz on chemical heat (and a close friend of Helmholtz); Hermann Knoblauch on the physics of heat; and Ludwig Wilhelmy, in Giessen, who published *Die Wärme als Maass der Cohäsion* in 1846. Helmholtz had entered into a local social network whose interests and expertise greatly expanded his capacity to ask and to answer questions about heat production. He had arrived with a draft of his review article,[32] but in the course of a year it would turn into a manifesto for the aims of the Physical Society and the groundwork for Helmholtz's classic *Ueber die Erhaltung der Kraft*. It also led to new experimental work, which I will briefly take up first, although it was not completed until a bit later.

After taking his state medical examinations in February 1846, Helmholtz returned to Potsdam and briefly continued his study of chemical change

during muscle action, but in retrospect his immediate aims were less important than the new methods he was learning. Wet chemistry gave way to dry physics. Five letters to Du Bois-Reymond from July to December 1846 were all about electrical instruments: Grove cell, induction coil, galvanometer, and compensator, as well as a sensitive chemical balance. Aside from the induction coil for stimulating muscles, these were instruments that Du Bois-Reymond had already built or improved for his work on animal electricity, especially through his relation with Halske. Helmholtz's requests and admonitions for Halske now became a regular part of the correspondence. If Du Bois-Reymond began as the instructor, especially with respect to the extreme care required for consistent physiological measurements with a sensitive galvanometer, Helmholtz very quickly became the creative force for precision. Particularly impressive is a long letter in December describing in detail the measures he had taken to maximize the sensitivity of his new galvanometer (apparently from Halske) using a Ruhmkorff compensator and his own procedure for calibrating it using a triple-junction thermocouple that he designed.[33]

This thorough reorientation and sophistication of Helmholtz's instrumental capacities coupled with the reviews on animal heat, which he completed in October, found their first expression in an attempt to measure temperature change in working muscles, which he began in December. Over the next year his further development of the thermocouple (fig. 7.2), operating between pairs of excited and unexcited frog muscles (and used in conjunction with his optimized galvanometer and a redesigned Neefian induction coil for continual excitation of muscles), would prove capable of detecting temperature differences of 1/1000°C.

This sensitivity enabled Helmholtz to confirm earlier results of Becquerel and Breschet with one-hundred-times higher precision. His published paper "Ueber die Wärmeentwickelung bei der Muskelaction"—which parallels the previous "Ueber den Stoffverbrauch bei der Muskelaction" but sharply contrasts with it in techniques, literature, and sophistication—consisted almost entirely of careful descriptions of his newly employed physical instruments.[34]

In comparison with all of this sophisticated instrumentation, Helmholtz's actual finding seems anticlimactic. He announced in one line that the contracting muscles did in fact increase in temperature relative to the resting muscles. Even though the result established close relations between *Stoffverbrauch*, *Muskelaction*, and *Wärme*, he had not measured their respective amounts and did not attempt to elaborate the relations further. With more enthusiasm, Du Bois-Reymond had already announced to the French scientific

Figure 7.2 Helmholtz's thermocouple (simplified), here showing three strips of silver and iron (Ag and Fe) connected in series but capable of six junctions in a second layer. The ends at *a*, *b*, *c* and *a'*, *b'*, *c'*, when extended, were inserted into pairs of excited and unexcited frog muscles to record temperature differences on a galvanometer. "Ueber die Wärmeentwicklung," plate 6, fig. 14.

public that the chemical changes of Helmholtz's *Stoffverbrauch* were actually the cause of the newly established temperature increase during muscle activity.[35] That causal claim, although Helmholtz surely believed it, is not one he could have justified experimentally. His interest had turned to the larger theoretical question of the nature of heat itself, on which in fact his review of animal heat had already settled a year earlier, in October 1846.

Reviews of Physiological Heat

Like Helmholtz's experimental work, his draft review article for the medical *Handwörterbuch* became a work in progress when he entered the social sphere of the Physical Society in the fall of 1845. With Du Bois-Reymond's

advice, it would go through multiple revisions before completion in October 1846, along with a much-abbreviated version for the *Fortschritte*. Symptomatic of his changing identity, Helmholtz sent the completed review not directly to Müller but through Du Bois-Reymond, who had become something like his agent in Berlin.[36]

For present purposes, the most important part of the review is a theoretical section "On the Origins of Animal Heat." It constituted a kind of tutorial for medics on the latest thinking about the nature of heat but contained no literature citations at all. Instead it drew on the collective knowledge of the Physical Society. Specifically, it juxtaposed material and dynamical theories of heat in order to establish that heat is motion. This thesis opened an entirely new line of argument for Helmholtz.

Dominant chemical theories still treated heat as a highly expansive, imponderable substance (*Wärmestoff*, or caloric fluid). When fixed in chemical combination, it existed in a latent, nonexpansive state. This latent heat was released as free heat, producing expansions and temperature increases, when the elements entered into successively higher-order combinations, from simple ones such as water to complicated organic compounds. Changes of state, from gas to liquid to solid, similarly released latent heat. Thus, for adherents of the material theory in 1845, all animal heat appeared as free heat released from the latent heat of chemical combinations, particularly combinations of respired air with ingested food. And all calculations rested on the necessary law, expressing conservation of caloric as a material substance, that the net result would be independent of the path of combinations:

> The sum of the heats, which become free in the unification of two or more elements, must be the same through whatever various intermediate steps the combination may have proceeded. For our present purpose, this law is of the highest importance; it is the foundation [*das Fundament*] for the chemical theory of organic heat.[37]

As happy a theory as this path independence was chemically, Helmholtz could confidently assert that it would not do physically, for it required that heat, being matter, could not be produced from other forces. Liebig had already remarked that "the most distinguished physicists accept the phenomena of heat only as phenomena of motion," citing production of heat from mechanical causes such as friction within a broader context of interconversion and conservation of forces.[38] But beyond Liebig, Helmholtz's missing citations surely referred to works discussed in the Physical Society during

the preceding year by at least Karsten, Knoblauch, Heinz, and Krönig, who were writing reviews for the *Fortschritte*. Most importantly, Knoblauch had reported on Melloni's experiments, supplemented by his own, showing that radiant heat behaved almost identically to light, which seemed to require a wave theory of radiant heat as motion. Other results, some known for decades, took on new weight. Electrical force generated heat in discharges, and electrical force could be produced by friction or by the motion of magnets. "Thereby the possibility of a material theory of heat disappears entirely— because in the material theory, constancy of quantity [of heat] would be the most essential requirement—and we are forced to think of heat, like light, as motion." One had now to adopt what Helmholtz asserted was "the constancy of quantity of motion, according to the fundamental laws of mechanics."[39]

"Quantity of motion" here meant *vis viva mv²* (rather than the traditional *mv*), and Helmholtz was invoking the principle of conservation of *vis viva*, which required that whenever a mechanical system returned to a preceding configuration, independent of the path taken, it would recover its original *vis viva*. But it is important to recognize immediately that in calling this relation a "fundamental law," he was overinterpreting contemporary mechanics, in which conservation of *vis viva* held only as a particular result for forces depending on distance alone and could not be shown to hold for either frictional forces or electrical discharges.[40] Proof of conservation of *vis viva* as a "fundamental law" was precisely what was required. Helmholtz's own agenda and that of the Physical Society is surely present in this rhetorical excess. So, too, is his adoption of the terminology of "equivalents" of force, already prominent in Liebig's discussion and widespread elsewhere. More uniquely, he wrote of corresponding "quantities" of force converted from one form to another, as opposed to their "intensities." Taken over in part from the more common distinction of quantity of heat from intensity of heat (as temperature), this quantity-intensity language would soon play a key role in Helmholtz's *Erhaltung der Kraft*.[41]

Already, however, the language provided a way of talking about a quantity of heat as motion being produced by a quantity of another force, say mechanical or electrical. This required "the determination of the equivalents of heat that can be generated by a definite quantity of a mechanical or electrical force."[42] Determining equivalents had become a critical empirical issue. Nevertheless, the *Fundament* of the chemical theory, the path independence quoted above, could now be replaced by a more general path independence

of "the mechanical laws": "a definite quantity of a moving force [*bewegende Kraft*], whatever the complication of its mechanism, can always generate only the same definite quantum of motion [*vis viva*, or here, heat]."[43]

Here again, support very likely derived from reviews being written by Heinz and Knoblauch, which Karsten would place directly before Helmholtz's own review of animal heat in the *Fortschritte*. Knoblauch, in fact, was reviewing James Joule's recent papers on the mechanical equivalent of heat. Their discussions, like other polemical demystifications in the *Fortschritte*, left no room for any unaccountable appearance or disappearance of heat. It was in this context, with repeated appeal to the "laws of mechanics," that Helmholtz explicitly pushed the *Lebenskraft* into the category of a mysterious power from which "forces of nature could be produced without limit, an assumption that indeed contradicts all logical laws of the mechanical natural sciences."[44]

Here for the first time—having transformed the path independence of heat (as caloric) released from chemical combinations into the path independence of heat (as *vis viva*) generated from mechanical forces—Helmholtz was invoking the prohibition on perpetual motion machines as the most general principle underlying path independence. He complained that experimenters, in their "one-sided" (*einseitig*) concern with whether or not animal heat derived from respiration, had only confused the issue, providing no rebuttal to those "physiologists who locate the essence of life just in this, its incomprehensibility [*Unbegreiflichkeit*]. . . . Precisely here it becomes clear how great is the importance of the question of the origin of animal heat for the theoretical view of the life process."[45] *Begreiflichkeit*, in mechanical terms, here became Helmholtz's criterion for legitimate physiology, as for all natural science, with the origin of animal heat as its crucial test.

But in representing the *Lebenskraft* as *unbegreiflich*, what was one to do about the ever-problematic Liebig, who had formulated his *Lebenskraft* precisely so as not to violate the laws of mechanics and who did not suppose *Lebenskraft* was converted into heat? Helmholtz seems once again to have made a strategic decision. In evaluating animal heat he would ignore entirely the crucial role Liebig assigned to the *Lebenskraft* in producing mechanical motion ($L = W$) and discuss only the inadequacies of his particular formulation of the chemical theory of animal heat ($O = H$). Thus, Helmholtz turned the final section of his paper into an extended attack on Liebig's arguments.

Briefly, Liebig essentially preserved the Lavoisier-Laplace respiration theory, that all animal heat derived from the latent heat released during combustion of carbon and hydrogen with respired oxygen. But the best measure-

ments done to test this respiration theory, by Dulong and Despretz, showed that the heat actually given off by guinea pigs in a calorimeter was far too high to derive from respired oxygen alone.[46] If so, the door was open to speculations by "the physiologists and many chemists" about some unknown nerve activity (or self-generating *Lebenskraft*, as Helmholtz put it) supplying the missing heat.[47] It was in response to just this kind of action that Liebig had stated that no force comes from nothing. He therefore contested Dulong and Despretz's measurements. But all recent experiments confirmed their work with even higher reliability.

Helmholtz took a different tack to preserving *Begreiflichkeit*. Neither the chemical theory as such nor the experiments were at fault but rather Liebig's version of the chemical theory as a monolithic respiration theory. New measurements by Favre and Silbermann (under review for the *Fortschritte* by Heinz) indicated that many food products would give off much more heat during oxidation than the respiration theory allowed. Liebig's faulty accounting, Helmholtz argued, might well explain the supposedly missing chemical heat in the results of Dulong and Despretz. Other experimental considerations led to similar conclusions. He followed up with a withering critique of Liebig's attempts to undermine the measured values of Dulong and Despretz.[48]

Having concluded that at the whole-body level of inputs and outputs no empirical evidence contradicted the chemical theory of animal heat, Helmholtz turned to the more difficult question of just where and how the heat was produced internally. He could point to heat released during muscle action (though not yet citing his thermocouple measurements) and to his related work on chemical transformations as well as Du Bois-Reymond's investigations of electric currents and nerve activity.[49] He could also cite work by his immediate mentors, Magnus and Müller, that reinforced how important it was to get beyond Liebig's simple respiration theory.[50] In sum, that theory was as inadequate as the *Lebenskraft* was superfluous.

Helmholtz's brief second review for the *Fortschritte* reiterated in more concise and forceful terms the basic concern of the Physical Society with the nature of heat and its interconversions. Key issues were the principle of "nothing from nothing," the attendant necessity of establishing force equivalents, and the principle of path independence. "If we conceive heat as motion, then it is first of all to be presupposed that mechanical, electrical, and chemical forces can always produce only a definite equivalent of heat, however complicated the mode of passage of the one force into the other may be."[51] In this emphasis Helmholtz surely recognized (without citations) that

the Physical Society was busy reviewing for the *Fortschritte* recent work done to establish equivalents in many of the relevant areas.

There must be some irony in the fact that Liebig had made the same arguments for heat as motion on which Helmholtz and his friends were relying: "because the very conception of the *creation* of matter, even though imponderable, is absolutely irreconcilable with its production by mechanical means, such as friction or motion."[52] Helmholtz no doubt asked himself how such a man could have made so much of a free *Lebenskraft* that was *unbegreiflich* in relation to any other force equivalents. Certainly he had no use for a force traveling freely through the nerves unless by some physical means, like a chemical change or an electric current, and he showed no inclination to try to make mechanical sense of a force of form or structure. He contented himself with the observation that "The principle of the constancy of force equivalents . . . has up to now neither been thoroughly articulated and accepted nor empirically carried through." Here is the challenge he had already set for himself, and he had learned, perhaps through Karsten's review in the *Fortschritte*, of works by Clapeyron and Holtzmann that opened promising avenues of articulation.[53]

Engineering Mechanics in the *Erhaltung der Kraft*

By the end of 1846 Helmholtz had begun work on the missing theoretical and empirical foundation for the principle of *Constanz der Kräfte*, which within six months would become his classic *Ueber die Erhaltung der Kraft* (*On the Conservation of Force*).[54] As above, he started from the all-important premise of *Begreiflichkeit*, meaning explanation according to laws governing invariable causes and excluding any forces that could not be understood in mechanical terms. He sought now a logically ordered proof of conservation. In a much-discussed philosophical introduction, Helmholtz developed a Kantian argument for mechanical reduction to which I will return in concluding this chapter. As a preliminary, *Begreiflichkeit* for Helmholtz now required that all natural phenomena be conceived in terms of the two abstractions of matter and force functioning together, never taking them to be independent concepts. Even more stringently, however, it required that every material system, regarded conceptually, must be reducible to material points interacting *in pairs* via "central" forces (acting along the line between them and dependent only on distance). On that ground alone Liebig's formulation of the *Lebenskraft*, as a multibody force of organization, would finally be excluded, along with any other noncentral or time-dependent forces.

I am interested initially in two aspects of Helmholtz's remarkable work:

his sources for the mathematical-physical arguments that ground *Ueber die Erhaltung der Kraft*; and his objectification of force (*Kraft*), both conceptually and instrumentally. Although the bulk of his small treatise was devoted to the full spectrum of known empirical results for particular interconversions of force and to assimilating them to his conservation scheme, I will not address that important survey here but will focus only on the basic conceptual issues.

Helmholtz actually divided his proof of conservation of force into two parts, occupying sections 1 and 2 of the main text. The first was a more commonsensical and practical discussion based on the engineering concept of work for a "system of natural bodies [*Naturkörper*]," while the second provided a more mathematical, even metaphysical treatment of a system of pairs of material points conceived as making up any body, which begins to suggest his Kantian grounding. The two perspectives—engineering mechanics and Kantian metaphysics—interact in important ways.

The Practical Perspective

Helmholtz began from the principle of nothing from nothing. But abandoning Liebig and muscle action, his attention now focused on the work done (*travail* or *Arbeit*) to produce a motion or raise a weight, as developed by French engineers. The work done by a force P acting on a body over a distance r in the line of the force was measured by their product, $W = Pr$. In terms of machines, the principle of nothing from nothing became more specifically the prohibition of any perpetual motion machine: "it is impossible, through any combination of natural bodies to obtain moving force [here mechanical work] permanently from nothing."[55] He took up this theme from the Carnot-Clapeyron-Holtzmann trajectory that Karsten had reviewed and that he himself had already referenced in his review for the *Fortschritte*. Like Karsten he also substituted the more usual engineering term *work* (*Arbeit*) for Clapeyron's *Quantität mechanischer Action*.[56]

Specifically, Helmholtz was drawing on Émile Clapeyron's presentation of Sadi Carnot's theory of the work done by an idealized reversible heat engine. In a sophisticated mathematical treatment of 1834, Clapeyron had depicted Carnot's engine cycle through a closed series of curves of pressure Y versus volume X, making up what has become universally known as a "Carnot diagram" (fig. 7.3).[57]

The diagram is actually an idealized version of indicator diagrams for steam engines, discussed below, but with heat rather than steam entering and leaving the engine. Clapeyron's figure consisted of constant-temperature curves on the top and bottom, where heat is absorbed at the higher tem-

Figure 7.3 Clapeyron's "Carnot diagram" (simplified). The same quantity of heat that enters the engine during the isothermal expansion *CE* (representing steam injection) leaves along the isothermal compression *FK* (representing condensation). "Ueber die Bewegende Kraft der Wärme," *Annalen der Physik und Chemie* 59 (1843), plate 2, fig. 13.

perature *CE* (boiler) and emitted at the lower temperature *FK* (condenser), and connecting adiabatic curves on the sides, where expansion *EF* and compression *KC* take place without any heat transfer. Clapeyron was able to produce a mathematically rigorous theory of the work obtainable from such a reversible "Carnot engine" operating between any two given temperatures. He assumed, however, like Carnot and in agreement with the caloric theory of heat, that as much heat left the engine at the low temperature as entered it at the high temperature. Heat, being material, was conserved. The work available from the engine derived only from the "fall" of heat from high to low temperature, by analogy to the fall of water driving a waterwheel. No heat could be converted into mechanical work.

From the prohibition of perpetual motion, Carnot and Clapeyron derived the principle that no engine could produce work more efficiently than a Carnot engine, for otherwise the superefficient engine could use just a portion of the work it produced to run the reversible Carnot engine backward, thereby continually restoring the falling heat to the higher temperature while supplying excess work for other purposes (fig. 7.4). Such an engine would be a perpetual motion machine that could produce work without limit (as Helmholtz had said of the *Lebenskraft*).

Clapeyron's treatment, like Carnot's before him, received almost no attention until resurrected in Berlin by Rudolph Clausius. (William Thomson

resurrected it independently in Glasgow.) And it was not until 1850 that Clausius (and Thomson) would reformulate the Carnot-Clapeyron principle of efficiency as the famous second law of thermodynamics, having recognized conservation of energy as a necessary first law, a form of which Helmholtz was trying to establish.[58]

As one of the first ten members of Magnus's new Physical Colloquium in 1843, Clausius had reported on Clapeyron's paper when Poggendorf republished it in German in his *Annalen der Physik*. Very likely Magnus himself suggested the paper, since he was one of Clausius's mentors and was writing papers at the time on power from steam. Clausius may also have learned of the paper from another of his Berlin teachers, Ferdinand Minding, who had just written an extensive review of mechanics, including engineering mechanics. By the time Karsten reviewed sources on the elasticity of steam for the *Fortschritte* of 1845, he simply treated Clapeyron's paper as known and devoted several pages to new developments by Karl Holtzmann.[59]

Clausius's dense network of intellectual connections is revealing of how the Physical Society was positioned in Berlin (though he did not join the Society until 1851). He is usually represented as an abstract mathematical theorist, but like most other members, his interests included experimental and technical physics, particularly in relation to Dove and Magnus. And he trained extensively in mechanics at the University with teachers who were deeply involved in the technical-industrial schools. With Minding, who taught also at the Bauschule (chap. 3), he studied mechanics and the theory of equations and copied out Minding's lecture notes on the history of mathematics. With Johann Philipp Grüson, who taught also at the Gewerbeinstitut, he studied both statics

Figure 7.4 Representation of a perpetual motion machine, a compound engine consisting of a superefficient engine on the right that powers a reversible Carnot engine working backward on the left while also producing excess work. All heat *Q* falling from high to low temperature through the superefficient engine would be restored by the Carnot engine working as a refrigerator, so that the excess work would be produced ad infinitum.

and dynamics. From 1844, while continuing his work with Magnus, Clausius taught mathematics and natural science at a *Gymnasium* in Berlin until 1850, when he succeeded Dove at the Vereinigte Artillerie- und Ingenieurschule. There the coupling of theory with practice provided the central pedagogical principle for training officers in the technical branches (chap. 4). And it was while there, from 1850 to 1855, that he published his famous papers on the mechanical theory of heat—including one on the application of the new theory to steam engines—before accepting a professorship in mathematical physics at the new Zurich Polytechnic. Once again, the technical school network provided an ever-present context for Berlin's striving young scientists.[60]

Of his contact with Clausius we have only Helmholtz's report of their having met almost daily during 1848–1849.[61] But Helmholtz had learned of the Carnot-Clapeyron theory well before that and had developed from it a fresh insight. Previously he had expressed the reservation regarding Clapyron's theory that it concerned only the production of mechanical force from the tendency of heat (as caloric) to expand rather than any conversion of heat into other mechanical forces.[62] He now recognized, however, that even if heat were motion, the Carnot-Clapeyron argument would still apply to the heat engine as a mechanical system.

Helmholtz invited the reader to consider any system of natural bodies (*Naturkörper*) that gained motion in passing from one configuration to another under the action of the forces between its parts (fig. 7.5). This motion, or *vis viva*, could be converted into work (e.g., by raising a weight m against the force of gravity mg to a height h, doing work mgh). If, he reasoned, we wanted to employ the same forces a second time to produce that work again, then we would first have to expend some amount of work from other forces to restore the system to its original configuration, following either the same or a different path (like returning the heat to its original temperature with a reversed Carnot engine). But if the work gained and lost along any two such paths were not equal, we could repeatedly employ the path producing more work to restore the system along the path consuming less, thereby generating excess work without limit for other purposes. "We . . . would have built a perpetuum mobile."

This reflection on perpetual motion guaranteed Helmholtz's earlier path-independence claim for any mechanical system. It also established conservation of *vis viva* as the "fundamental law" he had been seeking. That is, just as the work being gained or lost along any path could be represented as a weight m raised to a height h by an amount of work mgh, it could also be

first
configuration

gain of
vis viva
converted
to work

work
to restore
configuration

second
configuration

Figure 7.5 Representation of Helmholtz's argument for conservation of *vis viva*. If the *vis viva* gained (and converted into work) along one path between two configurations of a system were greater than the work done to restore the system to its initial configuration by any other path, then the cycle would constitute a perpetual motion machine.

represented as the equivalent *vis viva* that *m* would have needed to rise freely to that height; that is, work done = change in *vis viva*,

$$mgh = \tfrac{1}{2}mv^2.$$

So the *vis viva* would have to be the same every time the system returned to the same configuration. This was the famous principle of conservation of *vis viva*. To stress the identification of *vis viva* with work, Helmholtz now chose $\tfrac{1}{2}mv^2$ as its definition rather than the traditional mv², just as some engineers had done before him.[63]

He immediately generalized the principle to a system of arbitrarily many "material points" moving only under forces acting between them or toward fixed centers, whatever paths and velocities they might follow before their return. The question remained of whether any forces other than central forces dependent on distance alone could exhibit the path independence required for conservation of *vis viva*. Helmholtz offered a simple proof that seemed to eliminate forces long known to be problematic, both noncentral forces and those depending on time or velocity. And he asserted (prematurely) that these other forces would allow the existence of either a perpetuum mobile or

bodies that moved themselves by their internal action.[64] In that case, nature would be *unbegreiflich*.

The Metaphysical Perspective

Already in this last argument, Helmholtz had shifted attention from the practical image of a machine as a system of natural bodies (*Naturkörper*) doing work to the abstract image of a body as made up of material points interacting via central forces. "Material points" refer here simply to the smallest parts of a body, whatever they might be, whether atoms, molecules, or tiny volumes of matter. Helmholtz specified them (neutrally and ambiguously) as "points of space filled with matter."[65] The conceptual reduction to material points was common in rational mechanics, but as Olivier Darrigol has shown, it was especially the French engineers who incorporated that reduction with the principle of *vis viva* for their calculations on machines and who used it to explain apparent losses—occurring through friction, shock, vibrations, fluid eddies, etc.—in terms of microscopic molecular motions. With one exception, however, that of Adhémar Barré de Saint-Venant, whose work remained largely unknown, none of them asserted the conservation principle as a general law of nature.[66]

The exception is interesting for two reasons, both of which indicate how very particular were the conditions under which the principle actually emerged even when, in retrospect, all the stars seemed to be aligned and any knowledgeable person apparently could have stated it or supported it. First, Saint-Venant's work was suppressed by the committee of the French Academy of Sciences who evaluated it for publication (including his engineering hero Navier), and even other engineers such as Coriolis, who had every reason to agree with his arguments, did nothing to rescue it. In a similar way, Helmholtz's *Ueber die Erhaltung der Kraft* was rejected for publication in Poggendorff's *Annalen der Physik*, and even Magnus did not attempt a rescue. Among senior academics, only the mathematician Carl Jacobi appreciated its merits. Secondly, Saint Venant's own articulation of the universal conservation law in terms of molecular mechanics depended on his personal religious belief in a God who had created a perfect world in which nothing could be lost.[67]

Although no such religious beliefs animated Helmholtz's perspective, his particular expression of the conservation of *vis viva* in terms of material points had a definite metaphysical character. This was signaled first by his insistence that matter and force could only be thought of together, as two mutually necessary concepts, and secondly by the fact that he referred always to *pairs* of material points interacting via central forces. In books on mechanics, the explicit reference to interacting pairs seems to have been restricted to

German works, including Kant's *Metaphysical Foundations of Natural Science*.[68] These relational matter-force pairs constituted Helmholtz's basic conceptual unit for translating Kant into modern terms (see final section below). Taking central forces to be the only possible forces for the reduction of natural bodies to pairs of material points, he sought a perfectly general expression of conservation of *vis viva*.

Helmholtz's key creative move, as Bevilacqua has stressed,[69] was the introduction into mechanics of a new usage for a common term: *Spannkraft*. Suppose *m* is a material point located a distance *r* from another material point, and let *P* be the intensity of the force acting between them when *r* changes infinitesimally by *dr*. Then for a finite movement of the point *m* from *r* to *R* in which its velocity changes from *v* to *V*, its change in *vis viva* will be

$$\tfrac{1}{2}mV^2 - \tfrac{1}{2}mv^2 = -\int_r^R P\,dr.$$

Although the integral on the right corresponds to what Helmholtz had previously called "work" for a machine, or a system of natural bodies, he now expressed it for the point *m* as the "sum of the *Spannkräfte*": "The increase of *vis viva* of a mass point during its motion under the action of a central force is equal to the sum of the *Spannkräfte* that correspond to the change of its distance." The comparable equation for a system of arbitrarily many material points then followed from summing over all the points interacting in pairs. Since any expenditure of this full "sum of the *Spannkräfte*" in the system was always equal to the gain in its *vis viva*, Helmholtz emphasized his "most general law" of conservation as a law of unchanging quantity of force:

> *The sum of the available vis viva and Spannkräfte is therefore always constant*. In this most general form we can designate our law as *das Princip von der Erhaltung der Kraft*.[70]

The new locution "sum of the *Spannkräfte*" mirrors his earlier usage of "sum of the heats" in expressing the path independence of the quantity of heat released in chemical reactions but with heat now replaced by the *vis viva* produced by expenditure of a quantity of *Spannkraft*.[71] On this chemical analogy the "sum of the *Spannkräfte*" would be the internal work done by the chemical forces acting between pairs of material points during their motion. Beyond chemistry the forces could also be gravitational, electrical, magnetic, etc. Several aspects of Helmholtz's usage of *Spannkraft* will require further discussion below. Basically, I will present the view that the term differentiated a *quantity* of *Spannkraft*, measured by quantity of work (*Arbeitsgrösse*), from an *intensity* of *Kraft*, measured as a tension or weight. This distinction

produced a quantity-intensity *duality* somewhat like that between quantity and intensity of heat, that is, the quantity of heat contained in a body, measured with a calorimeter, and the intensity of that heat, or its temperature, measured with a thermometer. The duality, I will further suggest, was fundamental to Helmholtz's reformulation of Kantian metaphysics.

What now were Helmholtz's immediate sources for interpreting the principle of *vis viva* in terms of work? It has long been known that the work interpretation derived largely from French engineers, as above, and yet Helmholtz's access to these works has remained as obscure as their significance in the Berlin context.[72]

Local Sources

I observed in chapter 3 that promotion of French engineering practices occurred through the technical schools where all of Helmholtz's teachers of physical science had part-time appointments—Magnus, Dove, Turte, Mitscherlich—and provided many points of access. I also discussed briefly two major contributions to the *Verhandlungen des Vereins zur Beförderung des Gewerbefließes* of Beuth's *Gewerbeverein*. One was the series of articles on political economy in 1829–1839 by Captain Moritz von Prittwitz of the Corps of Engineers, who had been an important educational innovator at the Vereinigte Artillerie- und Ingenieurschule. Prittwitz followed Jean Baptiste Say at the Conservatoire national des arts et métiers in integrating political economy with the organizing concept of work among French engineers, citing especially Dupin, also at the Conservatoire. Work became the measure of economic value. The other long series, in 1837–1838, by factory-commission counselor Brix, constituted a treatise on friction. Brix taught mechanics at the Bauschule and Gewerbeinstitut and served on the administrative committee for mathematics and mechanics at the Gewerbeverein. His report highlighted the critical significance of friction for the work done by every kind of machine and described current measuring instruments. Taken together, the two series by Prittwitz and Brix make it clear how centrally important, both ideologically and technically, was the concept and the measure of work, seen as the motor of progress in a modernizing economy.

Both Prittwitz and Brix were relying on the tradition of French engineering mechanics focused on the theory of machines. The tradition had its home not only in the public Conservatoire but in the elite school of military engineers, the École polytechnique, as well as in the specialized *écoles d'application*: the École des mines, École des ponts et chausses, and the École de l'artillerie et du génie. Those who created the new subject form an engineering pan-

theon, including Carnot, Monge, Navier, Christian, Coriolis, Dupin, Poncelet, and Morin. To differentiate their subject from the "rational mechanics" (*mécanique rationelle*) of Lagrange, Laplace, and Poisson, they sometimes called it "industrial mechanics" (*mécanique industrielle*).[73] It centered on the concept of work, formalized as *travail* by Gaspard Coriolis in 1829 and on his restatement of the principle of *vis viva* as the "principle of the transmission of work" in machines.

Through this principle (chap. 3) engineers sought a systematic understanding of how work was done by machines of all kinds and how it was transmitted from a moving power or motor at one end of a train of mechanism through any series of mechanical linkages to machines producing useful work at the other end. Given the focus on work, Coriolis, like Helmholtz after him, redefined *vis viva* as $\frac{1}{2}mv^2$. The "principle of transmission of work" then stated that "in all systems of bodies in motion, the difference between the sum of the quantities of work due to moving forces and the sum of the quantities of work due to resisting forces during a certain time is equal to the change of the sum of the *vis viva* of the masses of the system during the same time."[74] The resisting forces included both useful forces and impeding forces, typically friction but also any other source of consumption of *vis viva*. In principle, if the impeding resistances could be eliminated, the *vis viva* produced by the motor at one end could be transmitted without loss to do useful work at the other end. The object of industrial mechanics, therefore, was to follow the circulation of work (the measure of economic value) through any train of mechanism and to learn how to minimize losses (of value) due to friction, vibration, and shock. Navier's unforgettable expression for work, *monnaie mécanique*, comes immediately into view. This economic significance is surely one of the most important aspects of the objectification of the concept of work.[75]

It is apparent that the focus in industrial mechanics on questions of work done shaped the meaning that Helmholtz attached to the basic ideas of rational mechanics. But we still lack a more specific location for his access to these innovations. A prime candidate is Ferdinand Minding.

As a typical link in the technical education network in Berlin, *Privatdocent* Minding taught higher mathematics and mechanics at the Bauschule from 1835 (chap. 2) as well as at the University from 1831 until in 1843 he obtained a professorship in applied mathematics at Dorpat. As noted above, Clausius had three courses with him. Minding was a gifted, largely self-taught mathematician, best known for having extended Gauss's differential geometry of bending surfaces and the theory of geodesic curves. But Minding, like Clausius after him, aimed to unite mathematical methods with practical utility.[76]

Minding published his lectures at the Bauschule—at the behest of "die hohe vorgesetzte Behörde dieser Anstalt" (Beuth)—in a two-volume *Handbuch der Differential- und Integral-Rechnung und ihrer Anwendung auf Geometrie und Mechanik.* His engineering orientation is evident in his sources. For the calculus volume of 1836, in addition to famous works of Lagrange, Cauchy, and Gauss, Minding mined the expertise of Dirichlet, his predecessor at the Bauschule, and of Oberbaurat Crelle at the trade ministry, editor of the *Journal für die reine und angewandte Mathematik.* For his theoretical mechanics of 1838 he relied almost entirely on French engineers, especially Poinsot but also Coriolis and Navier. The great names of rational mechanics, Lagrange and Laplace, nowhere appeared, although Minding did acknowledge Poisson's newly revised textbook for the École polytechnique.[77]

Presumably on the basis of Minding's *Handbook of Theoretical Mechanics,* Dove solicited from him an extensive review of the current status of mechanics for his *Repertorium der Physik.* Dove had founded the *Repertorium* in 1836 and edited it until 1845, when its reviews of the latest advances (*Fortschritte*) in whole fields were largely superseded by the yearly *Fortschritte der Physik* of the younger generation. Like Dove himself, the *Repertorium* stressed experimental physics, instruments, measurements, and practical problems, containing nothing speculative and little abstract mathematical theory. It seems quite likely that it was there, in Minding's 1844 review, that Helmholtz found the survey of contemporary mechanics that he needed, for the similarities are striking.[78]

The review ranged over theoretical mechanics (Gauss, Poinsot, Dirichlet, Lamé, Clapeyron, etc.), industrial mechanics (especially Navier, Coriolis, Poncelet, and Morin), and Pambour's theory of the steam engine. It also included much of what Helmholtz would employ in generalizing the *vis viva* principle as conservation of force, down to details such as defining *vis viva* as $\frac{1}{2}mv^2$. The section on industrial mechanics Minding titled "On the Application of the Theorem of Living Force [*vis viva*] in the Theory of Machines," observing that this theorem, under the name of the "principle of the transmission of work" provided the foundation for the contemporary theory of machines.[79] Minding's line of reasoning was closely bound up with another of his insights, one quite foreign to both industrial and rational mechanics but one that Helmholtz would also employ: he assimilated the work integral to Gauss's term *potential.*

For Helmholtz, there are two aspects of Gauss's "potential" concerning material points and the work integral that are now salient. In an extended article of 1840 on the inverse-square forces of gravity, electrostatics, and mag-

netism, Gauss had introduced "potential" to name a function used by Laplace and Poisson to express mathematically the three perpendicular components of a central force as derivatives of a single function. But Gauss provided no physical interpretation for the potential. Like his French predecessors, he concerned himself with "a material point out of which a repulsive or attractive force acts [or emanates]," and he considered the force at an *empty point in space*, an arbitrary point located a distance r from the material point.[80] Thus, the force F produced at r by an electrical material point e was the force that *would be exerted* on a unit electrical mass *if it were placed* at the empty point. The magnitude of this abstract force, $F = e/r^2$, could be expressed in terms of the equally abstract potential $V = e/r$ as a derivative:

$F = -dV/dr.$

And the change in potential between distances r and R would be

$V_R - V_r = -\int_r^R F dr.$

The integral on the right looks a great deal like a work integral, but here dr is not the displacement of a material point. It is just a distance in space. And F does not move anything. It does no work. The integral simply calculates changes in the function V.

I note immediately that the notion of a force at an empty point of space violated Helmholtz's perspective on the necessary interrelatedness of the abstract concepts of matter and force, specifically, his treatment of interacting pairs of material points as the basic units of matter-force analysis. So his attribution to Gauss of his own "potential" was deceptive. In fact he rewrote the forces as acting between two material points (or electrical or magnetic "elements of mass"),

$P = ee'/r^2,$

and took the potential to be

$V = ee'/r.$

With that modification, the change in potential when the material points moved from r to R under the action of the force between them became the same as the "sum of the *Spannkräfte*," or the work integral:[81]

$V_R - V_r = -\int_r^R P dr.$

If we ask about Helmholtz's probable sources for this last step, Minding again appears a likely candidate, for he had already correlated Gauss's term

potential with the work integral for real motions in the principle of *vis viva*, and in just the form Helmholtz gave here. He also emphasized its importance, remarking that the product *Pdr* "is a fundamental concept running through the entire theoretical and practical mechanics, which in itself cannot be called new, but on whose clear conception and emphasis a large part of the most important newer accomplishments in this science depend." He went on briefly to survey the principle of the transmission of work in the theory of machines.[82]

The preceding analysis has been a rather detailed way of saying two things. First, the particular conceptual resources that Helmholtz employed for his classic paper on the conservation of force lay very close at hand in the company of people with whom he interacted in Berlin. Second, the conceptual resources came especially from industrial mechanics, whose importance for industrialization in Berlin was embodied in the network of technical schools that Helmholtz's teachers helped to constitute. Minding very likely provided the crucial translation of the rational mechanics of material points and central forces into the principle of transmission of work for machines. Most importantly he showed how to read potentials in terms of work, making Gauss's mathematical apparatus for all inverse-square forces available in just the way Helmholtz used it for his doctrine of *Erhaltung der Kraft*. Interestingly, Helmholtz's British counterpart in enunciating a generalized principle of conservation was the much more mathematically sophisticated William Thomson, but he, too, drew extensively on his direct access to engineering mechanics through his brother James and the industrial city of Glasgow, and he, too, translated Gauss's potential (along with that of George Green) into the terms of work produced by engines.[83]

Dynamometers, Indicators, and the Quantity-Intensity Duality

One final feature of Minding's review of the theory of machines will take us back to the theme of objectification of *Kraft* in terms of work, suggesting that this objectification was above all embodied in instruments that measured work. But it will also give a concrete sense of Helmholtz's quantity-intensity duality.

Minding concluded his section on the theory of machines by describing some of the self-registering dynamometers that Colonel Victor Poncelet and Captain Arthur Morin had recently developed for recording the work done by both "animate and inanimate motors." Their efforts had originated at the artillery and engineering school in Metz and in association with the Société d'encouragement pour l'industrie nationale. In addition to Morin's own de-

scriptions of 1837 and 1838, Minding cited Brix's exhaustive local account of Morin's earlier use of a dynamometer to measure frictional forces. And Brix in turn regarded the work of the artillery captain and professor of mechanics in Metz as belonging to "the most noteworthy undertakings through which the mechanical sciences have most recently been enriched." This and Morin's subsequent work depended largely on his dynamometers, for which he won wide recognition, including the Prix de mécanique de la fondation Monthyon of the Paris Academy and the Médaille d'or of the Société d'encouragement.[84]

As noted above, industrial mechanics centered on the "principle of transmission of living force" to analyze how work traveled through a factory from its source to its output as a commodity. To be of practical significance, as both Minding and Brix made clear, this enterprise required measurements of the work being done at any point in a train of mechanism and at any moment during the course of its motion. Earlier determinations had been limited to estimates made with spring balances, especially the so-called Regnier dynamometer or *Federdynamometer*, after Edmé Regnier, who developed it for the army in 1798.[85] In its standard form, it indicated the force required to compress an elliptical spring. When attached at one end to a fixed or moveable load and pulled at the other end by a human, a horse, or another motive power, the compression of the spring indicated the pulling force by means of a scale and pointer (fig. 7.6*a*, *b*). But one could only read off static forces or estimate rough averages over time. It was Poncelet and Morin who invented self-recording dynamometers to inscribe variable forces dynamically as a continuous function of time or distance.[86]

Their innovation consisted in mounting a rotating disc (or continuously moving scroll) of paper under the dynamometer together with a stylus to

Figure 7.6 Pulling force of a horse (*a*) as measured by a Regnier dynamometer (*b*). Regnier, "Description," 179. The Morin dynamometer (*c*) inscribes the force on a rotating table as a function of distance or time traveled. Morin, *Divers appareils dynamométrique*, plate 1, fig. 3.

record the varying compression of the springs (fig. 7.6*c*). They also designed much more precise and sophisticated dynamometers to trace the moving forces of motors of many kinds and at any point in a train of mechanism.[87]

As Minding observed, these curves could be drawn either as a function of time, when the recording paper was propelled by a clock mechanism, or as a function of distance, when it was connected with the wheel of a wagon or a rotating drive shaft, producing diagrams with two different functions.

> By quadrature [integration] of the drawn curve one obtains in the first case, where the abscissas perpendicular to the ordinates *P* are proportional to the time, the integral ∫*Pdt*, or the average force [the integral divided by the total time]; in the second case, where the abscissas are proportional to the distance traveled, one obtains the integral ∫*Pds*, or the total work of the moving force during the observation.[88]

His alternatives correspond to two kinds of instruments designed by Morin. They also record the historical development of dynamometers: from measuring average force to measuring work done, a quantity much more important to industry, as Morin explained. With respect to mechanics itself, the two recordings reflect the transformation of the mechanics of force into the mechanics of work. That is, the area under the curve drawn by the dynamometer provides a visual embodiment of the concept of work.

Textbooks of rational mechanics did not mention dynamometers, nor did they measure potential or work as the area under a curve. Indeed, the curves produced by self-recording instruments did as much as any other mathematical or mechanical device to objectify the concept of work, making it a constitutive concept not only for machines but for *Naturkörper* in general.

Equally as important as self-recording dynamometers in this respect were their close cousins the "indicators" used for measuring the work done by a steam engine over the course of a cycle. Incredibly, although developed by James Watt and his mechanic John Southern in the 1790s, the indicator remained a trade secret of the Boulton and Watt firm for about thirty years before it became known to others.[89] But from the early 1820s its principle and its immense value to mechanics gradually became known. Subsequently, more sophisticated indicators developed rapidly and in close relation with self-recording dynamometers. Morin simply treated the indicator as a form of dynamometer.[90] Figure 7.7 shows an early Watt indicator and its "indicator diagram."

When screwed into the top of an engine cylinder, the indicator registered the pressure inside the cylinder via the compression of a small spring, which

Figure 7.7 Watt steam engine indicator. Science Museum, London, Science & Society Picture Library, Inventory number 1890-0083.

moved a pen vertically over a sheet of paper affixed to a board. Since the board moved back and forth as the piston moved up and down, the pen traced essentially a pressure-volume curve on the paper. The area inside the curve was therefore proportional to the total work done during a cycle. Changing the settings of valves and timing produced a different curve. Thus, the indicator served two important functions: it measured the power of an engine in horsepower equivalents to determine its value to an owner—say one who wanted to drive two thousand spindles and reckoned on one horsepower per hundred spindles—and it could diagnose faults in the engine's operation in order to maximize its efficiency. As one manual put it, "The Indicator is as

The Mechanism of Matter 275

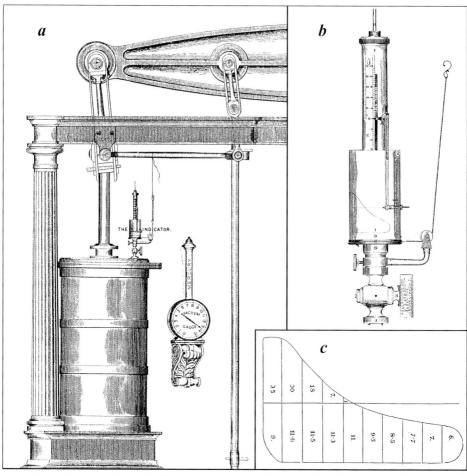

Figure 7.8 Improved form of indicator ca. 1840 installed on an engine (*a*), drawing its diagram on a rotating drum (*b*), and the resulting diagram (*c*). Hopkinson, *Working of the Steam Engine*, frontispiece, plate 2 (preceding p. 9), and diagram no. 13 (p. 70).

the stethoscope of the physician, revealing the secret workings of the inner system, and detecting minute derangements in parts obscurely situated."[91] Figure 7.8 shows a typical midcentury indicator mounted on the cylinder of an engine and drawing its indicator diagram on a rotating drum.

As noted above, Clapeyron's "Carnot diagram" was an idealized indicator diagram. Carnot himself likely knew of Watt's indicator and conceived his theory of heat engines partly in relation to it. Certainly Clapeyron did. He played a leading role in railroad construction and steam engine design in the 1830s and from 1844, when he became professor at the École des ponts et

chaussées, he taught the course on steam engines.[92] It may well be that Helmholtz in 1847 gained his newly concrete perspective on conservation of force when he juxtaposed Clapeyron's diagram and reversibility argument for the heat engine with Minding's account of dynamometer curves in relation to the principle of *vis viva* and the principle of transmission of work.

Minding's description of dynamometer curves, quoted above, provides a suggestive parallel to Helmholtz's own attempt to express visually and conceptually the relation of intensities of force P (acting between two material points) to the work integral $\int Pdr$ as "the sum of the *Spannkräfte*."

> In order to find the meaning of the magnitude $\int_r^R Pdr$, let us imagine the intensities of P . . . represented by perpendicular ordinates: then this magnitude would denote the area of the surface that the curve between the two ordinates at r and R encloses with the axis of abscissas [fig. 7.9].

So far, this expression is very like Minding's, but Helmholtz continued with what looks initially like a subtle misreading of Minding:

> Since one can regard this area as the sum of the infinite number of *Abscissen* [i.e., ordinates erected at the infinite number of points on the axis of abscissas] that lie between r and R, so this magnitude is the embodiment [*Inbegriff*] of all of the intensities of force [*Kraftintensitäten*] that act at the distances lying between R and r.[93]

As a careful teacher of the calculus, Minding would never have said that the area integral could be regarded as a sum of ordinates P (i.e., treating an area as a sum of lines placed side by side) but only as a sum of differential areas Pdr, representing elements of work. One might suppose that Helmholtz was simply making the elementary error of an autodidact or oversimplifying for the sake of intuition.[94] But the "error" seems to be more interesting than

Figure 7.9 Sketch of Helmholtz's integral $\int_r^R Pdr$ for the "sum of the Spannkräfte" represented as the area under a curve of intensities of force P between the distances r and R.

that, representing his struggle to capture the meaning of force as a relation between two material points in terms of two attributes, intensive and extensive. For although he spoke of the integral as summing and embodying the infinite number of *intensities* of force P between r and R, he was fully aware that no one of those intensities at a single point could do work. Only when conceived in the plural, and as summed over displacements that they themselves produced, could they do work and produce *vis viva*. This sum was what he termed "the sum of the *Spannkräfte*" or also the "quantity of *Spannkraft*":

> If we name the forces that tend to move the point m, so long as they have not yet actually effected the motion, *Spannkräfte*, in contrast to what in mechanics is called living force [*vis viva*], then we can denote the magnitude $\int_r^R Pdr$ as *the sum of the Spannkräfte* between the distances R and r.[95]

Here it seems clear, with Helmholt'z emphasis, that the sum of the *Spannkräfte* connotes a quantity that inheres in the relation of the material points, thought of in terms of all the distances they could occupy between R and r. That quantity—an extensive magnitude in Kantian terms—represented a capacity, or a "potential," to do work and produce *vis viva*. Bevilacqua has quite rightly, therefore, treated it as very like "potential energy."[96] Helmholtz made this meaning explicit with respect to two material points starting from an infinite distance apart and moving under an attractive force between them to a distance R. He designated the sum of the *Spannkräfte* between $r = R$ and $r = o$ as "still available" (*noch vorhanden*) for producing *vis viva* while the sum between $r = R$ and $r = \infty$ was already "used" (*verbraucht*) or "lost" (*verloren*).[97]

The term *Spannkraft* itself was a standard word for an intensity of force rather than a quantity. It connoted a tension in a spring or a muscle, as employed for example by Eduard Weber in a key paper that Helmholtz had read in 1846 (chap. 8). It also referred to a pressure—as in Magnus's papers of 1844 on the pressure of steam, a usage that Karsten continued in his review—with reference also to the Clapeyron-Holtzmann theory of "mechanical work" from steam.[98] But I have found no precedent for Helmholtz's treatment of *Spannkraft* not as an intensity but as a quantity of *Spannkraft*, a magnitude obtained by summing *Spannkräfte* over a range of distances to obtain a total capacity to produce *vis viva*. Again, he was not simply confused about the difference between the ordinates and the integral, for he consistently referred to the ordinates as "intensities" of *Kraft* and to the integral, or the "sum of the *Spannkräfte*," as the corresponding *Quantität der Spannkraft*.[99] These quantities of forces were the items that could be interconverted from one

kind of force to another and to which equivalents (*Kraftequivalente*) had to be assigned in the accounting scheme for conservation. Quantities of chemical, thermal, electrical, and magnetic force all had to have their mechanical equivalents.

The quantity-intensity duality is apparent in Helmholtz's full statement of "das Princip von der Erhaltung der Kraft":

> In all cases of motion of free material points under the influence of their attractive and repulsive *Kräfte*, whose *Intensitäten* are dependent only on the distance, the loss of *Quantität der Spannkraft* is always equal to the gain of living force, and the gain of the former to the loss of the latter. *Therefore, the sum of the available living forces and Spannkräfte is always constant.*[100]

Because Helmholtz so consistently employed the quantity-intensity language throughout his treatise, never confusing its double meaning either in words or equations, one might want to downplay the significance of its being a duality at all. That is, the duality might be read as simply the conceptual distinction of potential energy from force, which is precisely what it would become when Helmholtz adopted the English term *energy* for *Quantität der Spannkraft* by the 1860s.[101] But in 1847 it looked much more like dual aspects of the concept *Kraft*, which he aimed to clarify. Indeed, he had occasionally used *Energie* in his chemical and thermal papers discussed above as the effort (*Anstrengung*) of a muscle to exert a force, as had other physiologists. And he would employ that concept throughout his first big paper of 1850 on the contraction of frog muscles and propagation in the nerves (chap. 8). There, too, it will be essential to maintain the double meaning of *Kraft/Spannkraft*, but as a duality of *Energie*, referring to intensity and quantity of force, for it structured in detail the meaning of two closely related instruments that he would develop for drawing curves of the *Energie* of contracting frog muscles, one as capacity to exert a tension and the other as capacity to do work.

Reading slightly backward, we should probably interpret Helmholtz's concept of *Spannkraft* in 1847 as deriving in part from his chemical-physiological understanding of the capacity of a muscle both to exert a tension and to lift a weight, a dual capacity that developed in time as a result of the *Stoffwechsel*. The existence of the tension in the muscle, its intensity, already before its action, would also represent its capacity to do work in a contraction, its quantity of *Spannkraft* (as above, "the forces which tend to move the point m, so long as they have not yet actually effected the motion"). As the contraction pro-

gressed this dual capacity for tension and work, *Kraft* and *Spannkraft*, would be consumed (unless replenished by the *Stoffwechsel*).

Helmholtz's use of *Spannkraft* has long fascinated interpreters. Thomas Kuhn regarded it as a failure to associate the integral with work; Jehuda Elkana treated it as an ambiguous or confused concept, symptomatic of concepts in flux; while Bevilacqua has made it a major innovation that introduced a concept close to potential energy.[102] I have presented the view here that close attention to Helmholtz's regular use of the quantity-intensity duality both removes Elkana's ambiguity and helps to clarify Bevilacqua's potential energy. Helmholtz was quite consciously attempting to assimilate the engineering concept of work and Gauss's mathematical potential not only to each other, as Minding had done before him, but to the protean notion of *Kraft* as he had encountered it in physiology. Liebig's confusing attempt to employ the term in its multiple meanings for animal chemistry and heat provides an illuminating comparison. Seen in the light of Liebig's difficulties, the quantity-intensity duality supplied just the instrument Helmholtz needed to cut through the contortions and to make immediately *begreiflich* the relation of *Kraft* to force, work, potential, and *vis viva*.[103]

Kant and the Concept of Quantity

The consistency with which Helmholtz structured his *Ueber die Erhaltung der Kraft* using the quantity-intensity duality points to his Kantian metaphysics. He wrote to Du Bois-Reymond that he had prepared an introduction to his first draft, which "smelled of philosophy" and which he had "thrown overboard." Even after that cleansing, as he remarked in an addendum in 1881, the published introduction was "more strongly influenced by Kant's epistemological views than I would now like to allow."[104] He elaborated only on a shift in the status he ascribed to the law of causality, the main emphasis of the introduction, which he now viewed as "nothing other than the presupposition of the lawlikeness of all the appearances of nature." This shift made more cogent than ever his original remark: "It is illuminating that the concepts of matter and force may never be separated in application to nature."[105] I take this remark to lie at the center of his argument.

Discussions of Helmholtz's introduction[106] have focused on the general question of *Begreiflichkeit* with respect to the principle of causality and its formulation in terms of unchangeable laws governing central forces, typically with reference to Kant's *Metaphysical Foundations of Natural Science* (1786) and his discussion of the law of causality in the *Critique of Pure Reason*, for example,

Experience itself—in other words, empirical knowledge of appearances—is thus possible only in so far as we subject the succession of appearances, and therefore all alteration, to the law of causality; and as likewise follows, the appearances, as objects of experience, are themselves possible only in conformity with the law.[107]

I want to propose an elaboration of these discussions that focuses on the work done by machines as Helmholtz's object of analysis and on his use of Kant's concept of *quantity* in giving it a metaphysical foundation. In this, I will take the *intensity* side of the duality as relatively unproblematic for Helmholtz.

The ultimate object of Kant's attention in the *Metaphysical Foundations* was that icon of the Enlightenment, the Newtonian System of the World. He sought ultimately to establish the epistemological basis for representing celestial motions in terms of universal gravitation and absolute space.[108] Such a grounding required that he connect the principles of pure understanding from the *Critique of Pure Reason* (1781) with the empirical object of outer sensible intuition: matter as the moveable in space. That is, he needed to apply the table of categories of pure understanding to the concept of matter by supplying a spatiotemporal *schematism* of the categories, yielding the conceptual *determinations* of matter and thereby converting immediate sensory *appearances* of relative motion into objective *experience* of motion in absolute space. (Compare *appearance* and *experience* in the quotation above.) He did that in four chapters, closely following his general exposition in the *Critique* of the four basic categories of quantity, quality, relation, and modality, each with its three subcategories. As an extension of the temporal schematism of the *Critique*, this spatiotemporal schematism turned on the central concept of *quantity of matter* and on its measure in terms of *quantity of motion*.[109]

I will propose a reading of Helmholtz's introduction to his *Ueber die Erhaltung der Kraft*, along with the two succeeding sections 1 and 2, as a summary view of the kind of Kantian schematism that would be required to provide the metaphysical foundations for a world of mechanical work taken as the basis for representing the action of all forces and their interconversions. On my reading, it is altogether important that he began in the introduction by taking the empirical object of sensible intuition to be not matter per se but matter and force together as a conceptual pairing, formed from our sensations as inseparable "abstractions from the real."[110] From that starting point, Helmholtz was looking not outward to the heavens but inward to the determinations of matter-force that would transform the sensory appearances of all of nature's powers—mechanical, thermal, electrical, magnetic, chemical—into

the schematized experience of those powers as central forces between pairs of material points.[111] The matter-force abstraction in appearances would become the matter-force pair in experience. He aimed to establish that conception as necessary and therefore as objectively true for all of natural science, which entailed the general principle of conservation of "quantity of force," *die Erhaltung der Kraft.*

I will focus my discussion of Helmholtz's updating of Kant on what I take to be his reframing of the functions of Kant's concept of "quantity of matter" for his own concept of "quantity of force." Introduced initially in section 1 for the observable work done by macroscopic machines, quantity of force then centered in section 2 on the microscopically conceived and unprecedented *Spannkraft* of pairs of material points. I will limit the discussion largely to Kant's categories of relation and their correlated analogies of experience, which he developed as the laws of mechanics in chapter 3 of the *Metaphysical Foundations.* The five basic determinations of matter in Kant's exposition lead me to a portrayal of Helmholtz's conceptual reconfiguration— from quantity of matter to quantity of *Spannkraft*—in terms of five leading questions.

1. What Is Quantity of Matter (or *Spannkraft*) as Quantity?

In the *Metaphysical Foundations* Kant turned to an explicit discussion of quantity of matter only in his third chapter, on mechanics, beginning from explication 1: "Matter is the movable insofar as it . . . has moving force."[112] He would there show how the three subcategories of relation—substance, causality, and community—when applied to matter yielded three laws of mechanics. These laws, similar to Newton's laws of motion, governed the capacity of any one body to move another—its moving force. That subject placed Kant squarely in the midst of the so-called *vis viva* controversy over the proper measure of moving force, whether quantity of motion *mv* with Newton or *vis viva mv*2 with Leibniz. Kant opted unequivocally for *mv*, to which I return below. To develop that choice, however, he had first to specify a proper measure for *m* as the *mass* of a body (a bounded quantity of matter), beginning from the very concept of quantity of matter itself. Leibnizian-Wolffian monadology provided Kant's foil,[113] while his own reasoning seems to have offered to Helmholtz a key resource for the concept of quantity. For this perspective we need to recover a bit from Kant's previous chapters concerning quantity as an extensive magnitude.

Kant's earlier precritical response to the various Leibnizian-Wolffian versions of a "physical monadology" was his own *Physical Monadology* (1756),

according to which matter could be conceived as consisting of a composite of simple (indivisible) points from which attractive and repulsive forces emanated and whose intensities maintained the separated points in equilibrium.[114] But this view could not satisfy his mature conception of matter developed in the *Metaphysical Foundations*. In chapter 2, on dynamics, Kant had schematized the category of quality in terms of how matter must fill space dynamically by a balance of repulsive and attractive forces. He there demonstrated that the outer intuition of matter required that it actually occupy space as an infinitely divisible continuum rather than a discrete set of point monads, so that every part of the filled space was itself matter.[115] Thus, matter was to be represented in thought as a composite of parts obtainable by division and therefore of parts external to one another, like the similarly divisible parts of space itself. This property defined quantity of matter as an extensive magnitude, a quantity in the formal sense of what Kant called a *quantum*.[116] An intensive magnitude, by contrast, referred to a degree of intensity, like color, temperature, the speed of a moving point, or indeed, as he developed it here, the density of the matter filling space.[117]

Kant's full concept of quantity in the *Metaphysical Foundations* was quite nuanced, particularly as developed in chapter 1, on phoronomy, where he was concerned with the pure mathematics of quantity of motion as an object having both speed and direction (a velocity vector in modern terms).[118] But for physical objects considered only with respect to their extent (a scalar magnitude), he stressed only that they were to be thought of in terms of parts external to one another. To this property he nevertheless ascribed fundamental significance. In chapter 3, concerning matter he remarked,

> That the quantity of matter can only be thought as the aggregate of movables (external to one another) . . . is a remarkable and fundamental proposition of general mechanics. For it is thereby indicated that matter has no other magnitude than that consisting in the aggregate of manifold [elements] *external to one another*, and hence has no *degree* of moving force at a given speed that would be independent of this aggregate, and could be considered merely as intensive magnitude—which would be the case, however, if matter consisted of monads, whose reality in every relation must have a degree that can be larger or smaller without depending on an aggregate of parts external to one another.[119]

The key phrase, "parts external to one another," made quantity of matter an extensive magnitude and similarly for its quantity of moving force mv conceived as an aggregate of parts all having the same speed. By contrast, phys-

ical monads, as indivisible points, could yield only an intensive conception or degree of their moving force, whether as speed or as intensity of attractive or repulsive force.

Pursuing the general category of quantity one step further, Kant's three subcategories as articulated in the *Critique* were unity, plurality, and totality. *Unity* referred to any one unit or part of an aggregate, *plurality* to the indefinite sum of homogeneous units, and *totality* to the definite sum between end points (like the length of a line segment).[120] For the physical objects of the *Metaphysical Foundations*, this took the form that, as quantities, they should be representable as a bounded summation of parts external to one another, like quantity of motion mv and quantity of *vis viva mv*2.

Turning to Helmholtz, it may already be apparent that his usage of *quantity* conformed quite closely to Kant's exposition. He first employed the term in an unremarkable fashion for quantity of matter in his introduction and then in section 1 for the quantity of *vis viva* produced by the *Arbeitsgrösse* (amount of work) done by machines.[121] *Quantity* acquired its more special meaning only in section 2, with the metaphysical reduction of machines to systems of material points, where the directly observable *Arbeitsgrösse* of a machine became the unobservable quantity of force inhering in point pairs as quantity of *Spannkraft*. From that point Helmholtz regularly referred to its integral or aggregate value for any pair as "the sum of the *Spannkräfte*." Typical is his phrasing: "the magnitude $\int_r^R Pdr$ as *the sum of the Spannkräfte* between the distances R and r,"[122] which I have represented visually in figure 7.9. In Kantian terms, the definite summation of homogeneous units of *Spannkraft* between the end points r and R formed a totality. I start, therefore, from the assumption that Helmholtz adapted his conception of *Spannkraft* as a spatial quantity from Kant.

Nevertheless, articulating this innovative concept is not so straightforward, because Helmholtz's *Spannkraft* was just as abstract a conception as that of the point pairs that gave definite form to the abstractions of matter and force. In itself *Spannkraft* had no location or distribution in space. It inhered rather in the spatial relation of a matter-force pair, as a capacity to do work, existing before any action of the force to move the material points (thus the language of *Spannkraft* "still available" or already "used").[123] Nevertheless, the change in its magnitude for any change in the distance r between the points could be represented as a sum of parts or units external to one another, with each part represented by a differential distance dr multiplied by the intensity of the force P. In short, *Spannkraft* was a quantity of force

determined entirely by the configuration of material points in space and the intensities of the forces between them.

2. How Is Quantity of Matter (or *Spannkraft*) to Be Measured?

Kant answered in proposition 1: "The quantity of matter, in comparison with *every* other matter, can be estimated only by the quantity of motion at a given speed."[124] Our senses give us no access to the quantity of matter of one body relative to every other, perhaps of a different kind, except through the different effects of their motion, that is, through their capacity to move other bodies, or their moving force. The proper measure of this moving force, Kant insisted, was quantity of motion *mv*. As the most direct means for carrying out such a measurement, he apparently had in mind the action-reaction law for interactions (no. 5, below), whereby when two bodies interact, they both experience the same change in quantity of motion in opposite directions, $m_1 \Delta v_1 = -m_2 \Delta v_2$, which gives quantity of matter m_1 in comparison with any other matter m_2 as the inverse ratio of their changes in velocity.[125]

Kant's reasoning with respect to quantity of motion provides a nice example of how fundamentally his perspective differed from Helmholtz's and yet how readily Helmholtz could translate Kant's basic terms into his own. If *Spannkraft* were something real, to be understood in terms of the configuration of matter-force, it required a metaphysical grounding as a spatial quantity similar to the one Kant gave for matter. But as in that case, our senses could give us no access to the *Spannkraft* of a system of material points governed by any particular force, in comparison with every other such system, except its composite effect in doing work to produce changes in quantity of motion. "Quantity of motion," however, now had to be read not as Kant's *mv* but as the redefined *vis viva* ½*mv²*, which is precisely the change in meaning that Helmholtz originally employed.[126] Changes in *Spannkraft*, as work done at the level of pairs of material points, were to be measured by changes in their *vis viva*.

3. What Is Quantity of Matter (or *Spannkraft*) as a Conserved Quantity?

Kant's proposition 2, his first law of mechanics, stipulated that "in all changes of corporeal nature the total quantity of matter remains the same, neither increased nor diminished."[127] As the substance of outer intuition, matter fell under the schematized category of *substance* in the *Critique* as "permanence of the real in time" and as the "substratum of all change of appearances." All changes of material substance, therefore, could only be alterations of

form, such as configuration and velocity. From this principle of permanence of substance followed the principle of all conservation laws, that "nothing comes from nothing" (*aus nichts wird nichts*).[128] In the *Metaphysical Foundations* Kant tied his reasoning closely to the concept of quantity of matter as a sum of parts external to one another: "since all quantity of an object possible merely in space must consist of *parts external to one another*, these, if they are real (something movable), must therefore necessarily be substances," and thus conserved in total.[129]

Helmholtz's argument for conservation of force followed much the same principle of nothing from nothing with which he opened section 1 of *Ueber die Erhaltung der Kraft* on working machines: "We proceed from the assumption that it is impossible, through any combination of natural bodies, to create *bewegende Kraft* [here "mechanical work"] continually out of nothing."[130] From this long-standing prohibition of perpetual motion machines in mechanics followed conservation of *vis viva* for any system of natural bodies returning to its original configuration. The same result applied to the system of material points to which the natural bodies could be reduced, subject to the restriction that only central forces acted between the points. What Helmholtz added in his culminating section 2 was conservation of force throughout all changes of configuration. He formulated this generalized principle of *Erhaltung der Kraft*, through the introduction of *Spannkraft* to represent the quantity of force, as potential work, inherent in a spatial configuration of material points such that "the sum of the *Spannkräfte*" (the sum of parts external to one another) gained or lost when the configuration changed in any way would be interconverted with *vis viva*, and the total quantity of force would be conserved. Helmholtz's quantity of force thus occupied a place in nature closely analogous to matter as the Kantian substance in outer intuition.

Unfortunately, Helmholtz did not discuss the concept of substance. He did, however, suggest that the empirical object of sensible intuition was the conceptual pairing of matter and force as abstractions from the real. Following this lead, matter-force as Helmholtz's "substratum of all change of appearances" would be represented in experience as the *Erhaltung der Kraft* for all interconversions of force.[131]

4. Can Matter (or *Spannkraft*) Be Self-Moved or Have an Internal Cause of Change of Motion?

Kant answered by applying the category of *causality* to matter, yielding his second law of mechanics as the law of inertia for changes of motion: "Every change in matter has an external cause." His proof relied on the determi-

nation of matter as having parts external to one another: "Matter, as mere object of the outer senses, has no other determinations except those of external relations in space."[132] The same reasoning would also serve Helmholtz as the well-known and often-repeated theme of his introduction, in which he presented the law of causality as the precondition for *Begreiflichkeit*: "The appearances of nature should be reduced to motions of matter with unchangeable moving forces, which are dependent only on [external] spatial relations."[133]

But for both Kant and Helmholtz the most telling implication of the external spatial relations argument was that matter could have no *internal* causes of change and was therefore *lifeless*. In Kant's formulation, the object of internal sensible intuition, the substance of the soul (and life more generally) could indeed change its state through the internal activities of desiring and thinking, but these activities did not belong to the representations of the outer senses. "Hence all matter as such, is *lifeless*. The principle of inertia says this, and nothing more."[134] If one wanted to seek the cause of any change of matter in life, Kant continued, it would have to come from another substance somehow combined with matter, but such a pursuit would fall outside the domain of natural science. "The possibility of a proper natural science rests entirely and completely on the law of inertia [the law of causality as lifelessness] (along with that of the persistence of substance [conservation of matter])."[135] Kant thus provided Helmholtz with a ready-made exclusion of the *Lebenskraft* from his own analysis. The demand for *Begreiflichkeit*, he said already in his second paragraph, could be satisfied only by reducing all changes in nature to unchangeable causes. Whether in fact changes might occur that fell "in the domain of a spontaneity, freedom," was not here the place to decide: "The science whose purpose it is to comprehend nature must proceed from the presupposition of *Begreiflichkeit*."[136]

5. What Conditions Govern the Interactions of Matter (or *Spannkraft*)?

Kant obtained his third law of mechanics as a development of the category of *community* to the interrelations of matter, which yielded the Newtonian action-reaction law: "In all communication of motion, action and reaction are always equal to one another." This law of community rested on his argument that "all *active* relations of matters *in space*, and all changes of these relations, insofar as they may be *causes* of certain actions or effects, must always be represented as mutual," which required that their velocities be referred to their common center of mass.[137] Thereby the velocities would always remain in reciprocal proportion to their masses and in opposite directions

$(m_1 v_1 = -m_2 v_2)$. And since the center of mass would be unaffected by their mutual action, it could be taken as at rest in absolute space.[138] This basic result, especially in its more refined forms for rotating systems, provided the central pillar in Kant's reduction of all motion to absolute space, moving successively from the earth to the center of mass of the solar system to the center of mass of the milky way galaxy and thence by a never-completed process to the (regulative) idea of absolute space.[139]

It is interesting, therefore, that arguing from much the same principle of community or mutuality of interactions, Helmholtz would move in a quite different direction to reach the metaphysical centerpiece of his own determinations of matter-force.

> Motion can . . . in experience only appear as change of spatial relations of at least two material bodies with respect to each other; *Bewegungskraft*, as its cause, can therefore also only be developed for the relation of at least two bodies with respect to one another; it is therefore to be defined as the effort of two masses to change their relative position.

From this result Helmholtz could easily have derived the action-reaction law, just as Kant did, and have stated such principles of mechanics as conservation of motion of the center of mass. But instead, because he concerned himself only with the "earthly relations" (*irdische Verhältnisse*) of matter rather than with "completely free systems" moving in absolute space, he proceeded instead to the opposite scale of phenomena, to the internal relations of matter.[140]

For this purpose, when coupled with the concept of matter as divisible into parts external to one another, mutuality immediately gave the reduction to interactions of pairs of material points.

> The force, however, which two entire masses exert with respect to one another, must be resolved into the forces of all its parts with respect to one another; mechanics reduces (*geht zurück*) therefore to the forces of the material points, that is, the points of the space filled with matter.

And since two points had no other spatial relations than the distance along the line between them (as he mistakenly argued), the forces could only be determined by this distance.

> A moving force that they exert with respect to one another can therefore also only be a cause of change of distance, that is, attractive or repulsive.[141]

It was from this restriction of mutuality to attractive and repulsive central forces, as articulated mathematically for *Spannkraft* in section 2, that Helmholtz obtained his most general principle of *Erhaltung der Kraft.*

In summary, Helmholtz's metaphysical "determinations" of quantity of force in terms of the *Spannkraft* of pairs of material points can be read as a Kantian "schematism" of the categories of *relation* as applied to the object given in sensation as matter-force. His "determinations" yielded (1) *Spannkraft* as the quantity of force inhering in the spatial relation of pairs of material points, (2) *vis viva* as its measure, (3) conservation of quantity of force (as *vis viva* plus *Spannkraft*), (4) lifelessness of physical nature, or exclusion of the *Lebenskraft*, and (5) the restriction to central forces.

It remained only to show, in application of the categories of *modality* in Kant's chapter 4 on phenomenology and in completion of the transformation of appearance into experience, that as an empirical matter the reduction to point pairs and central forces covered all known areas of natural science. Such universal applicability would establish the reduction as a regulatory principle of reason, a necessary even if unending goal for *Begreiflichkeit*. As Helmholtz expressed it in the final paragraph of his introduction,

> The task [of theoretical natural science] will be complete when, in the first place, [empirically] the reduction of the appearances to simple forces is complete and, at the same time, [theoretically] it can be demonstrated that this is the only possible reduction that the appearances allow. Then [this reduction] would be established as the necessary conceptual form [*Begriffsform*] for the understanding of nature [*Naturauffassung*]. Objective truth would therefore also have to be ascribed to it.[142]

Having constructed the required concepts in sections 1 and 2, he turned to an extended survey of this pursuit for a wide range of conversion processes and their force equivalents, not only for working machines and the mechanics of solid and fluid bodies, but for heat, electricity, magnetism, electromagnetism, and (briefly) physiology. For Helmholtz, *Erhaltung der Kraft* had become a Kantian principle of reason.

NOTES TO CHAPTER SEVEN

1. Helmholtz, "Über Goethes naturwissenschaftliche Arbeiten," 35.

2. Otis, *Müller's Lab*, 119. Another key resource was Carl Ludwig, in Marburg, after he visited Berlin in 1847.

3. Helmholtz, "Erinnerungen," 6, 13.

4. Ibid., 7–9.

5. Helmholtz, "Über Goethes naturwissenschaftliche Arbeiten," 25, 37, 40–41, 44, 45. Presented to the Deutsche Gesellschaft in Königsberg, where Helmholtz became extraordinary professor in 1849 and ordinary professor in 1851. In 1875 he added a postscript (46–47) sharply qualifying his critique of Goethe. With his positivistically inclined colleague G. R. Kirchhoff, he now thought mechanics itself might best be called a descriptive science. His Kantian metaphysics had acquired an "empiricist" vein (chap. 8).

6. Bevilacqua, "Helmholtz's *Ueber die Erhaltung der Kraft.*" Still the best discussion of the broader intellectual context is Kuhn, "Energy Conservation." Darrigol's reevaluation, "God, Waterwheels, and Molecules," stresses the nonconservative character of eighteenth-century rational mechanics and the crucial role of French engineering mechanics, especially for the unknown case of Saint Venant. For Britain, see Smith and Wise, *Energy and Empire*, and Smith, *Science of Energy*.

7. Brain and Wise, "Muscles and Engines."

8. The *Lebenskraft*, although widely discussed in other contexts, has sometimes been rejected as primary background for Helmholtz's conservation analysis. Similarly, while French engineers are always cited for his concept of work, the engineering context runs much deeper. Finally, Kant has been widely invoked for Helmholtz's concern with *Begreiflichkeit* and with the force-matter relation (also sometimes called a duality), but the Kantian origins of his quantity-intensity duality in relation to *Spannkräfte* has escaped attention.

9. Helmholtz, "Über das Wesen der Fäulniss und Gährung," *WA*, 2:732, 728, 731. Olesko and Holmes, "Experiment," provide a thorough analysis of Helmholtz's attention to rigorous experimental methods and the analysis of error. They omit his attack on Liebig's oxygen theory of putrefaction and fermentation and on the *Lebenskraft.*

A valuable history of the problem of animal heat and work from Lavoisier to the post-Helmholtz period is Kremer, *Thermodynamics*, including the early Helmholtz papers discussed here, 237–55 and 292–307. In contrast with Olesko and Holmes, Kremer argued that Helmholtz was relatively ignorant of contemporary chemistry and physiology and that his work was much less pathbreaking than he imagined. He also did not allow Helmholtz the consistently antagonistic view of the *Lebenskraft* that I present here, which agrees more closely with that of Lenoir, *Strategy of Life*, 162–68, 195–215.

10. Helmholtz, "Über das Wesen der Fäulniss und Gährung," *WA*, 2:727.

11. Lenoir, *Strategy of Life*, 196; Liebig, *Die Thier-Chemie*, 84, 100–110; Müller, *Handbuch.*

12. Helmholtz to his parents, July 25, 1843, in Cahan, *Letters*, 105–6, and Koenigsberger, *Helmholtz*,1:51–53 (cf. Cahan, 76n2), on Helmholtz studying Mitscherlich. Schütt, *Mitscherlich*, 133–34, discusses the conflict with respect to catalytic or contact action and an 1839 article of Liebig's on fermentation. Satires in Schütt, *Mitscherlich*, 132n4 and 133.

13. Helmholtz, "Über das Wesen Fäulniss und Gährung," *WA*, 2:728; cf. Liebig, *Die Thier-Chemie*, 79.

14. Liebig, *Die Thier-Chemie*, 193.

15. Ibid., 105–6.

16. In an 1882 note, Helmholtz recognized that smaller microorganisms probably

crossed the semipermeable membrane. Helmholtz, "Über das Wesen der Fäulniss und Gährung," *WA*, 2:734.

17. Turner, "Liebig," documents Liebig's attack and its effects. Holmes's introduction to Liebig, *Animal Chemistry*, summarizes its reception: outright rejection by Berzelius (lviii–lxv), praise by Friedrich Mohr and Gustav Valentin (lxvi–lxviii), and measured appreciation by Johannes Müller, Theodor Bischoff, and Otto Kohlrausch (lxviii–lxxii).

18. Koenigsberger, *Helmholtz*, 1:44, 55, says Helmholtz knew Du Bois-Reymond in Müller's lab in 1841 and that Du Bois-Reymond often visited him in Potsdam from the fall of 1843, but without evidence. Their correspondence began only in July 1846 and switched to the familiar address in February 1847. Kirsten, *Dokumente*, 73–78.

19. Helmholtz, "Ueber den Stoffverbrauch," *WA*, 2:735.

20. Kremer, *Thermodynamics*, 340–51, treats Liebig's long pt. 3 as an aberration, borrowed from Müller and eliminated from the revised third edition of 1846.

21. Liebig, *Die Thier-Chemie*, 28, 210. See also 30–31 on interconversion and conservation of force.

22. For this reason, Lenoir, *Strategy of Life*, 158–18, gives Liebig a key role in his history of vital materialism in Germany.

23. Hankins, "*Vis Viva.*"

24. Liebig, *Die Thier-Chemie*, 183–84, 198; electric circuit analogy, 32, 195–98; "Current of chemical force," 196; "current of *Lebenskraft*," 209; "conductor of *Kraft*," 249. Concerning *Bewegungskraft*, Liebig did not distinguish lifting a weight (work done) from carrying a load (zero work), 223–24, a not uncommon problem.

25. Ibid., "current of oxygen," 56.

26. E.g., see Liebig, *Die Thier-Chemie*, 201–2: "*Stoffwechsel*, manifestation of mechanical force, and absorption of oxygen in the animal body, stand in so close a relation to one another that one can set the quantity of motion and the amount of living tissue transformed proportional to a certain amount of oxygen inspired and consumed in a given time by the animal. For a definite measure of motion [W], for a proportion of *Lebenskraft* consumed as mechanical force [$L = W$], an equivalent of chemical force [O] is manifested; that is, an equivalent of oxygen becomes a constituent of the organ that has lost the *Lebenskraft*; and an equal proportion of the substance of the organ is separated from the living tissue in the form of an oxidized compound [releasing heat, $O = H$]." This description applies to an equilibrium state. With loss of heat and decreasing temperature, the "moment of force" of the *Lebenskraft* would decrease in its "intensity." The consequent increase in oxidation would increase the temperature and thus the "measure" of *Lebenkraft* utilizable for mechanical purposes (214–15, 228–30).

27. Ibid., 219.

28. The alternative (Kremer, *Thermodynamics*, 237–38) is to discount Helmholtz's later recollection.

29. Helmholtz, "Ueber den Stoffverbrauch," *WA*, 2:736. Olesko and Holmes, "Experiment," 54–59, discuss Helmholtz's pursuit of rigor and precision.

30. Helmholtz, " Ueber den Stoffverbrauch," *WA*, 2:744. He promised further results later, but nothing came of it. His first four letters to Du Bois-Reymond, July–October 1846,

show him trying to work out how Du Bois-Reymond's frog current affected decomposition. Kirsten, *Dokumente*, 73–75; Liebig, *Die Thier-Chemie*, 200.

31. Helmholtz, "Zum Gedächtnis an Gustav Magnus," 38.

32. Olesko and Holmes, "Experiment," 59.

33. Helmholtz to Du Bois-Reymond, December 21, 1845, in Kirsten, *Documente*, 75–78. Olesko and Holmes, "Experiment," 64–74.

34. Helmholtz, "Uber die Wärmeentwicklung," presented originally to the Physical Society on November 12, 1847. The induction coil was a rotational apparatus of Eduard Weber of which Helmholtz learned when Du Bois-Reymond loaned him Weber's new paper on *Muskelbewegung* (see chap. 8). Helmholtz to Du Bois-Reymond, July 24, 1846, in Kirsten, *Documente*, 73.

35. [Du Bois-Reymond], "Progrès des sciences," 91.

36. Already on May 2, 1845, Du Bois-Reymond had reported to the Physical Society on the *chaleur animale* of John Davy and would normally have done the *Fortschritte* review, but Helmholtz replaced him. "Protocoll"; Helmholtz to Du Bois-Reymond, October 5, 1846, in Kirsten, *Documente*, 74–75; Helmholtz, "Wärme" and "Uber die Wärmeerscheinungen."

37. Helmholtz, "Wärme," 698. Called Hess's Law (and reinterpreted as conservation of energy) after Hess, "Recherches thermochimiques" and "Ueber die bei chemischen Verbindungen."

38. Liebig, *Die Thier-Chemie*, 31.

39. Karsten, "Gase und Dämpfe"; Heinz, "Wärmeentwicklung." Knoblauch reported on radiant heat April 4 and May 2, 1845: "Protocoll"; Helmholtz, "Wärme," 699.

40. Darrigol, "God, Waterwheels, and Molecules," 301–5, shows that classical rational mechanics, from D'Alembert to Lagrange, Laplace, and Poisson rejected conservation of *vis viva*, especially in its reliance on the concept of perfectly hard (inelastic) bodies.

41. Helmholtz, "Wärme," 696–97.

42. Ibid., 699, emphasis added.

43. Helmholtz, "Wärme," 699. *Bewegende Kraft* as a "quantity" must be distinguished from *Bewegungskraft* as an "intensity," Helmholtz's usual term for a Newtonian force. See also "Physiologische Wärmeerscheinungen," 350.

44. Helmholtz, "Wärme," 700.

45. Ibid., 700, 715.

46. Liebig, *Die Thier-Chemie*, pt. 1, "Der chemische Process der Respiration und Ernährung," 1–91, Despretz on 33–36; also pt. 3, "Theorie der Respiration," 241–50. Greatly extended in Liebig, "Ueber die thierische Wärme." Kremer, *Thermodynamics*, 206–15, describes Liebig's deceptive attempts to buttress the respiration theory.

47. Liebig, *Die Thier-Chemie*, 28; "Ueber die thierische Wärme," 63.

48. Helmholtz, "Wärme," 702–11.

49. Du Bois-Reymond, "Vorläufiger Abriss."

50. Helmholtz, "Wärme," 717–18. Magnus, "Ueber die im Blute enthaltenen Gase" and "Ueber das Absorptionsvermögen," both reviewed (unsigned) in *FdP [1845]* 1 (1847): 112–14. Müller, *Handbuch*, 1:81; Culotta, "Respiration."

51. Helmholtz, "Physiologische Wärmeerscheinungen," 349, 350.

52. Helmholtz, "Physiologische Wärmeerscheinungen," 349; Liebig, *Die Thier-Chemie*, 28, 30.

53. Helmholtz, "Physiologische Wärmeerscheinungen," 349–50; Karsten, "Gase und Dämpfe."

54. Helmholtz, *Ueber die Erhaltung*.

55. Helmholtz, *Ueber die Erhaltung*, 17. Here again, *Bewegende Kraft*, as a "quantity" of work, must be distinguished from *Bewegungskraft*, as an "intensity" of a Newtonian force.

56. Helmholtz, "Physiologische Wärmeerscheinung," 350.

57. Thorough historical analysis of Carnot's text by Fox in Carnot, *Reflexions*; Redondi, *Sadi Carnot*; Clapeyron, "Mémoire sur la puissance motrice de la chaleur."

58. On Thomson and Carnot-Clapeyron, see Smith and Wise, *Energy and Empire*, 249, 289–302.

59. Hoffmann, *Magnus und sein Haus*, 26; Magnus, "Versuche," "Ueber die Kraft"; Karsten, "Gase und Dämpfe," 98–104; Holtzmann, *Ueber die Wärme*. Holtzmann, a talented school teacher who in 1851 became professor for physics and mechanics at the Technische Hochschule in Stuttgart, published several books on mechanics and machines, including a translation of Morin, *Hilfsbuch*. See Morin's significance below.

60. Detailed survey of Clausius's activities in Ebeling and Orphal, "Clausius," and Wolff, "Clausius' Weg," esp. 55–56, 63–65. Jungnickel and McCormmach, *Intellectual Mastery of Nature*, 163–64.

61. Helmholtz, in "Zur Erinnerung an Rudolph Clausius," recalled that he met Clausius and Gustav Wiedemann (a physics student and charter member of the Physical Society) almost daily during the winter of 1848–1849 for meals and discussion at a Berlin restaurant.

62. Helmholtz, "Physiologische Wärmeerscheinung," 350.

63. Helmholtz, *Ueber die Erhaltung*, 17–18.

64. Helmholtz, *Ueber die Erhaltung*, 19–21, 26–27. As both Clausius and Wilhelm Weber were quick to point out, the proof was not sufficiently general, which led to controversies that went on for decades, primarily with respect to electromagnetic forces. Bevilacqua, "Theoretical"; Darrigol, "Electrodynamics," 225–33.

65. Helmholtz, *Ueber die Erhaltung*, 15, 17, and cf. 29 ("Theilchen Δm") and 35–36, 57 ("Atom"). Similarly, the terms *molecule* and *particle* were sometimes used to refer to a differential volume element of matter $dxdydz$. Smith and Wise, *Energy and Empire*, 159.

66. Darrigol, "God, Waterwheels, and Molecules," 318–25 (molecular reduction) and 325–41 (Saint-Venant).

67. Helmholtz, "Erinerrungen," 11.

68. Wise, "German Concepts."

69. Bevilacqua, "Helmholtz's *Ueber die Erhaltung der Kraft*," 309–15, has also nicely shown how Helmholtz used the concept of *Spannkraft* to tie together the engineering tradition with rational mechanics, particularly with "potential."

70. Helmholtz, *Ueber die Erhaltung*, 22, 25, his emphasis. Helmholtz immediately derived from the conservation law a form of the most basic relation in mechanics, the

principle of virtual velocities (25–26). But he did not address the meaning or significance of *virtual*. In rational mechanics virtual displacements *dr* (called virtual velocities) were any hypothetical changes in the configuration of a system that one could imagine under the given constraints, not real motions produced by the forces acting in the system. In particular, they did not involve any development in time during which changes might occur in the applied forces or in the constraints restricting the system's motion. Similarly, the product *Pdr* was simply a moment, a "virtual moment." Because the system was not supposed to be in actual motion, work was not quite a relevant concept. The difference is somewhat academic here, in the sense that the principle for virtual velocities holds also for the real motions of Helmholtz's material points moving under central forces. He may well have learned the required reasoning from Ferdinand Minding (nn79, 82, below) following Coriolis (n75, below). In Helmholtz's scheme *Pdr* is an infinitesimal quantity of work and is an action that actually produces *vis viva*. But the concept of work did not appear in rational mechanics.

71. "*Summe der Wärme*," in Helmholtz, "Wärme," 698–701.

72. Strangely, Kuhn, "Energy Conservation," 88n, while noting that Helmholtz used the term *work*, stated that he did not know the French tradition and that "he fails completely to identify ∫Pdr as work."

73. Darrigol, "God, Waterwheels, and Molecules," 311–17, gives a concise history, omitting Christian, *Traité*, the first text titled "industrial mechanics." From the time Christian became director of the Conservatoire national des arts et métiers in 1819 until Morin took the position in 1852, Dupin held the chair in mechanics. Grattan-Guinness, "Work."

74. Coriolis, *Du calcul de l'effet des machines*, 14–17, work (*travail*); 17, *vis viva* ($\frac{1}{2}mv^2$); 18, principle of transmission of work. For introduction, see "Avertissement," i–iv, and chap. 1, along with the report to the Academy of Sciences by de Prony, Girard, and Navier, 1–8. Interestingly, when Poisson wrote an "Addition" on industrial mechanics for his 1833 textbook on rational mechanics, he followed Coriolis closely (along with Navier and Poncelet) but maintained the traditional definition of *vis viva*, calling $\frac{1}{2}mv^2$ "one-half the sum of *vis viva*." Poisson, *Traité de mécanique*, 755. Poncelet, *Cour de mécanique industrielle*, gives a full discussion of production and consumption of *travail* in relation to *vis viva* (still as mv^2), 92–98 and 104–14.

75. The principle of virtual velocities (n70, above) also found reformulation in industrial mechanics; Coriolis, *Du calcul de l'effet des machines*, 10–14. To bring the principle into line with the action of working machines, Coriolis called the element *Pdr* "elementary virtual work," replacing the abstract term *virtual moment* from rational mechanics. Having then shown the conditions for replacing virtual displacements by real displacements, he further reduced *Pdr* simply to "elementary work." In this form the principle correlates mathematically (but not entirely conceptually) with Helmholtz's usage.

76. Werner Ebeling and Johannes Orphal, " Clausius," 214. An unusual example for practicality is Ferdinand Minding, *Die Einrichtung der Classen-Lotterie mit Freiloosen, in Hinsicht auf ihren durchschnittlichen Erfolg fuer Unternehmer und Spieler, arithmetisch beleuchtet: Ein Beitrag zur politischen Arithmetik* (Berlin: Veit, 1842).

77. Minding, *Handbuch*, 1:v–ix; 2:vi–viii. Poisson's "Addition" on industrial mechanics

surveys succinctly "the application of the principle of living forces in calculations of machines in motion." Poisson, *Traité de mécanique*, 2:747–82.

78. Not so telling but perhaps relevant is that Minding's *Anfangsgründe der höheren Arithmetik* was recommended at Helmholtz's Potsdam *Gymnasium*, "for purchase for the library or for use in instruction." *Zu der öffentlichen Prüfung des hiesigen Königlichen Gymnasiums* (1833), 27. I thank David Cahan for this reference. Another intriguing possibility for Helmholtz would be the engineering work of Moritz Jacobi (brother of Carl Jacobi, who supported Helmholtz's *Ueber die Erhaltung*), e.g., "Ueber die Benutzung der Naturkräfte." Jacobi drew heavily on the French engineers as well as on the article "Perpetuum mobile" in *Gehler*, vol. 7, 408–23. I thank Otto Sibum for these references.

79. Minding, "Mechanik," 72. Interestingly, although Minding in his 1838 *Handbuch der theoretischen Mechanik*, 216 (cf. 189–90 and 252) called attention to the similarity between a virtual moment in statics and the integral ∫Pdr in the principle of *vis viva*, he cautioned against identifying them (cf. Coriolis, n75, above). He also did not yet use the term *work*, nor did he include either Poncelet's theory of machines or the dynamometers of Poncelet's protégé Morin. The difference points to the late 1830s and early 1840s as the specific time frame in which French industrial mechanics and the measurement of work acquired prominence in Berlin, adding significance to Minding's *Repertorium* review for Helmholtz.

80. Gauss, "Allgemeine Lehrsätze, " 198–201.

81. Helmholtz, *Ueber die Erhaltung*, 41–42, and see 58–61 for magnetism. Bevilacqua, "Helmholtz's *Ueber die Erhaltung der Kraft*," 311–15. To Bevilacqua's account of Helmholtz's assimilation of work to potential, I add Minding's precedent and Helmholtz's focus on relational pairs of material points.

82. Minding, "Mechanik," 71–72. Minding, following Coriolis, also provided the justification for substituting real motions for virtual velocities and for reading virtual moments in terms of work.

83. Smith and Wise, *Energy and Empire*, 208, 240–56.

84. Minding, "Mechanik," 74–75; Poncelet, *Introduction*; Morin, *Nouvelle experiences*, *Description*, "Ueber zwei dynamometrische Apparate"; Brix, "Ueber die Reibung," quotation 183, Morin 183–89, 230–78; Fontanon, "Morin." Dynamometers of Poncelet and Morin in Hoff and Geddes, "Graphic Registration." Brain, *Pulse of Modernism*, 5–17, summarizes the development of the graphical method.

85. Regnier, "Description."

86. Poncelet, *Cours de mécanique appliquée aux machines*, 1:v; 2:274–88. Poncelet, charged by the minister of war in 1824 with creating a course on the science of machines at Metz, began by 1829 to suggest a series of dynamometers for accurate recording of the work being done by any motive power, analogous to an indicator diagram. Morin actually perfected the suggestions.

87. This same Regnier dynamometer could be employed to record the work done by a turning shaft by connecting it to a second standard dynamometer, the Prony brake, which measured the turning torque of the shaft against friction. During the 1830s and 1840s dynamometers were developed for rotating shafts using clutch or differential arrangements, were inserted anywhere along a train of mechanism, and were typically self-recording.

88. Minding, "Mechanik," 75. Morin, "Ueber zwei dynamometrische Apparate," 261.

89. Hills and Pacey, "Measurement."

90. Morin, *Divers appareils dynamométriques*, 47. In the second edition (Paris, 1841), p. 67, Morin included his own improved indicator. Development of the indicator, with examples from Conservatoire national des arts et métiers, in Herléa, "Les indicateurs," 195–205 for the 1830s and 1840s.

91. Main and Brown, *Indicator*, 5.

92. Lervig, "Carnot," includes lecture notes with a diagram of a Watt indicator (180), one of the earliest examples outside of Britain. Kerker, "Carnot" summarizes Clapeyron's career.

93. Helmholtz, *Ueber die Erhaltung*, 22. The first part of Helmholtz's description is also very like Clapeyron's for his Carnot diagram, "Ueber die bewegende Kraft der Wärme," 451.

94. A similar "error" appears in Helmholtz's definition of material points as "points of the space filled with matter" rather than differential volumes of the space. Helmholtz, *Ueber die Erhaltung*, 15.

95. Ibid., 22.

96. Bevilacqua, "Helmholtz's *Ueber die Erhaltung der Kraft*," 315.

97. Helmholz, *Ueber die Erhaltung*, 23.

98. Weber, "Muskelbewegung," e.g., 101; Karsten, "Gase und Dämpfe," 100.

99. Helmholz, *Ueber die Erhaltung*, 25, 28, 35, 37, 66.

100. Ibid., 24–25.

101. Helmholtz, "On the Application of the Law," and 1881 note to *Ueber die Erhaltung*, 29.

102. Kuhn, "Energy Conservation," 88n; Elkana, *Discovery* 137; Bevilacqua, "Helmholtz's *Ueber die Erhaltung der Kraft*," 315–16. A related quantity-intensity distinction was basic to Faraday's electromagnetism (avidly studied in the Physical Society), and it structured the dualistic force fields of Maxwell's field theory. Wise, "Mutual Embrace."

103. See also Magnus's discussion of superheating using a confusing mixture of *Kraft*, *Spannkraft, and Spannung*. Magnus, "Ueber die Kraft."

104. Helmholtz to Du Bois-Reymond, February 12, 1847, in Kirsten, *Dokumente*, 75–79. Helmholtz, *Ueber die Erhaltung*, 68. Helmholtz wrote to his parents, March 17, 1839, that he was reading Kant but "first had to work my way back in"; Cahan, *Letters*, 55. Koenigsberger, *Helmholtz*,1:30.

105. Helmholtz, *Ueber die Erhaltung*, 15. Friedman, *Zeichentheorie*, 28–37, has identified Helmholtz's shift as a major break between his earlier "causal realism" and his later "empiricism." My emphasis below on Helmholtz's view of matter and force as inseparable "abstractions from the real" tends to weaken the realist label while preserving the shift.

106. See Bevilacqua, "Helmholtz's *Ueber die Erhaltung*," 306–9, and several articles in Krüger, *Universalgenie Helmholtz*; Schiemann, "Die Hypothetisierung" (who believes the Kantian grounding overdone); Krüger, "Helmholtz über die Begreiflichkeit"; Darrigol, "Electrodynamics." Heimann, "Helmholtz and Kant," explored a systematic analogy between Helmholtz's argument and Kant's categories.

107. Kant, *Kritik der reinen Vernunft*, in *Kants Werke*, 4:189/3:234, with proof of the Second Analogy of Experience, 4:189–211/3:232–56.

108. I am adopting here Michael Friedman's comprehensive new interpretation in *Kant's Construction* and am indebted to him for illuminating discussions. Friedman demonstrates Kant's close engagement with Newton's *Principia*. I use also Friedman's edition of Kant, *Metaphysical Foundations* (hereafter *MF*), with references, in brackets, to Kant, *Metaphysische Anfangsgründe*.

109. Parsons, "Remarks," 226, suggests the term *second schematism*.

110. Helmholtz, *Ueber die Erhaltung*, 14.

111. A good marker of the difference in historical location between Kant and Helmholtz is Kant's famous exclusion of chemistry from mathematical science, whereas it lay at the center of Helmholtz's concern with interconversions and equivalents. Kant, *MF*, 4–7 [468–71].

112. Kant, *MF*, 75 [536].

113. For the distinction of Leibnizian-Wolffian physical monads from Leibniz's nonspatial conception, see Friedman, *Kant's Construction*, 159–66, drawing on De Risi, *Geometry*, 301–14.

114. Friedman, *Kant's Construction*, 101–3, 137–142, 145–154, 159–170, 321–322, 342–347.

115. Kant, *MF*, 40–45. Friedman, *Kant's Construction*, 143–56, develops Kant's argument from his radical revision of Leibniz's metaphysical concept of substance.

116. In an interesting example, he referred to the expansive continuum of repulsive forces filling space as a "quantum of extending forces" and thus an extensive magnitude. *MF*, 38 [501]. Very occasionally he also referred to an intensive magnitude such as speed as a quantity (*Quantität*) but as distinct from a *Quantum*. *MF*, 31–32 [495].

117. Kant, *MF*, 64–65 [525–26]. Friedman, *Kant's Construction*, 186–89, 320–22.

118. Along with the basic differentiation of physical (causal) from mathematical reasoning and geometrical from algebraic reasoning, Kant's exposition involved sometimes confusing distinctions between *Grösse* (magnitude), *Quantität* (quantity), and *Quantum*. Friedman, *Kant's Construction*, 52–67, n47, and 90–96, nn86, 87.

119. Kant, *MF*, 78 [539–40]. Friedman, *Kant's Construction*, 313, in relation to Kant's new concept of substance.

120. Kant, *Kritik der reinen Vernunft*, A142–143/B182, and the Axioms of Intuition, A163–166/B203–207.

121. Helmholtz, *Ueber die Erhaltung*, 14, 18. For Helmholtz's metaphysics of pairs of material points, one should keep in mind that they were not monad-like simple points but abstract "parts" of extended masses: "points of space filled with matter," whether as atoms or as differential elements Δm. See n65, above.

122. Ibid., 22.

123. Ibid., 23.

124. Kant, *MF*, 76 [537].

125. Ibid., 76–78 [537–40]. Kant actually preferred the comparison of weights on a balance, which he took to provide an equivalent measure through the equivalence of gravitational and inertial mass (*MF*, 80 [541]). Friedman argues that this preference re-

flects Kant's orientation to the universal law of gravitation in the celestial realm and to the weights of the planets. Friedman, *Kant's Construction*, 293–302, 331, 375–80.

126. Above at n39 and very occasionally in Helmholtz, *Ueber die Erhaltung*, e.g., 36.

127. Kant, *MF*, 80 [541].

128. Kant, *Kritik der reinen Vernunft*, A143/B183, A185/B228, and see the entire First Analogy of Experience, A182–189/B224–232. Friedman, *Kant's Construction*, 169–170, 313–16.

129. Kant, *MF*, 81 [542].

130. Helmholtz, *Ueber die Erhaltung*, 17.

131. An extended history of this topic would take up the prominence of energy as substance in the later nineteenth century (e.g., for the energeticists) and ultimately the conservation of matter/energy in special relativity.

132. Kant, *MF*, 82–83. Kant implicitly includes Newton's second law of motion, $F = ma$, in this law of causality.

133. Helmholtz, *Ueber die Erhaltung*, 15, also 13–17.

134. Kant, *MF*, 83 [543–44]; Friedman, *Kant's Construction*, 341–47.

135. Kant, *MF*, 84 [544].

136. Helmholtz, *Ueber die Erhaltung*, 13.

137. Kant, *MF*, 84 [544–45]. In *MF* Kant did not refer to the action-reaction principle as a law of conservation (of quantity of motion), although he had in his precritical writings, where, on Friedman's account, it was a principle of causality, of "the transmission of reality from cause to effect," rather than of the permanence of substance, which took priority in *MF* as conservation of quantity of matter. Nevertheless, conservation of quantity of motion remained thoroughly implicit in *MF* as the empirical manifestation of conservation of substance. Friedman, *Kant's Construction*, 298–311, 324–35.

138. Kant apparently regarded as paradigmatic the completely inelastic impact of two bodies: "the two [quantities of] motions are equal and opposite to one another, and, since they mutually cancel one another, the two bodies place themselves relative to one another, that is, in absolute space, at rest." *MF*, 86 [546]. The law applied quite generally, however, to both elastic impact and gravitational attraction. See Friedman's n50 of *MF*, 86, and *Kant's Construction*, 349–52.

139. Friedman, *Kant's Construction*, 474–503.

140. Helmholtz, *Ueber die Erhaltung*, 16.

141. Helmholtz, *Ueber die Erhaltung*, 15. Helmholtz was virtually quoting Kant regarding the internal forces of his dynamical construction of matter (*MF*, 35–36 [498–99]).

142. Helmholtz, *Ueber die Erhaltung*, 17.

"A SPECTACLE FOR THE GODS"

It is a spectacle for the Gods, to see the muscle working like the cylinder of a steam engine.

— Du Bois-Reymond to Helmholtz, February 9, 1852[1]

Introduction: *Lebendige Anschauung der Form*

In the spring of 1848 Hermann Helmholtz took up the question of the work done by a muscle from a new perspective. He had looked previously for chemical changes and for heat developed while a frog muscle repeatedly contracted. Although he conceived these conversions in terms of conservation of quantity of force (*Erhaltung der Kraft*), he had not tried to measure their external effect, the work that the muscle could do.[2] He had also not attempted to analyze either the temporal process through which the frog muscle developed its capacity to do work after being excited, whether directly or through its nerve, or the time elapsed after the excitation before the muscle began to contract. These are the accomplishments he reported in a large and stunning paper communicated to the Berlin Physical Society in July 1850: "Measurements of the Temporal Process of Contraction of Animal Muscles and the Propagation Velocity of the Excitation in the Nerves." A second paper, pursuing only the propagation velocity but with different means, would follow in 1852.[3] The works are famous, especially for their use of curves drawn by frog muscles to represent both contraction and propagation velocity.[4] Since extensive studies exist of the two instruments that Helmholtz developed to analyze these processes in terms of curves,[5] good reasons are required for going over the same ground again, and in some detail.

First, I explore how Helmholtz developed the subject of muscle contraction in terms of his recently completed work on the conservation of force and how he embodied that principle in the instruments. The relation of these two bodies of work has never been satisfactorily explained even though that relation can be said to have exploded the boundaries of physiology and initiated the physiology of work and energy.[6] My account of this aspect of his experiments will highlight his elusive term *Energie*.

Second, following on the analysis of "the line" in chapter 5,

I want to draw out the aesthetic character of Helmholtz's frog drawings as realized through the instruments. Conceptual and aesthetic interests here came together in material form. Helmholtz sought to capture, I will argue, the fundamental *Form* of the temporal processes in the muscle. This ideal *Form* would be expressed in a curve of *Energie*, as though drawn by the frog muscle.[7]

These two topics of *Energie* and aesthetics will be interrelated throughout the following analysis. It will be important to recognize at the outset, therefore, that Helmholtz himself had a long-term engagement with the practice and theory of drawing. Like other students at his *Gymnasium* in Potsdam (1830–38), he would have taken drawing classes two hours per week for five years, beginning with simple line drawings of mathematical figures as taught by the handwriting instructor and concluding with three years of instruction in shaded drawings of natural objects and plaster casts as taught by a local painter.[8] He also had a more personal relation to the subject.

Helmholtz's father Ferdinand, as subrector of the Potsdam *Gymnasium* (third in line), had addressed explicitly the role that drawing played in its curriculum in an article for the examination program of March 1837 (when Hermann was fifteen and had already completed the drawing courses). Titled "The Importance of General Education for the Beautiful," this highly idealist analysis, centering on the role of art, structured the curriculum in terms of the gradual acquisition of a deep feeling for and understanding of "the beautiful," which he identified with the "*Form* of the godly life." If drawing in particular played a subsidiary role in his grand humanist vision, it nevertheless epitomized the aim of bringing the idea or *Form* of any object of interest to intuitive (*anschaulich*) expression in its full force: "It is especially through drawing that this sense for the careful execution of the *Form* as beautiful down into the minutest details, this decisive power of the idea (*Kraft der Idee*), must be awakened and exercised."[9] Although Helmholtz by no means shared all aspects of his father's views on education—especially not his insistent Christianity and his emphasis on emotive feeling—he did adopt much of his father's idealist vocabulary of art. In the analysis to follow immediately, I want to bring out this context of meaning, focusing on *lebendige Anschauung der Form*. Because of the special significance of these terms, along with *Energie*, I leave them in italics.

In 1848, the year in which Helmholtz took up frog drawing, he also began teaching anatomy classes at the Academy of Art. These two activities should be understood in similar terms. Helmholtz's instruments enabled the frog

muscle to draw its own changing states, to express through their *Form* the idea he held of their states of *Energie* and of their beauty, using the aesthetic guidelines to which he subscribed. In his *Probevortrag* (trial lecture, or job talk) for the Academy of Art, Helmholtz's conception of *Form* can be discerned through the adjectives that he (like his father) regularly associated with the term—*lebendig* (lively, vivid), *ideal*, *harmonisch* (harmonious), *geistig* (intellectual, spiritual)—and with the artist's capacity to express it—*Anschauung der Form* (intuition of *Form*), *künstlerische Schönheitssinn* (artistic sense of beauty), *künstlerische Geist* (artistic mind or spirit).[10] An important but subtle distinction operated in Helmholtz's usage here between *Form* and the closely related term *Gestalt*. *Form* normally referred not to the particular shape, often flawed, that a muscle might have on a specific body or work of art but to its type, and especially to its idea. The artist had to be able to perceive this *Form* in an immediate and lively visual *Anschauung* if the particular *Gestalt* he drew was to capture the beautiful.

Anschauung occupied its usual central role in the language of idealism, where it referred to the result of seeing, whether metaphorically as insight or literally as visual image. An *Anschauung* was an intuitive idea, grasped immediately and as a whole, and complementary to a concept (*Begriff*), the product of conscious thought. In the Kantian tradition, unmediated intuition and reflective thought were related dialectically. By connecting in a certain order the manifold sensations with which we are always presented, *Anschauungen* provided the necessary material for concepts, while only through conceptual analysis could *Anschauungen* become knowledge.[11] In Helmholtz's own rendering for his *Probevortrag*, art students studying anatomy differed from medical students in that doctors had to lay the stress on clear, dry, analytic concepts while artists were especially in need of vivid, synthesizing, intuition. *Anschauung* as immediate visual intuition, even as romanticized genius, was the source of artistic creativity.

> The creative artist sketches his *Gestalt* without calculation [*Berechnung*] of all the details, guided only by the sense for the ideal beautiful [*das ideale Schöne*] which lives in his breast and in his eye. . . . But the genius of the artist is just the mysterious power to find and to represent, in original *Anschauung* and without calculating reflection, that which the pondering [*nachgrübelnde*] reflection must then also recognize and justify as the true and complete.[12]

One of Helmholtz's sources for this conception was surely Johann Gottlieb Fichte, both directly through his own study and indirectly through his father's

admiration for Fichte and close friendship with Fichte's son, Immanuel. In a characteristic expression Fichte wrote, "you should grasp it [the immediacy of life] not in thought but in *lebendiger Anschauung*." Ferdinand Helmholtz based his entire essay about "The Beautiful" on a Fichtean formulation of the never-ending dialectic of *Anschauung* and *Begriff*, the dynamic of opposites that governed historical development, reaching toward the unity of man with God. Because this process was life itself, the educator's highest ambition was to make knowledge of it *lebendig* (living, active, creative). The term was ubiquitous in Ferdinand Helmholtz's text, where to capture and convey a *lebendige Anschauung* was the goal of art.[13] Hermann Helmholtz, too, regularly coupled *lebendig* with *Anschauung* and with *Form*, both in his *Probevortrag* and later writing on art (epilogue). I will take *lebendige Anschauung* to capture as well something of what he hoped to accomplish with his frog drawings even though he did not employ the term there.

The question of how one acquires such an *Anschauung* had generated much discussion among philosophers and educators. Famously, Kant distinguished between pure and sensory *Anschauungen*, or a priori and empirical intuitions. Time and space alone were a priori; all other *Anschauungen* derived from the senses: "by means of sensuality [*Sinnlichkeit*] objects are given to us and it alone provides us with *Anschauungen*."[14] Equally famously, Helmholtz would reject Kant's a priori *Anschauungen* in his empiricist theory of spatial perception and geometry. He began to develop this position in a lecture on the physiology of vision at Koenigsberg in 1855, celebrating the one hundredth anniversary of Kant's inaugural dissertation, but it only reached its mature form in 1867 in part 3 of the *Handbuch der physiologischen Optik* (1856–67), which he produced for the monumental *Allgemeine Encyklopädie der Physik* (1856–69) of Gustav Karsten, first president of the Berlin Physical Society. Simply put, Helmholtz argued that to see objects as located in an external three-dimensional space is a learned skill, requiring a mutual adaptation of the ordering capacity of the mind to the physical movement of the eyes in a psychological process that he ultimately called "unconscious inference." Sufficient practice, or better, active experimentation, like a person adapting to new glasses, produces a kind of perceptual memory that becomes so automatic that it seems like an a priori *Anschauung* of space.

Because of the major scientific and philosophical import of Helmholtz's position, its historical development has received a great deal of attention.[15] As a baseline, it appears that virtually all of his predecessors, whether proponents of a priori or of sensory *Anschauungen*, acknowledged that learning

was required for full spatial localization of objects in binocular vision, especially for depth perception. Helmholtz's mentor Johannes Müller, as part of his theory of specific nerve energies, ascribed much of the capacity for spatial perception to the innate physiological organization of the two retinas and nerves, essentially extending the mind-brain relation to the nerve endings. But he also believed that learning was required to actualize this innate but latent capacity of the neurological system. The primary alternative theory of binocular vision derived from David Brewster's suggestion (associated with his invention of the stereoscope in 1838) that the mind learns to infer or calculate geometrically the location of any external object in the spatial field from its two projections on the retinas. With a strong tendency to prefer this sort of mathematical construction over innate understanding, Helmholtz moved gradually to his fully constructivist view through the 1850s and 1860s.

Timothy Lenoir has given an illuminating account of some of the experimental and mathematical resources for this development, emphasizing both a practical turn in philosophy in the 1850s—led in part by Immanuel Fichte—and new empirical work by optometrists and physiologists. But ultimately most decisive for the question of spatial *Anschauung* were attempts by the young researchers Adolph Fick and Wilhelm Wundt, both closely associated with the Physical Society and with Helmholtz, to find relations between mechanical models of the action of eye muscles (ophthalmotropes) and the mathematics that the mind might generate (i.e., learn) to govern their movements according to a principle of economy. Their attempts prefigured Helmholtz's own.[16] From a more sociological perspective, and recognizing the contingency of historical dynamics, Steven Turner has emphasized the role of controversy in shaping Helmholtz's developing views, partly in contemporary debates arising within an explosion of vision research but especially in polemical exchanges from 1864 with Ewald Hering. Hering was the "nativist" in Helmholtz's labeling of the methodological debate as nativism versus empiricism. Somewhat like Müller, Hering tended toward physiological shaping of innate ideas.

Michael Heidelberger has called Helmholtz's philosophy "experimental interactionism" and has located his main stimulus in an empiricist reworking of Fichte's views on self-consciousness and the I–not I relation, particularly the thesis that we can only have knowledge of an external world through our free action and from the inferences we make from the effect of that action on our consciousness of ourselves.[17] Through his empiricist rereading, Helmholtz converted Fichte's argument into a realist account of how we gain

knowledge of the natural world through action and inference, but without losing the idealist emphasis on the freedom and independence of the mind in producing *Anschauungen*.

Clearly Helmholtz was operating within an extremely rich context of meanings and values as his empiricist view of *Anschauung* evolved. It seems that from a very early stage he was contemplating the problematic relation between sense impressions and *Anschauungen* and looking for approaches to it through the relation between active intervention and mental representation, whether visual or mathematical. The problem, from this perspective, was how to educate the mind to form *lebendige Anschauungen*. And from that perspective the problem for artists was similar to that for physiologists.

Even in his early *Probevortrag*, and despite its romantic vision of genius, Helmholtz was already assuming that the artist's sense of beauty rests on *Anschauungen* that are acquired rather than innate. Artistic genius required education. The ancients, he suggested, possessed their wonderful "talent for truth and beauty" because they had "a much richer opportunity to educate their *Anschauung* of the human bodily *Form*" even though they lacked training in anatomy. Nevertheless, they sometimes made errors in execution that marred "the life and beauty of the *Gestalt*," as in the case of a sculpture in the Altes Museum of an Apollo figure, shooting an arrow, with a misaligned rear deltoid muscle. Modern artists, who typically lacked the Greek sense of beauty and suffered in addition from the fractionating tendencies of modern life, could compensate and avoid such mistakes through a more formal education of their own *Anschauung* in the anatomy class. There they would learn intuitively to see the "anatomical mechanisms" that underlay the external shapes of muscles.[18]

Helmholtz was here crafting his "job talk" as an attractively familiar argument for the faculty of the Academy of Art. His success is apparent in the judgment of the senate, sent to the cultural ministry, that he would have no trouble communicating "that characteristic *Anschaulichkeit* and *Verlebendigung*" required of anatomy for artists.[19] Indeed, widespread agreement already existed among progressive educators on the need to train the capacity for *lebendige Anschauung* as well as reflection. Their standard reference for self-realizing education was, once again, J. H. Pestalozzi. As Ferdinand Helmholtz somewhat grudgingly put it in 1837, in line with Fichte, Pestalozzi was among those who had "at least shown the necessity that all development of the concept [*Begriff*] must be accompanied and regulated by the immediate *Anschauung*." Although Pestalozzi regarded his notion of spatial *An-*

schauung as Kantian, his signature idea for later educators was learning by doing. Acquiring the capacity for *Anschauung*, or learning to see, required more than looking; it required hands-on practice. Thus lectures and lecture demonstrations alone would not suffice. In the *ABC der Anschauung* (1803), for example, Pestalozzi and his assistant Christoph Buss presented a detailed sequence of exercises on the geometry of a square (horizontal line, vertical line, angle, etc.), which elementary students would carry out with the guidance of their instructor in order to grasp the geometrical concepts in immediate *Anschauung*.[20] Similarly, in Hermann Helmholtz's plans for the artists' anatomy class, it is implicit throughout that students would be actively drawing for themselves the muscles and bones whose functions and shapes he would demonstrate on prepared specimens and on living models. Comparable students of medical anatomy, he would certainly have argued, should do anatomical dissections themselves as well as drawings. As we have seen in earlier chapters, this emphasis on active engagement was constitutive of the goals of the Physical Society, depicted in the activities of experimenting heroes in their certificate of membership (fig. 5.27).[21]

To recognize that *Anschauung* requires education through action brings the question of means—tools, practices, and technical knowledge—directly in contact with aesthetics. Helmholtz would later refer to this combination as *kunstlerische Technik* (epilogue; cf. *Kunst-Technik* in fig. 2.11, 3.4, and 5.12). But already in his *Probevortrag* he presented the view that technical training in anatomy was essential to recognizing *Forms* and their causes and to differentiating essential from nonessential features (*Züge*), even though it could never replace the artistic spirit (*künstlerische Geist*).

> [Anatomy] can never replace the *Anschauung* of these *Forms* and the artistic sense of beauty. It is a means that facilitates for the artist his spiritual victory over the ever-changing manifoldness of his earthly object, the human *Form*, a means that should sharpen his view of the essential in the *Gestalt* and that should equally make transparent to him the entire *Gestalt*. . . . But art, I would like to say, begins only beyond anatomy. The artistic spirit first reveals itself in the wise application of the *Forms* whose interconnection and elementary features anatomy has taught; it reveals itself in the decisive characteristic of the *Gestalt*.[22]

Thus, it was through the realization of the essential *Form*, assisted by technical anatomical knowledge, that an artist would draw out the beauty of a specific *Gestalt*. But just because it was the *Form* and not the *Gestalt* that

was of primary interest, the artist's task was not to copy nature but to capture *das Ideal*, to awaken in the viewer "the feeling of harmonious and lively beauty."

> The artist should never attempt to imitate in the truest possible way, because his model is always only a person grown up in earthly imperfection, never corresponding to *das Ideal*; rather, he should modify the individual *Gestalt* until it is the perfected impression of its spiritual content.[23]

With this understanding of the relation of *Form* and *Gestalt* for Helmholtz— spiritual or intellectual ideal as recognized in the material real—it will become easier to see the significance of the *Form* of his curve of *Energie* and to grasp the role of this ideal *Form* in his technical work. I aim in what follows to show how the two mechanical devices that Helmholtz developed to make frog drawings were related to the *lebendige Anschauung* that he sought to provide of the *Form* of the drawings. The machines and the aesthetics were inseparable in his *kunstlerische Technik*.

The Context for Recording the Work of Frog Muscles

To measure the force (intensity of *Kraft*, or tension) exerted by contracting frog muscles had been a goal of physiological experimenters well before Helmholtz. For that purpose several investigators had designed dynamometers analogous to those used by engineers for animal and mechanical powers in the economy. A snapshot summary of this tradition, closely connected with Bonn University, appears in figure 8.1, which shows four such devices. W. Krimer, *Privatdozent* in Bonn, writing already in 1820, coined the term *myodynamometer* for his muscle-force measurer (*Muskelkraftmesser*, here without the muscle). He investigated primarily the relation between muscle action and the central nervous system. Theodor Schwann (chap. 6) studied with Johannes Müller in Bonn in 1830, joined him in Berlin for his doctoral work from 1833 to 1834, and continued as his assistant. In 1835 Schwann sought to find the law relating the force of a muscle to its degree of contraction. It was Schwann who showed that, contrary to accepted wisdom, the force decreased as the muscle contracted very roughly in a linear relation, like the elastic force of a contracting rubber band or spring. That elastic analogy informed succeeding studies and will appear prominently in what follows. Eduard Engelhardt, in his inaugural dissertation at Bonn in 1842, followed Schwann's example and attempted to find a law governing the decrease with time of the force of the muscles of a decapitated frog.[24] Gabriel Valentin, a well-established professor at Bern University, who presented himself as

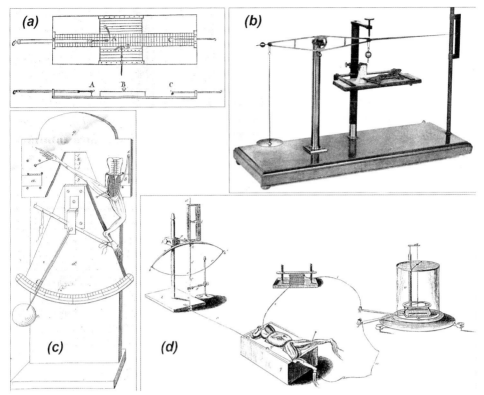

Figure 8.1 Myodynamometers by Krimer, 1820 (*a*), Schwann, 1835 (*b*), Engelhardt, 1842 (*c*), and Valentin, 1844 (*d*).

bringing modern physical science to physiology, reworked their findings for his two-volume *Lehrbuch der Physiologie des Menschen* (Textbook of human physiology; 1844). He employed a newly designed myodynamometer (with a galvanometer to measure the stimulating current from a galvanic cell) and attempted to establish his own measurements as definitive.

Valentin's move to take ownership of the tradition is of interest here because it represents everything the rather righteous young members of the Berlin Physical Society deplored in their senior colleagues, especially when it involved a slight to one of their own. In effect, Valentin co-opted the creative work of Schwann and Engelhardt by undercutting the trustworthiness of their measurements and their understanding of physical principles while repeating their investigations with an ostensibly more sophisticated instrument. But his own understanding of the mechanics employed by the engineers he cited was rather limited. Like Liebig (chap. 7), his discussion of the

working capacity of a muscle as *Nutzeffect* (useful effect) did not distinguish between a worker lifting a weight to a height (work done) and a worker carrying a weight along a level surface (no work done). Such a misconstrual of mechanics earned him the contempt of the new physiologists who were making physics their identifying mark. His stated goal of grasping physiological processes through physical laws by reducing everything to precise measurements yielded, in his critics' dismissive view, only a grand collection of meaningless numbers and misunderstood physics. Even in his second edition of 1847, Valentin failed to mention Du Bois-Reymond for animal electricity (inciting Du Bois-Reymond's polemics by relying on his nemesis Matteucci instead) or Helmholtz for animal heat (while citing his foil Liebig).[25]

Muscle physiology attained a new level of sophistication with the publication in 1846 of Eduard Weber's rigorous "Muscle Movement."[26] Weber's article had already been important for Helmholtz's work on the heat and chemical transformations of contracting muscles, and now in 1848 it would provide the immediate reference for his frog drawing machine. As the younger brother of Wilhelm Weber (Göttingen professor of physics and collaborator with Gauss) and Ernst Heinrich Weber (Leipzig professor of anatomy and physiology), Eduard Weber had at hand all of the technical resources that other anatomists and physiologists typically lacked. Cutting through traditional controversies and categories, he discarded the usual distinction between voluntary and involuntary muscles and instead distinguished "animal" muscles, which seemed to contract "instantly" (*augenblicklich*) upon stimulation, from "organic" muscles, with delayed response.[27] The nuances of muscle and nerve anatomy bearing on this issue occupied part 1 of his big three-part study.

In part 2 Weber turned to measurements of contractions of the tongue muscle of a frog (animal, instant) lifting various loads. For that purpose he had constructed a conceptually simple myodynamometer (fig. 8.2).[28] The muscle, approximately 40 mm long, exclusive of the tongue, hung from the top hook *a* while a second hook *b* through the tongue carried a pan to hold variable weights. A silk fiber eight feet long *hi* passed through the base of the tongue, allowing the length of the muscle to be read off the scale *g* with a precision of 0.1 mm through a telescope placed ten feet away.[29]

Wires *c* and *d* connected to the two hooks carried electrical excitation to the muscle from a generator whose rapidly alternating current would maintain the muscle in a state of contraction, allowing time for accurate observations.[30] Weber thereby measured the lengths of the muscle under various loads when unexcited and when briefly excited (5 s). He was interested in the determinants of *Muskelkraft*—the maximum weight that a muscle could just

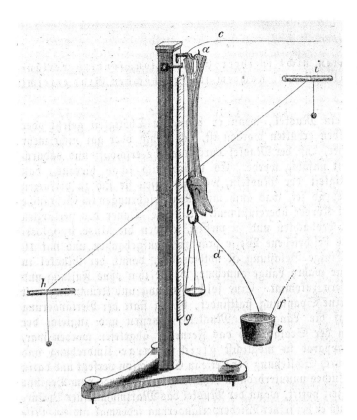

Figure 8.2 Weber's myodynamometer, 1846, measuring contraction of a frog's tongue muscle. Weber, "Muskelbewegung," 69, 86.

barely lift—and in the work the muscle could do in lifting various loads to a height (*Nutzeffect* or *mechanische Effect*).

Through an extended series of measurements using sophisticated inter-polations to account for muscle tiredness, Weber developed the background for what would be his ultimate argument in part 3: that the observable me-chanical behavior of a muscle could be rigorously understood through the analogy to a rubber band or spring, as Schwann's work had begun to sug-gest.[31] But his measurements also revealed a number of very strange (*höchst merkwürdig*) phenomena from the perspective of the elastic analogy. Briefly, "The force and the *Nutzeffect* as well [work done] . . . stand in no proportional relations to the magnitude of the contraction."[32] The analogy to a perfectly elastic band or spring clearly required qualification.

Far from abandoning the analogy, however, Weber chose to treat it in a more realistic manner, noting that no perfectly elastic bodies actually existed in nature and that physicists treated the deviations as modifications of the

"coefficient of elasticity."[33] Calling this coefficient k, the law of elasticity for an excited muscle took the usual form

$$F = kh,$$

where F was the tension in the muscle (the weight it could support) when stretched by h from its contracted length without the weight. Similarly for an unexcited muscle. But Weber's measurements showed that k differed dramatically between excited and unexcited muscles and that, for excited muscles especially, k decreased as the muscle tired before increasing again as the muscle died. The "influences of life" on the elasticity of muscles, Weber argued, acted analogously to the influence of heat on inorganic elastic bodies. So the anomalies of force and work revealed by his measurements could be treated as changes in the coefficient of elasticity k and of the natural length of muscles due to the influences of life. These effects in turn needed to be understood in terms of changes in the internal states of aggregation of the particles of the muscles. But of course the mechanics of those states were no better understood for muscle activity than for the internal effects of heat on solids.[34]

In summary, and with an eye on Helmholtz's subsequent work, the three parts of Weber's massive article may be seen as suggesting three points. (1) His distinction between animal and organic muscles (instant vs. delayed response) highlighted the temporal character of muscle excitation but without any corresponding measurements of time dependence. (2) His measurements with the myodynamometer were essentially static measurements made at equilibrium. (3) His extensive treatment of the muscle as an elastic band or spring with a variable coefficient of elasticity provided an analytic model, abstracted from the internal chemical and physical changes of "life," that Helmholtz would adopt as the basis for his own mechanical treatment.

Temporality, The Frog Drawing Machine, and *Energie*

From the beginning of his work on frog drawing in 1848, Helmholtz set out to investigate the temporal process of contraction of a muscle, in contrast to Weber. After writing his *Ueber die Erhaltung der Kraft* in 1847, he had no doubt recognized that the temporal dynamics of a muscle working might be significant, and he certainly was not happy with the notion of any physical process supposed to occur instantly. But importantly for consideration of Helmholtz's aesthetics, these physically motivated concerns merged with

one of the purposes of teaching anatomy to art students that he highlighted in his *Probevortrag* at the Academy of Art. Human models maintaining fixed poses, he observed, display nothing like "the *Forms* of the moved body" in its capacity to act. "The artist must know which muscles swell with the motion . . . if their figure should not seem to stand still like the model."[35] For muscles in action, ideal *Forms* were dynamic forms.

With these combined physical and aesthetic interests, Helmholtz began from early in 1848 to investigate the dynamics of a muscle doing work and to represent the process in curves. He would focus on single cycles of contraction and relaxation of the working muscle in much the same way that engineers investigated single cycles of expansion and compression in the cylinder of a steam engine, for which they employed the curves drawn by self-registering indicators (chap. 7). He opened the full published account of his new work in July 1850 by observing that although Eduard Weber had described the laws of action for muscles at rest and when continuously excited, laying the foundation for knowledge of their mechanical effect (*mechanische Wirkung* or *Nutzeffect*), he had not fully clarified the question of the mechanical work (*mechanische Arbeit*) of a muscle. Helmholtz explained:

> In order to perform an *Arbeit*, to produce motion of one's own body or changes in the external world, the muscle must alternate between rest and excitation, and the magnitude of its *Arbeit* will depend essentially on the speed of the alternation.[36]

Weber had measured a static mechanical effect—a stretched spring—but he had not studied the process of working, of *Arbeit* in the sense of a muscle or an engine doing work over time. Weber's *Nutzeffect* was to Helmholtz's *Arbeit* like the artist's static model to the moving body. Accordingly, Helmholtz focused attention on the cycle of contraction and relaxation.

On this understanding, Weber's measurements suffered from a major deficiency. They could not illuminate the development of a single cycle of contraction and relaxation following a sudden stimulus "of vanishingly small duration."[37] Helmholtz intended to investigate these elementary contractions as the basic constituents of the process of doing work. Again, the analogy with the individual cycles of a working engine lay close at hand, as did the artist's need for a *lebendige Anschauung* of a muscle's dynamic action.

Helmholtz would have liked to be able to analyze separately the different processes going on inside the working muscle, as he had attempted to do previously for the chemical and thermal aspects. Lacking the means for dif-

ferentiation and yet wanting to evoke the complexity of the internal state, he would choose in his big paper of 1850 to refer to the observable mechanical action as the measure of "the *Energie* of the muscle."

> Since the activity of the muscle in this condition is not only mechanical but also electrical, thermal, and chemical, and we do not know from the outset whether in every case all these different directions [of development] are simultaneously increased or diminished, we will designate the [external] mechanical expression of the activity in this article with the name of the *Energie* of the muscle.[38]

What in the world did he mean by *Energie*? It is not a word he used at all in *Ueber die Erhaltung der Kraft*—that is, not as "energy" in the modern conservation of energy—and it had no definite meaning in mechanics. Yet he had used it occasionally in his papers on the thermal and chemical effects of muscle action in the sense of the effort (*Anstrengung*) of a muscle to exert a force (*Anstrengung der Kräfte* or *Muskelanstrengung*) and thus as the *Energie* of its contraction (*Energie der Zusammenziehung*).[39] Valentin had used *Energie* in the sense of the inherent capacity of a muscle to exert a force, while Weber used *Muskelkraft* similarly as the maximum force a muscle could exert and *Spannkraft* as the force exerted to stretch a muscle.[40] We should probably view Helmholtz's choice, therefore, in a rhetorical light, as an effort to position his new physical measurements as the authentic basis for understanding the physiologists' notions of *Energie* and *Kraft* within the terms of his recent *Ueber die Erhaltung der Kraft*. But that returns us to the fundamental duality of the term *Kraft*, as both *intensity* of *Kraft* (force as capacity to exert a tension) and *quantity* of *Spannkraft* (force as capacity to do work).

We come here to issues of nontrivial detail in Helmholtz's exposition. Working through them will be worthwhile, however, because it provides the only means to understand how closely his muscle physiology was bound up with his *Ueber die Erhaltung der Kraft*. With that it will show why it has been so difficult for historians to interpret his language and why using "energy" as a shorthand for *Energie* has obscured his reasoning.[41] More specifically, it will show why the issue of duality of *Energie* is critically important for understanding the relation of the two instruments that he famously developed for drawing frog curves, such that the second was a direct continuation of the first, via different means. Most importantly, it is only through this somewhat technical detail that the role of aesthetic judgment, of *Form*, becomes visible in Helmholtz's use of the curves.

His immediate task, Helmholtz reported in 1850, had been to discover "in what lengths of time and stages the *Energie* of the muscle rises and falls after momentary excitation?"[42] The earliest record of the instrument he initially developed to draw curves of this rise and fall appears in a letter to his fiancée Olga von Velten on July 18, 1848.

> I have now finished building my frog drawing machine (*Froschzeichen-machine*) and have already made a few trial drawings on small sheets of mica, with a leaf spring inserted in place of the frog muscles. Carried by the spring, the weight oscillated up and down and sketched its motion. The drawings (*Zeichnungen*) are much more beautiful than the earlier ones, very fine and regular.[43]

Froschzeichenmachine is sometimes understood as frog tracing machine so that its *Zeichnungen* are "tracings" rather than drawings. This rendering tends to efface the aesthetic character of the curves. I want to stress that with his *Froschzeichenmachine* Helmholtz sought originally to make drawings with an ideal *Form* rather than literal tracings of a *Gestalt*. In this context, his attention to the beauty of the very fine and regular drawings is worth noticing. Their beauty apparently consisted here in their flowing line, smoothly following the motion of the leaf spring.

For this initial instrument Helmholtz modified Weber's dynamometer in the same way engineers had been modifying dynamometers for years; he made it self-recording (chap. 7). More exactly, he turned to an early version of the steam-engine indicator. Only a year earlier, his friend Carl Ludwig had taken the indicator as his model in designing his "kymograph" (fig. 8.3) for registering in a continuous curve the pressure of blood in arteries and of air in the lungs through a manometer. Initially, rather than using Ludwig's rotating drum, Helmholtz simply employed a plane sheet of mica as the drawing surface, much like the planar arrangement in James Watt's original indicators (fig. 7.7). Ludwig remarked in presenting the result in his *Lehrbuch der Physiologie des Menschen* (1852), "Helmholtz has had the curve . . . drawn directly by the frog muscle; this occurred according to the principles of the graphic method of Watt."[44]

Helmholtz gave a description of his original machine in his full paper of July 1850, which I have sketched in figure 8.4.[45] To a muscle hanging on a hook and supporting a weight at its lower end, as in Weber's measurements, he added an intermediate rod carrying a stylus. Through this stylus the frog muscle, when stimulated by a momentary current (<1/600 s), would draw

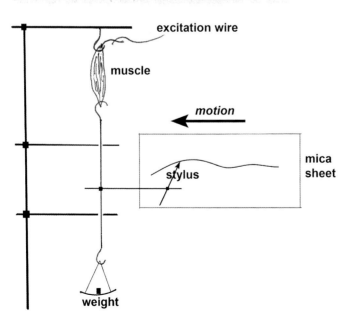

Figure 8.3 Ludwig's kymograph, *Lehrbuch*, 2:85.

excitation wire

muscle

motion

stylus

mica sheet

weight

Figure 8.4 Sketch of Helmholtz's initial frog drawing machine, 1848.

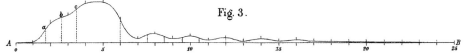

Figure 8.5 Curve from Helmholtz's original frog drawing machine. "Messungen über den Zeitlichen Verlauf," *WA*, 2, plate 5, Fig. 3.

its contraction and relaxation on the mica sheet, which, driven by a falling weight and clockwork, moved horizontally past the stylus. Just as the indicator (or the kymograph) drew a curve of the pressure inside an engine cylinder (or artery), the same technique drew the curve of a muscle lifting a weight.

The curve of figure 8.5 (his Fig. 3, published in 1850 as part of fig. 8.8, below) shows what Helmholtz called the "general *Gestalt*" of curves drawn in this way but on a sheet of smoked glass. The glass produced much less friction than the original stylus scratching on mica. Because of friction, the curves on mica failed to accurately represent the full work done by the muscle. But the low friction of smoked glass presented another problem. The elasticity of the muscle, interacting with its own internal friction and the remaining friction in the apparatus, produced the unnatural oscillations shown in the wavy line of the drawing, which would have been damped out by friction in curves on mica. Helmholtz thought that the regularity of the oscillations toward the end of the curve indicated that friction was too small to actually alter "the general *Form*" of what would have been the continuously declining proper motion.[46]

This problem of friction allows us to see how subtle was the difference in Helmholtz's use of *Gestalt* and *Form*. At the risk of overemphasizing the distinction, I suggest that *Gestalt* refers here to the shape of an existing imperfect curve (his Fig. 3; fig. 8.5), while *Form* refers to the shape the curve would have had in the absence of friction. Thus, we find "the influence of friction on the *Form* of the drawn curve." This influence appeared to be unavoidable and to require a new method. That method would occupy the remainder of the paper and produce a more truthful *Form*. In what follows, much will depend on the relationship between his Fig. 3 and this new *Form* (his Fig. 4, below).

Helmholtz remarked that he had intended his early apparatus only to allow him "to experience just so much of the simple contraction as I needed in order to be able to construct the definitive apparatus."[47] Nevertheless, it already produced a striking new result. The muscle did not begin to contract immediately upon being stimulated, as both Weber and Valentin had supposed for animal as opposed to organic muscles. Furthermore, it did not be-

gin to contract with its full *Energie*, like a stretched elastic band, with its maximum tension at the beginning and then decreasing. He drew this conclusion from the waves in the curve, which showed successive concave (accelerating) and convex (decelerating) portions. The inflection points, indicated by the dashed vertical lines *a*, *b*, *c*, etc., are equilibrium points at each of which the motion changes from accelerating to decelerating or vice versa, and the tension in the muscle must be just equal to the weight being raised. From the path of these "heights of equilibrium," Helmholtz drew his extraordinary new finding:

> These heights increase at the beginning and then sink gradually down. We extract from this the previously unknown fact that also in the animal muscles, as is the case in the organic muscles, only in very much longer times, the *Energie* of the muscle does not completely develop in the moment [*im Augenblicke*] of an instant excitation but largely only after the excitation has already ceased does it gradually increase, reach a maximum, and then disappear again.[48]

Looking aside from the waves, the smoothed-out "curve of heights of equilibrium" showed that the muscle, as it gradually shortened, continued to develop a tension equal to the weight, maintaining this tension as it raised the weight to its full height and lowered it again. (I note immediately that Helmholtz's entire reasoning rested on the shape of the curves.)

But again, what was this *Energie* that rose and fell? In one sense, the curve literally registered the height *h* of a weight *m* and therefore the work *W* (force × distance) done by the muscle to raise the weight *m*,[49]

$$W = mh.$$

So in this sense the muscle's *Energie* at a given time was just the developed capacity to have done this work. That corresponds to Helmholtz's interest in the temporal process of work (*Arbeit*) and to the modern "energy." In another sense, however, the *Energie* was the capacity of the muscle to exert the required lifting tension at a given time even as it contracted and relaxed. Helmholtz used both meanings, distinguishable only by context, which I take to be a point of considerable interest.

Here we meet directly the same ambiguity that attached to the quantity-intensity duality of *Kraft* in his *Ueber die Erhaltung der Kraft*. In a letter to Du Bois-Reymond in October 1849 describing the new instrument he was developing, the problem emerges in his use of *Kraft* where he would substitute *Energie* in the 1850 paper:

I told you earlier that I had concluded, from the curves that give the lifting of the weight as ordinates of the time, that the *Kraft* of the muscle is not strongest immediately after the excitation but rises a little later and then falls again.

Here *Kraft* refers to an *intensity* of force (tension). But a succeeding passage makes it also a *quantity* of force (work).

The intensity of the muscle activity decreases more quickly if it produces a motion than if this is not the case; therefore, just as for electrodynamic effects [as analyzed in *Ueber die Erhaltung der Kraft*], the motion produced weakens the *Kraft* that causes it.[50]

In other words, the work done by the muscle to move the weight comes at the expense of the *quantity* of *Kraft*, or *Quantität der Spannkraft*, available to the muscle, as required by the principle of conservation.

This duality of tension and work, intensity and quantity, is important because it provided the conceptual basis for Helmholtz to move from his original *Froschzeichenmaschine* to the new instrument, discussed below, on which the 1850 paper would actually focus. In this regard he would treat *mechanische Wirkung* (work), as though it could be represented either by the height to which a muscle could lift a small weight or by the maximum weight it could just barely lift (*Ueberlastung*). For example, in comparing excitations from two different places on a nerve, he wrote,

Equal electrical currents produce from both [places on the nerve] equally powerful mechanical effects: both the lifting-heights of the same weights and the largest just-liftable overload [*Ueberlastung*] are equal.[51]

This seems confusing, as he knew lifting height (work) and just-liftable weight (tension) are not at all the same thing and are not in general even proportional. The conundrum finds its resolution if we follow the consequences of Helmholtz's assumption that a muscle can be modeled on an elastic band or spring, but a variable one, so that the developing *Energie* of an excited muscle can be characterized by a coefficient of elasticity k that increases with time after the stimulus.[52]

By that analogy, two equations obtain for the muscle *at a given time* after stimulus (fig. 8.6). The first expresses the conservation principle: the work the muscle would expend to raise a small weight m to height h at that time would be $\frac{1}{2}kh^2$, which must be equal to the work gained by the raised weight, mh. The second equation expresses equilibrium of forces: at that same time after

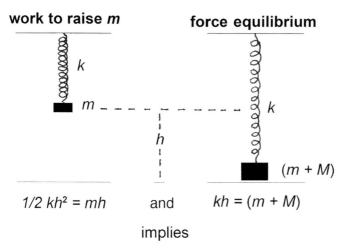

work to raise *m*

k

m

h

$$1/2\ kh^2 = mh$$

force equilibrium

k

$(m + M)$

and $\quad kh = (m + M)$

implies

h* proportional to *M

Figure 8.6 Muscle represented as a spring *k*. *Left*, work done by contracting muscle to lift *m* to height *h* at a given time after stimulus. *Right*, load *m* + *M* that the uncontracted spring could just barely lift at that time.

stimulation, the tension *kh* in the uncontracted muscle would be equal to the total weight that it could just barely support $(m + M)$. Eliminating *m* between the two equations shows that the height *h* to which the muscle would be able to lift *m* is proportional to the maximum additional weight *M* (overload) that the muscle could just barely support:

$h \propto M$.

Once you see it, the assumption is quite simple, and Helmholtz made it throughout his 1850 paper without ever giving an explanation. It implied that he could replace the height measurement *h* (work) with the weight measurement *M* (tension). The entire discussion to follow depends on keeping this relation clearly in mind, perhaps visually by reference to the springs of figure 8.6. With this understanding, Helmholtz's account of his experiments becomes fully consistent.[53]

In summary, the initial curve drawn by the working frog muscle showed that the electrical stimulus acted only like a trigger, initiating a process inside the muscle—a process of electrical, chemical, and thermal conversions—to develop its *Energie*, whether as tension or as capacity for mechanical work. This result followed from a simple drawing of the elementary cycle of contraction and relaxation, a curve that referred directly back to the indicator diagram for a cycle of a steam engine. Helmholtz's entire analysis depended

on a model of the muscle as a contracting elastic band or spring with a variable coefficient of elasticity corresponding to its changing *Energie* and on the principle of conservation applied to that model. The *Erhaltung der Kraft* was thoroughly embodied in the *Froschzeichenmaschine* itself and in its drawings.

"Die Form der Ansteigung der Energie"

Helmholtz apparently had the preliminary results from his frog drawing machine in hand when in the fall of 1849 he moved with his bride Olga von Veltin to Königsberg to become professor of physiology, once more taking up a position vacated by Ernst Brücke, who was moving to Vienna. He had pushed the temporal analysis of the frog curves as far as he could and was seeking a means of demonstrating with more accuracy and precision the course of the gradual development of *Energie*. As already noted, he had come to believe that the graphical method was irreparably compromised by the effects of friction. It would be two years before he published a new version of the graphical method but without solving the friction problem. Meanwhile, the first method had led him to an alternative.[54] It depended entirely on recognizing, as above, that he could replace the height h to which a muscle could lift a weight m in a given time after stimulation with the maximum additional weight M that it could just begin to lift at that same time.[55] The great advantage of this replacement was that problems of friction would not arise because no actual motion would occur. He had only to measure the times required for the muscle to develop the *Energie* to just begin to lift a series of different weights, thereby producing a curve of muscle tensions over time. Still, he needed a measure of the times.

When he wrote to Du Bois-Reymond in October 1849, Helmholtz reported that he had found his new method for demonstrating the gradual temporal development of the muscle contraction in what he optimistically regarded as "a much more evident manner." Once again, he had found the technical resources he needed in the engineering community, this time from the applied physicist Claude S. M. Pouillet in Paris, director of the Conservatoire national des arts et métiers from 1832 and professor of physics at the École polytechnique and the Sorbonne. Pouillet was a major figure in French industrial projects, including telegraphy. No doubt Helmholtz knew of Pouillet's work in part via Siemens, for Pouillet had been one of Siemens's competitors in measuring the very short time intervals required for determining the velocity of cannonballs (chap. 4).[56] Even more directly, Du Bois-Reymond, in a presentation to the Physical Society in 1845 and in his 1846 report published in

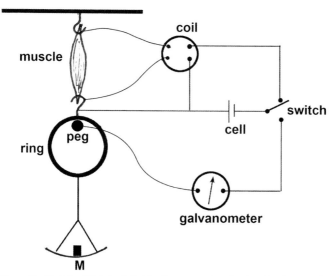

Figure 8.7 Sketch of Helmholtz's idea for measuring the time for the muscle to just lift *M*. Throwing the switch stops a current in the primary of the induction coil, producing a sudden pulse through the secondary and the muscle. Simultaneously, a current starts in the lower circuit, continuing until the muscle just lifts the ring from the peg. The time is proportional to the deflection of the galvanometer.

Paris, had suggested using Pouillet's techniques to determine the velocity of nerve propagation and of muscle activity. Curiously, Helmholtz would refer to Siemens but not Du Bois-Reymond.[57]

As a measure of a very short time interval, whether for ballistic purposes or otherwise, Pouillet had used the impulse delivered during that time by a known electric current to the magnetic needle of a galvanometer. In principle this would provide a sensitive measure of the exceedingly short time during which the current passed, because the duration of the momentary current would produce a slow but proportional deflection of the heavy needle, thereby amplifying the duration of the current by perhaps a thousand times. Although Pouillet had not been entirely successful, for reasons that Siemens had analyzed, Helmholtz saw that this electromagnetic method could be improved markedly in both instrumental and mathematical terms.[58]

He conveyed a verbal image of his new technique to Du Bois-Reymond (sketched in fig. 8.7).

> Think of a metal ring hanging on a muscle with a pan of little weight hanging on the ring, with the top part of the ring supported by a metal peg, so

that even with a larger weight in the pan the ring cannot descend. Now a current is closed, of which one part goes through the muscle [as stimulus] and the other [as time-measuring current] through a galvanometer and the above peg and ring such that the current in the galvanometer is broken again by the contraction of the muscle lifting the ring from the peg. While the current continues, however, it sets the [galvanometer] magnet with its mirror in motion, whose deviation is proportional to the duration of the current.

With this instrument Helmholtz intended "to establish the *Form* of the curve that expresses the *Ansteigen der Kraft* [rise of *Energie*, as tension]."[59]

The ring and peg, the two currents, and the galvanometer are the basic constituents of the sophisticated instrument that Helmholtz was busy developing. After complaining bitterly to Du Bois-Reymond about the incompetence of the mechanics he had encountered in Königsberg and imploring him to get their prime Berlin mechanic Halske moving on a new galvanometer, he would finally have the new instrument built to a high standard of precision by the Königsberg mechanic Egbert Rekoss.[60] Helmholtz himself did the basic design as well as the drawings shown in figure 8.8 (but without the electrical components and without his Fig. 3–5, the muscle contraction curves, to which I will be referring).

The frog muscle hangs inside the bell jar, kept saturated with moisture to preserve the irritability of the muscle and nerve for 3 to 4 hours. The wires *v* deliver the stimulus, either directly to the muscle or through the nerve. When the muscle contracts, it lifts the central structure shown in his Fig. 2, which plays the role of the "ring" above. This structure is shown rotated 90° in Fig. 1 and mounted in its supporting framework, which provides the supporting "peg" at *M*. Despite its intricate construction, the purpose of the moveable structure is simply to enable the muscle contraction itself to open the contacts at *mn* and *o*, thereby stopping the "time-measuring current," which begins simultaneously with stimulation of the muscle or nerve.[61] This stopping point is the point in time at which the muscle has developed sufficient *Energie* to just begin to lift the combined weight of the apparatus (weight *m* in the analysis above) plus any added weight *M* (the overload) in the pan at *K*.[62]

Helmholtz's extraordinary practical and theoretical skills combined to produce a precision time-measuring instrument, a calculation formula, and an associated calibration circuit that allowed him to go far beyond Pouillet while translating Pouillet's method from artillery to physiology.[63] Even Helmholtz's calibration, however, derived from the methods of artillery and

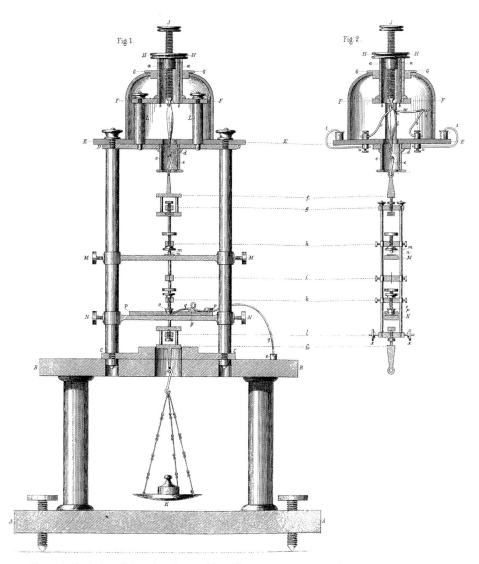

Figure 8.8 Helmholtz's frog drawing machine (electromagnetic method), 1850. "Messungen über den Zeitlichen Verlauf," *WA*, 2, plate 5, Fig. 1, 2.

telegraph engineers, in this case from Wheatstone, another competitor of Siemens, whose technique for precisely dividing a current, recently published in Poggendorf's *Annalen*, enabled Helmholtz to relate the deflection of his galvanometer for the somewhat variable time-measuring current to the deflection it would have had if the current had been constant.[64] I will refer to

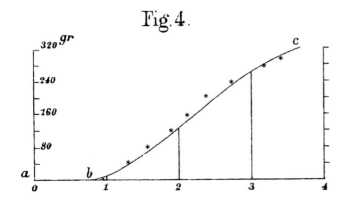

Figure 8.9 Rise of *Energie* with time as increasing capacity to just barely lift additional weights (data points added). "Messungen über den Zeitlichen Verlauf," *WA*, 2, plate 5, Fig. 4.

Helmholtz's remarkable technical skills as *Technik*, or better *Kunst-Technik*, because they relate to his aesthetic aims.

It may not be immediately apparent that the moveable structure (effectively the "ring") in the new electromagnetic instrument occupies a position much like that of the stylus in the frog drawing machine. By fixing the stopping point, it "draws" one point at a time on a curve of time versus *Energie*. Helmholtz designed the instrument precisely for this purpose: to fix successive points in time (fig. 8.9) at which the increasing tension in the muscle would be just able to lift increasing overloads *M* in the pan *K*. To emphasize this pointwise drawing, I have plotted on his Fig. 4 the data points he obtained as averages from his best series of measurements, carried out on a freshly caught, very strong frog before it began to tire. Time is on the horizontal axis in hundredths of a second and weight on the vertical axis in grams.

The smooth curve is the idealized image that Helmholtz now called *die Form der Ansteigung der Energie* (the *Form* of the rise of *Energie*).[65] He intended it to make immediately visible the expected increase of time with increasing weight, much as the curve of heights should have done, but with much more accuracy. In the terms introduced earlier, his Fig. 4 should have provided a *lebendige Anschauung* of the dynamic process of ascending *Energie* in a contracting muscle. But the curve did not actually show a muscle contracting or doing work; it showed only increasing muscle tension. Thus, it was *anschaulich* only in a rather abstract sense, by inference, appealing more to the "pondering reflection" than to "original *Anschauung*," and Helmholtz did not employ the term. Nevertheless, the basic purpose of the new instrument was to "draw" a curve, one point at a time, showing the true temporal development of the *Energie* in a frog muscle during its contraction phase. I take the curve of Fig. 4, *die Form der Ansteigung der Energie*, to be the center-

piece of Helmholtz's big paper, the realization of his initial goal to clarify the temporal process of *Arbeit* and the foundation of his subsequent analysis.[66]

Central to his presentation was his belief that the curve of tension had the same underlying *Form* as the curve of heights of contraction from his Fig. 3 (fig. 8.5), namely, the smoothed-out curve that would be obtained by connecting the equilibrium points at *a*, *b*, *c*, etc., the "curve of heights of equilibrium." He worked hard to convince his audience of this equivalence. Again, he was supposing that as the *Energie* of the muscle increased with time, its coefficient of elasticity was increasing, so that at a fixed length it could support increasingly heavy overloads *M*, and that these increasing weights could stand in for the increasing work the muscle would have been able to do had it been lifting the normal weight *m* of the apparatus to higher levels *h*.

This assumption of equivalence of *Form* is surprisingly explicit in a sketch (fig. 8.10) that Helmholtz sent to Du Bois-Reymond in January 1850 because it extends the equivalence even to the relaxation phase, which he could not observe. That is, the dashed line extends the measured curve of tension by continuing it with the smoothed curve of heights of equilibrium.

> By the way, the *Muskelkraft* [Weber's term for tension] rises according to the accompanying curve: *A* is the moment of the excitation, then comes a small concave piece, then an almost straight ascending line, which gradually becomes convex; the dashed line is inferred from the earlier drawing attempts, which had already given me the same *Form der Ansteigung* [his Fig. 3 (fig. 8.5)].[67]

It will become apparent below, with respect to propagation in the nerves, why it was actually essential for Helmholtz to extend the equivalence of *Form*

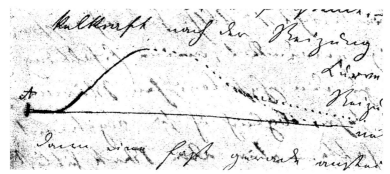

Figure 8.10 *Form* of curve of *Energie* as tension (*solid*) extended by *Form* of curve of heights of equilibrium (*dashed*). Staatsbibliothek zu Berlin-Preussischer Kulturbesitz, Slg. Darmstaedter F1a 1847: Hermann von Helmholtz, 35r.

to the full curve. He put the point strongly in the published paper: "[Fig. 4] must, in general *Form*, have great similarity with the curve of heights of equilibrium [from Fig. 3]." This great similarity suffered, however, from the limitation that M was not rigorously proportional to h. The coefficient of elasticity k, at a given time after stimulation, was not quite the same for the stretched muscle just barely lifting M and the contracted muscle lifting m to height h.[68] Nevertheless, so long as k was fairly well behaved, the elastic band analogy would support the view that the general shape of the two curves was the same, even though they were not quite proportional. At least, Helmholtz concluded, "a comparison of the curve [of tensions] in Fig. 4 with the beginning of the other [curve of heights of equilibrium], so far as we can approximately extract its *Gestalt* from Fig. 3, appears not to disagree with [this beginning]." So the imperfect *Gestalt* from Fig. 3 could still serve the important rhetorical function of helping to confirm Fig. 4 as the true *Form*.[69]

The precision of this new curve of *Energie*, demonstrating that the development of tension was very gradual, also revealed for the first time a yet more surprising result of the measurements: "*a time passes before the Energie of the muscle begins to increase at all*."[70] Even with no weight in the pan, there was a delay between stimulus and initial movement of about 1/100 of a second, easily observable with this sensitive apparatus. The initial portion of the curve was not simply concave, indicating a gradual rise with time, but perfectly flat. The muscle required time to even begin to develop its *Energie*.[71]

But it was still possible that this delay time was an artificial product of the instrument. To secure his measurements, Helmholtz went to great lengths to categorize and vitiate all sources of error, whether deriving from the very sensitive physical and electrical contact at mn, insufficient rigidity in the apparatus, nonparallel fibers in the muscle, the force of the muscle not passing through the center of mass of the apparatus, or the effects of pendular rather than strictly vertical motion.[72] Only with those possible disturbances eliminated did the curve of his Fig. 4 stand out as the pure *Form der Ansteigung der Energie* abstracted from all extraneous appearances.

Helmholtz's procedure is reminiscent of what he expected an art student to learn from anatomy, namely, to separate out the essential *Form* from the nonessential features of any particular *Gestalt*. They would thereby gain clarity and simplicity in the figures they ultimately produced, having learned how to modify the muscular appearance of an earthly model to obtain an expression of the ideal *Form*.

It was in seeking a similar clarity and simplicity in the *Form* of his curve of *Energie* that Helmholtz laid the foundation for his entire argumentative

Figure 8.11 Curves of rising *Energie* for a tiring muscle, showing proportional decrease of height for the whole curve. "Messungen über den Zeitlichen Verlauf," *WA*, 2, plate 5, Fig. 5.

structure. That is, the aesthetic argument was as important as the conceptual one. Having once established the true *Form*, he could refer to it in different circumstances as an idealized standard, an imagined curve that would be modified in nonessential ways under real-life conditions. Thus, if the muscle were initially stretched with a larger weight before measuring delay times for successive weights, it seemed entirely plausible that a curve similar to his Fig. 4 would emerge from the measurements, but displaced downward, with lower ordinates of tension for a given delay time. A similar displacement of the curve downward could be expected to occur if measurements were made with a stimulus of lower intensity, insufficient for the muscle to lift the weight to its maximum height. Helmholtz simply indicated that these modifications corresponded to his experience.

He did, however, extract from one extensive series of measurements the curves for a muscle at increasing stages of tiredness, as shown in his Fig. 5 (fig. 8.11). It seemed that one had only to glance at the curves to see that even in this case they expressed the *Form* of Fig. 4, with decreased amplitude: "the sight [of Fig. 5] seems to teach . . . that the ordinates along the whole curve decrease approximately in proportion to their magnitude."[73]

Velocity of the Nerve Impulse

To this point, Helmholtz had spent twenty-four pages describing his instruments and another twenty-three pages establishing the true *Form* of the curve of rising *Energie*. He had even taken the precaution of always exciting the contractions by stimulating the muscle itself rather than its nerve, although Eduard Weber had detected no difference.[74] This thorough treatment of the muscle curve in isolation made it possible to separate out whatever effect the nerve itself might have. Indeed, Helmholtz stated that the delay of contraction for the muscle had first paved the way to the even more surprising discovery for which he would quickly become famous. He showed that

the stimulus took time to propagate through the nerve, and he measured its velocity.[75]

There seems to be no evidence that Helmholtz had such a measurement of propagation velocity in mind when he began work on the temporal course of the muscle contraction. These were quite different conceptions physiologically. Still, measuring the velocity of the nerve stimulus seems a fairly obvious extension of Siemens's suggestion of adapting the ballistics work to measuring the velocity of an electric current and of Du Bois-Reymond's explicit suggestion of using Pouillet's method for muscle and nerve velocities. It may only have been insufficient precision in his initial adaptation of their ideas that kept him from making the extension to nerve impulses immediately.

In any case, the precision of Helmholtz's curves of *Energie*, which made the delay time for the onset of muscle contraction so evident, also made it conceivable to attempt to measure a much shorter delay time for propagation through the nerve. It was this even more extraordinary result, established in trials in late December 1849 and early January 1850, that he chose to proclaim first to the scientific world with a flurry of announcements in January sent to Du Bois-Reymond for the Physical Society, to Müller for presentation to the Berlin Academy and publication in its *Monatsbericht* (republished in Müller's *Archiv* and in Poggendorff's *Annalen*), and to Humboldt for the *Comptes Rendus de l'Académie des Sciences*. Ironically, it was what he did not include in these announcements, namely his extensive effort to determine the *Form der Ansteigung der Energie*, with its delay time for contraction in the muscle itself rather than for propagation in the nerve, that aroused skepticism in the audience for Müller's presentation, for they thought he had not accounted for delayed action in the muscle. Remarking to Helmholtz on how "excessively obscure" his written announcement was, Du Bois-Reymond explained it individually to the Berlin academicians and reworked it for clarity and to meet Humboldt's requirements for sending it to the *Comptes Rendus de l'Académie des Sciences*.[76] These events help to explain why Helmholtz placed so much emphasis on the invariable *Form* of the curve of *Energie* in his full exposition six months later, as described above. Indeed, his measurement of propagation time depended on it, as I will show.

From the beginning of his published account, Helmholtz conceived the measurement of propagation time through a nerve in terms of a displacement of two imagined but not realized curves of *Energie* (like the one in his Fig. 4): one from stimulating the nerve up close to the muscle and the other from the far end of the nerve. If he could assume that these imagined curves were congruent (had precisely the same shape) but were only shifted slightly

in time, the shift would measure the propagation time. Putting this in terms of the individual points he could establish, if the time interval (*Zwischenzeit*) between a stimulus at the near end of the nerve and the lifting of a given weight *M* had a certain value, then that interval for a stimulus at the far end of the nerve for the same weight *M* would be increased by a small amount. And if the curves were congruent, the increase would be the same *for all weights M*. That is, the entire curves would be shifted by a constant amount.[77] On this assumption of congruence—and only on this assumption, it should be emphasized—the measurement of propagation time required simply a determination of the time difference for a single weight *M* rather than for the entire curve of weights.

Helmholtz stimulated nerves 40–50 mm long through the fine wires *v*, first at one end of the nerve and then at the other. In an extended series of measurements, with six to eleven observations made at both ends of the nerve for each of five muscles lifting a different weight, he obtained a propagation velocity of approximately 27 m/s.

Although the procedure seems straightforward, its validity depended on two essential aspects, one physical, the other calculational. On the physical side, he had to ensure that the muscle was behaving in the same way when stimulated from near and far ends of the nerve or that the curves of *Energie* were in fact congruent. He was able to control one aspect of this congruence by assuring that the two stimuli would produce the same work (*mechanische Wirkung*), as indicated by the maximum height to which the muscle could lift a given weight. As usual, the technique depended on assuming that the curve of heights would follow much the same curve as the curve of tension.[78]

On the calculational side, it was conceptually trivial to measure nerve length and time difference and divide to get the velocity. But establishing a stable number was anything but straightforward. The exceedingly short time differences, of about 1/1,000 s, severely challenged the precision of the instrument. Measurements for a single muscle varied so much from one observation to another that they sometimes showed a longer propagation time from the near end of the nerve than from the far end. As Olesko and Holmes have stressed, it was only by applying the probability calculus—calculating the mean value of measurements for each muscle, calculating probable errors of the individual values and mean values, and applying the method of least squares to obtain a most probable mean value—that Helmholtz was able to extract from his highly variable data a most probable mean velocity of 26.4 m/s. The means and probable errors for five different muscles varied enormously, from 24.6 ± 2.0 to 38.4 ± 10.6. This variation was especially prom-

inent before he discovered that temperature differences strongly affected the results. Holding temperature constant at about 20°C for three new trials helped to stabilize a velocity of 27.0 m/s but still with a variation from 25.1 to 29.1 in the mean values. In other words, the time measurements in themselves were anything but precise. The quite limited precision he was able to achieve came from applying the probability calculus.[79]

Such "*Unsicherheit*" (uncertainty/insecurity) in the number compromised its reality as a definite object to the degree that Helmholtz was only willing to state in his conclusions that the propagation through the nerve "requires a measurable time."[80] His understated claim makes it all the more apparent why it was so important for him to establish that the basic *Form* of the curve of *Energie* was highly regular. If his audience were not fully convinced of that fact, his entire demonstration of the propagation time would be insecure.

More specifically, we see repeatedly his concern with the shape of the entire curve, not just its rising portion. Before, during, and after presenting his velocity measurements, he argued that the entire muscle curve remained invariant in *Form* no matter which end of the nerve was stimulated or which was stimulated first. The only effect of stimulating one end of the nerve versus the other, he insisted, was to displace the curve along the time axis by the amount of the propagation time, leaving "the *Form der Ansteigung der Energie* unchanged" and the new curve fully congruent with the previous one.[81]

Lacking any means to establish directly this full congruence of the curves, Helmholtz employed an indirect means. Altering his apparatus slightly, he measured the time during which the muscle held the contacts *mn* apart, that is, from the time it first began to lift a given weight *M* to the time it set it back down again, arguing that if this time interval (again *Zwischenzeit*) were the same for stimulations from the near and far end of the nerve and for all weights, then the imagined curves must have the same *Form*. By comparing mean values obtained from observations made on three continuously tiring muscles, one lifting 200 grams and two lifting 100 grams, he was able at least to make the congruence seem plausible to a reasoning mind.[82] If this were accepted, then his dramatic claim to have measured the propagation time for the nerve impulse would be validated as the displacement of the entire curve. But if not, not.

Back to the Frog Drawing Machine

The congruence that Helmholtz required was a congruence of two curves that the frog muscle had not yet drawn. Fully aware of this tenuous link in his argument, Helmholtz offered his readers in July 1850 the expec-

tation that his original graphical method "of drawing the temporal processes . . . probably will serve to give an easier and quicker demonstration [*Darlegung*] of our results on the propagation velocity in the nerves than so far pursued." It would do this by displaying in a direct visual image the shift in congruent curves. Even though friction made the method unusable for establishing the true curve of *Energie* (as work), it might establish the true displacement in time.[83] Already by December, he could describe a much more sophisticated version of his original *Froschzeichenmaschine* to the Physikalisch-ökonomische Gesellschaft zu Königsberg. A year later he had perfected his technique and sent for publication his short paper on "Measurements of the Propagation Velocity of Excitation in the Nerves: Second Series."[84] Meanwhile, in the summer of 1851, he had made an extended tour of key research sites in Germany, Switzerland, and Austria displaying his new curves and experiencing their remarkable effectiveness in convincing others of the reality of the propagation velocity.[85]

Figure 8.12 indicates how the new instrument replaces the previous one, using the same bell housing for the muscle (cf. fig. 8.8). In essence, it replaces an instrument that could register only one point at a time on the curve of *Energie* (as tension) with an instrument of somewhat less precision that draws the full curve of *Energie* (as work) on the drum at the left. Although the basic conception still came from the indicator for steam engines and Ludwig's kymograph, Helmholtz now needed a more precise timing mechanism to establish a uniform time line for the entire curve. He turned again to modern artillery measurements, this time to Siemens's "electrical chronoscope" (chap. 4).

Siemens's use of sparks triggered by a cannonball to register its own travel time on a rapidly rotating cylinder—his "happy idea . . . of letting the electricity itself do the drawing"—inspired Helmholtz's new frog drawing machine. It promised a simple, direct, and immediately intuitive result. Siemens's practice became what Helmholtz called the principle of "transforming time differences into space differences," or for this case, "the principle of the rotating cylinder."[86] Of course the principle had already been developed in the dynamometers and indicators of the engineers. All of these instruments also employed the "happy idea" of self-registration. But Helmholtz put the techniques and principles together in an impressive new way in his fully redesigned *Froschzeichenmachine*.

The new graphical recorder was again built to a very high standard of precision by the Königsberg mechanic Egbert Rekoss. Helmholtz designed its workings and made the technical drawings. As before, the refinement and sophistication of his untutored skill in mechanical contrivance is as impressive

Figure 8.12 Helmholtz's new frog drawing machine (graphical), 1850–1852. "Messungen über die Fortpflanzungsgeschwindigkeit," *WA*, 2, plate 2, with bell jar added from figure 8.8.

as his mathematical talent. Following his own description, the instrument consists of three basic parts, each adapted from the engineers and mechanics: (*a*) the inscription mechanism, (*b*) the clockwork to drive the revolving cylinder, and (*c*) the timing system.[87]

a) The inscription mechanism begins with the muscle and its nerve inside the same bell jar with the same electrical stimulation of the nerve *w* through the wires *v*. The small frame at *f*, however, now carries a drawing arm, shown separately and from above in his Fig. 2, which in turn carries the stylus mounted on rod *H* in Fig. 1. This rod is fixed to an axle mounted on bearing points at *G*. Under the pressure of the small counterweight at *c*, the stylus presses gently on the rotating cylinder *J* at *h*. The entire drawing arm, mounted on bearing points at *F*, restricts the stylus to vertical motion as the muscle contracts and extends. This much of the instrument reproduces the function of the stylus in the indicator and in Ludwig's kymograph.

b) Like Siemens's electrical chronoscope and Ludwig's kymograph, Helmholtz's drawing instrument employed a clockwork mechanism and conical pendulum to rotate the cylinder at a fairly precise and stable rate (6 r/s). Rekoss succeeded admirably with the precision of the cylinder (a ground and polished section of a champagne glass) and with its rate of rotation. Helmholtz had also wanted a high degree of uniformity in each rotation, but the conical pendulum did not suffice.[88] Failing as a regulator—a deficiency Helmholtz partially relieved by the heavy flywheel *K* running with its lower wings in an oil bath—it served nevertheless for gauging the rate of rotation of the cylinder.

c) Like Siemens again, Helmholtz needed to record accurately on his revolving cylinder the starting time of his measurements, the time at which the nerve received its electrical stimulus. This he arranged with the apparatus in Fig. 3 (fig. 8.12). A small tooth on the flywheel at *z*, corresponding to a specific position of the stylus on the cylinder, trips the lever at *μ*, which opens a circuit (not shown) to deliver a momentary electrical stimulus through an induction coil. Successive curves therefore begin at the same position, allowing a detailed comparison of their development.

To begin a measurement, Helmholtz set the clockwork in motion while pushing down gently on the rod that extends out to the right at *ξ*, thereby withdrawing the stylus from the cylinder while also raising the lever *μ* above the tooth. With everything running smoothly at a known rate indicated by the revolving pendulum, he lifted his finger from the rod. Simultaneously with the stylus contacting the cylinder, the tooth triggered the stimulus. The muscle then contracted, causing the stylus to draw a curve of the muscle con-

traction on the champagne glass, which had been lightly smoked. But the tendency of the arm to bounce on the elastic muscle remained a problem. To remove it, Helmholtz increased the pressure on the bearing points at *F*, producing sufficient friction to damp out the oscillations.[89] The result was a smoothed version of the wavy curve from his original *Froschzeichenmachine*, just as if he had returned to using mica rather than smoked glass to increase friction.

Helmholtz did not repeat his earlier discussion of the effects of friction, but the problem remained. The work that the muscle expended to overcome friction in the bearings was not recorded in the curve. Was this then a true curve of *Energie*? Did it show the ideal *Form* of that curve? Apparently not. Helmholtz used neither term. Instead he discussed the *Gestalt* of the new curves and the conditions under which pairs of particular curves either have or do not have the same *Gestalt*.[90] The *Form der Ansteigung der Energie* dropped out of his discussion, which now concerned only the propagation time of the nerve impulse. For that purpose consistency of *Gestalt* was all that he required and all that he claimed.

Figure 8.13 reproduces a surviving original of Helmholtz's curves as lifted from the glass drum. Following a technique used by engravers to copy drawings, he moistened a thin strip of isinglass (fish gelatin) by breathing on it before rolling the smoked drum over its surface, transferring a thin layer of

Figure 8.13 Original drawings of two curves from Helmholtz's perfected graphical method, showing a time delay due to propagation in the nerve. Staatsbibliothek zu Berlin-Preussischer Kulturbesitz, Slg. Darmstaedter F1a 1847: H. v. Helmholtz, fol. 64.

soot to the strip. By pressing the strip, soot-side down, onto a sheet of dampened white paper he obtained a sharp white-on-black image of the curve. This imperfect example of curves fixed on isinglass is one he sent to Du Bois-Reymond in July 1852.[91] Time runs from right to left. The displacement between the two curves records the time difference for contractions stimulated directly (the incomplete curve, barely visible left of center) and through 73 mm of nerve (complete curve, displaced to the left). These two curves, however, did not have the properties required for reliable measurement of displacement and the velocity of the nerve impulse. They did not have the same *Gestalt*.[92]

For this purpose, the curves had to be congruent throughout their length, for otherwise the displacement between them might derive from differences in muscle activity. Figure 8.14 shows Helmholtz's published curves as copied from the drum but with time running left to right. To make the problem of congruence apparent, he invoked the curves of his Fig. 4, which he obtained from separate recordings. They display a clear change in shape between the curves k_1 and k_2, when a muscle stimulated at the same point on the nerve, but tiring considerably for k_2, loses its capacity for stimulation. If the curves had been congruent throughout their length (*congruente Gestalt*), it would have shown that the muscle activity was not changing.[93]

The double curves of Fig. 5 and Fig. 6, recorded directly one over the other before copying, clearly display this full congruence and displacement for a fresh and for an only slightly tired muscle when stimulated at the two ends of the nerve. Fig. 7, for a slightly tired muscle stimulated at the far end of the nerve, shows that the displacement cannot depend on the more distant point being less irritable, because when stimulated more strongly it lifts the weight to a slightly higher level. Even with all these checks in place, actually measuring the displacement between congruent curves remained imprecise, but Helmholtz extracted from Fig. 5, perhaps by measuring the shift required to juxtapose the full curves, a velocity estimate of 27.25 m/s, in good agreement with his earlier electromagnetic measurements.[94] Because he gave no information on the variability of the number for different measurements, we know little of its precision.

More important than precision was the immediately graspable picture that the new measurement gave of the displacement of the full curve of contraction resulting from propagation in the nerve. In fact, the double curves in Fig. 5 match so perfectly in *Gestalt* that, if it were not for the friction they mask and the fact that Helmholtz did not say so, I would want to suggest that they realized with full *Anschaulichkeit* his original goal of representing the

Fig. 4.

Fig. 5.

Fig. 6.

Fig. 7.

Figure 8.14 Curves produced from stimulating the nerve of muscles under various conditions.
" Messungen über die Fortpflanzungsgeschwindigkeit," *WA*, 2, plate 2, Figs. 4–7.

elementary cycle of the muscle performing work, or that they displayed the sought-after *Form der Ansteigung der Energie*.[95]

Nevertheless, it was just because the shape of this curve was so highly reproducible that he could argue that the working process did not change from one measurement to another. Holmes and Olesko have stressed how important this visualizability was to Helmholtz's ability to convince other physiologists of the finite propagation time of the nerve impulse. They capture this quality under the perspicuous term "qualitative precision," arguing that Helmholtz's use of the graphical method provided a separate and more immediately graspable means of convincing his physiological audience of the validity of his more esoteric and highly variable electromagnetic measurements (with their heavy dependence on the probability calculus).[96] I would add a number of additional features, all of which are critical to understanding Helmholtz's accomplishment.

- The two methods were both means of drawing a curve of *Energie*, but they represent its two different aspects and use alternative drawing instruments—pointwise (for tension) and continuous (for work)— all within the same conceptual framework. The two instruments embodied the duality of *Kraft* in Helmholtz's *Erhaltung der Kraft*.
- The pointwise electromagnetic measurements were aimed at eliminating the disturbing force of friction from the continuous graphical recordings in order to reach the ideal *Form* of the curve of *Energie* as a curve of tension. The equivalence of its shape to the curve of work, however, required a nontrivial conceptual inference from the conservation principle as applied to the analogy of a spring or elastic band (h proportional to M).
- The security of Helmholtz's rather imprecise electromagnetic measurements of propagation time, even with the support of the probability calculus, depended on this *Form* being constant so that the propagation time would show itself as merely a displacement of congruent curves. But justifying that congruence required repeated reference to the original *Gestalt* of the curve of work and to indirect arguments for invariance of *Form* during the electromagnetic measurements. This aesthetic judgment played a necessary role in Helmholtz's argument.
- The new frog drawing machine, having incorporated rather than eliminated friction, could not draw the true *Form* of the curve of

Energie. It could, however, establish congruence by producing curves with a consistent *Gestalt.* It could thereby provide both the required justification of the electromagnetic measurements and a new form of measurement.[97] It established simply and immediately, in an unambiguous visual image, the propagation time of the nerve impulse, requiring a minimum of conceptual reflection.

NOTES TO CHAPTER EIGHT

1. Kirsten, *Dokumente*, 123.

2. I translate *Kraft* as "force" when it refers to Helmholtz's *intensity* of *Kraft,* like tension (chap. 7), and as "work" or "quantity of force" when referring to his *quantity* of *Kraft*, such as *Arbeit, mechanische Wirkung,* or *Nutzeffect.*

3. Helmholtz, "Messungen über den Zeitlichen Verlauf" (1850) and "Messungen über die Fortpflanzungsgeschwindigkeit" (1852).

4. The literature is correspondingly large. Schmidgen, *Die Helmholtz-Kurven*, 263–68, gives an extensive bibliography. Important for me have been the work of my colleagues De Chadarevian, "Die 'Methode der Kurven,'" and Frank, "The Telltale Heart."

5. The creative study by Schmidgen, *Die Helmholtz-Kurven*, deserves particular attention. While I am looking at Helmholtz's work here as a culmination of movements in the sciences and arts developing in the 1830s and 1840s involving the so-called discovery of time in history, natural history, and physics and from which his concern with work, energy, and temporality emerged, Schmidgen presents his experiments as the starting point for late nineteenth-century conceptions of time—the accelerated time of telegraphs, railroads, and publication rates—and of "lost time." This thread leads through a variety of intermediary figures to Marcel Proust's *A la recherche du temps perdu* (1913–27) such that *temps perdu* provides the touchstone for the book. This difference in historiographical orientation is far reaching, from aesthetic styles—neoclassical vs. modernist—to conceptions of time—temporal dynamics of nature vs. psychology of temporal perception—down into the details of interpreting the relation of Helmholtz's two instruments. While I treat the physics and technologies of engines and telegraphs as working together for Helmholtz, Schmidgen gives priority to the telegraph. And while I emphasize Helmholtz's curves of *Energie*, Schmidgen stresses his numbers for time intervals. I will argue that the two concerns were deeply interrelated through the conservation principle, with the time measurements arising as a direct continuation of the curve-drawing project, which continued to be required to legitimize the time measurements.

An important new source from Schmidgen's research is his discovery of some of Helmholtz's original curves from 1851, intended for presentation to the Paris Academy of Sciences, along with a text for publication in the *Comptes Rendus de l'Académie des Sciences*. The text, written by Du Bois-Reymond, is Schmidgen's starting point for following "temps perdu" (Helmholtz's "Zwischenzeit," questioned below) through to Proust. Another important aspect is Schmidgen's analysis of the experiments Helmholtz carried out on hu-

mans (never fully published) seeking to measure delay times in both motor and sensory nerves and including time for processing in the brain.

I have also made considerable use of the exemplary works on Helmholtz's quantitative and qualitative rhetorical strategies by Olesko and Holmes, "Experiment," and Holmes and Olesko, "Images of Precision." Finally, my own engagement with Helmholtz on the relation of conservation, instruments, and curves began with Brain and Wise, "Muscles and Engines."

6. On the sweeping significance of the physiology of work for cultural and political history, see Anson Rabinbach, *The Human Motor: Energy, Fatigue, and the Origins of Modernity* (New York: Basic Books, 1990).

7. Alexandra Hui, *Psychophysical Ear*, 30–35, 61–69, 70–74, has pointed out the close parallel with Helmholtz's emphasis on *Form* in his musical aesthetics, his love of classical music, and even his preference for Steinway pianos. I am grateful to her for extensive discussion. Similarly, on the aesthetics of instruments and experiments, see Jackson, *Harmonious Triads*. And for the extension of Helmholtz's curve-drawing methods into an experimental system for "physiological aesthetics" in the late nineteenth century, see Brain, *Pulse of Modernism*, esp. 17–36.

8. Course of study in "Der Jahresbericht," in *Zu der öffentlichen Prüfung der Zöglinge des hiesigen Königlichen Gymnasiums* (1837), 45–58, on 53.

9. F. Helmholtz, "Die Wichtigkeit der allgemeinen Erziehung für das Schöne," on 23 and 34.

10. Helmholtz, "Probevortrag."

11. Kant, *Kritik der reinen Vernunft*, B75, A51. The famous line is "Gedanken ohne Inhalt sind leer, Anschauungen ohne Begriffe sind blind."

12. Helmholtz, "Probevortrag," 99.

13. Fichte, "Der Patriotismus," 258, also 262, 264. F. Helmholtz, "Die Wichtigkeit der allgemeinen Erziehung für das Schöne," 8, 21. On the two Fichtes and the Helmholtzes, see Koenigsberger, *Helmholtz*, 1:161, 168–69, 242–44, 283–93, 332–42; Heidelberger, "Force, Law, and Experiment"; Turner, "Empiricist Vision." On *Anschauung* in Fichte, see Drechsler, *Fichtes Lehre*, 60–64.

14. Kant, *Kritik der reinen Vernunft*, A51/B75.

15. Hatfield, *Natural and the Normative*, gives a comprehensive survey (omitting Fichte, Schelling, and Hegel) with subtle readings of, e.g., Kant's a priori and empirical *Anschauungen*, pp. 87–108, and culminating in an indispensable chapter on Helmholtz. Friedman, "*Zeichentheorie*," 28–37, succinctly analyzes the foundations of Helmholtz's empiricism and its significance for our knowledge of objects in space. Turner, *In the Eye's Mind*, analyzes the origins, context, and significance of Helmholtz's famous contest with Hering. A number of penetrating essays appear in Cahan, *Helmholtz*: Lenoir, "Eye as Mathematician"; Turner, "Consensus and Controversy"; Heidelberger, "Force, Law, and Experiment"; DiSalle, "Helmholtz's Empiricist Philosophy."

16. Here muscle physiology met the principle of least action and its variants by Gauss, Jacobi, and W. R. Hamilton, which was becoming the new foundation of mechanics during the 1860s after the principle of conservation of force (as work or energy) had become

established. Helmholtz would convert Fick's and especially Wundt's principles into his own principle of easiest orientation for the eyes, suggesting that it could be understood as a mental calculation identical in form to the method of least squares for minimizing errors. Generalizing, Lenoir's analysis suggests how Helmholtz increasingly unified all areas of his research not only around conservation but also economy in nature, including physiology, mechanics, electrodynamics, thermodynamics, psychophysics, and even the analysis of error, whether of humans or machines.

17. Drechsler, *Fichtes Lehre vom Bild*, organizes Fichte's entire corpus around this free activity in constructing a picture (*Bild*) of the world and ourselves, regarding it as Fichte's unique creative accomplishment (e.g., 66–67).

18. Helmholtz, "Probevortrag," 100–101.

19. Koenigsberger, *Helmholtz*, 1:105. Helmholtz shared this emphasis on *Anschaulichkeit* with Du Bois-Reymond. Lohff, "Emil du Bois-Reymonds Theorie."

20. F. Helmholtz, "Die Wichtigkeit der allgeminen Erziehung für das Schöne," 9; Pestalozzi and Buss, *ABC der Anschauung*. Discussion in Ashwin, "Pestalozzi." Fichte's positive but qualified view of Pestalozzi and of his *ABC der Anschauung* appears in "Der Patriotismus," 266–74.

21. Schmidgen, "Pictures, Preparations," shows that while the new physiologists all stressed hands-on training, they largely presented visual demonstrations. Kremer, "Building Institutes," provides a detailed study of three proposals to the cultural ministry showing how the Pestalozzian goal of educating the *Anschauung* began to enter physiological training in Berlin and elsewhere. He suggests, however, in contrast to my own view, that no competitive market mechanisms or state interests were operating.

22. Helmholtz, "Probevortrag,"102–3.

23. Ibid., 101.

24. Krimer, *Physiologische Untersuchungen*, 63–71, image facing 132; Schwann, "Ueber die Gesetze." Image from Florkin, *Naissance et déviation*, 38. Work described in Müller, *Handbuch*, 2:59–62. Historical account in Kremer, *Thermodynamics*, 315–23. Engelhardt, *De vita musculorum*, end plate.

25. Valentin, *Lehrbuch der Physiologie*, 2:175–92 (myodynamometer image on 176); 2nd ed. (1847), 1:149–74 (heat), 175–92 (electricity). Full-scale attacks on Valentin are Volkmann (professor in Halle), *Streifzüge*, and Du Bois-Reymond, *Thierische Elektricität*, 1:xvii, xxii–xxiii, xxx–xxxiii, and pt. 1, chap. 3.

26. Weber, "Muskelbewegung."

27. Ibid., 1–5, 22–25.

28. Ibid.," 69, 86.

29. This myodynamometer, including the use of the telescope, is interestingly related to the *Elektrodynamometer* that Eduard's brother Wilhelm developed to establish his famous fundamental law (*Grundgesetz*) of electrical force in 1846, including a telescopic reading technique that Helmholtz would adopt. Weber, "Elektrodynamische Maassbestimmungen."

30. Weber, "Muskelbewegung," 11, depicts the generator, as does Valentin, *Lehrbuch der Physiologie*, 1:188–92, along with maladies for which it was used. Weber thought he

was the first to discover that tetanus depended on a constantly changing current, but he actually followed a long line of predecessors, including Du Bois-Reymond, as listed in Du Bois-Reymond's review, "Electrophysiologie."

31. Weber, "Muskelbewegung," 87, 91. The amount by which a muscle would contract, Weber showed, depended only on its length, while the force the muscle could exert depended only on its cross section. He therefore chose force-per-unit cross section as the "absolute value" of *Muskelkraft*. Importantly, this choice indicates that like his physicist brother Wilhelm and unlike Helmholtz, he regarded the law of force—not work done and its conservation—as the most fundamental quantity to be measured. He observed, however, that if one wanted to specify a quantity related to the weight or volume of the muscle, it would be work done (*Nutzeffect* or *mechanische Effect*) per unit volume, or force-per-unit cross section multiplied by contraction-per-unit length, for which he also gave extensive calculations. His emphasis on force and its absolute measure, versus work, is consistent with Wilhelm Weber's absolute measurements on the fundamental law of electromagnetic force and with Gauss's attempt to establish an absolute unit of force.

32. Weber, "Muskelbewegung," 99.

33. I have substituted Helmholtz's "coefficient" for Weber's "modulus" of elasticity. Weber actually preferred *Ausdehnbarkeit* (extensibility) as more *anschaulich*. Weber, "Muskelbewegung," e.g., 110–11.

34. Weber, "Muskelbewegung," 104–17.

35. Helmholtz, "Probevortrag," 102.

36. Hermann Helmholtz, "Messungen über den Zeitlichen Verlauf," *WA*, 2:764. Concerning *Form* it may be important to compare Helmholtz's usage, for temporal processes, with the more usual sense of form from morphology, as used for example by his teacher Johannes Müller, referring to the spatial shape of organic structures. See Nyhart, *Biology Takes Form*, 45–47, 65–76. The relation is probably closer than first appears, with similar roots in idealism.

37. Helmholtz, " Messungen über den Zeitlichen Verlauf," *WA*, 2:764–65. A second deficiency of Weber's technique was that it could not take into account the possibility that a continuously contracted muscle, holding a weight at a constant height, was actually undergoing continual contractions and relaxations. Helmholtz himself, in his 1848 paper on "Development of Heat in Muscle Action," had asserted with reference to continuous excitation by a Neefian induction coil, that "The effect of such discontinuous currents is known to be [following Weber] a constant contraction . . . which does not relax until the muscle's irritability begins to expire." But Du Bois-Reymond's recent experiments suggested that the muscle was actually undergoing successive contractions and relaxation, which would depend on "a rapid exchange of opposite molecular states."

38. Helmholtz, "Messungen über den Zeitlichen Verlauf," *WA*, 2:766.

39. "Anstrengung der Kräfte" (Helmholtz, "Wärme," *WA*, 2:683), "Lebensenergien" associated with "Muskelanstrengung" (Helmholtz, "Ueber den Stoffverbrauch," *WA*, 2:743), and "Energie der Zusammenziehung" (Helmholtz, "Wärmeentwickelung," *WA*, 2:757).

40. Valentin, *Lehrbuch der Physiologie*, 1:168; see also 59–66, 155, 167–71. "Very many

difficulties underlie the evaluation of the absolute force [*Kraft*] of a muscle because the maximum of the *Energie* is almost never developed" (101).

41. E.g., Holmes and Olesko use "energy" for *Energie* both when it refers to work done and to tension in a muscle: Holmes and Olesko, "Images of Precision," 203–5; Olesko and Holmes, "Experiment," e.g., 85, 103. I have used the same shorthand in Wise, *Neo-Classical Aesthetics*, 42, and in Wise, "What's in a Line?," 98.

42. Helmholtz, "Messungen über den Zeitlichen Verlauf," *WA*, 2:786.

43. Helmholtz to Olga von Velten, July 18, 1848, in Kremer, *Letters*, 43, emphasis added. It is unclear whether Helmholtz knew of an earlier recording instrument for muscle contractions by Matteucci, "'Electo-physiological Researches.'"

44. Ludwig, *Lehrbuch*, 1:333; see 2:85 for his similar referral of the kymograph to Watt.

45. Helmholtz, "Zeitlichen Verlauf," *WA*, 2:767–71.

46. Ibid., *Gestalt* on 768, *Form* on 770. Helmholtz observed the curve through a microscope and copied it onto ruled coordinates. Heights on the vertical axis are magnified by 6 2/3, while the distance between ticks on the horizontal axis corresponds to 3–4 hundredths of a second. Helmholtz, "Messungen über den Zeitlichen Verlauf," *WA*, 2:768. This timescale for contractions corresponds very poorly with the much more precise time measurements of his electromagnetic instrument (fig. 8.9), which show a delay time for contraction of only one one hundredth of a second. This may help to explain why he would abandon the original instrument.

47. Helmholtz, "Messungen über den Zeitlichen Verlauf," *WA*, 2:767.

48. Ibid., 770.

49. I leave out of account in this equation, as Helmholtz did in his discussion, the *vis viva* produced by the contracting muscle, which conservation would require to be included.

50. Helmholtz to Du Bois-Reymond, October 14, 1849, in Kirsten, *Dokumente*, 87.

51. Helmholtz, "Messungen über den Zeitlichen Verlauf," *WA*, 2:815. See similar explicit "conflations" at 808, 814, 816, and implicitly throughout.

52. Ibid., 766.

53. The model, however, assumes that at a given time after stimulation, the tensed but uncontracted muscle just able to support $m + M$ has the same coefficient k as the contracted muscle at height h would have at that time. This was not quite correct, as Helmholtz was aware.

54. Helmholtz, "Messungen über den Zeitlichen Verlauf," *WA*, 2:771.

55. This technique repeats in a new form a measurement Weber made of *Muskelkraft* by finding the maximum weight that a stretched muscle could lift in contracting to its unstretched length, but Weber did not measure the time. Weber, "Muskelbewegung," 84.

56. Siemens, "Geschwindigkeitsmessung," and "Anwendung." Pioneering studies of the ballistics connection, but omitting Siemens, are those of Hoff and Geddes, e.g., "Ballistics" and "Technological Background." Pouillet's widely used *Lehrbuch* was in its 3rd German edition in 1847.

57. Helmholtz, "Messungen über den Zeitlichen Verlauf," *WA*, 2:778. See Schmidgen, *Die Helmholtz-Kurven*, 107–16, on Pouillet's place in the Berlin-Paris relation and Sie-

mens's and Du Bois-Reymond's reports, particularly Du Bois-Reymond, "Progrés des sciences," 82.

58. Pouillet, "Note." Siemens, "Geschwindigkeitsmessung," 50. Helmholtz, "Messungen über den Zeitlichen Verlauf," *WA*, 2:767, 778.

59. Helmholtz to Du Bois-Reymond, October 14, 1849, in Kirsten, *Dokumente*, 87. Helmholtz used the same expression to refer to the unknown temporal shape of curves of inducing and induced current in electromagnetism—"die Form des Ansteigens der Ströme"—which precluded his drawing conclusions about conservation of force.

60. Helmholtz, "Messungen über die Fortpflanzungsgeschwindigkeit," *WA*, 2:876; "Ueber die Methoden" (originally read to the Physikalisch-ökonomische Gesellschaft zu Königsberg, December 13, 1850), *WA*, 2:851. It was also Egbert Rekoss who would invent the rotating discs for Helmholtz's famous ophthalmoscope in 1852.

61. Helmholtz, "Messungen über den Zeitlichen Verlauf," *WA*, 2:775–776. The lower contacts at *o* were Helmholtz's simple solution to the frustrating problem of preventing the time-measuring current from starting over again when the muscle relaxed and allowed the contacts to close. They consist of a tiny thimble of mercury and an amalgamated point placed just above its equilibrium surface. Dipping the point initially in the mercury leaves the mercury clinging to the point, thereby keeping the circuit closed until broken by contraction of the muscle, but the circuit does not close again on relaxation because the mercury meanwhile falls to its equilibrium level.

62. Interestingly, in his first public announcement of the results, Helmholtz called this *Energie* of the excited muscle its *Spannkraft*, recalling the quantity of *Spannkraft* available to do work from his *Ueber die Erhaltung der Kraft* but perhaps also Weber's use of *Spannkraft* as the force exerted to stretch a muscle. Helmholtz, "Vorläufiger Bericht," 72.

63. Helmholtz, "Messungen über den Zeitlichen Verlauf," *WA*, 2:777–82. To begin the stimulating and time-measuring currents simultaneously, Helmholtz devised an elegant little seesaw switch (*Wippe*), which I omit here along with its associated induction coil and galvanometer. The galvanometer consisted of an electromagnetic coil that delivered a twisting impulse to a 9 cm long magnetic needle hanging on silk cocoon fibers with a period of oscillation of nearly half a minute. Once calibrated, using a technique that Helmholtz developed, and which overcame the sources of error in Pouillet's measurement, the deviation of the needle gave a direct measure of the duration of the current.

Using a well-known technique developed by Gauss and Wilhelm Weber, Helmholtz read the deviations from a distance by mounting a small mirror on the needle and using a telescope focused on the mirror to reflect a scale placed below the telescope. His use of the ballistic galvanometer gains depth from a detailed study he made in 1847 of W. Weber's electrodynamometer, including its time-measuring properties in comparison with a galvanometer and its possible use for muscle currents. He also considered its sensitivity, its bifilar suspension, and telescopic reading. Helmholtz to Du Bois-Reymond, April 10, 1847. Kirsten, *Dokumente*, 79–81.

On this and the significance of the telescope, see Schmidgen, *Die Helmholtz-Kurven*, 84–91. I am skeptical of Schmidgen's insistence that Helmholtz employed a "scopic" as opposed to graphic regime (p. 89) for his time measurements, since the purpose of the

ballistic galvanometer read by a telescope was not simply to measure time but to establish the time axis for a curve of tensions. Use of the telescope per se seems to have had no deeper significance for Helmholtz than for Eduard Weber.

64. Helmholtz, "Messungen über den Zeitlichen Verlauf," *WA*, 2:778, 784–87.

65. Helmholtz, " Messungen über den Zeitlichen Verlauf," *WA*, 2:791–93, repeated at 820. Olesko and Holmes, "Experiment," 102, mistakenly say that this curve is drawn for no overload ($M = 0$) rather than for a series of increasing overloads.

66. My focus on the curve of *Energie* as a function of time produced by the whole instrument contrasts with the stress Schmidgen places on the time measured by the ballistic galvanometer, which he takes to be an output of numbers rather than curves. He does not discuss the curve of Helmholtz's fig. 4. Schmidgen, *Die Helmholtz-Kurven*, 99.

67. Helmholtz to Du Bois-Reymond, January 15, 1850, in Kirsten, *Dokumente*, 90–92, on 90. He sometimes continued to use *Muskelkraft* instead of *Energie* in "Messungen über den Zeitlichen Verlauf," *WA*, vol. 2, e.g., pp. 800–801.

68. Helmholtz, "Messungen über den Zeitlichen Verlauf," *WA*, 2:794. This he knew from Weber.

69. Ibid., 794. Similar usages of *Gestalt* and *Form* appear at 768 and 770. The distinction, however, remains subtle. My attempt to tease it out runs into some ambiguity with respect to a seemingly interchangeable use of *Gestalt* and *Form* for the changing anatomical shape of a muscle. Ibid., 802, 803, 806.

70. Ibid., 793, his emphasis.

71. Calling it "höchst curios," Helmholtz initially estimated a much larger delay time of 0.015 sec. Helmholtz to Du Bois-Reymond, January 15, 1850. Kirsten, *Dokumente*, 90.

72. Helmholtz, "Messungen über den Zeitlichen Verlauf," *WA*, 2:794–806.

73. Ibid., 807–810, on 808.

74. Ibid., 788, 811.

75. Ibid., 765.

76. Helmholtz to Du Bois-Reymond (sending the report), January 15, 1850, and Du Bois-Reymond's response, March 19, 1850, in Kirsten, *Dokumente*, 90–93. Olesko and Holmes, *Experiment*, 87–95, describe the order of experiments and announcements and analyze the significance of the initial reception for Helmholtz's full paper. Similarly, see Schmidgen, *Die Helmholtz-Kurven*, 143–51. The reports are Helmholtz, "Vorläufiger Bericht" (read by Müller on January 21, 1850); "Ueber die Fortpflanzungsgeschwindigkeit des Nervenprincips," read by Du Bois-Reymond to the Physical Society, either January 18, 1850 (Kirsten, *Dokumente*, n1 to letter 14) or February 1, 1850 (Olesko and Holmes, "Experiment," n86); and (after revision by Du Bois-Reymond and Humboldt) "Note sur la vitesse."

77. Helmholtz, "Messungen über den Zeitlichen Verlauf," *WA*, 2:812. On *Zwischenzeit*, see Schmidgen, *Die Helmholtz-Kurven*, 27–29, 47, 93, 169–74, 180, who reads it as empty time, like *temps perdu* or *verlorene Zeit*, rather than simply a time interval, as here and at 783, 784, and 832. Cf., however, Helmholtz, "Ueber die Methoden," *WA*, 2:864 and 878, concerning both the limits of human perception of time differences and the time delays for sensory perception.

78. Helmholtz, "Messungen über den Zeitlichen Verlauf," *WA*, 2:814–17. Helmholtz here drew repeatedly on the relation of mechanical effect as lifting height (work) to just-liftable weight (tension).

79. Helmholtz, "Messungen über den Zeitlichen Verlauf," *WA*, 2:821–31. Olesko and Holmes, *Experiment*, 95–100.

80. Helmholtz, "Messungen über den Zeitlichen Verlauf," *WA*, 2:820, 842.

81. Ibid., 820; equivalent statements 812, 831–32.

82. Ibid., 831–37, *Zwischenzeit* on 832.

83. Ibid., 837.

84. Helmholtz, "Ueber die Methoden" (1850); and "Fortpflanzungsgeschwindigkeit . . . Zweite Reihe" (1852).

85. Holmes and Olesko, „Images of Precision," 207–9.

86. Helmholtz, "Ueber die Methoden," *WA*, 2:867.

87. Helmholtz, "Messungen über die Fortpflanzungsgeschwindigkeit," *WA*, 2:844–61.

88. Helmholtz, " Messungen über die Fortpflanzungsgeschwindigkeit," *WA*, 2:847–49; "Ueber die Methoden," *WA*, 2:866. While Siemens's cylinder revolved sixty times per second, Helmholtz's revolved about six times per second, or only six times the rate of the conical pendulum, so small variations in the pendulum's motion (ellipticity) significantly affected the uniformity of the cylinder's rotation. The problem did not affect Ludwig's kymograph, which revolved only about once per minute.

89. Helmholtz, " Messungen über die Fortpflanzungsgeschwindigkeit," *WA*, 2:856.

90. Ibid., 856–60.

91. Helmholtz to Du Bois-Reymond, July 9, 1852, in Staatsbibliothek Preussischer Kulturbesitz, Haus 2, Sammlung Darmstädter F1a 1847: H. v. Helmholtz. Letter and image reproduced in Kirsten, *Dokumente*, 133–34. This image should be compared with Helmholtz's description to Du Bois-Reymond, already on January 15, 1850, of his attempt to measure the time delay for a secondary contraction with his electromagnetic instrument. Kirsten, *Dokumente*, 90.

92. These curves are unusual in that they show a primary contraction in a muscle when stimulated directly and a so-called secondary contraction when stimulated by another contracting muscle through a combined nerve length of 73 mm. The only other original curves from this period are those that Schmidgen discovered in Paris. They were intended to illuminate Helmholtz's report (prepared by Du Bois-Reymond) of "Deuxième Note." Schmidgen, *Die Helmholtz-Kurven*, images on 218–19, 225–26, with discussion on 41–56, 183–97. Felsch, *Laborlandschaften*, 99, reproduces a set of similar curves, perhaps from Helmholtz, but not for measuring propagation time.

93. Helmholtz, "Messungen über die Fortpflanzungsgeschwindigkeit," *WA*, 2:858–60; "Ueber die Methoden," *WA*, 2:877.

94. Helmholtz, "Messungen über die Fortpflanzungsgeschwindigkeit," *WA*, 2:860.

95. I made this mistake in Wise, *Neo-classical Aesthetics*, 42. I believe that in Helmholtz's usage, an *Anschauung* must provide a true image and not merely a clear one.

96. Holmes and Olesko, "Images of Precision," 198–221.

97. Schmidgen, *Die Helmholtz-Kurven*, 193–95, argues that Helmholtz did not actually

intend the curves as measurements because he did not put numbers on the time axis or give an error analysis. I would say instead that he did not have the same need for such analysis because the congruence and displacement of the curves throughout their length displayed directly the reality of the propagation time and its approximate magnitude. By contrast, the highly variable numbers from the electromagnetic measurements had no validity at all without sophisticated analysis to extract a probable value with a probable error, and even then they depended on establishing congruence of the displaced curves of *Energie*.

EPILOGUE
Kunst-Technik

In the two preceding chapters I have shown how closely interrelated two of Hermann Helmholtz's early works were: his theory of *Erhaltung der Kraft* and his experiments on muscle contraction and nerve propagation. They were interrelated both conceptually, in his dualistic understanding of *Kraft*, and instrumentally, in the dynamometers and indicators from which his own instruments derived. In both cases the background of engineering and industry played a prominent role. Yet the two works also represent subtly different emphases on what technical accomplishment can provide in relation to concepts and aesthetics. In closing this book, I want to consider the aesthetics of his curves of *Energie* a bit further and then give a retrospective account of the context of *Art, Industry, and Science* in Berlin.

Just as his *Erhaltung der Kraft* represents his early epistemology most directly, so Helmholtz's muscle physiology provides an entrée into his aesthetics. The fact that he signed his instrument drawings in the lower-left corner, "Drawn [*Gezeichnet*] by H. Helmholtz" (fig. 9.1), with the lithographer in the lower-right corner, as was the standard practice of artists, suggests that

Helmholtz regarded his accomplishment in aesthetic terms. The drawings themselves indicate the considerable skill he had acquired in five years of drawing classes at the Potsdam *Gymnasium*. I have suggested in addition that there are deep parallels between his work on the frog drawing machine and his *Probevortrag* at the Academy of Art, organized around the classical aesthetics of the idealized human *Form*.[1]

Gez. v. H. Helmholtz.

Figure 9.1 Helmholtz's signature. " Messungen über die Fortpflanzungsgeschwindigkeit," *WA*, 2, plate 2.

Verständlichkeit

Recall once again the neoclassical aesthetics of the line, as developed in chapter 5. There I showed that the view of the Berlin Physical Society, that a natural expression of a law would be a curve, was a view widely distributed in their resource base of art, engineering, and science (Burg, Hummel, Dirichlet, Humboldt, Dove, Du Bois-Reymond). Helmholtz's pursuit of the curve of *Energie* as the law of muscle contraction may be taken as representative for the movement and surely one of its masterpieces. But the aesthetics of the curve went well beyond the expression of laws alone. Helmholtz shared with Du Bois-Reymond and Brücke, among many other

Berliners, the view that the role of the artist, far from copying natural objects, was to discover in them the underlying ideal that made them worthy of the term *beauty*. The study of anatomy, according to Helmholtz, could never by itself supply this refined sense of beauty (*Schönheitssinn*), but it could open the way to acquiring it through an understanding of the causes of the various shapes (*Gestalten*) expressed in the human body. Most importantly, technical anatomy could teach the artist to differentiate essential from inessential features of the human *Form*, so as to eliminate everything accidental in the interests of reaching the clarity and simplicity of the ideal. I have shown that this goal matches rather well Helmholtz's procedure for revealing technically the *Form* of the curve of *Energie* with his frog drawing machines. If the beauty of the curve was not his primary concern, establishing its *Form* was his stated goal. As in the case of human muscles in motion, the *Form* was dynamic. He aimed to reveal the *Form* of the curve as it developed in time. Having attained that goal, if somewhat abstractly, with his electromagnetic instrument, he found that he could also display directly the propagation in time of the nerve impulse with his graphical instrument by juxtaposing congruent curves that displayed the same *Gestalt*.

Helmholtz would continue to develop his aesthetic values as his physiological work carried him from muscles to hearing to music and from vision to visual art with an ever-increasing emphasis not only on the laws but on the mechanisms underlying the beautiful. In this pursuit he employed a new term, *Verständlichkeit*, which bears comparison with the role of *Begreiflichkeit* in his theory of *Erhaltung der Kraft*. Both terms translate as "comprehensibility" or "intelligibility." But while *Begreiflichkeit* refers especially to concepts (*Begriffe*), *Verständlichkeit* draws more directly on intuitions (*Anschauungen*). One of Helmholtz's much-discussed popular lectures, delivered several times and printed in 1876, "Optisches über Malerei," will serve to make the issue more concrete. He reiterated his idealist perspective from the *Probevortrag* almost verbatim, although now substituting the language of a perfected *Gestalt* for his former use of *Form*:

> The human figures in the work of art cannot be the everyday people, as we see them in photographs, but rather expressively and characteristically developed *Gestalten*, where possible beautiful *Gestalten*, which perhaps correspond to no *Individuum* who is living or has lived but rather such a one as could live and as must exist in order to bring any particular side of the human essence into our *lebendige Anschauung* in full and undistorted development.[2]

Now in much greater detail than for anatomy in the *Probevortrag*, Helmholtz developed the argument that in order to bring such "idealized types" into existence, the artist had to understand, at least intuitively, the constraints imposed by the "physiological-optical" characteristics of vision on any attempt to reproduce on a flat surface the naturalistic effects of light, color, shade, and three-dimensionality. Most obviously, binocular vision, motion, and turbidity of the air always threatened to betray the naive use of perspective drawing and true-color pigments on a flat surface. Understanding their effects, however, could allow the artist to produce naturalistic imitations using shadows, shading, and subtle changes of color and focus. Much more difficult were the problems of natural brightness and color contrast versus the brightness and color of pigments, all as perceived through the eye's sensitivity to light and its three-color receptors. This discussion depends on the comprehensive physiology of vision that Helmholtz developed in his *Handbuch der physiologischen Optik* of 1867, which attained great currency in the theory and practice of painting in the late nineteenth century.[3]

One of Helmholtz's aims, with respect to art, was to show that aestheticians needed to take into account the technical means required by artists to produce representations having the "lightest, finest, and most exact *sinnliche Verständlichkeit* [sensual intelligibility]." Optics and physiology had taught him that "sensual intelligibility [here *sinnliche Deutlichkeit*] is definitely no base or subordinate determinant in the effects of art works; their importance has ever more impressed me the more I have recognized the physiological determinants in these effects."[4] Studying what was required to attain such sensual *Verständlichkeit* made it apparent that the task always involved "a kind of optical deception," that a literal copy of nature was simply a chimera, for even if it could be produced it would be unintelligible, a monster.[5]

Helmholtz put his conclusion in a pointed form: "The artist cannot copy nature; he must translate it. Nevertheless, this translation can give us an impression, *anschaulich* in the highest degree and penetrating, not merely of the represented objects but even of the strengths of light, modified in the highest degree, under which we see them." The goal of such translations of nature into *anschauliche sinnliche Verständlichkeit* was not ultimate reality; nor was it an unmediated and uninterpreted image; it was rather "truth to nature" (*Naturwahrheit*). Truth to nature is here the truth of an "ideal type." A work of art that attains this truth has the capacity "to integrate in *lebensfrischer Anschauung* an *idealen Typus*, which lies there in scattered pieces, overgrown in our memory by the wild underbrush of chance." This explains the power of art over reality. While reality always mixes the "disturbing, frag-

menting, and injurious in its impressions," art "can collect all the elements for the intended impression and allow them to act unconstrained."[6]

The translations required to produce such truth to nature, however, like *Anschauungen* generally, do not derive from untutored intuition. Just as ideal drawings of the human figure required knowledge of anatomy, so the translations demand a variety of acquired skills, techniques, and sensitivities. Helmholtz collected these acquisitions under the *Technik* of the artist. And it was this *Technik* that his scientific exploration of painting clarified. I take the term *Technik* here to be intimately related to *Kunst-Technik* (chap. 2, 3, and 5). It extends beyond both technique and technology, though it includes both, carrying also the connotations of basic knowledge and aesthetic striving. "Thus the characteristics of the *kunstlerische Technik*, to which the physiological-optical investigation leads us, are in fact intimately interrelated with the highest tasks of art."[7]

The Grimms' nineteenth-century *Wörterbuch* gives *Technik* as "the artistic or craft activity and the sum of experiences, rules, principles, and know-how according to which, through practice, an art or craft is pursued," with citations for the fine arts from Goethe, Schiller, and others. Still today, a standard definition of *Technik* is "the art of attaining, with the most purposeful or most economical means, a definite end or the best achievement."[8] In this connection of art to right action, *Technik* maintains its origins in the Greek *technê* and Latin equivalent. And it is surely these origins that Helmholtz's usage reflects directly, informed by his *Gymnasium* education and his philologist father. Of the various authors he might have considered, Plato seems most directly relevant here.

Greek usage made no sharp distinction between *technê* as art or craft and *epistêmê* as knowledge. According to a detailed survey of their relations by Richard Parry, *technê* included all kinds of practical action, from medicine, farming, and political rule to geometry, music, and painting, but it was also knowledge, *epistêmê*, rather than only practice, because it could give an account of its activities and accomplishments in terms of the nature of the object sought. For Plato, in the *Republic*, this knowledge of the "real" nature of things was the knowledge of forms, especially the forms of the beautiful, the good, and the just. It was the knowledge required of philosophical rulers. Such knowledge of unchanging forms, as *epistêmê*, is often understood as purely intellectual, inaccessible to the changeable world of the senses and therefore to *technê*. But in *Republic* VI, Plato had Socrates giving a more interesting discussion, one that represents more closely the view of Helmholtz and his contemporaries in humanistic Berlin. Political rule was *technê*. The

philosophical ruler employed knowledge of the forms as a guide in his craft, attempting to imitate them in practice, like a painter imitating the forms of nature. In Parry's distillation, "Like painters, philosophers look to (*apobleptontes*) the truest paradigm, always referring to it and contemplating it as accurately as possible; in this way they establish here the laws respecting the fine, the just, and the good."[9] Extending Plato's analogy, the painter, like the philosopher, was able to realize the forms and laws through his *technê*, or in Helmholtz's German, his *Technik*.

Like Plato's Socrates, Helmholtz sought to introduce technical science into the aesthetic considerations of academic art, through *Technik*, as a necessity for the highest ideals of art. And in much the same way, he and his compatriots in the Berlin Physical Society sought to introduce technical experimental science as a necessary component into the philosophical research ideal of the university. In both cases the claims of the intellectual ideal (Plato's "real" forms) could only be attained through a deep engagement with the technological real, which provided the means for translating nature into terms compatible with the human sensory apparatus and thereby accessible to human understanding. This is the lesson that Du Bois-Reymond inscribed in the certificate of membership (fig. 5.27), with his searching figure in Plato's cave who lacks the instruments that the young experimenters would employ for translating shadows on the wall into legible figures.

Künstlerische Technik, in Helmholtz's exposition, had a well-defined purpose. It generated the truth to nature of the immediate sensory impression, which had to meet the following requirement: "It must act certainly, quickly, unambiguously, and with precise definition, if it is to make a lively and powerful impression. These are the points that I have sought to summarize under the name of *Verständlichkeit*." As it happens, these are much the same criteria that Helmholtz sought to fulfill for his curves of *Energie*. In projecting a future improvement of the graphical method, he expected it to lead "to a more satisfying and quicker representation of our results."[10] He could have elaborated "more certain, quick, unambiguous, and precise," for these are the qualities that the *Technik* of the frog drawing machine needed to fulfill if it were to enable the muscle to produce direct visual impressions both of its dynamical action and of the propagation time of the nerve impulse.

The nature of the muscle and nerve processes stood in relation to the curve of *Energie* much as the nature of the human subject stood in relation to the lines and surfaces of a finely executed painting. Both required a highly developed *Technik* in order to translate nature into a refined representation. Far from producing a true copy of nature, the goal of the translation was

rather to produce an ideal image of essential qualities of the natural object. The curve of *Energie* was just such a universal image. It was a curve of an abstract concept, *Energie*, which had to be made understandable through the *Technik* associated with the mechanical instruments that made its representation possible while eliminating extraneous effects. The electromagnetic instrument succeeded admirably in drawing the *Form* of the initial portion of the curve, if somewhat abstractly, appealing more to reason than to *Anschaulichkeit*, but it could not display the displacement of congruent curves produced by propagation time. The graphical instrument, on the other hand, drew curves flawed by friction, but it succeeded marvelously with the direct image of propagation time. Together, the two machines made possible the kind of idealized and translated representation that was capable of producing an "unmittelbar anschaulichen Verständlichkeit."[11] It would not be too much to say that Helmholtz saw himself in the role of an artist of natural science, a master of the *Technik* that enabled a *Naturwahrheit* to be revealed.

In Retrospect

Looking backward now over the course of this book, I have attempted to depict Helmholtz as a microhistorical representative of possibilities that were present in the artistic, industrial, and scientific life of Berlin. His accomplishments were unique, and yet their content was informed and shaped by the context of their creation. In seeking to recapture some of the key ingredients in that context, I want to draw on just two remarkable images: the tree of knowledge that Du Bois-Reymond crafted to represent the Physical Society on their certificate, and Schinkel's image of Beuth riding Pegasus over a factory town.

The Physical Society

In the foreground of his iconographic image (fig. 5.27), Du Bois-Reymond presented the members of the Society as penetrating the deceptions of nature by employing physical instruments to translate its processes into curves, curves that expressed its laws even when not in mathematical form. He accompanied that theme by a historical narrative in the background that set the development of neoclassicism in parallel with industrialization. The instruments and the curves derived from the union of those two great movements. That perspective has provided the basic theme of this book, with Helmholtz as its culmination. Consider first the narrative of industrialization leading on the right from sailing ships to steamships and the railroad.

In the Physical Society (as in Du Bois-Reymond's iconography) Helmholtz

was surrounded by many other young men attempting to shape technical careers within their own perception of existing possibilities. On looking over table 6.1, the diversity of the members of the Verein is perhaps most striking. They came from all branches of the "public": aristocracy, state administration, the military, master mechanics, and various middle-class occupations. Although the great majority held doctoral degrees, they represented a broad spectrum of the natural sciences (though with little natural history). Their commonality as members of the same *Verein* lay in their dedication to instruments, whether in the pursuit of experimental science for its own sake, for technical industry, or often both. I have attempted in chapter 6 to give a representative sampling of these pursuits. They include people such as Karsten, Du Bois-Reymond, and Brücke, whose combination of mechanical, physiological, and artistic interests looks much like Helmholtz's and with whom he was most closely connected. They include also people with quite different orientations, such as the medic and geologist Braun, collaborating with the physicist Beetz on *Galvanoplastik* as a technique for duplication of small sculptures.

More generally, but as this example suggests, it was interactions between members that yielded so much of the creative technical work. If Siemens's working in Struve and Soltmann's Anstalt für künstliche Mineralwasser, generating ideas about the telegraph, is one of the most curious cases, it is only one of many, including Siemens's equally significant interaction with Du Bois-Reymond and then Helmholtz on the measurement of very short time intervals. Here the shaping and informing role of "context" refers to the sociality that the Verein provided for its broadly diversified members. At their meetings they organized their reporting functions by analogy with the division of labor in a factory, which allowed for concentrated study in specialized areas, but that concentration also provided access to valuable resources for other members, as Helmholtz's example so clearly shows. Knowledge of industrial processes and advanced instruments circulated through the Society along with the latest theoretical and experimental literature. That Rohrbeck was there with his supply store for chemical and physical instruments is illustrative.

The literature on the Berlin Physical Society has always highlighted the role of Gustav Magnus as its godfather, the one who inspired their dedication to experimental science and its current advances. Largely missing has been the direct contact he provided to local industry as the source of technological development and instrumentation. The significance of this role is apparent in the membership, with twenty-six of its thirty-eight Berlin members in the

first two years pursuing their interests in technical-industrial developments. Magnus's luxurious house and laboratory in the heart of Berlin and his unmatched collection of instruments no doubt leant centripetal force to his promotion of experimental science. But I have wanted to bring out more fully the very active part he played in promoting science-based industry more generally. His leading role in the great industrial exhibition of 1844, especially the instruments section, gives material visibility to this very public mission. But beyond the exhibition itself, it calls up his long service on the administrative section of Beuth's Gewerbeverein, the entire purpose of which was to promote Prussian industrialization. Magnus was by no means alone in this activity among the mentors of Physical Society members, but his prominence serves to make the point about industrialization as a crucial background for the membership as depicted in Du Bois-Reymond's iconography of young heroes deploying instruments of curve production.

The second movement in Du Bois-Reymond's historical narrative was neoclassicism, leading from Egypt to the Greeks to the Enlightenment before emerging on the promontory of actively experimenting youth. This neoclassical teleology gave priority to the curve as the proper expression of nature's laws. I have developed that thesis at length in chapter 5, showing its immediate scientific precedent in empirical and mathematical works of Alexander von Humboldt, Dove, and Dirichlet before it found expression in the Physical Society. More broadly, I have located the emphasis on the smoothly drawn line as capturing ideal *Forms* in the aesthetic commitments of both the Akademie der Künste and the Gewerbeverein. The series of paintings and drawings on "The Invention of Painting" were as characteristic for the *Akademie* as were the *Exemplars for Manufacturers and Craftsmen* for the Gewerbeverein. Together they show how the neoclassical aesthetics of *Kunst* extended over *Kunst-Technik*. In sum, during the 1820s and 1830s scientific and artistic expressions of the priority of the line worked together to ground a remarkable flowering of curve production in both aesthetic and epistemological terms. A significant marker for that development was the nearly simultaneous celebration in 1828 of the heritage of Dürer and the return of Humboldt to Berlin. Du Bois-Reymond's iconography captures some of the possibilities that emerged from that moment.

Beuth on Pegasus

The second image I would select for its similarly synthesizing capacity is Schinkel's rather humorous painting of Beuth riding Pegasus over a factory town (fig. 3.9). The books in his study, visible through the clouds below him

and bearing *Kunst* and *Gewerbe* in their titles, tell of his passion: the unification of art with industry under neoclassical aesthetics. But Beuth's vision here was not limited to a small *Verein* of scientists like the Physical Society, although their own practices descended from his accomplishments. Rather, Beuth envisaged a modernizing Prussian state that incorporated newly invigorated institutions of technical education and industrial advancement. To that end he founded the Gewerbeinstitut and the Gewerbeverein, rebuilt the Technische Deputation, and played a key role in reforming the Bauschule. Although he had little to do with the military schools, their goals for technical education largely coalesced with his, particularly with respect to the "method of application," self-motivated action, and *Bildung*. Thus, I take his ride on Pegasus to symbolize the role of all of the technical schools so far as their forming a crucial background for understanding the interrelation of art and industry as it emerged in the Physical Society.

In this respect, Dirichlet's arrival in Berlin in 1828, with Humboldt, provides yet another marker, for his teaching extended over the Kriegsschule, Bauschule, and Gewerbeinstitut, in addition to the University. He brought a more widely distributed engagement with descriptive geometry as a mediating link between drawing as art and drawing as science to all of these technical schools, just as Burg had done earlier at the Artillerie- und Ingenieurschule (to the benefit of Siemens). Dirichlet's several appointments suggest also how the ministries of war, trade, and culture interacted in the development of the technical school network. His appointment was the business of the state (even if, as here, through Humboldt's high-level contacts).

A central thesis of this book has been that the technical school network, constituted by professors and teachers holding multiple appointments, illuminates the path through which technical-industrial and experimental science entered into university research in a major way. The example of Helmholtz's teachers is illustrative: Magnus, Dove, Turte, Mitscherlich, Müller, Link, and (in effect) Minding and Dirichlet. A long-standing precedent for the thorough interrelation of practical laboratory research with theoretical science already existed in chemistry. But the new technical schools helped to spread that model through all of the natural sciences. And most importantly they made hands-on training a primary desideratum for science education.

The close relation of Beuth's activities in promoting industrial progress to the emphasis on technical-scientific training may not in itself seem surprising even though the means of its institutionalization and dissemination are of considerable historical interest. More surprising is their intimate relation

to the world of art, which Schinkel's watercolor makes so explicit. Beuth's vision for the future springs from Pegasus, the inspiration for the muses. Implicit in this portrayal is the view that both the mechanical arts and the fine arts find their source of creativity in collections of previous works, more or less successful, and regarded (in Schinkel's formulation) as experiments rather than as classics to be imitated. This is the conception of a collection—a collection of experiments—that naturalizes the relation of a museum to a laboratory while it puts a premium on innovation. And it makes immediately understandable that Beuth collected antiquities just as avidly as he collected the most recent machines and machine drawings.

That is the perspective I have developed for the University, Bauschule, and Gewerbeinstitut, as well as the Altes Museum, in chapters 2 and 3 on "Pegasus and the Muses." By highlighting the fact that the educational function of all of these institutions was organized around museums, including the basic concepts of *Wissenschaft* and *Bildung*, I have attempted to establish some of the institutionalized intellectual structure that informed the origins of the Physical Society. Its founding members can be seen as a second generation who in the 1830s entered into the new and dynamic constellation of art, industry, and science in Berlin while reconstituting its possibilities for their own ambitions. One of the most apparent outcomes of that reconstitution was an increasing split between the science museums, where this younger generation acquired their initial passion for experiment, and the dedicated laboratories that they would themselves establish. While both flourished in the late nineteenth century, they flourished to a large degree separately. Nevertheless, both art and industry were intimately involved in the creative accomplishments of the Society.

I have presented this narrative as a cultural history of science, meaning one that looks to cultural context for the intellectual and material resources that made the Physical Society possible. To put some initial specificity under that conception, I began with Franz Krüger's painting of the citizenry attending a celebratory parade down Unter den Linden. His depiction in miniature portraits made them specific individuals who were known and recognizable on the public stage. And the individuals he chose made up the trend-setting public who looked toward a progressive liberal future for Prussia. Visible, too, in the architecture, statuary, and individual people is the conception of civil society as civic humanism, with its appeal to neoclassical virtues. Thus Krüger's painting puts a specific face on suppositions that underlay both Beuth's symbolic ride on Pegasus over a factory town, uniting art with in-

dustry, and Du Bois-Reymond's vision of a late Enlightenment *Verein*, deriving from those same sources and organized to uncover nature's laws as expressed through curve-drawing instruments.

NOTES TO EPILOGUE

1. There is an interesting question here of the relation of Helmholtz's curve drawing to the enticing term *mechanical objectivity* that Lorraine Daston and Peter Galison introduced to describe a goal, becoming prevalent around the mid-nineteenth century, of obtaining facts by "mechanical" means independent of human intervention and judgment and giving unretouched images of nature's objects. Daston and Galison, *Objectivity*, chap. 3, 115–90; "Image of Objectivity." It might appear that Helmholtz's methods represent this goal; indeed, many readers have understood "mechanical objectivity" to be epitomized by self-recording, curve-drawing instruments. No doubt that is partly because Daston and Galison opened their original article with the physiologist Jules Marey, who took Helmholtz's work as one of his models for mechanically generated curves, representing them as direct and unvarnished recordings of nature, which contrasts with the account I have given. More importantly, Daston and Galison's analysis deals almost exclusively with atlases of images in the tradition of natural history rather than with natural philosophy in the sense of experimental and theoretical physics.

Although the analysis seems convincing for the atlases, I am skeptical that "mechanical objectivity" can cover the curve-drawing emphasis within natural philosophy if only because mathematical idealization played such a prominent role. The transformation of the mechanics' indicator diagram for a working steam engine into the physicists' Carnot diagram for an idealized reversible heat engine is perhaps exemplary. It was also one of the models Helmholtz employed when writing his *Ueber die Erhaltung der Kraft*. For the classicizing and idealizing members of the Physical Society, "mechanical objectivity" seems to miss a key aspect of their project: their neoclassical aesthetics. I have argued that they were looking for essences of nature in their curves, for *Anschauung* of *Form*, as opposed to photographic recording of the confusing appearances of contingent events. In this they need to be situated within the culture of civic humanism that Helmholtz continued to represent.

2. Helmholtz, "Optisches über Malerei," 60.

3. For a much more extended perspective on the relation of Helmholtz's (and others') physiological work to late nineteenth-century aesthetics, see Brain, *Pulse of Modernism*.

4. Helmholtz, "Optisches über Malerei," 96.

5. Ibid., 58.

6. Helmholtz, "Optisches über Malerei," 95, 96. Helmholtz's idealized "truth to nature" corresponds with the meaning Daston and Galison ascribe to that term from the eighteenth century and that they contrast with "mechanical objectivity." See Daston and Galison, *Objectivity*, chap. 2; "Image of Objectivity," 84–98.

7. Helmholtz, "Optisches über Malerei," 70, quotation on 97. There is a close parallel here with Helmholtz's musical aesthetics in relation to his deep technical knowledge of piano construction. Hui, *Psychophysical Ear*, 70–74. Schatzberg, "*Technik* Comes to

America," gives an illuminating discussion of the changing meanings of the term *Technik* after midcentury in Germany, when it became strongly associated with aspects of industrialization and engineering and seems to have lost its broad reference to the arts, including fine arts. The new Verein deutscher Ingenieure (1856) identified its members as *Techniker*, and later analysts of the important role of *Technik* in society, such as Sombart and Veblen, largely referred the term to aspects of industrialization.

8. Helmholtz, "Optisches über Malerei," 97. I thank Lorraine Daston for a helpful discussion of *Technik*. Grimm and Grimm, *Deutsches Wörterbuch*; Wahrig, *Deutsches Wörterbuch*.

9. Parry, Richard, "*Epistêmê* and *Technê*," in *The Stanford Encyclopedia of Philosophy* (Summer 2003 ed.), ed. Edward N. Zalta, 1–19, on 6, http://plato.stanford.edu/archives/sum2003/entries/episteme-techne/. Parry's discussion also includes relevant reflections of Xenophon, Aristotle, the Stoics, Alexander of Aphrodisias, and Plotinus.

10. Cf. Helmholtz, "Optisches über Malerei," 97, with "Messungen über den Zeitlichen Verlauf," *WA*, 2:837.

11. Helmholtz, "Optisches über Malerei," 96.

ACKNOWLEDGMENTS

How do you thank a city? This book owes its existence to many years of exploring Berlin—its streets and buildings, rivers and canals, parks and gardens, museums and libraries—aiming slowly to recover the nineteenth-century context on which the book's analysis is built. But if it is difficult to thank the city it is impossible adequately to thank the person who has shared its exploration with me. Elaine Wise has been my willing partner in coming to know Berlin as a rich and complex landscape in which aesthetics, industry, and science all thrived together. And as perceptive interlocutor, reader, critic, and loving friend she has questioned interpretations, discovered sources, and corrected mistakes. Her imprint lies hidden all over the book, beginning with the great *Parade* painting which sets its stage.

The key connector between these two, the city and my fellow traveler, has been the Max Planck Institute for the History of Science (Max-Planck-Institut für Wissenschaftsgeschichte [MPIWG]), whose history has been coeval with the gestation of this book. The MPIWG provided a kind of second intellectual home in Berlin from its beginnings with Lorenz Krüger before his death and with Christa Krüger, whose knowledge of German literature and history continues to enrich my understanding. Ever since those early days, under the visionary directorships of Lorraine Daston, Jürgen Renn, Hans-Jörg Rheinberger, and now Dagmar Schäfer, the institute has been a constant source of intellectual and material support as well as friendship. In fact, leading with their own prominent methodological perspectives and writings, they have developed over the years an expansive network of researchers and visitors who have provided much of the reference base for the basic themes of my own research, centering on the mechanisms of interaction between things and ideas, technologies and concepts. Besides the directors I am indebted for their explorations of materiality to Michael Hagner, Myles Jackson, Wolfgang Lefevre, and in particular to Ursula Klein, whose writings on chemical laboratories and practices in Berlin at the turn of the nineteenth century have been invaluable. A site of intense discussion and many visits was the Independent Research Group of Otto Sibum and his collaborators, including Charlotte Bigg, David Aubin, Annik Pietsch (deceased), Simon Werrett, and Richard Staley. John Tresch has produced a model book that is very close to my own aims for what cultural history of science might be.

The significance of materiality in relation to aesthetics has been another topic of continuing attention in all the departments of the institute. In particular, I had the good fortune to participate, collaborating with Elaine Wise, in the project on *Things That Talk*, led by Lorraine Daston. From Raine and all of the participants, who included Peter Galison, Caroline Jones, Joseph Koerner, Antoine Picon, Simon Schaffer, Joel Snyder, and Anke te Heesen, I gained insight and pleasure. In continuation, Anke and Mechtild Fend taught me about prototypes and designs as well as something of neoclassicism. In short, I have had the luxury of being surrounded by creative people who made experiencing the city a great joy.

My own attempt to grasp the cultural dynamics of the Berlin Physical Society in a

period of rapid industrialization had its inception in a joint project with Robert Brain on "Muscles and Engines" (1994). Although that project was not completed, I remain indebted to him for his always perceptive insights. The context of industrialization has also drawn the attention at the institute of Sven Dierig working on Emil du Bois-Reymond and Henning Schmidgen on Hermann Helmholtz. Their deeply researched studies have informed my own interpretation in critical ways. And their great efforts in establishing the Virtual Laboratory as a repository of sources and literature has simplified my life. Similarly stimulating in the cultural realm has been the biography of Du Bois-Reymond by Gabriel Finkelstein, with whom I first had discussions of *Vormärz* Berlin while he was completing his dissertation at Princeton.

Among the Helmholtz scholars whose careful work I have found particularly valuable are David Cahan, Fabio Bevilacqua, Kathryn Olesko, and Larry Holmes (deceased). And for years of fruitful discussion on the cultural as well as technical history of science in Berlin, I am indebted to Timothy Lenoir. His many writings on the subject have long been a source for reflection.

Having a second home in Berlin and the MPIWG as an incomparable research base, I have also had the luxury of academic homes at Princeton and at UCLA, surrounded by extraordinary colleagues. To Carl Schorske (now deceased), my original mentor in German history at Princeton, I am forever grateful for taking in a physicist and teaching him something of how the cultural and intellectual life of a city might be approached. He remained a friend and inspiration at Princeton during the 1990s, when this project was getting started. Sue Marchand then became my local source for German neoclassicism. In history of science, then and now, programmatically and personally, I have had the generous support of Angela Creager. Gerry Geison and Michael Mahoney (both now deceased) also energized our program seminar, where so many probing discussions took place. Typically those discussions were instigated by graduate students, whose critiques and contributions to my own work were enormously valuable, even before they moved on to their own positions. Suman Seth and David Aubin remain close friends and methodologists. Others to whom I am deeply grateful for those discussions so long ago are David Brock, Ann Johnson (deceased), Leo Slater, David Attis, George Sweetnam (deceased), Manfred Laubichler, Theo Arabatsis, Andrew Mendelsohn, and John Carson.

At UCLA another rewarding environment has continuously sustained me. It would be difficult to imagine a more supportive group of close colleagues, critics, and friends than Mary Terrall, Ted Porter, and Soraya de Chadarevian, who only occasionally have asked "Is the book finished yet?" while lending their wisdom to my presentations. Bob Frank, Joel Braslow, and Peg Jacob complete the atmosphere. Tiago Saraiva has been a frequent visitor and major ally, helping me to see potentials in my own analysis that I had not recognized. And once more, engaged graduate students have been a constant source of productive critique and insight. Alix Hui's book on music and experiment in the psychophysics of Helmholtz and others has directly fed my own knowledge and interests. Lino Camprubi has read, discussed, and even translated my papers. Marissa Petrou, Adam Lawrence, Rob Schraff, Hippolyte Goux, Robin Wasserman, and Sameer Shah have helped me to engage with "materialized epistemology" and with visualization in science.

With respect to those same topics, I have benefited greatly from the sociological and anthropological perspectives of Hannah Landecker and Chris Kelty, who now animate the Institute for Society and Genetics, which I helped to found.

As for every other historian, it is ultimately libraries, archives, and museums that have provided the content of my work. For many of my resources I have been able to rely on the immense collections of the University of California system. For materials specific to Berlin, however, it has again been the MPIWG and its marvelous library staff that has provided unfettered access to the many libraries in the city and throughout Germany, and I am indebted to its original director Urs Schöpflin and now to Esther Chen for their welcoming and always ready assistance. I want to thank specifically Ellen Garske, Ruth Kessentini, and Matthias Schwerdt, who have cheerfully located references no matter how obscure and delivered them to my shelf or e-mail. Urte Brauckmann has with incomparable efficiency arranged the permissions for my images, acquired from museums and archives all over Berlin and elsewhere. Outside the institute, archivists at the Staatsbibliothek (both sites), the Geheimes Staatsarchiv, and the Kupferstichkabinett have been immensely helpful in penetrating their sometimes inscrutable collections with finding aids.

As this book comes to completion, I am immediately conscious of how important the University of Chicago Press has been. Karen Darling has handled the reviewing and revising process with skill and understanding. Evan White similarly dealt with the critical details of getting the components of the manuscript into final form. And Steve LaRue, with formidable attention to copyediting, has managed to clean up many of my infelicities and to impose Chicago style on the text.

Finally, a long list of organizations has supplied the time and funding for years of research, thinking, and writing. They include in Berlin, in addition to generous support from the MPIWG, the Wissenschaftskolleg and the American Academy. Visiting positions have been energizing and productive at the Edelstein Center of the Hebrew University in Jerusalem (with Mara Beller [deceased] and Timothy Lenoir), in Paris at La Villette (with Dominique Pestre) and the École des mines (with Michel Callon and Bruno Latour), at Utrecht University (with Bert Theunisson, Frans van Lunteren, and Wijnand Mijnhardt), at Bielefeld University (with Martin Carrier), and at Stanford University (with Michael Friedman and Paula Findlen). Sabbaticals at Princeton and UCLA have provided free time, while research support and release time associated with the Institute for Society and Genetics at UCLA has helped make multiple commitments manageable.

BIBLIOGRAPHY

ABBREVIATIONS

ADB	*Allgemeine Deutsche Biographie*
AdP	*Annalen der Physik und Chemie*
FdP [1845]	*Fortschritte der Physik im Jahre 1845*
GStA PK	Geheimes Staatsarchiv Preussischer Kulturbesitz, Berlin
HSPBS	*Historical Studies in the Physical and Biological Sciences*
Müllers Archiv	*Müllers Archiv für Anatomie, Physiologie, und wissenschaftliche Medizin*
SMB	Staatliche Museen zu Berlin
SPSG	Stiftung Preussische Schlösser und Gärten Berlin-Brandenburg
VdPG	*Verhandlungen der Physikalischen Gesellschaft zu Berlin*
VdVBG	*Verhandlungen des Vereins zur Beförderung des Gewerbefleißes*
VuR	Hermann Helmholtz, *Vorträge und Reden*, 5th ed., 2 vols. (Brunswick: Vieweg, 1903)
WA	Hermann Helmholtz, *Wissenschaftliche Abhandlungen*, 3 vols. (Leipzig: Barth, 1883)

WORKS CITED

Accum, Friedrich. *Physische und chemische Beschaffenheit der Baumaterialien, deren Wahl, Verhalten und zweckmässige Anwendung: Ein Handbuch für den öffentlichen Unterricht in der Königlichen Bau-Akademie zu Berlin; Zum Selbststudium für Baumeister, Technologen, Kameralisten und Oekonomen.* 2 vols. Berlin: Reimer, 1820.

Adler, Jeremy. *"Eine fast magische Anziehungskraft": Goethes "Wahlverwandtschaften" und die Chemie seiner Zeit.* Munich: Beck, 1987.

Alder, Ken. *Engineering the Revolution: Arms and Enlightenment in France, 1763–1815.* Princeton, NJ: Princeton University Press, 1997.

Altcappenberg, Hein-Th. Schulze. "'Letzte Lebensphilosophie': Die Allegorien auf Peter Beuth." In Altcappenberg and Johannsen, *Schinkel*, 199–210.

Altcappenberg, Hein-Th. Schulze, Rolf H. Johannsen, and Christiane Lange, eds. *Karl Friedrich Schinkel: Geschichte und Poesie.* Munich: Hirmer Verlag, 2012. Exhibition catalog.

Altcappenberg, Hein-Th. Schulze, and Rolf H. Johannsen, eds. *Karl Friedrich Schinkel: Geschichte und Poesie; Das Studienbuch.* Berlin: Deutscher Kunstverlag, 2012.

Amtlicher Bericht über die allgemeine Deutsche Gewerbe-Austellung zu Berlin im Jahre 1844. Berlin: Karl Reimarus, 1845–46.

Ashwin, Clive. "Pestalozzi and the Origins of Pedagogical Drawing." *British Journal of Educational Studies* 29 (1981): 138–51.

Babbage, Charles. *On the Economy of Machinery and Manufactures.* 4th ed. 1835. In *The Works of Charles Babbage*, edited by Martin Campbell-Kelley, vol. 8. New York: New York University Press, 1989. Page references are to the 1989 edition.

Banken, Rolf. "Die Diffusion der Dampfmaschine in Preussen um 1830." *Jahrbuch für Wissenschaftsgeschichte* 2 (1993): 219–48.

Bartoschek, Gerd, ed. *Der Maler Franz Krüger, 1797–1857: preussisch korrekt—berlinisch gewitz.* Munich: Deutsche Kunstverlag, 2007.

Beck, Hanno. *Alexander von Humboldt.* 2 vols. Wiesbaden: Steiner, 1959.

———, ed. *Alexander von Humboldt: Studienausgabe.* 7 vols. Darmstadt: Wissenschaftliche Buchgesellschaft, 1989–97.

Beck, Hermann. "The Changing Concerns of Prussian Conservatism, 1830–1914." In Dwyer, *Modern Prussian History*, 86–105.

Becker, Christine, "Zur Geschichte des Magnus-Hauses." In Hoffmann, *Magnus und sein Haus*, 99–121.

Becker, Christine, and Brigitte Jacob, eds. *Das Magnus Haus in Berlin-Mitte: Geschichte, Wandel und Wiederherstellung eines barocken Palais.* Berlin: Bruckmann, 1994.

Becker, Josef. *Von der Bauakademie zur technischen Universität: 150 Jahre technisches Unterrichtswesen in Berlin.* Berlin-Charlottenburg: Technische Universität, 1949.

Beetz, Wilhelm. "Elektrische Phänomene." *FdP [1845]* 1 (1847): 463–64.

Belhoste, Bruno. "Représentation de l'espace et géométre de Dürer à Monge." In *La science à l'époque moderne*, Association des historiens modernistes des universités (France), 7–27. Paris: Presses de l'Université de Paris-Sorbonne, 1998.

Belhoste, Bruno, Amy Dahan Dalmedico, and Antoine Picon, eds. *La formation polytechnique, 1794–1994.* Paris: Dunod, 1994.

Belhoste, Bruno, and Antoine Picon, *L'École d'Application de l'Artillerie et du Génie de Metz (1802–1870), enseignements et recherches.* Paris: Musée des plan-reliefs, 1996.

———. "Les caractères généraux de l'enseignement à l'École d'Application de l'Artillerie et du Génie de Metz." In Belhoste and Picon, *L'École d'Application*, 18–31.

———. *La formation d'une technocratie: L'École polytechnique et ses élèves de la Révolution au Second Empire.* Paris: Belin, 2003.

Bergdoll, Barry, with photographs by Erich Lessing. *Karl Friedrich Schinkel: An Architecture for Prussia.* New York: Rizzoli, 1994.

Berthollet, Claude Louis. *Essai de statique chimique.* Paris, 1803. German translation by G. W. Bartoldy, commentary by E. G. Fischer, Berlin, 1811.

———. *Recherches sur les lois de l'affinité.* Paris, 1801. German translation and commentary by E. G. Fischer, Berlin, 1802.

Bessel, Friedrich Wilhelm. "Einleitung." *Astronomische Beobachtungen auf der Königlichen Universitäts-Sternwarte zu Königsberg* 1 (1815): i–xxxvi.

———. "Ueber das preussische Längenmaass und die zu seiner Verbreitung durch Copien ergriffenen Maassregeln." *Astronomische Nachrichten* 17 (1840): 193–204.

Beuth, Christian Peter Wilhelm. "Bericht des Geheimen Ober Finanz Raths Beuth, an den Herrn Minister für Handel und Gewerbe, über die auf dessen Befehl zur Ausbildung der Gewerbetreibenden getroffenen Einrichtungen." *VdVBG* (1822): 133.

———."Glasgow." *VdVBG* (1824): 156–206.

———. "Rede bei Eröffnung der Versammlung, von dem jetzt Vorsitzenden im Saale der Stadtverordneten gehalten." *VdVBG* (1822): 15–17.

———. "Schinkels Grabdenkmal." *VdVBG* (1843): 196–200, and (1837): plate.

[Beuth, P. C. W., and K. F. Schinkel, eds.] Technischen Deputation fur Gewerbe, *Vorbilder für Fabrikanten und Handwerker.* 3 vols. Berlin: G. Hayn, 1821 [text vol.]; Berlin: Prêtre, 1821, 1836 [plate vols.].

Bevilacqua, Fabio. "Helmholtz's *Ueber die Erhaltung der Kraft*: The Emergence of a Theoretical Physicist." In Cahan, *Helmholtz*, 291–333.

———. "Theoretical and Mathematical Interpretations of Energy Conservation: The Helmholtz-Clausius Debate on Central Forces 1852–54." In Krüger, *Universalgenie Helmholtz*, 89–106.

Bezold, Wilhelm von. "Festrede." In "Feier des 50 jährigen Stiftungsfestes der Physikalischen Gesellschaft zu Berlin." Special issue, *VdPG* 15 (1896): 1–40.

———. "Zur Vollendung des 50. Jahrganges der 'Fortschritte.'" *FdP* 50 (1896): i–xi.

Bialostocki, Jan. *Dürer and His Critics, 1500–1971: Chapters in the History of Ideas, Including a Collection of Texts.* Baden-Baden: Koerner, 1986.

Biermann, Kurt-Reinhard, ed. *Alexander von Humboldt: Vier Jahrzehnte Wissenschaftsförderung; Briefe an das preussische Kultusministerium, 1818–1859.* Berlin: Akademie-Verlag, 1985.

———. *Briefwechsel zwischen Alexander von Humboldt und Peter Gustav Lejeune Dirichlet.* Berlin: Akademie Verlag, 1982.

———. *Johann Peter Gustav Lejeune Dirichlet: Dokumente für sein Leben und Wirken.* Berlin: Akademie-Verlag, 1959.

Blomberg, Hugo von. *Karl Friedr. Schinkels Wandgemälde in der Treppenhalle des Königlichen Museums zu Berlin.* Berlin: Photographisches Institut von Laura Bette, 1863.

Bollé, Michael. "Bemerkungen zur Architektenausbildung in Berlin um 1800: Auf der Suche nach Struktur und Methoden." In Altcappenberg and Johannsen, *Schinkel*, 31–39.

Bonin, Udo von. *Geschichte des Ingenieurkorps und der Pioniere in Preußen.* 2 vols. Berlin: Mittler und Sohn, 1877–78.

Börsch-Supan, Helmut. "Adolph Menzel und der Berliner Kunst." In *Adolph Menzel, 1815–1905: Das Labyrinth der Wirklichkeit*, edited by Claude Keisch and M. U. Riemann-Reyher, 381–92. Berlin: Nationalgalerie und Kupferstichkabinett, Staatliche Museen Preussischer Kulturbesitz, 1997.

———, ed. *Die Kataloge der Berliner Akademie-Ausstellungen 1786–1850.* 2 vols. and *Registerband.* Berlin: Bruno Hessling, 1971.

———. "Karl Friedrich Schinkel: Persönlichkeit und Werk." In Börsch-Supan and Grisebach, *Schinkel*, 10–45.

Börsch-Supan, Helmut, and Lucius Grisebach, eds. *Karl Friedrich Schinkel: Architektur, Malerei, Kunstgewerbe* (Berlin: Verwaltung der Staatlichen Schlösser und Gärten und Nationalgalerie, 1981).

Borsig, August. "Beschreibung der . . . Lokomotive 'Beuth.'" *VdVBG* 23 (1844): 75–82, plates v–ix.

Bourget, Marie-Noëlle. "La république des instruments: Voyage, mesure et science de la

nature chez Alexandre de Humboldt." In *Marianne Germania: Deutsch-Französischer Kulturtransfer im europäischen Kontext 1789–1914*, edited by Etienne Francois et. al., 405–36. Leipzig: Leipzig Universität Verlag, 1998.

Brain, Robert Michael. *The Pulse of Modernism: Physiological Aesthetics in Fin-de-Siècle Europe.* Seattle: University of Washington Press, 2015.

Brain, Robert Michael, and M. Norton Wise. "Muscles and Engines: Indicator Diagrams in Helmholtz's Physiology." In Krüger, *Universalgenie Helmholtz*, 124–148. Reprinted in Mario Biagioli, ed., *The Science Studies Reader* (New York: Routledge, 1999), 51–66.

Brandt-Salloum, Christiane, ed. *Klosterstrasse 36: Sammeln, Ausstellen, Patentieren; Zu den Anfängen Preussens als Industriestaat.* Berlin: Geheimes Staatsarchiv Preussischer Kulturbesitz, 2014.

Brauns, David August. "Anhang zur Elektrochemie: Galvanoplastik." *FdP [1845]* 1 (1847): 482–98.

———. *Die technische Geologie; oder, Die Geologie in Anwendung auf Technik, Gewerbe und Landbau.* Halle: Schwetschke, 1878.

———. *Praktisches Taschenbuch für Ingenieure und Techniker.* 2nd ed. Brunswick: Schulbuchhandlung, 1865.

Bredekamp, Horst, and Jochen Brüning. "Vom Berliner Schloss zur Humboldt-Universität—und zurück?" In Bredekamp, Brüning, and Weber, *Theater der Natur und Kunst: Dokumentation*, 138–42.

Bredekamp, Horst, Jochen Brüning, and Cornelia Weber, eds. *Theater der Natur und Kunst: Wunderkammern des Wissens.* 3 vols.: *Katalog, Essays,* and *Dokumentation der Aussstellung.* Berlin: Henschel, 2000.

Bredekamp, Horst, and Adam S. Labuda. "Kunstgeschichte, Universität, Museum und die Mitte Berlins 1810–1873." In Bruch and Tenorth, *Geschichte der Universität*, 4:237–63.

Brewster, David. "Schreiben on A. v. Humboldt über isochromatische Curven." *FdP[1845]* 1 (1847): 187.

Brix, Adolf F. W. *Elementar-Lehrbuch der dynamischen Wissenschaften, mit besonderer Rücksicht auf technische Anwendung.* Vol. 3, *Elementar-Lehrbuch der Mechanik fester Körper, mit besonderer Rücksicht auf technische Anwendung: Zum Gebrauch beim Unterricht im Königl. Gewerb-Institut, und demnächst zum Selbststudium für Baumeister, Ingenieure und andere Techniker.* Berlin: Duncker und Humblot, 1831.

———. "Ueber die Reibung." *VdVBG* 16 (1837): 129–52, 182–223, 230–78, 306–43; 17 (1838): 74–89.

Broman, Thomas H. "Bildung und praktische Erfahrung: konkurrierende Darstellungen des medizinischen Berufes und der Ausbildung an der frühen Berliner Universität." *Jahrbuch für Universitätsgeschichte* 3 (2000): 19–35.

———. "Rethinking Professionalization: Theory, Practice, and Professional Ideology in 18th-Century German Medicine." *Journal of Modern History* 67 (1995): 835–72.

Brose, Eric Dorn. *German History, 1789–1871: From the Holy Roman Empire to the Bismarckian Reich.* New York: Berghahn, 2013.

———. *The Politics of Technological Change in Prussia: Out of the Shadow of Antiquity, 1809–1848.* Princeton, NJ: Princeton University Press, 1993.

Bruch, Rudiger vom, and Heinz-Elmar Tenorth. *Geschichte der Universität Unter den Linden, 1810–2010.* 6 vols. Berlin: Akademie Verlag, 2010–12.

Brücke, Ernst. "Anatomische Untersuchungen über die sogenannten leuchtenden Augen bei den Wirbelthieren." *Müllers Archiv* (1845): 387–406.

———. *Ernst Brücke.* Vienna: Springer, 1928.

———. "Physiologische Optik." *FdP [1845]* 1 (1847): 199–225.

———, *Schönheit und Fehler der menschlichen Gestalt.* Vienna: Braumüller, 1892.

———. "Über die stereoskopischen Erscheinungen und Wheatstones Angriff auf die Lehre von den identischen Stellen der Netzhäute." *Müllers Archiv* (1841): 459–76.

———. "Ueber das Verhalten der optischen Medien des Auges gegen Licht- und Wärmestrahlen." *Müllers Archiv* (1845): 262–76.

Büchel, Christiane. "Der Offizier im Gesellschaftsbild der Frühaufklärung: Die Soldatenschriften des Johann Michael von Loden." *Aufklärung* 11 (1999): 5–23

Burg, Meno. *Die geometrische Zeichnenkunst; oder, Vollständige Anweisung zum Linearzeichnen, zur Construction der Schatten und zum Tuschen für Künstler und Technologen, und zum Selbstunterricht; zunächst zum Gebrauche beim Unterricht in den Königlichen Artillerie-Schulen.* 2nd ed. Berlin: Duncker und Humblot, 1845.

———. *Geschichte meines Dienstlebens.* 3rd ed. Leipzig: Kaufmann, 1916.

Busch, Werner. *Die notwendige Arabeske: Wirklichkeitsaneignung und Stilisierung in der deutschen Kunst des 19. Jahrhunderts.* Berlin: Mann, 1985.

Busch, Werner, and Wolfgang Beyrodt, eds. *Kunsttheorie und Malerei: Kunstwissenschaft.* Vol. 1 of *Kunsttheorie und Kunstgeschichte des 19. Jahrhunderts in Deutschland: Texte und Dokumente.* Stuttgart: Reclam, 1982.

Buttlar, Adrian von. "Freiheit im Werden: Schinkels *Blick in Griechenlands Blüte* als Allegorie der Kultur." In Altcappenberg and Johannsen, *Schinkel,* 117–29.

Cahan, David, ed. *Hermann von Helmholtz and the Foundations of Nineteenth-Century Science.* Berkeley: University of California Press, 1993.

———, ed. *Letters of Hermann von Helmholtz to His Parents: The Medical Education of a German Scientist, 1837–1846.* Stuttgart: F. Steiner Verlag, 1993.

Carnot, Sadi. *Reflexions on the Motive Power of Fire: A Critical Edition with the Surviving Manuscripts.* Translated and edited by Robert Fox. Manchester: Manchester University Press, 1986.

Catalogue général des collections du conservatoire royal des arts et métiers. Introduction by Gérard-Joseph Christian, director. Paris: Huzard, 1818.

Chaouli, Michel. *The Laboratory of Poetry: Chemistry and Poetics in the Work of Friedrich Schlegel.* Baltimore: Johns Hopkins University Press, 2002.

Christian, Gérard-Joseph. *Traité de mécanique industrielle; ou, Exposé de la science de la mécanique déduite de l'expérience et de l'obervation: principalement à l'usage de manufacturiers et des artistes.* 3 vols. Paris: Bachelier, 1822–25

Clapeyron, Benoit Paul Émile. "Mémoire sur la puissance motrice de la chaleur." *Journal de l'École polytechnique* 14 (1834), 153–90. Republished as "Ueber die bewegende Kraft der Wärme." *AdP* 59 (1843): 446–51, 566–86, and plates.

———. "Memoire sur le réglement des tiroirs dans les machines à vapeur." *Comptes Rendus de l'Académie des Sciences* 14 (1842): 632–33.

Clark, Christopher. *Iron Kingdom: The Rise and Downfall of Prussia, 1600–1947.* London: Penguin, 2006.

Clausewitz, Carl. *Ueber das Leben und den Charakter von Scharnhorst.* Hamburg: Perthes, 1832. Reprinted in Werner Hahlweg, *Clausewitz: Verstreute kleine Schriften* Osnabrück: Biblio-Verlag, 1979.

———. "Ueber den Charakter des kleinen Krieges." In *Carl von Clausewitz: Schriften, Aufsätze, Studien, Briefe,* edited by Werner Hahlweg, vol. 1, 237–39. Göttingen: Vandenhoeck und Ruprecht, 1966.

Cole, R. J. "Friedrich Accum (1769–1838): A Biographical Study." *Annals of Science* 7 (1951): 128–43.

Conrady, Emil von. *Leben und Wirken des Generals der Infanterie und kommandirenden Generals des V. Armeekorps Carl von Grolman.* 3 vols. Berlin: Mittler, 1894–96.

Coriolis, Gaspard. *Du calcul de l'effet des machines; ou, Considérations sur l'emploi des moteurs et sur leur évaluation, pour servir d'introduction à l'étude spéciale des machines.* Paris: Carilian-Goeury, 1829.

Craig, Gordon. *The Politics of the Prussian Army: 1640–1945.* Oxford: Clarendon Press, 1955.

Culotta, Charles A. "Respiration and the Lavoisier Tradition: Theory and Modification, 1770–1850." *Transactions of the American Philosophical Society* 62 (1972): 3–40.

Daiber, Jürgen. *Experimentalphysik des Geistes: Novalis und das romantische Experiment.* Göttingen: Vandenhoeck und Ruprecht, 2001.

Damaschun, Ferdinand, Gottfried Böhme, and Hannelohre Landsberg. "Naturkundliche Museen der Berliner Universität—Museum für Naturkunde: 190 Jahre Sammeln und Forschen." In Bredekamp, Brüning, and Weber, *Theater der Natur und Kunst: Essays,* 86–94.

Darrigol, Olivier. "God, Waterwheels, and Molecules: Saint-Venant's Anticipation of Energy Conservation." *HSPBS* 31 (2001): 285–353.

———. "Helmholtz's Electrodynamics and the Comprehensibility of Nature." In Krüger, *Universalgenie Helmholtz,* 216–42.

Daston, Lorraine, and Peter Galison, "The Image of Objectivity." *Representations* 40 (1992): 81–128.

———. *Objectivity.* New York: Zone Books, 2007.

De Chadarevian, Soraya. "Die 'Methode der Kurven' in der Physiologie zwischen 1850 und 1900." In Hagner and Rheinberger, *Experimentalisierung des Lebens,* 28–49. Revised as "Graphical Method and Discipline: Self-Recording Instruments in 19th-Century Physiology." *Studies in History and Philosophy of Science* 24 (1993): 267–91.

Delbrück, Hans. *Geschichte der Kriegskunst im Rahmen der politischen Geschichte.* 4 vols. Berlin: G. Stilke, 1920–36. Reprint, Berlin: de Gruyter, 1962.

De Risi, Vincenzo. *Geometry and Monadology: Leibniz's Analysis Situs and Philosophy of Space.* Basel: Birkhäuser, 2007.

Dettelbach, Michael. "The Face of Nature: Precise Measurement, Mapping, and

Sensibility in the Work of Alexander von Humboldt." *Studies in History and Philosophy of Biological and Biomedical Sciences* 30 (1999): 473–504.

Dierig, Sven. "Apollo's Tragedy: Laboratory Science between Classicism and Industrial Modernism." In Epple and Zittel, *Cultures and Politics*, 122–44.

———. "Die Kunst des Versuchens." In *Kultur im Experiment*, edited by Henning Schmidgen, Peter Geimer, and Sven Dierig, 123–46. Berlin: Kadmos, 2004.

———. *Wissenschaft in der Maschinenstadt: Emil Du Bois-Reymond und seine Laboratorien in Berlin*. Göttingen: Wallstein, 2006.

Dierig, Sven, and Thomas Schnalke. *Apoll im Labor: Bildung, Experiment, Mechanische Schönheit*. Berlin: Berliner Medizinhistorisches Museum der Charité, Universitätsmedizin Berlin, 2005.

Dirichlet, Gustav Lejeune. "Sur la convergence des séries trigonométriques qui servent à représenter une fonction arbitraire entre des limites données." *Journal für die reine und angewandte Mathematik* 4 (1829): 157–69. Reprinted in *G. Lejeune Dirichlets Werke*, edited by L. Kronecker, vol. 1, 118–32. Berlin: Reimer, 1889.

———. "Ueber die Darstellung ganz willkührlicher Funktionen durch Sinus- und Cosinusreihen." *Repertorium der Physik* 1 (1837): 152–74.

DiSalle, Robert. "Helmholtz's Empiricist Philosophy of Mathematics: Between Laws of Perception and Laws of Nature." In Cahan, *Helmholtz*, 498–521.

Dobbert, Eduard, and Alfred G. Meyer. *Chronik der königlichen technischen Hochschule zu Berlin: 1799–1899*. Berlin: Wilhelm Ernst und Sohn, 1899.

Dorgerloh, Annette. "Wege zur Nation: Schinkels Denkmalsentwürfe." In Altcappenberg and Johansen, *Schinkel*, 96–121.

Dove, Alfred. "Dove, Heinrich Wilhelm." In *ADB*, online edition. http://www.deutsche-biographie.de/pnd116190949.html?anchor=adb.

Dove, Heinrich Wilhelm. *De barometri mutationibus*. Berlin: Starke, 1826.

———. "De distributione caloris per tellurem." Habilitationsschrift, Königsberg, 1826.

———. "Einige meteorologische Untersuchungen über den Wind." *AdP* 11 (1827): 545–90.

———. *Gedächtnissrede auf Alexander von Humboldt*. Berlin: F. Dümmler, 1869.

———. *Meteorologische Untersuchungen*. Berlin: Sander'schen Buchhandlung, 1837.

———. "Ueber das Gesetz der Stürme." *AdP* 52 (1841): 1–41.

Dove, Heinrich Wilhelm, and A. v. Humboldt. "Korespondierende Beobachtungen über die regelmässigen stündlichen Veränderungen und über die Perturbationen der magnetischen Abweichung im mittl. und östl. Europa." *AdP* 19 (1830): 357–91.

Drechsler, Julius. *Fichtes Lehre vom Bild*. Stuttgart: Kohlhammer, 1955.

Du Bois-Reymond, Emil. "Culturgeschichte und Naturwissenschaft." In *Reden von Emil Du Bois-Reymond*, 2nd ed., edited by Estelle Du Bois-Reymond, vol. 1, 567–629. Leipzig: Veit, 1912.

———. "Der sogenannte Frosch- und Muskelstrom, nebst der *Contraction induite* Matteuccis." *FdP [1845]* 1 (1847): 512–21.

———. "Einwirkung der Elektricität auf Tiere." *FdP [1845]* 1 (1847): 503–6.

———. "Electrophysiologie." *FdP [1846]* 2 (1848): 455–60.

———. "Gedächtnisrede auf Johannes Müller." In Du Bois-Reymond, *Reden*, 2:142–335.

———. "Johann Georg Halske." *VdPG* 9 (1891): 39–41.

———. *Laboratory Diary*. Staatsbibliothek zu Berlin, Preußischer Kulturbesitz, Nachlass Du Bois-Reymond, K. 10.

———. "Naturwissenschaft und bildende Kunst." In Du Bois-Reymond, *Reden* 2:390–425.

[———]. "Progrès des sciences physiques hors de France." *Quesnevilles révue scientifique et industrielle* 27 (1846): 81–96.

———. *Untersuchungen über thierische Elektricität*. 2 vols. in 3. Berlin: Reimer, 1848–84.

———. "Vorläufiger Abriss einer Untersuchung über den sogenannten Froschstrom und über die elektromotorischen Fische." *AdP* 58 (1843): 1–30.

Du Bois-Reymond, Estelle, ed. *Reden von Emil Du Bois-Reymond*. 2nd. ed. 2 vols. Leipzig: Veit, 1912. Reprint in Sven Dierig, ed. *Emil Heinrich du Bois Reymond, Werke*, vols. 7, 8. Hildesheim: Olms-Weidmann, 2011.

———, ed. *Jugendbriefe von Emil Du Bois-Reymond an Eduard Hallmann*. Berlin: Reimer, 1918.

Dufrénoy, Armand, Elie de Beaumont, et al. *Voyage métallurgique en Angleterre*. 2nd ed. 2 vols. plus atlas. Paris: Bachelier, 1837–39.

Dupin, Charles. *Développements de géométrie, avec des applications à la stabilité des vaisseaux, aux déblais et remblais, au défilement, à l'optique, etc. Ouvrage approuvé par l'Institut de France pour faire suite à la géométrie descriptive et à la géométrie analytique de M. Monge.* Paris: V. Courcier, 1813.

———. *Géométrie et mécanique des arts et métiers et des beaux-arts, cours normal . . . professé au Conservatoire. . . .* 3 vols. Paris: Bachelier, 1825–26.

———. *Voyages dans la Grande-Bretagne en 1816–1819. . . .* 6 vols. Paris: Bachelier, 1820–24.

Dürer, Albrecht, *Albrecht Dürers christlich-mythologische Randzeichnungen: Lithographien von J. N. Strixner nach den Randzeichnungen im Gebetbuch Kaiser Maximillians.* Munich: Lithographische Presse Alois Senefelder, 1808.

———. *Das Skizzenbuch in der Königlichen öffentlichen Bibliothek zu Dresden.* Strasbourg: Heitz, 1905.

Dwyer, Philip G., ed. *Modern Prussian History, 1830–1947.* New York: Longman, 2001.

———. "Prussia during the French Revolutionary and Napoleonic Wars, 1786–1815." In Dwyer, *Rise of Prussia*, 239–58.

———, ed. *The Rise of Prussia: Rethinking Prussian History, 1700–1830.* New York: Longman, 2000.

Ebeling, Werner, and Johannes Orphal. "Rudolph Clausius in Berlin (1840–1855)." *Wissenschaftliche Zeitschrift der Humboldt-Universität zu Berlin, Reihe Mathematik/Naturwissenschaften* 39 (1990): 210–22.

Ebert, H. "Die Gründer der Physikalischen Gesellschaft zu Berlin." *Physikalische Blätter* 27 (1971): 247–54.

Elkana, Jehuda. *The Discovery of the Conservation of Energy.* London: Hutchinson, 1974.

Engelhardt, Eduard. *De vita musculorum observationes et experimenta.* Bonn, 1842.

Engelmann, Wilhelm. *Daniel Chodowieckis sämmtliche Kupferstiche.* Facsimile of second edition. Hildesheim: Olms, 1969.

Epple, Moritz, and Claus Zittel, eds. *Cultures and Politics of Research from the Early Modern Period to the Age of Extremes.* Berlin: Akademie Verlag, 2010.

Erman, Wilhelm. *Paul Erman: Ein Berliner Gelehrtenleben, 1764–1851* (Berlin: Mittler und Sohn, 1927).

Felsch, Philipp. *Laborlandschaften: Phyisiologische Alpenreisen im 19. Jahrhundert.* Göttingen: Wallstein Verlag, 2007.

Fend, Mechtild. *Grenzen der Männlichkeit: Der Androgyn in der französischen Kunst und Kunsttheorie 1750–1830.* Berlin, Reimer, 2003.

Ferriot, Dominique "Le musée des arts et métiers." In Fontanon, Le Moël, and Saint-Paul, *Le conservatoire*, 146–54.

Fichte, Johann Gottlieb. "Der Patriotismus und sein Gegentheil: Patriotische Dialogen vom Johre 1807." In *Nachgelassene Werke*, edited by I. H. Fichte, vol. 3, 221–74. Bonn: Marcus, 1834–35.

Fiedler, Annett. *Die Physikalische Gesellschaft zu Berlin: Vom Lokalen naturwissenschaftlichen Verein zur nationalen Deutschen Physikalischen Gesellschaft, 1845–1900.* Aachen: Shaker, 1998.

Finkelstein, Gabriel. "Emil du Bois-Reymond: The Making of a Liberal German Scientist 1818–1851." PhD diss., Princeton University, 1996.

———. *Emil du Bois-Reymond: Neuroscience, Self, and Society in Nineteenth-Century Germany.* Cambridge, MA: MIT Press, 2013.

Fischer, Ernst Gottfried. *Lehrbuch der mechanischen Naturlehre.* Berlin, 1805. French translation by Madame Biot-Brisson and Jean Baptiste Biot, Paris, 1806.

———. "Nachricht von sehr vollkommenen Parallelspiegeln, die vom Herrn Mechanikus Duve in Berlin verfertigt warden." *Astronomisches Jahrbuch* (1815): 224–32.

———. *Über die zweckmässigste Einrichtung der Lehranstalten für die gebildeten Stände.* Berlin, 1806.

———. "Ueber Pestalozzis Lehrart." *Abhandlungen der Akademie der Wissenschaften zu Berlin* (1803): 181–90.

———. *Untersuchung über den eigentlichen Sinn der höheren Analysis, nebst einer idealischen Übersicht der Mathematik und Naturkunde nach ihrem ganzen Umfang.* Berlin, 1808.

Flaminius, Emil. "Uber den Bau des Hauses für die allgemeine Bauschule in Berlin." *Allgemeine Bauzeitung* (Vienna) 1, no. 1 (1836), 3–5, 9–13, 18–24, 25–26.

Florkin, Marcel. *Naissance et déviation de la théorie cellulaire dans l'oeuvre de Théodor Schwann.* Paris: Hermann, 1960.

Fontanon, Claudine. "Morin, Arthur (1795–1880)." In Fontanon and Grelon, *Les professeurs*, 2:311–21.

Fontanon, Claudine, and André Grelon, eds. *Les professeurs du Conservatoire National des Arts et Métiers: Dictionnaire biographique 1794–1955*, 2 vols. Paris: CNAM, 1994.

Fontanon, Claudine, Michel Le Moël, and Raymond Saint-Paul, eds. *Le conservatoire national des arts et métiers: 1794–1994.* Paris: CNAM, 1994.

Forgan, Sophie. "The Architecture of Display: Museums, Universities and Objects in Nineteenth-Century Britain." *History of Science* 32 (1994): 139–62.

Frank, Robert G. "The Telltale Heart: Physiological Instruments, Graphic Methods, and Clinical Hopes, 1854–1914." In *The Investigative Enterprise: Experimental Physiology in Nineteenth-Century Medicine,* edited by William Coleman and Frederic L. Holmes, 211–90. Berkeley: University of California Press, 1988.

Franke, Henrik. "Moritz Traube (1826–1894): Leben und Wirken des universellen Privatgelehrten und Wegbereiters der physiologischen Chemie." Diss., Dr. Med., Humboldt Universität zu Berlin, 1994. http://henrikfranke.npage.de (accessed October 4, 2013; no longer posted).

Franke, Renate. *Berlin vom König bis zum Schusterjungen: Franz Krügers "Paraden" Bilder preußischen Selbstverständnisses.* Frankfurt am Main: Peter Lang, 1984.

———. "Franz Krügers Zeitgeschichtsbilder: Stationen des Weges vom Untertanen zum Bürger." In Bartoschek, *Der Maler Franz Krüger,* 31–43.

Friedman, Michael. "Helmholtz's *Zeichentheorie* and Schlick's *Allgemeine Erkenntnislehre*: Early Logical Empiricism and Its Nineteenth-Century Background." *Philosophical Topics* 25 (1997): 19–50.

———. *Kant's Construction of Nature: A Reading of the Metaphysical Foundations of Natural Science.* Cambridge: Cambridge University Press, 2013.

Gale, W. K. V. *The Black Country Iron Industry: A Technical History.* London: Iron and Steel Institute, 1966.

Gauss, Carl Friedrich. "Allgemeine Lehrsätze in Beziehung auf die im verkehrten Verhältnisse des Quadrats der Entfernung wirkenden Anziehungs- und Abstossungs-Kräfte." In *Resultate aus den Beobachtungen des magnetischen Vereins im Jahre 1839,* edited by C. F. Gauss and Wilhelm Weber. Leipzig, 1840. Reprinted in *Carl Friedrich Gauss Werke,* vol. 5, 195–242, Göttingen: Königlichen Gesellschaft der Wissenschaften, 1877.

Gehlers Physikalisches Wörterbuch. Leipzig: Schwickert, 1833.

Goethe, Johann Wolfgang von. "The Experiment as Mediator between Subject and Object." In Goethe, *Scientific Studies,* 11–17.

———. "Flüchtige Uebersicht über die Kunst in Deutschland." *Propyläen* 3 (1800). Reprinted, Stuttgart: Cotta, 1965, 1065.

———. *Scientific Studies.* Edited and translated by Douglas Miller. Goethe Edition, vol. 12. New York: Suhrkamp, 1988.

———. *Zur Farbenlehre.* 2 vols. plus atlas. Tübingen: J. G. Cotta, 1810.

Goetzeler, Herbert. "Johann Georg Halske." In Treue and König, *Techniker,* 135–51.

Gooday, Graeme. "Placing or Replacing the Laboratory in the History of Science." *Isis* 99 (2008): 783–95.

Grattan-Guinness, Ivor. "Work for the Workers: Advances in Engineering Mechanics and Instruction in France, 1800–1830." *Annals of Science* 41 (1984): 1–33.

Grimm, Jacob, and Wilhelm Grimm. *Deutsches Wörterbuch (Erstbearbeitung) auf CD-ROM.* Edited by H.-W. Bartz et al. Universität Trier und Berlin-Brandenburgischen Akademie der Wissenschaften, 2001.

Grosse, Ingrid. "Friedrich Adolph August Struve." *Sächsische Heimatblätter* 56 (2010): 109–20. Abridged version in http://wiki-de.genealogy.net/Friedrich_Struve.

Grote, Andreas, ed. *Macrocosmos in Microcosmo: Die Welt in der Stube; Zur Geschichte des Sammelns 1450 bis 1800.* Opladen: Leske und Budrich, 1994.

Guntau, Martin. "The Natural History of the Earth." In Jardine, Secord, and Spary, *Cultures of Natural History*, 211–29.

Guts Muth, J. C. F. *Gymnastik für die Jugend. . . .* Schnepfenthal, 1804.

Haas, Eve, and Herzeleide Henning. *Prince August of Prussia: A Biography.* Berlin, 1990.

Hagner, Michael, and Hans-Jörg Rheinberger, eds. *Die Experimentalisierung des Lebens: Experimetalsysteme in den biologischen Wissenschaften 1850/1950.* Berlin: Akademie Verlag, 1993.

Hamm, Ernst P. "Goethes Sammlungen auspacken: *Das Oeffentliche und das Private im naturgeschichtlichen Sammeln.*" In Te Heesen and Spary, *Sammeln als Wissen*, 85–114.

Hankins, Thomas L. "Eighteenth-Century Attempts to Resolve the *Vis Viva* Controversy." *Isis* 56 (1965): 281–97.

Harnack, Adolf. *Geschichte der Königlichen Preussischen Akademie der Wissenschaften zu Berlin.* 3 vols. Berlin: Reichsdruckerei, 1900.

Harten, Ulrike, ed. *Die Bühnenentwürfe*, vol. 17 of *Karl Friedrich Schinkel, Lebenswerk*, edited by Helmut Börsch-Supan and Gottfried Riemann. Munich: Deutscher Kunstverlag, 2000).

Hartmann, Uwe. *Carl von Clausewitz: Erkenntnis, Bildung, Generalstabsausbildung.* Munich: Olzog, 1998.

Hatfield, Gary. "Helmholtz and Classicism: The Science of Aesthetics and the Aesthetics of Science." In Cahan, *Helmholtz*, 522–58.

———. *The Natural and the Normative: Theories of Spatial Perception from Kant to Helmholtz.* Cambridge, MA: MIT Press, 1990.

Haüy, René Just. *Lehrbuch der Mineralogie.* Paris: Reclam, 1804–10.

Heidelberger, Michael. "Force, Law, and Experiment: The Evolution of Helmholtz's Philosophy of Science." In Cahan, *Helmholtz*, 461–97.

Heimann, Peter M. "Helmholtz and Kant: The Metaphysical Foundations of *Ueber die Erhaltung der Kraft.*" *Studies in History and Philosophy of Science* 5 (1974): 205–38.

Heintz, Wilhelm. "Wärmeentwicklung: Durch chemische Verbindungen." *FdP [1845] 1* (1847): 317–43.

Helmholtz, Ferdinand, "Die Wichtigkeit der allgemeinen Erziehung für das Schöne." In *Zu der öffentlichen Prüfung* (1837), 1–44.

Helmholtz, Hermann. *De fabrica systematis nervosi evertebratorum.* Berlin: Nietack 1842).

———. "Deuxième note sur la vitesse de propagation de l'agent nerveux." *Comptes Rendus de l'Académie des Sciences* 33 (1851): 262–65.

———. *Die Lehre von den Tonempfindungen als physiologische Grundlage für die Theorie der Musik.* Brunswick: Vieweg, 1863.

———. "Erinnerungen: Tischrede gehalten bei der Feier des 70. Geburtstages. Berlin 1891." *VuR*, 1:1–21.

———. "Messungen über den Zeitlichen Verlauf der Zuckung animalischer Muskeln

und die Fortpflanzungsgeschwindigkeit der Reizung in den Nerven." *Müllers Archiv* (1850): 276–364; *WA*, 2:764–843.

———. "Messungen über die Fortpflanzungsgeschwindigkeit der Reizung in den Nerven. Zweite Reihe." *Müllers Archiv* (1852): 199–216; *WA*, 2:844–61.

———. "Note sur la vitesse de propagation de l'agent nerveux dans les nerfs rachidiens." *Comptes Rendus de l'Académie des Sciences* 30 (1850): 204–6.

———. "On the Application of the Law of the Conservation of Force to Organic Nature" [1861], *WA*, 3: 565–80.

———. "Optisches über Malerei." In *Populäre Wissenschaftliche Vorträge: Drittes Heft*, 55–97. Brunswick: Vieweg, 1876.

———. "Physiologische Wärmeerscheinungen." *FdP [1845]* 1 (1847): 346–55; *WA*, 1:3–11.

———. "Probevortrag." In Koenigsberger, *Helmholtz*, 1:95–105.

———. "Über das Wesen der Fäulniss und Gährung." *Müllers Archiv* (1843): 453–62; *WA*, 2:727–34.

———. "Über Goethes naturwissenschaftliche Arbeiten" *VuR*, 1:23–47.

———. "Ueber Combinationstöne." *AdP* 99 (1856): 497–540; *WA*, 1:263–302.

———. "Ueber den Stoffverbrauch bei der Muskelaction." *Müllers Archiv* (1845): 72–83; *WA*, 2:735–44.

———. *Ueber die Erhaltung der Kraft.* Berlin: Reimer, 1847; *WA*, 1:12–75.

———. "Ueber die Methoden, kleinste Zeittheile zu messen, und ihre Anwendung für physiologische Zwecke." *Königsberger naturwissenschaftliche Unterhaltungen* 2 (1850): 1–24; *WA*, 2:862–79.

———. "Ueber die Wärmeentwicklung bei der Muskelaction." *Müllers Archiv* (1848): 144–64; *WA*, 2:745–63.

———. "Vorläufiger Bericht über die Fortpflanzungsgeschwindigkeit der Nervenreizung." *Monatsbericht der Königlichen Preussischen Akademie der Wissenschaften* (January 1850): 14–15. Reprinted in *Müllers Archiv* (1850): 71–73, and *AdP* 79 (1850): 329–30.

———. "Wärme, physiologisch." In *Encyclopädischen Handwörterbuch der medicinischen Wissenschaften*, edited by members of the Berlin medical faculty, vol. 35, 523–67. Berlin, 1846; *WA*, 2:680–725 (incorrectly dated 1845).

———. "Zum Gedächtnis an Gustav Magnus." *VuR* 2:33–51.

———. "Zur Erinnerung an Rudolph Clausius." *VdPG* 8 (1889): 1–7.

Helmholtz, Hermann[, and Emil du Bois-Reymond]. "Deuxième Note sur la vitesse de propagation de l'agent nerveux." *Comptes Rendus de l'Académie des Sciences* 33 (1851): 262–65.

Hermann, Armin. "Physiker und Physik—anno 1845: 120 Jahre Physikalische Gesellschaft in Deutschland." *Physikalische Blätter* 21 (1965): 399–405.

Hermbstaedt, Sigismund Friedrich. *Grundriß der Technologie; oder, Anleitung zur rationellen Kenntniß und Beurtheilung derjenigen Künste, Fabriken, Manufakturen und Handwerke, welche mit der Landwirthschaft, so wie der Kameral- und Policeywissenschaft stehen; Zum Gebrauche akademischer Vorlesungen und zur Selbstbelehrung für angehende Staatsdiener, Kameral- und Policeybeamte,*

desgleichen für Landwirthe, Kaufleute, Fabrikanten, Manufakturisten und Handwerker. Berlin: Maurer, 1814.

Herléa, Alexandre. "Les indicateurs de pression: leur evolution in France au 19ᵉ siècle." In *Studies in the History of Scientific Instruments*, edited by Christine Blondel et al., 193–234. London: Rogers Turner Books, 1989.

Hess, Germain Henri. "Recherches thermochimiques." *Bulletin Scientifique Académie Impériale des Sciences* 8 (1840): 257–72.

———. "Ueber die bei chemischen Verbindungen entwickelten Wärmemenge." *AdP* 52 (1841): 114–18.

Hess, Volker. "Medizin zwischen Sammeln und Experimentieren." In Tenorth, Hess, and Hoffman, *Genese der Disziplinen*, 489–565.

Hiebert, Elfrieda, and Irwin Hiebert. "Musical Thought and Practice: Links to Helmholtz's *Tonempfindungen.*" In Krüger, *Universalgenie Helmholtz*, 295–314.

Hills, R. L., and A. J. Pacey. "The Measurement of Power in Early Steam-Driven Textile Mills." *Technology and Culture* 13 (1972): 25–43.

Hinz, Gerhard. *Peter Josef Lenné und seine bedeutendsten Anlagen in Berlin und Potsdam.* Dissertation, Berlin [Humboldt] University, 1937.

Hoff, H. E., and L. A. Geddes. "Ballistics and the Instrumentation of Physiology: The Velocity of the Projectile and of the Nerve Impulse." *Journal of the History of Medicine and Allied Sciences* 15 (1960): 133–46.

———. "Graphic Registration before Ludwig: The Antecedents of the Kymograph." *Isis* 50 (1959): 5–21.

———. "The Technological Background of Physiological Discovery: Ballistics and the Graphic Method." *Journal of the History of Medicine and Allied Sciences* 15 (1960): 345–63.

Hoff, Marlise, et. al. *Karl Daniel Freydanck, 1811–1887: Ein Vedutenmaler der KPM.* Berlin: Nicolaische Verlagsbuchhandlung, 1987.

Hoffmann, Dieter, ed. *Gustav Magnus und sein Haus.* Stuttgart: Verlag der Geschichte der Naturwissenschaften und der Technik, 1995.

Hoffmann, Stefan-Ludwig. *Geselligkeit und Demokratie: Vereine und zivile Gesellschaft im transnationalen Vergleich 1750–1914.* Göttingen: Vandenhoeck und Ruprecht, 2003.

Hofmann, August Wilhelm. "Gustav Magnus." In *Zur Erinnerung an vorangegangene Freunde: Gesammelte Gedächtnisreden*, vol. 1, 45–191. Brunswick: Vieweg, 1888.

———. "Magnus, Heinrich Gustav." *ADB* (1884). http://www.deutsche-biographie.de/pnd118576178.html?anchor=adb.

Holborn, Hajo. "The Prusso-German School: Moltke and the Rise of the General Staff." In Paret, Craig, and Gilbert, *Makers of Modern Strategy*, 281–95.

Hollander, Samuel. *Jean-Baptiste Say and the Classical Canon in Economics: The British Connection in French Classicism.* London: Routledge, 2005.

Holmes, Frederic L., and Kathryn M. Olesko. "The Images of Precision: Helmholtz and the Graphical Method in Physiology." In *The Values of Precision*, edited by M. Norton Wise, 198–221. Princeton, NJ: Princeton University Press, 1995.

Holtzmann, Karl H. A. *Ueber die Wärme und Elasticität der Gase und Dämpfe.*
Mannheim: Löffler, 1845.

Honisch, Dieter, and Peter Krieger. *Deutsche Malerei des 19. Jahrhunderts: 60
Meisterwerke aus der Nationalgalerie Berlin.* Berlin: Nationalgalerie, Staatliche
Museen Preussischer Kulturbesitz, 1980.

Hopkinson, Joseph, Jr. *The Working of the Steam Engine Explained by the Use of the
Indicator,* 2nd ed. London: Weale, 1857.

Hornung, Klaus. *Scharnhorst: Soldat-Reformer-Staatsmann; Die Biographie.* Munich:
Bechtle, 1997.

Hui, Alexandra. *The Psychophysical Ear: Musical Experiments, Experimental Sounds,
1840–1910.* Cambridge, MA: MIT Press, 2013.

Humboldt, Alexander von. "Des lignes isotherme et de la distribution de la chaleur
sur le globe." *Mémoires de physique et de chimie de la Société d' Arcueil, 3* (1817),
462–602; the chart appeared only in a separate publication with the same title (Paris:
Perronneau, 1817); German in Beck, *Humboldt: Studienausgabe,* 6:18–97 (chart on 19).

———. "Entwurf zur Reorganisation der Akademie, 4. November 1807." In Harnack,
Geschichte der Königlichen Preussischen Academie, 2:334–37. Harnack's description is
in vol. 1, pt. 2, 571–75.

———. *Essai politique sur le royaume de la Nouvelle-Espagne.* Paris: Schoell, 1808–14.
German in Beck, *Humboldt: Studienausgabe,* vol. 4, with plates from the *Atlas
géographique et physique du royaume de la nouvelle-espagne.*

———. *Ideen zu einer Physiognomik der Gewächse.* 1806. Republished with extensive
notes in Humboldt's *Ansichten der Natur,* 3rd ed., 1849; reprinted in Beck, *Humboldt:
Studienausgabe,* 5:184.

———. "Ueber die Mittel: Die Ergründung einiger Phänomene des tellurischen
Magnetismus zu erleichtern." *AdP* 91 (1829): 319–36.

———. *Vues des cordillières.* Paris: Schoell, 1810.

Humboldt, Alexander von, and A. Bonpland. *Ideen zu einer Geographie der Pflanzen
nebst einem Naturgemälde der Tropenländer.* Tübingen: F. G. Cotta, 1807. In Beck,
Humboldt: Studienausgabe, 1:43–161.

Humboldt, Alexander von, and H. Lichtenstein. *Amtlicher Bericht über die Versammlung
deutscher Naturforscher und Ärzte zu Berlin im September 1828.* Berlin: Trautwein, 1829.

Humboldt, Wilhelm von. "Bericht des Minsters Wilhelm Freiherrn von Humboldt an
den König vom 21. August 1830." In *Gesammelte Schriften. Bd. 12: Abt. 2, Politische
Denkschriften Bd. 3, 1815–1834,* 539–66. Berlin: Behr, 1904.

———. "Das achtzehnte Jahrhundert." *Gesammelte Schriften. Bd. 2: Abt. 1, Werke Bd. 2,
1796–1799,* 1–112. Berlin: Behr, 1904.

———. *Gesammelte Schriften.* Berlin: Behr, 1904.

Hummel, Georg. *Der Maler Johann Erdmann Hummel: Leben und Werk.* Leipzig: E. A.
Seemann, 1954.

Hummel, Johann Erdmann. *Die freie Perspektive erläutert durch praktische Ausgaben
und Beispiele, hauptsächlich für Maler und Architekten.* 2nd ed. 2 vols. (Berlin:
Herbig, 1833.

———. *Geometrisch-praktische Construction der Schatten für Architekten und andere zeichnende Künstler.* Berlin: Herbig, 1842.

Izumi, Chiye. "The Role of Stereometry in Plato's *Republic.*" *Plato: Le Journal Internet de la Société Platonicienne Internationale*, March 2012. https://gramata.univ-paris1.fr /Plato/article102.html.

Jackson, Myles. "Harmonious Investigators of Nature: Music and the Persona of the German *Naturforscher* in the Nineteenth Century." *Science in Context* 16 (2003): 121–45.

———. *Harmonious Triads: Physicists, Musicians, and Instrument Makers in Nineteenth Century Germany.* Cambridge, MA: MIT Press, 2006.

———. "A Spectrum of Belief: Goethe's 'Republic' versus Newtonian 'Despotism.'" *Social Studies of Science* 24 (1994): 673–701.

Jacobi, Moritz Hermann. *Die Galvanoplastik; oder, Das Verfahren cohärentes Kupfer in Platten . . . auf galvanischem Wege zu produciren.* St. Petersburg: Eggers,1840.

———. "Vorläufige Notiz über galvanoplastische Reduction mittelst einer magnetoelektrischen Maschine." *Bulletin de l'Academie à St. Petersburg* 5 (1846), 318.

———. "Ueber die Benutzung der Naturkräfte zur menschlichen Arbeiten." In *Vorträge aus dem Gebiete der Naturwissenschaften und der Oekonomie*, edited by K. E. Baer, 99–123. Königsberg: 1834.

Jahnke, Hans Niels. "Algebraic Analysis in the 18th Century." In Jahnke, *History of Analysis*, 105–53.

———. *A History of Analysis.* Providence, RI: American Mathematical Society, 2003.

Jardine, Nicholas, James A. Secord, and Emma C. Spary, eds. *Cultures of Natural History.* Cambridge: Cambridge University Press, 1996.

Johannsen, Rolf H. "Der Traum vom Bauen, Bilden und Schauen: Die späten Utopien." In Altcappenberg and Johannsen, *Schinkel*, 256–81.

Jungnickel, Christa, and Russell McCormmach. *Intellectual Mastery of Nature: Theoretical Physics from Ohm to Einstein.* Vol. 1, *The Torch of Mathematics, 1800–1870.* Chicago: University of Chicago Press, 1986.

Kant, Horst. "Gustav Magnus und seine Berliner Physiker-Schule." In Hoffmann, *Magnus und sein Haus*, 33–53.

Kant, Immanuel. *Kritik der reinen Vernunft.* 1781. Second edition 1787. In *Kants Werke*, vols. 4 and 3, respectively.

———. *Metaphysische Anfangsgründe der Naturwissenschaft.* 1786. In *Kants Werke*, 4:465–565.

———. *Metaphysical Foundations of Natural Science.* Translated and edited by Michael Friedman. Cambridge: Cambridge University Press, 2004.

———. *Kants Werke: Akademie-Textausgabe.* 1902. Facsimile edition, Berlin: Walter de Gruyter, 1968.

Karsten, Gustav. "Chemische Wirkung des Lichtes." *FdP [1845]* 1 (1847): 226–97.

———. "Gase und Dämpfe: Elasticität und Dichtigkeit derselben." *FdP[1845]* 1 (1847): 90–111.

———. "Hygrometrische Tabellen." *FdP [1846]* 2 (1848): 116–18.

———. "Hygrometrische Tabellen zur Anwendung bei Gebläsen und Gradirwerken." *Karstens Archiv für Mineralogie, Geognosie, Bergbau und Hüttenkunde* 21 (1847): 49–134.

———. "Untersuchungen über das Verhalten der Auflösungen des reinen Kochsalzes in Wasser." *Karstens Archiv für Mineralogie, Geognosie, Bergbau und Hüttenkunde* 20 (1846): 3–256. Reprint, Berlin: Reimer, 1846.

———. "Vorbericht," *FdP [1845]* 1 (1847), iii–x.

Katalog der Bibliothek des Königlichen Gewerbe-Instituts zu Berlin. Berlin: A. W. Schade, 1866.

Kerker, Milton. "Sadi Carnot and the Steam Engine Engineers." *Isis* 51 (1960): 257–70.

Kessel, E. "Zu Boyens Entlassung." *Historische Zeitschrift* 175 (1953): 53–54.

Kirchhoff, Gustav. "Ueber den Durchgang eines elektrischen Stromes durch eine Ebene, insbesondere durch eine kreisförmige." *AdP* 64 (1845): 497–514.

Kirsten, Christa, et. al., eds. *Dokumente einer Freundschaft: Briefwechsel zwischen Hermann von Helmholtz und Emil du Bois-Reymond, 1846–1894.* Berlin: Akademie Verlag, 1986.

Klein, Ursula. "Chemische Wissenschaft und Technologie in der Grundungsphase der Berliner Universität." In Tenorth and Hoffman, *Genese der Disziplinen*, 447–64.

———. *Humboldts Preussen: Wissenschaft und Technik im Aufbruch.* Darmstadt: Wissenschaftliche Buchgesellschaft, 2015.

———. "The Laboratory Challenge: Some Revisions of the Standard View of Early Modern Experimentation." *Isis* 99 (2008): 769–82.

———. "Shifting Ontologies, Changing Classifications: Plant Materials from 1700 to 1830." *Studies in History and Philosophy of Science* 36 (2005): 261–329.

Klemm, Friedrich. "Ernst Gottfried Fischer: Ein mitteldeutscher Mathematiker, Physiker und Schulmann." *Die Mitte* 2 (1966): 27–74.

———. "Geschichte der naturwissenschaftlichen und technischen Museen." *Deutsches Museum, Abhandlungen und Berichte* 41 (1973): 3–59.

Klinkott, Manfred. *Die Backsteinbau der Berliner Schule, von K. F. Schinkel bis zum Ausgang des Jahrhunderts.* Berlin: Mann, 1988.

Knoblauch, H. "Strahlende Wärme." *FdP [1845]* 1 (1847): 364–76.

———. "Ueber die Veränderungen, welche die strahlende Wärme durch diffuse Reflexion erleidet. *Monatsberichte der Königlichen Preussischen Akademie der Wissenschaften* (1845): 170–80. Also in *AdP* 65 (1845): 581–92.

———. "Wärmeentwicklung. Durch mechanische Einwirkung." *FdP [1845]* 1 (1847): 344–46.

Kocka, Jürgen. "The Difficult Rise of a Civil Society: Modern Germany, 1800–1990." In *Industrial Culture and Bourgeois Society: Business, Labor, and Bureaucracy in Modern Germany*, 275–97. New York: Berghahn Books, 1999.

Koehler, Friedrich. *Die Chemie in Technischer Beziehung: Leitfaden für Vorträge in Gewerbeschulen.* Berlin: Enslin, 1834.

———. *Grundriss der Mineralogie für Vorträge in höheren Schulanstalten.* Cassel: Kriegerschen Buchhandlung, 1831.

———. *Lehrbuch der Chemie.* 7th ed. Berlin, Müller, 1854.

———. "Ueber die Naturgeschichte des Kreuzsteins: Eine mineralogische Abhandlung." In *Zu der öffentlichen Prüfung der Zöglinge des Cölnischen Real-Gymnasii*, 1–11.

Koenigsberger, Leo. *Hermann von Helmholtz*. 3 vols. Brunswick: Vieweg, 1902–3.

Koerner, Joseph Leo. *The Moment of Self-Portraiture in German Renaissance Art.* Chicago: University of Chicago Press, 1993.

König, Wolfgang, "Technical Education and Industrial Performance in Germany: A Triumph of Heterogeneity." In *Education, Technology and Industrial Performance in Europe, 1850–1939*, edited by Robert Fox and Anna Guagnini, 65–87. Cambridge: Cambridge University Press, 1993.

———. "Zwischen Verwaltungsstaat und Industriegesellschaft: Die Gründung höher technischer Bildungsstätten in Deutschland in den ersten Jahrzehnten des 19. Jahrhunderts." *Berichte zur Wissenschaftsgeschichte* 21 (1998): 115–22.

Kremer, Richard L. "Building Institutes for Physiology in Prussia, 1836–1846." In *The Laboratory Revolution in Medicine*, edited by Andrew Cunningham and Perry Williams, 72–109. Cambridge: Cambridge University Press, 1992.

———, ed. *Letters of Hermann von Helmholtz to His Wife, 1847–1859*. Stutttgart: Steiner Verlag, 1990.

———. *The Thermodynamics of Life and Experimental Physiology, 1770–1880*. New York: Garland, 1990.

Krieger, Peter, and Elke Ostländer, eds. *Galerie der Romantik.* Berlin: Nationalgalerie, Staatliche Museen Preußischer Kulturbesitz, 1986.

Krimer, W. *Physiologische Untersuchungen.* Leipzig: Cnobloch, 1820.

Krüger, Lorenz, ed. "Helmholtz über die Begreiflichkeit der Natur." In Krüger, *Universalgenie Helmholtz*, 201–15.

———. *Universalgenie Helmholtz: Rückblick nach 100 Jahren.* Berlin: Akademie Verlag, 1994.

Kugler, Franz. "Vorhalle des Museums in Berlin: Drittes Bild." *Museum, Blätter für bildende Kunst* 1, no. 2 (1833): 9–12.

Kuhn, Dorothea. "Der Naturgegenstand als Vertreter der Schöpfung: Sammeln und Betrachten des jungen und des alten Goethe." In Grote, *Macrocosmos*, 721–32.

Kuhn, Thomas S. "Energy Conservation as an Example of Simultaneous Discovery." In *Critical Problems in the History of Science*, edited by Marshall Clagett, 321–56. Madison: University of Wisconsin Press, 1959. Also in T. S. Kuhn, *The Essential Tension: Selected Studies in Scientific Tradition and Change* (Chicago: University of Chicago Press, 1977), 66–104.

Kummer, E. E. "Gedächtnissrede auf Gustav Peter Lejeune Dirichlet." In *G. Lejeune Dirichlets Werke*, edited by L. Kronecker, vol. 2, 310–44. Berlin: Reimer, 1897.

Kunth, Karl Sigismund. *Nova genera et species plantarum quas in peregrinatione ad plagam aequinoctialem orbis novi collegerunt Bonpland et Humboldt.* 7 vols. Paris, 1815–25.

Lack, H. Walter. "Berlins grüne Schatzkammer: Botanischer Garten und Botanisches Museum Berlin-Dahlem." In Bredekamp, Brüning, and Weber, *Theater der Natur und Kunst: Essays*, 76–80.

Lammel, Gisold. *Adolph Menzel und seine Kreise.* Dresden: Verlag der Kunst, 1993.

Lampe, E. "Dirichlet als Lehrer der Allgemeinen Kriegsschule." *Naturwissenschaftliche Rundschau* 21 (1906): 482–85.

Lavater, Johann Caspar. *Physiognomische Fragmente zur Beförderung der Menschenkenntnis und Menschenliebe.* Illustrated by Daniel Chodowiecki. 4 vols. 1775–78. Reprint, Zürich: Füssli, 1968–69.

La Vopa, Anthony J. "Conceiving a Public: Ideas and Society in Eighteenth-Century Europe." *Journal of Modern History* 64 (1992): 79–116.

Lehmann, Max. *Scharnhorst.* 2 vols. Leipzig: Hirzel, 1886–87).

Lenoir, Timothy. "The Eye as Mathematician: Clinical Practice, Instrumentation, and Helmholtz's Construction of an Empiricist Theory of Vision." In Cahan, *Helmholtz,* 109–53.

———. *Instituting Science: The Cultural Production of Scientific Disciplines.* Stanford, CA: Stanford University Press, 1997.

———. "The Politics of Vision: Optics, Painting, and Ideology in Germany, 1845–95." In Lenoir, *Instituting Science,* 131–78.

———. "Science and Craftsmanship: The Art of Experiment and Instrument Making." *Comptes Rendus Biologies* 329 (2006): 348–53.

———. "Social Interests and the Organic Physics of 1847." In Lenoir, *Instituting Science,* 75–95.

———. *The Strategy of Life.* Dordrecht: Reidel, 1982.

Lenoir, Timothy, and Cheryl Lynn Ross. "Das naturalisierte Geschichtsmuseum." In Grote, *Macrocosmos,* 875–908.

Lervig, Philip. "Sadi Carnot and the Steam Engine: Nicolas Clément's Lectures on Industrial Chemistry 1823–28." *British Journal for the History of Science* 18 (1985): 147–96.

Liebig, Justus. *Die Thier-Chemie; oder, Die organische Chemie in ihrer Anwendung auf Physiologie und Pathologie.* 1842. Reprint of the first edition with different pagination. Brunswick: Vieweg, 1843). Facsimile of the English translation of the first edition, *Animal Chemistry; or, Organic Chemistry in Its Application to Physiology and Pathology,* edited by William Gregory and with a new introduction by Frederic L. Holmes, New York: Johnson Reprint, 1964 (many translation errors).

———. "Ueber die thierische Wärme." *Annalen der Chemie und Pharmacie* 53 (1845): 63–77.

Linnebach, Andrea. "Pegasus in der Kunst des 19. Jahrhunderts von Karl Friedrich Schinkel bis Odilon Redon." In *Pegasus und die Künste,* edited by Claudia Brink and Wilhelm Hornbostel, 111–23. Munich: Deutscher Kunstverlag, 1993.

Lippold, Katharina. "Backstein und Terrakotta: Wichtige Details von Persius' Italientraum." *Jahrbuch, Stiftung Preussische Schlösser und Gärten Berlin-Brandenburg* 5 (2003): 105–12.

Lohff, Brigitte. "Emil du Bois-Reymonds Theorie des Experiments." In *Naturwissen und Erkenntnis im 19. Jahrhundert: Emil du Bois-Reymond,* edited by Gunther Mann, 117–28. Hildesheim: Gerstenberg, 1981.

Lorenz, Werner. *Konstruktion als Kunstwerk: Bauen mit Eisen in Berlin und Potsdam, 1797–1850*. Berlin: Mann, 1995.

Lotz, Heinrich. "John Cockerill in seiner Bedeutung als Ingenieur und Industrieller, 1790–1840." *Beiträge zur Geschichte der Technik und Industrie* 10 (1920): 103–20.

Lübbe, Hermann. "Wilhelm von Humboldt und die Berliner Museumsgründung 1830." *Jahrbuch preussischer Kulturbesitz* 17 (1980): 87–109.

———. "Wilhelm von Humboldt und die Musealisierung der Kunst." In *Wilhelm von Humboldt: Vortragszyklus zum 150. Todestag*, edited by Bernfried Schlerath, 169–83. Berlin: de Gruyter, 1986.

Ludwig, Carl. *Lehrbuch der Physiologie des Menschen*. 2 vols. Heidelberg: Winter, 1852, 1856).

Lundgreen, Peter. "Engineering Education in Europe and the USA, 1750–1930: The Rise to Dominance of School Culture and the Engineering Professions." *Annals of Science* 47 (1990): 33–75.

———. *Techniker in Preussen während der frühen Industrialisierung: Ausbildung und Berufsfeld einer entstehenden sozialen Gruppe*. Berlin: Colloquium Verlag, 1975.

———. "Techniker und frühindustrieller Arbeitsmarkt in Preussen: Die Absolventen des Gewerbeinstituts, 1820–1850." In *Ingenieure in Deutschland, 1710–1990*, edited by Peter Lundgreen and André Grelon, 171–87. Frankfurt: Campus Verlag, 1994.

Lützen, Jesper. "The Foundation of Analysis in the 19th Century." In Jahnke, *History of Analysis*, 155–95.

Magnus, Gustav. "Ueber das Absorptionsvermögen des Blutes für Sauerstoff." *AdP* 66 (1845): 177–206.

———. "Ueber die im Blute enthaltenen Gase, Sauerstoff, Stickstoff und Kohlensäure." *AdP* 40 (1837): 583–606.

———. "Ueber die Kraft welche zur Erzeugung von Dämpfen erforderlich ist." *AdP* 61 (1844): 248–54.

———. "Versuche über die Spannkräfte des Wasserdampfs." *AdP* 61 (1844): 225–47.

Main, Thomas J., and Thomas Brown. *The Indicator and Dynamometer, with Their Practical Applications*. London: Hebert, 1847.

Manegold, Karl-Heinz. "Eine École Polytechnique in Berlin." *Technikgeschichte* 33 (1966): 182–96.

Marchand, Suzanne L. *Down from Olympus: Archaeology and Philhellenism in Germany, 1750–1970*. Princeton, NJ: Princeton University Press, 1996.

Matschoss, Conrad. *Die Entwicklung der Dampfmaschine: Eine Geschchte der ortsfesten Dampfmaschine und der Lokomobile, der Schiffsmaschine und Lokomotive*. 2 vols. Berlin: Springer, 1908.

———. "Geschichte der Königlichen Preussischen Technischen Deputation für Gewerbe: Zur Erinnerung an das 100 jährige Bestehen, 1811–1911." *Beiträge zur Geschichte der Technik und Industrie: Jahrbuch des Vereines deutscher Ingenieure* 3 (1911). 239–75.

———. *Preussens Gewerbeförderung und ihre grossen Männer, dargestellt im Rahmen der Geschichte des Vereins zur Beförderung des Gewerbefleisses, 1821–1921*. Berlin: Verlag des Vereines Deutscher Ingenieure, 1921.

———, ed. *Werner Siemens: Ein kurzgefasstes Lebensbild nebst einer Auswahl seiner Briefe.* Vol. 1. Berlin: Springer, 1916.

Matteucci, Carlo. "Lettre de M. Matteucci à M. Dumas, 'Electo-physiological Researches . . . upon the Relation Between the Intensity of the Electric Current, and that of the Corresponding Physiological Effect.'" *Philosophical Transactionsof the Royal Society* 137 (1847): 243–47.

———. "Lettre de M. Matteucci à M. Dumas,'Recherches sur les phénomènes électro-physiologiques.'" *Quesnevilles révue scientifique* 27 (1846): 96–100.

Matyssek, Angela. *Rudolf Virchow: Das pathologische Museum; Geschichte einer wissenschaftlichen Sammlung um 1900.* Darmstadt: Steinkopff, 2002.

Melton, James Van Horn. *Rise of the Public in Enlightenment Europe.* Cambridge: Cambridge University Press, 2001.

Mende, Matthias, and Inge Hebecker, eds. *Das Dürer Stammbuch von 1828.* Nuremberg: Carl, 1973.

Mercier, Alain. *Un conservatoire pour les arts et métiers.* Paris: Gallimard, 1994.

Mieck, Ilya. "Anton Franz Egells, die Gebrüder Freund und die Anfänge des Machinenbaus in Berlin." In Treue and König, *Techniker*, 65–83.

———. *Preussische Gewerbepolitik in Berlin, 1806–1844: Staatshilfe und Privatinitiative zwischen Merkantilismus und Liberalismus.* Berlin: de Gruyter, 1965.

———. "Sigismund Friedrich Hermbstaedt (1760 bis 1833): Chemiker und Technologe in Berlin." *Technikgeschichte* 32 (1965): 325–82.

Minding, Ferdinand. *Anfangsgründe der höheren Arithmetik.* Berlin: Reimer, 1832.

———. *Handbuch der Differential- und Integralrechnung und ihrer Anwendungen auf Geometrie und Mechanik: Zunächst zum Gebrauche in Vorlesungen.* 2 vols. Berlin: Dümmler, 1836–1838. Vol. 2 separately titled *Handbuch der theoretischen Mechanik.*

———. "Mechanik" [dated 1841]. *Repertorium der Physik* 5 (1844): 1–87.

———. *Sammlung von Integraltafeln zum Gebrauch für den Unterricht an der Königlichen Allgemeinen Bauschule und dem Königlichen Gewerbe-Institut.* Berlin: Reimarus, 1849.

Morin, Arthur. *Description des appareils chronométriques a style . . . et des appareils dynamométriques propres a mesurer l'effort ou le travail développé par les moteurs animés et par les organes de transmission du mouvement dan les machines.* Metz: Lamort, 1833, 1838.

———. *Hilfsbuch für praktische Mechanik: Zum Gebrauche von Artillerieoffizieren, Civil- und Militäringenieuren.* Karlsruhe: Groos, 1838.

———. *Notice sur divers appareils dynamométrique propres a mesurer l'effort ou le travail . . . la tension de la vapeur dans le cylindre des machines a vapeur a toutes les positions du piston.* 2nd ed. Paris: Mathias, 1841.

———. *Nouvelle expériences sur le frottement . . . faites à Metz.* 3 vols. Paris: Bachelier, 1832–35.

———. "Ueber zwei dynamometrische Apparate zum Messen der Kräfte welche von Triebkräften, denen Leben inwohnt, ausgeubt wird, und zum Messen der von ihnen vollbrachten Arbeit." *Dinglers Polytechnisches Journal* 65 (1837): 260–82.

Mosse, George. *The Image of Man: The Creation of Modern Masculinity.* New York: Oxford University Press, 1996.

Muecke, Frances. "'Taught by Love': The Origin of Painting Again." *Art Bulletin* 81 (1999): 297–302.

Müller, Johannes. *Handbuch der Physiologie des Menschen für Vorlesungen.* 2 vols. Coblenz: Hölscher, 1837; 4th ed. (Coblenz: Hölscher, 1844).

———. "Über den feinern Bau der krankhaften Geschwülste." *Monatsberichte der Königlichen Preussischen Akademie der Wissenschaften zu Berlin* 8 (1836): 107–113.

Müller-Wille, Staffan, and Katrin Böhme. "Biologie: Wissenschaft vom Werden, Wissenschaft im Werden." In Tenorth and Hoffman, *Genese der Disziplinen*, 425–46.

Muthmann, Friedrich. *Alexander von Humboldt und sein Naturbild im Spiegel der Goethezeit.* Zurich: Artemis, 1955.

Navier, Claude L. M. H. "Sur les principes du calcul et de l'établissement des machines et sur les moteurs." In Bernard Forest de Bélidor, *Architecture hydraulique; ou, L'Art de conduire, d'élever et de ménager les eaux pour les différents besoins de la vie*, edited by Claude L. M. H. Navier. Paris: Didot, 1819.

Neeff, C. E. "Das Blitzrad, ein Apparat zu rasch abwechselnden galvanischen Schliessungen und Trennungen." *AdP* 36 (1835): 352–66.

———. "Ueber das Verhältnis der elektrischen Polarität zu Licht und Wärme." *AdP* 66 (1845): 414–34.

———. "Ueber einen neuen Magnetoelektromotor." *AdP* 46 (1839): 104–9.

Neumann, Hans. *Heinrich Wilhelm Dove: Eine Naturforscher-Biographie.* Liegnitz: Krumbhaar, 1925.

Neumann-Redlin von Meding, Eberhard, and Klemens Adam. "Gotthilf Hagen (1797–1884): Der Reformator der Wasserbaukunst." In *Franz Ernst Neumann (1798–1895): Zum 200. Geburtstag des Mathematikers, Physikers und Kristallographen*, edited by Rudolf Fritsch et al. 196–219. Kaliningrad: Verlag Terra Baltica and Ludwig-Maximillians-Universität, 2005.

Neureuther, Eugen. *Randzeichnungen zu Goethes Balladen und Romanzen: Baierische Gebirgslieder.* 1829–1839. Second edition, 1855. Facsimile of the second edition, Unterschneidheim: Alfons Uhl, 1977.

Nottebohm, Friedrich Wilhelm, ed. *Chronik der Königlichen Gewerbe-Akademie zu Berlin.* Berlin: Königliches Ober-Hofbuchdruckerei, 1871.

———. *Hundert Jahre militärischen Prüfungsverfahrens: Die königlich preußische Ober-Militär-Prüfungskommission, 1808–1908.* Berlin: Ober-Militär-Prüfungskommission, 1908.

Nyhart, Lynn K. *Biology Takes Form: Animal Morphology and the German Universities, 1800–1900.* Chicago: University of Chicago Press, 1995.

———. *Modern Nature: The Rise of the Biological Perspective in Germany.* Chicago: University of Chicago Press, 2009.

———. "Natural History and the 'New' Biology." in Jardine, Secord, and Spary, *Cultures of Natural History*, 426–43.

Ohm, Georg Simon. *Die galvanische Kette, mathematisch bearbeitet.* Berlin: Riemann,

1827. Reprint with commentary by Lothar Dunsch. Berlin: Verlag der Wissenschaften, 1989.

———. *Gesammelte Abhandlungen*. Edited by Eugene Lommel. Leipzig: J. A. Barth, 1892. Reprint, Hamburg: Severus-Verlag, 2015.

———. "Noch ein Paar Worte über die Definition des Tones." *AdP* 62 (1844): 1–18; in Ohm, *Gesammelte Abhandlungen*, 634–49.

———. "Ueber die Definition des Tones, nebst daran geknüpfter Theorie der Sirene und ähnlicher tonbildender Vorrichtungen." *AdP* 59 (1843): 513–65. In Ohm, *Gesammelte Abhandlungen*, 587–633.

Olesko, Kathryn M. "Aesthetic Precision" In *Tensions and Convergences: Technological and Aesthetic Transformations of Society*, edited by Reinhard Heil, Andreas Kaminski, and Marcus Stippak, 37–46. Bielefeld: Transaction, 2006.

Olesko, Kathryn M., and Frederic L. Holmes. "Experiment, Quantification, and Discovery: Helmholtz's Early Physiological Researches, 1843–50." in Cahan, *Hemholtz*, 50–108.

Ostergard, Derek E., ed. *Along the Royal Road: Berlin and Potsdam in KPM Porcelain and Painting, 1815–1848*. New York: Bard Graduate Center for Studies in the Decorative Arts, Verwaltung der Staatlichen Schlösser und Gärten Berlin, 1993.

Ostländer, Elke. "Malerei des Biedermeier in Berlin." in Krieger and Ostländer, *Galerie der Romantik*, 140–61.

Otis, Laura. *Müller's Lab*. Oxford: Oxford University Press, 2007.

Pagel, Julius Leopold. "Ludwig Traube." *ADB* (1894). http://www.deutsche-biographie .de/pnd12248567X.html?anchor=adb.

Panofsky, Irwin. *Albrecht Dürer*. 2nd ed. 2 vols. Princeton, NJ: Princeton University Press, 1945.

Paret, Peter. *Art as History: Episodes in the Culture and Politics of Nineteenth-Century Germany.* Princeton, NJ: Princeton University Press, 1988.

———. *Clausewitz and the State: The Man, His Theories, and His Times.* 2nd ed. Princeton, NJ: Princeton University Press, 1985.

———. "Napoleon and the Revolution in War," in Paret, Craig, and Gilbert, *Makers of Modern Strategy*, 123–42.

———. *Yorck and the Era of Prussian Reform, 1807–1815*. Princeton, NJ: Princeton University Press, 1966.

Paret, Peter, Gordon A. Craig, and Felix Gilbert, eds. *Makers of Modern Strategy: From Machiavelli to the Nuclear Age.* Oxford: Clarendon, 1986.

Parsons, Charles. "Remarks on Pure Natural Science." In *Self and Nature in Kant's Philosophy*, edited by Allen W. Wood, 216–27. Ithaca, NY: Cornell University Press, 1984.

Peschken, Goerd. *Das Architektonische Lehrbuch: Karl Friedrich Schinkel.* Munich: Deutsche Kunstverlag, 1979.

Peschken-Eilsberger, Monika. "Das Schadow Haus und seine Bewohner, 1805–2008." *Schriftenreihe der Schadowgesellschaft* 11 (2009): 1–52.

Pestalozzi, Johann Heinrich, and Christoph Buss. *ABC der Anschauung; oder, Anschauungs-Lehre der Massverhältnisse.* Zurich: J. G. Cotta, 1803.

Phillips, Denise. *Acolytes of Nature: Defining Natural Science in Germany, 1770–1850.* Chicago: University of Chicago Press, 2012.

Pickstone, John V. *Ways of Knowing: A New History of Science, Technology, and Medicine.* Chicago: University of Chicago Press, 2001.

Pierenkemper, Toni, and Richard Tilly, *The German Economy during the Nineteenth Century.* New York: Berghahn Books, 2004.

Pierson, Kurt. *Die Beuth-Lokomotive von Borsig: Deutsche Eisenbahnen bis 1848.* Berlin: Museum für Verkehr und Technik, 1986.

Pohl, G. F. *Grundlegung der drei Kepler'schen Gesetze.* Breslau: Aderholz, 1845.

Poisson, Siméon Denis. *Traité de mécanique.* 2nd ed. 2 vols. Paris: Bachelier, 1833.

Poncelet, Jean-Victor. *Cours de mécanique appliquée aux machines.* Edited by M. X. Kretz (1836). Edited and with notes from the 1836 edition by M. X. Kretz, 2 vols., Paris: Gauthier-Villars, 1874.

———. *Cours de mécanique industrielle fait aux artistes et ouvriers messins, pendant les hivers de 1827–1829* Metz: Thiel, 1829.

———. *Introduction à la mécanique industrielle, physique et experimentale.* 2nd ed. Metz: Thiel, 1841.

Poten, Bernhard von. *Geschichte des Militär- Erziehungs- und Bildungswesens in den Länden deutscher Zunge.* Vol. 4, *Preussen.* Berlin: Hofmann, 1896.

Pouillet, Claude S. M. *Lehrbuch der Physik und Meteorologie.* Brunswick: Vieweg, 1847.

———. "Note sur un moyen de mesurer des intervalles de temps extrémement courts, comme la durée du choc des corps élastiques, celle du débandement des resorts, de l'inflammation de la poudre, etc.; et sur un moyen nouveau de comparer les intensités des courants électricques, soit permanent, soit instantanés." *Comptes Rendus* 19 (1844): 1384–89.

Priesdorff, K. von. *Soldatisches Führertum.* 10 vols. Hamburg, 1936–42.

Pringsheim, Peter. "Gustav Magnus." *Naturwissenschaften* 13 (1925): 49–52.

Prittwitz, Moritz von. *Die Kunst reich zu werden; oder, gemeinfassliche Darstellung der Volkswirtschaft.* Mannheim: H. Hoff, 1840.

———. "Ueber die Oekonomie der mechanishen Kräfte zu den Zwecken der Industrie." Pts. 1–3. *VdVBG* (1829): 188–218; (1835); 281–308; (1839); 136–56.

Prittwitz, Robert von. *Das v. Prittwitz'sche Adels-Geschlecht.* Breslau: W. G. Korn, 1870.

"Protocoll der Physikalischen Gesellschaft zu Berlin: 1845," [signed Dr. Beetz]. Akten vor 1945, 10001. Archiv der Deutschen Physikalischen Gesellschaft, Berlin.

Rave, Paul Ortwin. *Genius der Baukunst: Eine klassisch-romantische Bilderfolge an der Berliner Bauakademie von Karl Friedrich Schinkel.* Berlin: Gebrüder Mann, 1942.

———. *Karl Friedrich Schinkel, Berlin, erster Teil: Bauten für die Kunst Kirchen, Denkmalpflege; zweiter Teil: Stadtbaupläne, Brücken, Straßen, Tore, Plätze; dritter Teil: Bauten für Wissenschaft, Verwaltung, Heer, Wohnbau, und Denkmäler.* 2nd ed., 3 vols. Munich: Deutscher Kunstverlag, 1981.

Redondi, Pietro. *L'accueil des idées de Sadi Carnot et la technologie française de 1820–1860.* Paris: Vrin, 1980.

Regnier, Edmé. "Description et usage du dynamometer. . . ." *Journal de l'École Polytechnique* 2 (1798): 160–72, plate at 179.

Reichert, C. B. "Über den Furchungs-Process der Batrachier-Eier." *Müllers Archiv* (1841): 523–41.

Reihlen, Helmut. *Christian Peter Wilhelm Beuth: Eine Betrachtung zur preussischen Politik der Gewerbeförderung in der ersten Hälfte des 19. Jahrhunderts und zu den Drakeschen Beuth-Reliefs.* Berlin: Beuth, 1992.

Riemann, Bernhard. "Ueber die Darstellbarkeit einer Function durch eine trigonometrische Reihe." *Abhandlungen der Königlichen Gesellschaft der Wissenschaften zu Göttingen* 13 (1854). Reprinted in *Bernhard Riemann: Gesammelte mathematische Werke*, based on the edition prepared by Heinrich Weber and Richard Dedikind and newly edited by Raghavan Narasimhan, 227–64. Berlin: Springer, 1990:

Roberts, Steven. "20. The Instrument Gallery." In *Distant Writing: A History of the Telegraph Companies in Britain between 1838 and 1868.* http://distantwriting.co.uk/instruments.html.

Rosenblum, Robert. "The Origin of Painting: A Problem in the Iconography of Romantic Classicism." *Art Bulletin* 39 (1957): 279–90.

Rothenberg, Gunther E. "Maurice of Nassau, Gustavus Adolphus, Raimondo Montecuccoli, and the 'Military Revolution' of the Seventeenth Century." In Paret, Craig, and Gilbert, *Makers of Modern Strategy*, 32–63.

Rudwick, Martin J. S. *Bursting the Limits of Time: The Reconstruction of Geohistory in the Age of Revolution.* Chicago: University of Chicago Press, 2005.

———. "Minerals, Strata, and Fossils." In Jardine, Secord, and Spary, *Cultures of Natural History*, 266–86.

Say, Jean-Baptiste. *Cours complet d'économie politique pratique: Ouvrage destiné a mettre sous les yeux des hommes d'état, des propriétaires . . . et en géneral de tout les citoyens, l'économie des sociétés.* 2 vols. Paris: Rapilly, 1828–29.

Schadow, Johann Gottfried. "Ueber einige in den Propyläen abgedruckte Sätze Goethes. . . ." (1801). In *Gottfried Schadow: Aufsätze und Briefe*, edited by Julius Friedländer, 45–55. Stuttgart: Ebner und Seubert, 1890.

Scharfenort, Louis von. *Die Königlich Preußische Kriegsakademie, 15 October 1810–1910: Im dienstlichen Auftrag aus amtlichen Quellen dargestellt.* Berlin: Mittler, 1910.

Scharnhorst, Gerhard von. *Ausgewählte Schriften.* Osnabrück: Biblio, 1983.

———. "Entwicklung der allgemeinen Ursachen des Glücks der Franzosen in dem Revolutionskriege, und insbesondere in den Feldzügen von 1794" (1797). In Scharnhorst, *Ausgewählte Schriften*, 47–110.

Schatzberg, Eric. "*Technik* Comes to America: Changing Meanings of Technology before 1930." *Technology and Culture* 47 (2006): 486–512.

Schickert, Otto. *Die militärärztlichen Bildungsanstalten von ihrer Gründung bis zur*

Gegenwart: Festschrift zur Feier des hundertjährigen Bestehens des medizinisch-chirurgischen Friedrich Wilhelms-Institut. Berlin: E. S. Mittler und Sohn, 1895.

Schiemann, Gregor. "Die Hypothetisierung des Mechanismus bei Hermann von Helmholtz." In Krüger, *Universalgenie Helmholtz*, 149–67.

Schinkel, Karl Friedrich. "Bericht der Abtheilung für Baukunst und schöne Künste über die Lösung der Preisaufgabe betreffend eine Vermehrung des Verbauchs von Zink," *VdVBG* (1838): 21–22.

———. *Sammlung architektonischer Entwürfe.* Berlin: Ernst und Korn, 1866.

Schinkel, Karl Friedrich, and G. F. Waagen. "Über die Aufgaben der Berliner Galerie" (August 1828). In Friedrich Stock, "Urkunden zur Vorgeschichte des Berliner Museums." *Jahrbuch der Preußischen Kunstsammlungen* 51 (1930): 205–22.

Schmidgen, Henning. *Die Helmholtz-Kurven: Auf der Spur der verlorenen Zeit.* Berlin: Merve, 2009.

———. "Pictures, Preparations, and Living Processes: The Production of Immediate Visual Perception (*Anschauung*) in late-19th-Century Physiology." *Journal of the History of Biology* 37 (2004): 477–513.

Schmidgen, Henning, Peter Geimer, and Sven Dierig, eds. *Kultur im Experiment.* Berlin: Kadmos, 2004.

Schmiedebach, Heinz-Peter. "Pathologie bei Virchow und Traube: Experimental strategien in unterschiedlichem Kontext." In Hagner and Rheinberger, *Die Experimentalisierung des Lebens*, 116–34.

Schönemann, Heinz. "Peter Joseph Lenné in Berlin." In *Peter Joseph Lenné: Pläne für Berlin; Bestandskatalog der Lennépläne in der Plankammer der Staatlichen Schlösser und Gärten Potsdam-Sanssouci.* Pt. 2, *Berlin*, edited by Harri Günther and Sibylle Harksen, 3–11. Potsdam: Staatliche Schlösser und Gärten Potsdam-Sanssouci, 1984.

Schreier, Wolfgang. "Gustav Magnus und die Physikalische Gesellschaft zu Berlin: Ein ambivalentes Verhältnis." In Hoffmann, *Magnus und sein Haus*, 55–64.

Schreier, Wolfgang, Martin Franke, and Annett Fiedler. "Geschichte der Physikalischen Gesellschaft zu Berlin, 1845–1900." In *150 Jahre Deutsche Physikalische Gesellschaft*, edited by Theo Mayer-Kuckuk, F-9—F-60. Würzburg: Vogel Druck, 1995.

Schubarth, Ernst Ludwig. *Elemente der technischen Chemie, zum Gebrauch beim Unterricht im Königl. Gewerbinstitut und den Provinzial-Gewerbschulen.* Berlin: August Rücker, 1831.

Schubring, Gert. "Mathematics and Teacher Training: Plans for a Polytechnic in Berlin." *Historical Studies in the Physical Sciences* 12 (1981): 161–94.

Schulz, Bernhard. "Schinkels englische Reise: Wendepunkt oder Intermezzo? Die Industrie und die Poesie des Bauens." In Altcappenberg and Johannsen, *Schinkel*, 105–15.

Schumacher, H. C. "Beobachtungen mit den neuen Patent-Reflexions-Instrumenten der Herren *Pistor* und *Martins*." *Astronomische Nachrichten* 23 (1846): 321–40.

Schuster, Peter-Klaus. *Melencolia I: Dürers Denkbild.* 2 vols. Berlin: Mann, 1991.

Schütt, Hans-Werner. *Eilhard Mitscherlich: Baumeister am Fundament der Chemie.* Munich: Oldenbourg, 1992.

Schwann, Theodor. "Ueber die Gesetze der Muskelkraft." *Isis* (1837), col. 523–24.

Schwarz, Ingo, and Klaus Wenig, eds. *Briefwechsel zwischen Alexander von Humboldt und Emil du Bois-Reymond.* Berlin: Akademie Verlag, 1997.

Schwertfeger, Bernhard. *Die grossen Erzieher des deutschen Heeres: Aus der Geschichte der Kriegsakademie.* Potsdam: Athenion, 1936.

Segelken, Barbara. "Sammlungsgeschichte zwischen Leibniz und Humboldt." In Bredekamp, Brüning, and Weber, *Theater der Natur und Kunst: Essays*, 41–51.

Sheehan, James J. *German History, 1770–1866.* Oxford: Clarendon, 1989.

———. *Museums in the German Art World: From the End of the Old Regime to the Rise of Modernism.* Oxford: Oxford University Press, 2000.

———. "Von der fürstlichen Sammlung zum öffentlichen Museum: Zur Geschichte des deutschen Kunstmuseums." In Grote, *Macrocosmos*, 855–74.

Showalter, Dennis. "Prussia's Army: Continuity and Change, 1713–1830." In Dwyer, *Rise of Prussia*, 220–36.

———. *Railroads and Rifles: Soldiers, Technology, and the Unification of Germany.* Hamden, CT: Archon Books, 1975.

Shy, John. "Jomini." in Paret, Craig, and Gilbert, *Makers of Modern Strategy*, 143–85.

Sibum, Otto. "Experimentalists in the Republic of Letters." *Science in Context* 16 (2003): 89–120.

Siemens, Werner. "Anwendug des elektrischen Funkens zur Geschwindigkeitsmessung." *AdP* 66 (1845): 435–45. In Siemens, *Wissenschaftliche und technische Arbeiten*, 1:8–14.

———. "Beschreibung des Differenz-Regulators der Gebrüder Werner und Wilhelm Siemens." *Dinglers polytechnisches Journal* 98 (1845): 81–89. In Siemens, *Wissenschaftliche und technische Arbeiten*, 2:2–11.

———. *Lebenserinnerungen.* 3rd ed. Berlin: Springer, 1893.

———. "Patentgesuch auf eine neue Art elektrischer Telegraphen und eine damit verbundene Vorrichtung zum Druck der Depeschen." In Siemens, *Wissenschaftliche und technische Arbeiten*, 2:12–23.

———. "Preussisches Patent auf ein Verfahren, Gold behufs der Vergoldung auf nassem Weg vermittelst des galvanischen Stromes aufzulösen," 29 March 1842. In Siemens, *Wissenschaftliche und technische Arbeiten*, 2:1.

———. "Ueber die Umwandlung von Arbeitskraft ohne Anwendung permanenter Magnete." *Monatsberichte der Königlich Preussischen Akademie der Wisssenschaften* (1868): 55–58.

———. "Ueber Geschwindigkeitsmessung." *FdP* [*1845*] 1 (1847): 46–72.

———. *Wissenschaftliche und technische Arbeiten.* 2 vols. Berlin: Springer, 1891.

Sievers, Johannes. *Karl Friedrich Schinkel: Bauten für die Prinzen August, Friedrich und Albrecht von Preussen: Ein Beitrag zur Geschichte der Wilhelmstrasse in Berlin.* Berlin: Deutsche Kunstverlag, 1954.

Sikora, Michael. "Ueber die Veredelung des Soldaten: Positionsbestimmungen zwischen Militär und Aufklärung." *Aufklärung* 11 (1999): 25–50.

Smith, Crosbie. *The Science of Energy: A Cultural History of Energy Physics in Victorian Britain.* Chicago: University of Chicago Press, 1998.

Smith, Crosbie, and M. Norton Wise. *Energy and Empire: A Biographical Study of Lord Kelvin.* Cambridge: Cambridge University Press, 1989.

Spiker, S. H. *Berlin und seine Umgebungen im neunzehnten Jahrhundert.* Berlin: Gropius, 1833.

Stadelmann, Rudolph. *Scharnhorst: Schicksal und geistige Welt; Ein Fragment* (Wiesbaden: Limes, 1952).

Stamm-Kuhlmann, Thomas. "Restoration Prussia, 1796–1848." In Dwyer, *Modern Prussian History*, 43–65.

Steele, Brett D. "Muskets and Pendulums: Benjamin Robins, Leonard Euler, and the Ballistics Revolution." *Technology and Culture* 35 (1994): 348–82.

Stockhausen, Tilmann von. *Gemäldegalerie Berlin: Die Geschichte ihrer Erwerbungspolitik, 1830–1904.* Berlin: Nicolaische Verlagsbuchhandlung, 2000.

Straube, Hans Joachim. "Chr. P. Wilhelm Beuth." *Deutsches Museum. Abhandlungen und Berichte* 2 (1930): 117–52.

———. *Die Gewerbeförderung Preussens in der ersten Hälfte des 19. Jahrhunderts.* Berlin: VDI-Verlag, 1933.

Strecke, Reinhart. *Anfänge und Innovation der preussischen Bauverwaltung: Von David Gilly zu Karl Friedrich Schinkel.* Cologne: Böhlau, 2000.

Stübig, Heinz. *Scharnhorst: Die Reform des preussischen Heeres.* Göttingen: Muster-Schmidt, 1988.

Stürzbecher, Manfred. "Aus dem Briefwechsel des Physiologen Johannes Müller mit dem Preussischen Kultusministerium." *Janus* 49 (1960): 273–84.

———. "Zur Berufung Johannes Müllers an die Berliner Universität." *Jahrbuch für die Geschichte Mittel- und Ostdeutschlands* 21 (1972): 184–226.

Te Heesen, Anke. "Vom naturgeschichtlichen Investor zum Staatsdiener: Sammler und Sammlungen der Gesellschaft Naturforschender Freunde zu Berlin um 1800." In Te Heesen and Spary, *Sammeln als Wissen*, 62–84.

Te Heesen, Anke, and E. C. Spary. *Sammeln als Wissen: Das Sammeln und seine wissenschaftsgeschichtliche Bedeutung.* Göttingen: Wallstein, 2001.

Teja-Bach, Friedrich. *Struktur und Erscheinung: Untersuchungen zu Dürers graphischer Kunst.* Berlin: Gebrüder Mann, 1996.

Tenorth, Heinz-Elmar, with Volker Hess and Dieter Hoffman, eds. *Genese der Disziplinen: Die Konstitution der Universität.* Vol. 4 in Bruch and Tenorth, *Geschichte der Universität.*

Terrall, Mary. *Catching Nature in the Act: Réaumur and the Practice of Natural History in the Eighteenth Century.* Chicago: University of Chicago Press, 2014.

Tieck, Friedrich. *Verzeichniss der antiken Bildhauerwerke des Königlichen Museums zu Berlin.* Berlin: Akademie der Wissenschaften, 1833.

Todes, Daniel P. *Pavlov's Physiology Factory: Experiment, Interpretation, Laboratory Enterprise.* Baltimore: Johns Hopkins University Press, 2002.

Toulmin, Steven, and June Goodfield. *The Discovery of Time.* New York: Harper and Row, 1965.

Treitschke, Heinrich von. *Deutsche Geschichte im neunzehnten Jahrhundert.* Vol. 2, *Bis zu den Karlsbader Beschlüssen.* 6th ed. Leipzig: Hirzel, 1906.

Trempler, Jörg. *Schinkels Motive: Mit einem einleitenden Essay von Kurt W. Forster*. Berlin: Matthes und Seitz, 2007.

———. "Preussen als Kunstwerk: Schinkels Berliner Bauten." In Altcappenberg and Johannsen, *Schinkel*, 156–85.

Tresch, John. *The Romantic Machine: Utopian Science and Technology after Napoleon*. Chicago: University of Chicago Press, 2012.

Treue, Wilhelm, and Wolfgang König, eds. *Berlinische Lebensbilder*. Vol. 6, *Techniker*. Berlin: Colloquium Verlag, 1990.

Trischler, Helmut. "Das Technikmuseum im langen 19. Jahrhundert: Genese, Sammlungskultur und Problemlagen der Wissenskommunikation." In *Zur Geschichte der Museen im 19. Jahrhundert 1789–1918*, edited by Bernard Graf and Hanno Möbius, 81–92. Berlin: G + H Verlag, 2006.

Trost, Edit. *Eduard Gaertner*. Berlin: Henschel Verlag, 1991.

Trunz, Erich, ed. "Goethe als Sammler." In *Ein Tag aus Goethes Leben. Acht Studien zu Goethes Leben und Werk*, 72–100. Munich: Beck, 1990.

———, ed. *Goethes Werke: Hamburger Ausgabe in vierzehn Bände*. Vol. 1, *Gedichte und Epen I*. 12th ed. Munich: Beck, 1981.

Tuchman, Arleen, "Helmholtz and the German Medical Community." in Cahan, *Helmholtz*, 17–49.

Turner, R. Steven. "Consensus and Controversy: Helmholtz on the Visual Perception of Space." In Cahan, *Helmholtz*, 154–204.

———. "Hermann von Helmholtz and the Empiricist Vision." *Journal of the History of the Behavioral Sciences* 13 (1977): 48–58.

———. *In the Eye's Mind: Vision and the Helmholtz-Hering Controversy*. Princeton, NJ: Princeton University Press, 1994.

———. "Justus Liebig versus Prussian Chemistry: Reflections on Early Institute-Building in Germany." *Historical Studies in the Physical Sciences* 13 (1982): 129–62.

———. "The Ohm-Seebeck Dispute, Hermann von Helmholtz, and the Origins of Physiological Acoustics." *British Journal for the History of Science* 10 (1977): 1–24.

Valentin, Gabriel Gustav. *Lehrbuch der Physiologie des Menschen, für Aerzte und Studirende*. 2 vols. Brunswick: Vieweg, 1844.

Van Wezel, Elsa. "*Die Konzeptionen des Alten und Neuen Museums zu Berlin und das sich wandelnde historische Bewusstsein*. Jahrbuch der Berliner Museen, Beiheft 43. Berlin: Gebruder Mann, 2001.

Varentrapp, C. *Johannes Schulze und das höhere preussische Unterrichtswesen in seiner Zeit*. Leipzig: 1889.

Vatin, Francois. *Le travail: economie et physique, 1780–1830*. Paris: Presses Universitaires de France, 1993.

Verzeichniss der von Sr. Excellenz dem Wirkl. Geheimen Rath Beuth hinterlassenen Bibliothek, Gemälde und Antiquitäten. Berlin: Trowitzsch, 1854. Auction catalog.

Vogtherr, Christoph Martin. *Das königliche Museum zu Berlin: Planungen und Konzeption des ersten Berliner Kunstmuseums*. Jahrbuch der Berliner Museen, Beiheft 39. Berlin: Gebruder Mann, 1997.

———. *Zwischen Norm und Kunstgeschichte: Wilhelm von Humboldts Denkschrift von 1829 zur Hängung in der Berliner Gemäldegalerie. Jahrbuch der Berliner Museen* 34 (1992): 53–64.

Volkmann, A. W. *Streifzüge im Gebiete der exacten Physiologie: Eine Streitschrift gegen Herrn Professor G. Valentin.* Leipzig: Breitkopf und Haertel, 1847.

Vorsteher, Dieter. "August Borsig." In Treue and König, *Techniker*, 85–96.

———. *Borsig: Eisengiesserei und Maschinenbauanstalt zu Berlin.* Berlin: Siedler, 1983.

Voth, Hans-Joachim. "The Prussian Zollverein and the Bid for Economic Superiority." In Dwyer, *Modern Prussian History*, 109–25.

Waagen, G. F. *Verzeichniss der Gemälde-Sammlung des Königlichen Museums zu Berlin.* 4th ed. Berlin: Akademie der Wissenschaften, 1833.

Wahrig, Gerhard. *Deutsches Wörterbuch.* Gütersloh: Bertelsmann, 1979.

Warburg, E. "Zur Geschichte der Physikalischen Gesellschaft." *Die Naturwissenschaften* 13 (1925): 35–39.

———. "Zur Erinnerung an Gustav Kirchhoff." *Die Naturwissenschaften* 13 (1925): 205–12.

Weber, Eduard. "Muskelbewegung." In *Handwörterbuch der Physiologie mit Rucksicht auf physiologische Pathologie*, edited by Rudolph Wagner, vol. 3, pt. 2, 1–122. Brunswick: Vieweg, 1846.

Weber, Heinrich. *Wegweiser durch die wichtigsten technischen Werkstätten der Residenz Berlin.* 2 vols. Berlin: 1819–20.

Weber, Wilhelm. "Elektrodynamische Maassbestimmungen: Ueber ein allgemeines Grundgesetz der elektrischen Wirkung." In *Abhandlungen bei Begründung der kaiserlichen sächsischen Gesellschaft der Wissenschaften.* Leipzig: 1846. Also in *Wilhelm Webers Werke*, vol. 3, 25–214. Berlin: J. Springer, 1892–94.

Wesenberg, Angelika, ed. *Nationalgalerie Berlin: Das XIX. Jahrhundert: Katalog.* 5th ed. Berlin: Nationalgalerie, Staatliche Museen Preussischer Kulturbesitz, 2012.

White, Charles Edward. *The Enlightened Soldier: Scharnhorst and the* Militärische Gesellschaft *in Berlin, 1801–1805.* New York: Praeger, 1989.

Wiedemann, Gustav. "Feier des 50-jährigen Stiftungsfestes. . . ." *Verhandlungen der Physiologischen Gesellschaft zu Berlin* 15 (1896): 32–36.

Wille, Hans. "Die Erfindung der Zeichnenkunst." In *Beiträge zur Kunstgeschichte: Eine Festgabe für H. R. Rosemann*, edited by Ernst Guldan, 279–300. Munich: Deutscher Kunstverlag, 1960.

Wirth, Irmgard. *Berliner Malerei im 19. Jahrhundert: Von der Zeit Friedrichs des Grossen bis zum ersten Weltkrieg.* Berlin: Siedler, 1990.

Wise, M. Norton. "Architectures for Steam." In *The Architecture of Science*, edited by Peter Galison and Emily Thompson, 107–40. Cambridge, MA, MIT Press, 1999.

———. "German Concepts of Force, Energy, and the Electromagnetic Ether: 1845-1880." In *History of Ether Theories in Modern Science*, edited by G. N. Cantor and M. J. S. Hodge, 269-307. Cambridge: Cambridge University Press, 1981.

———. "Mediations: Enlightenment Balancing Acts; or, the Technologies of Rationalism." In *World Changes: Thomas Kuhn and the Nature of Science*, edited by Paul Horwich, 207–56. Cambridge, MA; MIT Press, 1992.

———. "The Mutual Embrace of Electricity and Magnetism." *Science* 203 (1979): 1310–18.

———. *Neo-Classical Aesthetics of Art and Science: Hermann Helmholtz and the Frog-Drawing Machine*, Hans Rausing Lecture 2007, Uppsala University. Uppsala: Tryck Wikströms, 2008.

———. "Time Discovered and Time Gendered in Victorian Science and Culture." In *Energy to Information: Representation in Science, Art, and Literature*, edited by Bruce Clarke and Linda Henderson, 39–58. Stanford, CA: Stanford University Press, 2002.

———. "What's in a Line?" Rothschild Distinguished Lecture, Harvard University, 2001. In *Cultures and Politics of Research from the Early Modern Period to the Age of Extremes*, vol. 1 of *Science as Cultural Practice*, edited by Moritz Epple and Claus Zittel, 61–102. Berlin: Akademie Verlag, 2010.

———, with the collaboration of Crosbie Smith. "Work and Waste: Political Economy and Natural Philosophy in Nineteenth Century Britain." *History of Science*, 27 (1989): pt. 1, 263-301; pt. 2, 391-449; pt. 3, 28 (1990): 221–61.

Wise, M. Norton, and Elaine M. Wise. "Staging an Empire." In *Things That Talk*, edited by Lorraine Daston, 101–145, 391–399. Cambridge: Zone Books, 2003.

Wolff, F. *Lehrbuch der Geometrie: Leitfaden für den Unterricht am Königl. Gewerbe-Institut. Dritter Theil, Analytische und höhere Geometrie.* Berlin: Petsch, 1838.

Wolff, Stefan L. "Clausius' Weg zur kinetischen Gastheorie." *Sudhoffs Archiv* 79 (1995): 54–72.

———. "Gustav Magnus: Ein Chemiker prägt die Berliner Physik." In Hoffmann, *Magnus und sein Haus*, 11–32.

Wolzogen, Alfred von. *Aus Schinkels Nachlaß.* 4 vols. Berlin: R. Decker, 1862–64.

Youschkevitch, A. P. "The Concept of Function up to the Middle of the 19th Century." *Archive for the History of Exact Sciences* 16 (1976): 37–85.

Zaun, Jörg. "Pistor & Martins, die Erbauer der Berliner Meridiankreise." In *300 Jahre Astronomie in Berlin und Potsdam*, edited by W. R. Dick and Klaus Fritze, 91–106. Thun: Deutsch, 2000.

Ziolkowski, Theodore. *German Romanticism and Its Institutions.* Princeton, NJ: Princeton University Press, 1990.

Zu der öffentlichen Prüfung der Zöglinge des Cölnischen Real-Gymnasii . . . ehrerbietigst einladet der Director. Berlin: C. Feister, 1831.

Zu der öffentlichen Prüfung der Zöglinge des hiesigen Königlichen Gymnasiums . . . laden ganz ergebenst ein Director und Lehrercollegium. Potsdam: Deckersche Geheime Oberhofdruckerei, 1833, 1837.

Zu der öffentlichen Prüfung der Zöglinge des Königlichen Friedrich-Wilhelms-Gymnasium . . . ladet ehrerbietigst ein der Director. Berlin, 1838.

INDEX

ABC der Anschauung (Pestalozzi), 162, 305

Accum, Friedrich Christian, 54

aesthetics: architecture and, 4–7, 16–29, 39–42, *43*, *57–58*, 106–7; *Bildung* and, x, xiii, xiv, xvi, 5, 17–19, 22, 25, 31, 35, 76, 113, 116, 120, 124, 163, 354; color theories and, 29, *30*; Helmholtz's values and, 346–51; Humboldt and, 33–34, 174–80, 246; neoclassicism and, 156–67. *See also* curves; descriptive geometry; *Energie* (Helmholtz's concept of); line

"Aesthetic View from Pegasus" (Brose), 17

Akademie der Künste, xvii, xx, 10–11, 25–26, *26*, 28–32, 43–48, 106, 109, 148–66, 301, 311

Akademie der Wissenschaften, 19, 31, 33–34, 44, 48, 52, 121, 203, 206, 236

Alexandra, Czarina, 1, 137

Allgemeine Bauschule. *See* Bauschule

Allgemeine Encyklopädie der Physik (Karsten), 302

Altenstein, Karl Freiherr von, 7, 10, 44–47, 134, 209

Altes Museum, 17, 21, *23*, 24, 28–29, 32–33, 38–39, *40*, 51, 158, 164, 304

Analytical Theory of Heat (Fourier), 179

Anatomical Institute, 204

Anatomical Museum, 32, 35, 135, 204–5

Andersonian Institute, 96

Anfänge und Innovation (Strecke), 64n59, 64n65

Animal Chemistry (Liebig). *See* Liebig, Justus

Animal Electricity (Du Bois-Reymond). *See Untersuchungen über Thierische Elekricität* (Du Bois-Reymond)

Annalen der Physik, x, 266

Anschaulichkeit, 304, 334, 351

Anschauung, xx, 122, 159, 162, 166, 185, 234, 300–306, 311, 323, 347–48. *See also Verständlichkeit*

Anstalt für künstliche Mineralwasser, 217–18

Apollo Musagetes, 23, 184

Arbeit. See work

Archduke Nicholas (Czar Nicholas I), 1, 3, 109

architecture, 4–7, 16–29, 39–42, *43*, *57–58*, 106–7. *See also Parade auf dem Opernplatz* (Krüger)

Artillerie- und Ingenieurschule, xviii, 105–10; curriculum of, 131–32, *132*, 136; formation of, 123; liberalism and the, 128; pedagogical methods of, 124–25, 130, 166, 210; resources for, 209–10; separation from the Kriegsschule, 123–24

Artillery Testing Commission, xvii, 137, 140, 228

August of Prussia (prince), 9, 106–8, 113, 123, 128–30

Austrian War of 1866, 127

Babbage, Charles, 230

Backstein. See brick construction

Baeyer, Adolf von, 94

ballistic pendulum, 141

barometric pressure measurements, 173–74

Baron, Hans, xiii

Bauakademie, 42–48, 52–55, 64n59. *See also* Bauschule

Bauer, Karoline, 9, 12

Bauschule, xiv–xv; collections of, 65n82, 66n84; construction of, 41–42, 55, 57; curriculum and instructors of, 47–48, *49–50*, 51, 53, 136, 167; formation of the Technical University and, 84; purpose of, 9. *See also* Bauakademie; *and specific instructors*

Dibutades, 157, 159, 161–62

Die Bauakademie (Gaertner), *41*

Die Eisengiesserei and Maschinenbauanstalt von A. Borsig (Biermann), *88*

Die Giesserei und die Werkstätten von Borsig im Jahre 1837 (Biermann), *86*

Die Helmholtz-Kurven (Schmidgen). *See* Schmidgen, Henning

Die Klosterstrasse (Gaertner), *69*

Die Konzeptionen (Van Wezel). *See* van Wezel, Elsa

"Die 'Methode der Kurven'" (De Chadarevian), 337n4

Dierig, Sven, 182, 189, 195, 235–36

Die Wahlverwandschaften (Goethe), *29*

Die Wärme als Maass der Cohäsion (Wilhelmy), 253

differential governor, 138–40, *139*

Dirichlet, Gustav Lejeune, xv, xvi, 52–53, 84, 124, 169–74, 179, 270, 354

division of mental labor, 230

Dohna-Schlobitten, Friedrich Karl von, 115

Dove, Heinrich Wilhelm: impact of, on the Berlin Physical Society, 180; laws of meteorology of, 179; marriage of, 123; *Repertorium der Physik* and, 170–72, 270; study of barometric pressure by, 173–74; teaching of, 94, 207, 211–12, 239n23, 270; use of curves by, 234; work of, with Humboldt, 176

Draper, J. W., 226

drawing instruction, 28, 44, 51–52, 106–7, 300. *See also* descriptive geometry; Helmholtz, Hermann

duality. *See* quantity-intensity duality

Du Bois-Reymond, Emil: artistic talent of, 148–51; Berlin Physical Society and, xvii, 8, 205; division of labor in the Society, 226–35; drawing practice of, 154, 156–57, 185–91, 351–53; electrophysiology of frog muscles and, 180–85, 233; microsocopic anatomy and, 205, 217; petition to the

Academy of Sciences by, 236; relationship of, with Helmhotz, 253–56, 319–20; reviews in the *Fortschritte* by, 224–25

Dühring, Eugen, 236

Dupin, Charles, 53, 77–78, 96

Dürer, Albrecht, 150–67, *186*

Dürerfest, 153–54, *154, 157*

Duve, F., 217, 237

dynamometers, 93, 141, 272–74, *273*, 277, 295nn86–87, 306–8, 313

École polytechnique, 6, 43, 53, 109, 117, 130, 268

"Economy of Mechanical Forces for the Purposes of Industry" (Prittwitz), 90

education. *See Bildung; and specific institutions*

Egells, Franz Anton, 40, 84–85, 103n46

Ehrenberg, Christian Gottfried, 35

Eichhorn, Karl Friedrich von, ix, 195

"Eighteenth Century, The" (von Humboldt), 24

"Eine École Polytechnique" (Manegold), 65n74

elasticity of steam, 224, 227

electrical chronoscope, 141–43, *142*, 330

electrical stimulation of nerves and muscles, 181–82, 231, 242n71, 332

electromagnetic chronoscope. *See* electrical chronoscope

electromagnetic induction, 233

electrophysiology, 229

electroplating, 136–37. See also *Galvanoplastik*

electrostatic circuits, 141

Electrotypie. See *Galvanoplastik*

Elemente der technischen Chemie (Schubarth), 54

Elkana, Jehuda, 280

Elkington, G. R., 137

Emil du Bois-Reymond (Finkelstein), 194n53

Encke, J. F., 214

quantity-intensity duality, xix, 247, 250, 257, 268, 272–80; in Kantian reading, 280–81; in muscle contraction, 312, 316–17, 336

Quesnevilles révue scientifique et industrielle, 226, 229

Quincke, Georg Hermann, 94

Radicke, F. W. G., 226

Radowitz, Joseph Maria von, 130–33

Randzeichnungen zum Gebetbuch Maximilians (Dürer), *155*, *158*

Rauch, Christian Daniel, 5, 10, 16, 68, 110, 164

Rauch, Gustav von, 9, 106, 123, 136

Réaumur, R. A. F., 35

Récamier, Julie, 107

reflection and refraction of radiant heat, 231

Regnault, Victor, 224

Regnier, Edmé, 273

Rekoss, Egbert, 321, 330–31

Repertorium der Physik, 170–72, 180, 211, 270

Revolution of 1848, xii, 87, 130, 222, 236–37

Riemann, Bernhard, 171–72

Rohrbeck, W. J., 219, *219*, 220

Romantic Machine (Tresch), 61n26, 127

Rose, Gustav, 33–35, 54

Rose, Heinrich, 33

rotating cylinder (principle of), 330

Rüchel, Ernst Friedrich von, 114

Rudolphi, Karl Asmund, 35

Rumohr, Carl-Friedrich von, 27

Rupp, Gerhard, 192n11

Saint-Venant, Adhémar Barré de, 266

Say, Jean-Baptiste, 77–78, 90–91, 130

Schadow, Johann Gottfried, 11, 16, 46, 152–53, 159, 164

Scharnhorst, Gerhart von, xvi, 5, 6, 7, 10–11, 45, 110–13, 115–18, 122, 128

Scharnhorst, Wilhelm von, 136

"Schattenwürfe eines Gebälks" (Hallman), *167*

Schauspielhaus, 19–21, *20–21*

Schelling, Friedrich Wilhelm Joseph, 25, 29

Schiek, F. W., 216–17, 239n12

Schinkel (Bergdoll), 60n21

Schinkel, Karl Friedrich, xiv, 25–27, 36, 97–99; architectural work of, 4–7, 16–29, 39–42, *43*, *57–58*, 106–7; artwork of, *55–58*, *72*, *76–77*, *98–99*, 151, *152*, 158, 354–56; *Die Klosterstrasse* and, 68; *Parade* and, 9; role of, in the Gewerbeverein, 87, 164. *See also specific works*

Schinkels Motive (Trempler), 63n52

Schlechtendal, D. F. L., 35

Schlegel, Friedrich, 28–29

Schleiden, Matthias, 206

Schleiermacher, Friedrich, 29

Schlemm, Friedrich, 204

Schloss Bellevue (Gaertner), *106*

Schmidgen, Henning, 337n5, 342n63, 343n66, 344n97

School of Athens, The (Raphael), 189

Schopenhauer, Arthur, 29

Schubarth, Ernst Ludwig, 53–54, 84, 89, 209

Schulze, Johannes, 124, 128, 134, 146n44

Schwann, Theodor, 206, 233, 247, 306–7

science: *Begreiflichkeit* and, xix, xx, 246, 258–60, 280–81, 287, 347; measurement and, 33–35, 92–94, 141–42, 173–79, 197, 214–16, 225–33, 241n60, 249–50, 270, 285. *See also* Berlin Physical Society; engineering; Helmholtz, Hermann; Humboldt, Alexander von; physics

Second Industrial Revolution, xii

self-registering instruments, 143, 184–85, 272, 313, 330–33

Seydlitz, E. L. A. F. K. von, 81

"Shifting Ontologies" (Klein), 63n47

Sibum, Otto, 195, 236, 294n78

Siemens, Werner, xvi–xvii, 9, 87, 108, 135–43, 166, 216, 218–19, 228–30, 236